PATRONS AND PAINTERS

PATRONS AND PAINTERS

A Study in the Relations
Between Italian Art and Society
in the Age of the Baroque

REVISED AND ENLARGED EDITION

FRANCIS HASKELL

YALE UNIVERSITY PRESS
NEW HAVEN AND LONDON
1980

For Larissa

and my friends in Italy

Printed in the United States of America
by the Murray Printing Company, Westford, Mass.

Published in Great Britain, Europe, Africa, and Asia (except Japan) by Yale University Press, Ltd.,
London. Distributed in Australia and New Zealand by Book & Film Services, Artarmon, N.S.W.,
Australia; and in Japan by Harper & Row, Publishers, Tokyo Office.

Library of Congress Cataloging in Publication Data

Haskell, Francis, 1928-
 Patrons and painters.

 Bibliography: p.
 Includes index.
 1. Art, Italian. 2. Art, Baroque—Italy.
3. Art patrons. 4. Art and society. I. Title.
N6916.H37 1980 709'.45 80-5213
ISBN 0-300-02537-8
ISBN 0-300-02540-8 (pbk.)

Preface to Second Edition

——————⊃∘◎∘⊂——————

SINCE *Patrons and Painters* was first published in 1963 a very great deal has been written about seventeenth- and eighteenth-century Italian art (though much less about the social and economic history of the period) and as my own interests have sometimes strayed from the field, I have certainly not been able to keep abreast of all new developments. However, although many of the emphases in *Patrons and Painters* would necessarily be very different were I now writing the book for the first time, I have the impression that there has not appeared any radically different interpretation of the whole period and that there has only been published one criticism of it so substantial that I feel the need to discuss it at some length.

I have, therefore, thought it best to respond to the challenge of a new edition in three separate ways. I have corrected in the text itself such errors of fact and judgement (as well as misprints) as can be altered without difficulty—a process which I began in the Italian edition of 1966. I have in a new introduction tried to face the specific problem to which I have just referred. And, rather than incorporate new material into the substance of the book itself and thus seriously distort the structure of the original narrative, I have in a postscript devoted an extended commentary to those new publications, or publications newly seen by me, which have a direct bearing on its theme—and where possible I have estimated as fairly as I can the impact made by this new material on my original arguments. In this section I have not aimed to mention works, however intrinsically important, on the art of the seventeenth and eighteenth centuries which are not immediately relevant to my purpose, and this has meant the conscious exclusion of many significant monographs. Nor have I made references to the excellent *Dizionario biografico degli Italiani* which has begun appearing over the last few years because I have taken it for granted that anyone interested in the figures I describe will want to make use of it as, like some noble glacier, it slowly moves down the alphabet. I am, however, all too aware that I will have omitted many other contributions that should have been included, and for this I apologise both to the authors concerned and to the readers of this new edition. For the sake of convenience I have divided my commentary according to the original chapters, and the publications mentioned in the notes to it have been incorporated into a new bibliography covering the whole book. The index also has been revised to take this additional material into account.

By far the most gratifying part of what has necessarily been a difficult and somewhat tendentious labour of revision has been the discovery of how many pictures which in 1963 were only known to me from documentary sources have subsequently come to light, and I am very happy to be able to add reproductions of a number of these to my original illustrations.

I am deeply grateful to the directors of Chatto and Windus (and especially to Mrs Norah Smallwood) for the constant support and encouragement I received from them when we worked together on the first handsome edition of this book. And I would also like to thank John Nicoll for proposing a new edition and for giving me so much help over it. Robert Enggass, Howard Hibbard and especially Anthony Blunt stand out among the many people who have pointed out to me some of my more glaring mistakes, and I am most grateful to them as well as to Bruce Boucher, Marco Chiarini, Ann Sutherland Harris, Pierre Rosenberg and Marianne Roland-Michel for suggestions in the preparation of my bibliography and illustrations and for help in many other ways.

One special cause of sadness has marred my satisfaction in preparing this new edition: the deaths of Tim Munby and Ben Nicolson, two very close friends to whom I turned so often for advice when writing this book, and the lack of whose assistance will certainly make itself felt in the present version.

Oxford,
November 1979

Preface to First Edition

————⊃∘◎∘⊂————

ONE of the problems that has caused me most trouble in preparing this book has been the choice of a suitable title. It is because the present one is so inadequate that I have found it essential to write a short explanatory preface.

For the sake of convenience I have termed 'Baroque' that whole phase of Italian art which came into being in Rome early in the seventeenth century, reached a climax during the pontificate of Urban VIII and lingered on in Venice until the downfall of the Republic. However, I soon saw that a mere list of the art patrons and their collections during this period would have filled much of this book and that rigorous selection was essential. Here I was faced with a vital problem of method. Should my concern with patrons be determined by the intrinsic interest of their personalities and tastes or by the quality and importance of the art they commissioned—for the two do not always coincide? Inevitably I was forced to compromise and in so doing I ran into some obvious difficulties. The chief of these was the relative amount of space to be allotted to the various figures with whom I was dealing. Every reader will see that very often —and especially in Part 2—this bears little relation to the actual merit of the work for which they were responsible. But this is not intended to be a history of painting, and it seems to me that some men and organisations were of such importance in helping to prepare the ground for later developments, and have been so little studied, that the method I have adopted is the correct one. And by accepting a compromise I soon found a pattern which governed my general principles of selection.

The first section of the book deals entirely with Rome and, for the most part, with the pontificate of Urban VIII and the various forces that helped to mould taste during his rule. After a chapter describing the relative decline of Rome I then leave the city altogether, never to return. This decision to neglect eighteenth-century Rome was a difficult one, and it has troubled some of those who have read this book in its early stages. Yet I believe it to be justified on the grounds that no new type of patronage emerged during the earlier years of the period and that thereafter, with the dawning of neo-classicism, a different artistic style began to emerge which could not legitimately be studied in a book which is essentially concerned with the Baroque.

The whole of the middle section deals with the vacuum that resulted from the decline of Rome. In these two chapters I am concerned to show that the most significant developments in art were largely fostered by two new and very different kinds of patron from any considered in the earlier part of the book: the foreigners, who now for the first time made an overwhelming impact on Italian painters, and a number of isolated individuals in remote provincial towns who built up small collections of contemporary art. These men I believe to be important because they inherited what had been the most fruitful elements in Roman patronage—its international character and its

refusal to be bound by dogmatic principles. There was, it is true, a coarsening of this inheritance, and except for Grand Prince Ferdinand of Tuscany none of them showed the delicacy and sureness of taste that had once been the glory of the great metropolitan patrons. None the less, it was their reaction against (or at least their ignorance of) contemporary, and now sterile Roman principles, and their appreciation of Neapolitan 'anti-classical' painting that prepared the ground for a new surge of the Baroque which spread from Venice to many parts of Europe.

The last part of the book is entirely concerned with the rise and fall of this great phase of Italian art. After the earlier chapters, in which the subject is treated in depth, I have adopted a more narrative form to show the encroachments into the Baroque of the neo-classical and other styles brought about by economic causes and new social ideas. It is because of this that in these later chapters I have gone beyond my title and have discussed architecture, sculpture and even gardens as well as painting. This was necessary because in my opinion many of the most interesting patrons of the period were deliberately turning their backs on painting since they no longer found in it a suitable medium for the expression of their 'enlightened' beliefs—a situation not un-familiar in our own times. When planning this last section I was worried because the final chapters became shorter and shorter and followed each other in quick succession before petering out altogether. But this now seems to me to reflect with such perfect accuracy the actual situation of painting at the time that I decided not to manipulate the material in any other way despite its inelegant appearance.

Any attempt to 'explain' art in terms of patronage has been deliberately avoided. I have also fought shy of generalisations and have tried to be severely empirical—even at the cost of shirking certain problems which have deeply interested me and which I know to be vital. Inevitably I have been forced to think again and again about the relations between art and society, but nothing in my researches has convinced me of the existence of underlying laws which will be valid in all circumstances. At times the connections between economic or political conditions and a certain style have seemed particularly close; at other times I have been unable to detect anything more than the internal logic of artistic development, personal whim or the workings of chance. I hope that the bringing together of so much material may inspire others to find a synthesis where I have been unable to do so. Nor have I gone to the opposite extreme and tried to trace or describe all the pictures to which I have referred. With few excep-tions the most general knowledge of an artist's style is all that is required to appreciate the points that are made about the tastes of particular patrons.

Although my publishers have been most generous, the illustrations are far fewer ideally than I would have wished. But much care has gone into their arrangement in the hope that each Plate will in itself help to explain many of the arguments which are more laboriously elaborated in the text. Here too this has sometimes resulted in a grotesque disproportion between merit and available space, and the reluctant omission of a number of masterpieces. I am deeply grateful to my friend Dr Enzo Crea of Rome for the trouble he has taken in helping me to organise this side of the book.

In writing about a subject which falls half way between History and Art History I am well aware of the risks I run in disappointing readers who are interested in either of these branches of knowledge. It is difficult to keep abreast of research in two fields, especially to-day when seventeenth-century studies are so active. But whatever the deficiencies of the final result I have no doubt whatsoever about the value of the attempt or the enjoyment I have derived from making it. Much of this enjoyment has sprung from the large number of friends I have made in Italy and England over the last few years, so many of whom have given me the most generous help.

All the libraries and archives which are referred to on a later page have received me with great kindness, and to these I would like to add especially the library of the Warburg Institute in London where I have always received so much encouragement and advice from everyone concerned with that great organisation. I am also deeply indebted to the Provost and Fellows of my own College who have made it possible for me to undertake and continue this book over a very much longer period than they originally bargained for. Mr A. N. L. Munby, the librarian, has solved countless problems for me and Mr G. H. W. Rylands has read much of the typescript and the whole book in proof and made many suggestions and corrections. I would like, too, to thank Mrs Elizabeth Orna for the trouble she took in compiling a full and necessarily rather complicated Index; and Messrs T. and A. Constable Ltd., the printers of the book, for their great care in setting and checking my text.

I have benefited from conversations with so many people that it is impossible to thank them all and I apologise to all who have been inadvertently omitted. In Italy I would like to single out especially Dr Terisio Pignatti, who has given me such marvellous facilities for working in the Correr Library in Venice, Dr Alessandro Bettagno, Dr Gianfranco Torcellan, Professors Franco Venturi and Gaetano Cozzi, and—above all—Professor Alessandro Marabottini Marabotti, in whose company I have seen so many of the works discussed and whose repeated hospitality has made the writing of this book such a pleasure. In England I am especially grateful to Professor Ellis Waterhouse, Mr Denis Mahon and Mr Peter Calvocoressi, all of whom have read the typescript and greatly improved it, to Professor Nikolaus Pevsner, who first interested me in the subject of art patronage, and to Sir Anthony Blunt and Mr Michael Levey, with whom I have had so many stimulating discussions. But my greatest debt of all is to Mr. Benedict Nicolson who has taken endless trouble with my text at every stage and whose encouraging but severe attitude has helped me more than I can express.

FRANCIS HASKELL

King's College,
Cambridge,
July 1962

Contents

List of Plates

—◦◉◦—

Photographic Sources

Where not otherwise indicated, photographs have been supplied by the
various museums, galleries, etc.

Agraci, Paris: 19a, 25; Annan, Glasgow: 35b; Balelli: 33b; Böhm, Venice: 41b, 44; Cacco, Venice: 48b, 48d, 55b, 60, 62; R. B. Fleming: 46; John R. Freeman: 36a, 48a, 57b; Gabinetto Fotografico Nazionale: 10b, 12, 15; Gilchrist, Leeds: 32b; Malborough Fine Art Ltd: 24; Ministry of Works: 29; Mansell-Alinari: 2a, 2b, 4a, 4b, 5, 6, 7, 8, 14, 21a, 22b, 23a, 32a, 36b, 37a, 37b, 37c, 40b, 41a, 42a; Mansell-Anderson: 10a, 13, 21b; National Gallery: 34, 52b; National Portrait Gallery: 52a; Rossi, Venice: 58a; Royal Academy: 3b, 30a, 30b, 31a, 31b, 47, 49b, 51, 54, 61b; Oscar Savio: 1, 11a, 11b, 16; Service de Documentation Photographique des Musées Nationaux, Paris: 27b; Soprintendenza alle Gallerie, Florence: 38a, 38b, 39, 40a; Stearn and Son, Cambridge: 17b, 26a, 28b, 55, 56, 63; Turners of Cambridge: 3a, 17c, 18a; University Library, Cambridge: 9, 57a; Villani, Bologna: 28a; Eberhard Zwicker, Würzburg: 50.

Introduction to Second Edition

THE most serious objection made to this book concerns its treatment (or rather lack of treatment) of eighteenth-century Rome. My original preface shows that I was aware of this potential weakness from the first, and in a generous review Hugh Honour pointed out that I preserved 'a charmingly old-fashioned distaste for Neo-classicism'.[1] Since then I have overcome this distaste and I would now certainly modify the tone of my few comments on the art of the second half of the eighteenth century. More to the point, however, is the issue of whether my 'anti-Roman' prejudices falsified my historical sense. Ellis Waterhouse has suggested that they did.

In an article, whose central theme was to refute Rudolf Wittkower's claim that 'the history of Italian eighteenth-century painting is, above all, the history of Venetian painting', Waterhouse commented that my 'splendid book has a fundamental defect in the author's desire to bring the great period of Roman patronage to an end about 1700, in order to support the view that this was taken over by other parts of Italy, in particular Venice'. Waterhouse emphasised that 'a number of the ablest painters in Italy, Conca, Giaquinto and Batoni for instance, moved to Rome from Naples or Tuscany; and the argument used by Francis Haskell to support the thesis of a decline of Rome in the eighteenth century from the fact that such minor personalities as P. G. Piola, Viani, or Lazzarini, refused to settle in Rome, though strongly pressed, is more likely to be explained by the fact that they feared competition. In the seventeenth century, Guido and Guercino, for instance, had refused to stay in Rome, at a time when this argument would have been absurd.'[2]

This criticism must certainly carry much weight, and I have thought about it carefully. In the end, however, I find it unpersuasive. The list of distinguished Italian artists who (unlike Guido and Guercino much earlier) either failed to paint anything of consequence for the principal churches and palaces of Rome or did not even visit the city as other than tourists is a formidable one—it includes Crespi and Solimena, to name only two who are surely superior to Conca who arrived in 1707 and did not receive his first public commission for seven years. Giaquinto and Batoni came only a generation later by which time the situation had begun to change—but by which time also Tiepolo was embarking on some of his most splendid works in the Veneto.

'Innocent XI (1676-1689) went to great efforts to keep money from the arts and he succeeded as no post-renaissance pope ever had', it has recently been claimed,[3] and though the situation improved after his death it remained bleak. Clement XI (1700-1721) 'kept himself free from all nepotism', which may be a relief for a modern historian of the papacy[4] but cannot have been very encouraging for painters looking for employment, and it is surely clear beyond doubt that the attractions of Rome as a centre of

[1] *Apollo*, December 1963.
[2] Waterhouse, 1971.
[3] Conforti, p. 557.
[4] Pastor (English edition), XXXIII, p. 13.

art patronage declined very seriously at this time. Indeed, in 1708, Charles-François Poerson, director of the French Academy in the city, wrote gloomily: 'Je crois, Mgr, que ce qui a beaucoup contribué à ce pittoyable relâchement [of painting in Rome] est le peu de fortune qu'il y a à faire en ce païs-cy. D'ailleurs les affreuses guerres, dont toute l'Europe est affligée, empêchent les Etrangers de venir icy, et c'étoient ces étrangers qui récompensoient les vertueux, car, pour MM les Italiens, ils ne sont magnifiques qu'en embrassades . . .'[1]

In the last analysis, however, it is a qualitative judgment that has to be made. In the second decade of the eighteenth century Pope Clement XI had the church of his patron S. Clemente freshly decorated.[2] As he bore a particular affection for the church we can assume that he went out of his way to employ the best artists available. The list of those chosen is therefore indicative: Sebastiano Conca, Pietro di Pietri, Giovanni Odazzi, Pier Leoni Ghezzi, Tommaso Chiari, Giovanni Domenico Piastrini and Giacomo Triga. I find it as impossible to believe to-day as I did in 1963 that such a commission can compare in quality with similar ones made in the previous century or with others being given elsewhere in Italy—and notably Venice.

Waterhouse himself and the late Anthony Clark have indeed shown us how many fine painters did work in Rome during the eighteenth century, but neither in the general opinion of the time (nor, yet, in that of our own day) was it accepted that their achievements dominated European art in a way that was even remotely comparable to what was happening in the age of Pietro da Cortona with which I was mostly concerned. I therefore believe that an opinion which would indeed have been absurd in a book dealing with architecture or sculpture is quite justified in one devoted to painting.

[1] Montaiglon, III, p. 240.　　　[2] Gilmartin.

Part I

ROME

Chapter 1

THE MECHANICS OF SEVENTEENTH-CENTURY PATRONAGE

– i –

'WHEN Urban VIII became Pope,' wrote the art-chronicler Giambattista Passeri, looking back nostalgically from the dog days of the 1670s, 'it really seemed as if the golden age of painting had returned; for he was a Pope of kindly spirit, breadth of mind and noble inclinations, and his nephews all protected the fine arts. . . .'[1] In fact, the long pontificate of Urban VIII which began in 1623 marked the climax of a most intensive phase of art patronage rather than the opening of a new era—the sunlit afternoon rather than the dawn. For at least thirty years the austerity and strains of the Counter Reformation had been relaxing under the impact of luxury and enterprise. Intellectual heresy was still stamped out wherever possible: artistic experiments were encouraged as never before or since. The rule of Urban VIII not only led to a vast increase in the amount of patronage, but also to a notable tightening of the reins.

Urban's immediate predecessors, Paul V (1605-1621) and to a lesser extent Gregory XV (1621-1623), had set a pattern which he was content to follow. The completing of St Peter's, the building and decoration of a vast palace and villa, the establishment of a luxurious family chapel in one of the important Roman churches, the support and enrichment of various religious foundations, the collection by a favoured nephew of a private gallery of pictures and sculpture—this was now the general practice. In it we can see reflected the contrasts, and sometimes the tensions, between the Pope as a spiritual and temporal ruler and the man as an art lover and head of a proud and ambitious family.

The Popes and their nephews were by no means the only patrons, but as the century advanced their increasing monopoly of wealth and power made them at first the leaders and then the dictators of fashion. This process reached its climax in the reign of Urban VIII and was in itself partly responsible for the relative decline in variety and experiment. For until the election of this Pope change and revolution were of the very essence of the Roman scene. '. . . It [is] a strange and unnaturall thing', wrote a correspondent to Lord Arundell in 1620 towards the end of Paul V's sixteen-year rule,[2] 'that in that place, contrary to all others, the long life of the Prince is sayd to be the ruyne of the people; whose wealth consists in speedy revolutions, and oft new preparations of new hopes in those that aspire to rise by new fam.es [families] who, w.th the ould, remayne choaked

[1] Passeri, p. 293. For an enthusiastic contemporary account of art patronage—as of everything else under the Barberini—see the Abate Lancellotti's *L'Hoggidì* first published in Venice in 1627 and often reprinted.

[2] Letter from Mr Coke of 8 October 1620—Hervey, p. 183.

w.th a stand, and loath to blast their future adresses by spending to court those that are dispaired of.' Exactly the same point was made with much greater force after the twenty-one years of Urban VIII's reign.[1]

These 'speedy revolutions' and the consequent rise of new families moulded the patterns of art patronage. As successive popes came to the throne they surrounded themselves with a crowd of relatives, friends and clients who poured into Rome from all over Italy to seize the many lucrative posts that changed with each change of government. These men at once began to build palaces, chapels and picture galleries. As patrons they were highly competitive, anxious to give expression to their riches and power as quickly as they could and also to discomfort their rivals. After the Pope died they were often disgraced, and in any case their vast incomes came to a sudden end, for nepotism no longer took the form of private empires carved out of the Church's territory. 'There is no situation more difficult or more dangerous', said Pope Gregory XV, who certainly knew what he was talking about,[2] 'than that of a Pope's nephew after the death of his uncle.' With the end of their incomes went the end of their positions as leading patrons. It was especially noted of Cardinal Alessandro Peretti-Montalto, nephew of Pope Sixtus V, that he was still respected and loved even after the death of that Pope, and that artists continued to work for him.[3] This was evidently not the usual state of affairs.

Rome was a symbol rather than a nation. The nobles who formed the papal entourage still thought of themselves far more as Florentines, Bolognese or Venetians than as Romans or Italians; and as the prestige of painting was at its height, it was a matter of some importance for a cardinal to be able to produce several painters of distinction from his native city. We are told that Cardinal Maffeo Barberini (the future Urban VIII) 'was most anxious to make use of artists from his native Florence', and that Pope Gregory XV 'was a Bolognese so there was little chance for anyone from anywhere else. . . .' The artists naturally made the most of their opportunities. In 1621 Cardinal Ludovisi was elected Pope. Domenichino had some years earlier returned to his native Bologna after a quarrel with Cardinal Borghese, but 'this news caused him great excitement, as the new Pope was a compatriot of his and the uncle of one of his friends', and so he hurried back to Rome where he was made Vatican architect by the Pope's nephew Ludovico.[4]

Indeed, if we study the careers of the most important artists who followed Annibale Carracci from Bologna at the beginning of the century and introduced a new style of painting to Rome, a very consistent pattern emerges. The young painter would at first be found living quarters, in a monastery perhaps, by a cardinal who had once been papal legate in his native city. Through this benefactor he would meet some influential

[1] Ameyden, *Relatione della città di Roma 1642*—MS. 5001 in Biblioteca Casanatense, Rome. Piety, says the author, diminished under Urban VIII because of the excessive length of the papacy 'non per colpa alcuna del Prencipe, ma che la nascita del Pontificato elettivo, et ecclesiastico ricerca mutazione più spesso, acciò molti possono godere de gli onori, e dignità ecclesiastiche, ricerche, e cariche della corte'.

[2] Quoted by Felici, p. 321.

[3] Passeri, p. 27.

[4] *ibid.*, pp. 44 and 132

Bolognese prelate who would commission an altar painting for his titular church and decorations for his family palace—in which the artist would now be installed. The first would bring some measure of public recognition, and the second would introduce him to other potential patrons within the circle of the cardinal's friends. This was by far the more important step. For many years the newly arrived painter would work almost entirely for a limited group of clients, until at last a growing number of altar-pieces had firmly established his reputation with a wider public and he had sufficient income and prestige to set up on his own and accept commissions from a variety of sources. Once this had been achieved, he could view the death of his patron or a change in régime with some degree of equanimity.

This essential pattern, which will have to be expanded and modified in later pages, determined the sites of the more significant works of modern art in Rome. There were, first, the great town and country houses, all of which—Aldobrandini, Peretti, Borghese and so on—contained early pictures and frescoes by the Bolognese painters. Secondly, there were the churches. The most important was naturally St Peter's, whose decoration was under the direct supervision of the Pope, but there were many others which were maintained by rich cardinals and noble families. They fall into two classes—those of which a cardinal was titular head or for which he had a special veneration; and those where he wished to be buried. Both, however, had one feature in common: their antiquity. A titular church was, by definition, one that had been handed down from cardinal to cardinal through the centuries; and in general the Popes and their families, perhaps to refute the charge of being nouveaux-riches, chose to be buried in the most ancient and venerable of basilicas such as S. Maria Maggiore and S. Maria sopra Minerva.

There was, besides, one other way in which a noble could add to the splendour of Rome and hope to find a suitable burying place for his family: he could build a complete new church. The demand was enormous. New Orders had sprung up to meet the threat of the Reformation—the Oratorians and the Jesuits, the Theatines, the Barnabites and the Capuchins; and the various foreign communities in Rome, the Florentines, the Lombards and many others, vied with each other in the erection of magnificent new temples. Such building, however, takes a considerable time, and the original estimate of the cost is usually well below the final result. It is rare that the man who decides to have a church built will survive to supervise the decoration; it is still rarer that his heirs will take the same interest as he himself did. And so the chapels have to be disposed of to anyone prepared to decorate them. But the great cardinals were interested primarily in furnishing their own titular churches, family palaces or burial places in the older basilicas. Besides, their acute sense of precedence and rivalry made them reluctant to undertake a relatively small feature in a church which had been begun by another cardinal. 'Although it was objected to him', we are told of Cardinal Alessandro Peretti-Montalto,[1] 'that it was not suitable for him to follow in a building [S. Andrea della Valle] which had been begun by someone else, he despised such human considerations and carried on with

[1] Panciroli, p. 800, quoted by Ortolani.

his plans to the glory of God. . . .' Much more usually, however, the completion and decoration of new churches were carried out by wealthy but politically unimportant patrons, who were not in touch with the most modern artists of the day and who were thus compelled to fall back on well-established favourites. It is therefore paradoxically true that a well-informed traveller in about 1620 would have found that most of the best modern paintings in Rome were in the oldest churches.

– ii –

Within the general framework that has been outlined there was a wide range of variation possible in the relationship between an artist and the client who employed him. At one end of the scale the painter was lodged in his patron's palace and worked exclusively for him and his friends; at the other, we find a situation which appears, at first sight, to be strikingly similar to that of today: the artist painted a picture with no particular destination in mind and exhibited it in the hope of finding a casual purchaser. In between these two extremes there were a number of gradations involving middle-men, dealers and dilettantes as well as the activities of foreign travellers and their agents. These intermediate stages became more and more important as the century progressed, but artists usually disliked the freedom of working for unknown admirers, and with a few notable exceptions exhibitions were assumed to be the last resort of the unemployed.

The closest relationship possible between patron and artist was the one frequently described by seventeenth-century writers as *servitù particolare*. The artist was regularly employed by a particular patron and often maintained in his palace.[1] He was given a monthly allowance as well as being paid a normal market price for the work he produced.[2] If it was thought that his painting would benefit from a visit to Parma to see Correggio's frescoes or to Venice to improve his colour, his patron would pay the expenses of the journey.[3] The artist was in fact treated as a member of the prince's 'famiglia', along with courtiers and officials of all kinds. The degree to which he held an official post varied with the patron; though some princes might create an artist *nostro pittore* 'with all the honours, authority, prerogatives, immunities, advantages, rights, rewards, emoluments, exemptions and other benefits accruing to the post',[4] such a position was more frequent with architects than with painters. In most cases within the prince's retinue there was a sliding scale of rewards and positions up which

[1] See many references in Pascoli—I, p. 93, and II, pp. 119, 332, 417, 435, etc.

[2] Montalto, p. 295, for the important evidence of Alessandro Vasalli, a painter who testified on Mola's behalf in his troubles with Prince Pamfili: 'Io so che quando una persona di qualche professione è arrollato tra la famiglia de' Principi e tra Virtuosi de Principi con assegnamento di pane sono obbligati a preferir qualche Pnpe o Prnpessa per ogni loro operazione, ma però pagandoglieli le sue opere quello che vagliono e perciò non è obbligato a servire quel Pnpe con la sua Professione, senza una mercede, o salario, ma come ho detto deve preferire quel Pnpe ad ogni altro per il tenor dela loro professione e questo lo so perchè così ne gli insegna la ragion naturale e per haverlo anco sentito dire tra Pittori in ordine alla Professione. . . .'

[3] Pascoli, II, p. 211—Cardinal Pio sent his protégé Giovanni Bonati to Florence, Bologna, Modena, Parma, Milan and Venice; *ibid.*, II, p. 302—Cardinal Rospigliosi sent Lodovico Gimignani to Venice.

[4] The appointment of Gio. Gasparo Baldoini 'per nostro pittore' by Cardinal Maurizio di Savoia—Baudi di Vesme, 1932, p. 23.

the artist might move on promotion. Thus from 1637 to 1640 Andrea Sacchi was placed in Cardinal Antonio Barberini's household among three slaves, a gardener, a dwarf and an old nurse; in the latter year he was moved up to the highest category of pensioners with writers, poets and secretaries.[1]

A position of this kind was eminently desirable for the artist, and all writers agree on its enormous and sometimes indispensable advantages.[2] There were occasional drawbacks: some artists had difficulty in leaving the service of their employer, and there were obvious restrictions on personal freedom which might be irksome.[3] On the other hand, paradoxical though it may seem, artists placed in these circumstances had unrivalled opportunities for making themselves known, at least within certain circles. For it has already been pointed out that the patron was not wholly disinterested in his service to the arts. A painter of talent in his household was of real value to him, and he was usually quick to sound the praises of his protégé and even to encourage him to work for others. In the absence of professional critics such support and encouragement was by far the easiest way for a painter to become known. 'To establish one's name it is vital to start with the protection of some patron', wrote Passeri when commenting on the early life of Giovanni Lanfranco,[4] for it was only the great families who were in a position to get commissions for their protégés to paint in the most fashionable churches, and this was an indispensable stage in any artist's career.

In view of the powerful national rivalries that prevailed in Rome it is not at all surprising that the artist's birthplace played an even more important part in determining his chances of enjoying *servitù particolare* than in obtaining ordinary commissions. Thus we hear of the Florentine Marcello Sacchetti who, on seeing some works by Pietro da Cortona, 'asked him about himself and where he came from. And when he heard that [Pietro] was from Cortona, he called him his compatriot', and put him up in his palace.[5] In the same way, at the end of the century, Cardinal Ottoboni provided rooms for his Venetian fellow-citizen Francesco Trevisani.[6] But good manners—a paramount issue for painters in the seventeenth century—could be almost as important as nationality in securing an artist a position of this kind.

Though this sort of patronage was very desirable in a stable society, the conditions of seventeenth-century Rome with its frequent and sometimes drastic shifts of power were by no means ideal for its furtherance. Too close an association with a disgraced patron could prove a serious bar to advancement when conditions changed. And there were always artists who found the restrictions on their freedom uncongenial despite

[1] Incisa della Rocchetta, 1924, p. 70.

[2] Pascoli, I, p. 93.

[3] For the Duke of Bracciano's reluctance to let Pietro Mulier leave Rome see Pascoli, I, p. 180. Pier Francesco Mola and Guglielmo Cortese had to get special permission to leave Valmontone for a few days when they were employed there by Prince Pamfili—Montalto, p. 288.

[4] Passeri, p. 141.

[5] *ibid.*, p. 374.

[6] See unpublished life of Trevisani by Pascoli in Biblioteca Augusta, Perugia, MS. 1383 and Battisti, 1953.

the security they seemed to guarantee.[1] Besides, there were not many families able or willing to support painters on such terms. And so we often find that this extreme form of patronage was extended to an artist only at the outset of his career. Arriving in Rome from some remote city, what could be more desirable than the welcome of a highly placed compatriot offering hospitality, encouragement and a regular income? But after some years, with a considerable reputation and Rome flooded with foreigners willing to pay inflated prices, the position must have looked rather different. Fortunately a compromise was always possible: the artist could live and work on his own but continue to receive a subsidy as an inducement to giving his patron priority over all other customers.[2]

It was much more usual, however, for a painter to work in his own studio and freely accept commissions from all comers. Whether or not an actual contract was drawn up between him and the patron would depend on the scope of the commission, but by examining such documents as have survived we can see the sort of conditions under which these independent artists worked. In the following pages the items most usually stipulated will be discussed in turn.

It was natural enough that the *measurements* and site of the proposed work should be laid down in some detail when a fresco or ecclesiastical painting was required, and only one point sometimes caused difficulties: when an altarpiece was commissioned from an artist living in some distant city, the problem of the lighting in the chapel might become acute. For though the painter was naturally told the destination of his picture, it was by no means certain that he always had the chance to inspect the site himself and long exchanges would then be needed to clear up the problem.

The size of pictures for private galleries was also a matter for discussion. Those complete decorative schemes that have survived show that in many cases pictures were used to cover the walls of a room or gallery in symmetrical patterns, and that often enough they were even let into the surface. Where this was the case it was obviously important to regulate the exact measurements of any new picture commissioned, and much surviving correspondence testifies to the patron's interest in the question. Again and again artists were commissioned to paint pictures in pairs, and in many instances it is possible to see how this preoccupation with the decorative and architectural function of paintings influenced their composition as well as their size.[3]

The artist was also usually given the *subject* of the picture he was required to paint, but it is difficult to determine how far his treatment of it was actually supervised by the patron. Clearly a great deal depended on the destination of the work. Stringent control may have been exerted over the subject of a religious fresco or an altar painting, but the

[1] See later, p. 22 ff., for Salvator Rosa and p. 23 note 3 for Benedetto Luti. Paolo Girolamo Piola 'amante di sua libertà' wanted to avoid living in the palace of his fellow Genoese patron Marchese Pallavicini when he came to Rome in 1690 and 'benchè a gran difficoltà' he got permission to reside elsewhere —Soprani, II, p. 185.

[2] Cardinal Flavio Chigi gave Mario de' Fiori a monthly allowance of 30 *scuti*—Golzio, 1939, p. 267.

[3] In relation to Claude see Röthlisberger, 1958.

contracts themselves only rarely go into much detail. Indeed, a surprising degree of freedom often seems to have been left to painters, even in important commissions, and this depended a good deal on the cultural sophistication of Rome. Contracts from smaller provincial centres show far more detailed instructions than those given to painters in the bigger towns.[1] Usually the outlines of the subject would be indicated, and it was then left to the artist to add to it those elements which he found necessary for its representation.[2] Often the request for further iconographical details came from the painter. Thus, in 1665, when Guercino was required to paint an altarpiece for a monastery in Sicily, he was given the measurements and told that the figures were to include the 'Madonna de Carmine with the Child in Her arms, St Teresa receiving the habit from the Virgin and the rules of the Order from the Child, St Joseph and St John the Baptist; these figures must be shown entire and life-size and the top part of the picture must be beautified with frolicking angels.' Not satisfied with such instructions (which in fact were more specific than usual), he wrote to ask whether the Madonna del Carmine 'is to be clothed in red with a blue cloak following church custom or whether she should be in a black habit with a white cloak. Should the rules of the Order which the Child is handing to the Saint be in the form of a book or a scroll? In that case what words should be written on it to explain the mystery? Further, should St Teresa go on the left or on the right?' He also wanted to know how the picture was to be hung and what the lighting would be like.[3]

In secular works, too, there were difficulties. The artist who was given such a vague theme as the Four Seasons was often in something of a quandary as to what he should actually paint, and we know that in these circumstances he would usually apply to a scholar or poet for advice, even if not specifically required to do so in his contract. When Prince Pamfili, for instance, commissioned Pier Francesco Mola to paint the Four Elements in his country house at Valmontone, the artist went to a lawyer of some standing in the district and asked to borrow a genealogy of the gods and a Virgil with a commentary so that he could pick suitable myths for representation. Basing himself on these books and on friendly conversations, he then chose to depict the Element of Air by showing 'Juno reputed to be the goddess of Air in the act of leaving the clouds; the Milky Way; the rape of Chloris by Zephyr; the rape of Ganymede; and the apparition of Iris to Turnus.'[4]

The artist's treatment of a particular subject could be affected in another way. Because the price of a picture or fresco was often determined by the number of full-

[1] See, for instance, the terms laid down for Saverio Savini in Gubbio in 1608 published by Gualandi, IV, p. 60; or for Mario Minnitti in Augusta (Sicily) in 1617, published by Giuseppe Agnello.

[2] Thus in his frescoes for the church of S. Antonino in Piacenza in 1624 Camillo Gavasetti was given the subject by the SS. i Deputati 'con libertà al medes.o Pittore d'inventare ed ampliare con prospettive, chori d'Angioli, Sibille, Profeti e come meglio li parerà secondo l'arte e pratica di perito Maestro'—Gualandi, I, p. 91. In 1682 Sebastiano Ricci was required by the Confraternità di S. Giovanni Battista Decollato in Bologna to paint 'La Decolatione di S. Gio. Battista con figure et altre conforme richiede il rappresentare detta decolatione'—von Derschau, 1916, pp. 168-9. [3] Ruffo, p. 109.

[4] Montalto, p. 290. There is also an undated letter from a certain Vincenzo Armanni (I, p. 215) to Camillo Pamfili with suggestions for the decoration of his villa at Valmontone.

length figures it contained, he was sometimes told just how many of these he was to include. Urban VIII, for instance, commissioned an altarpiece for the church of S. Sebastiano on the Palatine to represent 'the martyrdom of St Sebastian, with eight figures' which were evidently left to the discretion of the painter.[1]

The commissioning of pictures for a gallery would naturally leave a freer choice, for complete thematic uniformity of decoration was now only rarely insisted on. More and more the movable gallery picture was coming into its own—a largely Venetian innovation of over a century earlier which had made a decisive impact on Roman collecting. Pictures were bought, sold, inherited, speculated in and exchanged with bewildering speed so that biographers often no longer found it worth recording where a painter's works were at the time of writing. In these circumstances neither subject nor size held the vital importance of earlier days, and, with the added stimulus of connoisseurship, collectors were frequently more interested in choosing the work of specific artists than in going into great detail about what had actually been painted. Thus at the very beginning of the century the Marchese Giustiniani, whose taste is discussed in a later chapter, was such a wholehearted admirer of Caravaggio that, when an altarpiece by that artist had been rejected as unsuitable for its intended location, he acquired it for his gallery and hung it among a series of pictures which had been assembled far more for their affinities of style than for any consistency of subject-matter.[2] And some ninety years later another patron, Giovanni Adamo, when commissioning a work from the Genoese painter Paolo Girolamo Piola, gave the size and added only: 'As to the subject, I leave it to you whether to make it sacred or profane, with men or with women.'[3] We find here the culmination of an undogmatic approach to art which was characteristic of the whole century and which led to an invigorating freedom of experiment and invention. It was an approach that the more conservative patron could modify by choosing a single theme and commissioning pictures by different masters to be grouped around it—a suitable compromise between the old and the new for which there had been many precedents during the Renaissance. It occurs frequently in royal commissions where a number of painters would be required to celebrate the glories of Alexander the Great, and it was also popular with scholars collecting portraits of great men or reconstructing elaborate temples of learning. It was evidently some such scheme that the Duke of Mantua had in mind when he commissioned two Roman painters to represent for him various episodes from the story of Samson, but ordered them on no account to begin until he had told them just which ones he wanted.[4] And another great patron, the Marchese del Carpio, when Spanish Ambassador in Rome, commissioned a number of artists to draw for him any subject so long as it represented some facet of *Painting*.[5]

[1] The artist was Andrea Camassei—see the receipt published by A. Bertolotti (*Artisti bolognesi . . .*, pp. 161-2). In this connection it would be extraordinarily interesting to find the contracts for such masterpieces of restraint as Guido Reni's and Poussin's treatments of the *Massacre of the Innocents*.

[2] The significance of this has been pointed out by Friedlaender, p. 105.

[3] Letter of 3 February 1690—Bottari, VI, p. 147.

[4] Luzio, p. 292. [5] Bellori, 1942, p. 117.

Instructions to the artist would also depend on his reputation and temperament. How great, for instance, was the contrast between Pietro da Cortona and Salvator Rosa! Pietro, recognised for years as the most distinguished painter in Rome, indeed in Italy, refused to choose his own subjects and claimed that he had never done so in his whole life[1]; whereas Rosa told one imprudent client who had had his own ideas for a picture to 'go to a brickmaker as they work to order'—though this attitude did not stop him asking his friends for suggestions.[2] And, of course, certain artists had acquired a reputation for particular subjects. Thus it was that one collector called on the French painter Valentin, who specialised in Caravaggesque genre scenes, and asked him for 'a large picture with people among whom were to be a gipsy woman, soldiers and other women playing musical instruments'.[3]

The most effective way by which a patron could keep control over an artist working for him was by insisting on a preliminary oil sketch (*modello*) or drawings, but this practice was a good deal rarer during the first half of the seventeenth century than is sometimes supposed.

It is true that in 1600 Caravaggio agreed with his patron, before executing his altarpieces of *The Conversion of St Paul* and *The Martyrdom of St Peter*, that he would 'submit specimens and designs of the figures and other objects with which according to his invention and genius he intends to beautify the said mystery and martyrdom',[4] but this was exceptional, and Caravaggio was already notorious as a difficult character. For quite different but equally understandable reasons, Rubens, who was still only an unknown foreigner, was asked in 1606 to show examples of his painting before undertaking an altarpiece in the Chiesa Nuova.[5] In general, more confidence was shown in the painter's ability, though private and unofficial discussions with the patron must have been frequent. Even for such an important commission as the altar paintings in St Peter's, it appears not to have been obligatory for artists to produce *modelli* (though presumably drawings would have been necessary); when Lanfranco wrote in 1640 to Cardinal Barberini asking to be given the chance to paint the altar picture of *Pope Leo and Attila*, he specially mentioned that he would arrange for the Cardinal to see 'in tela il disegno', but he explained that he was doing this to illustrate the difficulties of the composition, and in any case the suggestion came from him and not from his patron.[6]

None of the Bolognese artists working in Rome is known to have produced a *modello*, and no certain examples survive even from such a great decorator as Pietro da

[1] Letter from the Savoy Resident in Rome, Onorato Gini, in 1666, summarised by Claretta, 1885, p. 516: 'ma prima patto apposto dal Cortona era ch'egli non voleva indursi a far ver una proposta [as regards subject], allegando che non avevane fatta alcuna in tutta la vita e che "questo sarebbe un non mai volere il quadro" '.

[2] Pascoli, I, p. 84.

[3] Costello, p. 278.

[4] The contract has been published by Friedlaender, p. 302.

[5] See later, Chapter 3, p. 70, note 2.

[6] Pollak, 1913, p. 26. Letter from Lanfranco in Naples dated 14 July 1640. 'In tela il disegno' must certainly mean that the general composition would be sketched in on the canvas. We know that this was a regular practice of Lanfranco's—Costello, p. 274.

Cortona.[1] On the other hand, the practice became widespread during the second half of the century, and is particularly associated with the painter Giovan Battista Gaulli, who may have been responsible for introducing it from his native Genoa where it was already well established. One factor is clearly important: Professor Wittkower has pointed out that 'most of the large frescoes in Roman churches belong to the last 30 years of the seventeenth and the beginning of the eighteenth century'[2] and it is obvious, as Rubens had shown in Northern Europe, that *modelli* could be exceedingly useful both to patrons and assistants in large-scale work of this kind. Moreover, the iconographical significance of these frescoes was often more complex. Ciro Ferri was required in 1670 to produce a coloured *modello* for the cupola of S. Agnese in Piazza Navona, and after it had been approved he was not to make any changes without special permission.[3] Such stringent control is exceptional, but—as will become apparent in a later chapter—the Pamfili family, who were responsible for this commission, were never altogether happy in their relations with artists. It is also possible that the insistence on sketches at this period was in some way linked to a growing appreciation of their more 'spontaneous' character—an appreciation that naturally accompanied the rise of the *amateur*, though the fashion for collecting them did not become general until the eighteenth century.

After the size of the picture and the subject-matter had been decided, there came the question of the *time limit*, a problem of particular urgency during the whole of the Baroque period. Nearly all patrons insisted that work should be finished as quickly as possible, and as often as not they were disappointed by the artists whom they employed. Some frescoes were, of course, such large undertakings that many years were required for their completion. Ciro Ferri was given four years for the cupola of S. Agnese in Piazza Navona, and Gaulli eight for the vault and transept vaults of the Gesù. Holy Years often provided a special incentive for artists to complete their work in some church,[4] and certain painters had a reputation for exceptional speed. It was claimed that Giovanni Odazzi worked faster than the notoriously rapid Luca Giordano, and Giacinto Brandi too was famous in this respect. Quick work might entitle the artist to greater rewards—we are told that Gaspard Dughet benefited in this way—but by no means always met with critical approval.[5] It was the Venetians who were especially famous for their speed and the fact earned them a certain amount of contempt elsewhere.

[1] L. Grassi published in 1957 what he claimed to be a series of *modelli* by Pietro da Cortona for the ceiling of the galleria in the Palazzo Doria-Pamfili, but these have not won general acceptance—see Briganti, 1962, p. 251. Nor is the so-called *bozzetto* for the Barberini Salone, kept in the palace, at all convincing. On the other hand, Professor Waterhouse has pointed out to me the existence of a *modello* by Camassei, *Saints Peter and Paul baptising in the Mammertine prison*, once belonging to the Barberini and now in the Pinacoteca Vaticana—No. 820, formerly 539 m. A number of *modelli* by Andrea Sacchi are also recorded. One of these, for an altarpiece in the Capuchin church in Rome, recently passed through a London gallery (Colnaghi's, May–June 1961, No. 2) and is now in the collection of Mr Denis Mahon.

[2] Wittkower, 1958, p. 218.

[3] Golzio, 1933–4, pp. 301–2.

[4] Tacchi-Venturi, 1935, p. 147.

[5] Pascoli, I, pp. 59, 61 and 132; II, pp. 390 and 395.

The final clause in any contract naturally referred to the *price* and financial arrangements. Certain formulas were always adhered to. Some proportion of the sum agreed was paid at once as a deposit. This ranged widely from a minimum of about one-seventh to a maximum of nearly a half. If the work was a picture, the artist was very often given a further payment when it was half finished and the remainder on completion, together with a final bonus. And, of course, there were many variations possible in this treatment. In the case of large-scale frescoes, the artist was usually paid at a regular monthly rate.[1]

More interesting and significant than obvious arrangements of this kind is the question of expenses incurred by the artist in his work. 'The usual thing is to pay painters for the stretcher, the priming and for ultramarine', wrote an agent to a prospective patron in 1647, and this is confirmed in many other documents.[2] Once again variations were possible[3]—sometimes the painter was responsible for all expenses; on other occasions he was given the canvas and had to pay for the ultramarine himself; very rarely he was told, as in mediaeval days, that the colours he bought must be of the very finest quality.[4] The patron invariably paid for the scaffolding needed for ceiling frescoes, and if the work took place away from the painter's residence he would also provide board and lodging for him. It was claimed of Prince Pamfili, for instance, that he treated Pier Francesco Mola, who was decorating his villa at Valmontone, like one of his own retinue, giving him 'fowl, veal and similar delicacies'.[5]

Prices for the work itself were regulated in widely different ways: many artists had fixed charges for the principal figures in the composition, excluding those in the background. Thus Domenichino was paid 130 ducats for each figure in his frescoes in Naples Cathedral and Lanfranco 100. This system was very widespread and allowed painters to make regular increases in price as their reputations grew.[6] However, the

[1] Many examples of different kinds of payment could be given here. In 1639 Francesco Albani was given an exceptionally high proportion of the total sum as *caparra*—450 out of a 1000 *lire* (Gualandi, I, p. 19). More typical is the case of Pier Francesco Mola who for his frescoes at Valmontone was to be given 300 *scudi* immediately and the remaining 1000 in stages as he worked (Montalto, p. 287); or of Ciro Ferri who was given 50 *scudi* as *caparra* and promised 180 more on completion of an altarpiece in Cortona for Annibale Laparelli (Gualandi, IV, p. 117).

[2] 'è solito che si paghi a tutti i pittori il telaro, imprimitura, et oltremare . . .'—letter from Berlingero Gessi to Don Cesare Leopardi d'Osimo, dated 10 July 1647, published by Gualandi, I, p. 40. And again: '. . . Sappia che questo è lo stile che si pratica con ogni minimo pittore, cioè consegnarli la tela impresa, e qualche denaro anticipato . . .'—letter from Carlo Quarismini to Conte Ventura Carrara, dated 11 July 1696, in Bottari, V, p. 186.

[3] In 1633 Camassei agreed in his contract with Urban VIII (see p. 10, note 1) to pay himself for 'tela colore e azzurri'; in 1639 Bonifazio Gozadini promised to supply Albani with the canvas and necessary ultramarine for his altarpiece in the Chiesa de' Servi in Bologna (Luzio, p. 48); in 1657 Prince Pamfili agreed to pay for 'il bianco macinato, pennelli, e coccioli smaltini, terra verde, verdetti, lacche fine, e pavonazzo di sole et azzurro oltramare' to be used by Pier Francesco Mola in his frescoes at Valmontone, while the artist was to pay for the remaining colours, paper, etc. (Montalto, p. 287).

[4] For instance Camillo Gavasetti agreed in 1624 to use 'colori de' più fini' for his frescoes in Piacenza —Gualandi, I, p. 91.

[5] Montalto, pp. 287 and 289.

[6] See letters from Mattia Preti and Artemisia Gentileschi—Ruffo, pp. 239 and 48.

status of the client was often as important as that of the artist in determining the price. In the 1620s the Sienese doctor and art lover, Giulio Mancini, wrote that a munificent patron would not condescend to go into the question at all, but would reward the artist as he saw fit.[1] It is true enough that we do find some examples of this. In 1617, for instance, the Duke of Mantua wrote to Guido Reni asking him for a painting of *Justice embracing Peace*. He gave the measurements, but made no mention of the price beyond saying that Guido would be 'generously rewarded'.[2] And artists were clearly glad to respond to such offers. The somewhat eccentric Paolo Guidotti used to say that he gave away his paintings as 'free gifts', but he had no hesitation in accepting the most expensive presents in return.[3] Claude Lorrain was equally shrewd: 'Or ce qui est pire', wrote Cardinal Leopold de Medici's agent in 1662 about the possibility of buying a picture by him, 'c'est qu'il faudra le payer largement car il ne fixe un prix qu'aux gens de médiocre condition.'[4] But in fact even by Mancini's date it is probable that such aristocratic largesse was the relic of an earlier age and already in decline. Painting was far more commercialised than these rare instances suggest. 'If His Highness wants to be served well and quickly,' wrote the Mantuan agent in Rome to a ducal chancellor, 'he must, indeed it is indispensable that he should, send some money here to give as a deposit to these painters. They have let it be clearly understood that they will only work for those who give them money [in advance]; otherwise it will be quite impossible to get anything good from them.'[5] And against the example of a Claude we must record the uncompromising rigidity with which Guercino enforced his own practice of charging a certain sum for every figure painted: 'As my ordinary price for each figure is 125 ducats,' he wrote to one of his most enthusiastic patrons, 'and as Your Excellency has restricted Yourself to 80 ducats, you will have just a bit more than half of one figure.'[6]

The type of patronage so far considered had done little more than modify the practice of earlier centuries: a client in direct touch with the artist; clear instructions as to size and, probably, subject; a well-established and recognised relationship. But now in seventeenth-century Rome the whole pattern was beginning to break down, for it had been evolved in relatively stable national societies based on city states and feudal courts. With the eclipse of many of these, Rome was in fact beginning to assume some of the functions of a capital. She was the richest city in Italy, and by her very nature as an international centre she attracted visitors and residents from all over the peninsula, and indeed Europe. To artists her appeal was twofold: on the one hand, as we have

[1] Mancini, I, p. 140.

[2] Luzio, p. 48.

[3] Faldi, 1957, pp. 278-95.

[4] Letter from Jacopo Salviati to Cardinal Leopoldo de' Medici, dated 22 July 1662, published by Ferdinand Boyer, 1931, p. 238.

[5] Letter from Fabrizio Arragona, Mantuan agent in Rome, to a ducal chancellor, dated 9 October 1621, published by Luzio, p. 295.

[6] Letter from Guercino to Don Antonio Ruffo, dated 25 September 1649, published by V. Ruffo, p. 97.

seen, the aristocrats were anxious to have painters of their own nationality in their entourage, and so did everything possible to invite them to Rome; on the other hand, the artists themselves felt that Rome alone offered them sufficient scope and rewards for their talents. The process was self-generating: supply and demand reinforced each other. There was, further, the overwhelming attraction of the city's great monuments, ancient and modern, at a time when the classical tradition was still of paramount importance. Rome herself was notoriously deficient in giving birth to artists, and so the city became the focus of a constantly shifting population of painters and dilettantes in search of each other. Moreover, new blood—new Venetian or Bolognese or Neapolitan blood—frequently brought about drastic changes as one régime succeeded another and supplanted its favoured artists. And underlying this was one constant threat. Only the family that actually had its hand in the treasury was able to provide patronage on the enormous scale that was associated with ruling clans such as the Borghese and the Barberini. Should there be, for some reason or another, any financial restriction, it was obvious that a very large number of artists, previously engaged in regular employment, would be thrown on to the market.

One result of all these circumstances was that painters did not always work directly to commission in any of the ways described above. It soon became a regular practice for them to keep in their studios a small number of pictures, often uncompleted ones, which they showed to visiting clients as samples of their work. If found attractive, the picture would then be finished once a suitable price had been agreed upon. The activities of Fabrizio Valguarnera, a Sicilian adventurer and diamond smuggler, give us a vivid insight into the situation. He paid two visits to Lanfranco and found, among other pictures, sketched-in canvases of the Magdalene and of the Crucifixion, both of which he asked the artist to complete. In Poussin's studio he came across the *Plague at Ashdod* in a preliminary stage, and was so pleased with it that he not only arranged to have it finished but also commissioned a totally new picture of *Spring* from the same artist.[1] And we read of similar encounters with other painters. Salvator Rosa, who hated to work to commission, had his studio full of pictures ready for sale, both large and small, and admirers of his landscapes would come and visit him, routing around to see what they wanted, and infuriating the artist when they insisted on choosing his small paintings instead of the large historical scenes which he valued much more highly.[2]

It was also as a direct result of the shifting social and political pattern of Roman life in the seventeenth century that art dealing and art exhibitions began to acquire the great importance that will be analysed in a later chapter.[3]

– iii –

Enough has been said of the varying conditions of patronage in seventeenth-century Rome to make it clear that no single definition can cover the position of the artist in

[1] Costello, pp. 274-5.
[2] Baldinucci, VI, 1728, p. 581.
[3] See Chapter 5.

society. There were endless changes and nuances that must be taken into account. Moreover, the problem of the artist's status was never really solved. The doubts that had persisted ever since the discussions of the Renaissance had been temporarily obscured by the hero-worship accorded to Michelangelo and Raphael, but never settled. Now in the relatively unstable society of Baroque Rome—the first great cosmopolitan town of modern Europe—the position was still further complicated by the rise of several new factors such as the arrival of foreigners, the formation of a 'bohemian' group and the sheer quantity of painters in the city.

The one vital and constant feature of the situation was that artists really were needed and, consequently, that their rewards both in prestige and in money were liable to be great. The Bolognese writer Malvasia puts into Pope Paul V's mouth words which echo the painter's aspirations though they did not altogether correspond to the realities of the situation: '*Pictoribus, atque Poetis, omnia licent;* we must put up with these great men because that excess of spirit which makes them great is the same that leads them to this strange behaviour.'[1] We might be living in the pages of Benvenuto Cellini's autobiography; but the difficulties faced by a number of artists who failed to conform to orthodox moral standards show that this was far from being the case. None the less, the leading artists of the day were given very great authority and treated with very great respect. We have letters to Bernini from high prelates, princes and others to prove to us the esteem in which he was held,[2] and writers hostile to him complained again and again that a successful artistic career in Rome was exceedingly difficult without his support.[3] Yet he never gained the mystical admiration that had been Michelangelo's, despite the fact that his opportunities for changing the whole face of Rome, and of Europe, were much greater than Michelangelo's had been. This reflected not so much a questioning of his merits (though he always had opponents) as a general decline in the status of the artist which had set in after the High Renaissance and had never been totally reversed. The very understanding of the social rôle that could be played by the artist—an understanding due to Pope Sixtus V in the 1580s as much as to anyone—and the fact that great works of art were no longer produced essentially for the private admiration of a court of hedonists were to some extent responsible for this decline in status. Art was no longer self-sufficient, as it had been in the days of Leo X. Platonism, which had played such a part in exalting the rôle of the creator, no longer dominated philosophical speculation. In a more utilitarian society the artist won a securer place, but lost some of his mystique. Not until the eighteenth century was the cult of the 'genius' to be revived. Meanwhile he had many reasons to be satisfied with his position.

The very large sums which the leading artists could earn were in themselves

[1] Even Malvasia is rather diffident about claiming that the Pope actually spoke these words—'corre voce' is his formula for introducing them—Malvasia, II, p. 27.

[2] Fraschetti, *passim*.

[3] Passeri, p. 236, and Pascoli, I, p. 134. Both were so prejudiced against Bernini that their evidence is not altogether reliable, but Professor Wittkower (1958, p. 96) agrees that 'for more than fifty years, willingly or unwillingly, Roman artists had to bow to his eminence'.

responsible for much of their social advancement. At the height of his fame Bernini was once paid 6000 *scudi* for a single portrait bust, but this fabulous sum far higher than any paid to his rivals was wholly exceptional even in his career.[1] The very fashionable Carlo Maratta, who was considered an exceedingly expensive painter, would get 150 *scudi* for a full-length portrait, and Gaulli, his closest rival, charged 100.[2] These high prices, besides making life more comfortable for the artist, had an important symbolic function. They raised the whole status of art in the eyes of the world. The historian Baldinucci was keen to report that at auctions Rembrandt would make very high bids for paintings and drawings 'in order to emphasise the prestige of his profession', and a similar attitude existed in Italy.[3]

Certainly the winning of a place in society was an overriding preoccupation with artists in the seventeenth century if we are to believe their biographers. It was this motive that inspired their renewed efforts to put their professional association, the Accademia di S. Luca, on a sound footing. This body had suffered several generations of almost continuous decline after Federigo Zuccari's well-meant, but not very successful, attempts to bring it to life in 1593 and 1594.[4] Every time a new pope came to the throne attempts were made to improve the status of the institution and encourage discrimination between serious artists and mechanical craftsmen. The popes were lavish with magniloquent gestures: 'Painting is a most noble profession, quite different from the mechanical crafts', recognised the clerk of the Apostolic Chamber in 1601, and in 1605 Paul V granted the Accademia the annual right on the feast of St Luke to free one man condemned to death. These were steps in the right direction, but hardly decisive ones. Gregory XV was encouraging, and in 1621 he confirmed the statutes of the Accademia, but he died before he could do anything else. It was left to Urban VIII to establish its absolute authority in the art world of Rome and finally crush any opposition from the gilds.[5] Fully as important as any legal decision in the matter was the moral support given to the Accademia by the appointment of the Pope's nephew, Cardinal Francesco Barberini, as its protector, despite the fact that the Cardinal sometimes declined to take its side in subsequent disputes.[6] In 1633 the Accademia was given the right to raise taxes on all the artists in Rome, whether or not they belonged to it, as well as on picture dealers and others living on the fringes of the art world. All public

[1] By the Englishman Thomas Baker for his bust now in the Victoria and Albert Museum—Baldinucci, 1948, p. 89. A letter from Fulvio Testi to Conte Francesco Fontana published by Fraschetti (p. 108) shows the prices that Bernini could command in 1633—a statue would be worth 4000 or 5000 *scudi*; he was paid 1000 *scudi* for the head of Cardinal Borghese; he received a regular salary of 300 *scudi* a month from the Fabbrica di S. Pietro.

[2] Bellori, 1942, p. 98, and Pascoli, I, p. 205.

[3] Baldinucci, VI, 1728, p. 477. Bellori, 1942, p. 123, writes of Maratta in similar terms: 'Circa i prezzi delle sue Opere, che da alcuni sono stati riputati eccessivi, si può dire che Carlo doppo Guido abbia rinumerato la Pittura indotto da quelli, che raddoppiavano più volte il premio delle sue fatiche. Laonde si propose di convertirlo in suo utile con aprire agl'altri la via della rinumerazione particolarmente in Roma, ove i Pittori gli deono restare molto obbligati, essendosi nel suo esempio avanzati a quella ricompensa, che prima non era stata pratticata.'

[4] Pevsner, p. 64, and Mahon, 1947, pp. 157-91.

[5] Missirini, pp. 81 and 87. [6] Hoogewerff, 1935, pp. 189-203.

commissions were to be the monopoly of the Accademia. The measures aroused furious opposition and were never fully enforced. Eventually they had to be withdrawn. But they served their purpose of giving new dignity to established artists. Indeed, quite apart from the financial benefits that accrued from Urban VIII's brief, this was certainly one of their aims, for in all their complaints the Academicians showed an unresting concern for their own social status.

Yet it is interesting that within the Accademia itself there was not nearly as much rigidity as might be expected, or as became the practice in later academies founded on roughly the same lines. Thus membership was by no means confined to 'history painters', and artists whose subject-matter was considered thoroughly objectionable had no difficulty in being admitted.[1] Moreover, even near craftsmen, such as gilders, seem to have belonged at first and did not become second-class members until 1645.[2] Indeed, it was only later, in the second half of the seventeenth century, largely under the influence of the French, that the Academy became an inflexible body closely associated with a specific doctrine. The aim of its founders and early supporters had been very different. In an age which revelled in such organisations the Accademia gave respectability to the artists who belonged to it and hence to art itself. It emphasised the intellectual aspects of creation somewhat at the expense of the mechanical. It enjoyed a prominent position in the life of Rome and played some part in bringing together artists, dilettantes and critics.[3]

But artists did not confine themselves to such 'official' steps as the reorganisation as the Accademia di S. Luca. Many of them followed a conscious policy of adapting themselves to society by observing the customs of those more securely placed than they were. As lavish spending was one of the signs of superior status, it is not surprising that this aspect of their lives should have been stressed again and again. Giacinto Brandi 'lived splendidly with servants and a carriage'; Ciro Ferri too had a carriage, a fully stocked larder, and arranged for his family always to be well dressed. Lodovico Gimignani 'treated himself in a gentlemanly way; he was well dressed with fine linen and a wig; well spoken with enviable manners and got on best with the nobility'. Giammaria Morandi 'danced extremely well, was an excellent horseman and fencer'; Andrea Procaccini lived in magnificent rooms with fine pictures, tapestries and other ornaments, and when he went to Spain, 'his style was more that of a gentleman than of a painter'.[4] Such characteristics are much more typical of the second than of the first half of the seventeenth century and they were evidently reflected in the dealings of artists with their patrons. There are sarcastic references to the difficulties of persuading Carlo Maratta 'to condescend (purely as a favour) to take our money' for a picture which was to be commissioned.[5] But, despite such grumbles, Roman society often seems to have

[1] Both Pieter van Laer and Cerquozzi (for whom see Chapter 5) were members—see the list published by Hoogewerff, 1913, pp. 49-50.

[2] Missirini, p. 115. [3] See later, Chapter 6.

[4] Pascoli, I, pp. 131 and 176; II, pp. 128, 307, 401 and 405.

[5] See letter from Francesco Novetti to Don Antonio Ruffo, dated 22 March 1670, published by V. Ruffo, p. 290.

been prepared to accept artists at their own valuation. True enough, many of the stories we hear are merely refurbished versions of Ridolfi's account of Charles V's picking up Titian's brushes for the artist—Cardinal Barberini holding a mirror for Bernini while he worked at his self-portrait in the guise of David,[1] Innocent X handing Pier Francesco Mola a canvas, and so on.[2] Such stories have at least symbolic value. More likely to be true in a strict sense are the accounts of Queen Christina taking the same artist (a particularly successful courtier) into her carriage, and the Spanish Ambassador taking out Giuseppe Ghezzi for drives. Ghezzi was a well-educated man, and he was elected a member of the distinguished Society of Arcadia, besides being given a benefice in St Peter's by Clement XI and being made a master of ceremonies by Innocent XIII and a 'gentiluomo d'onore' by the Duke of Parma.[3] The practice of giving titles to artists seems to date back to the later years of the sixteenth century and is directly related to the new awareness of their social value. By the middle of the seventeenth century most artists of any distinction were made 'Cavaliere dell'abito di Cristo', and this too was influential in establishing art on recognised and firm foundations.[4]

Painters themselves, and especially their biographers, were keen to respond and liked to stress their intellectual attainments. Thus we hear of Filippo Lauri carefully studying the news-sheets so as to be able to make suitable conversation at the various academies he would attend.[5] This points to an essential and obvious requisite for social success: a good general education. But the need for this was carried far beyond the occasion for shining at academic gatherings. It was inextricably involved with the business of keeping art respectable. 'From such a lack of education', writes Passeri, 'arise the absurdities which we find in some painters, who have some ability in their art but who outside the practice of painting are dull, raw and uncivilised. They are derided as *tavole rase della plebe più vile*, incompetent at telling a story, with a bad pronunciation, no good in serious conversation. They bring shame not only on themselves but on the whole profession—shame enough to make even the most half-witted blush.'[6] Ability to talk well and intelligently not only served to raise the status of art; it also helped to attract powerful patrons, for this was certainly no age for the untutored genius. We can see the artists of the day as they saw themselves by looking at their self portraits. Serene, elegant, as the years go by increasingly bewigged, self-satisfied and complacent, they gaze down at us, only rarely showing us the tools of their trade; more keen to resemble their clients than to point to any singularity in themselves.

[1] Baldinucci, 1948, p. 78.

[2] Pascoli, I, p. 122, where the episode is specifically compared to Charles V's famous gesture.

[3] Pascoli, I, p. 122; II, pp. 202 and 205.

[4] There had, of course, been cases long before the seventeenth century: the Emperor Frederick III had bestowed on Gentile Bellini the dignity of Count Palatine, and in 1533 Charles V created Titian a Count of the Lateran Palace, of his Court and of the Imperial Consistory. But such honours, deeply significant though they were, had always been marks of the most exceptional favour. Towards the end of the sixteenth century in Rome the granting of titles to artists became a more routine affair with some of the attributes of our modern civil service grading and honours lists.

[5] Pascoli, II, p. 202.

[6] Of Michelangelo Cerquozzi—Passeri, p. 285.

So much anxiety to appear respectable and prosperous was all the more natural in view of the squalor that always threatened the lower ranks of painters. We know of large numbers living in destitution,[1] and it is easy enough to imagine their lives, working for unscrupulous dealers at endless, mass-produced devotional pictures and occasionally showing their work at some religious festival. Roman patrons were extraordinarily quick to encourage new artists, and just because of this, the situation of those outside the ranks of accepted painters must have been desperately bleak. There was as yet no legend of the 'undiscovered genius' to sustain them in their misery.

On a higher level, but not very edifying, were the antics of the *bentveughels*, the colony of Dutch and Flemish artists living in Rome. The *Schildersbent*, a sort of mutual aid society to protect the interests of Northern artists in the city, was formed in 1623.[2] It thus ran parallel to similar efforts made by the Italian artists to organise the Accademia di S. Luca at just the same time. But the very name of the society—'birds of a feather'— and the absence of statutes or fixed leadership point to the differences in standing between the two organisations. This did not stop the *bentveughels* (largely through influential support) from successfully resisting the Accademia's attempt to impose a tax on all artists, including foreigners, living in Rome. Most of these Northerners lived in the district around the Via Margutta near the Piazza di Spagna, and their activities inaugur-ated a 'Bohemian' tradition which survives in the area to this day. They indulged in lavish banquets, mock ceremonials and pagan 'baptisms' and often attracted the atten-tions of the police. All this must have been fairly repugnant to the respectable artists of official Rome, but it did not stop the most characteristic of the *bentveughels*, Pieter Van Laer, from being a member of the Accademia di S. Luca.[3]

The success of all these attempts to turn painting into a respectable profession can be seen in the lack of opposition shown by parents to their sons becoming artists. Although the evidence of biographers so obviously biassed must be treated with caution, it is still remarkable how little we hear of difficulties in this respect.[4] That stock figure of later mythology—the artist struggling to express himself against the wishes of his father—was as yet unknown. It is true that the ranks of society from which artists were drawn were generally low, though we are told that Andrea Pozzo's parents were 'extremely well off and of good social standing'. They were anxious that their son should make a career in letters, but reconciled themselves easily enough to his desire to become a painter. In general, apart from ecclesiastical triumphs, a successful artistic career was probably still the best way to rise in the social hierarchy. It is indicative that Mario de' Fiori, an enormously successful painter himself, should have destined one of his sons for the Church while the other was to follow in his own footsteps.[5] And

[1] Narducci, 1870, pp. 122-6.
[2] Hoogewerff, 1952.
[3] See p. 18, note 1.
[4] Pascoli, for instance (II, p. 400), said that Andrea Procaccini's parents, who were well off, found painting a profession 'non del tutto confacevole al lor genio', but they did nothing to prevent their son taking it up.
[5] Pascoli, II, pp. 246 and 6.

Gianandrea Carlone was accepted by the master of the Marchese Costaguti's household as a suitable husband for his sister—a situation which echoed the theme of a burlesque comedy, performed in 1635, concerning a prince who wished to marry his daughter to a painter.[1]

Alongside these examples of social climbing another idea was making headway. At the time it sometimes seemed to conflict with the artist's painful struggles to achieve recognition, but eventually it was to be infinitely more successful in attaining exactly the same object. This was the acceptance of the painter as an exceptional, and sometimes very strange, being. We find proof of this in the diminishing tendency in Rome—though not in other towns—for it to be taken for granted that they would transmit their talent to their children. Family ability became increasingly the sign of the craftsman rather than of the artist. Though there were very notable exceptions to this—Bernini, the son of a famous sculptor who made some use of his brother as an assistant, is the most eminent example—the contrast with previous generations is striking. And especially marked is the contrast between Rome and Venice where the social position of the artist was always considered low and where families of painters went on working, often as teams, until the end of the eighteenth century.

Yet the very nature of the contracts that have been examined shows that artists were still generally looked upon as superior craftsmen: however lenient the control actually exerted, the fact that a price was agreed in advance and that some painters charged standard rates for the number of figures to be depicted is highly significant, for it shows how closely the concept of artistic creation was linked to that of more humble and familiar skills. Despite this, several powerful forces—largely embodied in one single man—were fighting vigorously in favour of a new outlook.

The 'artistic temperament' had been frequently and explicitly hinted at by Vasari, but it was not until the seventeenth century that it came to be widely accepted, and not until the eighteenth that it hardened into an article of belief.[2] Paul V's alleged comments about Guido Reni, quoted on an earlier page, may suggest that that Pope was among the first to recognise that some degree of eccentricity was inherent in the make-up of an artist; it is, unfortunately, our knowledge that this recognition was so much more current in Malvasia's own time, many years later than the reported conversation, that encourages us to be sceptical about its probability. In 1676, for instance, the Resident of the King of Savoy, writing of the unsatisfactory behaviour of Giovanni Perugini, a characteristically feeble protégé of the court of Turin, said that 'he would be no good as a painter if he did not have some element of madness in him'.[3] It is against this background of the artist as exceptional and inspired (an idea still only rarely expressed) that

[1] Pascoli, II, p. 193. This comedy, which I have unfortunately not been able to trace, is referred to in another connection by G. Delogu, 1928, p. 40, note 9.

[2] See, apart from many more familiar examples, a letter from G. L. Bianconi of 22 November 1762 published in Bottari, VII, p. 362: 'Pare che taluno s'imagini, che sia impossibile il dipingere eccellentemente senza avere un fondo di pazzia, e di vizi singolari. . . .'

[3] Letter from Paolo Negri to Marchese di S. Tommaso, dated 24 December 1676, quoted by Claretta, 1885, p. 542.

we must consider briefly some aspects of the career of Salvator Rosa, the painter who did more than anyone else to give the notion currency. Much of the glamour that surrounded the nineteenth-century view of Rosa has been swept away. The publication of his letters has finally displaced the hero of the legendary 'Compagnia della Morte' to reveal instead a man who was clearly hypochondriac. Yet he remains a figure of quite exceptional importance and would be so had he done no more than startle and fascinate his contemporaries by the extravagance of his behaviour and thus create, almost single-handed, the image of the artist as a being apart. It is an image that finds concrete expression in his many self portraits so utterly at variance with the smooth features of his fellow-artists. But Salvator Rosa did far more than that. He was quite clearly a man (the one man) who found the restrictions inherent in the nature of contemporary patronage irksome and intolerable, and therefore set out to try and do away with them. Many artists since his day have understood the part that dramatic self-advertisement can play in winning recognition: in the still fairly closed world of seventeenth-century patronage the effect was bound to be far more striking than anything seen since. There can be no doubt at all that Salvator Rosa's craving for publicity, which was demonstrated at the slightest opportunity, was often only the outward, superficial manifestation of a shrewd determination to break beyond the bounds of orthodox patronage. Again and again we find him making use of exhibitions to establish his reputation and organising a claque to proclaim his merits to all and sundry—thus notably widening the circle of appreciation within which most artists were quite prepared to live. The exploitation and projection of his personality served exactly the same purpose.

But Salvator Rosa was engaged in a yet more serious battle. He, alone among his contemporaries, was asserting the right of the painter to artistic independence as the term might be understood today. That he was launching a revolution purely to demonstrate his conformity with the critical canons of his age is a paradox that will have to be considered in a later chapter, but that does not affect the motivation and efficacy of his tactics. We learn for instance that he would refuse to accept the deposit which, as we have seen, was universally given to painters as a guarantee of the commission. And we are specifically told that he refused it not so as to get a better offer later on but because he did not want to 'enslave his will' by committing himself to complete one work when he might have another more interesting one in mind which would have to be postponed because of his previous obligations. 'I do not paint to enrich myself,' he boastfully wrote to a would-be patron, 'but purely for my own satisfaction. I must allow myself to be carried away by the transports of enthusiasm and use my brushes only when I feel myself rapt'[1]—an astonishingly early claim of the painter's complete dependence on inspiration. In any case, he used to assert, it was no use settling the price of a picture *before* he had even begun it. The price should depend on the quality of the finished work. This blow for the vagaries of talent struck at the very roots of the

[1] See the letter from Salvator Rosa to Don Antonio Ruffo, dated 1 April 1666, published by V. Ruffo, p. 180: '. . . perch'io non dipingo per arrichire mà solamente per propria sodisfazione, è forza il lasciarmi trasportare da gl'impeti dell'entusiasmo ed esercitare i pennelli solamente in quel tempo che me ne sento violentato. . . .'

generally held conception, the implications of which have already been examined, that an artist's capabilities could be assessed in advance. By implying that a painter might well paint a bad picture rather than a good one Salvator Rosa was paradoxically making far greater claims for the superior status of art than any of his rivals who so assiduously cultivated respectable table manners. He insisted on giving only of his best. 'From the little I have had to do with him', wrote an agent, 'I can see that he would rather starve to death than let the quality of his produce fall in reputation.'[1]

This integrity, as well as his appetite for publicity, his claims to independence and inspiration, and his apparent eccentricity were all closely linked, and impressed his more serious contemporaries fully as much as his strange and irregular behaviour intrigued the gossip writers of the day. Some of them at least understood the significance of his conduct. When summing up his career, Baldinucci made the point clearly enough: 'Of few, or indeed of no, painters who lived before or after him or who were his contemporaries do I find that it can be claimed that they maintained the esteem due to art as he did.'[2]

Yet the negative part of this comment is as important as the positive. Salvator Rosa had no real followers in his attempts to change the pattern of art patronage. He created an image of the artist which was to be fully appreciated only by the romantics of the nineteenth century. In his own day he stood alone.[3]

[1] Letter from Giuseppe de Rosis to Don Antonio Ruffo, dated 22 September 1663, published by V. Ruffo, p. 172.

[2] Baldinucci, VI, 1728, p. 579.

[3] Two other artists show some signs of having rebelled against the generally prevailing circumstances of art patronage. On 19 September 1672 Ciro Ferri wrote to Don Antonio Ruffo: '... è stato mio costume non pigliare danaro anticipato e questa per stare in mia libertà ...' but the effect of this is somewhat modified by the phrase that follows, 'tanto più sia detto a gloria di Dio, per la molteplicità degl'affari che tengo ...' (Ruffo, p. 298). And of Benedetto Luti much later Pascoli wrote (I, p. 233): 'Nè pur cercò mai protezioni de' Grandi, e siccome egli andava poco da loro, essi di rado givan da lui. Diceva, che la protezione dell'uomo dabbene esser doveva quella sola del bene oprare. ...'

Chapter 2

POPE URBAN VIII AND HIS ENTOURAGE

– i –

M AFFEO BARBERINI was born in Florence in 1568 of an old, distinguished and rich family of merchants.[1] He went to a Jesuit school where he showed great enthusiasm for classical literature, and at the age of 16 he was called to Rome by his uncle Monsignor Francesco, who held a number of posts at the papal court. There and at Pisa he continued his education and took a degree in law, although he was mainly interested in poetry, partly stimulated, no doubt, by the reputation of his famous fourteenth-century ancestor Francesco. A plan to marry came to nothing, and instead he began slowly to climb the ladder of papal preferment, making full use of his uncle's prestige and purse. From the first he showed a tenacious and skilful determination to rise, which impressed all who met him. St Philip Neri prophesied that he would one day be a cardinal. His own ambitions may well have been greater.

If so, the Rome of Sixtus V in which he was now living must inevitably have made a deep and lasting effect on him. That ruthless Pope was making the most determined efforts to give back to Rome its position as centre of the world. Lawlessness, encouraged by the ancient feudal families which still dominated the Campagna if no longer the city itself, was pitilessly trampled on, and the Pope was changing the government of the Church from an oligarchy to an absolute dictatorship. At the same time he was submitting the city of Rome to the most drastic treatment it had ever received and was laying the outlines of its future development for over two centuries. Streets were hacked through the clusters of mediaeval houses that still huddled round the nobles' palaces, opening up vast perspectives and joining the main churches across the hills and valleys. Egyptian obelisks, crowned with the emblems of triumphant Christianity, punctuated the squares and told their own story. Grandiose fountains brought fresh water to wholly new residential areas. The palaces and streets and fountains were austere, harsh and strictly functional, but towering over the city one glorious achievement was finally brought to fruition. In 1590 Michelangelo's dome of St Peter's was completed. Shortly afterwards the Pope died. He had reigned only five years, but during that time he had created a new city—Sistine Rome.

As the ambitious young prelate walked past the scaffolding and the gangs of workmen employed by Sixtus's energetic architect Domenico Fontana, he was thus able to see for himself what could be achieved by power, money and ruthlessness. Only one thing was missing—Taste. And of that Maffeo Barberini had plenty.

[1] For the Barberini and Urban VIII in particular see, unless otherwise indicated, Pastor, XIII, and Pecchiai, 1959.

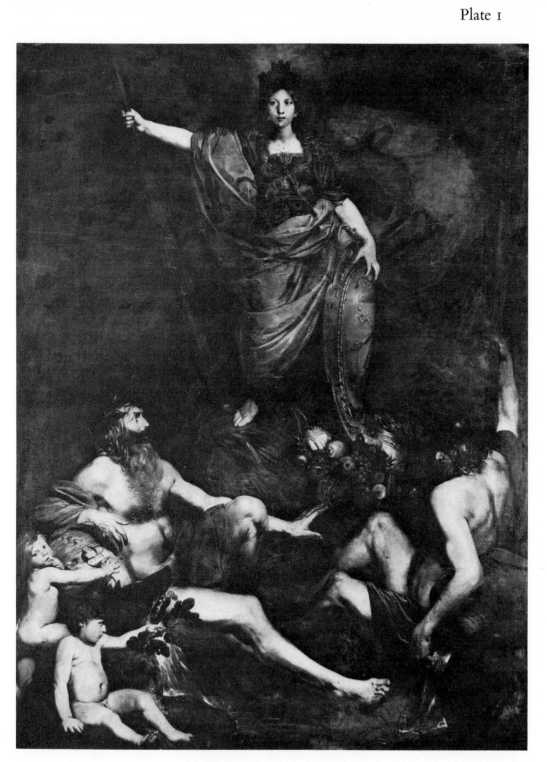

Plate I

Valentin: Allegory of Rome

Plate 2

THE BARBERINI PATRONS (*see Plates 2 and 3*)

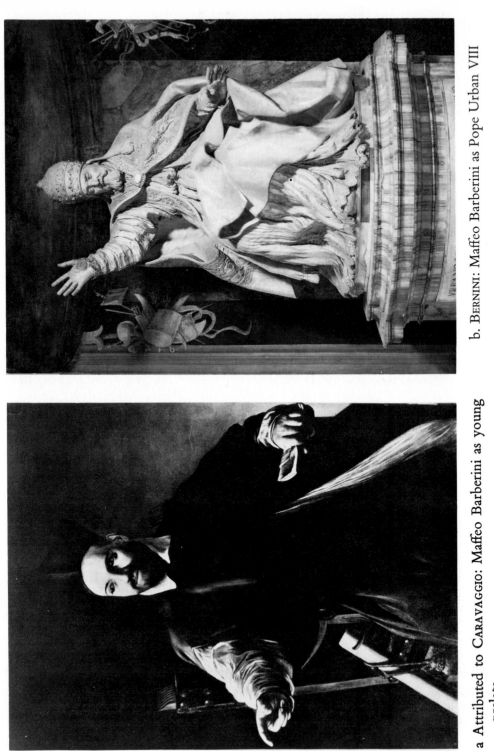

b. BERNINI: Maffeo Barberini as Pope Urban VIII

a Attributed to CARAVAGGIO: Maffeo Barberini as young prelate

Plate 3

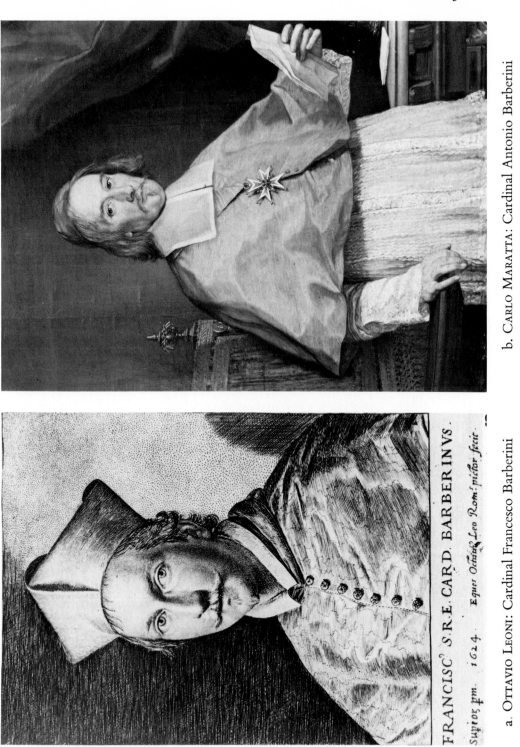

b. CARLO MARATTA: Cardinal Antonio Barberini

a. OTTAVIO LEONI: Cardinal Francesco Barberini

Plate 4

ARTISTIC ADVISERS TO THE BARBERINI

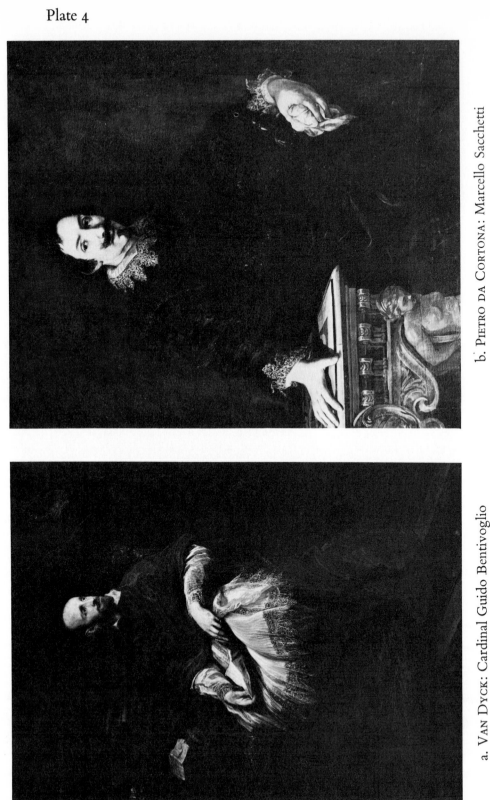

b. Pietro da Cortona: Marcello Sacchetti

a. Van Dyck: Cardinal Guido Bentivoglio

While his political career made satisfactory progress (by 1592, at the age of 24, he was governor of Fano), he continued to write poetry and began to show a discerning and adventurous liking for the arts. In about 1595 he had his portrait painted by a young painter who was just beginning to attract attention through the patronage of Cardinal Francesco del Monte—Michelangelo da Caravaggio[1] (Plate 2a). The painting which is thought to be this portrait shows us a seated Maffeo Barberini as he turns eagerly towards us, a lively but quizzical expression on his face, his right arm outstretched, while in his left hand he clutches a letter. Maffeo admired this powerful picture enough to return to the same artist (now very much better known) a few years later and commission from him a subject more suited to his talents—*The Sacrifice of Abraham*, 'who holds the knife near the throat of his son who screams and falls'.[2]

In 1598 Barberini accompanied Pope Clement VIII on his visit to Ferrara to take over the city, and learnt another lesson which was to stand him in good stead some thirty years later when Urbino too fell into the hands of the papacy. The town was won by a combination of firm diplomacy and unscrupulous pressure, and once there the Pope and his entourage took full advantage of their new prize. In particular the art treasures accumulated by the Este over the centuries were looted, and among the pictures which Cardinal Aldobrandini, the papal nephew, brought with him back to Rome were Titian's *Worship of Venus*, *The Andrians* and *Bacchus and Ariadne*.[3] Curiously enough these pictures attracted little attention in Rome until Maffeo Barberini himself became Pope nearly a quarter of a century later. They then helped to lay the foundations for a wholly new artistic style.[4]

In 1600 his uncle died and left him a fortune variously estimated at 100,000 and 400,000 *scudi*. He was now in a position to have a rich family chapel built for himself, and within four years he was boasting that he had already spent 'many thousand *scudi*'.[5] For this purpose he chose the recently begun Theatine church of S. Andrea della Valle, which was much patronised by the Florentine colony in Rome.[6] His architect, Matteo Castelli, was certainly more worthy than distinguished and he worked in a style that was becoming increasingly common: its effectiveness depended on the use of sumptuously coloured and polished marble as had been introduced by Sixtus V in S. Maria Maggiore and was later to be adopted by Paul V in the same

[1] Longhi, 1963.

[2] Bellori, p. 208. Mr Mahon dates this picture, now in the Uffizi, 1597-8. Roger Hinks (1953, p. 104) suggests a year or two later.

[3] A. Venturi, pp. 113-31.

[4] Though the Cavaliere d'Arpino copied them (see MS. note in Baglione, p. 372) and Albani must have studied them when he came to Rome in 1601-2. John Walker suggests that it is unlikely that Rubens made copies of the *Worship of Venus* and *The Andrians* during his visit to Rome. His versions of these pictures, now in Stockholm, date from very much later in his career and were probably made from copies by some other artist.

[5] See his letter to Barocci in 1604 published by Pollak, 1913, p. 5.

[6] Other chapels belonged to the Strozzi and the Rucellai—Ortolani.

basilica. Maffeo Barberini was, however, among the first to follow the fashion, and in the early years of the seventeenth century the richness and grandeur of his chapel, though smaller than those in S. Maria Maggiore, must have been startling—the more so as the church itself was only half constructed. Moreover, Barberini took a deep personal interest in the decoration,[1] and the final result when completed many years later reflected the fastidiousness of his taste. The quality of the detail is exceptionally high and the harsh, strident and over brilliant colouring of other patrician chapels is notably toned down (Plate 8). He was reluctantly compelled to admit that Federico Barocci was too old to paint an altarpiece, though he implored the artist to send him a picture for his private apartments in the palace he had acquired near that of the Farnese—'as long as it is by you I do not mind what the subject is'.[2] Instead he turned to his compatriot, Domenico Passignani, at the time one of the most fashionable painters in Rome. Passignani proposed that the cupola should be adorned with coloured mosaic and gilt stucco ribs, and he suggested a number of artists who would be suitable.[3] Eventually, however, he himself was commissioned to cover it with frescoes of the Virtues with angels and in the spandrels Moses, David, Solomon and Isaiah. He also painted the canvases and frescoes in the lunettes with Scenes from the Life of the Virgin, which are certainly his masterpieces.

At the end of 1604 Maffeo Barberini, by now a Bishop, was appointed Apostolic Nunzio in Paris. He had already paid a short visit some years earlier to congratulate Henri IV on the birth of his eldest son, and his return was warmly welcomed in France. His three years there proved immensely important, for they determined the whole of his political outlook. With strong backing from the French he was made Cardinal in 1606 despite the death of his special patron Clement VIII. When he returned to Rome a year later he took back with him great riches (the usual reward of a nunzio who went out of his way to please his hosts), 'un buffet de vaisselle d'argent vermeil doré pesant environ quatre cens marcs, duquel nous [Henri IV] luy avons faict dons' and, as his emblem, the bees from the French royal coat of arms. The cultural effects were even more important. Years later, when he was Pope, a Venetian ambassador was to write[4]: 'He has a special taste for the kind of studies which most appeal to the French, such as polite letters, out-of-the-way knowledge, poetry, an aptitude for languages. . . .'

He had continued, while in Paris, with the decoration of his chapel in S. Andrea della Valle, and had also joined with his brother Carlo in buying and furnishing a palace near the Via de' Giubbonari to match his new status. In fact, he stayed in Rome only a brief time during which, however, he argued with the greatest cogency against Paul V's intention to alter Michelangelo's plan for St. Peter's and add a nave as proposed by

[1] Besides the evidence in the two following notes, see the draft and completed version of a courteous letter, dated 30 April 1611, from Maffeo Barberini presumably to the architect in which he reproaches him for his absence and refers to 'mio disegno' for the chapel—Biblioteca Vaticana: Barb. Lat. 5820, cc. 14 and 17.

[2] Pollak, 1913, p. 5.

[3] ibid., p. 33: Letter of 26 July 1605 addressed to Maffeo Barberini in Paris.

[4] Barozzi e Berchet, I, p. 174: Renier Zeno, 1621-3.

Carlo Maderno.[1] He then moved out of Rome, first to Spoleto of which he was made Bishop and then, in 1611, to Bologna where he went as Legate—one of the most influential posts in the papal government. After another visit to Spoleto he returned to Rome in 1617 and stayed there for the rest of his life.

In Rome, Cardinal Barberini found the atmosphere very different from when he had last been settled there at the beginning of the century (he had, of course, paid repeated visits to the city in the meantime). Pope Paul V and his nephew Cardinal Scipione Borghese were spending spectacular sums on palaces, churches, chapels, fountains and picture collections, and their example was being followed by a host of courtiers. Their main resources were devoted to St Peter's, which had been radically transformed by the completion of the nave and façade, S. Maria Maggiore where the family chapel outdid that of Sixtus V in richness and colour, and the Quirinal Palace where teams of artists were at work on the decoration of the newly built rooms. Almost equal attention was being paid to the Borghese country houses, both on the Pincio and at Frascati.

The essential change that had occurred in the arts during the pontificate of Paul V was the abandonment of the austere functionalism that had characterised most architecture, painting and sculpture during the previous few reigns. After the beginning of the new century there was a revived delight in the texture of surfaces, the possibilities of enlivening façades through the interplay of light and shadow, a release of emotion through brilliant colour, an enjoyment of the solid body as opposed to the attenuated cryptograms of much late Mannerist painting, the exploitation of new themes such as landscapes and still lives, the re-emergence of the easel picture and lighter pagan subjects, all combined with a striking freedom from dogmatic theory and a readiness to indulge in every kind of experiment. No one played a greater part in the encouragement and enjoyment of these changes than Cardinal Scipione Borghese (Plate 5).

Though well-born, he was a man of few intellectual attainments, and characterised —as the Venetian ambassador pointed out[2]—by 'the mediocrity of his learning and a life largely devoted to the cultivation of pleasures and pastimes'. He was generally good humoured, but wholly ruthless in fulfilling his passionate love of art. He obtained 105 pictures—including a number of Caravaggios—by having them confiscated from the unfortunate painter Cavaliere d'Arpino, who was in difficulties with the tax collectors —and this despite the fact that d'Arpino was among the artists whom he himself often employed[3]; Raphael's *Deposition* was, on his orders, stolen from the Baglioni family chapel in Perugia and removed by night to his collection; Domenichino was imprisoned because he had the rashness to abide by his contract with Cardinal Aldobrandini, who had commissioned from him a *Hunt of Diana* which Scipione coveted. (Plate 7).[4] By these and more orthodox means Cardinal Borghese managed to accumulate a wonderful

[1] Pastor, XII, pp. 691-2.
[2] Barozzi e Berchet, I, p. 158: Renier Zeno, 1621-3.
[3] See articles by de Rinaldis in *Bollettino d'Arte*, 1936, pp. 577-80, and *Archivi*, 1936, pp. 110-18.
[4] For both these instances and a general account of Scipione's collecting see Paola della Pergola, Vol. I and II, 1955-59.

collection of paintings which, to the modern eye, appears to have been formed on no guiding principle other than an enthusiastic and undiscriminating appetite. Old masters, the Bolognese of every tendency, Caravaggio, Rubens, the elder generation of Mannerists—all were amply represented in his collections. His villa on the Pincio—the 'delizia di Roma'—set in an extensive park and enriched with niches and statuary like some fantastic confectionary was the centre of the most hedonistic society that Rome had known since the Renaissance (Plate 6). Indeed, astonishing as were Scipione's actual commissions to Guido Reni (who painted his fresco of *Aurora* for one of the Cardinal's *casini*), to Bernini and to innumerable other artists, the very example of his way of life and carefree patronage were even more important in bringing about a new era.

In 1621 Paul V died, and after a short conclave was succeeded by the old and ill Gregory XV. Quite suddenly everything changed. The cardinals who had flocked to Scipione's sumptuous banquets, the artists, retainers and sycophants who had thronged his halls, all deserted him. He was left alone and bitter among the treasures that had testified to his riches and enthusiasms—such drastic changes of fortune were now regular features of the Roman scene.[1] The new Pope and his vigorous young nephew Ludovico Ludovisi monopolised the finest talents, and, inevitably, gave their Bolognese compatriots Domenichino and Guercino complete supremacy. But now there was a definite policy to replace the cheerful chaos of Borghese patronage. Holding the influential post of Secretary of State was Monsignor Agucchi, also a Bolognese.[2] A man of wide learning and a theoretical cast of mind, he was highly selective in his love of painting and convinced that princes must be guided by men 'of enlightened knowledge' (such as himself) in their encouragement of it. He had watched Annibale Carracci at work in the Farnese palace and befriended his young pupil Domenichino. From his contacts with these artists, from his reading of literary criticism, especially Aristotle, and, no doubt from the promptings of his own temperament, he had sketched out a theory of art during a period of retirement from public life between 1607 and 1615. In this he rejected the views attributed to Caravaggio and his followers that painting consisted 'merely of the imitation of nature'. Rather it must aim at an ideal exemplified most fully in the works of the ancients, of Raphael and of his young Bolognese protégés. Now, in power, he had the chance for two brief years to assert these views. Domenichino was given every encouragement, and Guercino's painterly exuberance showed signs of modification. A brief 'classic' reaction set in after the wide tolerance of the previous twenty years.[3] If the immediate results were too few to be very noticeable, the long-term impact was none the less of the greatest importance.

Other patrons besides the Popes and their nephews were active and influential in Rome. The corrupt and sophisticated Cardinal del Monte, representative of the Grand Duke of Tuscany and living in the splendid official residence behind the Piazza Navona, was now (in 1617) an old man of 68—described a few years later as 'a living corpse . . .

[1] For the temporary disgrace of Scipione see Barozzi e Berchet, I, pp. 158-9, and Memmoli, p. 42.
[2] For the fullest account of Agucchi and his theories see Mahon, 1947, pp. 111-54.
[3] Pope-Hennessy, 1946, pp. 186-91.

given up entirely to spiritual matters, perhaps so as to make up for the licence of his younger days'.[1] At the beginning of the century he had, indeed, lived largely for pleasure —banquets, theatrical entertainment, parties 'where, as there were no ladies present, the dancing was done by boys dressed up as girls'. This side of his life had been reflected in a series of canvases of effeminate young boys by Caravaggio, whose first serious patron he had been and who had lived in his household.[2] But long after Caravaggio's death and right into old age Cardinal del Monte had continued to explore the studios for new artists of talent. He launched the landscape painter Filippo d'Angeli (Napoletano)[3] and shortly before dying he used his overwhelming influence on the Committee in charge of decorating St Peter's to obtain an important commission for the virtually unknown Andrea Sacchi, whom he had employed in his *casino* near the Piazza del Popolo.[4]

The Marchese Vincenzo Giustiniani (Plate 17b), the exceedingly rich son of a Genoese nobleman, was meanwhile filling his palace near S. Luigi dei Francesi and the country house at Bassano di Sutri, which he himself had helped to design, with antique sculpture and one of the most remarkable collections of paintings in Rome.[5] He and his brother Benedetto had been among Caravaggio's most enthusiastic supporters, and Vincenzo continued to employ some of Caravaggio's Northern followers after the master himself had died. In the 'large room with old pictures' in his palace were hung thirteen by Caravaggio—by far the largest group in existence—along with others by the Carracci, the great masters of the Venetian High Renaissance and by Luca Cambiaso, the Genoese painter whose experiments with lighting may well have seemed to anticipate those of Caravaggio. Most of these paintings were religious, but set apart, on the advice of the German Joachim von Sandrart, behind a special curtain, was the one that most appealed to its proprietor—the winged, yet all too human, Cupid sitting on a rumpled bed and scornfully trampling on all those symbols of culture that Giustiniani was so keenly fostering. This remarkable picture, with its sophisticated eroticism, was the only one to suggest that Giustiniani shared Cardinal del Monte's specialised interest in Caravaggio.

Vincenzo Giustiniani showed by the arrangement of his pictures that he placed contemporary art on the very highest level and their variety makes it clear that his taste, like that of all patrons at the time, was wide and catholic. Indeed he even wrote an essay to theorise his eclecticism and show that he was prepared to see the finer points in a number of different styles. And yet his taste, as revealed in his actual collection

[1] Barozzi e Berchet, I, p. 162. See also the many references in Orbaan, 1920, and the avviso of 1624 published in *Roma*, XVII, 1939, p. 270.

[2] For del Monte and Caravaggio see Friedlaender.

[3] Passeri, p. 293.

[4] Bellori, 1976, p. 541.

[5] For Giustiniani see the inventory of his pictures published by Salerno, 1960; and also the articles by Paolo Portoghesi, M. V. Brugnoli, Italo Faldi and I. Toesca in 1957. The work on the Giustiniani by Carlo Hopf which Dr. Salerno and other investigators have been unable to trace was published in the *Giornale Linguistico*, Genoa, in 1881 and 1882. It is of no importance for the Marchese Vincenzo.

rather than in his writings, was far more clearly defined than that of anyone else of his age. Almost alone, and with the perception that usually comes only from hindsight, he realised the full implications of the artistic revolution that had occurred at the end of the sixteenth century. The elder generation of Mannerists, the Cavaliere d'Arpino, Federigo Zuccari, Passignano and others who still played a notable part in the artistic life of the city, were scarcely represented in his palace, while all his attention was concentrated on the great reformers Caravaggio, the Carracci and their followers.

Giustiniani gave a special welcome to Northern artists in Rome, many of whom lived in his palace. He himself had travelled in the Low Countries during a four-month trip to Northern Europe in 1606, accompanied by the painter Cristoforo Roncalli, known as Pomarancio.[1] The two men had visited churches and private collections and discussed pictures and landscapes with an acuteness and expertise that were quite exceptional at the time. On his return Vincenzo Giustiniani had the broadest and most deeply experienced artistic culture of any man in Rome and indeed Europe—with the single exception of Rubens.

Cardinal Barberini meanwhile maintained a great household and lived splendidly. He moved, above all, in a circle of writers, scholars, scientists and poets, and engaged in a learned correspondence with the Provençal antiquary Peiresc.[2] He decorated his palace with paintings—by old masters such as Raphael, Correggio, Andrea del Sarto, Giulio Romano, Parmigianino and others[3]—and he also commissioned modern pictures by Guido Reni, who had worked for him during his legateship in Bologna,[4] and by Pomarancio from whom he acquired a *Jacob and the Angel*.[5] A group of Florentine sculptors was completing the decoration of his family chapel in S. Andrea della Valle, among them Pietro Bernini. Maffeo Barberini was quick to appreciate the genius of his son Gian Lorenzo, and he was among the first men in Rome to commission a work from him—a St Sebastian, designed originally for his chapel, but in fact retained in the palace.[6] But such recognition was as yet of little use: a sculptor as brilliant as the young Bernini soon showed himself to be could only be employed by the most powerful families in Rome, and the Barberini could not aspire to that claim. Above all the reigning Pope Paul V and his nephew Scipione Borghese and then, after 1621, the Ludovisi monopolised Bernini's output. Maffeo had to bide his time and content himself with writing witty moralising epigrams in Latin on the sculptor's group of *Apollo and Daphne* and holding up the mirror for him to carve his own features as *David*. As he did so he must already have been planning that when the moment came he would certainly put the sculptor to more spectacular use than such essentially minor though pleasing works.

[1] See the remarkable journal kept by Giustiniani's friend Bernardo Bizoni published by Anna Banti.

[2] Biblioteca Vaticana—MSS. Barb. Lat. 6502—Letters from Peiresc to Maffeo Barberini, 1618-23.

[3] Orbaan, 1920, p. 237.

[4] Letter from Guido Reni in Rome dated 15 February 1614—Pollak, 1913, p. 44.

[5] *ibid.*, p. 41.

[6] Wittkower, 1955, p. 176.

– ii –

That moment came in 1623. On 6 August, after a stormy conclave, Maffeo Barberini achieved his ambition and was elected Pope, as Urban VIII. He was only 55 and in the best of health. From the first he made it clear that his was going to be the supreme power in the state—'the only use of Cardinals these days', wrote the Venetian ambassador,[1] 'is to act as a grandiose crown for the Pope'. At once he began to surround himself with his relations and friends. Six weeks after his election he made his 26-year-old nephew Francesco a Cardinal; a year later his brother Antonio, a Capuchin monk, received the same dignity, as did his other brother's brother-in-law Lorenzo Magalotti. Four years later followed the Pope's younger nephew, Antonio, aged only 19. Antonio's brother Taddeo was given important political posts, great wealth and the prospect of a rich and aristocratic wife. Most of these men were fond of the arts, and to their patronage Rome owes some of its greatest achievements.

Nepotism was a recognised feature of the papal system—so much so that the ambitious nephew of one *papabile* cardinal was in 1635 to use witchcraft in an attempt to do away with Urban VIII and thus ensure his own fortune.[2] With jealousies so strong there was much to be said for the Pope employing a close relation as his most intimate adviser. Moreover, wealth and status went hand-in-hand, and the enrichment of the papal family was therefore looked upon as inevitable, if not actually desirable. Indeed status itself was so precarious in view of frequent shifts of power that extreme wealth provided the only ultimate security for those prepared to take office.[3] Nor was much distinction made between the papal treasury and any pope's personal income. Yet despite all this, Urban VIII was universally held by his contemporaries and by his successors to have exceeded all reasonable limits.[4] The consequences were many, and only a few can be referred to here. The still existing, though already shadowy, self-government of the city of Rome virtually came to an end, and the Senate did little more than propose the erection of monuments dedicated to various members of the Barberini family. And the great feudal clans which had once tyrannised the city suffered irreparable damage. Living on the fixed incomes of their landed estates and participating in the great European wars, they were quite unable to compete with the wealth that poured into the papal court from all over the world and was then consumed in spectacular monuments or great ceremonial occasions. Their disintegration had been going on for a long time: now it reached its climax. In 1624, for instance, the Orsini sold their estates at Monte Rotondo to Carlo Barberini; a year later the Colonna sold their Castle of Roviano to the same buyer. Finally, in 1629, another branch of the family was compelled to sell the principality of Palestrina to the Barberini for 175,000 *scudi*.[5]

[1] Barozzi e Berchet, I, p. 157.
[2] Rosi, pp. 347-70.
[3] See the acute comments of Pietro Contarini, 1623-7, in Barozzi e Berchet, I, p. 207.
[4] See J. Grisar, S. J., for the most modern study of the subject.
[5] Pastor, XIII, pp. 260-1. Prince Francesco Colonna's letter announcing the sale is published by the Abbate Michele Giustiniani, I, p. 116. See also *avviso* of 23 January 1630 in Biblioteca Vaticana—Urb. Lat. 1100.

Their only purpose, henceforth, was to provide suitably aristocratic wives for the upstarts who had taken their place in the government of Rome. After some hesitation, in view of the family's Spanish affiliations, Anna Colonna, daughter of the Contestabile, was chosen as bride for Don Taddeo, the Pope's nephew.[1]

When Urban VIII came to the throne the papal states were rich enough. The Venetian ambassadors estimated their income to be two million *scudi* a year, and pointed out that, despite the absence of trade, the city was almost self-supporting, 'being extremely fertile in wheat, wine, oil and all those things which make nations prosperous and esteemed'.[2] Moreover the pope's financial patronage extended all over Italy, and important posts could be—and were—sold to the highest bidder at large profits.

The new Pope professed himself determined to maintain this wealth. 'He blames those of his predecessors who have consumed the inheritance of the Church in buildings and other things of the kind.'[3] It was not long before he followed their example on a vast scale. The aggrandisement and beautifying of Rome had acquired an impetus of its own. To refrain from continuing needed far greater will power than Urban VIII possessed. Nor, despite his protestations to the commercially minded Venetian ambassador, can he ever have seriously thought such a move desirable. As the nation states of Europe increased their power, the prestige of Rome came to depend more and more on the grandeur of her impact. The ambassadors themselves recognised this: 'In Italy,' wrote Pietro Contarini in 1623,[4] 'the Pope owns a superb state with several cities well worthy of it; and Rome especially, where the Popes usually live in recognition of her having formerly been mistress of the world, both for the ancient survivals of her past greatness and for the modern features which can be seen and which are cared for with perhaps equal attention, is a sort of emporium of the Universe. To Rome people come from every country as they have done at all times to see her splendours; and it would scarcely be an exaggeration to say that they come to pay her tribute, as she is as much the motherland of foreigners, as of her own citizens.' Even had the economic situation been infinitely graver, was it not a duty to continue this policy of beautifying the city? Besides, there were other arguments in its favour. One Pope, we are told,[5] 'used to say that it was public charity to build, and all princes should do so: because it brought assistance to the public and to private citizens, and employment on buildings greatly helped the people'. And so Urban VIII could envisage personal satisfaction and general benefit in the great works he planned.

As Pope, Urban VIII combined three important functions. He was the spiritual director of the Catholic world whose centre was Rome; he was the absolute monarch of one of the richest states in Italy; and he was the proud head of an ambitious family. The nature and scope of his patronage was deeply affected by all three considerations,

[1] See the comments of the Venetian ambassadors in Barozzi e Berchet, I, pp. 153-4.
[2] *ibid.*, I, p. 228.
[3] *ibid.*, I, p. 230.
[4] *ibid.*, I, p. 200.
[5] Baglione, p. 4—of Pope Gregory XIII, quoted by Orbaan, 1920, p. xv.

which at times set up insoluble tensions. Yet greatly as they overlapped or conflicted, his patronage can perhaps best be appreciated by looking at them separately.

As a temporal and spiritual leader Urban VIII was faced with a situation whose all too obvious dangers were only surpassed by those more subtle threats which were eventually to undermine the whole status of the papacy. The immediate problem was no longer the Protestant advance which had caused so much trouble to his predecessors: the reconciliation of Henri IV in 1593 and the Battle of the White Hill in 1621 had proved effective barriers—indeed the sense of triumph which so many observers have noted in the style of the mature Baroque, contemporary with Urban VIII, no doubt reflected the impact of these overwhelming victories. The problem lay rather in the traditional enmity between the two great Catholic powers, France and the Hapsburg Empire, whose jockeyings for position and searches for allies frequently threatened the peace of Italy and the security of the papal states. And so the attention paid by Urban VIII to fortifications both in and out of Rome had a far greater effect on his contemporaries than is usually recognised, and was recorded in many works of art.[1] Though he tried to remain neutral, Urban was in fact compelled to lean much too heavily on his alliance with France—a situation that was eagerly turned to advantage by the unscrupulous Richelieu and that helped to reinforce the already strong French aspects of his culture.

But within Rome the situation was more complex and much harder to deal with. The severity of the Counter Reformation had uprooted the gravest evils of the city, but when it was relaxed a much more dangerous spiritual crisis was revealed. The old explanations no longer satisfied: instead, serious scientific experiments as conducted by the Accademia dei Lincei and Galileo, abstruse metaphysical speculations derived from certain materialist strands of Renaissance thought, the astrological theories of deliberate charlatans and a cynical or frivolous disbelief, all emerged from the stifling silence and penetrated to the very core of Roman society, affecting the papacy itself.[2] In the words of one well-informed but somewhat optimistic French disbeliever, 'on pardonne à Rome aux Athées, aux Sodomites, aux libertins et à plusieurs autres fripons; mais on ne pardonne jamais à ceux qui mesdisent du Pape ou de la Cour Romaine. . . . L'Italie est pleine de libertins et d'Athées, et gens qui ne croyent rien.'[3] The reaction was, in fact, a rather spasmodic persecution combined with an often secret indulgence. Above all there was the firmly held belief that by emphasising all the outward forms of orthodox religion it would be possible to win men back to the old ways. The immense stimulus to ecclesiastical architecture and decoration given by Urban VIII was at least partly aimed at stifling doubts within Italy itself—hence the emphasis on 'persuasion' which is the other feature of the Baroque that every observer has noted.

[1] Pastor, XIII, p. 865. As, for instance, *The forge of Vulcan* in Pietro da Cortona's ceiling fresco in the Barberini palace; also one of the tapestries designed for the palace to represent scenes from Urban's life— see later, p. 60. The Pope's defence of Rome was also intended to be shown allegorically on one of the walls of the palace—Pastor, XIII, p. 969.

[2] See below, p. 40, note 3.

[3] Gabriel Naudé—quoted by Pintard, p. 262.

The achievement of grandeur, triumph and persuasion so characteristic of the Barberini style was largely due to one man. 'As Urban VIII was a Florentine, the radiance of the Bolognese came to an end.' Thus Passeri many years later.[1] Gian Lorenzo Bernini (we hear from the same, hostile, source), though born in Naples of a Neapolitan mother, was most anxious to stress the fact that his father was a Florentine.[2] Part of the immense appeal he had for Urban VIII must certainly be attributed to this. During the early years of his pontificate especially Urban again and again showed his determination to give the best jobs to Tuscan artists. Yet he had had plenty of opportunity to see that the quality of Bernini's work was at least as good a recommendation as the circumstances of his birth. 'It is your great good luck, Cavaliere,' he is reported to have said soon after his accession, 'to see Maffeo Barberini Pope; but we are even luckier in that the Cavaliere Bernini lives at the time of Our Pontificate.'[3] Action was soon to prove how genuine was the sentiment even if the words themselves are apocryphal. Within a few months Bernini, who throughout the previous reign had been working on decorative sculpture and small-scale busts, was given his first official post and began his first monumental works.

The new Pope's main attention was centred on St Peter's, which he was able to consecrate in 1626. The exterior was now complete. The façade had been erected by Carlo Maderno by 1612, and malicious observers were quick to point out that far more prominence had been given to inscribing on it the name of Paul V than that of St Peter: 'It is not for the Prince of the Apostles that the Church has been built, but for his Vicar, Paul.'[4] Urban's plans for the interior were fully as grandiose, and even more ambitious. He chose for his special patronage the central area under Michelangelo's dome and by the end of his reign he and Bernini had dramatically established the main decoration of this, the most important part of the church. Yet though the rhythm of work was intense it is unlikely that Urban had started with an overall plan for the whole area. Only after the first great step had been undertaken did the nature of his ideas become fully apparent.

In July 1624, less than a year after Urban's assumption of power, Bernini began work on a gigantic *baldacchino* to replace the one that had been temporarily set above the supposed tomb of St Peter. There were a number of obstacles to overcome, and two in particular caused some trouble: the danger that early Christian tombs would be irrevocably disturbed by the foundations of the new structure and the shortage of bronze for columns that were to rise as high as the Palazzo Farnese, the greatest palace in Rome. The first problem was solved by careful archaeological investigation and the use of artists to record all discoveries; the second by the despoiling of the Pantheon. After nine years the whole project was eventually completed.[5]

[1] Passeri, p. 352.
[2] 'Cav.re Gio. Lorenzo Bernini Napoletano, o Fiorentino come egli vuole,' wrote Passeri sarcastically —p. 169.
[3] Baldinucci, 1948, p. 80.
[4] P. Romano, p. 41.
[5] For the documents see Pollak, 1931, II, pp. 306 ff., and Pastor, XIII, pp. 939-47.

Artistically Bernini's highly imaginative *baldacchino* was an immediate success, and contemporaries were all struck by the marvellous way in which it drew attention to itself without impeding the general view of the church. Iconographically it was relatively simple, as was most of the religious art of the period, but a change in conception when work had already been begun shows that the original intention had been somewhat different. It had been planned to crown the edifice with a huge statue of the Risen Christ. At a later stage this was changed to a Cross, and the effect was to dedicate the monument to Christ's passion rather than His triumph. References to St Peter himself and the establishment of the papacy were confined to relatively small angels above the cornice carrying his tiara and keys. But the most immediately striking feature of the *baldacchino* is the use of giant twisted columns, a form much admired by Raphael. The overwhelming religious precedents for these made them ideally suitable as the climax of the greatest Christian church: for the twisted column was supposed to derive from Solomon's Temple in Jerusalem, and against one of them, preserved in St Peter's itself, Christ was supposed to have leant. Moreover, the twisted column, intertwined with vine leaves, formed an essential feature of the screen of many ancient basilicas including that of St Peter's.

Urban VIII probably played a direct part in outlining the iconographical scheme: certainly he made sure that he should be closely identified with it. The Barberini bees crawl up the columns and hang down on bronze tassels from the cornice; the Barberini sun blazes above the rich capitals; an elementary knowledge of botany makes it clear that the leaves on the columns are those of the laurel—another Barberini emblem— and not the traditional vine. From now on their family history was to be indelibly linked with that of the great church. The cost had been enormous—200,000 *scudi* or a tenth of the annual income of the papal states; and the removal, at Bernini's suggestion, of bronze from the Pantheon, a step which led to a bitter little epigram from the Pope's own doctor and the first of the grumblings that were to accompany many of his enterprises.[1]

The influence of the Pope in the decorating of St Peter's was obviously decisive, but alterations were nominally controlled by a permanent committee which, when Urban came to the throne, was under the chairmanship of Cardinal Ginnasi. He was by now a very old man, of few gifts, one of the chief partisans in Rome of the Spanish cause, who had himself hoped to be elected Pope during the recent conclave.[2] In June 1627, a few days before Bernini's columns were unveiled, the committee decided to build special altars in the niches of the pillars supporting the dome.[3] Various proposals were made and the Pope, who saw them all, was careful to point out that the committee should choose which one it found most suitable. In fact, as was inevitable, Bernini's

[1] For the origins of the famous epigram 'Quod non fecerunt Barbari, fecerunt Barberini' see Pastor, XIII, p. 868, note 1, and p. 940, note 8.

[2] Pollak, 1931, II, *passim*. Pastor's statement (XIII, p. 232) that Ginnasi was unpopular with the Spaniards is difficult to understand in view of the document that he himself publishes on p. 1004 and constant reports about Ginnasi's Hispanophil tendencies from the Venetian envoys.

[3] Pollak, 1931, II, p. 426.

scheme was accepted and the plan was changed. The altars were to be placed in the crypt and the niches reserved for statues of the four saints whose relics were most venerated in the church.[1] Four leading sculptors were chosen by Bernini for this commission[2]—and he himself produced one of the figures, St Longinus. A Flemish sculptor François Duquesnoy, who had worked under him on the *baldacchino*, carved a St Andrew which aroused much controversy and was used as a touchstone by all those who were most hostile to Bernini's more decidedly Baroque tendencies. And at the same time as these plans were being put into effect, balconies were built above the niches so that the relics associated with the saints concerned could be displayed on certain feast days and recalled to the faithful by stone reproductions carried by angels.

Only two further direct commissions by Urban VIII for St Peter's need be considered here. At the end of 1633 Bernini with a number of assistants began work on a marble relief, which was intended to be placed inside the church but is now in the portico, representing Christ entrusting his flock to St Peter—the foundation stone, as it were, of papal claims; and at the same time he designed a tomb in the right aisle for the Countess Matilda whose body the Pope had specially transferred from the province of Mantua—that Countess, whose bequest at the end of the eleventh century of all her property to the Holy See had first established the territorial government of the church on a firm basis. To make sure that the implications of this should be fully realised, the principal relief on the tomb showed the Emperor Henry IV kneeling before Pope Gregory VII at Canossa.

When the scheme was eventually complete it was apparent that the Pope and Bernini had given new meaning to the whole church. As Urban in the last years of his life entered through the west door he must, like pilgrims to this day, have been drawn forward irresistibly to the dominating *baldacchino*. Standing there he could see the results of his patronage. All the elements echoed each other in style and theme: a great hymn of praise to the martyrdom of Christ, His Saints and His Apostles unequalled in emotional force anywhere in the world; but also, so fused as to be an essential part of the whole structure, a passionate reminder of the overwhelming glories of the papacy and of his own house.

The work took a large number of years and continued almost until the end of his pontificate, but long before that it had ensured Bernini's prestige in Rome and throughout Europe. Most important of all his authority with the Pope was now absolute. He was given 10,000 *scudi* for his building of the *baldacchino*, honours were showered on himself and on his family and he was made virtually artistic dictator of Rome. It became a standing complaint that to work for the Barberini without his patronage was impossible. 'That dragon who ceaselessly guarded the Orchards of the Hesperides', wrote Passeri[3], parodying a poem written in praise of Bernini, 'made sure that no one else should snatch the golden apples of Papal favour. He spat poison everywhere, and

[1] Wittkower, 1955, pp. 192-3.
[2] Pascoli, II, p. 428 for Bernini's choice of Bolgi.
[3] Passeri, p. 236.

was always planting ferocious spikes along the path that led to rich rewards.' Naturally enough his domineering attitude earned him many enemies, but as long as Urban VIII lived his position was impregnable. Indeed the Pope was as keen that Bernini should work exclusively for him as the artist was that no one else should usurp his place. Between 1623 and 1644 Bernini undertook almost no work of any importance other than that commissioned by the Barberini. Unquestionably this was largely because of the pressure of time and the gigantic nature of the papal commissions. But there was another reason. The Pope was not anxious that the great artist he had at his disposal should immortalise anyone other than himself—no doubt he was well aware of the opportunities that had been missed by successive patrons of Michelangelo (whose memory haunted both Urban and Bernini), and realised fully how much glory a commission to Bernini could confer on the patron as well as on the artist. Only very few cardinals or princes could obtain works from him. Just before dying Scipione Borghese, the sculptor's first important patron, had his jovial, acute features recorded in two splendid busts (Plate 5)—but only with special authorisation from the Pope.[1] In other cases the execution at least was often left to assistants. Foreign rulers—Charles I of England and Cardinal Richelieu of France—had to implore the Barberini to allow Bernini to make portraits of them, and permission was only granted as an exceptional favour in return for useful privileges.[2] Indeed, to stress the diplomatic importance of these occasions the Pope took special steps to stop Bernini working for anyone without his ruling. We hear from the English sculptor Nicholas Stone that when the artist was carving the bust of Thomas Baker (the man entrusted with conveying to Bernini Van Dyck's triple portrait of Charles I) '. . . it fell out that his patrone the Pope came to here of itt who sent Cardinal Barberine to forbid him . . . for the Pope would have no other picture sent into England from this hand but his Maity'.[3]

At much the same time as Urban VIII had commissioned the *baldacchino* for St Peter's he had also entrusted Bernini with his first purely architectural work—the reconstruction and decoration of the little church of S. Bibiana. That this unimportant and out-of-the-way church should hold such a vital place in the history of the Baroque is largely due to an accident. During some routine restoration the body of the Saint was discovered, and the Pope took the opportunity of having the church completely rebuilt.[4] Within a couple of years Bernini had finished the task and also made a statue of the Saint to be placed behind the High Altar—a restrained yet emotional work in which for the first time the combination of sensuality and mysticism which had appeared in so many Counter Reformation paintings was translated into sculpture.[5]

[1] Fraschetti, p. 107, publishes an *avviso* from the Este Resident in Rome dated 8 January 1633 (Borghese died in October): 'Il Cavalier Bernini di commissione del Papa ha fatto in marmo la testa de Cardinal Borghese che ha donato in ricompensa 500 *zecchini* et un diamante di 150 *scudi*.'

[2] Wittkower, 1955, pp. 200 and 202.

[3] Wittkower, 1955, p. 201, and Gould, 1958.

[4] Pastor, XIII, p. 955. For the documents see Pollak, 1927, I, pp. 22-30.

[5] Wittkower, 1955, p. 186, and for this whole chapter the same author, 1958.

On the same day that Bernini was given his first payment in connection with this statue, another Florentine artist, Agostino Ciampelli, was commissioned to paint on the walls a series of frescoes illustrating the life of the Saint. He was one of the group of 'reformed Mannerists' who had had considerable success in Rome especially in the prosperous Tuscan community, and the commission was therefore a natural recognition of his talents and nationality. He had scarcely been at work three months when a new painter was introduced and much to Ciampelli's disgust given the left-hand wall on which to paint three scenes from the life and martyrdom of St Bibiana.

This new painter, Pietro Berrettini from Cortona, was also a Tuscan and he was brought to the attention of Urban VIII by one of the Pope's closest friends, Marcello Sacchetti (Plate 4b).[1] The two brothers Marcello and Giulio, who came to play crucial rôles in the political and artistic world of Urban VIII, were the sons of an extremely rich Florentine businessman who had moved to Rome towards the end of the sixteenth century and had soon become one of the leaders of the Tuscan community there. Their palace was situated near the Tiber in the parish of S. Giovanni dei Fiorentini, in which church they founded a grandiose family chapel, and within a few years of their arrival they had begun building a villa near Ostia whose finely decorated gallery was considered one of the most beautiful in Europe. Both Giulio and Marcello were devoted to learning and poetry, and it was this which sealed their friendship with Maffeo Barberini. Marcello, who himself wrote Tuscan odes, had travelled throughout Europe and made contacts with scholars in many countries. Among his close friends was the most famous poet of the age, the Neapolitan Giambattista Marino, who returned to Italy from an eight-year visit to Paris in 1623.[2] Marino spent only a year in Rome before going to Naples where he died soon afterwards, disappointed in his hopes of papal patronage— no doubt the sensuality of much of his verse offended Urban's austerer taste. None the less he enjoyed a triumphant welcome in Rome, and he must have been particularly well received by Sacchetti, to whom he had dedicated a pretty song, for the two men shared a passion for painting. Marino had made a collection of his own and had persuaded the young Nicolas Poussin to follow him to Italy. Above all he had written a series of very popular poems on works by leading artists in which he specially singled out for praise their pagan qualities.[3] Sacchetti himself painted landscapes for pleasure, and he was always searching for new talent. One day on a visit to the studios he had come across a copy of Raphael's *Galatea*, and seeking out the artist had been overjoyed to find that he too came from Tuscany.[4] Pietro da Cortona was at once brought within the Sacchetti orbit and met Marino soon afterwards. Significantly one of his first commissions was to copy one of the Titians—a *Holy Family with St Catherine*—which

[1] Ceccarelli, 1946, and, above all, the life of Marcello by Jan Niceo Eritreo [G. V. Rossi] in *Pinacotheca*, III, pp. 26-33.

[2] Borzelli, 1898, pp. 164 ff.

[3] For the fullest account of Marino's relations with artists and his collections see Borzelli's rare pamphlet of 1891, and Ackerman, 1961.

[4] This is the account given by Passeri, p. 375. There are inevitably other versions of the meeting. For this whole section see *Mostra di Pietro da Cortona*, 1956, and Briganti, 1962.

had been acquired by Cardinal Aldobrandini from Ferrara. Marcello had decided views on painting and his encouragement of Pietro to copy Raphael and Titian marks a focal point in the history of seventeenth-century art: that combination of Raphael's freest, most imaginative design with Titian's warmth of colour was the foundation stone on which Baroque painting was established. Thereafter every artist was required to undergo similar training. Pietro was a docile artist who even in his later days of great fame would always ask his patrons for subjects,[1] and here too Marcello's influence was vital. He was a learned man, steeped in classical culture, and a poet, a new type of patron to whom the eager young Pietro was especially welcome. For Pietro could give warm and vivid life to his dreams of the past, could re-create for him all the trappings of antiquity and yet avoid the coldness of a 'classical' artist such as Domenichino. Annibale Carracci had had the same gift, but not since his death had a painter been as fresh, and yet as grand and as serious, in his evocation of the fables of ancient Rome and Greece as was Pietro da Cortona at this stage of his life when he painted for Sacchetti large canvases of *The Sacrifice of Polyxena*, *The Triumph of Bacchus* and shortly afterwards *The Rape of the Sabines* (Plate 10a). In these he moved from dark, and even crude, beginnings to a rich, warm, sun-soaked world of stately, processional figures which were soon adopted by other artists in the Sacchetti orbit (Plates 10b, 11a, 11b). Soon afterwards Marcello employed Pietro on a new and larger undertaking—the decoration of his country house at Castel Fusano near Ostia. Among the team of artists working under Pietro was another who was soon to achieve celebrity partly through the influence of the Sacchetti —Andrea Sacchi.[2] Once again Marcello chose the subjects—scenes from the Old and New Testaments in the chapel, and tales from ancient Roman history on the walls and ceiling of the gallery. In his successful interpretation of these themes, and his ability to adapt them to a convincing decorative scheme, Pietro da Cortona showed that he had found his true road.

By this time Urban VIII had become Pope and the position of the Sacchetti changed dramatically. Giulio was made a Cardinal in 1626 and thereafter enjoyed a highly successful career in the Church; Marcello became papal treasurer and was given the monopoly of the alum mines at Tolfa which he at once had painted by Pietro. Moreover, he became the Pope's closest friend, the confidant of his most intimate secrets until ill-health compelled him to retire to Naples, where he died. The Sacchettis' influence in matters of taste was decisive—their 'shadow was enough to protect any artist', wrote one chronicler[3]—and we hear that the brothers 'took pleasure in the success of their favourite [Pietro da Cortona] and never grew tired of promoting his chances'.[4] So it was that the young Pietro da Cortona joined Agostino Ciampelli in the church of S. Bibiana. To his frescoes he brought the warmth and breadth of his 'grand manner'

[1] See Chapter I, p. 11, note 1.
[2] Incisa della Rocchetta, 1924, pp. 60-76.
[3] *Vita di G. M. Bottalla*—Soprani, I, p. 303.
[4] Passeri, p. 378. For inventories of the Sacchetti collection, most of which is now in the Pinacoteca Capitolina, see the sources referred to by Briganti, 1957, pp. 5-14.

combined with the attention to classical detail which so delighted the connoisseurs. Henceforward his success was assured and he joined Bernini as the Pope's special artist. A triumphant career lay ahead.

– iii –

Urban VIII was a handsome, cultivated and friendly man liable to fits of extremely bad temper. He retained throughout his life a deep love of poetry and the company of poets. He himself wrote verses in Italian, Latin and even Greek, but he was especially keen to emphasise the religious content of his work and to encourage his friends to abandon the themes of pagan mythology. He devoted many poems to celebrating the beauties of nature and simple country life—in particular as it was lived in the villa he had built for himself at Castel Gandolfo, a stark and sober edifice added on to a mediaeval castle.[1] On occasions he would tell foreign diplomats to talk business with his nephew so that he could confine his audiences to those literary discussions which were nearer his heart.[2] In general, however, he was efficient, hard working and thoroughly well informed. He combined deep religious feeling with an element of crude superstition, and he dabbled extensively in astrology.[3] But his leading characteristics were extreme vanity and over-powering ambition unaccompanied by any compensating strength of will. His rule is disfigured by acts of petty meanness[4] and a complete failure to achieve that aggrandise-ment of the papacy which had been his original aim. The society in which he lived was one calculated to accentuate all his defects of character, yet to that society and to those defects we owe some of the most splendid monuments of his patronage. The art of flattery was an essential ingredient of the Baroque. Urban VIII gave it every opportunity for expression.

Within months of his accession the first fine editions of his poems began to pour from the presses of Rome, culminating in a splendid volume of 1631 produced by the Jesuits and illustrated by Bernini. Bernini also made many busts in bronze and marble of the Pope throughout his career.[5] Nothing gives us a better impression of how Urban VIII saw himself. There is none of the swagger and almost exaggerated elegance with which Bernini treated his royal patrons both at this period and in his later years. Such swashbuckling was quite unsuitable for the Vicar of Christ. After a few years of rule the Pope loses his early sparkle and is thereafter shown as grave, authoritarian and yet somewhat withdrawn from the world. These are images of hieratic dignity designed to portray a man who does not need to stress his right to be a ruler. And in all of them the Pope is shown as exceedingly handsome and aristocratic, his long moustaches and beard

[1] Bonomelli, pp. 41-69.

[2] Alfred de Terrebasse, p. 40.

[3] Urban VIII's astrological pursuits are well documented—see the astonishing material published by D. P. Walker, pp. 205 ff. which shows that Campanella helped him in his researches. The rather sinister spying on Campanella in Paris which was ordered by the Barberini (see Bazzoni) 'to prevent him revealing anything without special permission from His Holiness as he promised before leaving Rome' must certainly be connected with these activities. See also A. Bertolotti, 1878.

[4] Such as—despite all its deeper implications—his treatment of Galileo.

[5] Wittkower, 1955, p. 184.

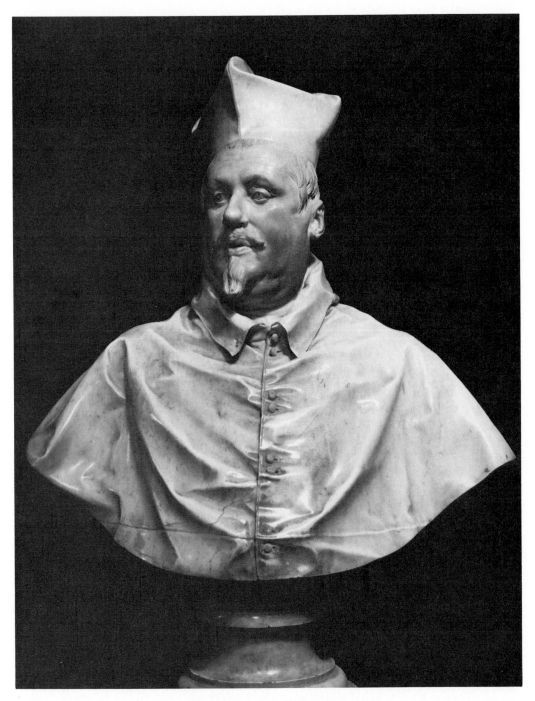

BERNINI: Cardinal Borghese

Plate 6

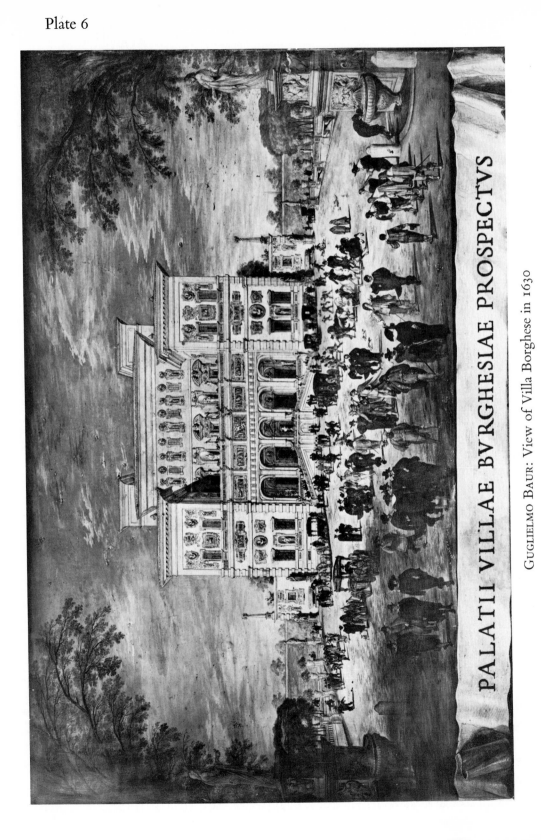

PALATII VILLAE BVRGHESIAE PROSPECTVS

GUGLIELMO BAUR: View of Villa Borghese in 1630

Plate 7

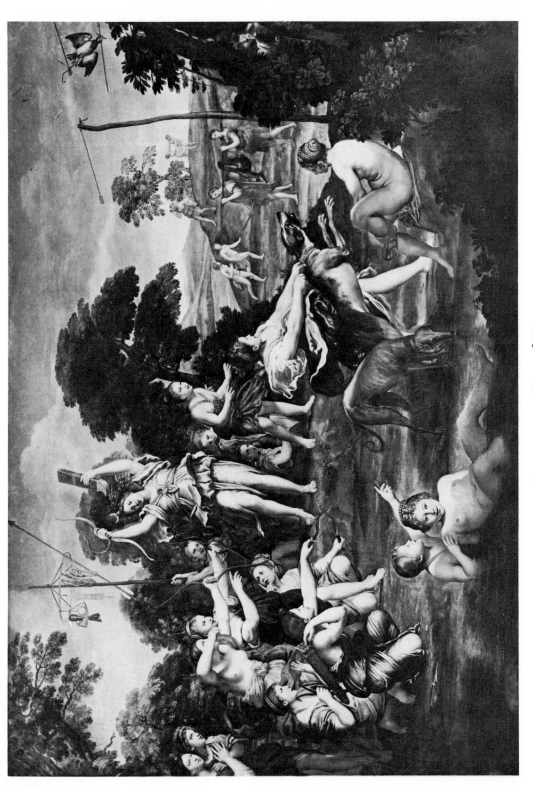

DOMENICHINO: Hunt of Diana

Plate 8 BARBERINI PATRONAGE (*see Plates* 8, 9, 12 *and* 13)

MATTEO CASTELLI: Family chapel in S. Andrea della Valle

beautifully groomed, his firm flesh fitting closely over the bones, his clear eyes sad but alert. The busts convey little of the excitability and enthusiasms of which we know from other sources.

At the same time the Pope allowed, if he did not actually encourage, grander and more public monuments to be erected to himself. As early as 1627 Bernini was commissioned to make a bronze statue which was set up six years later in Velletri.[1] And in 1635 the Roman Senate, by now a wholly anachronistic body, revoked a decree of 1590 by which statues of popes should not be erected on the Capitol during their lifetimes, and commissioned Bernini to make a large marble figure of Urban which was placed in the Palazzo dei Conservatori (Plate 2b). Meanwhile the Pope ordered Bernini to carve busts of the deceased members of his family—his father and mother and the uncle who had first encouraged his ambitions. When his brother Carlo died in 1630 the Pope commissioned a memorial plaque from Bernini and the Senate obsequiously followed suit by ordering the erection of a statue on the Capitol. An ancient torso of Julius Caesar was refashioned by the Bolognese sculptor Alessandro Algardi and Bernini himself provided the head.[2] Artistically the result is somewhat incongruous; psychologically much more so. Though commander-in-chief of the papal land and sea forces, Carlo had scarcely been a Julius Caesar. A mild and yet efficient businessman, he had, on the accession of his younger brother, been suddenly overwhelmed with such overpowering honours and dignities that they had gone to his head and he had rather strangely tried to cope with the situation by making a Latin synopsis of Machiavelli's *Prince*.[3] Even Bernini's genius and an antique torso do not quite carry conviction and the monument is a memorial more to the aspirations of the Barberini than to their prowess.

Urban VIII's greatest commission to record his own glory was that for his tomb which he ordered in 1627 after only three years on the throne.[4] It was to be built in his own lifetime and prominently placed in St Peter's. Not since Julius II had a pope taken such active steps to perpetuate himself in the greatest church in Christendom, though both Sixtus V and Paul V had had grandiose monuments built for themselves during their lifetimes. Bernini was, of course, entrusted with the work which was supervised by a protégé of the Barberini, the humbly born and rather mean Angelo Giori, who had walked to Rome from Camerino where he worked as a schoolmaster when he heard of the possibilities of preferment.[5] He was himself an enthusiastic art lover, a keen admirer of Bernini and Sacchi, but above all the special patron of Claude, seven of whose pictures he owned.[6] The work began quickly; a niche was built on the right of the apse and Guglielmo della Porta's tomb of Paul III, who had summoned the Council

[1] *ibid.*, p. 199.
[2] *ibid.*, p. 191.
[3] Pecchiai, 1959, pp. 130 ff.
[4] Wittkower, 1955, p. 193.
[5] Feliciangeli.
[6] These are now scattered all over the world. The most famous are the two great *Seaports* in the National Gallery and the Louvre—for the complete list see Röthlisberger, 1961, p. 153.

of Trent, was moved from one of the central pillars to a corresponding niche on the left of the apse. Soon afterwards the gigantic bronze figure of the blessing Pope was cast. Grander, more dramatically solemn than in any other representation, he sits far above the pilgrim, cut off even from the allegorical virtues well below, his right hand raised in an authoritative gesture that seems as keen to command or to ward off his enemies as to bless. There for eight years the tomb rested while Urban VIII overwhelmed Bernini with commissions designed to satisfy his more immediate ambitions. In 1639 work was resumed. The suave and attractive marble *Charity* accompanied by two putti was carved, followed by the grim, skeletal *Death* emerging from the sarcophagus to record on his scroll the name of *Urbanus VIII Barberinus Pontifex Maximus*. Again work stopped, and in May 1644 the now dying Pope, who carefully examined all these projects, made a final attempt to get the tomb finished in time. It was too late, and *Justice* was only completed in 1647 at a moment, ironically enough, when the Barberini had been driven from Rome for their part in exploiting the resources of the city for their own ends.

The strange confusions inherent in Urban VIII's patronage of religious foundations are even more obvious in his dealings with the church of S. Maria della Concezione.[1] His younger brother Antonio was a Capuchin monk, a retiring and not very intelligent man afflicted with a paralysing shyness, the only member of his family to be genuinely reluctant to accept the inevitable honours and titles that accompanied his brother's accession. Though made Cardinal di S. Onofrio, he continued to live as simply as his new circumstances would allow. In 1626 he decided to have built for his Order a new church and monastery adjoining the estates of Cardinal Ludovisi on the Pincio. A Capuchin architect was entrusted with the task and drew up a plan of extreme simplicity as befitted his Order. Urban VIII, however, was not the man to countenance such austerity and, undeterred by any of the inhibitions of his brother, he soon began to take the scheme in hand. He laid the foundation stone, visited the building and made over large sums for its erection. As it neared completion great figures from all over Europe competed for the opportunity to be associated with such a fashionable church so near to the Pope's heart. The Holy Roman Emperor asked to be allowed to build 'with royal munificence' a chapel dedicated to the Blessed Felice da Cantalice. In Rome Cardinal Magalotti accumulated precious stones and marbles for one dedicated to St Lawrence. Prince Peretti had similar plans. And then the Capuchins themselves intervened. When they heard that 'the Pope planned to have the altars built and decorated with precious stones as was the modern fashion in Roman churches . . . they humbly beseeched him to be pleased to condescend to the simplicity of our state . . ., and not to grant, under the guise of favours, special dispensations and allowances to our Order'. The Pope was moved by their plea and withdrew the permission he had given to foreign princes. But respect for Capuchin austerity was not his only motive: 'he did not think it right that others should play a part in the church . . . and that other princes' arms should be

[1] Passeri, p. 153, and Pollak, 1927, I, pp. 165-72. Above all see the well-documented study by P. Domenico da Isnello.

seen there besides those of his own family'. And so it was agreed that the Barberini only should be responsible for the decoration and that the chapels should be made not of precious marbles but of wood—'though of fine quality and suitable for such princes'.

So far so good—but soon there was further trouble. Cardinal S. Onofrio ordered a dozen candlesticks and two crucifixes, all of wood, and sent them to the church. He had stuck to his part of the bargain, but the Capuchin monks found them 'extremely curious and not like those used by our Order'. So 'with the most humble thanks' they sent them back. This time their protest met with no response. The Pope insisted; and the candlesticks were accepted. The same occurred with the High Altar. Urban VIII himself had had designed a bronze tabernacle and metal candelabra similar to those in his family chapel at S. Andrea della Valle with bronze candlesticks and an 'iron grating, well cast and elegant, adorned with metal or bronze'. So that these could be accepted, he ordered a special dispensation from the rules of simplicity which governed the decoration of Capuchin churches. This was exactly what they had dreaded. Fighting a lonely rearguard action in a society where riches and devotion had come to be treated as synonymous, they once again pleaded for their poverty. The Pope must have been bewildered; he was certainly adamant. The tabernacle had to be accepted, but as a concession he agreed that it should be made of *pietre fine* and not of bronze and that the candelabra could be omitted.

For the altar pictures the Pope and his brother commissioned works by the older generation of artists with whom they had been familiar in their youth—Guido Reni was written to in Bologna and sent *The Archangel Michael trampling on the Devil*, a work whose classical and somewhat mannered grace made it among the most admired of its time[1]; Domenichino and Lanfranco contributed other paintings, as did the young Barberini favourite Pietro da Cortona (and his master Baccio Ciarpi) and the still younger Andrea Sacchi. For a new generation of Barberini, the nephews, also took a part in this stage of the decoration.

– iv –

All three nephews of Urban VIII, Francesco, Taddeo and Antonio, played an increasingly important rôle in the artistic life of the city. Francesco was only aged 26 when his uncle was elected Pope and he himself was made Cardinal. Yet his hair was already thin and straggling at the sides, his moustache and miniature beard were growing grey, his expression was serious and a little careworn (Plate 3a). He was universally described as an attractive and gracious character, deeply attached to literature and the arts, though not outstandingly intelligent and distinctly averse from business.[2] His first crucial political test came early in 1625 when he was sent as special legate to Paris. Richelieu's unscrupulous policies and threatened war with Spain, which would have

[1] Malvasia, II, p. 26.
[2] Barozzi e Berchet, I, p. 214.

involved Italy, opened up a serious crisis. Francesco Barberini was instructed to propose a general armistice and above all to ensure that no concessions were made to the Huguenots.[1] The mission was a disastrous failure, but for Cardinal Barberini himself it proved of great consequence. He had set out with a brilliant retinue of friends and advisers which included the most cultivated and learned of all Italian art patrons, Cassiano dal Pozzo. They took advantage of their social opportunities and made special visits to examine the art treasures of the Louvre and Fontainebleau.[2] Everywhere they were received with extreme courtesy, and shortly before their departure they found, on returning to their apartments, a splendid gift sent by Louis XIII to sweeten their disappointment. Already hanging on the walls were seven great tapestries depicting scenes from *The Life of Constantine* woven from cartoons by Rubens.[3] Francesco was under strict instructions from his uncle not to accept gifts, and so he turned them down. It must have been a difficult decision for him—too difficult, indeed, to last for long, and soon afterwards he changed his mind and accepted the tapestries. His art collecting had certainly begun well.

But he took back with him from Paris more than a series of masterpieces by Rubens. He was even more struck than his uncle before him by the vitality of French culture, which was now very much richer and more complex than it had been twenty years earlier. Political rebuffs in no way diminished these feelings. From now on, until the end of his days, French writers, scientists, artists and thinkers of all kinds, were welcomed by him and corresponded with him. Indeed, hardly had he returned to Rome in December 1625, after nine months abroad, when he showed the first signs of these sympathies. He bought a picture of *The Capture of Jerusalem by the Emperor Titus* from the young Nicolas Poussin, who had arrived from Paris eighteen months earlier and had been introduced by Giambattista Marino to Barberini's friend Marcello Sacchetti.[4]

Another diplomatic mission followed almost immediately—this time to Madrid. It was an equal failure, and when the Cardinal returned to Rome in October 1626 he was to remain there, immensely rich and influential, indubitably the leading citizen but with little independent power of any real significance. Thereafter riches and influence were used largely to promote the arts, sciences and learning to which he was so devoted. His court became the centre of artistic and intellectual life in the city; he himself began to make an important impact on the great achievements which already marked the new reign.

His first serious opportunity came with the commissions for a whole series of new altarpieces for St Peter's. All over Italy, but especially in Florence and Rome, artists and their protectors were competing with each other for the great opportunities that now arose. The committee was being bombarded with letters; lists were being drawn

[1] Pastor, XIII, pp. 274 ff.
[2] Müntz et Molinier, 1885.
[3] U. Barberini, 1950.
[4] The picture which was later given away by Cardinal Barberini (perhaps to Richelieu) is now lost—see *Exposition Poussin*, p. 216.

up and amended; discussions were frequent.[1] The most influential member had hitherto been the extremely cultivated Cardinal del Monte, ever on the lookout for fresh talent. During the course of 1624 and early in the next year he had obtained commissions for Simon Vouet and the still virtually unknown Andrea Sacchi.[2] Now his position began to be eclipsed by the arrival of Francesco Barberini, who joined the committee on becoming Cardinal. Even before leaving for Paris, Francesco had tentatively made his first proposal—the ordering of an important picture to represent *Christ in the Boat calming His Disciples* from the well-established and persistent Lanfranco, who had written to him applying for the task.[3] On his return from this diplomatic mission Cardinal Barberini began to take a more decided and adventurous line. This was not altogether easy. The committee was especially keen to get paintings from the older generation of artists, notably the Bolognese, who had so distinguished themselves during the previous reigns. Indeed Cardinal Ginnasi, the chairman, was determined that the most important picture of all should be given to Guido Reni, and he asked the Legate in Bologna to approach the artist.[4] Francesco Barberini had to content himself with the offer of a smaller picture to Pietro da Cortona. After some months of negotiation and many advance payments Guido came to Rome; but after a short stay he left in a sudden fury brought on partly by what he considered to be the humiliating control that the committee insisted on exerting.[5] Cardinal Barberini had welcomed him warmly, but he was ready to seize the opportunity offered by the important rearrangement that now became necessary. He at once suggested that the main picture should be given to Pietro da Cortona, and that the one originally intended for him should be given instead to Nicolas Poussin.[6] The proposal was accepted, and thus through his efforts and those of Cardinal del Monte the three young artists of neo-Venetian tendencies encouraged by the Sacchetti, Cassiano dal Pozzo and the Barberini themselves made their first crucial appearances in the most important church in Rome side by side with world renowned artists of an earlier generation. From now on their triumph was complete, and the Cardinal's introduction of Pietro da Cortona and Sacchi into the Capuchin church being built by his uncles was an obvious and foregone conclusion.

Francesco bought for his own private collection one or two other works by Poussin —a *Samson*, which has disappeared, and *The Death of Germanicus*, a picture in which, despite the magniloquence of individual figures, the composition already seems to anticipate the austerity and classicism which the artist adopted in later years. It was probably just this tendency which discouraged the young Cardinal. On only one further occasion did he approach Poussin—for a second version of *The Capture of Jerusalem by the Emperor Titus*, painted some dozen years or so after the first. Once again

[1] See the many letters from artists and reports of meetings in Pollak, 1931, II.
[2] *ibid.*, pp. 230-1 and p. 294; Bellori, 1942, p. 47.
[3] Pollak, 1931, II, p. 566.
[4] *ibid.*, 1931, II, pp. 79 ff.
[5] Malvasia, II, p. 27, and Bottari, I, p. 296.
[6] Pollak, 1931, II, p. 87.

Barberini almost immediately gave the picture away to a foreign dignitary.[1] For his own taste was diverging more and more from the severity of his archaeologist friend Cassiano dal Pozzo. He himself preferred the more lush and showy. He patronised other French artists, Simon Vouet and Valentin, who lacked the fine restraint that Poussin later developed, and he paid much less attention to Andrea Sacchi, who after an early Baroque manner was increasingly turning to Raphael and Roman classicism for inspiration.

Both Valentin and Vouet had come strongly under the influence of Caravaggio, and the patronage of Cardinal Francesco and his friends, Marcello Sacchetti, Cassiano dal Pozzo and others, encouraged both artists to adopt a more florid, lighter, Baroque style in keeping with the grandiose history paintings that they were now required to produce. Valentin found the break much harder, and a huge *Allegory of Rome* represented rather an awkward attempt to use his Caravaggesque manner on an essentially unsuitable theme (Plate 1).[2] Vouet's talent was by nature more decorative and by the time he left Rome in 1627 he was already foreshadowing the grand manner which he then introduced into France.[3] Both enjoyed highly successful careers through the backing of Cardinal Francesco, culminating in altarpieces for St Peter's.[4] But their adoption by the Barberini circle effectively put an end to the direct influence of Caravaggio on Roman art.

Francesco's great opportunity to display his patronage and taste on a really large scale came with the decoration of the family palace. In 1625, during the short interval between his embassies to Paris and Madrid, he had bought the palace of Alessandro Sforza, duca di Segni, on the Quirinal. Shortly afterwards, on leaving for Spain, he gave it to one of his younger brothers, Taddeo.

– v –

Taddeo was at once the weakest and the most brutal of the Barberini. He lacked the

[1] *Exposition Poussin*, pp. 74, 216 and 219. The first *Capture of Jerusalem* and the *Samson* have disappeared. The *Death of Germanicus* is now in the Minneapolis Institute of Arts and the second *Capture of Jerusalem* is in the Kunsthistorisches Museum, Vienna.
Two other paintings by Poussin can be associated with the Barberini family—the *Landscapes with St Matthew and with St John* (Berlin and Chicago), the former of which came from the Barberini palace. Sir Anthony Blunt (*Exposition Poussin*, pp. 100 and 102) suggests that they are the first two of a series of Four Evangelists interrupted by the fall of the Barberini. It is also possible that the *Virgin protecting the city of Spoleto* at Dulwich (*ibid*, p. 78) may have been painted for Francesco who was Bishop of that city.
On 27 June 1642 Poussin wrote from Paris to thank Cassiano dal Pozzo 'che mi dà occasione di servire l'Eminentiss. Sig. Cardinal Barberino del disegno dell'istoria di Scipione' and asked him to convey his thanks also to the Cardinal 'dell'onore, che mi fa, di ricordarsi di me, e per pregarla di accettare quello per signo di tributo della mia servitù.'—Correspondance, pp. 165-6. This may be related to the drawing at Windsor, apparently from Poussin's studio, of *Scipio and the pirates* published by Blunt, 1945, p. 43.
[2] This picture, now in the Finnish Institute in Rome, was first recorded in the Barberini inventory of 1631—Orbaan, 1920, p. 506. It was published by J. Thuillier in 1958 and exhibited in *Les Français à Rome* (No. 250), held at the Archives Nationales in Paris, 1961.
[3] Vouet's pictures for Roman patrons are discussed by Louis Demonts. In 1624 he was elected Principe of the Accademia di S. Luca, the first foreigner to hold the post.
[4] Pollak, 1931, II, pp. 230-4 and 540-1.

intellectual resources of his elder and younger brothers and he was quite unable to cope with the overpowering position that his uncle planned for him. He was only 20 when Urban VIII became Pope, and he was then described as being 'all sugar, all honey'.[1] Within three years he was involved in a street brawl and a savage murder. A papal pardon, phrased so widely that it covered any interpretation put on the events that had occurred, settled that, but the deterioration in his character continued.[2] He was again and again the centre of trouble and even violence, yet on every such occasion there was someone to comment that it was not really his fault and that his only ambition was to live quietly—if splendidly.[3] And indeed only a very strong character could have withstood the temptations that were deliberately put in his way. For it was his rôle to sire a great new dynasty as important as any in Europe—the Barberini. In 1627 he was made to marry a devout and simple daughter of the Colonna, one of the oldest and most aristocratic Roman families. At about the same time he was appointed lieutenant-general of the papal armies under the supreme command of his father, whom he succeeded, and two years later his own nobility was assured by the purchase of the principality of Palestrina. In 1631 he was given the archaic title of Prefect of Rome, a post which had belonged until their extinction to the Della Rovere, the dukes of Urbino. His annual income was among the highest in the whole of Italy.

From the first the Pope was determined that Taddeo should assert his rights as vigorously as possible. The Prefecture of Rome was virtually obsolescent. It was now revived in all its authority. Dubious claims of absolute precedence on ceremonial occasions were strongly pressed—and as strongly resisted. For foreign embassies resented the humiliations which they felt were being imposed on them. The chronicles of the time are filled with accounts of the diplomatic incidents that followed. Torn between his natural laziness and the arrogance that was expected of him, Taddeo alternatively backed out or resorted to violence. Against his inclination he was turned into a public figure.[4]

Such was the man to whom in 1626 Francesco Barberini handed over the palace of the Sforzas, a family which was compelled a few years later to sell its property at Valmontone to the same purchaser. From the first the Barberini intended to have a new palace built on a much larger scale than the existing structure, part of which it was proposed to incorporate into the new scheme.[5] Taddeo continued to buy surrounding land and approached Carlo Maderno, the leading architect in Rome (Bernini had as yet only restored S. Bibiana), who had already been in the service of the Pope. Maderno or—more likely—some brilliant collaborator or adviser departed completely from the

[1] Barozzi e Berchet, I, p. 153: Renier Zeno, 1621-3.
[2] The documents published by Pecchiai (1959, pp. 161 ff.) effectively dispose of Pastor's claim (XIII, p. 263) that Taddeo 'brillava per la purezza di costumi . . .'.
[3] See constant reports over the years from the Venetian ambassadors—and this despite the fact that they were the ones most frequently embroiled with Taddeo.
[4] Giuho Pisano. 1931.
[5] Blunt's article in the *Journal of the Warburg and Courtauld Institutes*, 1958, needs to be supplemented by Hibbard's monograph on Carlo Maderno.

tradition of the sixteenth-century Roman palace. The courtyard was abandoned and replaced by a deep forecourt so that the main façade is approached through projecting wings at each end. This façade was then split up into seven bays of arcades three storeys high of which the bottom one forms an open loggia (Plate 9). From being a grim fortress, however grandiose, of the traditional type, the palace now turned into a light, welcoming country-house—indeed precedents for façades of this kind were to be found almost only in the villas scattered round Rome. Yet as a country house it was vast. It was certainly the largest private palace in the city and symbolised the fact that the Barberini were absolutely sure of themselves and of their complete supremacy over all rivals—a supremacy moreover based on money rather than arms. A new era had dawned.

Maderno died in 1629, and was at once replaced by Bernini, who with the help of his predecessor's assistant Francesco Borromini made a few modifications but kept to the main lines of the plan. By 1633—an astonishingly short time—the palace was virtually complete. Already the decoration was well under way.

Of all the Barberini, Taddeo was least interested in the arts. Unlike his uncle and brothers he had no special favourites among the talented group of painters, sculptors and architects who were creating the new Baroque style. There was, however, ready to advise him a family which had long enjoyed a special relationship with the raw, rich and art-loving popes of the seventeenth century. The Bentivoglio came from Ferrara, where they had for centuries been one of the most distinguished families.[1] When in 1598 the city had devolved to the papacy, the principal member Ippolito had made a last desperate attempt to maintain its independence by supporting the rather dubious claims of Cesare d'Este to the succession.[2] His younger brothers Guido and Enzo saw their duty in a different light. They rallied to the Church's cause and consequently reaped all the benefits that poured from a Pope anxious to appease the local nobility. Guido, a man of wide culture and very real ability, enjoyed an exceedingly successful career in the Church. In 1621 he was made Cardinal after having served as Nunzio in Flanders and Paris over the previous fourteen years—missions which strongly influenced his tastes and political sympathies and provided him with the material for his very popular historical writings. Enzo served for a time as 'ambassador' from Ferrara to Rome—a post specially created by the Pope to satisfy local sensibilities.

Both men were extremely fond of art, and showed a fine and adventurous taste. Early in 1623 Guido had his portrait painted by Van Dyck, who wonderfully rendered the sensitive, alert, powerful and ascetic features of a figure who seems to have strayed from another age, at once tougher and more spiritual, than that of the Barberini (Plate 4a).[3] Indeed he surprised his friends at Court by the relative austerity of his life[4]—

[1] Litta. The family originated in Bologna, but an important branch had long been settled in Ferrara.
[2] Bentivoglio, 1807, pp. 14 ff.
[3] The portrait is now in the Pitti. It was painted early in 1623—Bellori, p. 255, and Vaes, 1924, p. 211.
[4] Jan Niceo Eritreo, II, pp. 34-7.

relative because for a number of years he lived in the great Borghese palace on the Quirinal, decorated by Guido Reni, Tassi, Gentileschi and others which his brother Enzo bought in 1619 and which the family was forced to sell some years before Guido's death.[1] There he amassed a notable collection—there was a Van Dyck *Crucifixion* besides the portrait[2]—and became one of the first admirers of the young landscape painter Claude Lorrain, whose success was partly assured through his patronage.[3] Indeed, he introduced Claude to the Pope, who at once commissioned two pictures of fanciful and genre scenes and then asked for a further two to record his fortifications at Santa Marinella and his country house at Castel Gandolfo—themes which the artist treated in a romantically vague manner rather than literally as Urban had perhaps hoped.[4] It was no doubt this aspect of Claude's painting that made a special appeal to Cardinal Bentivoglio. Deeply involved in the intrigues of court life, he evidently felt at his ease with artists, especially those who could satisfy his love of colour and poetry. A letter from the Florentine painter Giovanni da San Giovanni who had been sent by Enzo to help to decorate the palace gives us a vivid impression of the Cardinal taking the artist round the ground-floor apartments and exclaiming, 'Giovanni, here on these unfinished vaults I want you to paint sea monsters and sirens engaged in battles in the water.' The artist obliged with three scenes full of vigorous fancy and colour depicting the Rapes of Proserpina, Amphitrite and Europa.[5]

Ever since the beginning of the century the Bentivoglio brothers had been helping succeeding popes with the purchase of the finest old masters and the employment of contemporary artists. Enzo Bentivoglio had shown no hesitation—indeed he had resorted to deliberate trickery—in helping to despoil his native Ferrara for the benefit of Scipione Borghese. In 1608 he had procured some of the finest Dosso Dossis in the Ducal collection for that Cardinal's gallery.[6] Under Gregory XV he had been put in charge of the decoration of the various Ludovisi palaces.[7] Now under Urban VIII it was to him that the uncertain Taddeo turned.

[1] The palace was bought by Bentivoglio from the Altemps family in 1619—see Callari, p. 298. The frescoes by Tassi and Gentileschi were painted in 1611 and 1612 when it still belonged to Scipione Borghese, and Passeri is therefore wrong when he writes (p. 125) that they were produced for Bentivoglio. The Bentivoglio sold the palace to the Lante family, from whom it was acquired by Cardinal Mazarin—see Chapter 7, p. 183, note 2.

[2] Bellori, p. 255.

[3] Baldinucci, VI, 1728, p. 354.

[4] The pictures are now distributed as follows: *Landscape with Rural Dance* (Lord Yarborough Collection); *Seaport* (two versions—Duke of Northumberland Collection and Louvre); *Santa Marinella* (Petit Palais, Paris); *Castel Gandolfo* (Fitzwilliam Museum, Cambridge)—see Röthlisberger, 1961, p. 121.

[5] Campori, 1866, p. 103. The frescoes are described and reproduced by O. H. Giglioli, 1949, who also publishes two other ceiling frescoes in the same palace of the *Death of Cleopatra* and the *Flight of Aeneas from Troy* which he attributes to the same artist and dates 1624. Baldinucci (VI, 1728, pp. 25-7) has a long story of Giovanni da San Giovanni working on a *Carro della Notte* to rival Guido Reni's *Aurora* in the palace and fighting with two Frenchmen who tried to wreck it. He says that Bentivoglio's patronage was responsible for the artist's success in Rome—i.e. before his frescoes for Cardinal Mellino in SS. Quattro Coronati which were painted in 1624.

[6] Paola della Pergola, I, p. 152, with documents.

[7] Passeri, p. 350.

One of the artists employed by the Bentivoglio and living in the palace was a young Umbrian follower of Domenichino, Andrea Camassei, who had been suggested to the Marchese by the somewhat elusive landscape painter Filippo Napoletano.[1] There he had decorated a room with scenes from the story of Cupid and Psyche which proved an instant success. The Bentivoglio accordingly recommended him to the Barberini and at about the same time he began working for the Sacchetti. The process was by now a familiar one, and his career seemed assured.

Camassei was at once given two ceiling frescoes to paint in small rooms in the new palace, representing *God creating the Angels* and *Parnassus with Apollo and the Muses, the Fates, and Heroes approaching the Temple of Immortality*. Like so much else in the palace, the combination of subjects was original and complex, but in a very vague way both of them foreshadowed some of the themes of the much larger scheme of decoration that was to follow. For among the hierarchy of angels brought into being by God two classes especially were singled out—those with crowns who protected provinces and kingdoms, and those with sceptres who assisted their rulers, thus symbolising the divine sanction given to the sovereigns of this world. The *Parnassus* contained more obvious references to the Barberini as protectors of civilisation and the arts. Apollo is crowned with laurel and his harp marked with the ubiquitous bee to identify him with the poet-Pope, and the Heroes who approach the Temple of Immortality on one side were soon interpreted as representing his ancestors. Both frescoes, painted in a dignified if flaccid classical style, were much admired, and great hopes were held out to Camassei.[2] Meanwhile another much finer artist of somewhat similar tendencies was introduced into the palace.

The claims of Andrea Sacchi had already been pressed by Cardinal Francesco Barberini in St Peter's. Now he was given his first large-scale work and was required to fresco the vault of one of the main reception rooms (Plate 12). The theme chosen was *Divine Wisdom*, derived from the Apocryphal Wisdom of Solomon, a subject not hitherto represented in art, but which, it was explained, was 'suitable for the majestic palace of the Barberini because it meant that as that fortunate family had been born and chosen to rule the Church in the place of God, so it did so with the aid of divine wisdom which it both loved and revered'.[3] There is no indication as to which of the Roman theologians chose the theme—it seems almost inconceivable that the artist himself could have been responsible for such a far-fetched idea. It was, in any case, as Sacchi must have been well aware, the most ambitious project to represent an abstract philosophical concept since Raphael's frescoes in the Vatican Stanze. The Biblical text on which the fresco was based called upon princes 'to honour Wisdom that ye may reign for ever'. In the hands of the artist's advisers this inevitably underwent a significant transformation. Wisdom was majestically exalted—but it was, to a large extent, identified with the particular princes who were required to honour it. For, from the breast of the female figure enthroned in the centre of the composition, there blazes

[1] Besides contemporary sources and Bellori, 1672, p. 360, see Presenzini. Cigoli had already painted scenes from this story in the palace when it belonged to Scipione Borghese.

[2] Girolamo Teti.

[3] Incisa della Rocchetta, 1924, p. 64.

forth the Sun itself. This Sun serves a double, punning purpose. On the one hand, it was a conventional emblem for Wisdom and had often been used as such[1]; on the other, it was one of the three special insignia of the Barberini family. The other two—the bees and the laurel—feature prominently in the friezes of paint and stucco which surround the main fresco. Sacchi, who always found conventional flattery difficult, treated this cosmic conceit with an intellectual severity that has no parallel in decorative painting of the seventeenth and eighteenth centuries. It is for this reason that its true implications have rarely been understood. Barberini-Wisdom, floating above the clouds on which are supported her attributes and manifestations (Eternity, Sanctity, Purity and so on) in the shape of beautiful maidens, is shown ordering Love and Fear to control the bestial passions of Lust and Wrath. The whole ceiling is covered with the fresco, but no attempt is made to represent the scene illusionistically. Sacchi painted his figures with great fluency in cool and subtle colours, mostly blues and greens and greys, but delineated each with the utmost care and did his best to subordinate the rather awkward groups into a composition of almost archaic simplicity. Urgency and passion played no part in his character or in the subject chosen for him, and by missing sublimity he inevitably missed too much.

In fact, his noble and austere fresco was much admired in certain circles in Rome, but within the Barberini family itself it only found one outright champion, Francesco's younger brother Antonio, whose special contribution to patronage will be discussed on a later page. Scarcely had the scaffolding been taken down than work was begun on the decoration of a much vaster setting—the principal reception-room of the palace. The original plan had been to give this room to Camassei, Taddeo's newly acquired protégé, but after his first works in smaller rooms it became apparent that his talents were not of the order required. For the proposals for the great hall were grandiose—indeed the most spectacular that had ever been seen in a work of the kind. The Pope's favourite poet, the Tuscan Francesco Bracciolini, was called in to devise an elaborate programme to the glory of the family, and the ceiling was clearly designed to be the greatest secular record of Barberini ambitions. With the relative failure of Camassei (only relative, for he was continually given minor commissions), one artist obviously stood out above all the rest. Pietro da Cortona's position was firmly established and he had already been engaged on frescoes in the chapel. He was powerfully backed by Cardinal Francesco and also by Jesuit advisers of the Pope. Some time towards the end of 1632 he began work on the great ceiling which he did not complete for another six or seven years.[2]

The Barberini at this time were at the very peak of their fortunes, and the programme which Francesco Bracciolini drew up and Pietro so brilliantly executed was designed as a hymn to their glory. Bracciolini, a mean character and a bad poet, had every reason to apply his flattery as intensively as possible. As a younger man he had served Maffeo Barberini as secretary for a few years and had accompanied him to

[1] Guy de Tervarant, column 356.
[2] For the most recent discussion of the fresco see Briganti, 1962.

Paris.[1] Then, at the only critical moment in the future Pope's career, when Clement VIII died in 1605, Francesco Bracciolini hurriedly left him. In 1623 he was distressed to find what a mistake this had been. Frantic letters were sent to all the Barberini. 'Now, as an old man and shorn of all pretensions,' he wrote to Urban, 'I only want to embrace Your Holiness's feet and then close my eyes.' Fortunately for him, no one took this seriously and after the publication of his sycophantic *L'elettione di Urbano VIII* he was loaded with honours and privileges. He followed the poem with a long series, dealing with such subjects as the capture of La Rochelle and the conversion of Bulgaria, dedicated to various members of the family. But the Pope had not entirely forgiven him, for he made Bracciolini secretary to his austere Capuchin brother Antonio who in 1627 became Bishop of Sinigaglia. Stranded in this little port on the Adriatic coast, Bracciolini poured out his complaints in letters full of self-pity until he was finally allowed back to Rome. There he and Cortona planned the decoration of the great Barberini ceiling (Plate 13).[2] In this room it is the Bees and the Laurel, the two emblems which had been relatively neglected by Sacchi, that are made the essential themes of the fresco. In the centre of the ceiling Divine Providence, the sovereign of the Present and the Future, of Time and the Fates, obeyed by all the Virtues, commands Immortality to crown them with a halo of stars as they form an escutcheon borne aloft by Faith, Hope and Charity. Above, Religion, with her keys, and Rome, holding the papal tiara, add their tribute to the reigning family. Four subsidiary themes break through the conventional bounds of the frame and allude in symbolical forms to the virtuous and efficient government of the Pope. These themes appear general enough—the fight against the Vices, the encouragement of learning, the provision of plenty—but interpreters, with or without the help of Bracciolini himself, were quick to give them more specific applications: Abundance stood for young Cardinal Antonio and behind him could be seen the granaries he built; Hercules fighting the Vices was a particular (though hardly very pertinent) reference to Taddeo's administration of Rome. And so through all the allegories.

Pietro da Cortona's ceiling opens a new chapter in Baroque decoration: the whole vast expanse is covered with one single fresco instead of being broken up into separate compartments; the painted 'frame' appears to be deliberately defied by a swirling crowd of figures, whose grandeur and richness of colour awe, almost crush, the visitor with the feeling of his insignificance; writhing masses of raw, red, tumbling giants convey the impression of some tremendous conflict being waged only just above his

[1] Barbi.

[2] Much light has been thrown on the Barberini ceiling and the varying meanings that it may have had for Pietro da Cortona's contemporaries by a stimulating article by Jennifer Montagu (1968, pp. 334-5). She refers to the interpretation of the iconography given by Rosichino in 1640 (who spoke of the mythological scenes in largely general terms), by Girolamo Teti in 1642 (who claimed that they alluded to specific events in the lives of the Barberini) and by other observers, at least one of whom thought that these scenes might represent the Four Ages. She also suggested that for many seventeenth-century writers the interpretation of pictures was to some extent an end in itself. See also Vitzthum, 1961, pp. 427-33.

head so that he too is inextricably involved in the Pope's strenuous war against the forces of evil.

But the very idea of such a theme was also quite new in papal patronage of the seventeenth century. No artist had been given such complex instructions for at least fifty years, for the Borghese and the Ludovisi had been content to have represented far more general historical and mythological subjects. In fact the ceilings by Sacchi and Pietro da Cortona both reflect the intensely literary interests of the new court which were comparable with those of the Renaissance humanists. But Pietro, in particular, was able to combine these interests with a sense of display such as had hitherto been achieved only in literature. The artistic synthesis that resulted was eagerly adopted by court painters for well over a century, for in his ceiling Pietro managed to incorporate an overall effect whose general meaning was startlingly clear with recondite allusions of great appeal to cultivated and sophisticated visitors. Moreover, the programme which he and Bracciolini devised carried princely flattery to a greater extreme than had yet been seen south of the Alps[1]; in this they were very likely encouraged by Cardinal Francesco, who must certainly have seen and been impressed by the early stages of Rubens's allegorical cycle in honour of Marie de Medici and Henri IV in Paris. This novelty was recognised at the time. From Naples Domenichino (who in his youth had himself helped to decorate a cardinal's gallery with themes suggesting the power of all-conquering love) wrote that, from what he had heard, the ceiling sounded more suitable for a secular prince than for a pope.[2] Despite some modern apologists there will be few to quarrel with his interpretation.

While Pietro was at work on the ceiling of the family palace, Cardinal Francesco began to employ his leading pupil Giovan Francesco Romanelli on the many other obligations which he had undertaken.[3] This artist, who retained the colour and mannerisms of his master without his fire or genius, was called upon whenever an altar or ceiling painting was required in one of the churches for which the Cardinal had assumed responsibility. He was also put in charge of the Barberini tapestry works. His painting became increasingly tired and flaccid rather than truly classic, and he never won many admirers other than the Pope and his nephew. But for that very reason he was utterly reliable, and was rewarded with pensions and honours. In 1638 he was made *Principe* of the Accademia di S. Luca 'on the orders of Cardinal [Francesco] Barberini' who entirely controlled that body and who had contributed large sums towards the complete rebuilding of its church by Pietro da Cortona. For a time, indeed, Romanelli's ambitions soared so high that he aimed to supplant his master in the Pope's service.

[1] I cannot accept Pastor's view (XIII, p. 968) that 'la personalità di Urbano VIII passa in seconda linea di fronte all'esaltazione del papa istituito da Dio'. In part this depends on an obvious misinterpretation of the iconography, for it makes nonsense of the theme to suggest that Immortality is crowning Divine Providence rather than the Barberini emblems.

[2] See his letter of 1 September 1640 to Francesco Angeloni published by Bellori, p. 358.

[3] For the relations between Romanelli and the Barberini see Passeri, pp. 305-14, and Pollak, 1913 and 1931, pp. 219-222, 548-9, 560-2, 580-1.

– vi –

The relations between temperament and aesthetic taste are complex and mysterious. The learned Cardinal Francesco, correspondent and friend of half the scholars of Europe, chose as his favourite artists the richly coloured and extrovert Pietro da Cortona and his somewhat more restrained follower Romanelli. Andrea Sacchi, a reserved and melancholy figure, whose development is marked by an increasing reluctance even to try and compete with his revered Raphael, had to rely for support almost entirely on Francesco's second brother, the impetuous Antonio. Antonio was the youngest of the Pope's nephews, and to the horror of the elder members of the Conclave, was made Cardinal in 1627 when aged only 19. For such a status he seems to have had no qualifications whatsoever beyond greed and ambition.[1] The former was to some extent appeased by the vast income he derived from his many official posts—though it is doubtful whether he ever achieved his aim of earning as much as Cardinals Borghese and Ludovisi; the latter was constantly thwarted by Francesco and the Pope himself, who sent him out of Rome as often as possible.

Antonio was an elegant figure, fatter in the face than Francesco, with alert and gleaming eyes, a neatly trimmed moustache carefully turned up at the ends and thick wavy hair; clearly a dandy and a bon vivant.[2] But he too shared the family enthusiasm for learning and art. His first real opportunity to assert himself in this field came in 1631 with the devolution of Urbino to the papacy. Ever since he had come to the throne Urban VIII had been pressing hard his indubitable claims to the city which was due to be incorporated in the ecclesiastical states on the death of the aged duke Francesco Maria della Rovere whose own heirless son had predeceased him. Urban persuaded the reluctant ruler to hand over all effective authority to a governor named from Rome, and when on 28 April 1631 the sad, lonely old man finally died, immediate steps were taken to gain possession of the State. Taddeo, who inherited the della Rovere title of Prefect of Rome, galloped across the frontier. He was followed soon after by Antonio who became the first Legate.

Antonio clearly hoped to enrich his collection of pictures from the marvellous supply in Urbino as greatly as the Aldobrandini and Borghese had done in Ferrara a generation earlier. This was not to be. Urbino was certainly despoiled—but the bulk of the collection went elsewhere. The old duke had left his private possessions to his daughter Vittoria della Rovere, wife of the Grand Duke of Tuscany. As Antonio arrived in the empty palace which nearly two centuries earlier Federigo da Montefeltre had built and turned into a symbol of Renaissance culture, packing cases loaded with Titians and Raphaels had already left for Florence.[3] Little enough remained, but in the *Studiolo* were still hanging on the walls those portraits of ancient and modern poets and philosophers which Justus of Ghent and Pedro Berruguete had painted for the original owner. They were at once removed and sent to Rome. There the Pope issued a special

[1] Apart from Pastor and Pecchiai, 1959, see the report of the Venetian ambassador Angelo Contarini, 1627-9, published by Barozzi e Berchet, I, p. 257.
[2] See the portrait on p. 73 of Teti. [3] [Gotti, A.]: pp. 102 ff.

decree to justify Cardinal Antonio's action and hand over the pictures to him and his heirs in perpetuity.[1]

Cardinal Antonio's most important contribution to artistic patronage was his regular support for Andrea Sacchi, without which, claimed Passeri, 'he would have lived like a beggar'.[2] Antonio played a part in obtaining for the artist the commissions in the Capuchin church and above all the family palace, and thereafter he was the only one of the Barberini to give him consistent employment. Such steadfast patronage at this stage meant taking an artistic stand which had not hitherto proved necessary, for it was not until the early 'thirties that the divergencies between Pietro da Cortona and Sacchi, both brought up in the Titianesque tradition, became strikingly apparent. But from now on, both in theoretical debates and in his works themselves, Sacchi showed that he disapproved of Pietro's exuberance and complexity. He more and more praised the merits of simplicity and looked to Raphael as his special inspirer. Cardinal Antonio, who gave him a monthly salary and enrolled him into his official retinue some time before 1637, must have been well aware of and have approved this attitude. Sacchi was also an excessively slow worker, and a large proportion of his regular output was painted for this one highly placed patron—mainly canvases for churches, notably the Lateran Baptistery, of which the *modelli* would be kept by the Cardinal in his private collection. He accompanied Antonio on his travels outside Rome and acted as general artistic adviser to him in the decoration of the palace for which Antonio assumed responsibility and in which he lived. When in 1639 the Cardinal organised a great reception in the Gesù to celebrate the centenary of the approval given to the Jesuit statutes, Sacchi designed the temporary decoration of the church and had it hung with tapestries. He also recorded the event in a special picture.

Indeed, the most surprising of Cardinal Antonio's commissions to Sacchi were those on which he employed him, together with a genre-painter, to record various scenes from contemporary Roman life in which he or his family was involved.[3] The most significant of these was the great 'mediaeval joust' which Cardinal Antonio organised in the Piazza Navona in 1634.[4] This had originally been planned as an entertainment for a Polish prince who was due to visit Rome, but when the visit was cancelled, the Cardinal determined to carry on 'as he desired to see revived among the young men of Rome their ancient taste for chivalry, which, owing to the state of the times, was ignored rather than wholly lost'. The Bentivoglio were in charge of the arrangements, and though spectacles of this kind were not rare in Baroque Rome there is a certain irony in the contemplation of this clerical society listening to grandiose challenges that 'Secrecy in love is a superstitious fallacy that assumes either little merit in the lady or lack of spirit in the knight'. None the less this elaborate pastiche of feudal practices met

[1] Pollak, 1927, I, p. 336. These pictures are at present divided between the Louvre and the Palazzo Ducale in Urbino. Other pictures which were taken from Urbino at this time include the so-called Tavole Barberini attributed by Federico Zeri to Giovanni Angelo da Camerino—see *Due dipinti, la filologia e un nome*, 1961. [2] Incisa della Rocchetta, 1924, p. 63, and Posse, 1925.

[3] Incisa della Rocchetta, 1959, pp. 20 ff.

[4] Bentivoglio, 1882. For earlier examples of such festivals see F. Clementi.

with delighted approval and Andrea Sacchi painted the culminating moment in the
Piazza Navona as well as drawing the illustrations for a book by Cardinal Bentivoglio
which described the occasion.

Antonio's joust forms part of a whole series of moves by the Barberini to emphasise
the chivalrous past of Rome and, by implication, to associate within it the history of
their own family. The elaborate and by now wholly artificial ceremonial with which
Don Taddeo was made Prefect of Rome—a scene which Agostino Tassi was required
to paint[1]—provides a further instance of the same attitude, as does his marriage into the
most venerable of Roman families and assumption of feudal rights over Palestrina and
elsewhere. At the same time as their lavish consumption of wealth was effectively
ruining the oldest families the Barberini were desperately trying to revive the ancient
forms for their own benefit.

Meanwhile the palace was being filled with works of art and treasures of all kinds.
In 1642 a lavishly illustrated folio volume was published with an ample, though some-
what generalised, account of its contents.[2] Breathlessly the writer described the rooms
filled with paintings by Raphael and Correggio, Titian and Perugino, the Cavaliere
d'Arpino, Guido Reni, Lanfranco, Guercino, Pietro da Cortona, Sacchi, Camassei and
others; the great allegorical ceilings; the vast collections of antiques; and above all the
splendid library which was the special concern of Cardinal Francesco with its Greek and
Roman manuscripts, its store of learning accumulated from all over the world, its
books of poetry and theology, law and history, music, architecture, astrology and
botany—a real Temple of the Muses to which the Cardinal would retire while the rest
of the palace resounded with courtiers and foreign delegates.

But the most immediately striking feature of the Barberini palace was the theatre.
Operatic performances were given for the first time in February 1632, though it was
probably not until a few years later that they were transferred from a large room in the
palace to a theatre specially built by Pietro da Cortona which was capable of seating an
audience of 3000.[3] Jean-Jacques Bouchard, the French 'libertin', was there for the first

[1] Incisa della Rocchetta, 1959, pp. 20 ff.

[2] Teti.
The Barberini inventories have been published by Marilyn Aronberg Lavin.
An inventory of 1631 was published in part by Orbaan, 1920, pp. 495-513, and of the many travellers'
accounts the fullest is that by Nicodemus Tessin the Younger and must date from 1687-8—Stockholm,
Kungliga Biblioteket, Handskriftsand S.41. I am most grateful to Miss Jennifer Montagu for pointing
this out to me and showing me a photocopy. See also Cantalamessa, 1894, pp. 79-101. As from 1935
large numbers of Barberini pictures have been sold either privately or, anonymously, in sale catalogues
such as *Preziosa Raccolta di Quadri . . . già appartenuti ad illustri famiglie patrizie*—Galleria l'Antonina, Roma,
16-23 January 1935. I wish to thank Professor Waterhouse for pointing this out to me and for lending
me his copy of the catalogue.

[3] There is great confusion about this date. Pastor (XIII, p. 972) and Ademollo (1888, p. 10) both say
1634; Blunt (*Journal of Warburg Institute*, 1958, p. 282) implies 1633; Prunières (1913, p. 8) 1632. This
latter date, confirmed by Bouchard's evidence and an *avviso* published by Clementi, I, p. 444, is the correct
one and the muddle has been caused by the repeat performances given in later years.

Plate 9

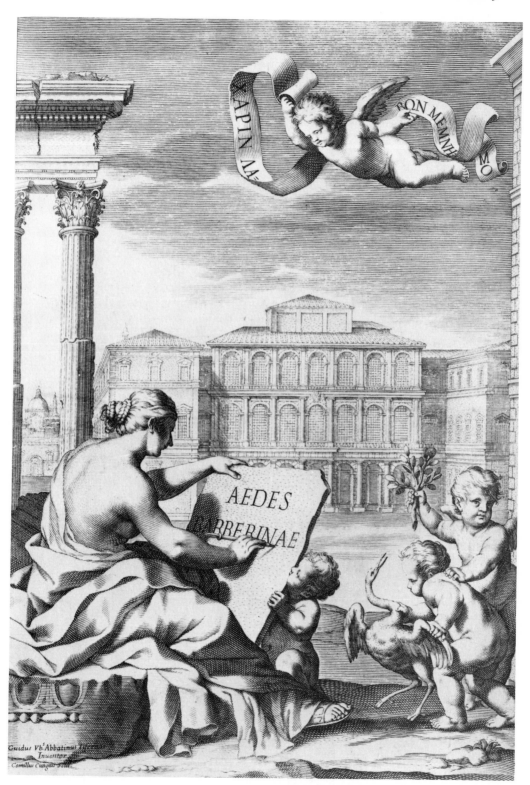

GUIDO ABBATINI: Frontispiece of *Aedes Barberinae* with view of family palace

Plate 10 SACCHETTI TASTE (*see Plates* 10 *and* 11)

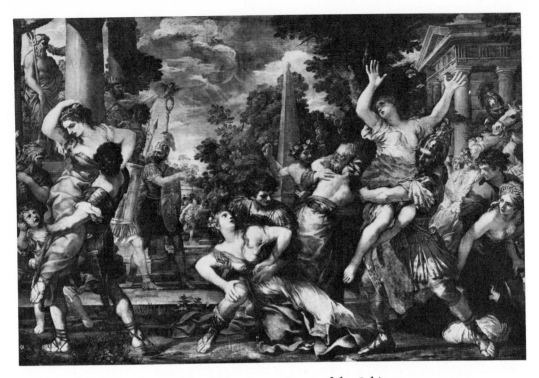

a. PIETRO DA CORTONA: Rape of the Sabines

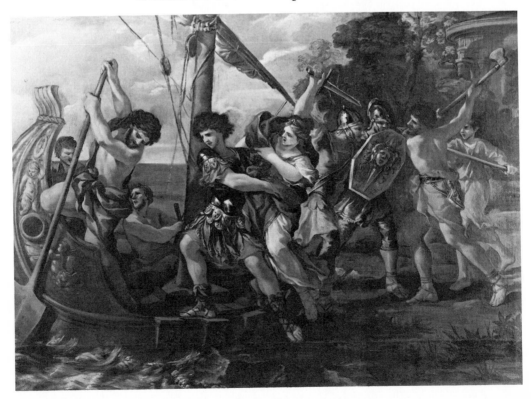

b. PIETRO DA CORTONA: Rape of Helen

Plate 11

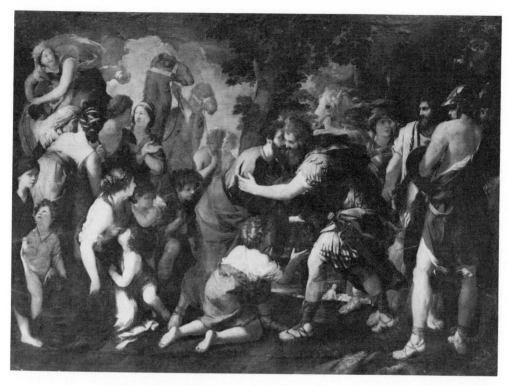

a. GIO. MARIA BOTTALLA: Meeting of Esau and Jacob

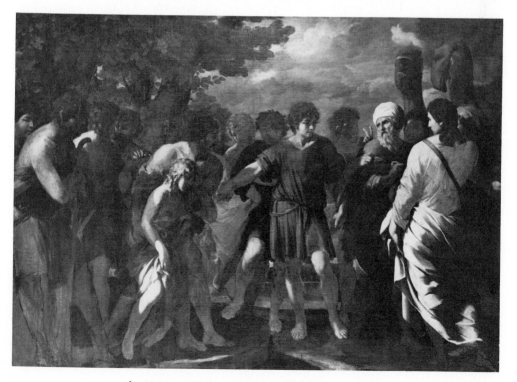

b. PIETRO TESTA: Joseph sold by his brothers

Plate 12

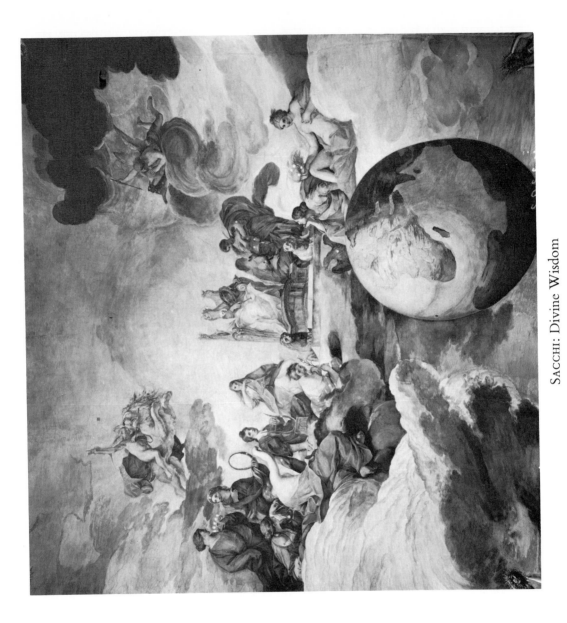

SACCHI: Divine Wisdom

performance, and he gives a vivid description of the room hung with red, blue and yellow satin, the two young Barberini Cardinals affably greeting their guests and begging them to squeeze closer together to allow more space, the prelates shouting with admiration at the beauty of the pages and castrati who were given the women's rôles. . . .[1]

The opera itself was *S. Alessio*, the story of a rich young man who wished to escape from the world. He disguised himself as a monk in his own palace and had to endure the torment of watching his wife and parents mourning over his supposed death. When the strain became too great and he was on the verge of revealing himself God showed him mercy by summoning him to the next world. The libretto of this curious, but affecting, story was written by Giulio Rospigliosi, the most attractive of the poets and art lovers who swarmed round the court of Urban VIII. Like most of the circle he was a Tuscan and his first literary work consisted of a commentary on the eulogistic *L'elettione di Urbano VIII* by his fellow Pistoian Francesco Bracciolini. This was published in 1628 when he was 28.[2] Naturally enough it won him the favour of the Barberini and thereafter his career was made. He accompanied Cardinal Francesco, whose literary and artistic interests he shared, to Spain. Back in Rome he became the discerning patron of a number of painters, and, in particular, he was able to find a congenial interpreter of his 'morality poems' in Nicolas Poussin. The artist painted three of these, though it is not absolutely certain that they were all for Rospigliosi himself—*The Dance of Human Life*, *Truth uncovered by Time* and *Happiness subject to Death* (or *The Arcadian Shepherds*).[3] All these themes, translated by Poussin into works of poignant beauty, reveal a grave, melancholy, yet ultimately hopeful view of man's destiny. But Rospigliosi was almost alone among Roman patrons in showing as great an appreciation for the wistful poetry of Claude as for the grander austerities of Poussin. He owned three landscapes by him and evidently became his close friend, for in his will the artist left Rospigliosi two drawings 'because I have always received good advice from him'.[4] Many other artists received patronage if not always advice at different stages in his life—Camassei and Lodovico Gimignani, Giovanni Francesco Grimaldi and Mattia Preti; Carlo Maratta

[1] Prunières, 1913, p. 9.

[2] Beani and Canevazzi.

[3] *The Dance of Human Life* is in the Wallace Collection; *The Arcadian Shepherds* in the Louvre and *Truth and Time* has disappeared. The first and last of these were engraved by Jean Dughet and dedicated to Rospigliosi, which seems to confirm the somewhat confused account by Bellori (p. 448) that the subjects were chosen by him. See also Panofsky (1957, p. 305) who is, however, mistaken when he writes that Rospigliosi may have been in contact with Guercino in 1621-3 through the artist's visits to Guido Reni's *Aurora* in the family palace, for at that time the Casino Rospigliosi belonged to Cardinal Bentivoglio—in this connection see letters from Denis Mahon to *The Listener*, 24 August and 14 September 1961. Mahon also suggests (1960, p. 304, and 1962, p. 111) that on stylistic grounds *The Arcadian Shepherds* may be dated 1640 instead of 1650-5, to which period it is usually given. This would also fit in far better with Bellori's account as Rospigliosi was in Madrid from 1644 to 1653 and *The Dance of Human Life* certainly dates from *c.* 1637.

In the *Nota dei Musei* Bellori mentions that Rospigliosi also owned a *Rest on the Flight into Egypt* by Poussin. See also Richard, VI, pp. 57-62.

[4] For Claude's will see Röthlisberger, 1961, p. 67. Two of the pictures are still in the Rospigliosi-Pallavicini collection in Rome—*ibid.*, p. 127.

and Bernini. And when in 1667 Rospigliosi became Pope Clement IX, he managed to give striking proof of his love of art though he only survived for two years.[1]

Under Urban VIII, Rospigliosi, who was given a number of important posts in the administration, was chiefly known for his poems and the verse dramas he wrote for the palace theatre—at first only religious and then, beginning in 1639 with *Chi soffre, speri* which was seen by Milton, also profane. In fact, however, it was neither the librettos nor the rather indifferent music of Stefano Landi and others which really excited the public, but the singers and, above all the spectacle.[2]

Bernini was of course in charge of the frequent changes of decor for *S. Alessio*, and though his surviving plans appear to us to be remarkably conservative and unadventurous, Roman spectators, who lacked much theatrical experience, were deeply impressed. All of them wrote with enthusiasm of the vividness of the scenes in Hell, the woody landscapes, the palace, the angels flying through the clouds, the final triumphant appearance of Religion. The performance stimulated a passion for sensational effects which were much more vividly produced in the provisional theatre which Bernini erected outside his own house. Here he directed plays written (and often acted) by himself, the most famous of which was *L'Inondazione del Tevere* given during the carnival of 1638 and inspired by a flood of the year before. As no drawings for it have survived, we have to rely entirely on the evidence of contemporary spectators. 'When the curtain rose,' wrote one of them,[3] 'a marvellous scene appeared showing the most distant buildings in perspective, above all St Peter's, the Castel S. Angelo and many others well known to those who live in Rome. Nearer, you saw the Tiber, which through hidden devices of the most ingenious kind, was shown to be rising. . . . Nearer that part of the stage where the acting took place was real water held back by dykes which had been specially placed all round the scene. And you saw real men rowing people from one side to the other, as if the river had submerged the lower part of the city and stopped traffic as it did last year. While everyone was stunned by the spectacle, various officials went to inspect the banks and repair the blocks and dykes so that the river should not flood the city. But suddenly the banks collapsed and the water, rising above the stage, began to pour down towards the auditorium. Those who were nearest thought that there was real danger and got up so as to run away. But just as the water was about to fall on them, a large dyke suddenly emerged at the edge of the stage and the water was diverted without harming anyone. . . .' It was only after this and similar accounts that the guests referred to the great satirical licence that was allowed to Bernini.

– vii –

In 1641 the War of Castro broke out. The final consequences of this absurd dispute with the Duke of Parma were insignificant, but its effects on the Barberini were of great

[1] For Rospigliosi and artists see also Bellori, 1942, pp. 87-8; Pascoli, I, pp. 41, 47, 138, and II, pp. 128, 155, 302, 482; De Dominici, IV, p. 13, and Pastor, XIV, pp. 553 ff. [2] Prunières, 1913, chapter I.

[3] Fraschetti, p. 264. Another account of the same occasion was written many years later by the artist's son Domenico (p. 55).

importance. All the latent hostility aroused by their twenty-year rule came to the surface and almost overwhelmed them. Troops marched on Rome, there was financial panic in the city, patronage suffered disastrously. A humiliating peace was imposed in 1644; a few months later the Pope died.

Giambattista Pamfili, who became Pope Innocent X in September 1644, was elected partly through the support of the two Barberini Cardinals after attempts to promote the cause of their friend Giulio Sacchetti had failed. Though there was every likelihood that Pamfili would reverse the foreign policies of Urban VIII, they were more concerned with their own security than any such consideration, and hoped that by backing the winning side they stood a good chance of survival. In this they were mistaken. An enquiry into their financial administration of the War of Castro was threatened. To avoid it Cardinal Antonio disguised himself as a sailor and fled to France in September 1645. Four months later he was joined by his two elder brothers Francesco and Taddeo. In Rome their palaces were taken over, their property confiscated, and Taddeo's wife (very soon to be a widow) was left penniless.[1]

The exile of the Barberini was a terrible blow to artists. Romanelli, indeed, wrote to Cardinal Francesco that 'it is impossible for one who has until now lived under the noble patronage of Your Eminence and has received so many favours, to live far from Your Eminence', and he joined his patron in France.[2] Bernini himself suffered for a time from his close association with the hitherto all-powerful family, and rivals and enemies such as Borromini and Algardi saw their opportunities and took them gleefully.

Yet even from a distance the Barberini managed to make their presence felt, though on a drastically reduced scale. While Francesco wrote from Paris that 'of the painters here none is better than Vouet',[3] Bernini at last completed the tomb that Urban VIII had so wished to see during his lifetime, and Angelo Giori, who was in charge, wrote to the exiled Cardinals and suggested that they should congratulate the artist.[4] Meanwhile weavers continued work on a series of tapestries illustrating the life of Christ taken from cartoons that the Barberini had commissioned from Pietro da Cortona.[5]

And then, only three years after the disaster, occurred one of those reversals of fortune so frequent in seventeenth-century Rome. In February 1648 Cardinal Francesco, after some negotiations, returned and was warmly welcomed by the Pope. Artists in Rome were overjoyed and when Antonio arrived in 1653 the brothers characteristically celebrated the occasion by ordering from Pietro da Cortona a picture of *Xenophon sacrificing to Diana after his return from exile*, a subject chosen by the Cardinals from the *Anabasis* to commemorate the restoration of their fortunes.[6] The theatre opened once more and Giulio Rospigliosi resumed work on his librettos.

Yet though the Barberini were back again their patronage of the arts was inevitably

[1] See her poignant letters published by Pecchiai, 1959, pp. 182 ff.
[2] Letter of 21 January 1646 published by Pollak, 1913, p. 50.
[3] Letter of 9 March 1646 to Cassiano dal Pozzo published by Lumbroso, p. 312.
[4] Feliciangeli.
[5] U. Barberini, 1950.
[6] Briganti, 1962, p. 254. The picture has disappeared.

only the shadow of what it had been. Pietro da Cortona was much in demand with the new régime; and Sacchi to whom Cardinal Antonio remained loyal was becoming increasingly reluctant to paint anything at all. Indeed he shocked his envious fellow-painters by refusing to fresco the vault of S. Luigi dei Francesi as commissioned by Antonio, who wished by this gesture to show his gratitude to the French for appointing him their Protector in Rome.[1] When Sacchi died in 1661 Antonio turned to his pupil Carlo Maratta. That artist carried on painting a series of Apostles which Sacchi had scarcely begun at the time of his death,[2] and also recorded his patron's features in some of the finest Roman portraits of the whole century (Plate 3b).[3] Old and rather feeble, yet immensely grand in his full Cardinal's regalia, deep red echoing deep reds in the background, he stands solemnly erect at a table and gazes at the spectator. His hand points not at the small carved crucifix to his left but at the Ordre du Saint-Esprit hanging on his breast; the very embodiment of declining power. In the last years of his life Antonio became increasingly attached to the Jesuits to whose noviciate church of S. Andrea al Quirinale he made large contributions. More and more of his time was spent in France—where he was given several important posts, including the Arch-bishopric of Rheims—but after a bout of ill-health he returned to Rome to die in 1671.

Francesco outlived him by eight years. The divergence between their tastes continued into old age, accentuated perhaps by their political differences as the elder brother's sympathies moved further and further away from France after his return from exile.[4] Francesco, as always, showed a love of colour and of richness that was alien to the more classically minded Antonio. He befriended Velasquez when the great Spanish painter came to Rome in 1650, but it is not certain whether or not he had his portrait painted by him.[5] Romanelli, whose attachment to the Barberini cause was rewarded by the gift of a country-house, continued to paint for Francesco. In particular he produced two large canvases of *The Marriage of Peleus* and *Bacchus and Ariadne* shortly before dying, in virtual retirement, in 1662.[6] In the next year Francesco began an important project whose completion he was not to see. He commissioned from Lazzaro Baldi and Ciro Ferri drawings and cartoons for a set of twelve tapestries designed to illustrate the main events of the life of Urban VIII.[7] The work lasted for more than twenty years mainly

[1] Passeri, p 301. [2] Bellori, 1942, p. 84. For the full history see Mezzetti, 1955, p. 253.

[3] For the most recent discussion of the portrait, now in the Galleria Nazionale di Arte Antica in Rome, and of others of the Cardinal (including two by Nanteuil), see Edoardo Lombardo, 1959, p. 2. It will be seen that the version reproduced here, from the collection of the Duke of Northumberland, is rather different from the one described above.

[4] See the biting comments made about him by the French ministers in 1654: '. . . tout à fait suspect à la France . . . jalousie, envie, vengeance, ingratitude. . . .' in Hanotaux, p. 8 and pp. 12-13.

[5] Palomino (III, p. 336) says that when in Rome Velasquez painted a portrait of Cardinal Antonio Barberini. In fact Antonio did not return from France until 1653, long after the departure of Velasquez, and Palomino must be confusing Antonio with Francesco.

[6] Pollak, 1913, p. 60.

[7] The tapestries are now dispersed; the cartoons are in the Palazzo Barberini. For their history see Adolf S. Cavallo, 1957, M. Calberg, 1959, and Blunt and Cooke, 1960, p. 36, who suggest Ciro Ferri as the artist. There had been a plan earlier to cover the walls of the Salone with frescoes representing rather similar subjects—Pastor, XIII, p. 969.

because Francesco insisted on using wool only from his own flocks. So for the last time
Urban VIII was commemorated in the grand Baroque style (though now only feebly
reflected) which he had done so much to promote—acquiring Urbino for the Church,
fortifying Rome, receiving the homage of the Christian world. . . . This commission
with its nostalgic yet eloquent echoes from the past in some ways symbolised the posi-
tion of Francesco Barberini during the years after his return from exile. The love of art
and learning remained as deep as ever—he continued to build up his marvellous
library and corresponded with scholars all over Europe[1]—but inevitably he played little
part in the more vital culture of the day. The artists he employed were mainly those of
an earlier generation; while Bernini, who owed so much to the patronage of his family,
was now transforming Rome for new dynasties and new generations. And although
the Barberini were represented in the patronage of younger artists—notably by Prince
Maffeo, son of Taddeo[2]—a real estimate of their contribution to seventeenth-century
art must be based on the period of their supreme power during the pontificate of
Urban VIII.[3]

– viii –

This contribution was not as strikingly apparent as that of certain other popes. Rome
itself was not transformed by Urban VIII. No great new squares recall his memory as
they do those of his successors Innocent X and Alexander VII. And yet the Barberini
heritage was more important than that of any other seventeenth-century dynasty, for
their choice of artists determined the style that was to influence all future building and
decorating in the city. Neither Bernini nor Pietro da Cortona had been originally
'discovered' by the Barberini, yet both were given their first supreme opportunities by
them, and with the exception of the highly original and individual Borromini no other
artist of equal stature was to appear in Rome. Their most important contribution to
patronage was their quick realisation of the greatness of these men and their support of
them in the most ambitious undertakings. The ease with which Camassei was dropped
when his limitations were only just becoming apparent and the tenacity with which
Bernini was retained when certain of his constructional errors were threatening to
overwhelm him show how certain was their sense of values.

Bernini was the genius of the age: his authority dominated all the arts and was
responsible for the relative neglect of Borromini until the very end of Urban's reign,
though the Barberini showed on occasion that they admired his talents.[4] It is doubtful
whether the relationship between an artist and his patrons has ever been more fruitful.
For Bernini and the Barberini had much in common: a remarkable width of culture,

[1] Biblioteca Vaticana, MSS. Barb. Lat. 6463, and many other collections.
[2] Bellori, 1942, p. 85.
[3] It will be obvious that in such a general survey I have omitted a great many important examples of
Barberini patronage. Very useful accounts are given in Baglione, pp. 177-83, and Pastor, XIII, pp. 903-
1000.
[4] See, for example, Cardinal Francesco Barberini's part in the building of S. Carlo alle Quattro
Fontane—Pollak, 1927, I, p. 45.

a deep respect for the past, a combination of real religious feeling with dramatic ostentation—above all the most strenuous ambition. The confidence between them allowed Bernini to experiment fully with his talent, but while working for Urban he never gave rein to that introspection and mysticism that characterise some of his later sculpture. Compared to the relationship between those two tragic giants Julius II and Michelangelo theirs was placid and free from tension. Both men were much more ready to accept the compromises of their age; both had more than a streak of worldliness.

Throughout Urban's reign the papacy was losing power and prestige and yet it still (for the last time) appeared to be an important force in international politics. The end of the Thirty Years' War and the arrogance of France were soon to change all that. Meanwhile court art reached a new pitch of grandeur and flattery. Religious imagery was used to buttress secular claims, and new techniques of illusionism were devised to overwhelm the onlooker. For all its apparent optimism and opulence there is perhaps a touch of hysteria about Pietro da Cortona's ceiling in the Barberini palace. Certainly no later pope was able to go so far in self-glorification. That was to be left to the King of France whose artist, Le Brun, adopted a modified version of Pietro's Baroque to express it.

Even from the purely artistic point of view one of the most significant characteristics of the Barberini and their circle was the great attention paid to learning. Scholars of all kinds were welcomed at their courts and brought into contact with painters, thus giving rise to an art of great intellectual subtlety and the growth of theories which were later to be highly influential. Yet the period itself is marked by a notable freedom from dogmatism and a wide measure of variety within certain well-established limits. This was very different from the frenzied experiments of earlier years and the generally uninformed or eclectic taste of Cardinal Borghese and his friends. The Barberini were much more coherent in their opinions, but thanks to Urban's nepotism and their own strongly individual characters, contrasting tendencies were all catered for, as the support given respectively by Cardinals Francesco and Antonio to Pietro da Cortona and Sacchi clearly testifies. When Urban VIII died everyone realised that the situation would never be the same again.

Chapter 3

THE RELIGIOUS ORDERS

– i –

DURING most of the seventeenth century the many religious organisations which had been formed within the Church to forward the aims of the Counter Reformation acquired increasing riches and influence. Jesuits, Oratorians and Theatines especially occupied important posts in the hierarchy; their churches were extended, rebuilt, decorated and copied; artists eagerly competed for their commissions. By about 1700 the mother churches of these Orders were the most richly furnished in Rome, and they have ever since appeared to travellers as the very embodiment of that Baroque taste which, it is inferred, they deliberately fostered as an instrument of propaganda.[1] The charge, later repeated *ad nauseam*, was first made by an English traveller in 1620.[2] 'In the next place', wrote Grey Brydges, 5th Lord Chandos, in his *Discourse of Rome*, 'the present Colledges, Churches and religious Houses come in turne, in which of late years, those of the Jesuits be of principall reputation where in their chiefe Church lyes buried their founder Ignatius, and his tombe is there to be seene.

'. . . Wherein is inserted all possible inventions, to catch mens affections, and to ravish their understanding: as first, the gloriousness of their Altars, infinit number of images, priestly ornaments, and the divers actions they use in that service; besides the most excellent and exquisite Musicke of the world, that surprizes our eares. So that whatsoever can be imagined, to expresse either Solemnitie, or Devotion, is by them used.'

This passage, though it contains an element of truth, is a tribute more to the staunchness of Brydges's Protestant convictions than to his real understanding of the situation. For in fact the patronage of the Jesuits and the other Orders was very much more circumscribed by a large number of complex events than is immediately apparent.

In the first place, their very success effectively put an end to much of the individual flavour that each had been able to contribute to the spiritual and intellectual life of Rome. In their origins they had to some extent been isolated, engaged not only in fighting the heretics but also in resisting some of the more worldly members of the papal court, even at times the popes themselves. They had in fact consisted of relatively small groups of the devout, clustered round some saint or natural leader, propagating ideas that were often looked upon with some suspicion by the hierarchy, and yet

[1] For the whole controversy about the Jesuits and the arts see Galassi Paluzzi, 1951, who, however, does not refer to the book mentioned in the next note nor to other passages to the same effect dating from before the nineteenth century.

[2] [Grey Brydges, 5th Lord Chandos]: *Horae Subsecivae*, pp. 386 ff.

encouraging in their followers an intensity of devotion that sometimes bore fruit in other fields. Thus it has been suggested that the Oratorians may have given some special encouragement to the anti-conformist religious painting of Caravaggio.[1] As the century advanced all that was changed. Even before Guido Bentivoglio came to Rome in 1600, he was advised to get in touch with the Oratorians as they were the most influential members of the clergy.[2] Paul V was friendly with the Jesuits. Gregory XV and his nephew had been educated by them. One of this Pope's most important actions was to decree the canonisation of the two great Jesuits, Ignatius and Francis Xavier, and the founder of the Oratorians Philip Neri—and the occasion was followed by spectacular ceremonies and the commissioning of paintings of the two Jesuits by Van Dyck who was in Rome at the time.[3] Urban VIII followed much the same policy. He at once published the bull of canonisation, and at all times he and his family showed their strong sympathies with the Orders, and especially the Jesuits. In 1639 and 1640 he paid two visits to their church, the Gesù, during the celebrations to mark the centenary of the approval of their statutes, and his nephew Antonio, who was a special benefactor of the Society, had one of these occasions recorded in a picture by Andrea Sacchi.[4] No wonder that the *Imago primi saeculi*, the magnificently produced volume which the Jesuits of Antwerp published to celebrate the centenary, stunned the world with the audacity of its self-satisfaction.

Thus it came about that the Jesuits (and the other religious Orders) were too closely integrated into the very fabric of society to impose any distinct accent of their own, even had that been their intention. Their influence on the arts can be found everywhere —or nowhere. It was a Jesuit, Padre Ottonelli, who pressed Pietro da Cortona's claims on the Barberini when they were having their palace decorated and who later wrote a highly casuistical treatise in collaboration with the artist on the persuasive possibilities of painting.[5] It was another Jesuit, Gian Paolo Oliva, who became one of Bernini's closest and most influential friends. And yet the Jesuits had to wait for decades before they were able to make any progress whatsoever with the decoration of their own churches. For, curiously enough, their triumphant success in every field was for a long time accompanied by an extreme shortage of money which made their church building absolutely dependent on the support of the powerful families who ruled Rome. The whole mechanism of patronage was determined by these families, and their superiority

[1] Friedlaender, p. 123, and the forceful, but not necessarily decisive, rejection of this opinion by G. Cozzi, 1961, pp. 36 ff.

[2] Bentivoglio, 1807, p. 48.

[3] *La Canonizazzione dei Santi Ignazio di Lojola e Francesco Saverio—Ricordi del terzo centenario*, Roma 1923; and also Redig de Campos, 1936.

On the other hand Leo van Puyvelde, 1939, pp. 225 ff., attributes the two pictures in the Vatican to Rubens and suggests that they must have been painted in 1608 when the beatification of the Saints was being discussed. There is absolutely no documentary evidence for this supposition and much that makes it inherently unlikely.

[4] Pastor, XIII, pp. 610-11. The picture is now in the Galleria Nazionale di Arte Antica, Rome.

[5] Odomenigio Lelonotti da Fanano e Britio Prenetteri [Gio. Dom. Ottonelli e Pietro da Cortona]: *Trattato*.

was assured by legal as well as by financial forces. For in an effort to encourage the reconstruction of Rome in the middle of the sixteenth century the rich aristocracy had been given the right to expropriate neighbours who had no desire to build and they were even allowed to dispossess unco-operative religious institutions.[1] The patronage of the Orders was deeply affected by this tendency, and the building and decoration of their churches can best be studied as a reflection of the dialectic that ensued from it—the clash, sometimes hostile, sometimes so smooth as to be almost imperceptible, between two different types of patron, one with the spiritual authority that came from having a saint as founder, the other with the money.

But another factor was involved: the limited number of artists of really first-class quality. On the whole the patronage of the popes and their courtiers was mainly directed into far more personal channels than the uncomfortably autonomous churches of the religious Orders. As long as this patronage was really intense, few of the great artists were given many opportunities of working outside St Peter's, the family palace or the titular church. Thus during the reign of Urban VIII neither Bernini nor Pietro da Cortona produced anything significant for the Gesù despite the fact that both men were closely associated with the Jesuits. It was only when this all-powerful source of patronage temporarily dried up that the religious Orders, especially the Jesuits, were able to call on the talents of really great artists. And even then it was recognised by everyone concerned that the claims of secular princes came first: at the very end of the century the Duchess of Savoy, who was most anxious to employ Ciro Ferri for a certain job, wrote that the engagements he would be breaking 'were only with nuns: she did not therefore believe them to be such as to prevent him coming to Turin'.[2]

Thus the decoration of the Gesù, S. Ignazio, S. Andrea della Valle, the Chiesa Nuova and other churches belonging to the principal religious Orders depended on a synthesis derived from conflicting forces which varied greatly in strength at different periods of the seventeenth century. This can best be understood if these churches are studied before, during and, above all, after the reign of Urban VIII.

– ii –

The Gesù, the principal church of the Jesuits, was built for them by the most powerful of sixteenth-century Cardinals, Alessandro Farnese.[3] His assumption of its patronage in 1568 had at first seemed like a wonderful gift from Heaven; it soon became clear that there were many drawbacks. The Cardinal treated the new church as his private property—it used to be said, in a phrase that reveals much about the spiritual confusion of a Renaissance prelate surviving into the Counter Reformation, that he owned the three most beautiful objects in Rome: his family palace, his daughter Clelia and the church of the Gesù. Farnese paid no attention to the wishes of the Jesuits; he employed his own architect Vignola and his own painters. None of this mattered very much as

[1] Delumeau, pp. 238-41.
[2] Claretta, 1893, p. 33.
[3] For fully documented history of the church see Pecchiai, 1952.

long as he lived, for his schemes were as grandiose as could be desired. He commissioned Girolamo Muziano to paint *The Circumcision* for the High Altar; Giovanni de' Vecchi began frescoes on the pendentives and the dome, 'very lavish with various adornments and putti'; plans were made for the apse to be covered with mosaics.[1] But when he died in 1589, with the decoration scarcely begun, the effect was disastrous. Not only did work stop immediately, but as Farnese had specifically reserved the adornment of the tribune and the High Altar exclusively for his family, nothing could be done without the permission of his heirs. These showed a total lack of interest in the whole matter and for generations the Jesuits were unable, despite repeated efforts, to carry on with the decoration. They were thus compelled to concentrate on the side-chapels.

These chapels had a great attraction for pious ladies belonging to those older aristocratic families of Rome, such as the Orsini, the Caetani, the Mellini, which were already being submerged in wealth and political importance by the new rich who made up the papal entourage. Some of them introduced their own artists, men like Scipione Pulzone, Agostino Ciampelli and Federigo Zuccari; others paid for the main structure of the chapel, but left the essential decoration in the hands of the Jesuits. Forced back on their own resources, the Society cut down the expense by employing as principal painter one of their own members, Padre Valeriano, whose crudity and clumsiness can be benevolently interpreted as mystery and power.[2] When they moved outside their own ranks and commissioned an established painter their financial weakness became dangerously obvious. Five years after producing a picture of *The Resurrection* Giovanni Baglione was forced to complain to the Pope that he had not yet been fully paid by the Jesuit fathers but was constantly being put off 'with good words and the excuse that they had no funds for the moment'.

In these circumstances it is not surprising that the decoration of the Gesù in its early stages, far from reflecting any concerted Jesuit plan, was in fact achieved only haphazardly and with the greatest difficulty. An informed visitor inspecting the church in about 1623 (or even 1663) would have found an element of richness in the display of coloured marbles but a thoroughly old-fashioned atmosphere about the half-completed frescoes and altar paintings.[3] Not a single one of the Bolognese artists who had helped to transform church decoration at the beginning of the century was represented. For all its grandeur, and despite the impression it made on a raw English traveller, the general effect must have been a little bleak.

But the Gesù, which was designed for public worship, was not the only Jesuit church in Rome. They were just as concerned with the more private training of their own novices many of whom would be sent abroad on horribly dangerous missions. In the venerable early Christian temple of S. Stefano Rotondo, which they had been

[1] For the contract with Muziano see Ugo da Como, p. 186; for the frescoes by Giovanni de' Vecchi see Baglione, p. 128; for Cardinal Farnese's plans for mosaics see MSS. in Jesuits Archives, Borgo S. Spirito: Rom. 143, f. 251.

[2] See the brilliant interpretation of Valeriano's style in Zeri, 1957, and the present writer's review, 1958, p. 396.

[3] See the Sacchi painting and the description of 1650 in Pecchiai, p. 104.

allotted by Gregory XIII,[1] a truly Jesuit style was brought into being for the first time. The church was given to the German college, and the rector commissioned from Nicolò Circignani dalle Pomarance a series of exceedingly brutal frescoes designed to illustrate the martyrdoms of early Christian saints mostly enacted under the late Roman empire. They were deliberately painted in great detail (curiously enough a last feeble glimmer of the Venetian High Renaissance lingers in the murderous subjects), the explanation of the torture was attached to each fresco, and the Jesuits took a certain pride in these innovations of subject-matter and treatment.[2]

Indeed they planned to adopt them in the third church that they owned in Rome. This was another early Christian building, S. Vitale, which was given to the Society by Clement VIII.[3] The decoration was directed by a Jesuit painter Giovanni Battista Fiammeri under the immediate control of the General, Claudio Aquaviva, who took a strong personal interest in the scheme and made suggestions of his own.[4] Once again the subjects were almost exclusively concerned with torture, but in the generation that had passed since the decoration of S. Stefano Rotondo the atmosphere had so relaxed that the true nature of the frescoes is not at first apparent. Rather, they give the impression of idyllic pastoral landscapes (in the nineteenth century they were attributed to Gaspard Poussin), and it is not until we have examined them and the inscriptions below with some care that we see that nailed to one tree is a martyr, and that in some distant valley, shaded by hills, is a soldier undergoing the most exquisite tortures. Only in the choir were the painters encouraged to throw off their restraint—here the exact mechanism of how to pull a man to pieces is displayed with the cold, clinical observation that comes naturally to those to whom such sights are familiar.

In practice, therefore, the contribution to patronage made by the Jesuits had been exceedingly limited, however startling. This was largely due to their desperate shortage of funds. The decoration both of another little church, S. Andrea al Quirinale,[5] and of S. Vitale was constantly being held up for this reason, and the correspondence of General Aquaviva is often concerned with the problem of how to raise more money—jewels to be sold, gifts to be solicited and so on.[6] But the very austerity which they were compelled to adopt could, if necessary, be turned to good account. In 1611 a French Jesuit Louis Richeôme wrote a book, which he dedicated to Aquaviva, about the

[1] Armellini, I, p. 160.

[2] Jesuit Archives—MSS. Rom. 185, f. 25: *Necrologio del P. Michele Lauretano, scritto dal P. Fabio de Fabiis, 16 Agosto 1610*—'Fu il primo che io sappia che cominciasse a far dipingere nelle chiese li Martirii patiti da S.ti Martiri per la confessione di Christo, con le sue note che dichiarono le persone et le qualità de tormenti, come si vede in S.to Stefano Rotondo; et dopo fù seguitato et imitato da molti altri.'

An anonymous Latin life of the same rector (*ibid.*, Rom. 188, I, ff. 81-82) says that the example he set was followed in other Jesuit churches.

[3] Huetter e Golzio.

[4] See the interesting letter from Aquaviva to Fiammeri of 22 August 1599 published by Pirri, 1952, p. 40.

[5] For the history of this which was pulled down to make way for Bernini's church see the account written between 1606 and 1612 by P. Ottavio Novaroli in Jesuit Archives—Historia Domus Professae Romae—Rom. 162, ff. 2-184.

[6] *ibid.*, MSS. Med. 22, f. 143[2].

paintings in S. Andrea and S. Vitale.[1] Extravagant pomp, he said, was nothing: he had no use for the fake pilasters and columns, or the marble altars with which the Society had pathetically tried to enrich their churches. 'Car les ordonnances du tableau, ces colonnes Ioniques, couronnées de volutes; ces pilastres, ces corniches et piédestals, & autres peintures, & reliefs, ornements d'architecture ne touchent point votre dévotion. . . .' Attention must be concentrated exclusively on the subject-matter of the frescoes, which should be read like a sermon, more effective because paint lasted and words vanished. But Richeôme's was a last, lonely voice from the harsher days of the Counter Reformation, valid more because it justified an unwanted simplicity than because it proclaimed a doctrine that was at all likely to be followed in the more prosperous and relaxed age of Urban VIII.

During the first twenty years of the seventeenth century the contribution made to the artistic life of Rome by the Oratorians was very much more impressive than that of the Jesuits.[2] There was both in their selection of artists and in the inspiration that they provided for them a fineness of taste and a sense of exaltation that for long made them true pioneers among the religious Orders of the Counter Reformation. This is not altogether surprising. Despite their insistence on powerful visual imagery as a help for devotion, none of the Jesuit leaders showed any subtlety of appreciation. St Philip Neri, on the other hand, was a man of the profoundest aesthetic sensibility who responded passionately to painting and music. He naturally attracted to himself many of the most cultivated spirits of the time and he personally took an enthusiastic interest in the decoration of his church. Moreover, the circumstances of its construction were very different from those of the Gesù.

S. Maria della Vallicella was assigned to him in 1575 by Pope Gregory XIII. It lay in the very heart of fashionable and cultivated Rome. It was, however, immediately felt to be too small and was pulled down to be replaced by a larger building of the same name, often called the Chiesa Nuova. St Philip's early biographers delighted to tell how the saint, with his unlimited trust in divine providence, ordered the destruction of the old church without any idea of where he would get the money from with which to build the new; and how this faith was rewarded by the people of Rome, rich and poor alike, who flooded him with generous contributions. This attractive story is not wholly accurate—there were grave financial difficulties, and Cardinal Farnese, jealous of this potential rival to 'his' Gesù, was obstructive—but it illustrates one very significant point about the new church: it did not depend for its construction and decoration entirely on the goodwill of one all-powerful patron. St Philip himself worked in close co-operation with the architect Matteo da Castello whom the Oratorians chose and the church was built on the same general lines as those of the Gesù. The foundation stone was laid in 1575 by Alessandro de' Medici, Archbishop of Florence and ambassador of the Grand Duke, and at first work proceeded quickly. However, the usual financial

[1] Richeôme, p. 21. It must be remembered that these churches were intended for Jesuit novices and not for the general public.

[2] I have derived this account of the early history of the Chiesa Nuova from two fully documented works which frequently refer back to the original sources: Strong, and Ponnelle and Bordet.

difficulties soon intervened, and the Oratorians were now compelled to turn to a patron. Cardinal Pier Donato Cesi was obviously very much under the influence of Cardinal Farnese. He shared his love of art and of splendour and many of his plans were directly based on those of the older and more powerful figure. When, therefore, he agreed to pay for the completion of the Chiesa Nuova, he went out of his way to insist that he should enjoy the same rights as those of Farnese in the Gesù. His arms too were to be set up in the church, and he and his family were to enjoy overriding privileges in the affairs of the Congregation. His terms were accepted, but he interfered little enough in the building of the church and some years after his death in 1586, his brother Angelo Cesi, Bishop of Todi, continued the family patronage.

The Oratorians thus kept the affairs of the Chiesa Nuova largely in their own hands. Martino Longhi the Elder replaced Matteo da Castello as architect and by 1590 the main structure was complete, though the façade by Fausto Rughesi was not erected for another sixteen years. St Philip Neri insisted that the walls and the vault should be merely whitewashed and not decorated with stucco, though whether for reasons of taste or economy is not clear. The chapels were then dedicated to the mysteries of the Virgin, the High Altar being assigned to Her Nativity and those in the transepts to Her Presentation and Her Coronation.

In 1582, well before the completion of the church, the Oratorians had commissioned an altar painting to be placed in the Chapel of the Visitation. For this they turned to Federico Barocci in Urbino. The tender, feminine, almost morbid delicacy of his picture, with its soft, smoky colouring, which reached Rome four years later, made a special appeal to the mystical strand in St Philip's nature. We hear that 'he would sit on a small chair in front of it and all unconsciously be rapt into a sweet ecstasy'. Then the down-to-earth side of his character would reassert itself: irritated by the women who came to gaze at him, he would have them angrily sent away and would do all in his power to conceal the effects of the picture on him. Not surprisingly the Oratorians were anxious to obtain other works by the same artist: they were unsuccessful in getting from him an altarpiece of the *Coronation of the Virgin*, but they managed to commission one of *The Presentation of Jesus in the Temple*. Another artist especially popular with the Congregation was Pomerancio, for he had painted St Philip's portrait, as well as an altarpiece showing St Domitilla with a rapt expression, eyes raised and mouth half open, between Saints Nereus and Achilleus in Cardinal Baronio's titular church of that name.

In fact, however, the Oratorians, like the Jesuits, generally allowed the rich families who took over the chapels to be responsible for their decoration, and the result was to change the character of the church and make it difficult for us to speak of a definite 'Oratorian' taste. Many of the new patrons were Florentines, like St Philip himself, often of great culture, and thus it was that the paintings in their chapels were sometimes of high merit. But with their intervention there was introduced a new note—of variety, richness and colour. The same process had occurred many years earlier in the musical performances for which the Oratorians were so famous. 'Some years ago', wrote the

composer Giovanni Animuccia as early as 1563, 'I published my first book of *Laudi* for the consolation of those who came to the Oratory of S. Girolamo. In these I tried to maintain a certain simplicity which I thought suitable to the words themselves, the nature of that place of devotion and to the end I had in view which was only to excite devotion. But the aforesaid Oratory having, by the grace of God, steadily grown by reason of the concourse of prelates and most distinguished gentlemen, it has seemed proper to me in this second book to develop the harmonies and to give variety to the music—composing it sometimes to Latin words and sometimes to Italian, sometimes to many voices, sometimes to fewer, sometimes with one kind of rhyme, sometimes with another; but I have refrained as far as I can from the complications of fugues and other devices so as not to obscure the sense of the words: so that their power, helped by harmony, may the more sweetly penetrate the hearts of those who listen.' In other words, the presence of 'prelates and most distinguished gentlemen' led to the artist relaxing his austerity and relying on more attractive and varied means to touch the emotions of his new patrons.

This inherent conflict between the Congregation itself and the fashionable society that flocked to it is apparent also in the decoration of the church. Alessandro Vittrice, who in about 1601 commissioned a picture from Caravaggio of *The Entombment of Christ* for his family chapel, was the nephew of one of St Philip's closest friends, and it is therefore possible that the Oratorians welcomed the picture. In any case Caravaggio seems to have taken special trouble to produce a somewhat more orthodox treatment than he was accustomed to—the circumstances of the commission have not yet been clarified.[1] The way in which the next great picture entered the church is, however, entirely characteristic of the pressures at work on the Oratorians.

The High Altar had been originally dedicated to the Nativity; its decoration had been promised by Cardinal Angelo Cesi. In about 1605, however, two extremely important events occurred.[2] A majority of the Oratorians, after much debating, decided to move to the High Altar a 'miraculous' image of the Madonna and Child, preserved from the original church, and the money set aside for its decoration was found to have been absorbed in the unexpected expenses of the façade. In 1606 Cardinal Cesi died. At this moment of crisis, when the Oratorians were faced with a situation so familiar to the Jesuits, they were approached by a highly influential cleric, Monsignor Giacomo Serra. He was interested in an artist whom he was particularly anxious to promote, a young Flemish painter Peter Paul Rubens.[3] If the Oratorians would agree to Rubens being assigned the altarpiece Serra would pay 300 *scudi* towards its cost, leaving only a bonus to be defrayed by the fathers themselves. Coming at that moment, the offer was very tempting. And yet the Oratorians were cautious. They had never heard of this man, and the thought of giving the main commission in their church to a Flemish artist when there were so many Italians around was clearly repugnant to them. But Serra

[1] Friedlaender, p. 187, and Cozzi, p. 51.
[2] Jaffé.
[3] Serra was also a patron of the young Guercino—see Mahon, 1947, pp. 67-71.

said that if they did not accept his terms he would give away his money elsewhere, and so, rather reluctantly, they agreed. They laid down stringent conditions. Rubens must show them examples of his work, he must contribute towards the cost of the picture, he must paint exactly what they told him: the Virgin and Child above, and below six saints particularly venerated in the church. All this was agreed to and Rubens painted the picture to their entire satisfaction. He then himself found that the lighting was unsatisfactory, and persuaded the Oratorians to accept a wholly new proposal—a central picture to enclose the miraculous Virgin and Child and two lateral ones, each with three of the six saints. All were to be painted on slate to avoid reflections of light.

There is every reason to believe that the Oratorians were delighted with the result, but it was undeniable that, as had occurred earlier with music, the pressures of 'prelates and most distinguished gentlemen' had wholly altered the nature of their church. Rubens had faithfully interpreted the instructions which had probably been handed to him by the Oratorian historian Cardinal Baronio, but the spirit of the painting was quite his own and, despite his great admiration for both artists, utterly unlike the altar-pieces of Barocci or Caravaggio. It blazed with Venetian colour and vitality and radiated an exuberant pathos which was later to prove of crucial importance for the development of Bernini and Pietro da Cortona. Thus quite by accident the Chiesa Nuova became one of the cradles of the Baroque. But an Order which could assimilate within a period of fifteen years masterpieces by Barocci, Caravaggio and Rubens, to say nothing of minor works by other artists, cannot be said to have had a specific and individual 'taste' of its own. And it was not long before important contributions from Guido Reni, Alessandro Algardi and others added to the stature of the church and also proved who were the real patrons within it.

So austere had the Theatines been that the word lingered on as a nickname for special gravity.[1] In building and decorating their church they too experienced the advantages and drawbacks of princely support.[2] In 1582 a legacy from Donna Costanza Piccolomini d'Aragona gave them a palace in the centre of Rome and the little adjoining church of S. Sebastiano—it also obliged them to found a church dedicated to St Andrew, the patron saint of Amalfi of which Donna Costanza had been duchess. Soon afterwards the Neapolitan Cardinal Gesualdo agreed to build them a large new church, but—just as Cardinal Farnese had done in the Gesù—he insisted that his own architects, first Giacomo della Porta and then Pietro Paolo Olivieri, should have complete authority over the man whom the Theatines themselves had proposed for the commission. After the death of Gesualdo in 1603 there was the usual delay, with the church, already planned as 'one of the most magnificent to be seen', by no means complete. Finally in 1608 Cardinal Peretti-Montalto, despising the advice 'not to carry on with a building begun by others', took it in hand and guaranteed the vast sum of 160,000 gold *scudi*. He brought in the best known architect in Rome, Carlo Maderno, and work proceeded

[1] Cozzi, p. 46, and Ponnelle and Bordet, p. 343.
[2] Ortolani, and, above all, Hibbard, 1961, pp. 289-318.

quickly enough for the ambitious young Maffeo Barberini to start planning his family chapel a year later, followed soon after by a number of other Florentine families, 'each of whom is straining to make his chapel more beautiful than that of the others so that it will be the most beautiful church in Rome'.[1]

Cardinal Montalto, as was usual in the circumstances, had reserved the main features of the decoration for himself, and he too had grandiose plans. In about 1616 he promised Giovanni Lanfranco, who was then working for him elsewhere, that when the time came he would be entrusted with the entire tribune and dome—by far the largest commission of its kind yet given to a single artist. However, in 1621 Pope Paul V died and was succeeded by Gregory XV, whose nephew Cardinal Ludovisi was the particular patron of Domenichino. That artist, reluctant to miss such a wonderful opportunity, approached Ludovisi and asked to be given the commission instead of Lanfranco. Ludovisi had no rights whatsoever in the church, but, as Passeri succinctly pointed out, he had all the irresistible power that came from his position as papal nephew and he began to apply it to Montalto.[2] The pressure was naturally decisive, and Domenichino was given the job. However, Montalto then made a determined effort to reassert his rights, and insisted that Lanfranco should at least be given the dome. To Domenichino's somewhat unreasonable fury this compromise was agreed upon, and the two artists, by now irreconcilable enemies, shared the commission. The Theatines, it need hardly be said, played no part whatsoever in these decisions.

For all the trouble it had caused, the decoration of S. Andrea della Valle was by far the most important achievement of the Baroque as yet. Lanfranco's dome, which was completed in 1627,[3] was the first of its kind since Correggio's in Parma more than a century earlier and it served as a model to artists for the next hundred years. Light is the centre, radiating out from Christ, its source in the lantern, and gradually filling the whole surface, around which the choirs of saints, martyrs, prophets, apostles and cherubs hymn their praises. Towards that light the Virgin gazes in ecstasy, her arms outstretched both to welcome it and to point out with an expressive gesture the adoring figures on each side of her—St Andrew who sponsors S. Gaetano, founder of the Theatine order, and St Peter with St Andrew Avellino, the Theatine beatified in 1624 when the fresco was probably begun.

Meanwhile Domenichino was at work on his share of the commission. Breaking away from his more classical manner, he produced in the pendentives four monumental figures of the Evangelists, clearly derived from Michelangelo and stored with potential energy, surrounded by putti, traditional emblems and the arms of his reluctant patron. In the apse he portrayed scenes from the life of St Andrew. By 1628, when both artists had completed their tasks, there could be no doubt that S. Andrea della Valle was the finest modern church in Rome and that the Theatines without much effort on their part had far outdistanced the Jesuits and the Oratorians.

[1] *Avviso* of 30 April 1608, quoted by Orbaan, 1920, pp. 107-8.
[2] Passeri, pp. 45 and 148.
[3] Pastor, XIII, p. 965, note 3.

Plate 13

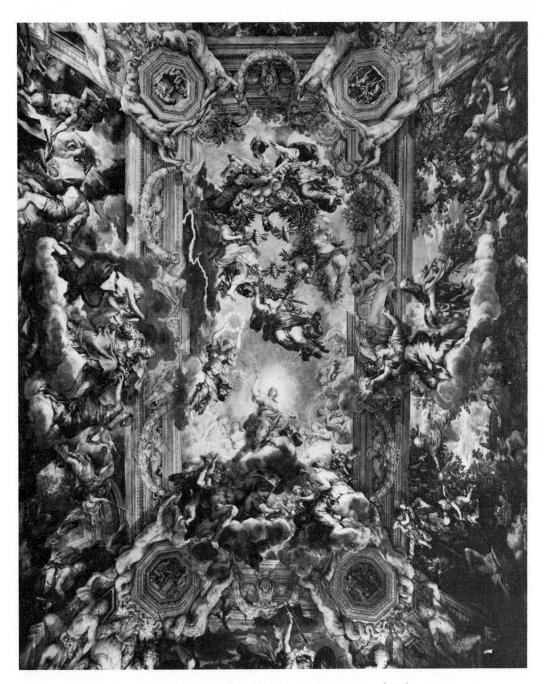

PIETRO DA CORTONA: Glorification of the Reign of Urban VIII

Plate 14

JESUIT PATRONAGE OF THE ARTS
(see Plates 14, 15 and 16)

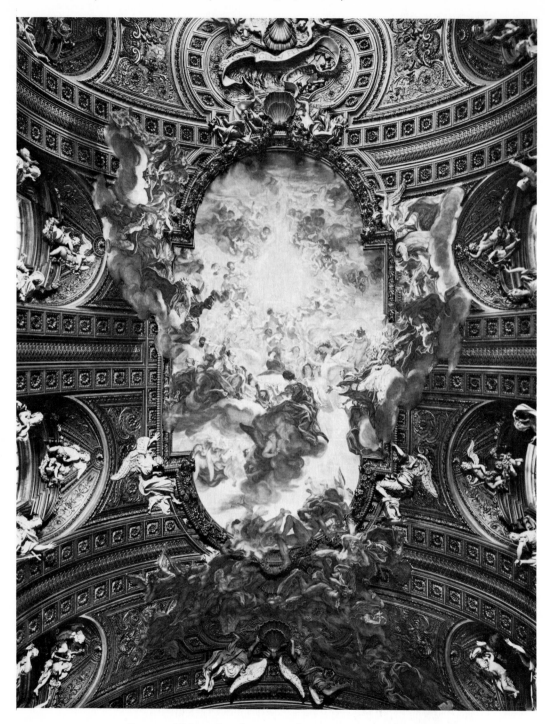

GAULLI: Triumph of Name of Jesus on nave of Gesù

Plate 15

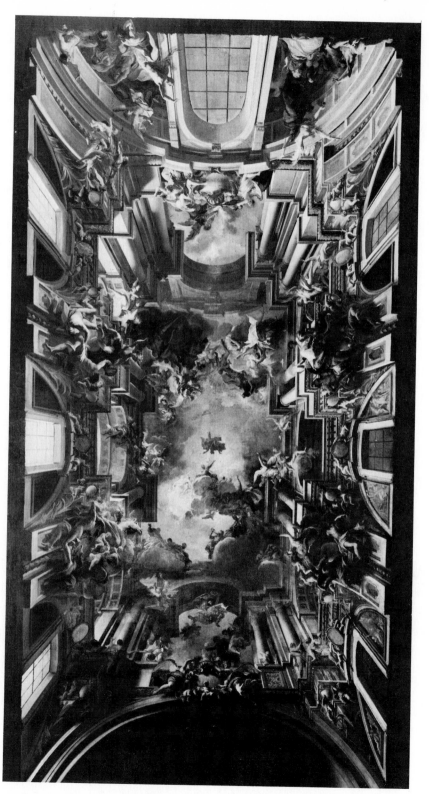

Andrea Pozzo: *Modello* for fresco on vault of S. Ignazio, Rome

Plate 16

BERNINI: Interior of S. Andrea al Quirinale

– iii –

It is an ironical fact that for all the general benevolence shown towards the Jesuits by the Barberini it should have been left to the chief rival and bitter enemy of the family to have built a second great church for the Society. Cardinal Ludovico Ludovisi was an intelligent and energetic young man who had enjoyed for only two years the privileges and status of papal nephew. He had made the most of them. With the riches poured on him by his uncle Gregory XV he had accumulated vast estates in and around Rome, built up what was possibly the finest collection of antique sculpture ever seen in the city, and patronised the leading artists of his native Emilia to marvellous effect, as is shown by Guercino's fresco of *Aurora* on the ceiling of the *casino* on the Pincio which he had bought from Cardinal del Monte. The Pope was old at the time of his election and in constant ill-health; Cardinal Ludovisi had thus been a powerful figure politically and had acted in the interests of Spain. In the conclave of 1623 which followed his uncle's death he did what he could to prevent the election of Maffeo Barberini. He failed in this aim and paid the inevitable price. After a succession of disputes with the new Pope, he was at one stage ordered to return to his archbishopric at Bologna on pain of being sent there by force. He died after a stormy life in 1632 at the age of 37.[1]

In 1622 Cardinal Ludovisi decided to use a significant proportion of his immense wealth on building a new church for the Jesuits to be dedicated to St Ignatius. His affection for the Society went back to his school days, and he decided that the building, for which he at once laid down 100,000 *scudi*, should be 'second to none for size and beauty'. But his first move was not a success. He had planned it near the novitiate of S. Andrea. The Pope at once objected as he said that the height of the new building would interfere with his view from the Quirinal. So Cardinal Ludovisi moved it next to the Collegio Romano, the Jesuit college in the centre of Rome,[2] and building began in 1626. From now on his difficulties were to be with the Jesuits themselves.

The situation of the Society had greatly altered since the days when they had quietly accepted the instructions of the all-powerful Cardinal Farnese. Indeed, Cardinal Ludovisi himself explained that his admiration for the Jesuits was partly due to 'the power and authority that they have over nearly all princes'.[3] Now he too was to experience this power, though its workings can only be dimly discerned through the inferences and hints of contemporary authors. All sources agree that Cardinal Ludovisi organised a competition for the architect, and that among those who submitted plans was Domenichino, his special protégé. Then the mystery begins. Passeri, the artist's great friend, is strangely reticent[4]: '. . . and Domenico was among those who competed; but God knows what fate dealt out to him: indeed there is no point in talking of the matter'. Bellori, on the other hand, is much more explicit.[5] He says that Domenichino made

[1] Pastor, XIII, p. 445. For all available information about his collections see Felici.

[2] Jesuit Archives, No. 1238—1ᵃ theca; *Vita e fatti di Ludovico, Card. Ludovisi d.o S.R.C. Vice cancel. Nepote di Papa Greg. XV scritta da me Antonio Giunti Suo Servitore da Urbino*—Biblioteca Corsini, Rome, MSS. 39. D. 8. [3] *ibid.* [4] Passeri, pp. 66-7.

[5] Bellori, p. 350. Pope-Hennessy (1948, p. 121, No. 1741) publishes a drawing by Domenichino probably connected with his project for S. Ignazio.

several drawings for Cardinal Ludovisi, but that some Jesuits then went to the artist's house 'and told him not to bother about the matter; because they wanted to follow the design of the Gesù. This was the first and most beautiful of their churches and had served as a model for others. Domenico answered that they ought to be pleased to have two models, and that he would suggest an alternative; but it was all in vain.' In the end a Jesuit father, Orazio Grassi, of no architectural experience but celebrated for a controversy with Galileo, was appointed. An eighteenth-century account says that Domenichino withdrew from the whole affair in a fury when Grassi made an amalgam of the two designs that he had submitted, both of which were criticised by the Jesuits.[1] The Jesuit sources, on the other hand, do not mention Domenichino but merely say that Cardinal Ludovisi chose Grassi's plan from a number that had been proposed to him.[2] It is clear that the pressure must have been considerable. Although Ludovisi continued during the few remaining years of his life to show great interest in the construction and insisted on a committee of architects, including the painter Domenichino and Carlo Maderno, closely examining all Grassi's plans, the evidence suggests that he was patron in name and financial aid rather than in any control he might exert. One of his last acts before dying was to leave the Society a further 100,000 ducats.[3]

The Jesuits had taken so much trouble to keep control in their own hands in order to reproduce on a larger scale the essential elements of the Gesù. But the church was intended to serve for the students of the Collegio Romano rather than for the general public, and the patronage of the side chapels was not therefore entrusted to the Roman patrician families but was assumed by the Jesuits themselves. That being the case, money had to be economised, and the Society therefore followed its usual policy in the circumstances. It turned to one of its own members to carry on with the decoration. In this instance the artist was a young Frenchman, Pierre de Lattre, from St Omer who had entered the novitiate of S. Andrea in 1626.[4] Two years later he went to the Collegio Romano, where he remained until his death in 1683. His obituary tells us that he led an exemplary life and that he painted all the pictures that were to be seen at that date in the church and sacristy of S. Ignatio. His name first appears in the account books in 1638 and turns up repeatedly for a dozen years. During that time he frescoed the vault of the sacristy, completed six pictures for the side chapels and painted an imitation altar on the inner wall of the apse. The little of his work that has survived shows him to have been an utterly insignificant artist.

Cardinal Ludovisi had died in 1632, and as usual in such cases his heirs proved reluctant to carry on with the great expenditure that was still needed. In 1640 the first mass could be celebrated in the new church, but it still had no vault. Not for another ten years was it finally opened to the public; even then it was half unfinished and

[1] Soprani, II, p. 10.

[2] MS. by P. Gerolamo Nappi (1584-1648) quoted by [Bricarelli], 1924.

[3] Besides the documents in Pollak, 1927, I, pp. 144-58, see *Libro Mastro A* of the church in the Jesuit Archives. See also Hibbard, 1971, pp. 232-4.

[4] Besides repeated entries in *Libro Mastro A* see Galassi Paluzzi, 1926, p. 542.

for another full generation the temple that was to have been so 'magnificent' lay white and bare.[1] Once again the Jesuits had been outdistanced by their rivals.

During the reign of Urban VIII the Oratorians commissioned two works which were of very great consequence for the development of Baroque art—a fresco by Pietro da Cortona on the ceiling of their sacristy and a building adjoining the Chiesa Nuova by Borromini to accommodate the library and the concerts of religious music for which they were famous.

Pietro's small frescoes of *Angels carrying the Instruments of the Passion* and of *St Philip in Ecstasy* (in a chapel in one of the saint's rooms), though in themselves not very important, were of great significance for the future. For they began his close association with the Oratorians which was to lead to his transforming their whole church, and began it at a time when he was already the most fashionable and powerful artist in Rome. Indeed, Pietro was compelled to interrupt his work on the ceiling of the Barberini palace towards the end of 1633 in order to fulfil his obligations to the Chiesa Nuova, and the fact that he was allowed to do so suggests that the Oratorians must at that time have been exceedingly influential at court.[2]

The choice of Borromini as architect for the Oratorio was made by one of the fathers living there, Virgilio Spada.[3] He and his brother Cardinal Bernardino were both protégés of Urban VIII and enthusiastic connoisseurs. In the great sixteenth-century palace near that of the Farnese which Bernardino acquired from the Mignanelli in 1632 there was assembled an exceedingly rich collection of pictures, many of them from Bologna, where the Cardinal had served as legate between 1627 and 1631.[4] Virgilio was more interested in architecture—he himself was a dilettante who many years later helped to design the richly coloured family chapel in S. Girolamo della Carità—and he was a special admirer of Borromini whom he was to employ on certain alterations in the palace and on the construction of an illusionistic colonnade in the garden.

When Borromini began work on the Oratorio in 1637 he had just begun to make an outstanding name for himself. For many years he had been employed on comparatively minor tasks under Maderno and Bernini, but his wholly individual personality and principles made a dispute with the great Barberini architect inevitable. Thereafter he was largely kept away from official commissions until the death of Urban VIII.[6] In 1634 he had been entrusted with the building of a monastery and church for the Discalced Trinitarians who had left their original base in Spain and settled in Rome at the beginning of the century. The site adjoining the Quattro Fontane, very near the Barberini palace, was particularly small and inconvenient, and a great measure of the enthusiastic praise which Borromini received was unquestionably due to the

[1] Jesuit Archives: No. 1238—I[a] theca: *actorum ac diversarum cartarum inscripta: Ecclesia S. Ignatii de Urbe: saec. XVII-XIX, uti infra—Notizie storiche della Chiesa, 1712.*

[2] For the date see Pollak, 1927, I, p. 436, and Briganti, 1962, p. 205.

[3] Passeri, p. 262.

[4] For Spada and his collections see Zeri, 1953.

[5] For Virgilio Spada see Ehrle; Blunt, 1979, pp. 205-207.

[6] Though he was made architect of the Sapienza in 1632.

highly ingenious manner in which he solved the problems it posed.[1] However, it was also recognised that the style marked a radical departure from anything that had hitherto been seen in Rome.[2] This originality, as well as Borromini's cheapness, was a cause of special satisfaction to the Scalzi. 'The plan of the church,' they wrote, 'is so exceptional in everybody's opinion that it seems that nothing like it with regard to artistic merit, caprice, excellence and singularity can be found anywhere in the world....' This was written some years later, but in 1637, when Borromini was asked to design the Oratorio, his plans for the Scalzi church were already known, and there can therefore be no doubt that the Oratorians were deliberately hoping for an architect whom their Trinitarian brothers found admirable for his revolutionary qualities.

These qualities found expression chiefly in the façade, where the delicate subtlety of the broken curves matched the emotional tone of the music that was played within. Like Barocci many years earlier, Borromini was able to interpret that particular strain of Counter Reformation sensibility, tormented, attenuated yet sensuously appealing, that was the special contribution of the Oratorians and that had no counterpart in the more rough-and-ready spirits of the Jesuits.

– iv –

Thus by the time that Urban VIII died in 1644 only the Theatine church of S. Andrea della Valle contained any considerable painting by the Baroque artists with whom the religious Orders have often been closely associated.[3] The Gesù, S. Ignazio, the Chiesa Nuova all remained largely undecorated and the spectacular enrichment for which they are famous today was carried out only in the second half of the century. The Capuchins alone had been the unwilling recipients of Barberini patronage.

It was the Oratorians who took the next step, although in grandeur of conception, in artistic importance and in devotional innovation they were later to be far outclassed by their Jesuit rivals. Ever since Pietro da Cortona had painted his small fresco on the ceiling of the sacristy the fathers of the Chiesa Nuova had been trying to commission further works from him. But the artist's engagements with such powerful patrons as the Sacchetti, the Barberini and the Grand Duke of Tuscany made it impossible for him to undertake anything else. Now, however, thirteen years later, the situation was quite different: the Barberini were in exile, and Pietro, who had already been working for some years on the decoration of the Palazzo Pitti, was seeking every opportunity to leave Florence. So when in the summer of 1646 the Oratorians renewed their appeal and at the same time asked the Grand Duke to grant Pietro temporary leave of absence, they were in a much stronger position. And after some delays and many promises to continue working for the Medici, Pietro began painting cartoons for the cupola of the

[1] See *Relatione del Convento di S. Carlo alle 4 Fontane di Roma, 1610-1650*, published by Pollak, 1927, I, pp. 36-51. [2] Wittkower, 1958, pp. 131 ff.

[3] That is, of comparable importance to those discussed. There were, of course, other churches belonging to the Orders with frescoes by leading seventeenth-century artists. The most significant was the Barnabite S. Carlo ai Catinari in which Domenichino painted complex allegories of the Cardinal Virtues on the pendentives of the dome (itself painted by a pupil of Guido Reni) for Cardinal Borghese soon after those of S. Andrea della Valle.

Chiesa Nuova in November 1646. Though he had had to convince the Grand Duke that his absence from Florence was to be a short one, the frescoes were not ready till May 1651, and even then he had not completed the four pendentives.[1] Yet the work had not been particularly complicated for the basic problems it posed had all been solved by Lanfranco a quarter of a century earlier, and in his fine *Adoration of the Trinity and Glorification of the Instruments of the Passion* Pietro did little more than produce an elegant variation of the cupola of S. Andrea della Valle. Now once more an all-powerful Pope temporarily put an end to the Oratorians' plans for completing the enrichment of their church. Innocent X after some hesitation turned to Pietro da Cortona to fresco the vault of his family's palace in the Piazza Navona, and not till he had completed this at the end of 1654 was he able to resume work on the Oratorian church. He then painted on the pendentives of the cupola the four prophets who had foretold the coming of the Virgin and the Redeemer—Isaiah, Jeremiah, Ezekiel and Daniel; and in the apse *The Assumption of the Virgin*, acclaimed by a number of saints, among whom the most prominent was St. Philip Neri. He began work rapidly, but once again there were long delays owing to the intervention of the Pope, by now Alexander VII. In fact, the whole history of Pietro's relationship with the Oratorians shows how subordinate it was to his commitments with more highly placed patrons. Not until 1664 did he undertake his last and most important commission for the church—the vault of the nave. In this he was required to depict a miraculous intervention of the Virgin Mary which had occurred during the construction of the Chiesa Nuova. In recording the event the artist completely abandoned the illusionistic devices which he had used to such great effect on the ceiling of the Palazzo Barberini thirty years earlier. The scene is wholly removed from the spectator in an elaborate frame surrounded by richly gilded coffers, and its self-contained nature is emphasised by the fact that the fresco represents—though on different planes—both the real world of St Philip Neri and workmen and the supernatural world of the Virgin and angels. The worshipper in the church is not required to participate in the drama being enacted above him.

In fact, all Pietro's frescoes for the Oratorians, though sumptuous and finely executed, show a certain lack of imagination. He was a man, as is shown by his work in the Barberini, Pitti and Pamfili palaces, who found greater inspiration in the triumphs of this world than in those of the next. Mysticism did not come easily to him, and the passionate nature of St Philip which had meant so much to earlier artists and writers filled him with goodwill but never lifted him to the heights. None the less, when he had completed his commissions in the Chiesa Nuova, the Oratorians could claim to own the most completely decorated church of any Order in Rome. The whole scheme was eventually concluded in about 1700 when a number of leading artists chosen by the Oratorian scholar and collector Padre Sebastiano Resta painted fifteen oval scenes from the Old and New Testaments which were placed above the arches of the nave and transepts.[2]

Some years after Pietro da Cortona had resumed work in the Chiesa Nuova,

[1] Briganti, 1962, pp. 248-9.
[2] Letter from Resta to Giuseppe Ghezzi, dated 28 January 1695, published in Bottari, III, pp. 490-1.

further decorations were undertaken in S. Andrea della Valle. In about 1650 Pope
Innocent X's all-powerful sister-in-law, Donna Olimpia, persuaded the Theatines to
commission Mattia Preti to paint the apse of their church. The artist divided the wall
into three large compartments and depicted scenes from the saint's martyrdom. But
by now the frescoes of Domenichino (whom Preti tried to imitate) and Lanfranco of a
generation earlier had come to be looked upon as classics, and this combined with the
chauvinism of Roman painters led to the denigration of Preti's style and his enforced
and embittered departure from Rome.[1]

In 1665 when Pietro da Cortona completed the great scheme which he had begun
in the Chiesa Nuova thirty years earlier, the Gesù still looked essentially the same as it
had done in 1589, the year of Cardinal Farnese's death. Tapestries specially hung out on
ceremonial occasions might temporarily conceal the bleakness, but it was all too obvious
that the church had had no share in the great decorative schemes that were so striking
elsewhere in Rome. This was not due to want of trying. The Cardinal had reserved the
decoration of the tribune and the High Altar for himself and his family, and though he
had conceived grandiose plans for it, the work had scarcely been begun at the time of
his death. His heirs had proved wholly recalcitrant. Alessandro, the great captain, spent
all his life in the north, and his son and grandson had no particular sympathy for the
Jesuits.

In 1661, however, a new General, Gian Paolo Oliva, was elected, and under his
rule everything was changed.[2] A cultivated man and a great lover of the arts, he showed
the stubborn patience and diplomatic finesse required when dealing with difficult
patrons. He also had at hand a most unusual and fortunate opportunity. In 1657 a French
painter, Jacques Courtois, had entered the Society. Courtois—or Giacomo Borgognone
as the Italians called him—had come to Italy from Dijon when still only 15,[3] and had
been taken up by Guido Reni and later made friends with Michelangelo Cerquozzi and
Pietro da Cortona. He had seen army life and he soon made a name for himself as a
painter of battle scenes. In about 1654 his wife died after some years of stormy married
life and there were rumours that he had murdered her. Shortly afterwards he decided
to become a Jesuit and approached the rector of the Society's college in Siena. He was
sent with letters of introduction to the General in Rome, and was there required to
prove his good faith by making strange use of his undoubted skill. 'Finally my confessor
gave me a small portrait of a woman on copper and told me to change it into something
spiritual. I turned it into Our Saviour. . . .' He then took the final vows and spent the
rest of his life in the novitiate of S. Andrea and the Casa Professa. The General of the
Jesuits at this time was the Belgian Goswin Nickel, but the outstanding personality was
already the Vicar, Oliva, and there can be little doubt that it was he who took advantage
of the new situation. Borgognone had entered the Society without brushes intending to
give up art for ever. Within a year he was painting in the Casa Professa a series of

[1] De Dominici, IV, p. 27. For the comments of Cassiano dal Pozzo see Lumbroso, p. 195.

[2] There is no full-scale life of Oliva, but references to him are frequent in seventeenth-century
literature, and many volumes of his Letters and Sermons were published.

[3] Salvagnini.

lunettes and frescoes glorifying the Virgin as well as a number of scenes depicting famous Christian battles. He was also encouraged to go on painting for private patrons and hand over his earnings to the Society. He and his brother Guglielmo painted much for Oliva, but his great masterpiece was to be the decoration of the tribune, upon which the new General had set his heart. To achieve this, however, the permission and financial support of the leading member of the Farnese family, Duke Ranuccio of Parma, were essential, and in 1671 the Jesuits opened negotiations with him.[1] But the Duke was a vacillating man who found it quite impossible to make up his mind. To persuade him of the importance of the decoration that they required the Jesuits sent him their plans for the rest of the church with only the tribune left bare. This, surely, would provoke him into action.

The sketches, however, were not a success. The Duchess did not like them and said that she had in mind an artist of her own 'molto stimato et accreditato' whom she wished to paint the vault. The Duke remained cautious. He reluctantly agreed to spend 30,000 scudi on the tribune, but he was thoroughly confused by the Jesuit plans and soon began to think of reasons for delaying them. If the dome was to be painted, he declared, the ribs would have to be removed and this would not be safe. Admittedly he had no authority over this part of the decoration, but he managed to imply that the Jesuits were wrecking the church and lacking in respect to the memory of his ancestor Cardinal Alessandro. He was always professing his anxiety to have the tribune decorated, but whenever pressed he would say coldly that he was 'not ready to do so at present and that this was not the time to begin'. In vain did Oliva insist on the claims of Borgognone—'our brother who is so excellent in things of this kind'—and encourage the artist to make drawings of *Joshua stopping the Sun*.[2] Months and years passed and still nothing happened. In despair the Jesuits proposed moving the remains of St Ignatius from the High Altar to the chapel in the left transept. If the Duke would not agree to the decoration of the tribune, they argued, would he not at least release them from their obligations to him and his family? But by now it was too late. In 1676, with the preliminary sketches made but with no opportunity to achieve his masterpiece, Borgognone died.

This brought the affair to a standstill. It was not merely that the Duke who had been difficult enough about the expense of 30,000 scudi would surely be far more so when he also had to pay the painter. It was that the Jesuits had genuinely wanted Borgognone to decorate the central feature of their greatest church. He was, they felt, the one artist capable of carrying out the vast work they had in mind. There was, besides, the undoubted satisfaction that it was a Jesuit who was to undertake this great glorification of the Triumph of the Order of Jesus. The insistence of Oliva and his emissaries that Borgognone should be employed occurs throughout their letters—indeed it marks the first step in a definite Jesuit policy towards the arts since the scenes of martyrdom which they had had painted at the end of the sixteenth century.

[1] Pecchiai, 1952, p. 109, for these and subsequent negotiations.
[2] The subject is the same as that chosen for Carlone in the Jesuit church at Perugia.

During the course of his futile negotiations with the Duke of Parma, Oliva had been looking around for another artist to paint those parts of the church over which the Jesuits had complete authority. He had originally considered three painters, Carlo Maratta, Ciro Ferri and Giacinto Brandi, whose diversity of styles shows that he had no preconceived ideas on the matter.[1] Then he saw some frescoes by the young Giovanni Battista Gaulli in the church of S. Marta and immediately included him in his list of possible painters. Bernini, who had already employed Gaulli on some decorative work of his own, was enthusiastic, and the artist had one further claim of overriding importance. Like Oliva he came from Genoa. In August 1672 a contract was signed between the two men.

Gaulli—or 'Baciccio'—had been born in 1639 and had already made a name for himself as a brilliant portrait painter. But his only important decorative work had caused him some trouble. The Jesuit confessor of his patron Prince Pamfili had decided that the nudity of his figures on the pendentives of S. Agnese in Piazza Navona were 'lascivious' and they had had to be hurriedly clothed.[2] It was a strange beginning for one who was now to be entrusted by the Jesuits with the most elaborate commission in Rome. For Gaulli agreed to paint the entire dome (including the lantern and the pendentives which had already been frescoed by Giovanni de' Vecchi); the entire vault including the window recesses; and the vaults of the transepts above the chapels of St Ignatius and St Francis Xavier. He was to omit only the vault of the tribune which was being kept for Borgognone. All this enormous area was to be painted and gilded by the artist at his own expense. The dome was to be completed within two years, and all the rest of the work—gilding, painting and stucco—within eight years from then, i.e. by the end of 1682. If the work was considered by experts to be other than perfect Gaulli undertook to correct it without charge. If all went well he was to be paid 14,000 *scudi* as well as all the expenses of scaffolding and so on.[3]

As the work progressed Oliva's ambitions grew. The dome was ready by April 1675,[4] and four years later the vault was completed. The experts who were invited to a private showing were not enthusiastic,[5] but with the general public it won 'universal admiration both for the beauty of the painting and for the arrangement of the stucco which makes it still more worthy of applause'. When trying to resume negotiations with the Duke of Parma for the decoration of the tribune, Oliva naturally spoke of Gaulli's work with the most fervid admiration and pressed home the moral[6]: 'We have at last,' he wrote in September 1679, 'through the grace of God, removed the scaffolding

[1] In fact, as we learn from Pascoli, I, p. 125, Oliva had hoped many years earlier that Pier Francesco Mola, who died in 1666, would undertake the decoration. The account of Oliva's later plans is also taken from Pascoli, I, p. 200. [2] See *avviso* quoted in *Roma*, XVIII, 1940, p. 238.

[3] Tacchi-Venturi, 1935, pp. 147-56. [4] See *avviso* quoted in *Roma*, XVIII, 1940, p. 238.

[5] See *avviso* of 12 August 1679 published by Pastor, XIV, parte II, p. 26: 'conclusero tutti che sarebbe bellissima, se fossero pitture meno spropositate et di qualche altra mano', and further *avviso* if 6 January 1680. [6] Tacchi-Venturi, 1935, pp. 154-5.

from this church of the Gesù, founded by Your Highness's ancestors for the Society and renowned among the miracles of Rome. . . . Already the parts which remain to be painted and gilded are being prepared, and all that remains is the head of this famous temple, which by special rights belongs to the house of the founder. The very crown of the work depends on the tribune. But, without the special command and generosity of Your Highness, the scaffolding cannot go up nor can the work be completed.' He scarcely dared, he added, suggest that Gaulli be given this further task, although that painter had 'surpassed himself in the work and is considered to be as good as the very best artists'. Ranuccio's reaction was entirely characteristic. He agreed to the employment of Gaulli and offered to pay 3000 *scudi*—exactly one-tenth of what had been asked for. So the tribune and High Altar remained bare and Gaulli merely painted a small fraction of the vault above it and the conch of the apse. Finally in 1685 he completed his work in the church by painting the left transept above the altar of St Ignatius; for, as will be seen on a later page, the chapel of St Francis Xavier was decorated by another artist after giving rise to further difficulties.

The respective parts played by Oliva, Bernini and Gaulli in the frescoes of the Gesù are not known. No programme has come to light, and it is probable that the relations between the three men were so close that more was arranged by the spoken than by the written word. Certainly Bernini's part in the undertaking was stressed from the very first and has been accepted by historians ever since.[1] The share of Oliva can be inferred from a certain complexity in the iconography.

During the 1670s, when the frescoes were being devised and executed, the Roman Church was shaken by the most serious controversy that had faced it since the Council of Trent.[2] Crucially implicated, at the very centre of the whirlwind, was the Society of Jesus and, in particular, its General, Oliva. The trouble had started soon after the arrival in 1664 of a Spanish priest, Miguel de Molinos, who rapidly acquired a wide and exceedingly influential following by preaching two especially appealing doctrines: that communion could be administered daily to the faithful if they required it and that far more stress should be placed on passive contemplation than active meditation. Both of these views—and particularly the latter—were directly opposed to those of the Jesuits, who soon reacted strongly with all the intellectual and political weapons at their command. It is always difficult for the opponents in any serious controversy to distinguish between real questions of principle and more petty motives of jealousy. Certainly the Jesuits, quite apart from the doctrinal issues which divided them from Molinos, cannot have viewed with any enthusiasm his growing prestige in those very spheres

[1] Thus an *avviso* of 1675 (*Roma*, XVIII, 1940, p. 238) reported the occasion as follows: 'hanno li P. P. Giesuiti scoperto la cuppola della loro Chiesa . . . dipinta da nuovo con disegno del Cavalier Bernini, a fattura d'un tale Baccici Fiorentino [*sic*], e da molti virtuosi non viene troppo lodata l'invenzione del primo, come anche il lavoro del secondo'. For a modern examination of the problem see Enggass, 1957, pp. 303-5.

[2] For all this section see the well-documented but very hostile Paul Dudon and also J. de Guibert, as well as the various collections of Oliva's sermons and the account given in Pastor, XIV, parte II, pp. 325 ff.

which had hitherto been subject almost exclusively to their own influences—the aristo-
cratic society of Rome and the papal court itself. This, no doubt, played its part in the
violence of their reaction and made them more determined than ever to assert their
irresistible power as ostentatiously as possible. Some such consideration must have
weighed in Oliva's mind as he took time off from the problem of Molinos to consider
the decoration of the Gesù.

Yet, as often happens in complex disputes, the issues were not wholly clear-cut.
Both sides were arguing within the same climate of ideas, and in many cases the discus-
sion concerned nuances rather than easily explicable doctrines. A theme especially dear
to Molinos—and one, of course, by no means new—was that of the Blood of Christ in
which the soul could purify itself of guilt and sin. 'It is certain', he wrote in his *Guida
Spirituale*,[1] 'that before the soul is ready to enter into the presence of the divinity and
unite with it, it must wash itself with the precious Blood of the Redeemer and adorn
itself with the richness of His Passion.' Among those deeply affected by this same con-
cept—though it is impossible to say whether or not he derived the notion from Molinos
—was Bernini. 'He would sometimes think very deeply and also talk about a matter of
the highest consequence—the belief that he always had in the powers of the Blood of
Christ in which, he used to say, he hoped to drown his sins.'[2] And in about 1668 he
employed an etcher to reproduce one of his drawings in which the blood streams down
from the wounds of the crucified Christ into an eternal, boundless ocean.

It was presumably Bernini who first suggested to Gaulli that he should adapt this
theme to the dome of the Gesù. A number of the painter's drawings, almost certainly
connected with the project, survive—but were never made use of.[3] Perhaps the theme,
innocuous when Bernini had first drawn it a few years earlier, had by now become too
closely associated with Molinos to be palatable to the Jesuits. Certainly they themselves
always avoided the mystical, and the etching taken from Bernini is unquestionably
tinged with feelings of passivity and quietism. More likely they realised that, whatever
its significance for private devotion, it was wholly unsuitable for the decoration of a
dome. In any case, Gaulli's scheme, when finally brought to fruition, was based on a
different subject, although it retained links with the Blood of Christ and although it too
had been treated by Bernini. This was the *Duplex Intercessio* in which the kneeling
Virgin, trampling on a serpent and pointing to Her breast, and Christ, indicating His
Cross which is being carried by angels, together appeal to God for mercy for suffering
humanity. Below the Cross Adam and Eve join in the supplication, and around this
principal scene are groups of saints and kings in adoration.[4]

[1] Book I, chapter 16, verse 117. [2] Baldinucci, 1948, p. 135.
[3] These drawings are in Berlin and Düsseldorf. This whole interpretation of the iconography of the
Gesù frescoes is derived from Lanckoronska, 1935.
[4] Panofsky, 1927, p. 290. The presence of Adam and Eve is unusual. The figures were, however,
generally included in versions of *The Blood of Christ* and thus constitute a link between the two program-
mes. Admittedly Adam and Eve do not appear either in Bernini's or in Gaulli's drawings of *The Blood of
Christ*, but these are in far too early a stage to constitute serious evidence. When Gaulli adapted Bernini's
Duplex Intercessio (for which see Brauer und Wittkower, plate 128) he put Adam at the foot of the Cross
instead of Christ, whose pose he almost exactly retained.

It was usual in Roman churches to fill the triangular spaces below the dome with figures of the Doctors of the Church, the Prophets or the Evangelists. Oliva decided that he would include all three and add to them a group which had not hitherto been represented, the Judges. With miraculous ease the artist solved the problems posed by presenting four figures in a single pendentive and made them sweeping enough to fit in with his grandiose patterns, yet sufficiently individualised to be easily recognisable and never monotonous.

It is, however, Gaulli's fresco in the nave which is the most striking feature of the Gesù, although it was originally to be no more than a prelude to the climax of the tribune (Plate 14). Here the Jesuits were able for the first time to display on a large scale what had for some years been an essential feature of all their visual propaganda through the medium of book illustrations and the like[1]: the theme that theirs was essentially a missionary society concerned more with the winning of this world for Catholicism than with the fate of souls in the next. With the dangerous heresies of Molinos daily gaining ground, the theme was one of ever greater urgency and, as the vault was much more accessible to the general public than the dome, the symbolism with which the message was conveyed could be expressed in much more simple terms. To represent the theme Gaulli ignored the classicising tendencies of his immediate predecessors and returned for inspiration to Pietro da Cortona's daring and revolutionary ceiling in the Barberini palace of forty years earlier. Everything radiates from the golden circle of light which emerges from the Society's emblem IHS at the far end of the vault. The rays plunge out through the circle of cherubs and throw into dazzling relief the ranks of the saints and the blest, the Three Kings who first worshipped the Name of Jesus, the prominent figure of the Church and the House of Farnese holding aloft a model of the Gesù.[2] From these it re-emerges with renewed and searing intensity to strike the damned and the heretics, who are blinded by it and hurtled past the frame of the painting on to the stucco decoration of the vault and, by implication, into the body of the church. The colours are warm and brilliant, and an effect of cosmic drama is established by the contrast between the blues and reds and browns of the figures and the golden glare from the Name of Jesus, Whose triumph the fresco celebrates. To attract the eye of the worshipper to this tremendous spectacle Gaulli devised sixteen figures, which were executed by his followers in stucco and placed in the window niches along the nave, whence they gaze upward in awe. They serve not only to bring into close emotional contact the two realms of matter and spirit but also to emphasise once again the overwhelming power of the Jesuit missionaries, for they represent all those regions— from Ethiopia to Peru, from China to Mexico—where the disciples of St Ignatius had made their presence felt.

[1] See, for instance, the frontispiece to Daniello Bartoli: *Della vita e dell'istituto di S. Ignatio* . . . Roma, 1659.

[2] Lanckoronska.

In the apse, which was completed only after the death of Oliva, Gaulli was required to return to the more abstruse levels of theology which had characterised his frescoes in the dome. He revived the subject of *The Adoration of the Lamb* which had been hardly seen in Rome since the mosaics in S. Prassede and S. Maria Maggiore many hundred years earlier. The choice of such an archaic theme may have represented a concession to the original intentions of the church's founder, Alessandro Farnese, for that Cardinal, whose patronage was often marked by strange, mediaeval echoes, had once had the intention of decorating the tribune with mosaics. But there is another possible reason for the choice. In a less mystical and more attractive form it incorporated much of the idea which had originally been proposed for the dome—the glorification of Christ's suffering—and at the same time fitted in more easily with the triumphant tone of the rest of the church.[1] Much of the traditional iconography was used. The Book on the throne is sealed with seven seals, and before it burn seven torches. Twenty-four ancients adore the Lamb; behind are youths with palms and angels trumpeting and lifting up their thuribles to fill them with prayers. The theme appears frequently in Oliva's writings; but, despite all the brilliance of Gaulli's handling, the transference into Baroque terms of imagery, which had been so effective in formalised mosaic, has not proved wholly satisfactory.

Gaulli's achievement had exceeded all Jesuit expectations and he had been gener-ously rewarded by Oliva who showed great patience in dealing with his fits of tem-perament and angry outbursts.[2] But the contract between them could not be completed, for though the Jesuit missionaries might assert their authority to the ends of the earth, the Society was still not master in its own house. Even at this stage the pressures that had bedevilled Jesuit intentions ever since their early impoverished dealings with Cardinal Farnese could prove irresistible.

The chapel in the right transept was one of the only ones that long remained exclusively under Jesuit patronage. It had originally been dedicated to the Saviour and then to the Resurrection; for it Baglione had painted an altarpiece in 1602.[3] On his canonisation in 1623 the chapel was dedicated to St Francis Xavier and in it was placed a picture of the saint which had been painted by Van Dyck. Towards the end of the 1660s, however, the patronage of the chapel was acquired by Monsignor Negroni, an exceedingly rich and powerful prelate 'tutto spirito e fuoco' who was later made Cardi-nal.[4] From the first, Negroni showed that he considered himself the final arbiter in his own chapel and that he intended to ignore Oliva's plans for the rest of the church. He commissioned drawings for a grandiose altar from Pietro da Cortona just before the artist's death in 1669, and so high was the projected pediment that the cornice had to be broken. After Pietro's death rival architects were soon writing to Duke Ranuccio at Parma that this was ruining the architecture designed by his great ancestor. But Negroni showed that he had powerful friends, for he caused the arms of Popes Clement

[1] Lanckoronska.
[2] Pecchiai, 1952, p. 129, and Pascoli, I, p. 201.
[3] Pecchiai, 1952, p. 101.
[4] Cardella, VII, p. 299.

IX and Innocent XI to be carved on the front of the altar and then wrote to Oliva to make sure that the implications of this gesture should be fully understood: 'As I told Your Reverence, I have ordered the stone masons to set to work on a record to the eternal memory of these two Popes whom I venerate.'

But this was only a beginning. Though in later years he was to sit to Gaulli for his portrait, Negroni did not wish to have his chapel painted by the artist and he chose instead another Genoese painter, Gianandrea Carlone,[1] and the most famous artist of the day, Carlo Maratta.[2] Very reluctantly and under extreme pressure Oliva was compelled to agree to the change, and from the bitter controversy that followed we can see what rights a patron claimed to exert over the decoration of his chapel.[3]

'Worship of the Holy Relic',[4] wrote Negroni, 'will be open to the public; the rights of the chapel will belong to him who has dedicated it; and its upkeep will be the responsibility of the Jesuit fathers.' Neither the tone nor the substance were conciliatory and the Jesuits were infuriated by Negroni's claims. But the Cardinal remained stubborn. He only wanted the authority that all patrons naturally possessed 'as regards the essential arrangement of the chapel—for instance, neither the picture, nor the capitals, nor the columns were to be altered without his full agreement'. But this was to be the last clash in the long series between the Society and its benefactors.

Many years earlier another great monument to the power of the Jesuits had appeared in Rome. In the rebuilding of their novitiate church, S. Andrea al Quirinale, they were faced not with the tyranny, hesitation or meanness of a rich patron, but with the absolute supremacy of the most gifted and successful architect since Michelangelo. Fortunately he was a man who profoundly shared their ideals and he was given a free hand by the Society.

Bernini's relations with the Jesuits remained very close throughout his life. As a young sculptor one of his first tasks had been to help his father on the monument to Cardinal Bellarmine in the Gesù, and, soon after, he had collaborated with the Jesuits in the production of a superbly illustrated edition of Urban VIII's Latin poems. Since then he had maintained the firmest contacts with the Society. Domenico, his son, claimed that for forty years he went regularly once a week to the Gesù.[5]

When in 1661 Oliva became General, this connection was still further strengthened by the great friendship between the two men. Bernini frequently gave Oliva advice, which was always accepted, on matters of artistic policy, and he also produced a number of illustrations for an edition of his sermons. Oliva made use of the artist to forward his diplomatic ends.[6]

[1] Carlone had painted the tribune of the Jesuit church in Perugia where Negroni had completed his studies—MS. at Gesù in Perugia—Busta 152/1526–5 and 6.

[2] Maratta painted *The Death of St Francis Xavier*.

[3] Pecchiai, 1952, pp. 132–7.

[4] The arm of St Francis Xavier which was kept in the chapel.

[5] Domenico Bernino, p. 171.

[6] Thus he was especially anxious that Bernini should make the difficult journey to France at whatever cost to his health and that Louis XIV should be informed of the pressure he was exerting.

Bernini's relationship with the Society was not confined to friendship with its members and work for its establishments. In France he often visited Jesuit churches, and talked much of his sympathy with Jesuit ideas. Oliva said that he could discuss matters of spiritual importance with the deepest understanding,[1] and all modern historians have commented on the fact that much of his best work seems to fulfil the ideals of the Society. In the novitiate church of S. Andrea which he began to build in 1658 he had his greatest opportunity of doing so. He was well pleased with his achievement, for when many years later he was discovered by his own son in a corner of the church, he said to him: 'My son, this is the only piece of my architecture for which I feel special satisfaction in the depth of my heart, and often when I need rest from my troubles I come here to gain consolation from my work.'[2]

This was at a time when the building was already considered one of the finest in Rome, but as usual there had been many complications before the project could actually be carried out. As the Jesuits had increased in power and numbers, the restricted size of their patched-up novitiate on the Quirinal had become more and more unsatisfactory, until by 1642 they claimed that darkness and humidity made it almost unusable.[3] Two serious difficulties stood in the way of any rebuilding or expansion. The first was the refusal of Cardinal Bandino to sell any of his land which surrounded the novitiate, and the second was the strong objection of the Pope to anything which would obstruct the view from his palace.[4] This had stopped Cardinal Ludovisi founding S. Ignazio on this site as he had wished, and even after the Bandino property had been acquired, the papal interdiction was strictly enforced. In 1649 Cardinal Ceva agreed to build a new church and lodgings, and he chose for the purpose Borromini, the most prominent architect of the day since the temporary eclipse of Bernini.[5] The drawings were made, but Innocent X forbade their being executed. Seven years later, however, the Rector of the novitiate appealed once again to the new Pope, Alexander VII, whose close friend he was. This time he was successful, and after the Pope had satisfied himself that his view would not be disturbed, he strongly encouraged all his entourage to contribute towards the expense. By far the largest sum was given by Prince Camillo Pamfili, nephew of Pope Innocent X, who assumed the patronage for himself and his family. Like all patrons he declared at the outset his intention that the church should 'rival the most magnificent buildings in Rome erected through his munificence'.[6] But unlike many of them (and most unlike his usual self)[7] he carried out these intentions fully until his death in 1665, after which his example was loyally followed by his son. We hear less of financial troubles in S. Andrea than in any of the other churches that have hitherto been considered, and the

[1] Domenico Bernino, p. 171.
[2] *ibid.*
[3] MSS. in Jesuit Archives: Rom. 164, ff. 193-4.
[4] *ibid.*, Rom. 21, f. 174.
[5] *ibid.*, Fondo di Gesù, N. 865-18.
[6] *ibid.*, Rom. 163, f. 304—'gareggiasse con le più magnifiche fabriche inalzate in più luoghi di Roma della sua liberalità . . .'.
[7] For Camillo Pamfili see later, Chapter 6.

spirit of the enterprise, as regards both finance and the authority of the artist, can best be gauged from an episode in 1663 when Prince Pamfili went to visit the work in progress. Finding that the expense was going to be much higher than anticipated, he left 1000 *scudi* on the spot and said: 'You must do whatever Cavalier Bernini orders, even if all my substance should go in the process. . . .'[1]

In fact Bernini's authority was felt at every stage of the building. Each bill, each contract was scrutinised by him and endorsed with his vigorous initials.[2] Workmen engaged on the most menial tasks came under his direct supervision. He was himself the virtual patron of the whole enterprise and refused all payment, including even battle pictures by Giacomo Borgognone.[3] Nor can his assistant Mattia de' Rossi have put much of a strain on Jesuit resources, as he was paid only in wine, the inevitable battle pictures and 'two old majolica plates, which we have never succeeded in selling, painted, it is thought, by Raphael of Urbino or at least someone of that school. At one time they were valued at 50 *scudi*, but this was probably too high an estimate'.[4]

This marvellous church, with its richly coloured marbles and sumptuous decoration entirely subordinated to an immediately striking and simple oval plan, was thus a pure expression of Bernini's genius, unfettered by the instructions of patrons or shortages of money (Plate 16). Yet by comparing it to his other works we can see that its Jesuit destination provided a very special impulse. Nowhere else is the iconography planned so coherently with every element of the decoration symbolising in some degree the dominating figure of St Andrew who rises triumphantly from the broken pediment above the main chapel. And, as later in the Gesù and S. Ignazio, the emotional pressure is such that normal architectural barriers are broken down to link Heaven and Earth in a single unity. Daylight streams in from the lantern above the High Altar and is symbolically identified with the glory of golden rays which radiates from the drum; while spilling down into the chapel is a mass of golden putti—at first only heads and wings and then, as they come nearer the ground, more and more solid. When the sun lights up the gold and white coffers of the dome the effect of divine intervention is far more poignantly communicated than in any fresco.

As soon as the main structure of the church was complete, the Jesuits began to consider the problem of altar paintings. Although Bernini's advice must have been taken, the actual arrangements with artists were made directly by the Jesuits, though they were paid for by the heirs of Prince Pamfili who had died in 1667.[5] Guglielmo Borgognone who was commissioned in 1668 to paint *The Martyrdom of St. Andrew* for the High Altar had already been employed in the novitiate with his Jesuit brother

[1] MSS. in Jesuit Archives: Fondo di Gesù, N. 865-18—'Si faccia quanto il Cavalier Bernino ordinerà, benche c'andasse tutto il mio. . . .'

[2] *ibid.*, Fondo di Gesù—N. 865—4/6/7/8.

[3] *ibid.*, Fondo di Gesù—N. 865-19.

[4] *ibid.*, Fondo di Gesù—N. 1017, p. 95.

[5] *ibid.*, Fondo di Gesù—N. 865-13: Thus Gaulli was paid 100 *scudi* 'per le mani del P. Francesco Scaramuccia quale disse pagarli di denari propri di detto Noviziato con animo di rivalersene dal Signor Principe Panfiglio . . .'.

Giacomo. Gaulli was an equally obvious choice. In 1676 he painted the *Death of St Francis Xavier* for the altar dedicated to that saint and was paid 100 *scudi*. He also painted two more scenes from the life of the saint for the same chapel after a series of complicated financial disputes.[1] Negotiations with another artist, Giacinto Brandi, to decorate the Chapel of the Passion with pictures of the *Pietà, Christ and St Veronica* and *The Flagellation* were prolonged and difficult,[2] and Carlo Maratta, the best known (and best paid) artist in Rome, took eight years to deliver his altarpiece of *St Stanislas Kostka*.[3]

The last chapel to be adorned was that dedicated to the Madonna. In 1691, twenty-one years after the church had been opened to the public, a Jesuit document complained that it was 'affatto rustica'.[4] It was then taken over by Cardinal Ottoboni, nephew of Pope Alexander VIII, who commissioned altarpieces from Ludovico David of the *Nativity*, the *Adoration of the Magi* and the *Flight into Egypt* and paid for them from the funds left by Prince Pamfili. The latter's heirs reserved the right, which they later assumed, to change the decoration when they decided to embellish the chapel.

With the decoration of the Gesù and S. Andrea al Quirinale either complete or under way only one large problem now faced the Jesuits. S. Ignazio, though open to the public since 1642, still looked a vast white mausoleum, wholly unenticing amid the coloured marvels of other churches. When in 1680 General Oliva summoned to Rome the 38-year-old Andrea Pozzo to remedy this state of affairs his ambitions must at last have seemed fulfilled. For here was an artist of real talent who was himself a Jesuit—a new Borgognone, in fact. Pozzo, who was born in Trent, had entered the Society as a lay-brother at the age of 22, and had enjoyed an enormous success in North Italy, where he had decorated several Jesuit churches, notably at Turin and Mondovi, with spectacular effects of perspective.[5] Some of his paintings had reached Oliva who had shown them to Carlo Maratta. On his advice Pozzo was ordered to Rome. When he arrived after an unhurried journey, Oliva was dead.

The story of what followed was admirably suited to his romantically minded eighteenth-century biographers, and they revelled in telling how the artist with the utmost humility accepted the ordinary lay duties he was given by his superiors, unaware of his talent; how he went through Rome, collecting alms; how one day these superiors were discussing the spectacle they were to put on for the Forty Hours, and saying that economies would be necessary in the stage-sets; how Pozzo volunteered to construct the theatrical apparatus out of rags and used canvas—an offer that was rejected with scorn; how finally it was accepted and the result was a triumph. It is a success story familiar through countless fairy tales. But Pozzo, despite the recognition of his talents, was still faced with many difficulties.

[1] MSS. in Jesuit Archives: Fondo di Gesù—N. 865-13.

[2] *ibid.*, Fondo di Gesù—N. 865-13. For the full text of Brandi's letters to the Jesuit fathers see Appendix 1.

[3] *ibid.*, Fondo di Gesù—N. 865-13. For Maratta's dealings with the Jesuits see Appendix 1.

[4] *ibid.*, Fondo di Gesù, N. 101, p. 191, and see also Pascoli, I, p. 172.

[5] See MSS. Cod. Palat. 565, ff. 120-42, in Biblioteca Nazionale, Florence: *Francesco Baldinucci: Vita del Padre Pozzo.*

He was first required to paint the corridor linking the little rooms where St Ignatius had lived.[1] These had been preserved when the Casa Professa was built adjoining the Gesù in 1602, and converted into chapels. The task of decorating this corridor had been begun by Giacomo Borgognone, and left incomplete at his death. Because of its shape it could not be treated as a single unit, and the artist therefore divided the walls and vault into small scenes, separated by elaborate frames and putti. In them he depicted various aspects of St Ignatius's sojourn in this world and the next, and made such excessive use of his great technical virtuosity that, looked at from the wrong viewpoint, the decoration appears grotesquely distorted.

Just when Pozzo was beginning to be appreciated by the Jesuits, an incident occurred which almost made them lose him. The Duke of Savoy, in whose service the artist had previously worked and who had reluctantly given him permission to obey Oliva's summons to Rome, now called him back to decorate a gallery. Pozzo asked the new General to refuse him permission, but was told that it was his 'duty to satisfy great princes in their lawful demands'. He then appealed secretly to the Pope, above the head of the General, and by him was authorised to turn down the Duke's request. This prince, thinking that it was the Jesuits who had refused permission, wrote another personal letter, and when told by Pozzo of the Pope's intervention, appealed to him also. But the Pope confirmed his instructions to Pozzo, and the Duke was therefore reduced to making life as disagreeable as possible for the Jesuits in his dominions, who, in turn, blamed Pozzo for their difficulties.

The church of S. Ignazio had never been completed owing to financial difficulties and disputes with the Ludovisi descendants. The Rector of the Collegio Romano now determined that if he could not have a real dome, at least he would have something which would fill the awkward gap where the dome had been planned. Various artists and architects were consulted and among those who submitted plans was Pozzo, who proposed to paint in perspective a flat piece of canvas to give the illusion of a dome. On the advice of Mattia de' Rossi, Bernini's successor in S. Andrea al Quirinale and now architect of St. Peter's, his plans were accepted. Though he met with the derision of his fellow-Jesuits, Pozzo claimed that he was as sure of the result as of a proposition of Euclid,[2] and his optimism was at first justified. When shown to the public in June 1685 his device was described as 'very beautiful and ingenious, and it is thought that it will be many years before they decide to build a real dome'.[3] A later writer was quick to point out that being on canvas the dome was bound to darken,[4] and in fact within a few years of being painted it was all but invisible.

For some years after 1685 Pozzo painted frescoes in the tribune and the apse, representing there some of the principal events in the early history of the Society, culminating in Christ's amply fulfilled promise to St Ignatius at La Storta: 'Ego vobis Romae propitius ero.' Both in subject-matter and in treatment these differ greatly from

[1] Tacchi-Venturi: *La casa di S. Ignazio in Roma*, n.d.
[2] Pascoli, II, p. 265.
[3] Quoted by Pastor, XIV, parte II, p. 26. See also Baldinucci MS. *cit.*
[4] Pascoli, II, p. 256.

Gaulli's frescoes in the Gesù: they lack both the theological complexity and the emotional power of the earlier work. In some ways they mark a reaction against the Baroque. Every figure is displayed to the full and the whole composition is given rigidity by a bold architectural framework. That a work so immeasurably different in feeling and style from *The Adoration of the Lamb* was accepted and welcomed by the Jesuits shows either that their taste had changed out of all recognition in the last few years, or that this taste was sufficiently catholic to include anything grandiose without too much concern for its style. On the pendentives Pozzo wished to avoid the subjects usual for this position—the Evangelists and the Doctors of the Church—and to choose something different.[1] And so he painted Judith with the head of Holofernes, David with the head of Goliath, Jael hammering a nail into Sisera, and Samson killing a thousand with a jawbone. Though designed to illustrate the zeal with which heresy must always be thwarted, the Roman populace was less reverent, and the word went around that: 'anyone who wants to buy good meat should go to S. Ignazio, as four new butchers have just opened there!'

'It was', wrote the artist's biographer 'because of the extraordinary reputation acquired through this painting [the dome], not only by Padre Andrea, the artist, but also by the Society, which commissioned it, that the idea was born of painting the entire vault of the same church of S. Ignazio, the greatest task that could be performed by an artist; and although the reverend fathers were agreed to employ Padre Pozzo, yet they moved with considerable caution before undertaking it, so as to consult the famous painters and architects of Rome.'[2] The vault had previously been decorated with stucco work, which the artist ruthlessly destroyed, saying that it was 'more suitable for a kitchen than for a church'. For this step, inevitable, of course, if he was to paint the vault, he was so bitterly attacked that the Jesuits were frightened of going about for fear of receiving some public affront. They considered, therefore, abandoning the work and leaving the vault as it was. But by now it was too late, and in 1688 Pozzo began his colossal undertaking (Plate 15).

In later years the artist himself explained the meaning of his fresco at great length.[3] Essentially it was based on the words of Christ as reported by St Luke: 'I am come to send fire on the earth: but what will I, if it be already kindled?' Adapting this reference from the Church to St Ignatius himself—had not the saint often encouraged his disciples with the words 'Go and set everything aflame'?—Pozzo turned the whole ceiling into a vast celebration of the Jesuit missionaries. '. . . In the middle of the vault I have painted the figure of Jesus, who sends forth a ray of light to the heart of Ignatius, which is then transmitted by him to the most distant hearts of the four parts of the world. . . . From the breast of the Redeemer there emerges another ray which strikes a shield, on which is painted the Name of Jesus, the crown of light. And this means that the Redeemer, having as his purpose the glory of His name, wishes to honour Ignatius. . . .'

[1] Pascoli, II, p. 257: '. . . volle uscir da tali soggetti, et inventarne altri nuovi. . . .'
[2] Baldinucci MS. *cit.*
[3] Tietze, 1914-15, pp. 432-46.

This short extract from Pozzo's description makes it clear that he too was following one of the constant features of Jesuit decoration—the impact made on this world by the forces of the next instead of the more usual scheme in which the saints are shown receiving their rewards and rising to eternal bliss.

All this lavish decoration turned the three principal Jesuit churches into the most spectacular in Rome, as they were the first to point out.[1] But even after they had been completed, the very energy that had been employed seemed to encourage further efforts, and in the last few years of the century many new works were undertaken. Among them was the most elaborate chapel ever conceived, dedicated to the founder of the movement which had so signally triumphed.

The chapel in the left transept of the Gesù belonged to the heirs of Cardinal Savelli.[2] Dedicated originally to the Crucifixion, the altar had been designed but never completed by Giacomo della Porta. After the death of the Cardinal, his heirs seem to have taken no interest in the chapel for over a century, and it thus reverted unofficially into the hands of the Jesuits. When Ignatius was canonised in 1622, they moved his remains to this chapel, and above them placed the picture painted for the occasion by Van Dyck. Fifteen years later, the Jesuits were offered a superb urn, modelled by Algardi, in which to place the saint's bones, and at the same time Pietro da Cortona built a new altar to replace della Porta's uncompleted one, the expense of which was presumably borne by the Jesuits themselves. In 1646, the Eighth General Congregation of the Society agreed that a more ambitious monument should be established. They drew up a memorandum which pointed out that St Dominic in Bologna, St Francis in Assisi and St Benedict in Montecassino were all suitably commemorated; surely St Ignatius, who alone of all the saintly founders of Orders was buried in Rome, should also have a fine memorial. In view, however, of the Society's 'extreme poverty and the disastrous times', nothing further was done. Four years after this a vast legacy was left to the Jesuits in Peru, who thereupon planned to build a college in Ignatius' birthplace in the province of Vizcaya. The General of the Society, Padre Nickel, suggested that the money would be better employed in decorating a chapel in the Gesù in Rome. But the Spaniards evidently did not welcome this idea, and soon began to spread rumours that the General wanted the money 'for his own private use'. Again, the matter was dropped.

Meanwhile, vast sums began to pour in from all over Europe for the building of the chapel. When Oliva became General, he was determined to have the monument to Ignatius not in the transept but under the High Altar, as the most spectacular feature of the tribune, which was to be lavishly decorated by Giacomo Borgognone. It has been pointed out that the parsimony and delay of the Duke of Parma made this impossible, and Oliva died, disappointed, in 1681. The four-year Generalship of his Belgian successor, Charles de Noyelle, was too short for much to be done, but under the Spaniard, Tirso Gonzalez, who took over in 1687, the undertaking was again resumed in the transept chapel. But there was yet another problem. The Jesuits were anxious that the

[1] Pascoli, II, p. 260.
[2] Pecchiai, 1952, pp. 259 ff.

building of the chapel of St Ignatius should remain entirely in their own hands. The site officially still belonged to the Savelli, and it needed the mediation of the Holy Roman Emperor to induce Prince Giulio, the head of the family, to give up its patronage in return for special references to the beneficence of his ancestor, the Cardinal.

The Jesuits thus had the money and the rights of patronage with which to build the great altar they planned. But many members of the Society, as well as various architects who were consulted, still thought, as Oliva had done, that the tribune was by far the most suitable position. This, however, was impossible as the Duke of Parma flatly refused permission, and so the Jesuits reluctantly resigned themselves to the left transept.

A competition was organised and caused an uproar. Architects and their patrons, aware that this was the finest opportunity in Rome, jockeyed for position, slandered their rivals and intrigued with gusto. The inevitable choice of Pozzo's plans did nothing to help the situation. Letters, signed and anonymous, poured in on the unfortunate father in charge of the arrangements. The Duke of Parma was told that the church was being wrecked; that in order to economise, white marble was being rubbed with yoke of egg to make it appear yellow; that the whole organisation was a 'confusion of babel'. Pozzo threatened to withdraw; there were endless debates as to whether a statue or a picture inspired greater devotion; more architects were consulted. Finally, in May 1695 after much hesitation, the General, Tirso Gonzalez, made his irrevocable decision and forbade any further criticisms. Pozzo was put in complete charge of the altar.

He chose the craftsmen and organised competitions for the sculptors. To avoid still more intrigues all the drawings and models were exhibited in the Galleria Farnese, and the artists invited to be present. They were then asked to vote, in private, for the one they thought the best, excluding their own. The most important piece of sculpture was, naturally, the statue of St Ignatius, and the competition for this was won by the Frenchman Pierre Legros. While the voting took place crowds waited impatiently in the Casa Professa, and when the decision was announced, French students carried him through the streets in triumph, shouting 'Viva, viva, Monsù Le Gros.' The authorities of the French Academy in Rome, where Legros was a student, were less enthusiastic, and after he had also agreed to make a large marble group of *Religion triumphing over Heresy* to be placed on one side of the altar, he was dismissed for accepting private commissions in defiance of his status as a pensioner of the King of France.[1] He thereupon remained in Rome and became the Jesuits' principal sculptor. However, as if to show that they were in no way concerned to promote one particular style, they chose for the group of *Faith crushing Idolatry*, to be placed on the other side of the altar, the work of another Frenchman, Jean Baptiste Théodon, whose heavily classical lumpiness was a total contrast to Legros' dramatic, Baroque vigour. Two further large figures showing Doctors of the Church were also planned, but because it was 'considered not suitable that [they] should pay court to the Saint', this scheme was abandoned.

Within the altar itself there is much fineness of craftsmanship and complexity of detail. But these more subtle features—such as the bas-reliefs depicting the life and

[1] Baumgarten.

miracles of St Ignatius—are embedded in such a mass of colour and riot of ornamentation that they are easy to overlook. For here at last is that direct Jesuit assault on the emotions that the Protestant traveller from England thought he had experienced nearly a century earlier.

That this policy was now deliberate is shown by other commissions of the time— most notably the gruesome polychrome figure by Legros of St Stanislas Kostka on his deathbed, which was kept in a badly lit room in the novitiate 'where it powerfully moves those who come to see it'.[1] But to sum up Jesuit art in this way, as did nineteenth-century writers, is wholly inaccurate. All the art of the Baroque had a strongly emotional character, and for much of the seventeenth century the Jesuits were merely trying to follow current styles—often with some difficulty owing to lack of money or patrons. When in the second half of the century they were at last able to employ artists for themselves, their tendency was to stress the doctrinal elements of their beliefs in rather greater detail than was usual in Roman churches. In fact, the powerfully illusionistic art that they fostered in S. Andrea al Quirinale, the Gesù and above all S. Ignazio long after such decoration had vanished elsewhere was prompted by just such considerations. The Jesuits, even when spiritually decadent and attacked on all sides for the corruption of their ideals, were above all missionaries. Their art was therefore worldly in a truer sense than is generally meant by that term. They always aimed to display the workings of God's grace (naturally through the Society of Jesus) on the human soul and they showed correspondingly less interest in the individual salvation of the already blessed. It was this that gave a logical force to the ceilings of their churches that is lacking in most others. In the Chiesa Nuova we look up and see a private miracle, wholly characteristic of an Order that worshipped the Virgin and St Philip above all else; in the Gesù and S. Ignazio we are witnesses of a universal theme in whose development we ourselves play an essential part.

[1] For the history of this figure and the very interesting debate among the Jesuits that resulted from a proposal to move it to the church itself see F. Haskell, 1955, pp. 287–91.

In 1697 Padre Pozzo designed an altar in the left transept of S. Ignazio which Legros completed with an appealing bas-relief representing *The Assumption of the Blessed Luigi Gonzaga*. The chapel in the right transept was only completed in 1749 when Filippo della Valle and Pietro Bracci made a marble bas-relief of the *Annunciation*—see Fabrini.

In 1710 Pierre Legros completed the monument to Pope Gregory XV and Cardinal Ludovisi in the same church. Many documents relating to this project are preserved in the Jesuit Archives: *Ecclesia S. Ignatii de Urbe*, 1255.

Chapter 4

THE PRIVATE PATRONS

THERE were other sources of patronage besides the papal court and the religious orders. Rome teemed with *amateurs* and *virtuosi* of all kinds, each with his gallery of pictures and antiques which were eagerly visited by the foreign travellers who flocked to the city. The vast majority of these private collectors were content to follow the general fashion set by the court. It would be wholly tedious to discuss in detail the innumerable cardinals, princes and private citizens who accumulated works of art during the seventeenth century—though it is painful to have to refrain from considering figures such as the engagingly named Jacopo Ghibbesio, a university professor born of English parents, with a facility for writing poetry in six languages and the enthusiastic owner of many paintings and drawings by Pietro da Cortona.[1] A few men, however, stand out as being of real importance in the artistic life of the city—either because their towering wealth made them indispensable to the painters who swarmed into Rome from all over Europe or because a firmly held and sometimes eccentric taste led these artists into unexpected channels.

– i –

Of the private collections in Rome at the time of Urban's accession, by far the most striking was the one belonging to the Marchese Giustiniani (Plate 17b).[2] But he was henceforward to be a somewhat isolated figure. Politically he belonged to the Spanish faction which lost all influence at court; artistically his taste had been formed during the first twenty years of the century, and now at the age of 59 he made little attempt to change it. It was a taste capable of appreciating quality in widely varying artists, and in a letter to one of his closest friends, Dirk Ameyden, a Flemish agent of the Spanish crown, he justified his eclecticism.[3] With a remarkable lack of dogmatism he ran through the various themes and styles of painting. He contrasted those who painted 'di maniera' —'where the artist after long study of drawing and painting does not copy but represents what he sees in his imagination'—such as Barocci, Passignano and the Cavaliere

[1] Bertolotti, 1886, who has, however, missed the reference to him in Skippon, p. 650.

[2] Salerno, 1960.

[3] This famous letter (Bottari, VI, p. 121) was published for the first time by the Abate Michele Giustiniani in 1675 (III, p. 417). It is undated but is always assumed to have been written in the 1630s because of a strange reference to Romanelli who only emerged as an independent artist at about that time. When reprinting this letter in 1951 (*Paragone*, 17, p. 50) Roberto Longhi made a wholly convincing emendation and changed Romanelli to Pomarancio. Benedict Nicolson plausibly suggested to me (verbally) that the error arose through a copyist substituting Romanelli for the similar word Roncalli (i.e. Pomarancio). This artist was Giustiniani's special painter and his exclusion from the list would be most surprising. We can now date the letter much earlier in the century—probably well before 1620.

d'Arpino—with those who painted making direct use of the model—such as Rubens, Honthorst, Ribera, the Flemish above all. And he concluded that the best way lay in combining these two styles as did Caravaggio, the Carracci and Guido Reni.

Now, however, he found himself unable to appreciate the Baroque masters of the new generation. Though he lived until 1637, he showed an interest only in three of the painters who had come to the fore under the aegis of the Barberini: Nicolas Poussin, Claude Lorrain and Pietro Testa, all of whom lay outside immediate court circles. With great discrimination he commissioned early works by these masters which showed that he retained all his suppleness of taste where his sympathies were engaged. Poussin painted for him a *Massacre of the Innocents*, remarkable for the austere restraint which he imposed on so brutal a subject, and an *Assumption of the Virgin*, which was among his first works to reveal the impact of Venetian colour and classical studies. From Claude he obtained a mythological painting notable for its romantic stillness.[1] But in general Giustiniani turned more and more to the past and devoted himself to his passion for the antique. Between about 1628 and 1631 he was concerned with the production of two splendid volumes of plates to record the main masterpieces of ancient sculpture in his palace. Northern artists chiefly were engaged on the enterprise, and on the publication of the volumes his gallery became better known in the Rome of Urban VIII for its antique statuary than for its early seventeenth-century paintings, many of which must have appeared unsympathetic to the younger generation.

While Giustiniani, the excessively rich Genoese banker with his newly acquired title and somewhat marginal position in Roman society (to be rectified in the next generation by the marriage of his heir Andrea to Maria Pamfili, niece of Innocent X), was steadily accumulating treasures of all kinds, the descendants of the great old Roman families were plunging ever further into debt and disintegration. And yet they too contributed, if only precariously, a lively note to artistic patronage in the city. Paolo Giordano II Orsini, Duke of Bracciano, was the last but one of his family to hold the title which he inherited in 1615 at the age of 24.[2] Brought up in Florence for the most part, he absorbed from his father Virginio a passionate love of music and spectacle which remained his prime interests to the end of his life. Year after year the chroniclers report him visiting the theatres, taking part in amateur productions of plays and ballets, and indulging to the full in the brilliant and cultivated social life of the Medici court,[3] around which there gravitated a dazzling group of artists and musicians, including Giulio Parigi, Jacques Callot, Giovanni da San Giovanni, Filippo Napoletano and Gerolamo Frescobaldi. After travelling throughout Europe as far as Scandinavia (where,

[1] Poussin's *Massacre of the Innocents* at Chantilly, incidentally the one of his pictures most likely to appeal to an admirer of Caravaggio, probably dates from 1628-9 and *The Assumption of the Virgin*, now in Washington, from a year or two later—*Exposition Poussin* and Mahon, 1960, pp. 288-304.

The figures in the Claude, formerly in Berlin, are described merely as 'ninfe'. Röthlisberger, 1961, p. 512, suggests that they represent Cephalus and Procris reunited by Diana. He points out that this is Claude's first landscape with an unusual subject.

[2] See Ferdinand Boyer's two articles of 1934, and Borsari.

[3] Solerti.

according to an attractive but probably inaccurate report, the Norwegians asked him to be their King) and soldiering in Germany, he moved to Rome and his life resumed its normal course.[1] He befriended musicians of all kinds, including Monteverdi[2]; he was responsible for publishing the poems written by a number of admirers in honour of Leonora Baroni, the singer who so captivated Milton[3]; and he invented a new musical instrument which he called Rosidra after the rose on his escutcheon.[4] His two volumes of poetry in the style of Marino are respectfully mentioned and sometimes even quoted by the more indulgent literary historians.[5]

Orsini's position in Rome was a strange one. Brilliant, versatile and handsome, the head of one of the oldest and most distinguished families in the city, he was inevitably attracted into the Barberini circle.[6] Yet he belonged to the Spanish faction, and his fortune and status were drastically falling as a direct result of Urban VIII's policies. In the fifteenth-century fortress of his ancestors, towering over the lake of Bracciano, where he came to relax from his palace on Montegiordano, he still went on with the old rituals—corresponding as an equal with sovereigns, reading news-letters that poured in from all over Europe, using his authority to secure advantageous positions for his retainers. . . . But these moves were gradually losing all real meaning, and he must sometimes have surveyed the Roman scene with a certain bitterness, enjoying no doubt the tart little notes from his more sarcastic correspondents: 'A gentleman who was asked what he had specially noticed in the play given by the Jesuits answered that he had seen three things—*raggion di stato* represented by the Jesuits, atheism represented by four Pantaloni and idolatry represented by the Prelates of the Court—and though this was said as a joke, yet as it has an element of truth I thought it right to mention it to Your Highness.'[7]

Paolo Giordano was a vain man and something of a dandy. His variation of the current fashion—thick wavy hair, bristling moustaches and pointed beard stemming from the lower lip—carried it to the verge of caricature. He was most anxious to have his features recorded by the best artists of the day—who clearly delighted to oblige him. Ottavio Leoni made a superb etching (Plate 17c),[8] and in June 1623, a few months before the election of Urban VIII, Bernini was already modelling his head in wax

[1] All the earlier accounts (such as Crescimbeni, Vol. III, lib. IV, p. 197) tell the story of Paolo Giordano being offered the crown of Norway. So too does Litta. But C. de Bildt in his important article of 1906 gives cogent reasons for rejecting it.

[2] Prunières, 1926.

[3] *Applausi poetici alle glorie della Sig. a Leonora Baroni*, Bracciano 1639.

[4] Mandosio, II, p. 35.

[5] *Rime, e Satire di Paolo Giordano II, Duca di Bracciano.* In Bracciano, 1649. See Croce, 1910, and Ferrero.

[6] Arch. del Gov. di Roma—Biblioteca Vallicelliana: *Fondo Orsini.* The vast collection of documents relating to Paolo Giordano contains a number of letters to the Barberini, though mostly formal Christmas wishes and so on.

[7] Vallicelliana—*Fondo Orsini:* 170, c. 529, 10 February 1623. It is true that this dates from before the Barberini assumption of power, but the series of gossipy, dry and sometimes cynical news-letters from a writer who signs himself only *Il solito humil. mo Ser.re* continues in much the same vein in later years.

[8] Bartsch, XVII, p. 253.

'with the very greatest pleasure'. A little more than a year later a bronze cast was made, and Bernini took time off from his work on the *baldacchino* to direct the operation.[1] Everyone agreed on its success, but unfortunately the head has disappeared, as have certain other smaller works which he undertook at this time. In 1631, however, we see him once more in a superbly spirited medal perhaps by Giulio della Greca[2] and a year or two later marble busts of him and his wife Isabella[3] who had already been painted by Simon Vouet.[4] The concern for elegance remains, but a decade of pleasure and anxiety have left their mark—the features are coarser, layers of fat bulge round the neck, aristocratic refinement has given way to vulgar sensuality. Troubles were great, though he tried adventurous methods to retrieve his fortunes. Lord Arundel, ever on the lookout for possible treasures, wrote to his agent in 1636 of rumours that the Duke though 'a generous Prince [is] mightily indebted, therefore methinks you might easily have of him the *vaso*, and those things you mentioned of his'.[5]

Yet he remained an enthusiastic if limited patron. He was very keen to obtain a bronze equestrian statue from the sculptor Pietro Tacca in Florence who sent him a *modello*.[6] He commissioned a picture from Claude (a notoriously expensive artist) of *A storm at sea*, designed perhaps to illustrate his motto of *contra ventos et undas*,[7] and he was in touch with the Genoese engraver Andrea Podestà, who dedicated to him various prints of Bacchanals loosely based on the Aldobrandini Titians.[8] He was the special patron of the Flemish artist Jan van den Hecke who dedicated to him a set of twelve etchings of various animals.[9] He passionately collected medals[10] and he took a personal interest in the decoration of churches on his estates in Southern Italy.[11] Above all he devoted his attention to music while keeping a close watch on developments in all the arts. He was therefore an ideal correspondent for the ardent young Queen Christina of Sweden, who was pining for news of the Roman scene.[12] In 1649 through the intermediary of a Swedish diplomat they began to exchange letters and she was soon telling him of her picture gallery which had been recently looted from Prague: 'an infinite number of items, but apart from 30 or 40 original Italians, I care nothing for any of the

[1] This early bronze has disappeared and has never hitherto been mentioned in Bernini literature. In Appendix 2 I reproduce four unpublished letters to Paolo Giordano relating to Bernini.

[2] See Dworschak, 1934.

[3] Faldi, 1955, pp. 13-15, dates the busts *c*. 1630. Wittkower (1955, p. 199) points out that the portrait of Isabella is largely studio work and suggests a date nearer 1635.

[4] Demonts, p. 314. The portrait has not been identified.

[5] Letter to William Petty from Ratisbon, dated 8 September 1636, published by Hervey, p. 386.

[6] I can find no reference to this work in Tacca literature, and in Appendix 2 I publish the letter from him to Paolo Giordano.

[7] Röthlisberger, 1961, p. 161. The picture has been lost, but it is recorded in the *Liber Veritatis*, No. 33. It probably dates from 1638-9.

[8] For Podestà see Blunt in *Revue des Arts*, 1958, pp. 5-16.

[9] Baldinucci, VI, 1728, p. 377, and Bartsch, I, pp. 103 ff. The Duke of Bracciano for whom Pietro Mulier painted so many pictures (see Chapter 1, p. 7, note 3) was a descendant of Paolo Giordano II.

[10] See various letters in the Vallicelliana—*Fondo Orsini*—184, cc. 212 and 218.

[11] *ibid.*, 181, cc. 227 and 267.

[12] de Bildt, 1906, pp. 5-32.

others. There are some by Alberto Dürer and other German masters whose names I do
not know, and anyone else would think very highly of them, but I swear that I would
give away the lot for a couple of Raphaels, and I think that even that would be paying
them too much honour.' Paolo Giordano told her all the latest news—Pietro da Cortona
was working better than ever, though he knew of no other famous painters in Italy
except for Guercino who was now too old. Sculpture was in a much better way—
apart from minor figures there were two most excellent masters: Algardi and Bernini.
Both, said the Duke, were great friends of his and both, he flatteringly implied, would
be delighted to work for the Queen. Three years later, in 1655, when she came to Italy
after her sensational conversion, she spent a night at Bracciano on her way to Rome.
Paolo Giordano ended a day of splendid ceremonies with a special concert in her
honour.[1] Within six months he was dead. Less than half a century later his nephew sold
the castle and estates of Bracciano to the papal nephew of the day, Don Livio
Odescalchi.

Paolo Giordano's collection had probably never been a large one. He was impor-
tant chiefly as a friend of *virtuosi*, poets and singers, all of whom could meet in his palace,
and as an exceptionally highly placed example of those gentlemen such as the Barberini
nephews and Marcello Sacchetti who were themselves dilettante artists.[2] Through men
like Paolo Giordano, whose ancestors only a couple of generations earlier had been
engaged in murderous blood feuds[3] and who themselves retained the most exalted ideas
of their status, the arts entered into the very fabric of aristocratic life. No doubt manners
were softened thereby; it is easier to show that the arts themselves were affected by
such patronage.

– ii –

One private collector, however, entirely dominated the scene during the reign of
Urban VIII and by his taste and intelligence exerted an influence on the arts wholly
out of proportion to his income or limited political power. When Urban became Pope
in 1623, Cassiano dal Pozzo had been living in Rome for about twelve years and had
just begun to play an important rôle in the intellectual life of the city.[4] Though born in
Turin in 1588 and educated partly in Bologna, he had spent most of his earliest years in
Pisa in the household of an uncle, the extremely dominating Archbishop of the city.
He was thus, to all intents and purposes, a Tuscan, as were most of his friends. In Rome
he made little attempt to gain political preferment, but instead began to move in the
intoxicating but risky world of scientific investigation. He consolidated a close friend-
ship with Galileo whom he had probably first met in Florence or Pisa, and in 1621 the

[1] Galeazzo Gualdo Priorato, 1656, p. 183.
[2] Baglione, p. 367.
[3] His grandfather Paolo Giordano I had had his wife Isabella de' Medici strangled—an episode which
inspired Webster's *White Devil*.
[4] The incidental literature on Cassiano dal Pozzo is enormous, but Lumbroso's is still the only broad
outline of his life with a large selection of documents.

organisers of the Accademia dei Lincei, the recently created ancestor of all European scientific societies, proposed his name for membership. A year later he was admitted and thereafter much of his time and energy was devoted to the Accademia.[1] When Prince Federico Cesi, its founder, died in 1630 Cassiano bought a large number of his books and scientific instruments. He collected quantities of material relating to natural history and sponsored the publication of works on medicine, botany and ornithology.[2] Though he wrote nothing himself he was widely respected as a serious scholar.

The systematic organisation of scientific thought and experiment was a new idea, and it was promoted with a hard and tense fervour that must have left a deep mark on all those eager young men who participated. Only bachelors were admitted to the Accademia dei Lincei and the clergy were expressly excluded.[3] Clerical patronage was naturally sought, but the overriding objective of its members to discover and spread knowledge of 'the essence of things in order to ascertain their causes' inevitably led to trouble with the Church, however pious they might be individually. The steady, penetrating eyes of the lynx were not encouraged in seventeenth-century Rome and attempts were soon made to blind them. Dangerous charges of heresy and the first attacks on Galileo left the Lincei exposed but still firm; after Cesi's death in 1630 they quickly disintegrated.

The pursuit of scientific knowledge deeply affected Cassiano's interests in many other fields. His religious opinions which will be explored on a later page seem to have been independent and not wholly orthodox. His patronage of archaeological studies and contemporary painting had a seriousness and a consistency which were unique at the time.

Among his close friends during these early years in Rome were Alessandro Orsini, brother of Paolo Giordano, and the young Francesco Barberini. When Maffeo became Pope and Francesco a Cardinal, Cassiano was naturally among the very first to be favoured. He was given a series of posts in the Barberini household and many new sources of revenue. Yet by the standards of the day he was never a very rich man and certainly never a very ambitious one. His father bombarded him with advice: to marry into the rich nobility; to acquire a really lucrative job, anything: 'the only thing I beseech you is to do something, do not just idle, time is so precious. . . .'[4] Cassiano certainly took what opportunities came his way, but he showed no particular desire for office. At the height of his career his income was estimated at six thousand *livres* annually, and he used these entirely to promote the arts and sciences.[5] He was enthusiastically

[1] See Giuseppe Gabrieli, 1941, Parte seconda, sezione seconda, p. 736.

[2] Lumbroso: *passim*.

[3] Carutti, 1883.

[4] Lumbroso, p. 137—Letter of 27 August 1617.

[5] See the comment in *Naudaeana et Patiniana*, Amsterdam 1703, p. 29. 'Cassianus a Puteo est un Chevalier Piemontois, qui demeure à Rome, agé de quarante huit ans [in 1636]. Il a six mil livres de rente & est neveu d'un Archeveque de Pise qui portoit ce nom; il n'est point marié, & est fort versé aux choses naturelles; il nourrit quantité d'animaux étrangers & entretient commerce avec plusieurs Savans.'

admired by scholars all over Europe with whom he collaborated loyally. Peiresc called him 'la fleur des bons amys',[1] but to us, as to many of his contemporaries, he seems a figure more worthy of admiration than affection. He was a bachelor, rather cold and reserved, unwilling to disclose his inner feelings. As he grew older his features became distinctly military, the eyes ruthlessly clear, the moustaches stiff and defiant. Bernini's caricature (Plate 17a) confirms the impression made on us by the only known portrait: hard, splenetic, importunate.[2]

In 1625 and 1626 Cassiano accompanied Francesco Barberini on his missions to Paris and Madrid. His accounts of these travels show him carefully studying paintings and antiquities and during the course of them he became particularly interested in Leonardo da Vinci, whose *Leda and the Swan* and *St John the Baptist* he saw at Fontaine-bleau.[3] Characteristically he was fascinated by the 'very great diligence' with which the plant life was rendered in the former picture. Of the latter he noted that 'it is a most delicate work but does not please because it does not arouse feelings of devotion'. The reticent ambiguity of this comment is entirely typical of Cassiano. Whom does it not please? The French? Or himself? Would he have been so worried by a picture that did not 'arouse feelings of devotion'?

On his return to Rome he moved to the palace in the Via Chiavari behind S. Andrea della Valle which was to be his home until the end of his life. He shared it with his younger brother Carlo Antonio and his sister-in-law Teodora. Carlo Antonio too had considerable scientific and artistic interests and there is some evidence to suggest that his patronage was almost as significant as that of Cassiano—but as often happens in such cases it is the elder brother and head of the family who has been given all the credit.

In the palace Cassiano began to assemble a library and museum which soon attracted international attention. Rare living birds and plants were added to skeletons and anatomical drawings. Medals, prints and precious stones were stored with books, sculpture and mechanical instruments. Yet the collection had none of the recherché fantasy of a late mediaeval *wunderkammer*; it was, rather, an embryonic university

[1] Peiresc, IV, p. 107.

[2] This portrait forms the frontispiece to Carlo Dati's panegyric. For the question of dal Pozzo's portraits and for the most complete inventory of his pictures that has so far come to light see Haskell and Rinehart, 1960. In the inventory there published there is a portrait of Cassiano (and others of unnamed figures) attributed to 'Padov.no'. This was assumed by the authors to refer to Alessandro Varotari, 'il Padovanino', who is known to have gone to Rome in about 1638 and whose Venetian affiliations would certainly have made him attractive to Cassiano. However, it now seems far more likely to the present author that the reference is to Ottavio Leoni, the well-known portrait draughtsman and engraver, who is frequently called 'Padovano' in seventeenth-century literature. He was above all famous for his portraits of *virtuosi*, and it would be most surprising if he had omitted the most distinguished of them all. I know of no drawing by him that corresponds to Cassiano's features; there is, however, a drawing in Munich which A. Marabottini (1954, No. 2, fig. 13) attributes to Pietro Testa and which may well portray Cassiano.

[3] See Müntz and Molinier, 1885.

designed as an instrument of study and research—one of the first of its kind in Europe. From all over the Continent serious scholars and dilettantes would write to Cassiano asking for information and in return would send him reports of strange natural occurrences and local antiquarian investigations. In Spain vegetables had been found growing out of a man's stomach; from Milan a correspondent wrote, half convinced, half sceptical, of the ointments that were being deliberately used by diabolic agents to spread the plague; near Florence two bronze gladiators had been dug up by a peasant; in Provence an artist was carefully copying the Roman remains. Meanwhile Cassiano himself recorded everything of interest: the statue of a reclining figure 'with a most immoral inscription in praise of the Epicurean way of life' dug up during the excavations for the *baldacchino* in St Peter's; 'the very strange Priapic idol' in his collection found near S. Agnese beyond the Porta Pia; the two manuscripts of Cicero and Seneca 'written several hundred years ago with notes which are not contemptible' rescued by him from a goldsmith.[1]

In fact, nothing shows Cassiano's deep seriousness more clearly than his attitude to archaeology. He was a man of only moderate means and could not therefore collect ancient marbles on the scale of a Cardinal Ludovisi or a Vincenzo Giustiniani—indeed he once referred rather wistfully to the latter's 'very great wealth'.[2] But his criteria were in any case different. For him antiques were certainly objects of great beauty—though he is nearly always guarded in the expression of his feelings. But they were not just to be collected as one collected the paintings of Caravaggio (in the eyes of his contemporaries, at least, the most unclassical of painters). For Cassiano the remains of ancient Rome were the fragmentary clues to a vanished world whose values were of the greatest intrinsic interest. Consequently, everything that had survived was important, for even the most battered bas-relief or imperfect inscription might throw light on some Roman custom or ceremony. He therefore undertook an amazing enterprise— the recording of all traces of Roman civilisation that had survived. He collected the drawings and prints of earlier artists and for many years he employed young draughtsmen to copy antiquities throughout the length and breadth of the city. He then bound these drawings into volumes (over 23 of them according to contemporaries) which constituted what he himself called his 'paper museum'—the direct ancestor of the modern 'musée imaginaire'.[3] Veneration for antiquity had been common enough among artists and connoisseurs. Cassiano, however, gave this emotion a wholly new precision

[1] Lumbroso, pp. 176, 179, 197, 251, 299; Bottari, I, p. 369; Peiresc, IV, p. 525. See also the accounts of Cassiano's collection given by Naudé (p. 99, note 5), Evelyn, II, p. 277, and Skippon, p. 679.

[2] Lumbroso, p. 211.

[3] For Cassiano's *Museum Chartaceum* see Carlo Dati, 1664, who gives a list of its contents and mentions 23 volumes. Cassiano's brother Carlo Antonio says that there were more than this—Lumbroso, p. 167. The only modern treatment of the subject is by Vermeule, 1956, pp. 32-46. The drawings are now divided between the British Museum and the Royal collection. Blunt and Cooke, 1960, p. 81 point to a group at Windsor that derive from Pietro da Cortona and his studio, and Vitzthum, 1961, pp. 513-18, adds a few more. Blunt, 1971, pp. 121-3 also attributes a large group of these drawings at Windsor to Testa.

and historical interest. For his drawings were divided up according to subject-matter: 'in the first', wrote Baldinucci of some of Cassiano's volumes,[1] 'are contained all those objects which relate to the false opinions [of the ancients] as regards the Deity and sacrifices; in the second are drawings, also taken from antique marbles, of nuptial rites, the costumes of consuls and women, inscriptions, workmen's clothes, funerary customs, theatrical spectacles, and matters relating to the countryside, baths and *triclinia*; in the third are carefully drawn bas-reliefs from triumphal arches—Roman histories and fables; the fourth contains vases, statues, various ancient utensils and other things of interest to scholars; and finally in the fifth are figures taken from the ancient manuscripts of Virgil and Terence in the Vatican, the mosaic from the Temple of Fortune at Preneste, known today as Palestrina, and other things in colour.'

This iconographical collection naturally provided the artists who worked for Cassiano with material which they eagerly absorbed into their own pictures. For he was, in fact, almost as enthusiastic about contemporary painting as about the art of the past. The first artist whom he employed on a large scale to produce original painting as opposed to illustrations of antiquity or natural history was the Frenchman Simon Vouet, who had arrived in Rome in about 1614[2] and had quickly acquired a reputation as a follower of Caravaggio by painting scenes of melodrama and genre. Cassiano, who appears to have been Vouet's most consistent supporter in Rome, owned one such picture but he evidently preferred the artist's more flashy, bravura portrait busts of young rakes and dandies—derived, it is true, from the pages and subsidiary figures in Caravaggio's religious paintings, but, in their isolated context, turned into something more aristocratic and romantic.

This early appreciation of Vouet—Cassiano owned some fourteen pictures by him —is interesting partly because it marks a certain contrast with the manner of painting that he so soon began to encourage to the exclusion of almost every other style and partly because it shows that his tastes were much wider than is often implied. Although he owned one picture attributed to Caravaggio himself and although he occasionally made very cautious sorties into the Caravaggesque succession—a genre picture by Pieter Van Laer, two large architectural scenes by Viviano Codazzi—Cassiano's consistent preference was for a very different type of artist. In nearly every case the painters whom he took under his wing were men who either shared instinctively, or who were prepared to adopt, that passion for antiquity and the 'rational' which can legitimately be traced to his archaeological and scientific training.

Galileo himself had been the first to show how a scientific attitude almost inevitably gave a particular turn to aesthetic taste.[3] His favourite painter and occasional collaborator was Ludovico Cigoli, the leader of those Florentine artists who were breaking away from a late Mannerist style to a more rational and naturalistic manner.[4] When still

[1] Baldinucci, VI, 1728, p. 479.
[2] See the letters from Vouet to Cassiano of 1621 published by Bottari, I, pp. 331-3, and Demonts, p. 322.
[3] For all this paragraph see Panofsky, 1954.
[4] See Cigoli-Galilei Carteggio edited by A. Matteoli.

quite young Galileo gave a vivid impression of his views on painting in a discussion of the relative merits of Tasso and his own favourite Ariosto: 'Tasso's narrative more closely resembles a tarsia picture than an oil painting . . . dry, hard, without roundness and relief . . . Ariosto shades and models in the round. Tasso works piecemeal, dryly and sharply. . . . When setting foot into the *Orlando Furioso* I behold, opening up before me, a treasure room, a festival hall, a regal gallery adorned with a hundred classical statues by the most renowned masters, with countless complete historical pictures (and the very best ones, by the most excellent painters) . . . [with Tasso] . . . the study of some little man with a taste for curios . . . a petrified crayfish; a dried-up chameleon, a fly and a spider embedded in a piece of amber . . . and, as far as painting is concerned, some little sketches by Baccio Bandinelli or Parmigianino.' Galileo's was a plea for the classical against the Mannerist, the full-blooded and rational against the perverse and the illogical. When Cassiano began patronising modern artists, the situation was not quite the same. The Mannerists were no longer of much interest. The great generation reaching maturity in the 1620s—Bernini, Pietro da Cortona, Andrea Sacchi, Poussin and the slightly older Vouet—all embodied those very qualities that Galileo had specially singled out for admiration. Cassiano eagerly took them up. Well before his travels to France and Spain he owned 'a number of things' by Pietro da Cortona.[1] Bernini made him a posthumous bust of his uncle, the Archbishop of Pisa. But, in fact, these artists capable of working on a large scale were inevitably enrolled into the service of the Pope and his nephews. Cassiano, established at the very centre of power, was well placed to employ them and we know that on occasion he did so—he owned at least two large pictures by Pietro da Cortona (a *Madonna and Child* and an *Allegory of Coral fishing*) besides drawings by Bernini. But such works were exceedingly expensive, far beyond the resources at his disposal. And there was another, even more important consideration. As the reign of Urban proceeded it became clear that the balance between classical and colourful, restraint and exuberance, which all these artists had shared in the early 'twenties, was becoming more and more distorted. Grandiose effects were what the Barberini wanted even if the rules had to be broken to achieve them. Bernini experimented with techniques designed to break down the barriers between sculpture and paint, the spectator and the work of art. Pietro da Cortona made nonsense of his painted frame and his stucco borders in the interests of more powerful illusionism. To Cassiano dal Pozzo all this was clearly most distasteful although he remained on friendly terms with Pietro.[2] 'It's the great disgrace of our age', he used to say,[3] 'that although it has before it such beautiful ideas and such perfect rules in venerable, old buildings, none the less it allows the whim of a few artists who wish to break away from the antique to bring back architecture to barbarism. This was not the way of Brunelleschi, Buonarotti, Bramante, Serlio, Palladio, Vignola and the other restorers of this great art, who took the true proportions of those perfectly regular orders from Roman buildings. Departing

[1] Mancini, I, p. 263, and Haskell and Rinehart, 1960.
[2] See Pietro's letters to him published in Bottari, I, pp. 413-20.
[3] Carlo Dati [no pagination].

from these always leads to errors.' Borromini is usually singled out as the target for this outburst. No doubt he was, but not even Bernini is listed among the true heirs of antiquity, and it is the whole age that is being attacked. In fact, Cassiano's views of Bernini were changeable. In 1647 he drily reported without comment the fact that the tomb of Urban VIII 'though it has been praised has in no way diminished the reputation of Paul III's [by Guglielmo della Porta] opposite'. Seven years later he showed unreserved enthusiasm for the Fountain of the Four Rivers—but fountains notoriously were entitled to display the workings of an artist's fantasy.[1] The sculptor who really appealed to Cassiano's tastes and whose wax and terracotta *modelli* he collected was Bernini's Flemish rival, François Duquesnoy, who used to call the Greek style 'the true teacher of perfection' and whose own *St Susanna* in the church of S. Maria di Loreto was judged by his contemporaries to be equal to anything produced by the ancients.[2]

In fact, to others beside Cassiano dal Pozzo the extreme high Baroque style of the 'thirties cultivated by the Barberini appeared to be as opposed to the straight and narrow path of true, classical painting as had been the Mannerism or Naturalism of earlier generations. Of the team of artists who had made their first appearance in St Peter's under the auspices of the Barberini, only Sacchi and Poussin had kept to that path. Cassiano clearly admired Sacchi and obtained the *modello* for one of his most famous altarpieces, the *St Romualdo* of 1638. But the artist was interminably slow and constantly employed by Cardinal Antonio. Poussin, on the other hand, was Cassiano's closest protégé.

Poussin probably met Cassiano very soon after his arrival in Rome through Marcello Sacchetti, to whom he had been introduced by the poet Marino. But their relationship was almost at once interrupted by Cassiano's departure first for Paris and then for Madrid with Cardinal Francesco Barberini. Only on his return to Rome towards the end of 1626 could he begin to take a serious interest in the artist who was some six years younger than himself. Cassiano at once began to employ him to further the two interests which were nearest his heart—archaeology and the natural sciences. Poussin associated with that group of artists who were recording the vestiges of ancient Rome in some fifteen hundred drawings bound up into volumes according to subject-matter. He also painted large pictures—often life-size—of birds (eagles, ostriches and others) which were of special interest to Cassiano's brother, Carlo Antonio.[3] There can be little doubt that it was the first of these experiences that proved the more decisive. At this formative stage of his Roman career he was plunged into a world of classical studies, directed by the greatest European connoisseur of the age. More than any of the other artists employed in the enterprise Poussin absorbed the essential spirit of classical art, not only in formal methods of composition, which were indeed to become more pronounced later in his

[1] Lumbroso, pp. 190 and 194. [2] Passeri, p. 107.

[3] P. Olina's *Uccelleria* of 1622, dedicated to Cassiano, specially mentions Carlo Antonio's interest in the subject. Unfortunately these, surely the most surprising of all Poussin's paintings, have not been identified. When Skippon was taken round the collection in 1663 (p. 679) by Cassiano's nephew he noted a large number of bird paintings, but he failed to record whether or not they were by Poussin, the 'old French painter', who, he was told, was still living in Rome.

a. BERNINI: Cassiano dal Pozzo

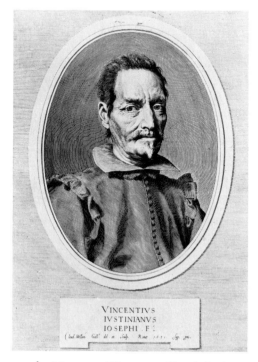

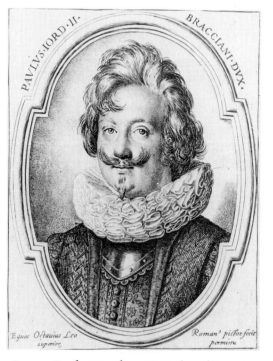

b. MELLAN: Vincenzo Giustiniani c. LEONI: Paolo Giordano II, Duke of Bracciano

Plate 18 CASSIANO DAL POZZO AND RELIGIOUS ART

a. TESTA: Rest on the Flight into Egypt

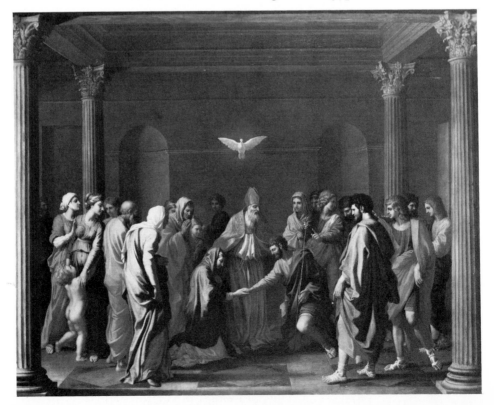

b. POUSSIN: The Sacrament of Marriage

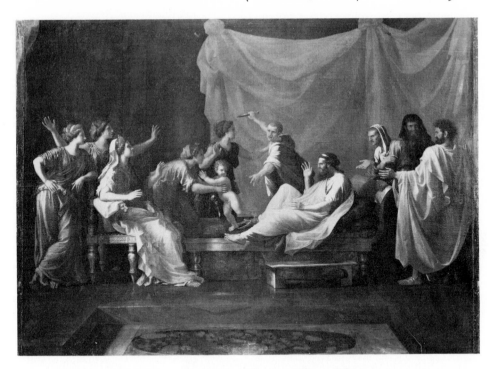

a. POUSSIN: Moses trampling on Pharaoh's crown

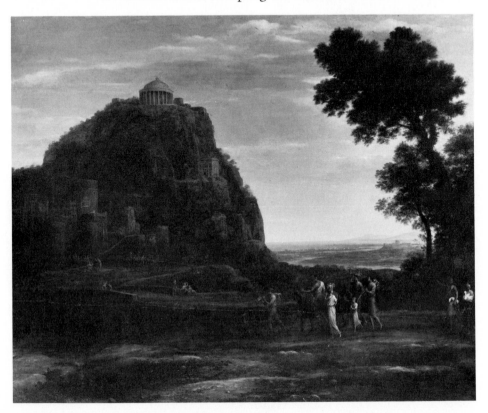

b. CLAUDE: View of Delphi with a procession

Plate 20

VELASQUEZ: Camillo Massimi

life, but in its more complex, intimate manifestations. Cassiano must have realised quite soon that he had in his service a painter who could do very much more than merely reproduce the remains of antiquity, and that Poussin was capable of breathing life into the old forms. For whatever his scholarly inclinations, Cassiano's taste in modern art was certainly not rigidly dogmatic or excessively pedantic. Indeed he fully appreciated the nostalgic associations of the antique: 'These remains of ancient buildings,' he wrote in 1629 of some *capricci* by Poussin's friend, Jean Lemaire, 'such as arches, the Colosseum, temples, aqueducts and such things are marvellously effective and give great delight.'[1] And he was also one of the most enthusiastic among that group of Roman connoisseurs who helped to launch the vogue for Venetian painting. The Genoese engraver Andrea Podestà dedicated to him a print taken from Titian's *Worship of Venus*; when that picture was sent to Spain in 1637 and Alessandro Varotari, 'il Padovanino', rushed to Rome to copy it, Cassiano acquired a number of pictures from the artist; and he maintained a watchful interest in the state of the Venetian picture market.[2] Indeed it was this combination of classical erudition and Venetian colour that was to prove so stimulating to Poussin. Cassiano was evidently keen that his favourite protégé should not adopt too dry a manner. 'Copy from the Carracci and leave your marbles', he is reported to have told him[3]—a significant choice, for Annibale Carracci had hitherto been the supreme interpreter of antique forms into acceptable seventeenth-century language.

All travellers to Rome were struck by the number of Poussins in Cassiano's collection—some fifty in all, according to the general estimate. Of those that have been identified a number are quite conventional in subject-matter, however fresh in treatment: a scene from Tasso's *Gerusalemme Liberata*, a *Mars and Venus*, an *Aurora and Cephalus*—these all belonged to the stock repertoire of the seventeenth century. So too did many of the religious subjects—a *Sacrifice of Noah*, an *Assumption of the Virgin* and a *Mystic Marriage of St Catherine* possibly painted to celebrate one of his nieces Maria-Caterina. On the other hand there may well be far more recondite subjects among the pictures that have disappeared or that have not been directly associated with Cassiano. What of the *Sacrifice* mentioned by one traveller? This was a theme that enthralled Cassiano and that was recorded for him in many drawings. Or the *Bacchanals*? And even some of the many paintings so laconically referred to as *Landscapes* most likely contained mythological figures to give them deeper implications than mere records of nature, even though Cassiano did own some straightforward paintings of this kind. On the other hand, it is almost certainly a mistake to read too much esoteric significance into the nature of Cassiano's patronage of Poussin. On only very rare occasions do we have

[1] '... danno nell'occhio mirabilmente, e dilettano'—from a letter dated 3 November 1629 to Agnolo Galli in Florence for whom Cassiano was buying pictures—see Rinehart, 1961, p. 52.

[2] Haskell and Rinehart, 1960, but see also p. 100, note 2.

[3] According to Brienne in 1693-5—quoted by Thuillier, 1960, in *Actes du Colloque Poussin*, II, p. 210.

concrete evidence of his demands and then they were evidently simple, for we find Poussin writing to him from Paris[1]: 'I would like to be able to undertake the subject you propose of the *Marriage of Peleus* because it would be hard to find another giving the opportunity for greater invention than that (*plus pleine d'invention*).' In fact, the artist's really profound pictures were nearly all painted much later when he was working for different patrons. On the whole the very learned and subtle Cassiano certainly gave him the chance to widen and deepen his culture (Poussin acknowledged his debt as a 'pupil' of Cassiano's 'paper museum'), while himself commissioning a more conventional style of picture. There is little in Poussin's work before he made his visit to Paris between 1640 and 1642 to suggest that he was an isolated figure.

There are, however, two crucial exceptions to this estimate of the conservative nature of Cassiano's patronage. Among the papers in the Barberini library was a manuscript of Leonardo da Vinci's *Trattato della pittura*.[2] Cassiano who had seen the Florentine artist's *Leda* and *St John the Baptist* at Fontainebleau and who himself owned two portraits of women attributed to him—one of them apparently 'an indifferent copy' of the Mona Lisa—was deeply interested in this. In about 1635 he copied out the *Trattato* in his own hand and began to engage in correspondence with other scholars and owners of Leonardo manuscripts, notably the Barnabite monk Ambrogio Mazenta whose important collection had been dispersed even before his death and had then been largely reconstructed by Galeazzo Arconato, another acquaintance of Cassiano. His copy of the *Treatise* was designed for publication and he chose Poussin to illustrate Leonardo's notes. Though the resulting drawings are very fine, Poussin does not seem to have been enthusiastic about the task. His feelings about Leonardo were mixed, and in one angry outburst he exclaimed that 'anything of value in the book could be written in large letters on a single sheet of paper'. What in fact really irritated him was the actual publication. Cassiano kept the original drawings for himself and had them copied together with the version he had made of the manuscript. This set he gave to Poussin's friend, Paul Fréart de Chantelou, who took it to Paris where the *Treatise* was published in 1651. Poussin's vigorous drawings though far more finished than Leonardo's short-hand sketches were not considered elegant enough for the occasion. So before being engraved they were embellished by Charles Errard with architectural and landscape backgrounds, angrily described by Poussin as 'gaufes'. In fact, Poussin's real tribute to Leonardo was made many years after these drawings (though at about the same time as the publication) and took a very different form.

But by far the most startling of Poussin's work for Cassiano consisted in the series of the *Seven Sacraments* which he began to paint in the second half of the 1630s. Both the

[1] On 4 April 1642—see Poussin *Correspondance*, p. 130.

[2] For Poussin's reactions to Leonardo see the two articles by Jan Bialostocki, 1954 and 1960, and also Kate Trauman-Steinitz, 1953. For Cassiano's part in the venture see the important and little-known article by Enrico Carusi, 1929. There is a reference to Leonardo MSS. in one of the letters from Mazenta published by Lumbroso, p. 258. It is generally accepted that Cassiano's own version of the *Trattato* with Poussin's drawings is the one in the Ambrosiana, Milan [H 228 inf] and that the one given to Chantelou for publication is in the Hermitage, Leningrad.

general subject and Poussin's actual treatment of it are revolutionary events in the history of seventeenth-century painting. There are mediaeval precedents in sculpture, and very rare examples in Northern painting: in Italy the Sacraments had only once been painted as a series—in some frescoes ascribed to Roberto Oderisi in fourteenth-century Naples. But Poussin's iconography is quite new.

The *Seven Sacraments* have been acutely and rigorously analysed for the light that they throw on Poussin's religious views. Jansenism? Some schismatic sect? Possibly.[1] The artist had a stubborn mind capable of independent thought. But it is clear beyond any reasonable doubt that the idea for such an important set of paintings can only have come from Cassiano himself, and it is more than likely that he played a vital part in their development. It is thus worth trying to speculate what were his motives for the commission and what were his religious views in general. For Cassiano was in touch with artists and scholars of all kinds and we can perhaps trace echoes of his ideas in other works apart from those he ordered for himself.

The investigation is mysterious and treacherous, lit up only occasionally by fragments of gossip or confusing hints. Cassiano was the most prominent figure in the immediate entourage of the Barberini. But that was no guarantee of religious orthodoxy, as the French 'libertins', Jean-Jacques Bouchard, Gabriel Naudé and many others could readily testify.[2] They were among Cassiano's close friends. Was he then one of them, 'complètement déniaisé', one of those of whom Italy was full 'qui pénètrent le plus avant qu'il leur est possible dans la nature, et ne croyent rien plus'.[3] This is unlikely. Nowhere is he directly mentioned as sharing their beliefs by the French 'libertins', so keen (like all persecuted minorities) to proselytise.[4] In his jottings he insisted on the importance of decorum and expressed angry distaste for the kind of homosexual misbehaviour in church that most titillated and amused Bouchard and his friends.[5] He was by temperament a far graver, more serious man than they were. But that he knew of their beliefs we can hardly doubt. It was to Cassiano, 'viro nobilissimo eruditissimo et humanissimo' that Bouchard left not only his library and antiquities but also his private papers—those

[1] Blunt, 1967, pp. 177-207.

[2] See especially Chapter 2—'Les "déniaisés" d'Italie'—in Pintard's marvellous book on the subject.

[3] *Naudaeana*, p. 8.

[4] There is, however, one very strange passage in a letter from Peiresc to Monsieur de Saint-Saulveur dated 9 January 1635—III, p. 252: '. . . Je vous remercie trez humblement du soing que vous prenez des memoires du Cavalier del Pozzo pour les oeuvres de Baccon, dont il me mande avoir recouvré les considerations de la guerre d'Espagne, mais il m'en fauldra pourtant supleer un exemplaire pour moy si ne les avez desja envoyez, parce que le mien avoit passé les monts sur la demande du dict cavalier, ne l'ayant faict plus tost à cause de certaines paroles libertines que j'y avoys rencontrées. . . .' Unfortunately, it is not clear whether the 'paroles assez libertines' are attributed to Bacon or to Cassiano. Even allowing for the very widest interpretation that can be given to the word 'libertines' and assuming that in this case it means no more than 'politically suspect', it is still interesting to note that Cassiano was so keen to own the work and prepared, therefore, to risk the displeasure of the papal customs and police in getting it. I am most grateful to Professor Pintard for helping me to unravel the syntax and meaning of this quotation.

[5] Lumbroso, p. 207. After describing the incident in some detail he comments: 'tanto è poco il rispetto, che da questa sorte di gente alle chiese si porta.'

obscene and dangerously compromising documents that uncovered the coarse disbelief hidden under the professions of a potential bishop.[1] In 1641 we find Cassiano showing these to Christophe Dupuy, the prior of the Carthusian Order in Rome, a man who had known only the 'official' Bouchard 'whose conversation was so restrained'. Rather incoherently he wrote about this harrowing experience to his brother in Paris.[2] 'The Cavaliere dal Pozzo also showed me a large collection of the most impious verses that can be imagined in Latin, French and Italian; and with these was a collection of all the filth that can be envisaged, mostly of the kind that most pleases in this country, devilish things, so that when I began to glance at them, I was quite unable to continue any more, so horrified was I from the very beginning of the collection that I shut it up to send it back to the said Cavaliere, as I did that very hour.' We are not told whether Cassiano shared Dupuy's indignation. He can hardly have been surprised at the nature of his strange legacy.

It is, none the less, most unlikely that Cassiano himself was a 'libertin'. It is almost equally unlikely that he was a very convinced adherent of the orthodox religious views of his day. He was, after all, a passionate student of science, and when it came to a con-flict between the papacy and the new thought, he showed where his sympathies lay. We find him writing in the most friendly spirit to his old colleague Galileo about a year after his condemnation by the Inquisition; and in 1641 he received a letter from the scientist, written 'from the Villa d'Arcetri, my unending prison and exile from town'. In this Galileo thanked Cassiano for including his portrait among those which he kept in his library.[3]

The serious pursuit of science certainly had its spiritual dangers as Cassiano's contemporaries recognised. There is surely something a little over-shrill in the page after page devoted by Carlo Dati, his Florentine disciple and friend, to the orthodoxy of his religious opinions and his detestation of alchemy.[4] How can anyone who studies Nature and Science, he asks rhetorically, 'not only not hate Atheism, but rather refrain from incessantly proclaiming and preaching the intoxicating greatness and goodness of the Almighty? Just as Cavalier Cassiano tirelessly exalted and demonstrated them with the most eloquent praise and the strongest arguments'. Certainly this was a possible, indeed a widely followed, response to the discoveries of science. Cassiano's great friend Gabriel Naudé was there to show that it was not the only one.

It is through the portraits (with suitable Latin inscriptions written by Naudé)

[1] Bouchard's will was published by Tamizey de Laroque in 1886. In it he leaves 'omnes libros meos manuscriptos, vel a me compositos' to Cardinal Francesco Barberini, but in fact he must have made an exception for his more dangerous papers. It is inconceivable that he can have meant them to be read by such an unlikely sympathiser. Moreover, Christophe Dupuy said that 'il laisse au dit Cavalier [dal Pozzo] tous ses escrits dont il faisoit un grand cas' (Pintard, p. 238), though in his will the only legacies to Cassiano that Bouchard mentions are his 'libros impressos', antiques, scientific instruments, etc. This suggests that he may actually have given his more private papers to Cassiano *before* his death, which would be still more compromising.

[2] Pintard, p. 238.

[3] Galilei, XVIII, pp. 290 and 296.

[4] Carlo Dati.

represented in Cassiano's collection that we can trace another of his unorthodox relationships.[1] In 1647 we find him pressing the scholar Paganino Gaudenzi to send him his likeness 'so that I can carry out my intention and with such a notable purchase increase the collection I have of the most illustrious men'. Some weeks later he acknowledges 'with the greatest pleasure [a portrait] which is very like and as it is derived from a most perfect original by the late Gherardo Saracini, the copy cannot help being good. . . . It will allow those who have not had the fortune to enjoy your pleasing and learned conversation at least to share your company in effigy . . .'.[2] As Cassiano well knew, however, Gaudenzi's conversation was likely to be unusually bold as well as 'pleasing and learned'. Some years earlier this former Calvinist of Grison origin, 'hardi et peu respectueux au Baronio' and a bitter enemy of the Jesuits, had come to conclusions in his History of the early church 'qui ne plaisent pas trop aux Ecclesiastiques de ce pays'.[3] Not surprisingly he had found it difficult to secure patronage at the papal court. The man who had done most to help him through his troubles had been Cassiano. Money was tight, he explained, owing to the 'unbelievable expenses of these gentlemen, especially our Cardinal Patron [Francesco Barberini]. I may speak quite freely with my Sig. Paganino. . . .' None the less he would do his best.[4]

It is not really surprising that Cassiano found Gaudenzi's work and ideas deeply interesting for he was always fascinated by the religious beliefs and rituals of different societies. His collection of antiques contained many examples of strange pagan imagery and we know that one of his volumes of drawings was entirely devoted to 'those objects which relate to the false opinions [of the ancients] as regards the Deity and sacrifices'. By extension he carried this interest into the forms of the early church and the society of his own day.[5] He himself gives us a direct clue to this attitude. 'To explain the purpose of my collecting them', he wrote,[6] 'I would put as a preface to my volumes of drawings copied from ancient marbles what P. Denis Petau wrote as a preface to his edition of the works of Julian the Apostate republished in Paris in 1630.' That devout and learned Jesuit had felt some alarm about his undertaking. There were people, he wrote in the preface designed to justify it, who said that no one should read the works of so wicked a man. But this was wrong. The true religion was now so firmly established that Julian represented no danger whatsoever. He could rather be read for the most interesting information he provided about early Christian practices.

This, no doubt, was what led Cassiano to commission the *Sacraments*. His devotion to the classics did not, as with so many scholars before and after, lead to a sort of neo-paganism. Rather, it encouraged in him a dispassionate enquiry into the fundamental

[1] *Epigrammata in virorum literarorum imagines, quaes Illustrissimus Eques Cassianus a Puteo sua in bibliotheca dedicavit, Cum appendicula variorum carminum*, Romae, excudebat Ludovicus Grignanus, 1641.

[2] Letters from Cassiano to Gaudenzi between 1641 and 1647 in Biblioteca Vaticana—Urb. Lat: 1626 and 1628, cc. 19, 89, 105 and 139, 164, 195, 200, 327.

[3] Pintard, pp. 251-3.

[4] As in note 2, above.

[5] Lumbroso, p. 165, points out Cassiano's interest in the ceremonial occasions of his own day.

[6] Lumbroso, p. 199.

rites of other religions. This was an attitude that could reconcile many differing view-points—his probably sincere if not ardent Christianity; his scholarship; his scientific enquiries; his 'libertin' connections. The marvellous solemnity of Poussin's paintings (Plate 18b) has, until recently, helped to disguise the fact that he took endless trouble to specify early and obscure Christian practices that were, however, certainly familiar to Cassiano and his learned friends. And although the motives for such accuracy were probably inspired mainly by historical curiosity—he took equal trouble to ensure exactitude in some of his pagan scenes of Sacrifices to Priapus and so on—it is perfectly possible that in his pursuit of authenticity he was driven to portray a kind of severe and purified religious imagery that was more acceptable to Cassiano than the flamboyant Baroque of some of his contemporaries. We know at least that he was enormously proud of the *Sacraments* and refused permission to have them copied.

This view of his beliefs is perhaps confirmed rather than belied by the unusual nature of some of the other sacred art produced under Cassiano's auspices. For, as was almost inevitable with a man of great culture and searching intelligence, his religious horizons must have been considerably wider than his position at the centre of the papal court might lead one to suppose. Besides Poussin's *Sacraments* there was also a print fulsomely dedicated to him by Pietro Testa, depicting a unique representation of the *Flight into Egypt* (Plate 18a).[1] In this the artist has relegated the figure of St Joseph to the background. Scarcely visible in the shadow of a huge gnarled tree which lifts its twisting branches to the very top of the sheet, he sleeps with his head resting on his hand while an angel appears to him and points out the route of his flight. The whole foreground is taken up by the Virgin, the Child, St Mary Magdalene and a host of angels and putti who stand or kneel in adoration of the Cross and the Instruments of the Passion. Above are God the Father and the Dove of the Holy Ghost. It was frequent enough in the imagery of the Counter Reformation to associate the Flight into Egypt with the Passion, as it was also with the Massacre of the Innocents—a theme which Testa himself treated in his masterpiece, a large and vigorous picture in the Spada Gallery.[2] In both instances, however, the artist has reversed the usual practice and has given the Flight itself an entirely subsidiary rôle. Such a treatment of the subject is unique, and Testa seems aware of the fact for he has found it necessary to provide a long explanation of his print. Despite the dedication there is no proof that Cassiano himself actually chose the subject. But Testa's other religious prints are all conventional enough and we can therefore assume that Cassiano was at least a willing recipient of such new ideas if not their positive inspirer. But what is the significance of the theme? In the whirling exuberant clusters of putti and angels who swarm above the Cross in the very centre of the composition and in the tender, almost child-like, simplicity of the kneeling Virgin it recalls a type of mysticism more common in Spain than in Italy. In sentiment it certainly stands at the opposite extreme from the austere world of Poussin's *Sacraments*. Yet the

[1] Bartsch, XX, p. 216.
[2] Zeri, 1954, p. 131. For other representations of *The Flight into Egypt* in seventeenth-century art see articles by Mitchell, 1938, and Voss, 1957, pp. 25-61.

work of both artists is linked by a common determination to move away from the more ordinary expressions of religious emotion to a private devotional imagery. And here surely we can trace the influence of Cassiano.

Testa, in fact, was anything but an ordinary artist and his tragic career brilliantly illuminates the fascination and power of Cassiano's inspiration. Like his close friend Poussin he was a stubborn, proud, self-educated man of independent views. He had come to Rome from his native Lucca when in his early twenties, sometime before 1630, and had at once drifted into the orbit of the private connoisseurs rather than the great patrons of the church.[1] He made a drawing for one of the prints of the *Galleria Giustiniani*, painted pictures for Marcello Sacchetti and members of the Lucchese community in Rome, especially the Buonvisi, and was taken up quite early in his career by Cassiano. This was the decisive point in his life. He was set to work drawing antiquities for the 'paper museum' and thereby acquired a vast classical culture which was only occasionally to prove of advantage to his art. For, unlike Poussin, Testa could not fuse a genuinely romantic temperament with an intellectually acquired classicism and thereby give added intensity to his recreation of antique myths. In him these opposing tendencies only rarely met to good purpose and then chiefly when he was under the direct impact of Poussin. His biographers all describe him as strange, solitary and melancholy, and his more attractive paintings reflect this side of his character—landscapes, above all, of Titianesque origin often disturbed by threatening winds, with small figures from the Old Testament or mythology sheltering from the elements or occasionally relaxing in the sun. In the intense intellectual climate of Cassiano's world such a 'frivolous' attitude may well have seemed insufficient—though more to a highly sensitive and self-conscious artist like Testa than to his patron. Indeed there is little reason to believe that Cassiano objected to such themes. Some of the landscapes that Poussin painted for him, though constructed on much more solid intellectual principles, have little more ideal content.[2] Yet the pressures in favour of classical painting were always strong wherever the theory of art was discussed. Salvator Rosa, himself probably influenced by Testa's romantic views, suffered bitterly from such conflicts, but for all his incessant grumbling he was a much tougher character and had a much wider clientèle. For Testa the clash seems to have been insuperable. He might perhaps have done better to escape from his excessively benevolent but oppressive patron. On one occasion he tried to do so—only to find himself in prison for breach of contract.[3]

And so he set about stifling one aspect, surely the most natural aspect, of his talent in order to concentrate on those ideas which he misguidedly felt would most appeal to

[1] Marabottini, 1954.

[2] Such as, for instance, the two landscapes formerly in Sir George Leon's collection published by Blunt in *Burlington Magazine*, 1945, p. 186. Contrary to Sir Anthony Blunt's opinion Denis Mahon suggests convincing reasons for believing that these were painted in 1638-9 before the artist's visit to France—1961, p. 120.

It is all the same worth noting that though Cassiano made one passing reference to him (Lumbroso, p. 196), he evidently owned no landscape by Claude or by Testa's friend, Pier Francesco Mola, let alone Salvator Rosa.

[3] See Testa's letters from prison in September 1637 published by Bottari, I, pp. 358-61.

Cassiano's learned circle. He wrote a muddled *Treatise* on painting in which flashes of genuinely sensitive observation and a deeply felt love of colour alternate with second-hand doctrines 'that those arts which are nearest mathematics are the noblest because they are based on true reason. Of such is painting.' He put his increasingly classical ideas into practice, planning to represent in the apse of S. Martino ai Monti 'a glory of Paradise which should break away from the general custom started by Correggio. He wished to show it without clouds, for he said that it was a very serious mistake to surround the Throne of Light of the Trinity and the Home of the Blessed with clouds. For such places were havens of peace and everlasting serenity, and clouds only made them turbulent and dark.'[1] This was a direct attack on the whole Baroque tradition. Meanwhile the figures in his pictures became more and more hard and 'classical', and at the same time increasingly unpopular. In his discouragement he turned to engraving. Full of self-pity, he used all those trappings of antiquity which he had picked up on his drawing expeditions to portray 'the oppression of Virtue, the triumph of Vice, the misfortunes, the discomforts and the miseries of the Virtuous'.[2] Here, at last, he met with the success he deserved—but even that was bitter, for it only emphasised his failure as a large-scale painter. In an agony of despair he threw himself into the Tiber. Cassiano, who owned a number of pictures by him, summed up his career with a certain hard fairness: 'He was a good painter and an excellent draughtsman of the antique.'[3]

Testa's suicide took place in 1650. By this date Cassiano's own position had greatly changed. Under the régime of the Barberini he had been acknowledged as the most important private art patron in Rome and his reputation had travelled far beyond the frontiers of Italy. He was, wrote M. de Noyers, Surintendant des Bâtiments of the King of France, 'icy en un'estime singulière et tient lieu du chef des vertueux'.[4] Then in 1644 Urban VIII died. Cassiano recorded his last illness with a mixture of true scientific precision and deep regret for the head of a family which had so helped his career.[5] 'When the corpse was opened just two hours after the poor man's death they found six stones in his gall bladder, the largest of them the size of a cashew nut. . . . His heart was extraordinarily small, a sign of his vivacity and magnanimity, so the natural scientists say. . . .' With the flight of Cardinal Barberini his own official post, and part of his income, came to an end—though on the Cardinal's return to Rome he was reinstated.[6] Pope Innocent X was hostile both to associates of the Barberini and to the pursuits which appealed to Cassiano, as the latter acknowledged in a bitter comment.[7] Reluctantly or not, he was compelled to withdraw from 'the boring exercise of empty ceremonies'. In 1655 his friend Fabio Chigi was elected Pope Alexander VII, but by now

[1] Passeri, p. 187.
[2] *ibid.*, p. 186.
[3] Lumbroso, p. 211.
[4] Poussin: *Correspondance*, p. 34.
[5] Lumbroso, p. 185.
[6] In records of payments which appear to be dated 1656 he is listed in Cardinal Barberini's *famiglia*—Biblioteca Vaticana, Barb. Lat. 5635.
[7] Lumbroso, p. 202.

Cassiano's health was too weak to enjoy the revival of his fortunes. In 1657 he died, survived for more than thirty years by his brother Carlo Antonio.

It was all very well to withdraw from court life, but in the seventeenth century the arts were so closely linked to the centres of power that Cassiano's patronage suffered fully as much as his political status. Remarkably few pictures in his collection can be dated from after the death of Urban VIII and though he continued his scholarly and scientific activities as intensively as ever, his collection almost ceased to grow during the decade or so of activity that remained to him. Only the drawings after antiquity, made largely by secondary artists whose names have not survived, continued to enrich his museum. Poussin himself, after his return from Paris in 1642, now worked almost exclusively for the French friends and clients he had made on that unfortunate trip. Only one, though magnificent, picture was apparently painted by him for Cassiano during these years.[1] In 1651 the artist put to use the researches he had made into Leonardo's thought at Cassiano's behest many years earlier.[2] Clearly basing himself on a passage in the *Trattato* in which Leonardo describes the effects of a storm, Poussin wrote that he had painted 'un grand païsage, dans lequel . . . j'ai essayé de représenter une tempeste sur terre, imitant le mieux que j'ay pû l'effet d'un vent impétueux, d'un air rempli d'obscurité, de pluye, d'éclairs et de foudres qui tombent en plusieurs endroits non sans y faire du désordre. Toutes les figures qu'on y voit joûent leur personnage selon le temps qu'il fait. . . .' This picture was the *Tempest with Pyramus and Thisbe*, whose tragic story is portrayed in the foreground to introduce a note of human grief into the scene of natural desolation. In its wild, almost romantic, impetuosity, perhaps derived from the landscapes of his brother-in-law Gaspard Dughet, the picture is unique in Poussin's production and marks a worthy climax to his long co-operation with Cassiano. The two men went on seeing each other, but there is reason to believe that their friendship may have cooled.

Even in his retirement Cassiano naturally remained an influential figure. It was to him that the Archbishop of Tarso wrote in 1646 to announce the forthcoming visit of Velasquez, and the relationship between the two men probably resulted in an unfinished portrait.[3] But on the whole it was his encouragement of scholars that was most important, and that side of his activities cannot be discussed here.[4]

Cassiano was probably the first private patron in history to exert a serious influence on the arts of his day. Wielding no political authority and with only limited means he was yet able to give consistency to certain currents of taste which were undoubtedly shared by many others at the time but which were not those backed by the Court or the

[1] As stated in note 2, p. 111, Mr Mahon believes that the ex-Leon landscapes date from before Poussin's visit to Paris.

[2] See p. 106, note 2.

[3] Lumbroso, p. 314, and Haskell and Rinehart, 1960.

[4] For the eventual fate of the *Museum Chartaceum* see Vermeule, and Fleming, 1958, p. 164. The collection of paintings probably began to be dispersed not very long after Carlo Antonio's death in 1689— see Haskell and Rinehart, 1960. Only a small fraction of it can now be identified.

religious Orders. In its simplest form his taste can be summed up as 'classical', but in fact it was of sufficient intellectual and spiritual richness to imply far more than mere opposition to the prevalent course of Baroque art. Other men, such as his friend the archaeologist Francesco Angeloni with his large collection of medals and his drawings by Annibale Carracci, certainly endorsed this opposition but were not able to make of it anything constructive.[1] In Cassiano the very complexity, perhaps the very mystery, of his beliefs with their suggestions of hidden depths and contradictory forces, and the very width of his culture, open to ideas from all over Europe, could give valid inspiration to one of the most subtle of all seventeenth-century artists. Poussin was always ready to acknowledge his overwhelming debt to Cassiano, and it was, of course, he who gave lustre to his patron's collection. Without the fifty or so Poussins contemporary art would certainly not have made a specially good showing there; many other *amateurs* owned fine paintings by Vouet, Pietro da Cortona and Testa. But besides the work, which he actually owned, Cassiano's fertile ideas inspired many artists in whom he is not known to have taken a direct interest. There are, for instance, strangely beautiful drawings by the Genoese painter Giovanni Benedetto Castiglione, an admirer of Poussin, representing still unfathomed pagan ceremonies which must surely be derived from the 'paper museum'. There are the romantic landscapes by Testa's great friend, Pier Francesco Mola, which remind us that for all his intellectual interests Cassiano was among that group in Rome which had 'discovered' the beauties of Titian.

Unfortunately it was just this complexity in Cassiano's taste which was missed by the generation that followed and deeply admired him. Both the Italian critic Bellori and the French historian Félibien codified their enthusiasm for Poussin into a dogma. They paid attention only to the classical theorist and tended increasingly to ignore the other sides to him which had been appreciated by Cassiano. It is interesting to speculate whether, in fact, Cassiano's relative neglect of Poussin after his return from Paris was only due to the extreme pressure of work on the artist. Can it be that, despite his special admiration of the *Sacraments*, he did not altogether approve of the rigorous austerity of much of Poussin's figure painting at this time? It is certainly true that the one work he did commission from him, *The Tempest with Pyramus and Thisbe*, is striking as much for its romanticism as its learning, and it is notable that he owned copies of two or three of his 'heroic' landscapes painted between 1648 and 1651 but of nothing else.[2]

– iii –

This more picturesque tendency is well brought out if dal Pozzo's pictures are compared with two that were painted by Poussin soon after his return from Paris for his one other considerable Italian patron, Camillo Massimi. *Moses trampling on Pharaoh's Crown*

[1] There are frequent references to Angeloni by Cassiano himself (Lumbroso, p. 200), Poussin (*Correspondance—passim*) and other contemporaries. See Mahon, 1947, pp. 144 ff., and also later Chapter 6.

[2] See Sheila Rinehart in *Actes*, 1961, pp. 19-30. The pictures are versions of the *Landscape with Woman washing her Feet* (Ottawa), *Funeral of Phocion* (collection of Lord Plymouth), and possibly of the *Landscape with Man killed by Serpent* (National Gallery, London), though this has perhaps been confused with the (original) *Landscape with Man fleeing from Serpent* (Montreal).

(Plate 19a) and *Moses changing Aaron's Rod into a Serpent* are treated in his most uncom-
promisingly severe and learned manner. In both cases the colours are harsh and the
dramatic events are frozen into a stiff, rhetorical formula. Rarely, if ever, did he paint
concentrated action so tensely. The subjects are of equal interest. Though *Moses and
Aaron's Rod* had appeared from time to time in art, the scene where as a child he
accidentally trampled on Pharaoh's crown and only just escaped being stabbed to death
was very rare. The story which does not occur in the Bible was taken from Josephus,[1]
and although episodes from the life of Moses clearly obsessed Poussin he had never
painted any for Cassiano dal Pozzo. His choice of this exceptional scene certainly
suggests an exceptional patron. Such was indeed the case.

Camillo (*né* Carlo) Massimi was born in 1620 from a branch of one of the oldest
and most distinguished of all Roman families.[2] He received a sound humanist education
from private tutors and at the Sapienza. When aged 20 he succeeded to the estate of his
cousin Camillo and took his name. This fact is of some interest for the elder Camillo
had been the nephew, companion and testamentary executor of Vincenzo Giustiniani
to whom the younger Camillo—the subject of this study—was himself slightly more
distantly related through his grandmother. There is thus a direct link between the first
and the last of the great Roman patrons of the seventeenth century, and there can be
little doubt that Camillo inherited his love of art and antiquities—as well as a sizeable
income—from his distinguished ancestor.

The two pictures by Poussin must have been among Camillo Massimi's earliest
commissions, given at the very outset of his advancement which began with the down-
fall of the Barberini and the election of Giambattista Pamfili as Pope Innocent X in 1644.
Almost at once Massimi, though still only in his twenties, began to gravitate round the
centre of the new court and above all to give evidence of his considerable taste for the
arts. It was during these years that he also acquired a large number of drawings by
Poussin that had originally been commissioned by the painter's first known admirer,
the poet Giambattista Marino. They consisted mainly of mythological subjects loosely
inspired by Marino's most famous poem, the *Adone*. Marino bequeathed them to some
unidentified friend, possibly Cassiano dal Pozzo, and when the French writer Félibien
was in Rome, between 1647 and 1650, they belonged to Massimi, 'who kept them
most carefully among several others by Poussin's hand.'[3]

[1] *Exposition Poussin*, p. 109.
[2] For Camillo Massimi see Litta, Moroni and the Abbate Michele Giustiniani, III, p. 319. To save
future researchers the futile labour in which I have had to engage I would point out that Moroni is mistaken
in his reference to a life of Massimi by Luca Bartolotti published at Asti in 1677. This book is, in actual
fact, a biography of Cardinal Bona *dedicated to* Massimi. For other important references to him see Patri-
gnani, 1948. The inventory of Massimi's collections was published in part by Orbaan, 1920, pp. 515-22.
A photographic copy of the original (Biblioteca Vaticana: Capponi Lat. 260) is in the Library of the
Warburg Institute.

For the first Camillo see Abbate Michele Giustiniani, II, pp. 62-3, and the will of Vincenzo Giustiniani
in the Archivio di Stato, Roma—Archivio Giustiniani, Busta 10, n. 39.
[3] For the history of these drawings see Blunt, 1945, p. 32. Blunt has also shown (*ibid.*, p. 45) that
Massimi must have been in contact with Poussin even before 1640.

Camillo Massimi was also one of the rare connoisseurs who appreciated the pictures of Claude as well as those of Poussin. This was a taste not always easy to gratify, for Claude was in constant and overwhelming demand from the highly placed and powerful. The yearly records of his patrons read like a guide to the varying fortunes and revolutions of social and political life in seventeenth-century Italy and France. A spate of those magical, sunlit landscapes would make life yet more pleasant for the successful; there would be none to comfort his disgrace. However, in the late 1640s Massimi's star was in the ascendant, and we find his name along with Camillo Pamfili and other new ones among the lists of Claude's clients. Two large pictures of *Argus guarding Io* and *A Coast View with Apollo and the Cumaean Sibyl* testify to his love of unusual subjects in pagan as well as sacred literature. Like Poussin's scenes from the life of Moses they may well conceal some more complex allusion to his own circumstances.[1]

There is another wonderful memorial to Massimi's success and perspicacity in these years. In 1649 Velasquez arrived in Rome.[2] We know that he was greeted by Francesco Barberini and Cassiano dal Pozzo—but that his principal portraits were all of members of the new régime: unforgettably, of course, of Innocent X, but also of Camillo Massimi (Plate 20). Though all reports speak of Massimi as a highly cultivated and attractive man, it must be admitted that the bulbous features, the thick, heavy nose and lips, the dark, unshapely moustache all suggest rather a surly and coarse character. He himself must, however, have been well satisfied, for he formed a close friendship with Velasquez that was to bear fruit somewhat later. He also acquired from the painter a portrait of Donna Olimpia, the Pope's greedy, ambitious and overbearing sister-in-law whose influence at court entertained and outraged the Roman newswriters.

In 1653 Massimi, who thus at the age of 33 owned some half-dozen masterpieces by three of the greatest painters of his (or any other) time, was made Patriarch of Jerusalem and a year later was sent as Nunzio to Spain. And now, for the first time, his brilliant career received a setback. Intrigues by the Spanish ambassador in Rome led to Philip IV refusing to receive him at court on the grounds that he was too friendly with the French. For a year he was forced to live in a small town between Valencia and Madrid. While negotiations proceeded he sought relaxation by visiting the local antiquities, a Roman theatre, fragments of statues and other ruins. He showed a certain contempt for prevalent standards of scholarship and took pleasure in deciphering Hebrew and other inscriptions for the researches of his learned friends in Italy.[3] While still waiting to be received in Madrid, he wrote to Velasquez and received a most friendly reply. With some courage the artist offered to be of service in any way he could and looked forward to seeing his former patron at court.[4]

This became possible only in 1655 after the accession of the new Pope, Alexander VII, and at some stage during the next few years Velasquez painted four more pictures

[1] Lord Leicester Collection and the Hermitage, Leningrad—see Röthlisberger, 1961, p. 240.

[2] Enriqueta Harris in *Burlington Magazine*, 1958, p. 299.

[3] Abbate Michele Giustiniani, II, p. 471. He had also taken with him the miniaturist Antonio Maria Antonazzi—MS. inventory of Antonio degli Effetti referred to in note 2, p. 156.

[4] Enriqueta Harris in *Burlington Magazine*, 1960, p. 162.

for Massimi—portraits of the King and Queen and of two Infantas. The purchase of these and of various jewels and other *objets d'art* must, however, have seemed the only benefits arising from his new circumstances. For Massimi's service as active Nunzio was almost as unproductive as his earlier humiliation. As if to belie his damaging reputation he wholeheartedly backed the Spaniards in their quarrels with France. Naturally enough the French, who were everywhere taking the initiative in Europe and who were about to seal the new balance of power through the Peace of the Pyrenees, protested violently. So too did the Venetians. Unfortunately for Massimi, a change of Pope in Rome had, as so often happened, led to a change in policy. Alexander VII was making great efforts to conciliate the Venetians, who had agreed to re-admit the Jesuits into their territory for the first time since their expulsion some fifty years earlier, and he was most anxious to avoid offending the French whenever possible. In 1658 Massimi was recalled to Rome and was given no further job for the next twelve years.

Disgrace, as always, led to difficulties in procuring work from the most fashionable modern artists. We hear little of Camillo Massimi's patronage during these years, and there is no doubt that he was now concentrating primarily on his library and his wonderful collection of antiquities. In many ways he seems to have been deliberately assuming the rôle left vacant by the death of Cassiano dal Pozzo whom he had known and accompanied on his visits to connoisseurs.[1] He too arranged for copies to be made of many of the older Roman buildings and paintings,[2] and above all he too enjoyed the closest relationship possible with Poussin, one of the only artists in the city whose independence allowed him to remain comparatively unaffected by changes in status among his clients. It may well have been now—and possibly even from the heirs of Cassiano, though there is no direct evidence for this—that he acquired a pair of that painter's most beautiful early works, whose melancholy mood if not actually moral was particularly appropriate to the circumstances of his own chequered career: the *King Midas washing his Face in the River Pactolus* and the first version of the *Arcadian Shepherds*, 'the one warning against a mad desire for riches at the expense of the more real values of life, the other against a thoughtless enjoyment of pleasures soon to be ended'.[3] Certainly the two men established a very close friendship. Bellori gives us a charming picture of Poussin showing Massimi downstairs late one night after they had been talking together in his studio[4]—Massimi was an amateur artist and probably took lessons from him[5]—and Poussin must have made many visits to Massimi's library when working on the increasingly abstruse pictures of his final years. One such—the very last of all and left uncompleted—he gave to Massimi in 1664 shortly before dying. This is the

[1] Lumbroso, p. 228.

[2] Thus he owned 160 drawings by Pietro Santo Bartoli of antique paintings—Michaelis, p. 50.

[3] For a discussion of these pictures, whose original patron is not known, see Blunt, 1938 and Panofsky, 1957.

[4] Bellori, p. 441.

[5] 'è di ottimo gusto, come intelligentissimo della pittura, disegnando egli di sua mano perfettissimamente et è partiale del signor Carlo Maratta' wrote the Resident of the Duke of Savoy in 1675—see Claretta, 1885, p. 550. For Massimi's lessons from Poussin see the inscription on the artist's self-portrait drawing in the British Museum.

Apollo and Daphne in which with a wealth of classical allusion which has still not been fully interpreted he summed up a theme that had long fascinated him: the conflict between fertility and sterility.[1]

In 1670 there was another sudden change in Massimi's fortunes. The newly elected Pope Clement X made him simultaneously Cardinal and Maestro di Camera. Massimi, who now began to shine 'no less for the troubles he has sustained with nobility and prudence than for the glory with which he has overcome them,'[2] celebrated the occasion by having his portrait painted by Carlo Maratta, the most distinguished representative of the classical trend in Roman painting. He commissioned several other works by this artist who was now his favourite, and when his connoisseurship was officially recognised and he was asked by the Altieri to superintend the decoration of their new palace (the kind of post held by Cardinal Bentivoglio nearly half a century earlier) he obtained for him the most important and influential opportunity in Rome—the main ceiling fresco depicting the *Allegory of Clemency*. This decoration, based on a punning allusion to the name assumed by the Pope, became a model for court art all over Europe.[3]

Massimi was now at the very centre of social life. He reorganised the most famous of Roman academies, the Umoristi, which had fallen into decay,[4] and he was at last in a position to obtain further work from Claude. In 1673 and 1674 that artist painted two large pictures for him—of pagan subjects as he always had for Massimi: *A View of Delphi with a Procession* (Plate 19b) taken from the obscure historian Justinus and obviously chosen for him by his patron, and *A Coast View with Perseus and the Origin of Coral*. The subject of this, possibly the most magical painting in the whole range of Claude's œuvre, was significant because Massimi already owned a drawing of it by Poussin in the volume he had acquired from the successors of Marino.[5]

In 1677 Massimi undertook the enterprise which most struck the imagination of his contemporaries. He had copies made by Pietro Santo Bartoli of the illustrations of one of the oldest and most famous manuscripts in the Vatican library—a late antique edition of Virgil.[6] This was to be his last service to the arts, for within a few months he was dead. His younger brother inherited his collections and his debts. He rapidly disposed of the former to liquidate the latter. Among the purchasers of some of the finest pictures, drawings and antiquities were the King of France, the Spanish Viceroy of Naples and an English gentleman, Dr Richard Mead. The transaction is almost symbolic. There were, of course, other important collectors in Rome at the time, but they were becoming increasingly rare. The combination of wealth, enthusiasm, catholicity of taste and discrimination that had marked the leading Italian patrons of

[1] Bellori, p. 444, and Blunt in *Journal of Warburg Institute*, 1944, pp. 165 ff.

[2] Barozzi e Berchet, II, p. 359: Antonio Grimani, 1671.

[3] See Chapter 6.

[4] Abbate Michele Giustiniani, III, p. 567.

[5] Röthlisberger, 1961, pp. 428 and 433. The pictures are now in the Chicago Art Institute and Lord Leicester Collection. Cassiano dal Pozzo had also owned a painting by Pietro da Cortona of the *Origin of Coral* the precise significance of which for seventeenth-century connoisseurs is not quite clear.

[6] The plates were not published until 1725 and were republished with a text by Bottari in 1741—de Nolhac, p. 25.

the seventeenth century did not really survive Massimi, and a largely new tradition had to be forged again in the neo-classical period. Opulence certainly continued; and also pedantry. But neither had been the distinguishing marks of the tradition that has here been examined. Massimi, a relation of Vincenzo Giustiniani and a friend of Cassiano dal Pozzo, had carried their principles into the last great creative period of Baroque art. With his masterpieces by Claude, Poussin and Velasquez, he was able to prove that a love of classical antiquity need in no way inhibit an appreciation of the most vital painting of his own day, and that profound learning and creative inspiration were not mutually exclusive.

Chapter 5

THE WIDER PUBLIC

– i –

POUSSIN became one of the leading painters in Rome. Yet he never worked in fresco, was hardly ever employed by the Pope, only once or twice painted an altarpiece.[1] Such was now the power of the independent patron to make the reputation of an artist and to guide his development. Deliberately confining himself to a restricted circle of scholars and humanists, he soon moved from the generalised battle pictures with which he had been forced to begin his career to a more and more complex interpretation of religion and mythology, often as difficult to understand as the great paintings of the Florentine Renaissance produced in somewhat similar circumstances nearly two hundred years earlier. The times were favourable. Never was Rome so closely aligned to French policy and culture as during the twenty-odd years of Urban VIII's pontificate. Not for many generations had there been such a circle of intellectually minded connoisseurs, interested in all the latest developments in science and aesthetics, ready to encourage complex imagery and a more aristocratically restrained form of artistic expression than that which filled the churches and palaces of the great. Yet independent patrons of this kind were not the only ones who broke down the monopoly of Church and aristocracy in early seventeenth-century Rome. With the increasing attraction of the city to tourists and growing economic uncertainties conditions of patronage gradually loosened and we come across an ever larger number of professional art dealers in direct contact with living painters.

Dealers at first played an important part only in the careers of young and unknown artists. Every time we hear of them it is in connection with some painter newly arrived in Rome, unable to fit at once into the established system. Such, for instance, was the case of Caravaggio, who sold some of his early works to a French dealer called Valentin and through him met the Cardinal del Monte[2]; or of the Spaniard Giuseppe Ribera, who on his arrival in Rome 'took to painting by the day for those who deal in pictures with all the trials such work involves for young men'.[3] Indeed, once an artist had made his reputation there would be no question of his ever working again for a dealer unless driven by the most acute distress. For they had a bad reputation both with painters and with the public. We hear that they tried to keep the young Salvator Rosa away from

[1] The *Martyrdom of St Erasmus*, now in the Vatican Gallery, is the only altarpiece that Poussin painted for an Italian church—St Peter's in 1628-9; for this, incidentally, he did make a preparatory *modello* (Ottawa). There is a tradition that the *Annunciation* (National Gallery, London) comes from Pope Alexander VII's chapel at Castel Gandolfo. As it is inscribed with his name this may well be correct, though the evidence is not conclusive—see Blunt in *Société Poussin*, 1947, pp. 18-25.

[2] Friedlaender, p. 101. [3] Mancini, I, p. 249.

direct contact with possible clients so that he would be forced to work exclusively for them, and as early as 1635 Claude found himself compelled to keep a record of all his paintings, as copies of his works were being sold 'throughout Rome' as originals.[1] One of the collectors who may well have been tricked by unscrupulous dealers of this kind was Lelio Guidiccioni, a poet in the Barberini circle, who 'burned with extraordinary zeal and lust for pictures and spared no labour or expense in acquiring them'—only to find that he had been landed with many a doubtful 'Michelangelo', 'Raphael' and 'Perino del Vaga'.[2]

But quite apart from cases of dishonesty, it was felt that the whole business of dealing in the liberal arts was degrading and somehow humiliating to the arts themselves. 'It is serious, lamentable, indeed intolerable to everybody to see works destined for the decoration of Sacred Temples or the splendour of noble palaces, exhibited in shops or in the streets like cheap goods for sale'—so complained the Accademia di S. Luca. For these reasons it forbade its own members to engage in dealing on pain of expulsion.[3] But the Accademia was ever on the lookout for new sources of income, and in 1633 it managed to get papal authority to impose a special tax of ten *scudi* a year on all art dealers. As might be expected this caused a good deal of trouble, and ensuing controversies give us some insight into the situation.[4]

Dealers usually combined their businesses with some other activity on the fringes of art such as selling colours or gilding. But—and this obviously accounts for much of the resentment—they also included barbers, tailors, cobblers and so on.[5] They were prepared to sell both old masters and works specially commissioned from those unfortunate enough to fall into their clutches. There were also sellers of rosaries and other religious goods who dealt only in small devotional pictures. All of them were bitterly hostile to the proposed tax and many succeeded in dodging it for years, although it was not until 1669 that they managed to get it reduced. By then their numbers had grown considerably and in 1674 there were at least a hundred, most of them installed around the Piazza Navona.[6] As in so many branches of European trade, the great majority seem to have been Genoese, who naturally often dealt in the works of their compatriots.[7]

[1] Pascoli, I, p. 65, and Baldinucci, VI, 1728, p. 357.

[2] Jan Niceo Eritreo, II, pp. 127-30. There is a print by Giovanni Battista Mercati after Correggio's *Marriage of St Catherine* dedicated to Lelio Guidiccioni with an inscription recording his love of painting.

[3] Missirini, pp. 126 and 122.

[4] Hoogewerff, 1913, p. 116, and 1935, pp. 189-203, with bibliography.

[5] Missirini, p. 96. In the Archives of the Accademia di S. Luca (Filza 166, n. 68 c. 22r) is a 'Nota delli Rivenditori di quadri che devono pagare alla Chiesa di S. Luca per 1636.' This includes dealers in the Piazza Navona, Campo Marzio, Trastevere and other parts of Rome.

[6] Hoogewerff, 1913, p. 104. Many guidebooks refer to the Piazza Navona in this connection. In 1645 Evelyn (Vol. 2, p. 368) 'spent an Afternoone in Piazza Navona, as well to see what Antiquities I could purchase among the people, who hold Mercat there for Medaills, Pictures, & such Curiosities, as to heare the Mountebanks prate, & debate their Medicines'.

[7] Giovanni Stefano Roccatagliata, who was in close touch with Poussin and who sold pictures to Valguarnera, was a Genoese—Bertolotti: *Artisti subalpini*, p. 185. So too was Antonio Maria Visconti, whose shop was near the Albergo del Moretto and who in 1699 denounced the theft of eleven pictures—*ibid.*, p. 199. And see the following note.

We hear frequently of one Pellegrino Peri who lived near the statue of Pasquino during the second half of the seventeenth century and who employed the young Gaulli on his arrival in Rome, as well as Gian Andrea Carlone who refused to pay back a debt he owed him.[1] The Flemish were also prominent dealers. The artist Cornelius de Wael, for instance, who left Genoa in 1657, engaged in extensive commercial activities and had a large gallery of pictures which were evidently for sale. He dealt principally with his own compatriots, both as regards artists and clients. Though he also owned early works by Gaulli whom he must have known in Genoa as well as smaller pictures by Italian genre, flower and battle painters, he played little part in the lives of the more important artists.[2]

It was the financial turmoil that followed the pontificate of Urban VIII that changed the whole situation and gave dealers their first large-scale opportunities. Artists were left helpless by the policy of economic retrenchment pursued by Innocent X. Large numbers had been attracted to Rome and their clientèle was mainly Roman, built up over the long and prosperous reign of Urban VIII. Now suddenly the market seemed to crash. We get vivid accounts in contemporary biographies of what this meant to artists at the time.[3] Among other results more and more painters had to work for dealers, many of whom exploited their distress to the full. Others apparently offered generous terms. Thus we hear of one Pellegrino de Rossi who gave work to Mattia Preti among a number of unemployed artists who were attracted by his kindness.[4] Another factor that encouraged the rise of dealers was the increasing number of Italian pictures which were being sent to France, Spain, England and other European countries during the second half of the century. Foreigners who came to Rome for a short time must certainly have found it easier to go to dealers than direct to the painter, who might often be capricious and unreliable. Similarly dealers themselves sometimes took the initiative in exporting works of art. Thus an innkeeper called Andrea Ottini used to get Giacinto Brandi to settle his debts in pictures. He did so well out of this that he said that if Brandi could be induced to work regularly for him he would close his inn and take to the art trade. Without going as far as that, he still commissioned several works from him and sent them to France.[5]

But in general such commissioning of pictures from artists was rare enough, for as one dealer, Cornelius de Stael, explained to a client in 1663: 'It's very troublesome to do business with these gentlemen [painters]. I find it much better to buy pictures already painted than to commission new ones.'[6] Professional dealers did play a significant

[1] For Pellegrino Peri and his dealings with Gaulli see Pascoli, I, p. 198. In 1666 he was attacked by Giovanni Andrea Carlone, who refused to pay him back a loan. In 1681 he denounced the robbery of two pictures by Filippo Lauri and Giovanni Perusini which had been stolen from his shop—Bertolotti: *Artisti subalpini*, p. 199.

[2] Vaes, 1925, pp. 137-247.

[3] Passeri, p. 301. The whole question is discussed at some length in Chapter 6.

[4] De Dominici, IV, p. 19.

[5] Pascoli, I, p. 66.

[6] Letter from Cornelius de Stael to Don Antonio Ruffo dated 9 June 1663 published by V. Ruffo, p. 170.

part in breaking down the tight relationship between artist and patron, but although we hear more and more of them as the years go by, it is very doubtful whether, in the seventeenth century, they ever ventured much beyond the relatively unknown painter.[1]

However, alongside dealers of this kind were figures more difficult to define—those *marchands-amateurs* whose activities even today are often not easily determined and who turn up again and again in any history of patronage. This type of dealer makes his first appearance cautiously, so cautiously that for a long time we fail to notice him. Thus Ferrante Carlo, born in Parma in 1578, was a most cultivated lawyer and poet who was employed as secretary first by Cardinal Sfondrato and then by Cardinal Borghese, in whose palace he lived.[2] Of a rather combative temperament, he took part in many of the literary and artistic quarrels of the day and managed to become embroiled with the two greatest favourites of the early seventeenth century—first the poet Marino and then Bernini whom he 'wished to see exterminated' because of some precarious alterations the architect had made in the structure of St Peter's.[3] His real passion was for pictures, and although contemporaries were doubtful about his taste and understanding, he was in touch with Cassiano dal Pozzo and many leading artists. His special favourites were the Bolognese and Giovanni Lanfranco from his native Parma. He befriended and commissioned works from all of these and owned a notable collection. But his passion was not wholly disinterested as we gather from an episode in 1631 when the Sicilian adventurer Don Fabrizio Valguarnera called on Ferrante Carlo with a few friends. For a time they talked in generalities about the qualities of the various painters represented on his walls and then Valguarnera asked if Carlo was prepared 'to deprive himself of some of his pictures'. The answer was immediate: 'I agreed,' said Carlo when describing the incident later, 'as long as I received an honourable deal.' We recognise the type. Beneath the Oriental courtesies there must have been some shrewd bargaining.

Another strange sort of dealer, even better placed for taking advantage of his connections, was the Pope's doctor Giulio Mancini.[4] Like many a man in such a situation his inflated reputation as a great healer allowed him a degree of freedom unimaginable to ordinary citizens. A virtually self-confessed atheist, he deliberately encouraged his friends to eat meat during Lent and carried on a notorious affair with a married woman whose criminal sons he successfully saved from justice. As a doctor he was said to be

[1] Certainly there are no cases, other than those referred to here, of distinguished artists working systematically for dealers. This should be compared with the situation in contemporary Holland—Martin, 1907.

[2] For Ferrante Carlo see above all the evidence quoted by Miss Jane Costello. Dumesnil in 1853 devoted a chapter to Carlo, but this does little more than summarise the many letters to him published by Bottari, I. Like all writers before Miss Costello, he was unaware of Carlo's activities as a 'dealer' and considers him purely as a patron. There is further information in Borzelli, 1910, about his contacts with Cassiano dal Pozzo which are documented in letters now in the Montpellier Library. Some most interesting letters from Ludovico Carracci to Carlo have been published by Giorgio Nicodemi, 1935, who also refers to other sources for his career.

[3] Fraschetti, p. 71, publishes an *avviso* of 1637 which refers to Carlo as a 'nemico' of Bernini 'et che vorrebbe vederlo esterminato'.

[4] The main and most vivid source for Mancini's life is Jan Niceo Eritreo, II, pp. 79-82. See also the critical edition of his works, 1956.

efficient but brusque and he cunningly made use of his medical gifts to further his very real artistic interests. For when visiting his distinguished and fashionable patients he would suggest at the critical moment that some of their pictures would make an acceptable gift. Few felt like refusing just then, and from such opportunities he derived decisive advantages over all rival dealers and the knowledge needed to write a learned and most valuable artistic *Treatise*.

A third and almost equally influential figure who indulged in a certain amount of unofficial dealing was Niccolò Simonelli.[1] An obviously efficient administrator, he served under various cardinals before ending up in charge of the Chigi household during the papacy of Alexander VII. He had some reputation as a connoisseur and liked to give advice on artistic matters. He assembled a notable collection of drawings by Giulio Romano, Polidoro da Caravaggio and Annibale Carracci, his special favourite, as well as paintings, antiquities and cameos. He was clearly a man of independent and cultivated taste, for he was in very close touch with a number of interesting artists outside the main stream of fashion—Salvator Rosa whom he helped to launch, Pietro Testa to whom he lent money, Castiglione whose publisher dedicated to him a fine print of Diogenes searching in vain for one honest man. Simonelli too took advantage of these contacts though he was obviously a much more respectable figure than Mancini. When the French traveller Monsieur de Monconys visited Rome in 1664 it was Simonelli who took him round the studios, introduced him to Poussin and Claude and sold him the odd picture. No doubt he did the same for other visitors.

All three figures, Carlo, Mancini and Simonelli, thus had many features in common. All enjoyed distinguished careers in the clerical bureaucracy of the mid-seventeenth century without themselves being in the Church, and all were friends and patrons of many of the leading artists of their day. But though they were prepared to use these

[1] See Monconys' *Journal des Voyages*, 2ème partie, p. 439, for Simonelli's contacts with artists in 1664. Some information about his own collecting is given in Bellori's *Nota dei Musei*, which says that he owned a 'Studio di disegni li più eccellenti di Giulio Romano, di Polidoro, di Annibale Carracci, & de'migliori Artefici, con vario museo d'intagli, gemme, antichità, e cose peregrine, siccome anche di varie pitture eccellenti'.

Passeri, p. 388, who refers to his relations with Salvator Rosa, says that Simonelli 'stava in credito d'intendente' and there are many references to him in Rosa's letters.

Luigi Scaramuccia dedicated a print to him of *Venus and Adonis* on which he writes that Simonelli was 'inamorato dell'Opere dei Carracci'. On the back of a drawing by Pietro Testa at Windsor is a letter from the artist to Simonelli which seems to show that he owed him money—Blunt and Cooke, 1960, p. 115.

The occasional fact about his career in the Chigi household can be traced in that family's archives— Golzio, 1939, p. 155. The suggestion that his outlook on the world was not wholly conformist comes from Castiglione's print of *Diogenes* with its strange dedication from the publisher: 'Al Sig: Nicolo Simonelli Mio Sig.re—Quel Diogene Cinico che con tanta gloria serba piu vive che mai le sue memorie baldanzoso risorge al mondo co delineamenti del Celebre Castiglioni e perche so quanto ella l'imiti ne suoi virtuosi Costumi e particolarmente nel cercar con la lanterna gli uomini ho giudicato che il dedicarlo a lei sara un accoppiamento felicissimo e che in altro non discordaranno salvo che esso pote con tanta severità disprezzare i favori d'un Alessandro e V.S. per superarlo ne gli atti della benignita sapra con cortesissimo animo gradire gli Ossequij della mia devotione la quale vivam. te la riverisco Di V.S. Aff.mo Amico e Servitore G.D.R. [Gian Domenico Rossi] D.D.D.'

advantages, shrewdly yet discreetly, to deal in pictures, to call them professional dealers would not only have bitterly offended them but would also give a wholly wrong impression.

– ii –

Far more effective than any kind of dealer in bringing the artist into contact with a wider public was the gradual extension of art exhibitions.[1] The principal occasions for these were provided by the many saints' days and processions which were such a feature of seventeenth-century life. The feast of Corpus Domini above all was associated with the display of pictures, but it certainly had no monopoly. No exact spot seems to have been indicated and artists probably exhibited indiscriminately with other craftsmen or merchants showing their wares. Obviously no artist of established reputation would ever think of lowering his dignity in this way, and those that we generally come across are minor specialists in landscape and genre and above all painters newly arrived in Rome or returning after a long absence. For such men exhibitions seem to have been useful and to have attracted connoisseurs of standing. They also inspired other artists: we hear of a young peasant boy who decided to take up painting as the result of seeing a stall covered with pictures at the fair of Sinigaglia, and Claude is supposed to have seen landscapes by the Flemish artist Goffredo Wals at an exhibition in Rome and to have been so struck with them that he went to study under him in Naples—a move which played a decisive part in his career. And another exhibition—though very different in aim and organisation—was actually arranged under pressure from the painters in Rome. In 1607 the Duke of Mantua's agent was forced to satisfy them by putting on view Caravaggio's *Death of the Virgin* which he had just bought for the Duke on Rubens's advice—an occasion which was apparently attended by all the leading artists, who thus provided striking evidence of their growing influence and emancipation.

More organised exhibitions were sometimes held on 24 August by the Bergamasque community in Rome to celebrate the feast day of their patron saint, St Bartholomew. These took place in the courtyard of the church of S. Bartolomeo and were paid for by the *Guardiano*. As in all Roman exhibitions of this kind, the occasion served primarily to put on a spectacular decorative show in honour of the saint and his devotees. The façade of the church was hung with tapestries, as were the houses round about, and an observer confessed that it was hard to decide which was the more impressive: the general effect created by the hangings outside or the pictures spread round the inner courtyard. It is not certain when the exhibitions began, but they were certainly flourishing by 1650. S. Bartolomeo all'Isola arranged exhibitions for the saint's name day, but they were less important. Despite their devotional purpose the exhibitions certainly provided artists with the opportunity to display their works and were far more dignified

[1] See Haskell, in *Studi Secenteschi*, 1960, for the whole section on exhibitions with full references. For the exhibitions at S. Salvatore in Lauro I have made extensive use of the papers of Giuseppe Ghezzi now in the Museo di Roma.

occasions than the casual saints' day fairs. They attracted the attention of potential buyers, but it seems certain that here, as in all these exhibitions, purchases could not be made on the spot.

The most famous and well attended of all the regular exhibitions in seventeenth-century Rome was the one held in the Pantheon each year on 19 March to celebrate the feast day of St Joseph. This was organised by the Congregazione dei Virtuosi, a confraternity consisting largely of artists which had been founded in 1543. Created in the characteristic Counter Reformation atmosphere that prevailed at the time, its main purpose was to promote good works in the form of charity and so on. As a secondary aim it planned to make use of the fine arts to glorify religion. These objectives were responsible for the nature and scope of the exhibitions which were certainly not designed to serve the artist's desire for recognition and were at first rarely so used. They probably began early in the seventeenth century and came to an end some time before 1764. Each artist could submit one picture and a selection was made by the members of the Congregazione. The pictures chosen were then arranged under the colonnade of the portico, while above the balustrade was hung a large *Dream of St Joseph* and probably tapestries. Both old masters and contemporary works were shown.

Quite soon artists began to make use of the Pantheon exhibitions in order to attract attention to themselves. In 1650, for instance, Velasquez, then on his second visit to Rome, showed the portrait of his servant Pareja which understandably caused a sensation. As the great Spanish artist was already a member both of the Congregazione dei Virtuosi and of the Accademia di S. Luca, and as he had already been commissioned to paint his famous portrait of Pope Innocent X, he probably wished to make his name known to an even wider public. In this aim he was certainly successful and it is all the more surprising that we hear so little of other artists taking advantage of the opportunity. In the seventeenth century by far the most conspicuous of those who did so was Salvator Rosa, who exhibited whenever possible. He was engaged in a running fight with the critics, he loved publicity and he was therefore determined that every year the public should see something new by him: 'The important thing', he wrote before the exhibition of 1651, 'is that until now no one except Simonelli has seen the picture, as I have always kept it shut up in a special room.'

For Salvator Rosa, as for Velasquez, exhibiting at the Pantheon was exceedingly useful. 'Last week', he wrote in 1652, 'I turned down the chance of going to Sweden—it all sprung from the applause I won from the last picture I exhibited in S. Gioseppe in Rotonda.' In fact, the painter's main intention was to increase his reputation rather than bring in immediate cash, for pictures were not sold on the spot and admirers waited for the artist to take his canvas home before making an offer.

Some still saw the occasion primarily as a means for paying homage to St Joseph. When making his will in 1654, the Flemish painter Jan Miel left 300 *scudi* to the Congregazione (to which he had belonged since 1650) on condition that a yearly mass was sung for his soul 'and that the brethren be obliged to celebrate every year the feast of the glorious St Joseph by having the portico of the Madonna of the Rotonda decorated

with pictures, as is and has been done each year'. But although the main purpose of the exhibition was religious, the earliest records we have make it clear that devotional pictures were not insisted on and that portraits and pagan history paintings were often among those shown. Indeed, at the exhibition of 1680 the authorities ordered the police to seize two of the pictures on the grounds that they were indecent. We need not take the charge too seriously—a wave of puritanism swept through Rome that year and in any case among those who sprang to the defence of the offending pictures was a cardinal.

The other great annual exhibition held in Rome took place in the cloisters of S. Giovanni Decollato on 29 August, the saint's day. The circumstances were somewhat different. It was held under the auspices of the leading patrician families and evidently redounded to their credit at least as much as to that of the artists represented. It is recorded as a regular institution as early as 1620, but there are traces of it some twenty years previously. In 1603 Orazio Gentileschi explained to the judge during the course of a trial that there was a good deal of rivalry among the artists at work in Rome. 'For instance,' he went on, 'when I had placed a picture of the Archangel Michael at S. Giovanni de' Fiorentini, he [Giovanni Baglione] competed with me by putting a picture just opposite it. And this picture which was called *Divine Love* he had painted in competition with Michelangelo da Caravaggio's *Earthly Love*.' But though painters might look upon the exhibition in this light, it is most unlikely that this was the sort of purpose it was intended to serve. Almost certainly the pictures were designed to decorate the church as part of the celebrations in honour of the saint. Salvator Rosa, however, made full use of the exhibition to show his work to the public, and much of our information about it is derived from him and dates from rather later in the century.

In 1662 it fell to the Sacchetti to organise the exhibition. Naturally, writes Rosa, pride of place was given to Pietro da Cortona, the family painter. But as the Sacchetti still had great influence with the Roman aristocracy they were also able to obtain the loan of old masters from many of the most famous galleries of the city. Six years later the Rospigliosi were responsible and they challenged all previous patrons by the lavishness of the display they organised. For Camillo Rospigliosi was the Pope's brother, and he and his four sons had just been admitted as novices to the Compagnia della Misericordia which administered the church. The whole façade, the cemetery, the piazza and even the adjoining street were draped with rare and precious tapestries, silver and magnificent pictures. Owners of private galleries willingly lent their masterpieces, whereas before they had always been reluctant to do so because, so an *avviso* informs us, the papal nephews of the day found some pretext or other for laying hands on them. In particular Queen Christina lent some of her most famous pictures. The Rospigliosi decided that only old masters should be shown and that all contemporary work should be excluded. But this resolution merely encouraged Rosa to challenge it. Though, because of the spectacular competition he was forced to face, he called the occasion the 'Valley of Jehoshaphat', he managed—alone among living artists—to get two of his pictures exhibited. It may well have been, therefore, in this year that his band of supporters went round Rome asking people: 'Have you seen the Titian, the Correggio,

the Paolo Veronese, the Parmigianino, the Carracci, Domenichino, Guido and Signor Salvatore? Signor Salvatore is not afraid of Titian, of Guido, of Guercino or anyone else.' But this misguided enthusiasm appears to have done the artist more harm than good.

Another lavish exhibition was arranged for the Holy Year of 1675 when over two hundred pictures were shown by the Medici. Outside the church were hung tapestries and damasks giving the illusion of stage scenery as the public walked among them; while inside the cloisters and in one of the rooms opening on to them were works by living and dead artists including Raphael, Titian and the Carracci.

In later years when the great patrician families were more interested in selling than in displaying their pictures, the exhibitions seem to have become far more commercial. Thus 212 pictures, old and modern, were exhibited in 1736, a catalogue was issued, and there were hopes that the Pope would make a bid.

There was one more regular art exhibition which began much later in the century than those so far considered. This was held in the beautiful cloisters of S. Salvatore in Lauro, a church that was bought for the Marchigian colony in Rome by Cardinal Azzolini in 1669. Soon afterwards the members of this group began to celebrate the anniversary of the arrival of the Holy House in Loreto on 10 December with elaborate celebrations which included concerts and a picture exhibition. We know that in the Holy Year of 1675, so rich in exhibitions, the one at S. Salvatore in Lauro was said to equal any held in Rome. But here too the intention was to decorate the church and glorify the lenders—often families from the Marche—rather than provide publicity for the painters. Despite this, the exhibitions in S. Salvatore in Lauro were organised far more professionally than any of the others. As from 1682 the painter Giuseppe Ghezzi, life secretary of the Accademia di S. Luca and himself from Ascoli Piceno, was in charge of the arrangements and he went to great trouble to perfect them. Families prepared to lend had to be approached in good time; reliable porters had to be hired for the transport and soldiers employed on 24-hour guard duty over the 10 and 11 December, during which days the paintings remained on view; adequate lighting had to be arranged and criticisms of the public taken into account. Pride of place was always given to a representation of the Madonna, but every kind of painting was included in the exhibition. Ghezzi recommended five or six large canvases and about 200 smaller ones as the ideal to be aimed at, but numbers obviously varied from year to year.

Quite soon considerable prestige attached to creating a striking effect, and—as so often in Rome—rivalries between the various owners came powerfully to the fore. Thus in 1697 Prince Pio agreed to lend his pictures entirely at his own expense—on condition that his alone were shown. They included a number of Venetian old masters and were all hung together under the arcades of the loggia. But in order to satisfy other collectors who also wanted to display their treasures further pictures were hung separately in the upper gallery of the cloisters. The occasion turned into a brilliant social ceremony with a sermon from the preacher of St Peter's and a great assembly of cardinals. We find a similar situation in 1708 when the Marchese Ruspoli at first

insisted that only his 194 pictures should be exhibited but finally agreed to Ghezzi's tactful suggestion that Monsignor Olivieri be allowed to hang 23 of his.

In all these exhibitions old masters were given far greater prominence than contemporary work and many pictures were repeatedly shown year after year. Sometimes, however, they provided an opportunity for the public to see current painting of a kind that would not normally be easily accessible. Thus Cardinal Ottoboni showed pictures by Trevisani whom he assiduously employed, and in 1707 Cardinal Grimani, in a fit of patriotic enthusiasm, sent in 23 'historie di maniera veneziana' by Antonio Molinari who, although he had died 25 years earlier, was still quite unknown to Roman collectors. At other times the exhibition was used for more directly propagandist purposes. In 1704, for instance, the Pope wished to make better known the victories won by King John of Poland and encouraged his widow to lend a series of portraits and battle pictures for this purpose.

Thus by the end of the century there were four regular exhibitions in Rome each year—in March, July, August and December—quite apart from a large number of occasional ones arranged for special events and casual affairs spontaneously organised by a particular patron or artist. But none of the regular exhibitions had as its primary aim the opportunity for a painter to show new work, and some deliberately excluded this. Essentially all of them made use of pictures, as of tapestries and banners, for decorative purposes. From the strictly artistic point of view it is probable therefore that the more informal showings were the most fruitful and that it was only gradually that artists managed to turn to their own purposes what had been designed as a religious function. For this reason the importance of regular patronage, and the need to exhibit work on a permanent basis by painting altarpieces in the more frequented churches, were comparatively little affected by seventeenth-century exhibitions.

None the less, the exhibitions cannot be considered in isolation. We must remember also the increasing prevalence of dealers as Rome became more easily accessible to travellers of all kinds, including Protestants; the ambitions of foreign rulers and patrons who wanted artists from their own countries to record the glories of Rome and reproduce for them the triumphs of Italian painting; the consequent settling in Rome of different national colonies of artists who often drew attention to themselves by their strange dress and still stranger customs. When all this is taken into account it will be appreciated that exhibitions were among a number of factors that introduced into Rome the art of alien cultures often bearing little organic relationship to conditions in the city. Still more significant, exhibitions helped to make painting a far more 'public' business than it had ever been before. Pictures were readily available and within the reach of everybody: no longer confined to the altar or to the family palace, they now hung outside the church on ceremonial occasions, were propped up against the walls of cloisters on specified days of the year, enticed the public into the dealer's shop, were bought, sold, exchanged, criticised, argued about. The artists themselves were more visible than they had been: sketching in the ruins or among the great modern buildings that sprang up everywhere and sketching each other so doing; making rapid impressions

of the colourful life that they saw around them to send back to their northern homes, reeling back drunk after the traditional ceremony of enrolling a new member into the *bentveughels*. All this was leading to a growing appreciation of pictures as pictures rather than as exclusively the records of some higher truth; a body of connoisseurs was coming into being prepared to judge pictures on their aesthetic merits, and consequently the subject-matter of painting was losing its old primaeval importance. This attitude is one that only generally becomes apparent in the eighteenth century and that has been pushed to its extreme limits in our own day; but it is already noticeable in a patron such as Vincenzo Giustiniani and is enshrined in Caravaggio's comment to him 'that it was as hard work to paint good pictures of flowers as of figures'.[1] It is an attitude that inevitably led to the triumph during the early years of the seventeenth century of still-life painting, landscapes and a whole range of subjects which had hitherto not been treated as worth attention in their own right. As an explanation of the main currents of painting during the century it is fully as important as the far more publicised counter-attacks of those theorists who wished to enforce a rigid hierarchy of suitable subject matter on the artist.

At the same time, and partly owing to these very circumstances, a very wide and hitherto unimportant range of the general public was beginning to take an interest in painting and consequently to influence its development. We frequently come across references to these anonymous patrons in the artistic literature of the seventeenth century. Giulio Mancini was among the first to address them. In his *Treatise* he devoted a small section to the 'rules for buying, hanging and preserving pictures'.[2] Carefully distinguishing between the rich and the aristocratic on the one hand and the 'huomini di stato mediocre e di stato basso' on the other, he pointed out that the latter would not be in a position to distribute their largesse very freely. If they had to bargain with the painter over the price, they should find out how long the work took him and estimate what his daily earnings should be 'by comparison with the pay of a craftsman engaged on similar work'. They were only likely to have two rooms available for hanging pictures—the bedroom and the reception room. Devotional works should be placed in the former; 'cheerful and profane' ones in the latter.

But what were the actual pictures owned by this submerged public? We can safely assume that the great majority would today be of little interest to the art historian: devotional pictures, above all, mass produced in the studios of successful painters or copied from the most influential altarpieces. We often hear of young artists being employed on such work when they first came to Rome, and no doubt this was the public with which they bargained for their living. If we move rather higher up the social scale—to the clergy, traders, doctors and lawyers outside the ruling circles—we are no better informed, but certain possibilities suggest themselves. Can it have been for men such as these that Sassoferrato painted his restrained and archaising devotional pictures which were long taken to be by some follower of Raphael (Plate 21b)? A

[1] Bottari, VI, p. 123.
[1] Mancini, I, p. 139.

prolific painter, unrecorded by his contemporaries, he came to Rome from his native Marche some time during the reign of Urban VIII. There he confined himself almost exclusively to pictures of the Holy Family, basing himself on three or four prototypes which he varied from time to time. His models were Raphael, Annibale Carracci and Domenichino at his most austere, and his simple pictures, which at their best are very beautiful, appear to be almost polemical in their opposition to the current Baroque style.

At the beginning of his career he enjoyed a certain success. In 1641 the priests of the Calabrian national church dedicated to S. Francesco da Paola commissioned from him a painting of the titular saint kneeling in adoration while the Virgin and Child appears on the clouds holding an emblem of charity. As the same priests also employed their fellow-Calabrian Francesco Cozza on an altar painting it was probably he who recommended Sassoferrato, for both had been pupils of Domenichino and were almost certainly associated.[1] Two years later what must have been an especially congenial task led to his masterpiece. The Dominicans of Santa Sabina, anxious to raise money, had decided to sell a Raphael *Holy Family* in their possession to Vincenzo Giustiniani, who offered 2000 *scudi*. When negotiations fell through in 1636 they rashly gave it to Cardinal Antonio Barberini on the understanding that he would make it worth their while. The Cardinal gratefully took the picture and regarded the matter as closed. Only in 1643 did the Princess of Rossano, wife of Pope Innocent X's nephew Camillo Pamfili, decide to have it replaced by a *Virgin and Child holding Rosaries with Saints Catherine and Dominic* for which she paid Sassoferrato a hundred *scudi* (Plate 21a).[2]

Despite its great beauty the picture evidently did not please, for thereafter Sassoferrato's public commissions became exceedingly rare. He was not ignored by the grander patrons since the odd work by him turns up in many patrician collections, though probably acquired towards the end of his life when classicism and Raphael were once again the supreme and unchallenged guides. He drew and painted many clerics, including an occasional cardinal and governor of some of the papal states.[3] But the great bulk of his work was for unknown patrons, and this fact, together with its unfashionable style and limited range of subject-matter, strongly suggests that Sassoferrato was principally employed by the professional community of which we know so little—men like Giacinto Gigli, minor civil servant and amateur poet, who kept a detailed diary diligently recording the great religious festivals and miraculous occurrences which were the most striking aspects of Baroque Rome to those outside the grander circles of society.[4]

– iii –

The self-made man, unaffected by the traditional values and culture of those called upon to rule, has often expressed an artistic taste offensive to the established canons.

[1] Pollak, I, 1927, p. 129. [2] Berthier, p. 315.
[3] Blunt and Cooke, pp. 102 ff. In the Galleria Nazionale di Arte Antica in Rome is a signed portrait of Monsignor Ottaviano Prati, who at different times was Governor of Benevento and Viterbo-Moroni, LXI, p. 216, and CII, p. 363. [4] Gigli *passim*.

When not in a position to enforce such taste, his expression of it has been of little consequence. But when singly or in concert with his fellows he has become sufficiently influential to attract artists willing to gratify him, denunciations have been many and scathing. Such was the case in Baroque Italy. Beginning rather tentatively, the attacks on the 'ignorant', those who were not wellborn or true connoisseurs, mounted in violence as the numbers of such patrons increased. One fact was especially outrageous: the support that was won by the *bambocciate*, those little pictures which represented scenes from everyday life. Though this support eventually came from the highest ranks of society (an additional cause for indignation) there is reason to believe that it started with the 'uomini di stato mediocre e di stato basso'. Certainly a desire for the more picturesque aspects of 'reality' in art has linked the uninitiated connoisseurs of many different civilisations, and has been met by artists ranging from the sublime to the abysmal. The history of the movement in seventeenth-century Rome is difficult to unravel, but its occasionally visible course throws light on many different aspects of patronage there.

The *bamboccianti*—so called in derision from the nickname given to their deformed leader Pieter van Laer—were (in the words of the critic Giambattista Passeri) opening a window on to life.[1] What did they see out of it? Men at work—the cakeseller with his ring-shaped loaves; the water-carrier outside the walls of the town; the tobacconist filling the pipes of resting soldiers; the peasant feeding his horses; the smith. Men at play —gulping down a quick drink at the inn but still on horseback to save time; dancing the tarantella before a group of admiring spectators; playing *morra* in an old cave; dressed in brilliant costumes for the carnival procession. Or a sudden glimpse of violence as the dandified brigand—plumed hat gay against the stormy sky, pistol about to fire— rides into the farm and terrorises the stable lad and his dog. Sometimes, but very rarely, the *bamboccianti* turn some simple scene from ordinary life into a story—an old donkey has died at last, fallen to the ground while still at work; the owner casts a last lingering look at the pathetic corpse as he carries away the saddle; his womenfolk give way to unconcealed grief. The one support of their livelihood has gone. What will they do now? Much more often an ostensibly 'historical' subject is treated as a setting for a realistic representation of everyday life. Erminia arrives distraught among the peasants and finds them milking the cows while the washing hangs out on a line outside the thatched cottage; John the Baptist preaches to a crowd of gossiping, dice-playing country-folk and soldiers. Such is the world of the *bamboccianti* in the 'thirties and 'forties.[2] The setting is Rome and the campagna, but not the great city of the humanists and the tourists. It is a Rome where the broken column is used as a rough and ready chair or the foundation for a farm house; where the fragment of a classical statue lies unheeded beside a horse-trough; where buying and selling take place in dingy archways

[1] Passeri, p. 72: '. . . egli [Van Laer] era singolare nel rapresentar la verità schietta, e pura nell'esser suo, che li suoi quadri parevano una finestra aperta, per la quale si fussero veduti quelli suoi successi senza alcun divario, et alterazione. . . .'

[2] For a general survey see introduction by Giulio Briganti to *I Bamboccianti* exhibition, Rome 1950.

and side-streets and no one bothers to look at the soaring obelisks or fountains dimly visible in the distance. The characters are a satisfied and lively peasantry, hard working and sober, merging almost imperceptibly into an urban proletariat of reasonable prosperity.

The most regular condition of the Italian peasant's life in the seventeenth century was one of extreme poverty punctuated by periods of real starvation. Grain shortages were endemic. Desperate and extraordinary measures totally failed to cope with them. In 1648 free pardons were offered to the bandits who ravaged the campagna if only they would bring corn into Rome. Beggars roamed the streets often in organised bands held together by strange rituals. Epidemics threatened the population herded together in overcrowded hovels. At frequent intervals the Tiber burst its banks and devastating floods swept through the low-lying parts of the city. Unrest was always present; when the Pope died and Rome was only partially governed by authorities with temporary powers this permanent discontent would become crystallised. Crime assumed terrible proportions, libels and riots came out into the open; soldiers were stationed at strategic points to prevent the mob destroying the statue which only a few years earlier a syco-phantic administration had erected to the Pope's eternal memory. And the soldiers themselves who came in large numbers to protect the princes and cardinals as they assembled for the conclave took part in the riots and fought with the regular police appointed to keep order. But such violence was prevalent enough without the occasion of a vacant papacy to provide further stimulus. The French and the Spaniards attached to their respective embassies lived in a state of permanent tension: often this exploded into bloody riots which the armed police of the popes found exceedingly difficult to repress.[1]

All this violence and misery was recorded with monotonous regularity by con-temporary diarists: yet we find only the barest hint of it in those works of the *bamboc-cianti* which have come down to us and which tend to convey a picture of untroubled serenity. The view from their window was evidently a somewhat restricted one. We do not find in their works the distortions of Georges de la Tour or the brutality of Jacques Callot; nor yet the vulgar buffoons that so many of their contemporaries accused them of putting into their pictures. It is certain that many *bambocciate* have not survived; yet few of those that have, or that are recorded in inventories, have that aggressively offensive character that their very vocal opponents claimed. How then should we interpret them? Certainly not as social protest. Only Michael Sweerts gives his peasants the dignity and monumentality that is almost polemically asserted by their contem-poraries in the paintings of Le Nain or Velasquez. Such an attitude was scarcely con-ceivable in seventeenth-century Rome where cultivated society and all who aped it looked upon the poor with extreme distaste. Arcadian sentiment was a purely literary phenomenon with no repercussions as yet on actual social behaviour or inclinations. 'It must not be imagined', wrote Giovanni Battista Doni of contemporary operatic performances, 'that the shepherds who are brought on to the stage are the sordid and

[1] Gigli *passim*, especially pp. 77, 162, 290, 324-5.

vulgar fellows who look after the flocks these days. . . .'[1] There is much point in Salvator Rosa's bitter protest about the welcome given to the *bambocciate*:

> Cosi vivi mendichi affliti e nudi
> non trovan da coloro un sol danaro,
> che ne' dipinti poi spendon gli scudi:
>
>
>
> Quel che aboriscon vivo, aman dipinto;
> perchè omai nelle corti è vecchia usanza
> di aver in prezzo solamente il finto . . .[2]

'What they abhor in real life they like to see in a picture'—within limits at least. The figures in the *bambocciate* are the 'good poor', and they are cut down to safely small proportions. Everyone insisted on this: 'Every day', wrote Passeri of Van Laer, 'he would paint pictures of varying size but with small figures, about one *palmo* ($22\frac{1}{2}$ cm.) high—never any bigger.'[3] Later the backgrounds were to increase—the hills and the trees, the churches and palaces with great flights of steps and spacious colonnades were to assume overwhelming proportions and engulf the little beggars and shepherds who lay at their bases; and then the poor would become purely 'picturesque' additions to the setting. It is an attitude that is already implicit even in much of the earlier work of the *bamboccianti*.

None the less, Pieter Van Laer did introduce something quite new into Italian painting; he and his followers brought within the scope of art an enormous range of new material; his shepherds were not those 'of the past when the profession was still a noble one'.[4] There had been some precedents of course—Bassano and Caravaggio perhaps, who are linked together in Bellori's denunciation of the trend, but how much more satisfying they had been for the cultivated *amateur*! And Caravaggio himself had never painted a secular painting of ordinary people going about their ordinary occupations. The proletarian models of his earlier works, dazzlingly dressed or undressed, are clearly adapted to a sophisticated, not to say corrupt, taste. And the deeply moving peasants of his later pictures always take part in a conventional religious scene. But Caravaggio's was the spiritual and aesthetic revolution that cleared the ground for the *bamboccianti*. For the first time the poor emerge from a shadowy background and are given as much prominence as the great or the sacred. His immediate followers in Italy only rarely pursued the line of development implicit in this attitude. A sober appraisal of daily life is not what we look for in their work, which recalls far more the fanciful and sometimes grotesque incidents of the picaresque novel. More significant had been some of the pictures of Annibale Carracci—the *Beaneater* in the Colonna gallery, for instance, or his drawings of the working classes at their daily occupations. But these

[1] G. B. Doni, II, p. 16: '. . . non debbiamo immaginarci, che i Pastori, che s'introducono, siano di questi sordidi, e volgari, che oggi guardono il bestiame. . . .'

[2] Rosa: *Della Pittura*, lines 255-8 and 262-5.

[3] Passeri, p. 72.

[4] Continuation of quotation in note 1, above: 'ma quelli del secolo antico, nel quale i più nobili esercitavono quest'arte'.

had only been incidental to a far more orthodox career, as had all such ventures until now. Thus there were no real forerunners to the *bamboccianti*, and this absence was in itself a significant indication of some of the difficulties which were bound to face any artist interested in breaking away from the recognised categories of painting.

When Pieter Van Laer came to Rome in 1625 he was already 31 years old, and hence a fully mature painter. He had grown up in the Protestant town of Haarlem where a tradition of 'realistic' painting was firmly established, free from the interference of aristocratic or idealistic prejudice. In Rome itself he associated with the newly formed *schildersbent*, and lived the typically 'bohemian' existence of its members. Thus by religion and social circumstances he was for some years at least totally cut off from official patronage. Unattached to the household of any prince or ambassador, he evidently sold his little scenes of peasant and animal life how and where he could—at the fairs of Corpus Domini, perhaps, and certainly to dealers.

Success came quite soon; within ten years he could ask 30/35 *scudi* a picture, an astonishingly high price, much more than many an established painter of the day could expect.[1] Indeed Van Laer soon acquired a reputation, which he never lost, of being a very expensive artist. But it is difficult to find out exactly who bought his works. Other painters, we are told, 'even those of some reputation looked at his pictures with great delight, and tried to possess some for themselves as examples of how to express reality so well'.[2] His Northern compatriots must have been in the forefront of these admirers; indeed we know that Hermann Swanevelt, the Dutch landscape painter, owned two.[3] It is a greater surprise to find that Pietro Testa himself, in later years so scornful of realism in art, was in touch with the world of the early *bamboccianti* and may therefore have owned examples of their work.[4] Quite soon the most influential patrons in Rome began to take a cautious interest in this new phenomenon. Niccolò Simonelli, the amateur dealer, a man very proud of his discernment as a collector, owned two for a short time—one showing a peasant with a lamb and a dog, the other a night scene— before exchanging them for something else.[5] Vincenzo Giustiniani, the especial protector of Caravaggio's Northern followers, acquired two rather uncharacteristic examples —a *Landscape with figures and animals* and a small scene of *St Eustace hunting*—though he did not bother to frame them. Even Cassiano dal Pozzo seems to have been tempted and to have owned one painting by Van Laer. Finally about three years before leaving Rome the artist dedicated a series of eight engravings of animals to Don Ferdinando

[1] In 1636 two small paintings by Van Laer were worth 32 *scudi*—see note 3, below.

[2] Passeri, p. 74.
Lely seems to have been an admirer, for in his sale catalogue (*Burlington Magazine*, 1943, pp. 185-191) various genre scenes are attributed to 'Bamboots'. For the reactions of painters to other *bamboccianti* see Baldinucci, VI, 1728, pp. 602-4.

[3] Bertolotti: *Artisti belgi e olandesi*, pp. 127 ff., reports the case brought by Swanevelt against Francesco Catalano of Benevento whom he accused of stealing two pictures by Van Laer. The testimony provides much useful information about the artist's circumstances.

[4] *ibid.*, p. 134.

[5] *ibid.*, p. 133. Another friend and admirer of Van Laer was the Roman merchant Bernardino Lorca—see letter of Sebastiano Resta dated 27 February 1704 published by Bottari, II, p. 106.

Afan de Ribera, the Viceroy of Naples—but, as will become clear, the Spaniards were at all times closely associated with the success of the *bamboccianti*.

For all this success Van Laer himself probably remained on the outer fringes of society and we must assume that the bulk of his clientèle was not made up of the great princes and the learned patrons who figure so prominently in this story but was to be found rather among the anonymous 'uomini di stato mediocre' about whom we know so little. It is therefore a significant sign of the times that he was able to make such a great impact on painting in Rome and indeed Europe. By the time he left Rome in about 1639 he had proved that the demand for his little genre paintings was large and rewarding. There were many ready to exploit it.

Among these was Michelangelo Cerquozzi, a Roman by birth.[1] He too probably began by selling his pictures cheaply to dealers before attracting the attention of connoisseurs. But his nationality, if nothing else, made his situation much easier and brought him into far closer contact with his patrons than had been possible for a foreigner such as Van Laer. Because of this, Cerquozzi's life and work perfectly illustrate the limits within which a 'realistic' painter could express himself in the essentially aristocratic society of seventeenth-century Rome.

He too was much admired by his fellow-artists. His two closest friends were painters—Domenico Viola and Giacinto Brandi—and he was on excellent terms with Pietro da Cortona. He was always generous with younger men and he went out of his way to encourage his potential rival Giacomo Borgognone. We also know that some of his most important admirers and patrons came from the professional classes. There was, for instance, the distinguished lawyer Raffaelo Marchesi to whom he bequeathed some of his works, and the doctor Vincenzo Neri whom with a group of other friends he immortalised in one of his finest paintings (Plate 22a).[2]

Cerquozzi was soon taken up by some of the leading aristocratic families, but of a kind rather different from those who circled round the Barberini court and helped to spread the fame of artists such as Romanelli, Poussin and Testa. His first great successes were apparently painted for an official at the Spanish Embassy and it is possible that he may have been employed there at the very time that Velasquez came to stay as a guest of the Ambassador Monterey in 1630.[3] There is also some evidence to suggest that both Cerquozzi and Velasquez painted *bambocciate* for the most important of the Hispanophil clans in Rome, the Colonna, though this is more likely to have been during the great artist's second visit.[4] Certainly Cerquozzi's career was closely linked to Spain and her supporters in Rome. He himself used to wear Spanish dress and until his later years

[1] See the lives of Cerquozzi by Passeri and Baldinucci and also his will published by Bertolotti in *Arte e Storia*, V, 1886, p. 22. [2] *ibid.*

[3] Baldinucci, VI, 1728, p. 190. It is however exceedingly unlikely that this early work was painted in 1615 when the artist was aged only 15. Van Laer did not come to Rome until 1624. The significance of Cerquozzi for Velasquez was pointed out by Roberto Longhi in 1950, and though his attribution to Velasquez of the so-called 'Rissa all'ambasciata di Spagna' is not altogether convincing, the general point is valid, and it is perfectly reasonable to assume that the two men may have met at the Spanish Embassy.

[4] In Ghezzi's notes on the Colonna collection (see p. 125, note 1) there is a reference to *Due bambocciate di Velasco*. Cerquozzi certainly painted a good deal for the Colonna—see Ferdinando Colonna.

Plate 21

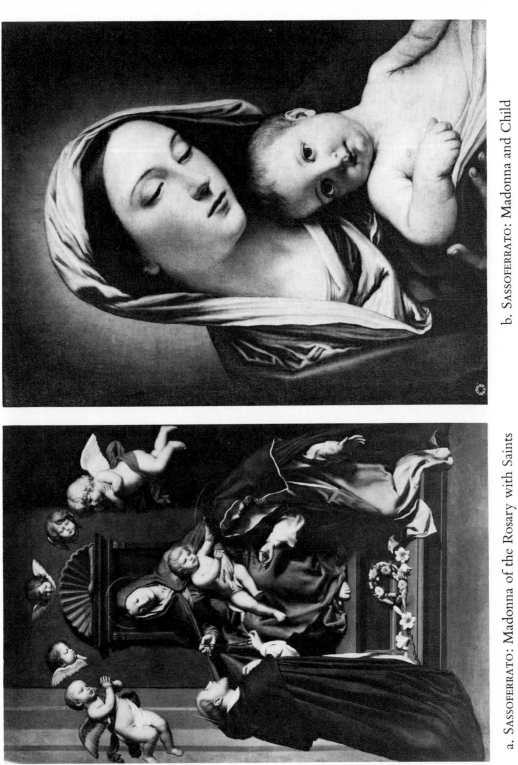

b. SASSOFERRATO: Madonna and Child

a. SASSOFERRATO: Madonna of the Rosary with Saints

Plate 22

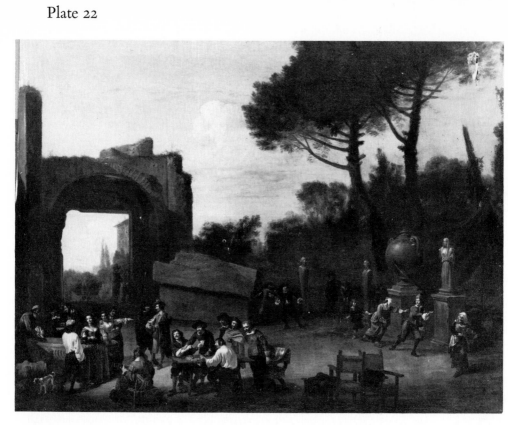

a. CERQUOZZI: The artist with a group of friends

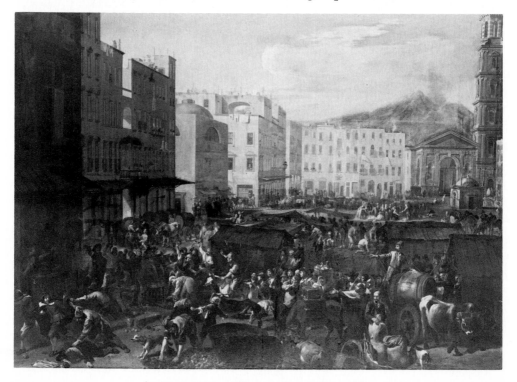

b. CERQUOZZI: The revolt of Masaniello

Plate 23

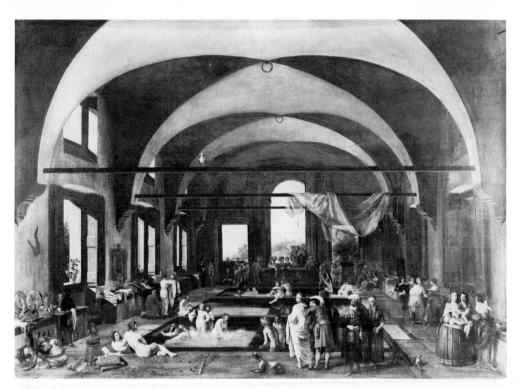

a. CERQUOZZI: Women's bath

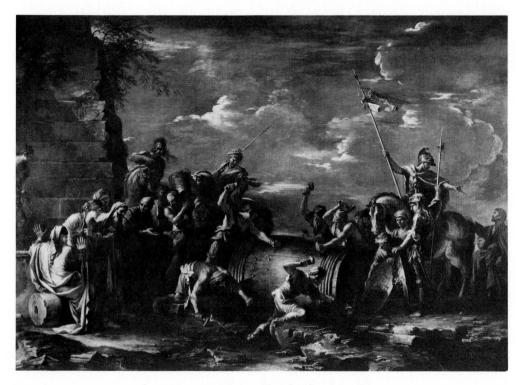

b. SALVATOR ROSA: The death of Regulus

Plate 24

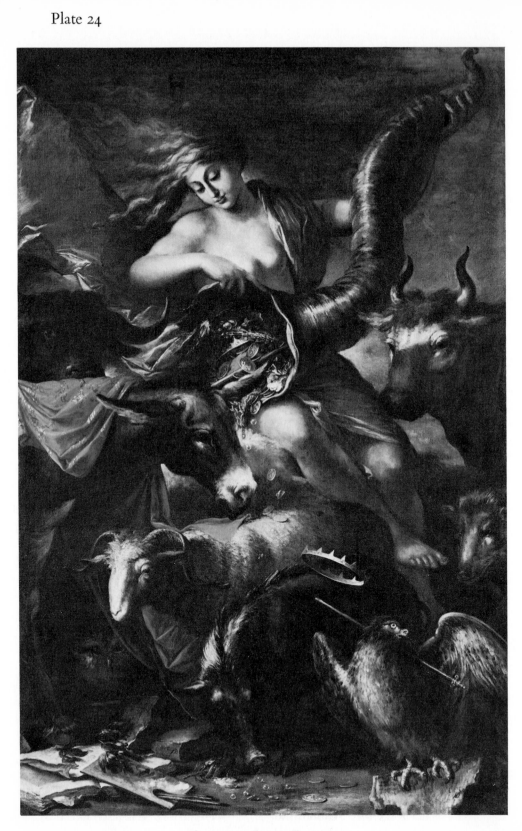

SALVATOR ROSA: Fortune

nearly all his more important patrons were within the Spanish sphere of influence. In 1647, for instance, he was collaborating with Jan Miel, Giacomo Borgognone and others on the illustration of the second volume of Famiano Strada's *De Bello Belgico*, a celebration of Alessandro Farnese's campaigns on behalf of the Spaniards in the Low Countries; Cardinal Rapaccioli, who died in 1657, and who owned many of his pictures, was boycotted by the French in the conclave of 1655 because of his Spanish affiliations[1]; Monsignor Raggi, another of his admirers, was a Genoese and also devoted to the Spanish cause. So too was the Modenese Count Camillo Carandini.[2]

Whatever their political affiliations, most of these families showed a striking contrast in taste with the more cultivated Barberini circle. They tended to ignore the grander history painters and the noble balance between classicism and Venetian colour which these artists were fostering as well as the exuberance of the Baroque. Again and again we find them concentrating on landscape painters such as Gaspard Dughet or Salvator Rosa as well as on other artists who specialised in subjects similar to those of Cerquozzi—Jan Miel, for instance, or Giacomo Borgognone, the battle painter—and *bamboccianti* of later generations. Three of Cerquozzi's most enthusiastic patrons, the Counts Carpegna and Carandini and Monsignor Raggi, were all collectors of this type of picture.

And yet his success with the aristocratic society of Rome is certainly reflected in his art. As far as dating can be established at all, it seems that the small pictures with scenes from popular life belong mostly to his early years when he was closely following Van Laer and largely working for dealers, but that later he turned more and more to much larger pictures, which were painted to commission, and that he then widened the range of his subject-matter. There is not much reason for believing that this change was the direct result of specific pressures from his patrons, for we know that the more authentically popular and coarse *bambocciate* continued to fetch very high prices.[3] Rather it seems to have sprung naturally from his closer association with them and, consequently, from a gradual acceptance of their values—a process not unknown among artists of all kinds since Cerquozzi's day. It may not be extravagant to see his dilemma reflected in the manner of his private life—the life of a man who painted the essentially anti-Spanish common people for sympathisers with Spain[4]: careful and conscientious in his

[1] In 1654-5 the French Ambassador reported that Rapaccioli was 'autant Espagnol que Cardinal'—Valfrey, p. 220.

[2] Raggi's patronage of Cerquozzi is mentioned by Baldinucci and is confirmed by the fact that in 1701 the Marchese Raggi lent 'cinque quadri bellissimi bislunghi tutti d'una misura' by the artist to the exhibition at S. Salvatore in Lauro—Ghezzi papers in the Museo di Roma.

Conte Camillo Carandini (1619-1663) is referred to briefly in the history of the family by G. A. Lotti of 1784. I am most grateful to the Marchesa Elisa Carandini for drawing my attention to this book.

[3] Even in Florence the Marchese Filippo Corsini was proud to own a painting by Jan Miel of a 'barone, che in atto di sedere, attraversatosi alle ginocchia un piccolo fanciullo, con un certo suo straccio gli toglie l'immondezza dalla deretana parte'—Baldinucci, VI, 1728, p. 368.

[4] In 1642 Amayden reported that on the French side were the 'bottegari e Gente bassa' and on the Spanish side the 'Gentiluomini e cittadini più onorati'—*Relazione della Città di Roma fatta nell'Anno 1642*—MS. in Biblioteca Casanatense, Rome, 5001. Amayden was a Spanish protégé and this should be borne in mind when evaluating his report.

work, the friend of princes and prelates, yet coarse and vulgar in his speech; ordering a couple of artichokes on his deathbed 'che io mi voglio saziare a mio modo' in an almost symbolic last minute return to the popular life he had so often depicted, and then buried with full pomp by the Accademia di S. Luca, by now the very stronghold of that classical idealism which he had seemed to thwart but which had perhaps thwarted him.[1] In fact, once Cerquozzi was taken up by the Roman aristocracy it became almost impossible for him to paint the life of the very poor with sympathy and under-standing.

This is apparent in his large still lifes with figures—lush clusters of grapes cascading down over prettified boys and girls, somewhat sentimentally or erotically posed.[2] In these pictures he showed that he was quite prepared and able to move away from the direct observation of the life which he saw around him 'without any kind of alteration' —the claim that Passeri made for Van Laer. Indeed, his reputation to some extent rested on the extraordinarily imaginative nature of his talents—his ability to paint scenes he had never actually witnessed himself. And these paintings could be admired by his contemporaries for certain purely aesthetic elements—'that exquisite quality of his paint and colour which made it appear like crushed jewels'.[3] This, presumably, was the appeal of his work to a cultivated connoisseur such as Cardinal Massimi, the admirer of Claude, Poussin and Velasquez, but also the owner of four scenes of country life by Cerquozzi.

Above all he specialised in battle pictures, a more respectable genre than *bambocciate*, and one in which his success is testified by the nickname of 'Michelangelo delle Battaglie'. His work in this field demonstrates the truth of Fritz Saxl's subtle analysis of the 'battle scene without a hero'—pictures painted for a society that was only indirectly affected by the wars that raged throughout Europe during most of the seventeenth century.[4] Brilliantly dressed cavaliers charge at each other; solidly built horses collapse and trample soldiers underfoot; the air is lit up with the flames from discharged guns and smoke rises to the clouds; afterwards the dead are plundered, the wounded are treated, and couriers are sent off to announce victory. Victory for whom? That hardly mattered; the attraction of these pictures lay in the opportunity that they offered for vicarious participation in battles that were changing the shape of Europe far outside the backwater into which Italy had now sunk. Such detachment also played its part in stressing the 'realism' of the scene. The anti-heroic confusion, the smoke rising from distant battle-fields—at times these almost seem to foreshadow Stendhal's equally incoherent, though far more subtle, view of Waterloo.

Cerquozzi's position was naturally affected by the death of Urban VIII, when exclusive French influence came to an end and his natural patrons, the Spanish party, began to occupy the centre of the stage. A crisis may have occurred in about 1648 when

[1] Passeri, p. 289.
[2] Briganti, 1954, pp. 47-52.
[3] Passeri, p. 288.
[4] Saxl.

he probably painted one of his masterpieces *The Revolt of Masaniello* (Plate 22b). The circumstances are very mysterious and in many ways the picture marks something of a turning-point in his career, for such records of contemporary events were almost unknown in Italian art of the seventeenth century unless specifically associated with a particular patron.[1] Who commissioned this remarkable picture? We only know that by the end of the century it belonged to the Spada collection.[2] If it was actually painted for Cardinal Bernardino, who brought together most of the pictures in the palace, it must surely have had some political significance. For Spada who had been papal nunzio in Paris was firmly in the French camp. Indeed a few years later Mazarin told the supporters of France to vote for Spada in the conclave that followed the death of Innocent X: but the plan came to nothing for the Spaniards used their veto.[3] Cerquozzi, deeply committed to the Spanish cause, painting the spectacle of their most humiliating defeat for the most Francophil of Cardinals—it was typical of much in his career. The picture itself is inscrutable; never was Cerquozzi's 'neutrality', his anti-heroic element, so much in evidence. Vividly it portrays the events of 7 July 1647 with the most scrupulous accuracy, a remarkable instance of objectivity exercised on a subject that stirred the passions of Europe.[4] It has none of the melodramatic features that we find in the portraits of the fishmonger destined to pass into Neapolitan folk-art. Compared to the almost mediaeval vision of Cerquozzi's contemporary Micco Spadaro who depicts Masaniello like some early saint twice in the same canvas—in the background exhorting the crowd with his crucifix, in the foreground at the height of his power, in velvet headdress and white plumes on his way to visit the Spanish viceroy—the Roman seems cold and detached.[5]

With the *Revolt of Masaniello* probably began Cerquozzi's main phase of collaboration with the architectural painter Viviano Codazzi who arrived in Rome from Naples towards the end of 1647 and who may well have supplied the eye-witness account on which the picture is based.[6] The collaboration was of great importance because it confirmed Cerquozzi's move away from the more simple and direct presentation of peasant life towards the grandiose and even the exotic. Some time after 1657, only three years before Cerquozzi's death, the two artists painted several pictures for Cardinal Flavio Chigi, nephew of Pope Alexander VII and consequently the most influential

[1] The most extraordinary case of such a painting is *The Death of Wallenstein* by Pietro Paolini—see Marabottini, 1963.

[2] Baldinucci, VI, 1728, p. 192, says only: 'si vede nel Palazzo del Bali Spada. . .'.

[3] Leman, pp. 13 ff., and Hanotaux, p. 9.

[4] There are a number of accounts of Masaniello's revolt, but for the immediate impact it made in Rome at the time see the dispatches of Cardinal Filomarino published in *Archivio Storico Italiano*, IX, 1846, pp. 379-393.

[5] Micco Spadaro's pictures are in the Museo di S. Martino, Naples.

[6] To claim as Professor Longhi and Estella Brunetti (1958, p. 311) have done that Codazzi was painting with Cerquozzi and others in Rome between 1625 and 1635 is to fly in the face of Codazzi's own words of 1636: 'Io venni dalla predetta mia patria [Bergamo] da quindici anni e venni in Napoli, et sempre ho abitato in Napoli al Baglivo'—Prota-Giurleo, p. 77. None of Dr Brunetti's evidence, stylistic or documentary, seems to me to be really conclusive and I can see no reason for not assuming that the collaboration between the two artists began in Rome after 1647.

patron in Rome.[1] Two of the works that Cerquozzi, now at the centre of the artistic scene, painted for him stand out for their curious subjects, about which we can only say that they are certainly not representations of anything seen in seventeenth-century Italy. Indeed no actual villa or palace ever corresponded to the vast, fantastic structure that Codazzi envisaged as the setting for Cerquozzi's princely family in *The Arrival at the Palace*, although these figures, with coach and horses, retinue and dogs, are acutely realised as, still more, are the peasants selling water melons or lounging on the ground unperturbed by the general grandeur. Still less plausible is the vaulted *Women's Bath* (Plate 23a)—in itself a surprising choice for a cardinal, were it not for the fact that Chigi 'only thought of hunting, of conversations and of banquets in order to overcome the venereal impulses which powerfully raged within him'.[2] A turbaned Oriental wistfully surveys the scene while elegant young dandies prepare to make the most of the obvious opportunities that await them. Though the dress is certainly contemporary, the events described must surely refer obliquely to the notorious *stufe* of Renaissance Rome or perhaps evoke some traveller's tales from the East. So far had Cerquozzi moved from his original inspiration.

The allurement of a predominantly aristocratic patronage was the most important but not the only obstacle that stood in the way of a school of 'realistic' painting in Rome; there was also the antagonism to such painting expressed on theoretical grounds —in some circles even before the arrival of Van Laer and later to become a widely held dogma. This need not in itself have proved decisive, for the very bitterness with which contemporary writers reported the success of the *bamboccianti* shows that many patrons were far outside the reach of such theoretical considerations when buying pictures. But it did serve to keep the *bamboccianti* in an inferior position from which they were always tempted to extricate themselves once they had achieved any success. Cerquozzi toyed with becoming a 'history painter' and Jan Miel also found himself veering between a profitable *bambocciante* manner, which earned him discredit in the social circles to which he aspired, and the more acceptable branch of 'history painting' which was far less suited to his talents.

To a large extent the theoretical objections to the *bamboccianti* were the direct outcome of the very conditions which had made their success possible: the democratis-ation of art and its wider response to a growing public. Rome in the seventeenth century was a society of constantly changing *nouveaux-riches* and parvenus desperately anxious to conceal the fact by marrying into the great old patrician families, now bereft of

[1] Once again it cannot be conclusively proved that the two pictures, along with a number of others recorded by contemporary sources and still in the collection of the Chigi descendants, were actually painted for Cardinal Chigi although all writers of the time refer to his owning them and they are listed in his inventories. There is, however, no document showing any actual payment to Cerquozzi and it is just conceivable—though most unlikely—that these pictures also were painted for the Colonna and then acquired with many others by the Chigi in 1661 when they bought the palace (later Palazzo Odescalchi) at SS. Apostoli with all its contents from the Colonna—Golzio, 1939, p. 3.

[2] From a report by Ferdinando Raggi, Genoese diplomatic agent in Rome quoted by Achille Neri, 1883.

power and bankrupt. But an aristocratic taste had to be acquired as well as aristocratic relations, and the problem was not always as easy to solve. Again and again the attacks launched on the *bamboccianti* by other artists and theorists were deliberately designed to rub this sore spot of the new ruling class. The most powerful plea to snobbery was scarcely even concealed by more abstruse considerations. Admiration of the trivial world of Van Laer and Cerquozzi was contemptible because it was widespread, an attribute of the crowd rather than the connoisseur. All the still embryonic distinctions between the general public and the man of taste were pressed into service to discredit the movement, and in the course of these attacks the *bambocciate* were described in terms that often bore little resemblance to the actual pictures. And inevitably the onslaught grew more fierce as that more 'liberal' form of connoisseurship, which was one of the reasons for Cerquozzi's success, became more widespread.

His early admission into the Accademia di S. Luca shows indeed that in the 'thirties there was no hostility from that quarter.[1] The attacks seem rather to have reached their peak in the late 'forties and 'fifties, at the time when he was achieving his greatest triumphs. This was a period of acute financial depression, and no doubt the success of the *bamboccianti* was linked to their considerably cheaper prices in the struggle for survival. Indeed this is one of the charges specifically brought against them by the many artists who were among their most ferocious enemies. Guido Reni (who died in 1642) was among the first of these, but the terms in which he expressed his hatred of the movement make it reasonably clear that his biographer Passeri was attributing some of his own feelings to the master.[2]

In 1651 came a famous exchange of letters between Andrea Sacchi and Albani.[3] The Roman artist wrote to his ageing master in Bologna to tell him of the success of the *bamboccianti* and to ask for his opinion on the matter. This came quickly enough in the form of a stream of abuse. But though the correspondence has always been treated as of cardinal importance in the history of the movement, in fact its significance is not altogether clear. When Sacchi wrote to Albani of this new and deplorable phenomenon, the *bamboccianti* had already been painting for a quarter of a century. And the reference to their earning six or eight *scudi* for a picture is absurd, as both artists must have known.[4] Long before this the leading figures had been charging several times that sum. Though Albani and Sacchi no doubt held the hostile views attributed to them, it seems quite possible that the letters themselves were carefully doctored by their not very scrupulous editor Malvasia. Two points, however, stand out: that intense hatred for the *bamboccianti* developed relatively late, when for the first time they were being taken seriously by the grandest patrons, and that financial questions played a considerable part in their success and in the opposition they aroused.

[1] Hoogewerff, 1913, p. 50.
[2] Passeri, p. 96.
[3] Malvasia, II, pp. 179 ff.
[4] Between 1646 and 1648, for instance, Don Antonio Ruffo bought a battle picture by Cerquozzi, size 4 × 6 palmi, for 80 ducats. By 1671 a Van Laer, size 4 palmi, was valued at 350 ducats—Ruffo, p. 189.

– iv –

Some years earlier another opponent with very mixed motives had joined the virulent onslaught. Salvator Rosa's career was confused with and bedevilled by the triumph of the *bamboccianti* from the very start. On his arrival in Rome in 1637 one of his first patrons had been the amateur dealer Niccolò Simonelli who also showed an interest in Pieter van Laer.[1] Driven from Rome not long after, partly through the hostility of the all powerful Bernini, he settled in Florence only to find there some of Michelangelo Cerquozzi's keenest admirers, above all the Corsini and Salviati families. Cerquozzi and Rosa were considered to be rivals as landscape painters[2]—an outrageous insult to Salvator who looked upon himself as a serious painter of moral 'histories', only compelled to indulge in landscapes and battles because of the obtuseness of his clients. Back in Rome in 1649 he found Cerquozzi more fashionable than ever. Unable to bear the situation, he launched into the attack.[3] After enumerating the sort of subjects that were treated by the artist and his followers, he too showed that his real bitterness was reserved for their patrons: 'And these pictures are so much admired that they can be found magnificently framed in the apartments of the great.' That was the real insult. But still the *bamboccianti* pursued Rosa. No sooner was Cerquozzi safely dead in March 1660 than he found himself having to buy a copy of a Van Laer to gratify his closest friend Giambattista Ricciardi.[4]

Rosa's career was, in fact, a tribute to the good judgement of a wide variety of Roman connoisseurs who compelled him to stick to the small romantic landscapes which show his true genius. But to him it appeared very different. He was desperately anxious, and even prepared to humiliate himself, to be given some great public commission and it is somewhat surprising that he so dismally failed.[5] Far worse painters than he were given the chance, and his bitter quarrels with the Accademia di S. Luca would not have deterred a really authoritative cardinal. However, there is little doubt that Rosa wished above all to find some Cassiano dal Pozzo or Camillo Massimi to foster what he considered to be his special talent—the painting of tragic and complex allegories and histories. Though he referred to him only once in passing, he seems to have visualised himself as a Poussin working for a cultivated élite, and curiously enough when settled in Italy at the end of the century Lord Shaftesbury drew a parallel between these two 'honest moral men' who had, so he heard from 'old virtuosos and painters', been good friends.[6] But Rosa never succeeded in his ambition. In Florence he did indeed find himself at the centre of a brilliant society where his talents for conversation, music,

[1] Passeri, p. 388. It was Simonelli who in 1638 arranged for the exhibiting of Rosa's *Tityus* at the Pantheon.

[2] Baldinucci, VI, 1728, p. 191.

[3] The date of Rosa's satire on Painting is not certain. It was mentioned for the first time in a letter of 1651 and may have been written in Florence. For an analysis see Limentani, 1961, pp. 163-79.

[4] Letter from Salvator Rosa to G. B. Ricciardi dated 2 April 1660—de R....ldis, 1939, p. 109.

[5] See the lives of Rosa by Passeri and Baldinucci.

[6] Shaftesbury, *Second Characters*, p. 15. As far as I am aware this interesting passage has never been noticed by art historians.

poetry and mime were as much admired as his painting, and it is true that in Rome also he fascinated a number of highly placed churchmen, but never in the way that he really wanted. 'I know that as a Stoic you would mock all this,' he wrote to a friend, describing some social success, 'but what is one to do? He who cannot have the roast meat must needs satisfy himself with the aroma.'[1] With its combination of bitterness, assumed self-depreciation and homely proverb the phrase is characteristic. So too is the allusion to Stoicism. All over Europe this philosophy had been gaining ground ever since the late sixteenth century until for some daring thinkers it virtually replaced Christianity as a guiding creed. Even when not so intense it still coloured the ethics and imagery of men of action and artists alike. With its proud disdain for the vicissitudes of fortune it was a philosophy well suited to the storm-tossed seventeenth century. And as men are more likely to look to their beliefs for support in misfortune than for self-control in triumph, it particularly appealed to those who felt that the world had treated them badly or that its more ostentatious prizes were not for them. Plutarch and Seneca were ransacked for quotations, and innumerable paintings recorded the deeds of the virtuous, iron-willed heroes of antiquity. Salvator Rosa, in particular, would passionately study the Stoics and search in their writings for themes for his pictures and prints. But far from tapping a responsive chord in a public which doted on such stories, he would find that his potential clients only wanted his landscapes, small ones at that, 'always they want my small landscapes, always, always, my small ones'.[2] He did not make it easy for them. When the unfortunate prelate who was responsible for this outburst tactfully enquired about the price of a large picture, Rosa merely answered 'a million', and thus ended the discussion.[3] In another fit of ill-temper he wrote: 'I am delighted that these pictures of mine are going to the bad, so that people will forget that I ever painted landscapes.'[4] Of course they did not forget, for he was keenly and rightly admired. But always by the wrong people—those who specialised in *bambocciate*, like the Conte Carpegna and the Marchese Teodoli, or those whose tastes were notoriously frivolous like the Duke of Modena who wrote to his agent in Rome asking for battles by Rosa and Borgognone, flower pictures by Mario 'de Fiori' and Cerquozzi, landscapes by Gaspard Poussin and fables by Pier Francesco Mola.[5] Only rarely did the learned connoisseurs whom he hoped to impress with his frigid and rhetorical history paintings show any interest.

His greatest patron in Rome was his banker, Carlo de' Rossi, brother of the famous composer Luigi and himself a talented musician.[6] De' Rossi paid him a regular 6 per cent. interest on the 4000 *scudi* that Rosa deposited with him, but in 1667 the two men quarrelled bitterly—'he has treated me very meanly and showed little gratitude',

[1] Letter to Ricciardi of 9 October 1666—Limentani, 1950, p. 138.

[2] Baldinucci, VI, 1728, p. 581. Rosa referred to himself as a Stoic in a letter to Ricciardi dated 27 May 1651—Limentani, 1950, p. 79.

[3] Baldinucci, VI, 1728, p. 581.

[4] In 1666—de Rinaldis, 1939, p. 191.

[5] A. Venturi, pp. 264-5.

[6] Limentani, 1950, p. 139.

claimed the artist.[1] Before that, however, De' Rossi had assembled what amounted to a private museum of Rosa's works consisting of a large gallery and several small rooms.[2] In these he hung allegorical and history paintings such as the *Prometheus*, *La Fortuna* and above all the artist's masterpiece, *Regulus killed by the Carthaginians* (Plate 23b), in which Rosa's grudging obligation to the *bamboccianti* and instinctive love of the picturesque are raised to high, heroic tragedy through his study of the Stoic historians. De' Rossi also obtained quantities of the smaller pictures which Rosa so affected to despise— battles, sea pieces, landscapes and weird scenes of witchcraft—and he combined his esteem for the artist with a shrewd sense of business by filling the family chapel in the Madonna di Montesanto with altarpieces which Rosa painted without charge so as to make at least one appearance in public.[3]

Yet De' Rossi, for all his friendship, was no Dal Pozzo. There is no evidence to suggest that he ever gave Salvator Rosa the encouragement and intellectual stimulus which he clearly wanted despite his show of bravado. To find such a patron Rosa had to turn to Florence, the home of his closest friend the poet Giambattista Ricciardi. For him he went on painting a number of pictures long after he had settled in Rome and to him he looked for constant advice: 'if you happen to get hold of some lively story involving a soldier with a woman I would be very grateful . . .', he wrote on one occasion.[4] Or again, in a revealing letter: 'Remember that I want something new with only a few figures. And as the canvas is a tall one, it would not matter if there had to be a figure in the air above the clouds or something. I had wondered (if you thought so too) whether that image in Virgil's *Georgics* might not be suitable: when Justice departs from the Earth and leaves her sword and scales with some shepherds. Do please think about this; Rome has heard that I have the most original ideas, and so I must live up to this reputation as much as possible.'[5]

To Ricciardi too he disclosed those astonishing impressions of the landscapes he visited which showed how deeply felt and genuine was the romantic sentiment in his painting. The country, he wrote,[6] 'is such an extravagant mixture of the horrid and the tame [d'un misto cosi stravagante d'orrido e di domestico], of the flat and the precipitous, that the eye cannot hope to find anything more pleasing. I can swear to you that the colours of one of those mountains are far more beautiful than everything I have seen under the Tuscan sky. Your Verrucola (which I used to think had a certain horrid quality) I will in future call a garden by comparison with the mountains I have crossed. Good God, how many times I wanted you with me, how many times I called to you to look at some solitary hermit sighted on the way—Fate alone knows how much they tempted me! We went to Ancona and Sirolo and on the way back to Assisi over and above the journey—all places of extraordinary fascination for a painting.

[1] De Rinaldis, 1939, p. 199.
[2] Baldinucci, VI, 1728, p. 570. There is also a reference to De' Rossi's collection in Bellori's *Nota de' Musei*. [3] *ibid.* p. 569. The paintings are now at Chantilly.
[4] De Rinaldis, 1939, p. 17—Letter of 24 April 1651.
[5] *ibid.*, p. 19—Letter of 12 May 1651.
[6] Bottari, I, p. 450. Letter of 13 May 1662.

'At Terni (that is four miles off our road) I saw the famous waterfall of the Velino, the river of Rieti. It was enough to inspire the most exacting brain through its horrid beauty: the sight of a river hurtling down a half-mile mountain precipice and raising a column of foam fully as high. Believe me, nowhere there did I look or move without thinking of you. . . .'

Would Ricciardi, in fact, have responded to Rosa's precocious eighteenth-century enthusiasm? As his letters have not survived, we must accept the artist's trust, but nothing in his frigid and pedantic literary work suggests that he was the sort of man to have any true appreciation of Rosa's qualities. He was certainly a devoted and much-loved friend, but Rosa does not seem to have thought very highly of his artistic judgement: 'the little picture which you consider to be Florentine seems to me to be Flemish, and the one which you damn I find the least bad', he wrote on one of the rare occasions he ever discussed pictures other than his own.[1] And, in any case, Ricciardi lived in a different town and could not therefore give him the personal patronage he wanted.

Thus Rosa, despite his immense, though fitful, artistic and social success, was rather an isolated figure, proud and melancholic though buoyant, fiercely independent and contemptuous of most of his fellow-artists, a failed intellectual painter whom no one would take seriously and who was all too frequently confused with the *bamboccianti*—the very artists who most consistently rejected the elevated moral and poetic qualities to which he so avidly aspired. It was in these circumstances that he found it necessary to launch the onslaught on conventional patronage which has already been described: to use every method open to him to impose the image of an intensely serious artist of a wholly new kind.[2] Failing to appeal to a select clientèle of fastidious tastes, he was paradoxically forced to look beyond even the outer circles of contemporary patronage, and thus, as Passeri points out in commenting on his situation, 'by one of those strange and unavoidable accidents that intervene in the affairs of this world, his pictures could be seen not only in many houses belonging to gentlemen and princes but also in those owned by "persone di mediocre stato" '.[3] It can scarcely have comforted this most disdainful of artists to know that such pictures must have been of a higher quality than any that had yet been seen in such humble dwellings, but perhaps, like Luca Giordano, 'he used three brushes—one of gold to satisfy the nobility, one of silver for private citizens, and one of copper for the populace'.[4]

[1] De Rinaldis, 1939, p. 164—Letter of 31 May 1664.
[2] See Chapter I.
[3] Passeri, p. 396.
[4] De Dominici, IV, p. 186.

Chapter 6

THE DECLINE OF ROMAN PATRONAGE

– i –

IN August 1645, a little more than a year after the death of Pope Urban VIII, Poussin wrote to his Parisian patron Chantelou, who was trying to buy some antique marbles, that 'things in Rome have greatly changed under the present papacy and we no longer enjoy any special favour at court'.[1] But it was not only French interests that suffered with the election of the Hispanophil Giambattista Pamfili as Innocent X. The arts as a whole received a blow which had the most lasting consequences. Many factors were involved, great and small: the European balance of power and the political ambitions of a single family; economic collapse and individual quirks of temperament; plague, starvation, sudden death and changes of fashion.[2]

The decline had already begun some three years earlier with the outbreak of the War of Castro, a little town belonging to the Duke of Parma but situated well within papal territory.[3] A series of financial disputes with the Duke led to his excommunication and the rapid occupation of the town. But the campaign which had begun so well suddenly changed its nature when France, Tuscany, Venice and Modena banded together, either openly or in private, to put an end to what had now become an ambitious Barberini scheme to extend their private dominions. Don Taddeo showed his disastrous limitations as commander-in-chief; foreign troops once more marched on Rome and the panic of a second 1527 swept through the city. New taxes were raised, private silver was confiscated. This was hardly the moment for artistic patronage. In March 1644 a humiliating peace was signed, and, soon after, Urban VIII died amid the execration of his subjects.[4]

The Conclave that followed was particularly stormy. In Rome armed guards were called in to defend the principal palaces from roaming mobs, and clashes were frequent. The civic authorities made a feeble attempt to take over responsibility, only to be overruled by the College of Cardinals. The Pope who emerged from all this confusion, Innocent X, was inclined neither by race—he was a Roman, a nationality notorious to this day for its lack of interest in the arts—nor by his financial situation—wholly chaotic after twenty years of Barberini extravagance—nor yet by personal temperament to continue the sumptuous patronage that had distinguished the previous reign. Only ambition remained; and here he faced a difficult problem. For he had only one nephew,

[1] *Correspondance*, p. 316.
[2] Passeri, p. 301, gives a very vivid account of the situation. See also Haskell, 1959.
[3] Pastor, XIII, pp. 881-95.
[4] For the effects of the war in Rome see Gigli, pp. 203-40.

Camillo. Should this young man of 22 be given political power in the only manner possible by being made a cardinal or should he be encouraged to marry and found a princely dynasty? The Pope hesitated, and then decided that the second course was the right one. An outsider was brought in as Secretary of State, while, undeterred by the disastrous failure of Taddeo Barberini, Camillo was made commander-in-chief of all the land and sea forces and governor of the more important strong points. Hardly had this been settled when the plan was changed. In November, only two months after these arrangements, Camillo was made Cardinal nephew and given a pile of benefices. He began his duties as legate at Avignon with some enthusiasm, which rapidly decreased when he found that the Pope and the already appointed Secretary of State firmly retained all serious political authority in their own hands. And so, once again, he changed his mind and in 1647 he went through the almost unheard-of procedure of resigning his cardinalate and marrying. In these complicated manœuvres he had been alternatively encouraged and thwarted by his formidable mother, the Pope's sister-in-law, Donna Olimpia Maidalchini. This legendary figure, whose dominating position in Innocent X's court, led to endless scandals and ferocious quarrels, was shrewd, greedy and ambitious. Above all she was excessively jealous of anyone replacing her as the first lady in Rome, and she showed her displeasure at Camillo's marriage by making sure that neither he nor his wife should be allowed into the city.[1]

All this will have made it clear that for some years Camillo Pamfili was in no position to replace Francesco Barberini as the leading art patron in Rome. The Barberini themselves fled when an investigation of their incomes was threatened and the 17-year-old Francesco Maidalchini who was chosen by his aunt Donna Olimpia to supersede Camillo as papal nephew was clearly not destined to make an impact on Roman culture.

Thus it was the Pope himself who directed what patronage there was. He was determined on two things: to erect the usual great family palace and ecclesiastical buildings and to make as little use as possible of the artists most closely associated with his predecessor. Pietro da Cortona carried on working for the Oratorians; Bernini undertook his first large private commission for a generation—the Cornaro chapel in S. Maria della Vittoria with the famous *St Theresa*—and expressed the bitterness of his feelings in a group of *Time unveiling Truth*. His official career reached its lowest point when, under the chairmanship of the Pope, a special committee decided to pull down the first of the two proposed campaniles which he had added to the façade of St Peter's for Urban VIII. His place as leading architect was taken by two men—Girolamo Rainaldi, a totally unfashionable figure nearly thirty years older than himself, and Francesco Borromini, his hated rival. Rainaldi planned the vast palace on the Piazza Navona where Innocent had lived as a cardinal, and Borromini took over the complete remodelling of St John Lateran, the Cathedral of Rome, whose decrepit and still largely mediaeval condition was the more glaring by contrast with the splendour of Urban VIII's decoration of St Peter's. Both these major works were somewhat 'reactionary' in

[1] Besides Pastor, XIV, see Ciampi and Brigante Colonna.

character, as were most of those created under Innocent's auspices—the family palace because of Girolamo Rainaldi's age and limitations, the church because of the inhibiting instructions given to Borromini. These will not at once be apparent to the visitor struck by the dazzling white interior of the Lateran basilica and the fantasy of its ornamentation which, as he will subsequently learn, replaces frescoes by Gentile da Fabriano and Pisanello destroyed during the rebuilding. In fact, however, Borromini, the most daring of Baroque architects, was told to preserve the essential structure of the old basilica and thus had to use his brilliantly imaginative gifts on decoration rather than on the designing of a wholly new cathedral. Moreover, the financial troubles which afflicted Innocent's reign made it impossible for him to replace the sixteenth-century wooden ceiling with the vault that he had planned.[1]

Bernini also lost his position as the most favoured sculptor of the day and was replaced by Alessandro Algardi, who not only made busts of Innocent and Donna Olimpia, but was given vital commissions in St Peter's and in the construction of a villa for the Pope's family. In all these he moved away from the warmth and vigour typical of Bernini and adopted a colder, more classical manner that fitted in well enough with the disillusioned atmosphere of the 'forties. In fact, however, Bernini's achievements and reputation were too great for him to be neglected for long, and with his Fountain of the Four Rivers in the Piazza Navona, the square that Innocent made the centre of his patronage, he climbed back quickly to favour though not yet to his previous position of complete authority.[2]

It was not until the end of 1651, seven years after the change of papacy, that Pietro da Cortona was given his first official commission—to fresco the ceiling of the gallery in the papal palace in the Piazza Navona. The palace itself had been assigned to yet another substitute for a true papal nephew, Camillo Astalli, inevitably a relation of Donna Olimpia, who added to the general confusion by calling himself Pamfili. But the actual choice of Pietro da Cortona may, perhaps, reflect the reviving fortunes of the authentic Prince Camillo Pamfili, the only member of the family to show a keen interest in the arts and to have any real taste. After a series of inconclusive skirmishes with his mother, Prince Pamfili finally returned to Rome and was received by the Pope early in 1651. His 'exile' had not been very arduous or painful. During the course of it he had been responsible for the construction by Algardi of one of the most magnificent of all Roman villas. This he filled with antiquities and had lavishly decorated. In Rome he now set about building a palace for himself opposite the Collegio Romano for which he employed Antonio del Grande, and he also took in hand a number of other projects, both public and private. Indeed, after his return to the city artistic life notably revived from the torpor which had been so evident during the earliest years of Innocent X's reign, and some of the most beautiful and familiar achievements of the Roman Baroque

[1] For all these see Wittkower, 1958, and Portoghesi, 1955.
[2] Besides the Fountain of the Four Rivers Bernini's only important commissions from Innocent were the equestrian statue of Constantine and a series of portrait busts.

were created—Pietro da Cortona's frescoes of *Scenes from the Aeneid* in the gallery of the papal palace, and Borromini's dome and façade of the adjoining S. Agnese.[1]

Yet, despite all this, neither now nor later did Prince Pamfili prove a satisfactory art patron. He was an amiable man, but very lazy and uncultivated and much more interested in riding than any other activity.[2] Above all he was mean. 'Though he, more than anyone of his time, gave opportunities to painters and sculptors,' wrote Passeri soon after his death,[3] 'he was always having trouble with them over questions of money.' Pierfrancesco Mola painted frescoes for his palace at Valmontone which were pulled down and replaced by others by Mattia Preti after one such dispute.[4] Both the sculptors Francesco Baratta and Ercole Ferrata were involved in prolonged financial difficulties with Pamfili and his heirs, and other artists also suffered complications of the same kind.[5] Only in his support of Bernini's S. Andrea al Quirinale, begun after the death of his uncle, did Prince Pamfili display the enlightened generosity that had marked the rule of the Barberini. So that although many very fine artists were employed by him in enterprises of the greatest distinction, his patronage was never very inspiring.[6] The reasons for this, however, were not wholly personal, for from the 'forties onwards the economic climate became ever more menacing.

– ii –

The difficulties facing the student of papal finances are as insuperable today as they were in the seventeenth century. That the basic resources were vast is shown by the repeated recovery and aggrandisement of Rome long after every observer had noted impending disaster. Yet expenses too were on a huge scale and a pope sensitive to change and anxious to maintain his prestige was bound to try and cut them down. Urban VIII had begun his rule with assurances to this effect, but had followed them up with unparalleled expenditure. When he died he left the Treasury hopelessly indebted and it never fully recovered. It took about two generations for the situation to become clear to everybody, but already under Innocent X some steps had to be taken. As always they were only fitful and did nothing to remedy the real troubles facing Rome. Indeed this was hardly possible. For apart from local difficulties such as a disastrous drought, the expensive, though victorious, second War of Castro and repeated financial scandals in the court itself, the papal states were more and more affected by the general collapse of the Italian economy which reached its climax in the middle of the century, due largely to competition from England, France and Holland.[7] In Rome itself, where

[1] Pietro da Cortona's frescoes were painted between 1651 and 1654—see Briganti, 1962, p. 146. Borromini took over the building of S. Agnese in Piazza Navona from the Rainaldis in 1653—see Wittkower, 1958, p. 141.

[2] Barozzi e Berchet, II, pp. 71 and 98.

[3] Passeri, p. 337.

[4] *ibid.*, p. 371, and Montalto, pp. 267-302.

[5] Passeri, p. 337, and Golzio, 1933-4, p. 304.

[6] A eulogistic account of Pamfili's patronage is given in the poems edited by Girolamo Brusoni under the title *Allori d'Eurota* in 1662.

[7] For a general outline of the situation see Cipolla, 1952, pp. 178-87.

trade and industry were negligible, the effects were only indirect. Gradually, however, the tributes from abroad, upon which the city had always relied, began to dry up, and the process was intensified as mercantilist doctrines made headway. 'Today', wrote the Venetian ambassador in 1660,[1] 'there is no ruler who does not look to the good of his own subjects and who does not therefore prevent the incomes from ecclesiastical bene-fices (especially the richest ones) from leaving his territory and being enjoyed by foreigners. At Rome they put up with their disappointment in patience so as not to have to face worse troubles.' But these troubles came none the less.

Meanwhile sudden and improvised taxes were imposed and in the general hardship that resulted the public naturally began to resent the vast sums that were being spent on building and decorating the papal palaces and squares. As the magnificent reconstruction of the Piazza Navona proceeded, notes with poignant and bitter little rhymes were found attached to the stones[2]:

> Noi volemo altro che Guglie, et Fontane,
> Pane volemo, pane, pane, pane.

This was not a hint that the Pope and his courtiers were at all likely to take, for the grandiose adornment of Rome was far too deep rooted an ambition to be deterred by such considerations as a starving population. As often happens in such situations it was smaller scale enterprises that suffered rather than the vast showy undertakings. In 1648 the Accademia di S. Luca, which only a few years earlier had been so well endowed by the Barberini, faced great difficulties. The director 'did everything to restore its fortunes, and proposed many sound arrangements, but only a few of them were carried out . . .'.[3] At first minor, but later quite well established, artists began to suffer. Mattia Preti found many of them unemployed when he came to Rome in the middle 'forties.[4] It was now that dealers began to play an important rôle and that the first serious complaints began to be made about the comparative success of the *bamboccianti*.

As a final economy measure, and one which in its squalid avarice and feuds sym-bolises much of Innocent X's reign, Donna Olimpia and Prince Camillo Pamfili refused to pay for a coffin for the Pope when he died in January 1655. While the corpse lay rotting in a cellar, mother and son quarrelled over who should be charged for the burial. 'He says that he has never received anything from His Holiness. . . . She replies that she is not the heiress. . . .'[5] The accession of Fabio Chigi as Pope Alexander VII at least removed the personal obstacles that stood in the way of enlightened patronage. He was a direct descendant of the fabulously rich Sienese banker Agostino 'il Magnifico' whose friendship with Raphael was legendary and whose life he himself had written.[6] Before spending thirteen years as Papal Legate in Cologne he had been the intimate friend of

[1] Barozzi e Berchet, II, p. 214.
[2] Gigli, p. 233.
[3] Missirini, p. 116.
[4] De Dominici, IV, p. 19.
[5] Pastor, XIV, p. 37.
[6] Cugnoni, 1879-81.

the circle of poets, intellectuals and artists which gravitated round the court of Urban VIII. He was therefore deeply cultivated and he at once showed that he intended to fulfil the high hopes that were aroused by his distinguished ancestry and associations. On the very day of his election he summoned Bernini to tell him of his ambitious plans for St Peter's and to order him to continue the work he had already begun on the family chapel in S. Maria del Popolo.[1] During the twelve years of Alexander's pontificate Bernini enjoyed once again the complete supremacy that had been his under Urban VIII, and he put it to even more spectacular use. For the new Pope seemed to be making a deliberate attempt to undo the eleven-year interruption of Innocent X and to resume the projects of Urban.[2] Once more St Peter's returned to the centre of the scene. Bernini crowned his life's work there by erecting in the apse the Apostle's chair in an overwhelmingly rich decor of golden putti and Doctors of the Church. A mystical and expressionist element which had first entered his work after the death of Urban VIII was here turned to dramatic use. Light streams through the window and takes corporeal shape in the gilt stucco rays, clouds and putti which converge round it and are at the same time forced by the violence of the centrifugal pressure to break through the classical framework of the architecture. At the base of the Chair itself, guarded by angels bearing the palms of martyrdom, the Doctors are frenziedly distorted by the tense, quivering and yet ascetic passions that rage through their bodies—such nervous religious energy had not been seen in Italian art since the work of those Milanese painters who had been inspired by Cardinal Federico Borromeo in the early years of the century. Bernini was also commissioned to build the papal tomb, though work on that great, macabre memorial, so different in spirit to the triumphal monument to Urban VIII, only began after the Pope's death. Outside the church he reverted to his more extrovert manner and built the huge colonnade which stretches out to embrace the square. In the Vatican palace he designed the Scala Regia and almost completed the statue of Constantine the Great. Elsewhere he and his pupils were responsible for new palaces, churches, fountains, streets and squares. It seemed as if the golden age had returned, and Alexander certainly earned his punning nickname as a 'Papa di grande edificazione'.[3] In the Quirinal, meanwhile, the Barberini favourite Pietro da Cortona was in charge of a large decorative scheme which employed all the leading Roman artists in painting scenes from the Old Testament in the great gallery.[4] Pietro also worked on the reconstruction of S. Maria della Pace and, despite his increasing age and gout, painted a number of altarpieces for other churches patronised by Alexander VII, as did many other artists.

This astonishing flowering of the Roman Baroque proves how difficult it is to make any real estimate of the economic crisis that afflicted the city during the second half of the seventeenth century. It is evident that despite the tremendous drains on the

[1] Baldinucci, 1948, p. 107.
[2] For general surveys of Alexander VII's patronage see P. Sforza Pallavicino, Libro V, cap. 5, Pastor, XIV, pp. 506 ff., and Ozzola, 1908, pp. 5-91.
[3] Ozzola, 1908, p. 6.
[4] Wibiral, 1960, pp. 123-65.

Pope's finances, his accumulated resources were still plentiful. Yet the decline continued without interruption and the contrast between his spectacular building policy and the general state of the city was starkly apparent. To the Venetian ambassadors the Pope complained of his poverty,[1] and they in turn watched the ruinous expenses of Bernini's portico and cautiously drew some obvious conclusions. 'The Pope has long paid particular attention to beautifying the city and repairing the roads,' wrote Niccolò Sagredo in 1661,[2] 'and truly in this labour he has far surpassed his predecessors. . . . The building of the colonnades which encircle the piazza di S. Pietro will be an achievement to recall the greatness of ancient Rome. It is estimated that the work is about half way through and that in three years it will be complete. I am not going to discuss whether such efforts are advisable at the present moment and will leave that to those who understand these things better than I do. It is true that Rome is getting more and more buildings and fewer and fewer inhabitants. This decrease is very striking and obvious to everyone, and in the Corso and the busiest streets one sees nothing but empty houses and the sign *To Let.*' Seven years later Sagredo's heir, Giacomo Querini, had no such hesitations. 'One very striking reason for the waste of so much treasure', he wrote after describing the state of papal finances under Alexander VII,[3] 'has been the putting up of buildings which have destroyed rather than added to this city, the capital of the world. The erection of the porticos at St Peter's is without any conceivable advantage. There are obvious weaknesses in the architecture for which Bernini has been blamed. The three hundred columns, arranged according to an oval plan, merely serve as an architectural precinct for the marvellous church of the Prince of the Apostles. But they will make the Leonine city permanently uninhabitable, cause the Vatican to be abandoned and perhaps make it impossible to hold the conclave there. For the razing of houses, the increase in water for fountains and the extinction of fires will lead to malaria. All this confirms the worst rumours that over a million *scudi* have been spent on a series of catastrophic mistakes.'

Querini was exaggerating for political reasons. But, in fact, much of the desolation he referred to was real enough, though its origins were very different. In 1656 the last great plague to afflict Europe began moving north from Naples and struck Rome a few months later at the very beginning of Alexander VII's reign. Though we are specifically told that work on the decoration of the Quirinal continued throughout this terrible year,[4] the long-term effects on the economy were serious. As usual it was the independent artists who suffered most from the impoverishment of Rome. 'For seven months now people have been talking only of reforms and retrenchment', wrote Salvator Rosa in 1662, and two years later the situation was no better: 'As for commissions, I haven't had any, even from a dog, for a full year, and if the war news gets any worse, I might as well plant my brushes in the garden. . . .'[5]

[1] Barozzi e Berchet, II, p. 247: 'e sempre si duole non della ristrettezza, ma della povertà sua . . .'.
[2] *ibid.*, II, p. 245.
[3] *ibid.*, p. 320.
[4] Bellori, 1942, p. 82.
[5] De Rinaldis, 1939, pp. 150 and 161-2.

The war to which Rosa alluded was averted by the total surrender of the Pope to Louis XIV who was threatening it. And, in fact, the political situation of Rome was as important as the financial decline in affecting patronage. The career of Alexander VII demonstrated the collapse. As legate in Germany he had vainly protested against the peace settlement of 1648 which put an end to the Thirty Years War without taking papal interests into account. As Pope he soon began to suffer from Louis XIV's aggressive nationalism. This reached a climax in 1662 when his ambassador, the Duc de Créqui, seized on one of the characteristic street brawls of the time as a pretext for inflicting the most bitter humiliation that any pope had suffered since the Sack of Rome in 1527. Alexander's nephews and representatives were publicly insulted and compelled to apologise for an incident that they had not provoked; Avignon was threatened with French occupation; the Pope was forced to dismiss his guard.

The effects of this crushing defeat soon made themselves felt in other spheres. Within a month of the Treaty of Pisa, which settled the immediate crisis, Bernini and a number of other architects were approached and asked to provide designs for the rebuilding of the Louvre. A year later Bernini was invited to Paris to supervise his proposals. The correct forms were upheld. The letters from Colbert and from the King himself were exceedingly flattering. Permission was sought from the Pope with great delicacy. But beneath the exchange of courtesies more powerful forces were at work. Bernini was actively engaged on the colonnade of St Peter's at the time. His presence in Rome was very desirable as the Pope acknowledged. Yet 'in view of the arrangements then being made with that Crown', Alexander VII gave him three months leave of absence, and Oliva, the General of the Jesuits, who was most anxious to appease the French, put the greatest moral pressure on him to go. After he had been away some six months, the feeling in Rome was tense and nervous. 'Many people, and not least the Pope and his principal courtiers, were . . . daily expecting to hear that Bernini had decided to stay in Paris.' To such a state had the Pope's authority now fallen.[1]

The unwelcome departure of Bernini for a few months was the most immediate artistic result of Alexander VII's defeat. Psychologically the effects were much more profound and, in the long run, much more disturbing. Humiliated abroad, the Pope's prestige naturally suffered in Rome itself. Anti-clerical literature and pasquinades had had a long and vigorous history in the city. The extravagance of the Barberini and the War of Castro, followed by the dominance at court of Donna Olimpia, provided obvious and much appreciated targets. Now, under Alexander VII, satirical contempt for the Pope, and sometimes even for the institution of the papacy, reached new heights.[2] The general dissatisfaction was focused in a picture painted by Salvator Rosa for Carlo de' Rossi (Plate 24). This represented *Fortune*, who, seated at the top of the canvas with a great cornucopia, indifferently poured out her riches to a gathering of

[1] Baldinucci, 1948, pp. 111 ff. In a note (107 on page 249) in this edition Samek Ludovici says that one of the clauses of the Treaty of Pisa actually granted the French King the right to employ the Pope's artists. This clause certainly does not occur in the published versions of the Treaty.

[2] For examples see Spini and Limentani, 1961.

pigs, wolves, foxes, wild birds and beasts of prey. It has already been shown that Rosa had his own motives for bitterness which were not necessarily inspired by the political situation. None the less the allusions of this picture were too obvious to pass unnoticed, and jealous rivals were quick to point to its potentially subversive significance when Rosa exhibited it at S. Giovanni Decollato. 'The affair assumed such proportions', wrote Baldinucci,[1] 'that the painter was on the point of having to explain the meaning of his picture in prison', had it not been for the intervention of Don Mario Chigi, the Pope's brother and, incidentally, one of those most obviously implicated in Rosa's satirical interpretation of Fortune.

There is a double irony in Don Mario's generous move, for at about this time his son, Cardinal Flavio Chigi, was commissioning from a second-rate Sienese painter, Bernardino Mei, a ceiling fresco of *Fortune under the control of Virtue*.[2] The issue was thus a live one, but general opinion certainly shared Rosa's view that the overwhelming riches that accrued to the papal family were the results of Fortune only, with little or no sign of Virtue. In fact, the hostility aroused by the Pope's brother Mario, and his two nephews, Flavio and Agostino, was all the greater because it had seemed for a time that he had decided not to summon them from his native Siena. As the traditional pattern developed, and the family grew ever richer and more overbearing, disappointment became intense. Neither of the Chigi nephews showed any great intelligence or culture, but Cardinal Flavio was fond of painting and he naturally employed Bernini to build, or rather rebuild, the palace in piazza SS. Apostoli which he bought from a branch of the Colonna family in 1662. The result of Flavio's mediocrity of taste and Bernini's genius led to a situation rare, if not unique, in Rome at the time: a spectacular façade with colossal pilasters running through the top two floors led into a building whose decoration and pictures must have appeared as an extraordinary anti-climax. There were the allegories by Mei—*Fortune under the control of Virtue, Justice and Peace* and *Youth rescued from the Pleasures of Venus*—a theme of special relevance to Cardinal Flavio, who, in his country house at Ariccia some years later, was to hang a collection of portraits of the thirty-six most beautiful women in Rome[3]; there were other ceilings by Giovanni Angelo Canini whom the Cardinal had taken with him to draw scenes of interest on his humiliating visit to Paris; there were, above all, mythological paintings and portraits by Gaulli and, of course, antique statues in plenty. No doubt there were some fine pictures, but, compared to the collections of earlier papal nephews, the list is not a distinguished one.[4]

– iii –

Flavio's limited interest was not the only reason for this lack of distinction. The very extent of his uncle's patronage reduced his opportunities for employing first-rate

[1] Baldinucci, VI, 1728, pp. 558-9. The picture is now the property of the Paul Getty Museum, Malibu.

[2] Golzio, 1939, p. 14.

[3] Pastor, XIV, p. 329.

[4] Apart from Golzio, 1939, see also for Flavio's collecting Incisa della Rocchetta, 1925, pp. 539-44.

artists—it is significant that Bernini did not begin to reconstruct the palace until Alexander VII had been on the throne for nearly ten years. It is also true that the wide choice of talent that had been available to Paul V and Urban VIII was no longer in existence. But this, in turn, was at least partly due to a general decline in the numbers and standards of great patrons. The reasons for this decline are not very far to seek. The economic collapse, which has already been referred to, and a number of measures introduced by the Pope to prevent prelates deserting their provincial sees and living in Rome, played a considerable part in the process.[1] The old families were increasingly impoverished; new ones more and more reluctant to settle in Rome. Indeed, of the old-established clans only the Colonna continued, almost without interruption, to acquire important new pictures. Their palace, situated near the one sold to the Chigi, had been largely rebuilt and decorated by Filippo and his son, Cardinal Girolamo, during the first half of the century, despite the poverty which had compelled them to sell their principality of Palestrina to the Barberini.[2] But the most interesting and influential patron of the family was Lorenzo Onofrio, Grand Constable of the Kingdom of Naples. In 1661, at the age of 24, he married Maria Mancini, the niece of Cardinal Mazarin and the first love of Louis XIV. When she arrived in Rome she was struck, as so many visitors have subsequently been, by the splendour of her husband's family palace after the comparative meanness of its exterior. For some years, while she bore him son after son, she was one of the two leading ladies in Roman society, rivalled only by Queen Christina of Sweden. Lorenzo Onofrio, meanwhile, continued to make a series of impressive additions to the family picture collection which had so impressed Maria on her arrival. His taste was eclectic and at one time or another most of the principal Roman artists worked for him, from the *bamboccianti* to history painters.[3] But his greatest passion seems to have been for mythological fables and landscapes, wherever possible in combination. Gianfrancesco Grimaldi and many other artists were engaged to paint landscapes in his palace, and he commissioned innumerable pictures by specialists in the subject such as Salvator Rosa and, above all, Gaspard Dughet (sometimes with figures by Carlo Maratta) and Claude.[4] In this striking preference for landscape decoration Lorenzo Onofrio helped to launch, or at least to confirm, a fashion which did not meet with general critical approval. Commenting on the constant demand for landscapes which reached its peak at the beginning of the new century, Padre Sebastiano Resta, a scholarly collector and pioneer in the study of Renaissance drawings, wrote rather acidly that he did 'not derive much pleasure from these landscape artists and *bamboccisti* . . .' and that even in his earlier days he had 'not much enjoyed such finicky modern works'.[5] Colonna, however, was far too lively and expansive a patron to take any note

[1] Barozzi e Berchet, II, p. 245.

[2] Prospero Colonna, 1925.

[3] See the catalogue of the collection published anonymously in Rome in 1783 and the brief modern account by Corti.

[4] Seventeenth-century artistic literature contains a large number of references to Colonna patronage. See, in this connection, especially Pascoli, I, pp. 35, 60, 72, 115, 125, 139, and also Bellori, 1942, p. 128.

[1] Bottari, II, pp. 115-16.

of the complaints of scholars or pedants, and his employment of Claude, ranging over a period of nearly twenty years, showed the discrimination of his taste.[1] After a *Landscape with the Flight into Egypt* which he bought from the artist in 1662, the year after his marriage, he subsequently commissioned from him a series of eight mythological scenes, including the so-called *Enchanted Castle* and Claude's last picture, *Ascanius shooting the Stag of Sylvia*, now in the Ashmolean Museum.

The unusual nature of many of the subjects, and the fact that some of them almost certainly contain allusions to the Colonna family and estates, suggest that Lorenzo Onofrio himself was closely connected with the creation of these beautiful pictures. Certainly, his love of art was in no way diminished by the growing complications of his private life. Within a few years of his marriage he was compelled to agree to his wife's demand for a 'separatione di letto', and his reckless infidelities led to her leaving him in 1672. A fantastic pursuit delighted the scandalmongers but served little other purpose, and after a brief visit to Spain, with which country his connections became ever closer, he virtually retired from public life and died in 1689. Fourteen years earlier he had employed the two Lucchese artists Giovanni Coli and Filippo Gherardi on one of the most important decorative schemes of the second half of the seventeenth century: the frescoes, recording the exploits of his ancestor Marc'Antonio Colonna at the Battle of Lepanto, on the ceiling of the great gallery in his palace. This battle scene with its plunging ships and toppling masts all rendered in bold Venetian colouring is in a category of its own as decoration and has little connection with Gaulli's contemporary frescoes in the Gesù or Carlo Maratta's in the Altieri palace. But the scheme is also significant from another point of view. The Colonna, though greatly impoverished, were among the few families still in the very forefront of Roman society who could genuinely claim an ancestry of heroic antiquity. As the 'new' families usurped more and more of their previous glories, contemplation of past prowess was one of the most obvious consolations, as the Venetian patricians were soon to discover in somewhat similar circumstances.

– iv –

While grandiose schemes of this kind could still occasionally be promoted by the nobility, the more subtle and discriminating patronage of contemporary art, which had been such an important feature of earlier years, now began to decline in significance. Cardinal Massimi has already been discussed, but he was an exceptional figure. More characteristic of the second half of the century were a number of scholars and men of letters who projected into their art collecting their predominantly literary interests.

The strangest of all these collectors was the antiquarian and local historian Antonio degli Effetti.[2] His pictures have disappeared, and thus our knowledge of his taste can

[1] For Lorenzo Onofrio and Claude I have closely followed Röthlisberger, 1961, p. 374, and other references indicated there.

[2] For Antonio degli Effetti see the many references in Moroni; also Orbaan, 1914, p. 46; Vaes, 1925, p. 171; Bellori, *Nota dei Musei* and, above all, the manuscript account and inventory of his collection in the Biblioteca Casanatense, Rome, MS. 2372.

be derived only from the catalogue that he himself drew up. Doubts have even been expressed as to whether he owned, rather than imagined, some of the pictures he mentions, but we have independent evidence that he was known as a collector. To foreign travellers Antonio's *Studiolo* might appear to consist of little more than 'petites peintures, mignatures, pierres precieuses, et autres bijoux'.[1] For himself its significance was very much greater and of a totally different order. Antonio was above all a man of letters and he had been deeply impressed by a Platonic dialogue called *The Table*, at the time attributed to a Theban disciple of Socrates called Cebes.[2] The vogue of this work, which later caught the fancy of Lord Shaftesbury, was largely due to Agostino Mascardi, a well-known Professore d'Eloquenza at Rome University under Urban VIII, who had translated it with an extremely long commentary in 1629. It purports to describe a picture, which represents an allegory of human life, found by two travellers in front of the temple of Kronos. A stranger explains the details of the picture, pointing out the follies of vice and false values and the rewards of virtue; neither in form nor in content does the dialogue show much originality. But ever since the Renaissance patrons and artists had eagerly seized on descriptions of antique pictures, and it is easy to understand the appeal to the erudite Antonio degli Effetti of such a neglected and recherché example. He had a version of it reproduced at the entrance of his gallery and most of the pictures he owned were designed to illustrate its lessons. Antonio (as was natural in a scholar) seized on one of these especially. 'Consider how often a man is to be found possessed of wealth, but living an evil and wretched life. . . . Wealth is not a good thing if it does not help men to be better.' Virtually all the artists he employed were required to illustrate the effects of wealth on man's destiny. But just as many seventeenth-century poets, and in particular Marino, were so taken with the elaboration of their metaphors that they ignored their original purpose and continued to enrich them to the detriment of the theme, so Antonio degli Effetti clearly took delight in the idea of wealth for its own sake with or without moral implications. The Bible, ancient literature and history, as well as sixteenth-century poetry, were all indiscriminately ransacked for suitable chances to portray gold and precious jewels. *King Midas* hung near *The Feast of Cleopatra*, *Armida* next to *Danaë* and *The Judgement of Paris*.

There is no doubt that Antonio degli Effetti revelled in the literary possibilities of such a gallery. But, in general, the artists represented were so modest—many have fallen into total obscurity—that we can certainly accept the truth of his claims. Of established painters only Pietro da Cortona and Carlo Maratta, with one picture each, were included. The others were men like Bernardino Gagliardi, Francesco Allegrini and, above all, a great number of Flemish artists. The minor reputations of these painters and the small dimensions of the pictures doubtless brought them within the range even of a man as obsessed with the benefits of poverty as was Antonio degli Effetti.

Another interesting patron and collector was the Florentine Francesco Marucelli,

[1] Spon and Wheler, I, p. 232.
[2] In fact the *Pinax* is by a totally different author and probably dates from the first century A.D. I have used the English version by H. E. Seebohm, Chipping Campden, 1906.

who lived in the piazza di Spagna.[1] Books were his real passion and he amassed a considerable library which he recorded in a work of a great scholarly erudition. But he also showed a keen interest in the arts of his day. He wrote the lives of some of the principal painters, many of whom were his friends, and he sent details about artists working in Rome to Filippo Baldinucci when that scholar was writing his great history of Italian art. His patronage shows an inconsistency which is characteristic of the break-down of taste which occurred in the second half of the seventeenth century but which is certainly refreshing when compared to the arid pedantry of many of his contemporaries. On the one hand he commissioned busts in stucco, wood, marble and paint of the great writers whose works filled his excellent library; on the other, he delighted in the *bamboc-ciate* of the Flemish painter Theodor Helmbrecker whose most enthusiastic admirer he was and who painted sixteen pictures for him, some of them scenes of country life and some with a hint of allegory.[2]

And a third and more modest of these scholarly collectors was a certain Luigi Adami. He too was keen to obtain portraits of the most significant men in history. In 1667 we find him writing that he has just obtained pictures of Lord Essex and 'Francesco Drach' among the English as well as distinguished Germans, Spaniards, French and Portuguese. And he observed sententiously that 'there is no history which does not provide me with some flower capable of delighting the eye of the curious with the beauty of its colour and reviving the spirit of the idle with the strength of its perfume'.[3]

But all these men, and others like them, are interesting more for themselves than because they play any significant part in the history of painting. Not one of them was able through a combination of wealth, intellect and taste to influence the development of art. That rôle was now taken over from the patron by the critic. Indeed to some extent the growing importance of the latter was the direct result of the fall of the former.

The most important of all the Roman critics who began to make their influence felt in the second half of the seventeenth century was Gian Pietro Bellori.[4] He was born in about 1615 and was said to be the nephew of the antiquarian collector and writer Francesco Angeloni who was certainly his guardian. In Angeloni's house Bellori could see Annibale Carracci's drawings for the Farnese Gallery and could meet Domenichino from whom he took lessons. At an early date he became an active member of the Accademia di S. Luca, but instead of practising art he began to write about it, at first rather haphazardly and then with growing assurance. Like Angeloni he devoted much of his time to the study of antiquity, but he also watched contemporary developments with keen interest. He drew up a catalogue of some of the leading Roman collections, and in 1664 he delivered a lecture to the Accademia on the 'Ideal' in art. He was already engaged in writing the Lives of a number of important painters and when he published

[1] For the life of Marucelli see the introduction by Guido Biagi to his *Mare Magnum*.
[2] Baldinucci, VI, 1728, p. 597.
[3] Abbate Michele Giustiniani, I, p. 336.
[4] For the life of Bellori see Donahue, 1946.

these in 1672 he included his lecture of some years earlier as a preface to the book. From then onwards he was a dominant figure in artistic circles, more influential, both in the short and the long run, than the Jesuits, the popes or any of the other bodies which are held to have moulded stylistic developments.

For Bellori, unlike these others, had an absolutely consistent point of view which he expressed with clarity and authority.[1] It is this last feature which makes him so important, for his views in themselves were derived from many different sources, and he was more of a transmitter than an originator. Bellori broke with the art historical tradition that had been established by Vasari and feebly continued into the seventeenth century by Baglione. He did not aim at completeness either in his selection of artists or in his accounts of their lives or yet in his listing of their works. He ruthlessly subordinated studio gossip and even serious biographical information to a critical examination of what he regarded as the most significant achievements of the seventeenth century. His criterion of judgement was based on the concept of the Ideal as it had already been elaborated by pioneers such as Monsignor Agucchi. After the Renaissance, art had degenerated into senseless mannerism from which it had eventually been rescued by Annibale Carracci and his Bolognese followers. They had turned back to nature and also to a profound study of the antique and of the great masters, especially Raphael. For extreme naturalism was just as dangerous as extreme mannerism. The *Lives* had an enemy—Caravaggio—though one whom Bellori was compelled to respect, for he was a sensitive judge of quality as well as a deeply intelligent man. But, fortunately, there were also heroes—Domenichino, from whom he had once taken lessons, and Nicolas Poussin, his great friend, who unquestionably inspired many of the ideas in the book. It was, therefore, the 'classical' qualities in his contemporaries and predecessors that he singled out for praise. The sculptor Algardi was given a full-scale life; Bernini a few casual mentions. He wrote, but was unable to publish, a life of Andrea Sacchi; Pietro da Cortona was wholly ignored. But of all the artists of his time it was Carlo Maratta, Sacchi's pupil, who most appealed to him. In 1652 he helped to get Maratta one of his first important commissions and in later years he had his portrait painted by the artist, whose reputation he did everything he could to promote.[2] It was to Bellori that Maratta and his pupil Giuseppe Chiari went for iconographical and no doubt other advice when given difficult commissions.[3] The devout love for Raphael that both men felt was genuinely, if unfortunately, expressed by Maratta's restoration of the frescoes in the Vatican and the Farnesina and Bellori's *Descrizione delle Immagini dipinte da Raffaello d'Urbino*. Furiously he attacked those who refused to subscribe to the cult, and he wrote sarcastically of 'some people who in their schools and their books teach that Raphael is dry and hard, that his manner is statuine (a word that has come into the language in our own day), and who claim that he had no fire or spirit [furia o fierezza di Spirito]'.[4] In passages like this he was at once preparing the way for neo-classicism

[1] For the literature on Bellori's critical theories see Schlosser Magnino.
[2] Bellori, 1942, p. 99.
[3] *ibid.*, p. 92, and Pascoli, I, p. 211. [4] Bellori, 1942, p. 115.

and doing everything that he could to oppose a rival view of art that was soon to gain ground in much of Europe—a love for brio, the unfinished, the sketchy, the *belle matière*. In a later chapter it will be shown that it was, in fact, partly owing to the overriding influence of Bellori that this view made few converts in Rome.

It is a strange experience to confront Bellori's words, which when taken up by followers hardened into dogma for over a century, with the paintings of his favourite Maratta. To us his watered-down versions of the Baroque bear little relation to the classical ideal of antiquity or Raphael; none the less when compared to the high Baroque of Pietro da Cortona or Gaulli the move towards simplicity and respect for the rules is obvious. Indeed the hostile reception that Gaulli's frescoes in the Gesù met with in certain circles[1]—'all the artists concluded that [the vault] would be beautiful if the proportions of the painting were less inaccurate and by someone else'—was no doubt due in part to the classicising influence of Bellori, and in his subsequent works Gaulli himself adopted a far more classical style. Artists from other cities, particularly Naples, were generally scorned in Rome and, if they came to work there, were compelled to regularise their style in conformity with the prevailing dogmas. And the rise of articulate criticism had another effect. More than ever before there was a widely held sentiment that art was not what it had been. 'All over Europe there is a shortage of good artists and even in Flanders there are no longer the painters that there once were', wrote Jacomo di Castro in 1670, echoing a general feeling.[2] In part this was merely the recognition of what was an undoubted fact; but in part it reflected the growing attention being paid to critics such as Bellori.

His influence grew with the years. In 1671 he was made secretary of the Accademia di S. Luca and not long after he was appointed librarian and antiquarian to Queen Christina of Sweden. This extraordinary figure, 'cross-backed . . . [with] a double Chin strew'd with some long Hairs of Beard', weirdly dressed in a man's cloak and wearing a cravat round her neck,[3] had first come to Rome in 1655 after her sensational conversion to Catholicism at the age of 28. Apart from voyages, which were frequently lengthy, to France and Sweden, she remained in the city until her death in 1689. She soon intrigued, and sometimes horrified, society by the eccentricity of her behaviour, but none the less began to exert great influence in political, literary and artistic circles. In the palazzo Riario on the Lungara she displayed the marvellous collection of pictures which her father Gustavus Adolfus had looted from Prague—Raphael, Titian, Correggio, Veronese, Rubens and other old masters.[4] It was, however, a sign of the times that artists in Rome no longer possessed the creative vitality to make use of these in the way that a previous generation had drawn inspiration from the Aldobrandini Titians. In her patronage of contemporaries Christina was not very imaginative nor did she have much scope. She particularly admired Pierfrancesco Mola, the most genuine heir to the

[1] See the *avvisi* published in *Roma*, XIX, 1941, p. 392.
[2] In a letter to Don Antonio Ruffo of 20 September 1670 published by V. Ruffo, 1916, p. 290.
[3] Skippon, p. 676, and Misson, 1717, II, p. 167.
[4] Bildt, 1904, pp. 989-1003.

Venetian tradition, and his pupil, Antonio Gherardi, another special devotee of Venetian colour. When she let herself be guided by Bellori, the results were different, for he encouraged her to patronise one of Domenichino's most faithful pupils and a protégé of his own, Gianangelo Canini.[1] In fact, however, the Queen's patronage of living painters was of little significance and her influence made itself felt far more in the literary field, where it led eventually to the formation of the Society of Arcadia a year after her death.

– v –

After the death of Pope Alexander VII official patronage of the arts declined precipitously. The deeply cultivated Giulio Rospigliosi, who became Pope Clement IX in 1667, reigned for only two years, barely enough to commission a magnificent portrait from Carlo Maratta and figures of the Angels carrying the Symbols of the Passion from Bernini to be placed on the Ponte S. Angelo. His successor, Clement X, was already aged 80 when he came to the throne, and the great and natural preoccupation of his family, the Altieri, was that he would die before they had time to complete the new family palace which they were building next to the church of the Gesù to the great indignation of the Jesuits.[2] Work continued throughout the night with the help of torches and by 1673 the ceiling of the principal hall was ready for decoration. On the advice of Camillo Massimi, the artist chosen was Carlo Maratta and he in turn consulted Bellori as regards the iconography. The fresco was thus the most considered work of the late seventeenth century in Rome, as representative of its period as Pietro da Cortona's Barberini ceiling had been of the rule of Urban VIII. Here too the climax of the fresco is a female figure, Clemency (a punning reference to the Pope's name), bathed in golden light. But with that the similarity between the two works ends. Everything has shrunk. The fresco is now reduced to a thin oval rigidly enclosed within a carved stucco frame. The adulation survives—one of the figures standing with the three cardinal virtues is Public Happiness holding a standard to symbolise Don Gasparo Altieri, the Pope's adopted nephew and Gonfaloniere of the Church—but the means to express it have been so controlled that the painting loses all its propagandist fervour and is turned instead into a remote, impersonal and frigid allegory. The formal language is that of the Baroque, but the life has been drained away and only a still, flat echo remains.[3]

It is also characteristic that the work dragged on for some twenty years and that the decoration planned for the palace by Carlo Maratta and his pupils was never completed owing to some unspecified differences with Don Gasparo Altieri.[4]

The differences were no doubt economic. Pope Clement X was making a serious, and not wholly unsuccessful, attempt to reduce excessive nepotism, and Don Gasparo, though keenly fond of luxury, was unable to indulge his tastes on the scale of a Barberini

[1] Pascoli, I, p. 124, and II, pp. 119 and 290.
[2] See the *avviso* of 9 April 1672 published in *Roma*, XVIII, 1940, p. 57.
[3] Bellori, 1942, pp. 91-4 and, for the work by Berrettoni in the palace, A. Clark, 1961, pp. 190-3.
[4] Pascoli, I, p. 140.

or a Chigi so that the most memorable record of his patronage is Claude's *The landing of Aeneas in Latium* which he added to the same artist's *Sacrifice to Apollo*, painted for his father some twelve years earlier.[1] Clement X had good reason to try to economise. 'The States of the Church are very impoverished', wrote the Venetian ambassador.[2] 'The treasurers report that when their officials proceed against debtors they do not get the gold and silver that they used to, but only worn and wretched rags. In the country-side around Rome cultivation is being increasingly abandoned because of the losses suffered by farmers owing to excessively low prices. This state of affairs is made worse by the habit adopted by the Genoese three years ago of getting their grain from the Adriatic so that crops from the Roman shores remain unsold. In the Marches, Romagna and nearby provinces the ease of navigation encourages the supply of money, but the land is short of ready cash. In any case even there the disadvantages of luxury are making themselves felt.' It was natural that the opposition to extravagant art patronage, which was always latent in certain sections of the community, should become vocal once again. A plan of Clement IX to remodel the tribune of S. Maria Maggiore, and thus provide a burial-place for himself even more imposing than those of Sixtus V and Paul V in the same church, was dropped after his death—to the great satisfaction both of his family, which feared that they would be called upon to assume the expense, and of the clergy which disliked the threat to the venerable mosaics.[3] Meanwhile the municipal authorities were said to be drawing up a 'resolution to give to His Holiness which was directed against the Cavaliere Bernini, who was the instigator of the Popes' indulging in useless expenses in such disastrous times'.[4] Of Innocent XI, who succeeded Clement X and ruled for thirteen years, we are told that 'his whole mind was given to driving back the Turks who had descended with all Asia on Vienna and Hungary' and that for this reason Carlo Maratta, by now unquestionably the most famous artist of the day, did not have the opportunity to be introduced to him.[5] This is not wholly true, as Maratta was certainly employed on one very characteristic task—the covering of an over-exposed breast of the Virgin Mary painted in the Quirinal by Guido Reni at the beginning of the century.[6] For this was a period of great austerity. The theatre and the carnival were discouraged and everything was done to suppress indecency in art—not with complete success, if we are to believe a French envoy, who found that Cardinal Basadonna's bedroom was full of 'tableaux de nudités'.[7] 'La misère est déjà très grande à Rome, et le gouvernement odieux, et haï extrêmement', wrote another witness in

[1] For the history and significance of these two Claudes, now at Anglesey Abbey, see Röthlisberger, I, p. 369.

[2] Barozzi e Berchet, II, p. 360.

[3] Pastor, XIV, p. 558.

[4] See *avviso* of 2 August 1670 published in *Roma*, XVIII, 1940, p. 95. Bernini was under constant attack at this period—see further *avvisi* published *ibid.*, pp. 58 and 95.

[5] Bellori, 1942, p. 107.

[6] *ibid.*, p. 108.

[7] See the report of the French envoy, l'abbé de Servient, to M. de Croissy in 1683—quoted Michaud, I, p. 176. Cardinal Basadonna's tomb with a penetrating bust is in the church of S. Marco in the Palazzo Venezia.

1685.[1] In these circumstances it is hardly surprising that the Pope 'did not have much taste for building'[2] and did 'not have the ambition to leave behind any permanent memorial of himself'.[3] He refused to allow the chapter of St Peter's to build a third colonnade and thus enclose altogether the square in front of the church; and when the Jesuits, who had been given a large sum of money by the King of Spain with which they hoped at last to decorate the tribune of the Gesù, asked for permission to make use of the papal foundries, he replied that 'if they had any money they should keep it and not spend it, for this was not the time to indulge in useless luxuries'. Most significantly of all, the chronicler who reported this added that 'a hundred craftsmen could have lived for at least three years on the work'.[4]

And, indeed, if an artist of the stature of Carlo Maratta could see his official commissions almost vanish during two successive papacies, the situation of lesser men can easily be imagined. It was undoubtedly the threat of unemployment on this scale, as well as the increasing dogmatism of Roman critics, that discouraged so many painters from other Italian cities from coming to live and work in Rome towards the end of the century. This in turn naturally affected such patrons as still survived and wished to continue the great traditions of the Barberini and their entourage. For it must not, of course, be imagined that extensive building and decoration came to an end during the last phase of the century. If the darker side has here been singled out for special attention, that is because it was the side that struck contemporaries with special force; and it is impossible for us to survey the patronage of the whole century without noticing the great decline that set in during its second half and thereafter gathered weight. None the less even a drastic decline from the standards set by the Barberini could still leave rich, and sometimes magnificent, results, and there were certainly a number of important figures who greatly contributed to Roman art life at the turn of the new century. For reasons that have already been suggested the popes themselves were not usually the most prominent of these. The situation of Clement XI (1700-1721) is indicative. He commissioned many works from leading artists all over Italy, 'and his feelings for painting were certainly not less than those of his predecessors, and he would have done very much more had he not been snatched away [from such plans] by the death of Charles II [of Spain] and the rapid and fierce flames of war which swept through the whole of Europe'.[5] It is symbolic of the conditions to be described in the following chapter that when Clement commissioned statues and paintings for the Lateran basilica, other potentates, including the Schönborn family of Pommersfelden in Franconia, had to pay for most of them.[6]

Characteristic also of this state of affairs was the career of the most adventurous

[1] *ibid.*, I, p. 68. In estimating the reliability of these reports account must be taken of the extreme French hostility towards the Pope.

[2] Pascoli, I, p. 311.

[3] See *avviso* of 28 January 1679 published in *Roma*, XIX, 1941, p. 161.

[4] See *avviso* of 18 February 1679 published *ibid.*

[5] Pascoli, II, p. 546.

[6] Hantsch und Scherff, pp. 92 and 93.

patron of the time, Pietro Ottoboni, nephew of Pope Alexander VIII who reigned for only two years.[1] Pietro who was made cardinal in 1689 was then aged 22. He sprang from the Venetian nobility, but on different occasions both he and his father were temporarily struck off the *Libro d'Oro* by the jealous Republic for accepting stipends from foreign governments. The offence was a natural one, for most of Pietro Ottoboni's long life was passed in a desperate attempt to raise money from whatever source was available. He was a man with all the extravagant tastes of the traditional Cardinal-nephew who was able to enjoy the rôle for only two years. None the less he continued under successive régimes to hold the post of papal Vice-Chancellor and until his death in 1740 the palace of the Cancelleria in which he lived was the centre of the most enlightened and extravagant patronage in Rome.

It is, in fact, with some reluctance that one discusses Pietro Ottoboni in a chapter devoted to the decline of patronage. He was by far the most cultivated papal-nephew since Francesco Barberini, and it is perfectly possible to see him as a figure just as influential—and perhaps even as constructive—in his effect on the arts.[2] He was a versatile musician and a composer of operatic librettos; he fostered an important theatre whose scenery was managed by Filippo Juvarra[3]; at one time or another he acquired pictures by most of the leading Italian artists. None the less, Pietro Ottoboni was living during a period when the creative impulse in Rome was at a low ebb. He was able to revive for some half-century an echo of the Barberini glamour, but he left little behind him of permanent value. To his contemporaries he rightly seemed to be a figure of exceptional importance; to us he emerges as a man of the most amiable character and of consummate taste from an essentially second-rate epoch. Despite this he certainly deserves a full-length essay to himself; for a few pages, such as the following, coming at the end of a study devoted to patronage in Baroque Rome, cannot but judge him unfairly.

Ottoboni was a Venetian and the artist whom he patronised with the greatest enthusiasm was Francesco Trevisani who came to Rome from Venice in about 1682.[4] For his chief protector Trevisani painted innumerable pictures of religious, historical and genre scenes as well as portraits.[5] Many of these are of high distinction and some are painted with the sensitivity to colour one would expect from a man of his origins. But the classical ambience of Rome and the influence of Carlo Maratta, whom Trevisani eventually succeeded as the leading Roman painter, were too powerful to be withstood, and it was as a gentle, sweet and academic artist that Trevisani won his European reputation. Such was indeed the effect of Ottoboni's circle on most of the painters who

[1] For a summary of Cardinal Ottoboni's political career see Cicogna, I, pp. 269-70.

[2] Every author of the period writes at length about Ottoboni's passion for art; the fullest evidence for this is to be found in the manuscript inventory of his pictures in the Archivio di Stato, Rome—Atti del notaio de Caesaris, 1740, protocolli 1838 and 1839.

[3] For this theatre see Rava, 1942.

[4] For Ottoboni's relations with Trevisani see the unpublished life of this artist by Lione Pascoli in the Biblioteca Augusta di Perugia, MS. 1383.

[5] For Trevisani's portrait of Ottoboni, now in the Bowes Museum, see Waterhouse, 1953, p. 120.

worked for him. Sebastiano Conca, the pupil of Solimena in Naples, gradually lost the vigorous brio of his early years when he came to Rome in about 1706 and was taken up by the Cardinal and his friends.[1] Gaulli, another favourite, also became flaccidly academic as the years went by. Only Juvarra, whose architectural style was certainly affected by the ten years during which he absorbed the academic Baroque of Carlo Fontana between 1704 and 1714, produced new work of exceptional verve and vitality when working for Cardinal Ottoboni. But that was confined to his marvellous stage sets for the theatre in the Cancelleria.[2] In so far as one can point to any specific influence of Pietro Ottoboni on the arts it must be sought in a rather bland sweetness, restrained by the rules of academic classicism from verging too far in the direction of the rococo, and tending towards a certain cool anonymity. It was a style easily transmitted from master to pupil, from court to court, and easily appreciated by princes and general public alike. It lacked the vigour of the true Baroque, the intricate fantasy of French rococo, with which it was contemporary, and the severity of later eighteenth-century painting. With the coming of neo-classicism it was condemned out of hand and it still has not found many friends.

But Pietro Ottoboni's significance in this story is not only that of a patron who affected those artists who came into close contact with him and his circle. It is also important to consider his failure to attract other painters who worked for him but who would not be lured to Rome. And these included the very men under whose genius and guidance a great revival of Italian painting was springing up at the turn of the century in almost programmatic opposition to the values fostered by Rome. The case of Sebastiano Ricci is symptomatic. He came to Rome at about the time that Ottoboni was attaining power, and, being a Venetian, he naturally did some work for him and his friends.[3] But, says Mariette 'j'ai entendu dire . . . que, lorsqu'il fut venu à Rome et qu'il eut commencé à étudier d'après les fresques de Raphael, il souhaita de retourner promptement à Venise, disant que la manière de ce grand homme étoit capable de corrompre la sienne. Il sentait bien qu'il ne pourroit jamais atteindre à la pureté de son dessein, et il craignoit que son coloris faible ne gatât le sien. Il n'avoit pas tout à fait tort.'[4]

More than thirty years later Ricci's pupil, Gaspare Diziani, also came to Rome and was at once taken up by the patriotic Cardinal. But he produced nothing more for him than a magnificent stage set for the ceremony of the Forty Hours in Ottoboni's titular church of S. Lorenzo in Damaso.[5] Another artist, closely associated with Venice though he lived in Bergamo, Fra Galgario, refused to come to Rome when called there by Ottoboni.[6]

[1] Loret, 1934, p. 545.

[2] Many of his sketches for these are in the Victoria and Albert Museum, DT.33.b.

[3] Among these friends was the great violinist Arcangelo Corelli. He owned a *Europa* by Ricci—see the inventory of his pictures published by Alberto Cametti, 1927, pp. 412-23.

[4] Mariette, IV, p. 393.

[5] See the unpublished *Zibaldone* by Tommaso Temanza—MS. 796 in Seminario Patriarcale, Venice. [6] Tassi, II, p. 60.

From Bologna Giuseppe Maria Crespi sent the Cardinal one of his most attractive and adventurous pictures—*The Confession*, in which a subject that had not been painted since Poussin was treated as the pretext for an affectionate yet slightly ironic scene from clerical life. Ottoboni, who was as easy going as Cassiano dal Pozzo had been austere, was delighted, and commissioned the remaining six Sacraments. These were equally successful, but Crespi remained as firmly in Bologna as did Solimena (who also sent pictures to the Cardinal) in Naples.[1]

Other patrons, besides Ottoboni, were finding it increasingly difficult, if not impossible, to attract their favourite artists to Rome.[2] Financial uncertainty and the rigours of a classical taste, already outmoded elsewhere, were taking their toll. And, besides, two important rivals to the city of the Popes were now making themselves felt—the European powers and the other towns of Italy.

[1] L. Crespi, p. 213. These pictures are now at Dresden.

[2] For instance the Marchese Niccolò Maria Pallavicini who was, after Ottoboni, the most munificent art patron in Rome during the early years of the eighteenth century, found it impossible to keep Paolo Girolamo Piola as his private painter—Soprani, II, p. 186; Cardinal d'Adda, seconded by Cardinals Gozzadini and Albani, was unsuccessful in getting the Bolognese painter Domenico Maria Viani to come to Rome—Guidalotti Franchini, p. 19. Lazzarini, the Venetian, also refused to come, though strongly pressed—da Canal, p. 69.

Part II

DISPERSAL

Chapter 7

THE INTERVENTION OF EUROPE

– i –

IN 1669, five years after his bitter complaints about the impossibility of finding a patron in Rome, Salvator Rosa was writing to his loyal and long suffering friend G. B. Ricciardi that 'every day I have to turn down commissions (and important ones at that) from all over Europe'.[1] And indeed the patronage that the popes found increasingly difficult to maintain owing to the catastrophic financial and political decline of Rome was being taken over by a wide variety of figures from outside Italy.[2] Within a relatively short time a recession, so critical that it might well have inhibited the whole future of large-scale painting in Italy and turned the peninsula into a provincial backwater, was halted by foreign intervention and then actually reversed. Italian painters were soon in greater demand than ever before and they were quick to take advantage of the situation. In Messina, Don Antonio Ruffo was severely snubbed when, in 1671, he tried to get a picture from the Venetian Girolamo Forabosco.[3] He would have to wait two years and he would have to pay 80 *doppie* for two half-length figures. It was no use, he was told, asking a painter of Forabosco's standing for cheaper work, as he was daily implored by the greatest princes in Europe to send them something. They were ready to pay anything he asked for the smallest head and they considered it a real favour to own anything by him at all. . . .

Blackmail of this kind was already commonplace. By the end of the century there were few Italian artists who did not rely upon foreign clients for a significant proportion of their commissions. Some lived in their native cities and painted for the princes and viceroys of Germany and Spain. Others found it more profitable to leave and settle in new countries. By playing off their Italian and many foreign patrons against each other these artists could claim exorbitant terms.[4] Soon after the turn of the century the Bolognese painter G. M. Crespi wrote to the Prince of Liechtenstein who wanted him to come to Vienna to help in the decoration of his palace that 'I will be delighted to accept the proposed honour provided that suitable arrangements can be made between him who gives the orders and him whose duty it is to serve'.[5] He then laid down his conditions: he refused to work in collaboration with an architectural painter; his

[1] Letter of 8 June 1669—De Rinaldis, 1939, p. 221.
[2] Haskell, 1959.
[3] Ruffo, p. 289.
[4] See, for instance, the case of Albani as reported to Don Cesare Leopardi d'Osimo as early as 1647: 'non la può servire sollecitamente perchè ha obbligo di alcune altre pitture da finire per varj Personaggi, per Francia, Spagna, et Italia. . . .'—Gualandi, I, p. 38.
[5] Miller, 1960, p. 530.

travelling expenses and those of his servant must be paid in full; both of them must be lodged in the palace which was to be painted; he must be given two hundred Spanish *doppie* for every space to be filled. And so the list proceeded. Crespi was exceptionally successful, and not all artists could afford to adopt such an independent attitude. In fact, in the artistic as in other fields, the law of supply and demand was relentless, but it operated with painful clumsiness. Some foreign princes were disappointed after repeated and strenuous attempts to attract a painter; some painters of equal merit were unable, despite the most sycophantic perseverance, to arouse sufficient interest in the courts of Europe. But in general the outlines are clear enough. Until the downfall of the Barberini the opportunities for work in Rome were so great that few foreign rulers had much chance of success when competing with the popes. With the decline of papal patronage, however, the situation was reversed and many painters became aware of the fact that there were greater opportunities for them abroad.

– ii –

Ever since the High Renaissance the complete predominance of Italian art over that of all other countries had been accepted without question by the rest of Europe. During much of the sixteenth century rulers such as François I, Charles V and Philip II had spent large sums in building up collections of paintings which they acquired either through agents or directly from the artist. No one yet believed in the superiority of the 'Old Master', but after the deaths of Titian and Michelangelo there was a general recognition that a great creative period had come to an end, and work by these artists continued to be revered and avidly sought for in a way that had hitherto occurred only with Raphael. None the less many modern painters were still greatly esteemed, and artists from all over Europe were drawn to Italy as much by the reputations of her existing masters as by the memory of those who had only recently died. And then, at the beginning of the seventeenth century, new stars appeared on the horizon. 'Some painters have made marvellous progress and improved their art', wrote the Flemish artist Carel van Mander in Amsterdam[1]; 'among them there is one called Carracci, who is lodged by the illustrious Cardinal Farnese for whom he has painted many excellent works, especially a beautiful gallery which is so exquisitely painted in fresco that people say that it surpasses the manner of all other artists and that its beauty cannot be expressed. Another man working in Rome is someone called Michelangelo da Caravaggio, who does wonderful things. . . .'' Such was the heady news that reached the North and turned the concentration of patrons once more to Rome and to Italy.

Throughout the first three or four decades of the seventeenth century we find frequent references in artistic literature to the odd commission from abroad, but these were busy times in Rome itself and few foreign princes could make much of an impact. Only one power was so firmly established in the peninsula that her rulers could compete on almost equal terms with the popes for the services of the leading Italian artists. Lords of Milan and Naples, enjoying the closest economic collaboration with Genoa and able

[1] Vaes, 1931, p. 202.

at times to apply decisive pressure on Rome, the Spaniards commissioned important works from painters in all four cities. It was in Naples, above all, that they were active. The viceroys maintained there a form of government which is still proverbial for its combination of ceremonial and exploitation, and in these conditions the visual arts flourished as never before. Moreover, Spanish love of the picaresque and a tendency to mock that classical mythology which still meant so much to Italian humanists gave a special imprint to painting in the city, exemplified in the cruel realism and grimy 'philosophers' of Ribera and his followers. The viceroys, almost without exception, employed these artists to decorate churches, palaces and galleries, and on their return to Spain they took back with them large and influential collections.

It was, however, a frequent practice to appoint as viceroy a man who had already served for some years as ambassador in Rome,[1] and this sometimes led to his developing a taste at odds with that of the subjects whom he later ruled. We find a striking example of this in the career of the Count of Monterey, the most conspicuous Spanish patron in Italy during the first half of the century. This small, vain, greedy man, whose features showed 'a certain ugly majesty', owed his position to the influence of his brother-in-law, the King's favourite, Count-Duke Olivarez.[2] In Rome, where he welcomed Velasquez in 1630, he purchased 'une infinité de beaus originaus de Raphaël et du Titien et autres excellents peintres',[3] among which were two pictures of such outstanding importance that they were perforce acquired for the King. Titian's *Bacchanal* and *Worship of Venus*, which had so intoxicated Roman artists when in the collection of Cardinal Aldobrandini, had passed into the possession of the Hispanophil Ludovisi family. It was from them that Monterey managed to buy these masterpieces to the natural grief and indignation of all Italians.[4]

Monterey had also made contact with a number of contemporary painters and sculptors and when he was transferred to Naples in 1631 he wished to go on employing them. This was not altogether easy. Neapolitan artists were ferociously jealous of competition and were prepared to threaten violence in order to enforce their monopoly of local commissions. When Domenichino came to the city in 1631 to paint frescoes in the cathedral, he found himself compelled to seek the Viceroy's protection. This Monterey was prepared to give on his own terms: he insisted on the artist breaking his contract with the ecclesiastical authorities and working for him instead.[5] Lanfranco, who had come to Naples to paint frescoes in the Jesuit church, was also employed by Monterey, who commissioned from him pictures in his palace and altarpieces for the Augustinian convent and church which he had founded in Salamanca.[6] When the sculptor Giuliano Finelli, of Neapolitan parentage, came from Rome to work in the

[1] Colapietra, p. 30.

[2] Capecelatro, p. 94.

[3] Jean-Jacques Bouchard—Marcheix, p. 61.

[4] J. Walker, p. 78.

[5] Passeri, pp. 61 and 64, note 3.

[6] *ibid.*, p. 157; Trapier, p. 109. A series of ancient Roman scenes painted for the King of Spain is now in the Prado (Nos. 234-236), some of which are by Lanfranco.

Cathedral he too was at once taken up by the Viceroy, who commissioned life-size portraits of himself and his wife. He then used his influence with the Cathedral authorities to get Finelli a far larger share in the decoration than had originally been planned, though this met with the strongest opposition from the local sculptor Cosimo Fanzago.[1]

Monterey's preference for the artists he had known in Rome did not, however, cause him to neglect the Neapolitan school. In particular he employed his compatriot Ribera on a number of altarpieces for his Augustinian church. But it is possible that the new Baroque composition and much lighter tonality of these pictures represented a concession by the artist to Monterey's clearly demonstrated admiration for Roman and Venetian painting. Certainly he, like other painters in the city, owed much to this Viceroy's patronage.[2] And as the Neapolitans watched him depart in 1637 with his forty shiploads of booty they must have had mixed feelings. Even by the standards to which they were accustomed he was outstanding for the zeal and ingenuity with which he had drained his provinces of men and money to help the Spanish cause during the Thirty Years War. Yet his extravagance and greed had undoubtedly given the arts a remarkable stimulus—and there might well be worse to come.

During all this time King Philip IV, whose appetite for painting was by no means satiated by the employment of Rubens and Velasquez, remained deeply interested in the Roman scene. In 1628 his ambassador commissioned one of Guido Reni's largest, most splendid and romantic compositions, *The Abduction of Helen*, to be followed three years later by an even finer pendant of *The Death of Dido* from Guercino in Bologna; but owing to some diplomatic confusion neither picture was sent to Madrid.[3] Then, in about 1636, an agent of the King negotiated an ambitious commission for a set of more than a dozen large landscape paintings each of which was to include the figure of some hermit or anchorite.[4] These were designed to decorate the palace of Buen Retiro which was being built at this very time on the site of a monastery of Jeronymites. The choice of subjects given to the artists is therefore self-explanatory: equally clear is the reason why Philip found it necessary to turn to Rome for the series. The type of picture in which landscape and figures balance each other in composition and echo each other in mood had been created in Venice in the early sixteenth century and then largely neglected until its reappearance in Rome about a hundred years later. Though the initial impulse for this revival had come from the classically minded Annibale Carracci and Domenichino, the convention had been greatly enriched by the more picturesque and irrational contributions of Northern artists, who by the 1620s and 1630s enjoyed almost a monopoly of the genre. It was practised mainly by the young Claude, by a number of Flemish painters, of whom the most distinguished was probably Jan Both, and, to a lesser extent, by Nicolas Poussin. All of them were only just beginning to make names for themselves and it was precisely to them that the King of Spain now turned.

[1] Passeri, p. 251.
[2] Trapier, p. 72.
[3] Costello, p. 247.
[4] Röthlisberger, 1961, I, pp. 155-60; Blunt, 1959, pp. 389-90.

It has been acutely pointed out by M. Marcel Röthlisberger that only a man who was in close touch with the very latest developments in Roman art and also fully aware of Philip IV's requirements could have been responsible for such an adventurous commission; and the same author has indicated one man who had both these qualifications. Giovanni Battista Crescenzi, who was born in 1577, came of a noble Roman family. His brother was a cardinal and the two men were not only enthusiastic patrons and collectors but also among the very first to employ Claude, who painted frescoes in their palace. Moreover, both were devoted to the Spanish cause. Giovanni Battista went to Spain 'ostensibly to serve as an architect, but some say that this is a pretext and that what he really plans to build is his [the Cardinal's] career as Pope'.[1] The Venetian ambassador was being too suspicious, for Crescenzi really did practise architecture and he played an essential rôle in the building of the Buen Retiro. It is therefore more than likely that either he himself, on a quick visit to Rome, or his brother, who was living there, ordered the landscapes. This was, in any case, the most important foreign commission placed in Italy during the first half of the seventeenth century. For Claude it was decisive. In all he painted several other large landscapes, besides those with hermits, for the King of Spain, and these firmly secured his reputation as the leading practitioner in the genre. Poussin painted one or possibly two which were among his earliest ventures into the field, and, in general, the whole school of landscape painting was given a vital impulse which helped to establish its respectability.

Only one other nation was in a position to rival Spain in the claims that it could make on Italian artists. Throughout the century French monarchs, statesmen and princes kept at least one eye turned to the south, but the extent of their actual patronage varied greatly with the confusing developments of international politics.

'On dit que je suis chiche, mais je fais trois choses bien éloignées d'avarice, car je fais la guerre, je fais l'amour et je bâtis', boasted Henry IV.[2] His assertion of the royal supremacy through great works of architecture was of revolutionary and decisive importance for the whole history of Paris; but, consciously or not, it was an essentially 'patriotic' programme, put into effect almost entirely by French architects and craftsmen —the first large-scale enterprise of the kind to be executed without Italian help or even specific Italian models in mind. Such a policy was justified by its triumphant success; but in the field of painting it led only to the provincial decoration of latter-day Mannerists such as Toussaint du Breuil and Ambroise Dubois. Henri's wife, however, was not a Medici for nothing, and it was largely under her guidance that a certain Italian influence began to make itself felt in Paris.

Historians are agreed that Marie de Medici was never very intelligent and always excessively stubborn in defence of the two causes that were nearest her heart: pleasure and power.[3] Nor was her taste in any way remarkable. But she was closely related to two of the most cultivated families in Italy—the Medici in Florence (she was the niece

[1] Barozzi e Berchet, I, p. 242.
[2] Crozet, p. 49.
[3] Batiffol; Tapié, p. 67.

of Grand Duke Ferdinand) and the Gonzaga in Mantua (her sister married Duke Vincenzo)—and she was able to put these connections to good use. On her arrival in Paris in 1601 she was horrified by the Louvre—'more fit for a prison than for the home of a great prince'—and she stayed for a time in the splendid palace of the Gondi, a Florentine family which had settled in Paris some fifty years earlier. The garden especially was famous and the King was so struck by a fountain of *Orpheus enchanting the wild beasts*, made by the Flemish-Florentine sculptor Pietro Francavilla, that he summoned him to Paris where he soon arrived with his assistant and future son-in-law Francesco Bordoni.[1] It was in 1604 that Marie undertook her first important service to the arts. She persuaded her uncle the Grand Duke to commission an equestrian statue of Henri IV from Francavilla's master, Giambologna. This was to be placed on the newly built Pont Neuf. So impatient was she for the monument to arrive that she even asked Ferdinand to dismantle the one that had been made for himself and to send her the horse on which sat his own effigy. She explained that there would be plenty of opportunity for him to have it replaced at leisure. It need hardly be said that this request was not granted, and the monument, which was completed by Pietro Tacca and Francavilla, did not arrive for another ten years.[2]

From Florence Marie then turned her attention to Mantua and summoned to Paris the painter who is most associated with the earlier part of her reign, the Flemish Franz Pourbus the Younger. He arrived in 1609 and painted many portraits of her and the court. On the whole, however, while Henri IV was still alive, Marie confined her artistic interests largely to jewelry, silverware and other crafts. But after his assassination in 1610 she grew more ambitious as her regency became ever more disastrous. In 1611 she ordered her architect Salomon de Brosse to build for her a huge palace on the site of the one which she had bought from the duc du Luxembourg. Once again she looked to Florence for inspiration and she wrote to her aunt the Grand Duchess for the plans of the Palazzo Pitti on which she hoped that the new building would be based.[3] In fact it was designed on wholly different lines and the work was in any case held up by the internal problems in which she soon became involved. By 1620 she was back in power and anxious to impress the world with the nature of her triumph. This she did through a commission so spectacular in conception and achievement that it overshadows everything else in her life. It was in 1621 that Rubens, himself probably chosen because of his connections with the court of Mantua, was approached and asked to paint the two long galleries in her new palace with allegorical scenes of her life and that of her husband. The project is of such immeasurable importance that it must at least be referred to; yet, in a chapter devoted to the work of Italian artists, more attention must inevitably be paid to another painter who entered her service not long afterwards, the Tuscan Orazio Gentileschi.[4] He arrived in 1623 after sending a picture in advance from Genoa, and

[1] Baldinucci, IV, 1688, pp. 206-7; Desjardins, p. 49; Dhanens.

[2] Desjardins, p. 50. The monument was destroyed in 1792. In 1559 Catherine de' Medici had commissioned an equestrian statue of Henri II from Michelangelo, but this was never executed. Tacca later made a similar monument for Philip III of Spain.

[3] Batiffol, p. 430. [4] Sterling, pp. 112-20.

stayed for less than two years, discouraged no doubt by the welcome given to Rubens. During that time, however, he painted a number of pictures, the influence of which has been traced on the styles of artists as different as Louis Le Nain, Laurent de la Hyre and Philippe de Champaigne. Only one certain commission from Marie de Medici survives, but it is entirely typical of her interests at this time. It is a large allegorical painting of *Public Felicity triumphant over Dangers* (Plate 25)—a magnificent female figure holding the attributes of French royalty who gazes, defiant and yet serene, at the tempestuous storm clouds above her.

Marie de Medici was not the only ruler who was obsessively concerned with the promotion of her personal prestige. In 1624, while Rubens and Gentileschi were making use of all their gifts to this effect, her nephew Ferdinando, now Duke of Mantua, was worried by similar problems. He was most anxious to be addressed as 'Altesse' by the French court and he wrote to his ambassador in Paris for advice.[1] In reply he was told that pictures for the new palace would make a suitable gift. This answer must have delighted him, for Ferdinando like his father Vincenzo was a fanatical collector and patron who employed many of the leading artists in Italy, above all that most sensitive and poetic of painters Domenico Fetti. He therefore proposed sending ten pictures of Apollo and the Muses which Giovanni Baglione had brought with him from Rome a few years earlier. Marie especially asked that the Muses should not be 'tout à fait nues, ni trop lascives', but otherwise her reactions to the bribe are not known. On one man, however, they did make a great, if only indirect, impact. They turned the attention of her minister, Cardinal Richelieu, to Mantua whence he—and so many others—were soon to obtain treasures of incalculably greater importance than anything that poor Baglione could paint.

Yet Richelieu, though 'le plus grand ministre de la France et le plus illustre de ses amateurs', plays little part in this story.[2] In Italy he made use of agents of all kinds to acquire such masterpieces as the pictures painted for Isabella d'Este's *studiolo* by Perugino, Mantegna, Costa and Correggio—but all these artists were long since dead. For most of his career his dealings with the living were confined to Frenchmen and Flemings such as Simon Vouet, Philippe de Champaigne and Rubens. Indeed, even when he turned to Italy it was at first to commission the works of another Frenchman, Nicolas Poussin, from whom in 1635 he ordered three *Bacchanals* for his château at Richelieu. And then during the last few years of his life he suddenly embarked on a new policy of trying to bring to Paris all the leading artists south of the Alps.

The reasons for Richelieu's volte face are not hard to fathom. He must by now have heard with some envy of the triumphant success of the Barberini, who had turned Rome into a permanent memorial to their glory, and he must have realised that for all his encouragement there was no comparable talent available in Paris. Above all, an Italian protégé of his, Giulio Mazzarini, was beginning to play an important rôle in French politics. Throughout 1639 Richelieu was using all his pressure to have him made

[1] Baudson, pp. 28-33, and *Il Seicento Europeo*, 1956, p. 64.
[2] Bonnaffé, p. 269.

a cardinal and at the very end of that year he persuaded him to settle in France.[1] Soon Mazarin was appointed as delegate to represent French interests at the Congress of Cologne and thereafter he acted exclusively for the French court. In view of his nationality, his love of art and the vital rôle he was later to play in the policy of attracting Italians to Paris, it is not unreasonable to give him the credit for having initiated it.

Early in 1639 Poussin wrote to his friend Jean Lemaire that he was worried by these developments.[2] He realised that the best Italian painters were still far too well treated in Rome for them to want to accept French offers and he thought that only second-rate men 'autour desquels les François s'abusent très grossièrement' would be likely to go. In the event his prophecy proved accurate enough. Some months earlier pressure had been put on him and the sculptor Duquesnoy to come to France, but both men had jibbed, and Poussin had laid down the most demanding conditions. To his surprise, and no doubt to his regret, these were accepted, and in May 1640 the Surintendant des Bâtiments sent his agent, Paul-Fréart de Chantelou, to Rome to bring back Poussin and with him the 'plus excellents peintres, sculpteurs, architectes et autres fameux artisans'. All of them, it was hoped, would respond to the appeals made by Mazarin and his friends in the upper reaches of Roman society.[3] One of the artists they wished to attract was Pietro da Cortona[4]; another was Guercino.[5] But it soon became clear that they had aimed too high. By October, after a series of refusals from everyone concerned, Chantelou had to be content with escorting Poussin and a few quite secondary painters. Even this limited success had been achieved only by using the most extreme pressure ranging from ugly threats to bribery. Two other positive results emerged from Richelieu's Italian policy. The brilliant etcher and draughtsman Stefano della Bella, who came to Paris in the service of the Florentine ambassador, found the climate sufficiently encouraging to settle and work there for ten years.[6] And, after much begging, the Barberini finally allowed Bernini (and his pupils) to make a bust of the Cardinal, the most tremendous and dangerous of their so-called allies. This was almost certainly derived from a triple portrait by Philippe de Champaigne and it arrived in Paris in August 1641—cold, aloof and elegant—little more than a year before the death of its subject.[7]

Richelieu's death in no way interfered with French plans, as the Surintendant hastened to inform 'toute la troupe des vertueux' which now included Pietro da Cortona, Alessandro Algardi, François Duquesnoy and Poussin, who after an unfruitful two years in Paris had just got back to Rome on the pretext of fetching his wife.[8] At long last Duquesnoy agreed to go to Paris—only to die as he was about to set sail from Livorno.[9] This disaster merely spurred Mazarin, who had now replaced Richelieu, to more ambitious heights. Early in 1644 he made a determined effort to get Bernini himself to settle in France by offering him a huge salary. He was reckoning without Urban VIII,

[1] *Mazarin*, 1961. [2] Correspondance, p. 15.
[3] *ibid.*, p. 31, note 2. [4] *ibid.*, pp. 36 and 37; Briganti, 1962, p. 142.
[5] Malvasia, II, p. 264. [6] Blunt, 1954, p. 89.
[7] Wittkower, 1955, p. 202. [8] Poussin: Correspondance, p. 188.
[9] Passeri, p. 115.

who, although nearly on his deathbed, still retained his authority over the great artist. 'You are made for Rome and Rome is made for you', he is reported to have told him—words powerful enough to detain Bernini even when this munificent patron died and bad days followed.[1]

And so the utmost exertions by the most vigorous of European nations had almost wholly failed to compete with the attractions of the Barberini régime. English efforts to dislodge the principal Italian artists met with very similar results.

The passionate love of art felt by Lord Arundel, Charles I and a few of his courtiers is too well known to need stressing.[2] Equally familiar is the story of the King's purchase of the Duke of Mantua's collection of pictures and the great repercussions that this had on other European rulers.[3] By 1638 Gabriel Naudé could already write, in terms that were to become so familiar in the eighteenth century, that some pictures in which he was interested would probably go to Lord Arundel, 'who leaves no stone unturned in his efforts to strip Italy of all her precious treasures'.[4] Yet we hear very much less of the repeated failures of Charles I and his agents to patronise Italian artists and encourage them to come to England—failures that have been largely forgotten in our fully justified satisfaction over his employment of Rubens and Van Dyck. There is reason to believe that the King himself saw matters in rather a different light.

Charles I and his ministers were making a conscious effort to break down the isolation between England and Rome that had lasted ever since the most ferocious years of the Counter-Reformation.[5] His own wife and many of his courtiers were Catholic; conversions were not infrequent; the penal laws remained in force but were applied with much less rigour. In Rome reciprocal gestures were made: Englishmen could travel there without fear of the Inquisition—indeed they were warmly welcomed by Cardinal Barberini—and diplomatic exchanges were encouraged. With this political relaxation came a growing English respect for contemporary Italian culture. The new Catholic humanism appealed to many who had been repelled by the intransigeance of the previous half-century and, in any case, the rise of connoisseurship promoted a certain discrimination between the aesthetic merits of a work of art and its representational content. Such sophistication was, however, characteristic only of a small, privileged élite, and, as puritan objection to the court increased, it became more and more difficult to maintain. The whole precarious balance broke down in 1642, but the tensions had been there from the start and must be taken into account in any estimate of Charles's artistic policy.

Almost as soon as he came to the throne in 1625 the new King made his first attempt to bring a leading Italian painter to England. After seeing a picture of *Semiramis* by Guercino he offered the Bolognese artist the most favourable terms if he would

[1] Baldinucci, 1948, p. 92.

[2] Stone, p. 92, and also Betcherman, pp. 325-31.

[3] Luzio, pp. 63-167.

[4] Lumbroso, p. 369, and in 1645 Gabriele Balestrieri wrote to the Duke of Modena that 'gli Inglesi . . . non hanno guardato a spesa per haver pitture di qual si voglia sorte'—A. Venturi, p. 252.

[5] Albion, *passim*.

settle at his court. But, we are told, Guercino 'refused to accept, as he did not want to have dealings with heretics and thus contaminate his angelic character; nor did he want to undertake such a dreadful journey in a climate so different from that of his own country'.[1] It may have been immediately after this that Charles 'invited Albano into England in a letter written with his own hand'.[2] Whether it was the climate or the heretics that worried Albani is not known, but he too declined the offer. Nor was Charles any more successful with the sculptor Pietro Tacca whom he wished to come to London 'to make two horses for him'; the Grand Duke of Tuscany refused to authorise the visit.[3] However, after some perseverance, the King managed to get both his painter and his sculptor, though neither was of the stature he had originally hoped for.

Orazio Gentileschi had already been working for some time in Paris when he was induced to come to England, probably at the end of 1625.[4] He had there begun to shed the strong Caravaggist influence of earlier years and had developed a lighter, less idiosyncratic, more decorative style. In England, where he was enthusiastically welcomed by Charles and the Duke of Buckingham, this process was carried still further, though his easel pictures retained a rather intimate, informal narrative approach to Biblical subjects which need not have offended any but the most rabid Protestant. His large-scale commissions were equally harmless politically—Stuart propaganda for the Divine Right of Kings was entrusted to the far abler brush of Rubens—and less up to date artistically. On a ceiling of the Queen's house, built by Inigo Jones, he painted canvases of the Muses and Virtues which looked back to Veronese and the Libreria in Venice. They are now badly worn and were probably never very distinguished. Gentileschi was old, tired and homesick, and, as in Paris, he found himself surpassed by the ubiquitous Rubens.[5]

Charles I was just as keen to employ an Italian sculptor and in about 1635 his efforts were rewarded. Francesco Fanelli, the 'one-eyed Italian', was a Florentine brought up in the traditions of Giambologna, Pietro Tacca and Francavilla.[6] His work in England was almost entirely confined to small-scale bronzes whose restricted subject-matter— horses and portraits—seems like a parody of the perennial national taste but in fact reflected the special interests of one of his principal patrons, the Duke of Newcastle. The Duke was governor of Charles, Prince of Wales, and an enthusiastic rider. For him and his circle Fanelli ransacked sacred and profane literature to dignify his portrayals of the horse. He also made an attractive little bust of the young Prince and another of the King, whose features he caught in a work of great distinction though the expression is somewhat strained and the eyes lifeless (Plate 27a).

[1] Malvasia, II, p. 261, and Mahon, 1949, p. 222, who suggests that there was no link between the *Semiramis* and Charles I's invitation.

[2] Walpole, 1762, II, p. 51. Though this cannot be accepted as reliable evidence there is no reason to doubt its substantial truth.

[3] Baldinucci, V, 1702, p. 361.

[4] Crinò, p. 203; Hess, 1952, pp. 159-87.

[5] Orazio's daughter, the painter Artemisia Gentileschi, also came to England for a year or two in about 1638.

[6] Pope-Hennessy, 1953, pp. 157-62; Whinney and Millar, pp. 121-2.

Fanelli's reputation in England was such that Lord Arundel planned to employ him on his tomb. But Charles's imagination was clearly stirred by more exalted visions. He used all his influence to obtain the authorisation of the Barberini for Bernini himself to carve his portrait, and by playing on the Pope's hopes and fears for English Catholics he achieved his aim. In July 1637 the bust, which was based on a triple portrait by Van Dyck, reached England. There it could be seen that Bernini, despite his reverence for royal splendour, had captured from Charles's favourite painter all the poetic and dandified melancholy that has so endeared the King to subsequent generations—and that was so appreciated by the sitter himself. Charles was delighted and loaded Bernini with rich presents while plans were put in hand for another bust to be made of the Queen.[1] Meanwhile his courtiers were intoxicated by the possibilities that appeared to open before them. Thomas Baker, who took Van Dyck's portrait to Rome, just managed to get the master to record his own fantastical features before the Pope, unwilling to devalue his original concession, clamped down on further English commissions.[2] Lord Arundel was less successful. 'I send by Francesco a Picture of my owne and my little Tom bye me', he wrote in November 1636 to William Petty in Rome,[3] 'and desire it may be done at Florence in marble Basso rilievo, to try a yonge Sculptor there whoe is said to be valente Huomo, Francesco hath his name. I could wish Cavaliere Bernino, or Fra[ncesco Fi]a mengo [Duquesnoy], might doe another of the [sam]e.' But he wished in vain.

Many contemporary works of art reached England from Italy before 1642. We hear for instance that the King commissioned a number of paintings from Angelo Caroselli[4]; and Cardinal Barberini sent the Queen so many pictures that she put them on view in her private chapel at Somerset House—a particularly tactless gesture as there were already complaints that the King was being deceived by 'gifts of paintings, antique idols and such like trumperies brought from Rome'.[5] The most famous of all these gifts was Guido Reni's large *Bacchus and Ariadne*, but the picture arrived when the civil war was already on the verge of breaking out and it was soon in French hands.[6] Bernini's bust of the Queen had to be cancelled, Fanelli hurried off to Paris, and at about the same time Gentileschi died.

– iii –

The 1640s and 1650s mark a turning-point in the dissemination of Italian art abroad. In 1644 Pope Urban VIII died and, soon after, his nephews fled from Rome, thus removing from the scene by far the most important source of patronage in Italy. By the same year an Italian amateur of fine taste and insatiable appetite was in total control of French affairs. In 1648 peace at last returned to Germany and Central Europe, and

[1] Wittkower, 1955, p. 201.
[2] *ibid.*, with bibliography.
[3] Hervey, p. 391.
[4] Passeri, p. 191.
[5] Albion, p. 395.
[6] *Guido Reni*, p. 109.

thereafter recovery from the devastation of the Thirty Years War led to a new demand for Italian art just when England under the Puritans seemed to be losing interest. Whereas the period so far chronicled witnessed the powers struggling in vain to share in the marvellous flowering of the Italian Baroque, the second half of the century saw a comparative decline in talent accompanied now by Italian efforts to win a place in the new European balance of power. But this was not immediately obvious.

Cardinal Mazarin, who took over the government of France immediately on the death of Richelieu in 1642, had been born forty years earlier in a little village in the Abruzzi. He was educated by the Jesuits in Rome and soon entered the service of the Colonna for whom his father worked as *intendant*. He accompanied Girolamo Colonna to Spain and then served as captain of a regiment raised by the family to reconquer the Valtellina in North Italy. There his very great diplomatic ability attracted the attention of Giovanni Francesco Sacchetti, brother of Giulio and Marcello, and he soon became a special protégé of that all-powerful family. His position was further strengthened by the support of the Bentivoglio, who, as has been pointed out in an earlier chapter, were always on the alert for new talent. With such powerful backing he could hardly fail, and he was soon acting under Cardinal Antonio Barberini who was trying to put an end to the war between France and Spain over the succession of Mantua. It was in connection with this problem that Mazarin pulled off his most brilliant diplomatic coup and almost single handed fulfilled the Pope's highest hopes of him. He returned to Rome in 1632.

He was handsome, cunning and ambitious and he moved in the very highest ranks of the most brilliant social circles in Europe. He was befriended by the greatest families of the day, and he chose as his mistress Leonora Baroni, the singer whose fabulous success inaugurated the long and frenzied tradition of operatic 'stardom'.[1] The families with whom he was especially associated—the Barberini, the Sacchetti and the Bentivoglio— were all exceptional art patrons and it is certain that Mazarin now acquired that passion for collecting which never left him. It is much less certain how and in what way he expressed it. He was not yet rich, though the Bentivoglio apparently lent him money[2] and he had been appointed to a canonry of S. Giovanni in Laterano which brought him in a regular income. Most reports speak of him as mean where his own money was at stake, though always ready to spend that of others on himself. In view of all this it is significant that the artist from whom he first seems to have commissioned paintings was Poussin[3]: the nationality was suitable for a patron just beginning to show his political sympathies; the price was doubtless reasonable as Poussin was not yet celebrated; the artist was easily accessible in the centre of the Barberini circle yet not engaged on official commissions. Poussin may have painted for Mazarin two of his most beautiful pictures —the *Inspiration du Poète* and *Diana and Endymion*.[4] Like the *poesie* of Giorgione and the

[1] Prunières, 1913, p. 41.

[2] Brienne, I, p. 315.

[3] It is most unlikely that Mazarin could have commissioned anything serious before 1632, the date that Mahon (1960, pp. 352-4) has suggested for his purchase of the two Poussins.

[4] In the Louvre and Institute of Arts, Detroit—see *Nicolas Poussin*, pp. 46 and 65.

young Titian, to which they owe so much, both are bathed in golden light and, although the subject of the former has not yet been fully determined, both look back to the lyric poets of antiquity and the world of fable and mythology which, as we know from other sources, so strongly appealed to Mazarin. Thereafter he took no further interest in Poussin's career and when, many years later, his taste was analysed by the intelligent, malicious and not wholly accurate courtier Loménie de Brienne he was reproached for his neglect of the artist's mature, severe and classical pictures.[1] When due account has been made for Brienne's prejudices his description of Mazarin emerges as consistent and generally convincing: a passionate enthusiast, unscrupulous in his ambition to acquire pictures, yet fastidious, almost effeminate, in his love of *objets d'art* and finery. We can visualise him, his beautifully expressive hands bathed in perfume, discussing the merits of some new acquisition with other amateurs and artists and carefully selecting exactly where to place it, for 'Son Eminence n'avoit point de plus grand plaisir qu' à ranger son garde-meuble et qu'à placer en symétrie, dans les armoires diverses, dont il est plein, ses superbes buffets d'argent et de vermeil doré, ses vases de porphyre, de porcelaine de la Chine, ses cristaux et ses aigues-marines, et mille autres raretés dont il faisoit ses délices. . . .'[2]

As yet this rich life of the senses was only just opening up to him. Increasing duties kept him away from Rome for years at a time as his association with France grew closer and closer, and he finally settled in Paris early in 1640 and was made Cardinal at the end of the following year. By the middle of 1643 both Richelieu and Louis XIII were dead and he was able to satisfy his artistic tastes and ambitions on an unparalleled scale.

It has already been pointed out that Mazarin's earliest attempts to attract Italian artists to France, made while Urban VIII was still alive, met with no success. He not only failed to get Bernini to enlarge the palace that he had forcibly acquired from the financier Jacques Tubeuf; he was at first not even able to bring to Paris some of the best Italian musicians, including his former mistress Leonora Baroni. But he was determined to make use of Italian artists of all kinds. It was the change of régime in Rome that made this possible. Early in 1646 Francesco Barberini fled from the persecution of Innocent X and arrived in Paris to put himself under the protection of his former protégé, Mazarin. Back in Rome his favourite painter Giovan Francesco Romanelli began to suffer from the first cold winds of neglect and hostility. A suitable arrangement was easily reached and by June Romanelli was already at work painting the newly built upper gallery of Mazarin's palace (Plate 26a).[3] The artist proposed a series of Roman histories. But the Cardinal 'showed that he preferred the Metamorphoses of Ovid as being gayer and comforming more to the taste of the country'.[4] The choice was wholly characteristic, as has been seen from the account of his probable relations with Poussin. It was also

[1] In fact Brienne says (I, p. 302) that Mazarin did not own a single Poussin, but he almost certainly meant one of the artist's later works which were far better known in France than his early pictures.

[2] Brienne, I, pp. 293-4.

[3] *Mazarin*, p. xxxiii.

[4] Letter from Romanelli to Francesco Barberini of 6 July 1646—Pollak, 1913, p. 52.

a wise one in view of the nature of Romanelli's talents. He was clearly far more at home in scenes of erotic or Arcadian feeling, such as *Ariadne being woken by Love, Narcissus* or *Romulus and Remus* (Plate 26b) than in those, such as *Jupiter sending down his Thunderbolts on the Gods*, where a more martial spirit was required. Glorification of Mazarin was out of the question in view of his nominal dependence on the boy King Louis XIV and the Regent Anne of Austria, and in any case the long tunnel vault of the narrow gallery was scarcely adapted to a great unified fresco as in the Palazzo Barberini. In the event, Romanelli divided the area into a number of oval, circular, rectangular and square compartments separated from each other by frames of gilt stucco. His figures are somewhat pale, academic and lacking in energy, and paradoxically enough, these frescoes played their part in conditioning French taste against the more exuberant and vital creations of the true Italian Baroque.

These early years of Mazarin's rule were important ones for the diffusion of Italian art. Operas, ballets, fashions of all sorts, as well as pictures, sculptures and works of elaborate craftsmanship were constantly arriving in Paris. In 1645 Giacomo Torelli, the most distinguished of all Italian stage designers, was sent there by the Duke of Parma for whom he had been working, and the beauty of his décors, as well as the elaboration of the new techniques which he introduced, attracted (as they had done in Italy) far more attention than the operas for which they were designed.[1] Then in 1648, soon after the departure of Romanelli, the Bolognese painter Giovanni Francesco Grimaldi came to complete the decoration of the Cardinal's gallery, by painting landscapes in the niches and embrasures of the windows.[2] In Rome, and indeed all over Italy, potentates who were anxious to secure his favour sent him pictures. His old friend the Marchese Bentivoglio had started the process as early as 1639 by commissioning for him a *Carità Romana* by Guercino.[3] Some years later Mazarin himself acquired three further paintings direct from the artist—a *St Peter*, a genre picture of a girl with a basket of fruit, and a *Venus mourning over the Death of Adonis*.[4] In 1647 we find him commissioning a landscape with the *Flight into Egypt* from Claude.[5] And so the process continued.

Mazarin's ambitions to bring Italian artists to Paris had not been satisfied by the arrival of Romanelli and Grimaldi. In 1648 he wrote personally to Algardi and tried, through the most generous offers, to persuade him to reverse his refusal of some six years earlier. So advantageous were the terms proposed that the sculptor was on the point of departing when once again papal policy interfered. Algardi occupied the same pre-eminent position in the Pamfili court as Bernini had held in that of the Barberini. However mean Innocent X and his nephew might be, they could scarcely allow their principal artist to leave Rome, and so 'they made him so many offers, so many promises,

[1] Prunières, 1913, p. 68; Bjurström, 1961.

[2] Félibien, III, p. 530.

[3] Malvasia, II, p. 264.

[4] ibid., II, p. 327.

[5] Röthlisberger, 1961, I, p. 274, who points out that although Claude recorded the purchaser of this picture (now in Dresden) as the otherwise unknown 'M. Parasson', it belonged to Mazarin by 1653 and was most likely painted for him through an agent.

plied him with so much flattery and aroused in him so many hopes that they made him change his mind and cancel all his contracts [with the French]'.[1]

Mazarin's assumption of power in France strengthened his position in Rome itself despite the hostility of the Pope. Soon after 1644 he bought the great palace of his one-time patrons, the Bentivoglio, and planned to use it for distinguished French visitors to the city.[2] Though he himself never returned to see once again the rooms where he had been received as an obscure and ambitious young diplomat, the thought that he owned the vast palace, whose casino contained the world-famous fresco of *Aurora* painted by Guido Reni for Scipione Borghese, must have given him intense satisfaction. Soon afterwards he commissioned, through Paolo Maccarani, an agent in Rome, the architect Martino Longhi the Younger to add a façade to the church of SS. Vincenzo ed Anastasio in the Piazza di Trevi.[3] Mazarin himself could exert only little control over the architecture, and as the work dragged on he became increasingly harassed by economic difficulties. 'We are always talking about building,' he wrote to Maccarani shortly before his death in 1661, 'and yet it might be better to think of building for ourselves a certain and everlasting room in Paradise.' But such hesitations did not last and already the triumphantly bold façade served to proclaim the splendour and arrogance of the Cardinal's authority in the very centre of fashionable Rome.

In 1649 Mazarin's patronage of Italian artists met with a disastrous, though temporary, set-back. The first Fronde—that strange and shifting alliance of aristocratic and bourgeois factions—turned against the Cardinal with great violence. The political implications of the affair are far too complex to warrant investigation here, and it need only be said that one of the special targets of Mazarin's enemies was his employment of Italian artists in the field of music and painting—described in a coarse and cheap little lampoon as 'de ridicules personnages/Avec de lascives images'. Giacomo Torelli was financially ruined and imprisoned for many months.[4] Stefano della Bella rushed back to Italy after a narrow escape from lynching.[5] Giovanni Francesco Grimaldi had to hide in a Jesuit seminary before he too managed to get back home.[6]

The next four years saw a series of fantastic reversals of fortune in Mazarin's position. A return to power followed by exile; marches and counter-marches; sudden changes of alliance; the sale of his library and threatened dispersal of all his collections

[1] Passeri, p. 210.

[2] Mazarin bought the palace from the Lante family which had acquired it from the Bentivoglio. The exact date of the transaction is not certain, but it must have been before 1647—d'Aumale, p. 8. See also Callari, p. 298.

[3] In 1646—see *avviso* published in *Roma*, 1938, p. 477. See also Elpidio Benedetti, p. 5, Mazarin: *Epistolario inedito*, p. 119 (letter of 3 June 1650 to Maccarani: 'mi piace riesca di Sua soddisfatione, perchè non può essere, se non bella . . .'), and Mazarin: *Lettres pendant son ministère*, IX, p. 693 (letter of 6 March 1661 to Maccarani). The inscription on the façade reads: ANNO GIUBILEI MDCL IULIUS S.R.E.D. CARD. MAZARINUS A FUNDAMEN. EREXIT. Besides being Mazarin's agent, Maccarani was a collector in his own right. In 1675 he owned 'une galerie de statues et de tableaux'—Spon et Wheler, I, p. 236.

[4] Prunières, 1913, p. 149.

[5] Baldinucci, VI, 1728, p. 245.

[6] Pascoli, I, p. 47.

alternating with vital new purchases. For in the middle of these troubles, Charles I in England was being faced with far more ruthless and successful opponents, and his execution, followed by Parliament's sale of his picture gallery, put on to the international market the most remarkable treasures in European history. Somehow, in the intervals of his difficulties, Mazarin managed to take an interest in these affairs across the Channel and commissioned the rich German banker Everard Jabach to buy for him a number of pictures from the collection of his former rival.[1]

By 1653 Mazarin was firmly back in power again and found that the vast majority of his paintings had survived the threats to which they had been exposed. An inventory was at once drawn up and from it we can gauge the extent of his collecting and patronage during the previous twenty years.[2] He owned some 500 pictures which, apart from Old Masters, had mostly been painted by artists with whom he had become familiar in his younger days in Italy. Guido Reni and Guercino were the best represented of seventeenth-century painters, but he also owned works by Sacchi and Pietro da Cortona among the Barberini favourites. To this taste he remained faithful all his life, paying almost no attention to the developments in Italian painting that had taken place since his departure or to pictures painted in cities other than Rome and Bologna. Nor did he modify his position now that he had the chance to resume collecting. Among all the works that he acquired between 1653 and his death in 1661 there is only one—a *Landscape with Apollo* by Salvator Rosa—painted by an artist whom he had not known when living in Italy.[3] So many of the pictures in Mazarin's gallery were given to him by friends and clients that it is not always easy to understand his own taste from an investigation of their quality and subject-matter, but when we have specific evidence of direct commissions by him we see that he nearly always preferred to choose profane, even erotic, themes. The accusations of his enemies about 'lascives images', though grotesque when applied to a Titian or a Correggio, are not wholly incomprehensible.

Perhaps the best way of estimating Mazarin's taste is to compare it with that of his contemporary, Louis Phélipeaux de la Vrillière, a secretary of state.[4] Brienne said that he would prefer 'quatre tableaux de la galerie de la Vrillière à tous ceux du Cardinal Mazarin si l'on en excepte les trois Corrège et la Venus du Titien'. In his palace, specially built for him by François Mansart, La Vrillière kept splendid paintings by most of the artists represented in Mazarin's apartments. But the accent was very different. Far from finding that mythological subjects 'conformed more to the taste of the country', La Vrillière chose from the artists he employed themes taken from the high, heroic world of antiquity. Some time before 1635 he acquired a large and famous picture by Guido Reni of *The Rape of Helen* which had been purchased by Marie de Medici a few years

[1] de Cosnac, p. 144, and Taylor, p. 332.

[2] d'Aumale, pp. 293 ff.

[3] See the inventory of 1661 in de Cosnac, item 1240. Incidentally, among those who drew up this inventory was the Genoese painter and engraver Giovanni Andrea Podestà whose connection with Mazarin has not hitherto been noticed—see Blunt in *Revue des Arts*, 1958.

[4] Bonnaffé, pp. 168-70, and Briganti, 1962, p. 230. Guercino's *Cato* is now at Marseilles—Hoog, pp. 270 ff.

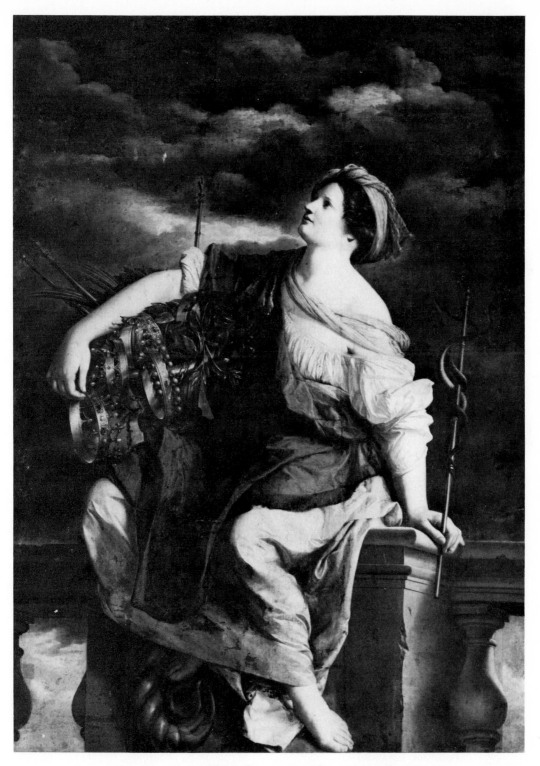

GENTILESCHI: Public Felicity triumphant over Dangers

Plate 26 CARDINAL MAZARIN AND ITALIAN ART

a. NANTEUIL: The Cardinal in his gallery

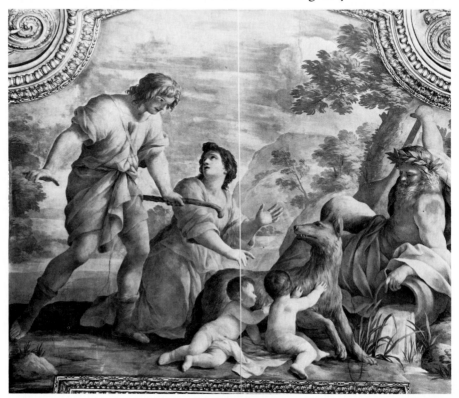

b. ROMANELLI: Romulus and Remus from ceiling of gallery in Palais Mazarin

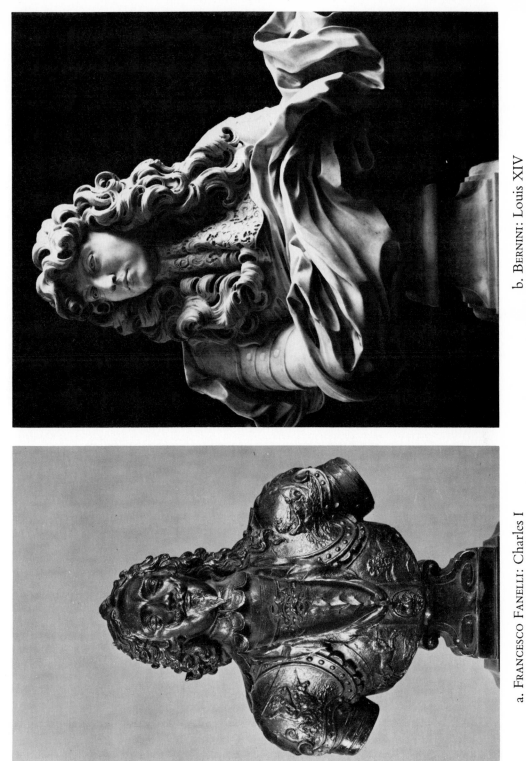

Plate 27

FOREIGN ROYALTY AND ITALIAN SCULPTORS

b. BERNINI: Louis XIV

a. FRANCESCO FANELLI: Charles I

Plate 28 ITALIAN ART AND CENTRAL EUROPE

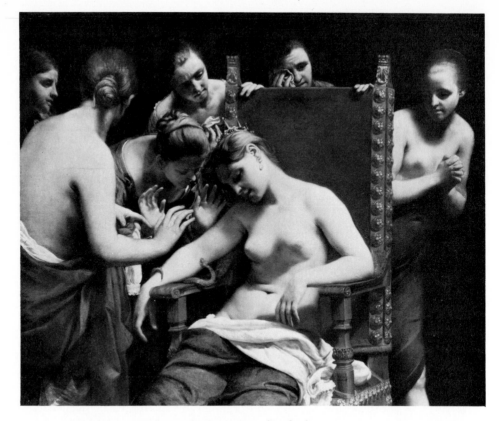

a. CAGNACCI: Death of Cleopatra

b. BURNACINI: *The Elysian Fields* from the opera *La Monarchia Latina Trionfante*, Vienna 1678

earlier. He followed this with a commission to Guercino for a *Scene from the Life of Cato*, and in 1637 he ordered from Poussin *Camillus handing the Schoolmaster of the Falerii to his Pupils*. The subject was chosen from Livy and told of the generosity of the Roman republican hero Camillus who when besieging Falerium refused the offer of a school-master to deliver his pupils as hostages and handed over the treacherous teacher to be stripped and beaten by the schoolboys all the way back to town. It is one of Poussin's largest paintings, austere, harsh and brutal. In the 1640s La Vrillière added to these a series of paintings by Guercino (*The War between the Romans and the Sabines* and *Coriolanus and his Mother*), Pietro da Cortona (*Caesar restoring Cleopatra to her usurped Throne, The Sibyl announcing the Birth of Christ to Augustus* and the *Finding of Romulus and Remus*) and Alessandro Turchi (*The Death of Cleopatra*). The series was completed some years later with *Augustus closing the Temple of Janus* by Carlo Maratta. Even a bare list of the titles of these ten huge paintings is enough to indicate the differences in taste between La Vrillière and Mazarin. On the one hand we have the France of Corneille and the elaborate 'Spanish' tragedies of the early seventeenth century; on the other the world of Italian opera and ballet, of refinement and delicacy. Yet from one point of view both men shared the same ideals. For while they continued to look to Italy for their artists, a different group of patrons, made up mostly of bankers, lawyers and merchants, was beginning to reject the attractions of contemporary Italian painting and develop what was later to be considered a more specifically French taste for reticence and classicism. Neither quality was especially attractive to La Vrillière or Mazarin.

When Mazarin returned to Paris in 1653, the sale of Charles I's pictures in London was still proceeding. He was now far better placed to acquire some of the finest of them than he had been three years earlier. Through his ambassador M. de Bordeaux he was able to buy Correggio's *Jupiter and Antiope*, Titian's *Venus of the Pardo*, and a number of Van Dycks, including *The Children of Charles I*.[1] Perhaps it was because even he was satisfied by this fabulous haul that his collecting and patronage much decreased during the last years of his life. Romanelli was called back to Paris in 1655 but worked exclu-sively for the Queen Mother in the Louvre: this time he was encouraged to paint the Roman histories which Mazarin had rejected nine years earlier.[2] Gaspare Vigarani was summoned from Mantua in 1659 to build a theatre in Mazarin's palace, but found that there was not enough space and moved to the Tuileries instead.[3] Mazarin was still the promoter of all these enterprises but, as if foreshadowing the coming rule of Louis XIV, they were executed far more in the name of the monarch than under his own aegis. Perhaps the hostility of the Fronde had had some effect. None the less his passion for Italian precious brocades and stuffs of all kinds was as strong as ever, and these he continued to acquire with febrile voracity.[4] A month before his death he paid a last visit to his pictures, and the account given by Brienne of this occasion, familiar though it is, is too beautiful and too relevant not to be quoted once more[5]: '. . . je me promenois

[1] de Cosnac, pp. 169 ff.
[2] Hautecœur, pp. 39-49.
[3] *ibid.*, pp. 84-9.
[4] Alazard, pp. 18-28 and 55-86.
[5] Brienne, III, pp. 88-90.

à quelques jours de là dans les appartements neufs de son palais et j'étois dans la petite galerie que étoit tapissée de Scipion tout de laine qui avoit été au maréchal de Saint-André, la plus belle tapisserie du Cardinal, sur les desseins de Jules Romain, je l'entendis venir au bruit que faisoient ses pantoufles qu'il trainoit comme un homme fort languissant et qui sort d'une grande maladie. Je me cachai derrière la tapisserie et je l'entendis dire "Il faut quitter tout cela!" Il s'arrêtoit à chaque pas, car il étoit fort foible, et se tournoit tantôt d'un coté tantôt de l'autre, et jetant les yeux sur l'objet qui lui frappoit la vue, il disoit du profond du coeur: "Il faut quitter tout cela!" et se tournant, il achevoit: "Et encore cela! Que j'ai eu de peine à acquérir ces choses! Puis-je les abandonner sans regret? Je ne les verrai plus où je vais." J'entendis ces paroles très distinctement. Elles me touchèrent peut-être plus qu'il n'en étoit touché lui-meme. . . . Je fis un grand soupir que je ne pus retenir et il m'entendit. "Qui est là? dit-il. Qui est là? —C'est moi, Monseigneur, qui attendois le moment de parler à Votre Éminence d'une lettre de M. de Bordeaux, fort importante, que je viens de recevoir.—Approchez, approchez", me dit-il d'un ton fort dolent. Il étoit nu dans sa robe de camelot, fourré de petit-gris et avoit son bonnet de nuit sur sa tête. Il me dit: "Donnez-moi la main; je suis bien foible, je n'en puis plus.—Votre Éminence feroit bien de s'asseoir." Et je voulus lui porter une chaise. "Non, dit-il, non. Je suis bien aise de me promener et j'ai affaire dans ma bibliothèque." Je lui présentai le bras et il s'appuya dessus. Il ne voulut point que je lui parlasse d'affaires. "Je ne suis plus, me dit-il, en état de les entendre. Parlez-en au Roi et faites ce qu'il vous dira. J'ai bien d'autres choses maintenant dans la tête." Et revenant à sa pensée: "Voyez-vous, mon ami, ce beau tableau du Corrège, et encore cette Vénus du Titien, et cet incomparable *Déluge* d'Antoine Carrache (car je sais que vous aimez les tableaux et vous vous y connoissez très bien). Ah! mon pauvre ami, il faut quitter tout cela! Adieu, chers tableaux que j'ai tant aimés et qui m'ont tant coûté!" '

'Il faut quitter tout cela'—yet even from the grave Mazarin was able to promote the patronage of Italian art which had meant so much to him. In 1644 he had summoned to Paris a branch of the Theatine order, which settled on the banks of the Seine. In his will he left them a large sum with which to rebuild the church of St Anne-la-Royale and directed that his heart be buried in it. For this purpose the Theatines summoned a member of their own order, Guarino Guarini, who arrived in 1662. There he began work on the church which was interrupted in 1669 and only completed some fifty years later. With its curving façade, derived from Borromini's S. Carlo alle Quattro Fontane, and highly idiosyncratic vault, the plan made no concession whatsoever to current French practice and remained as a wholly isolated example of Italian Baroque architecture in the Paris of the Grand Siècle.[1] As such it may well have served more as a deterrent than as an inducement to further experiments of the same kind. For a reaction was already under way, though it was not yet apparent.

Both Fouquet, the unfortunate finance minister who was arrested as soon as Louis XIV took over power, and Colbert, who replaced him, had been employed by Mazarin,

[1] Wittkower, 1958, p. 269.

and both were enthusiastic collectors of Italian art.[1] For all his patriotic ambitions the young King found it absolutely natural to look to Italy for the painters, sculptors and architects whom he wished to employ. In Florence Baldassare Franceschini was commissioned to paint *Fame carrying the Name of the King to the Temple of Immortality*.[2] In Rome Ciro Ferri was also working for Louis XIV[3] and Pier Francesco Mola was invited to come to Paris where he was offered an enormous stipend, but died as he was about to set off.[4] Like other painters he had seen which way the wind was now blowing, and though the independent-minded Salvator Rosa refused an invitation to Paris in the same year (1665), he was soon writing that 'there is not a Frenchman fond of art who comes here without trying to get hold of something by me'.[5] But the culmination and crisis of this French enthusiasm are to be found in Louis XIV's plans for the Louvre.

Soon after the onset of his rule Louis and Colbert began to consider proposals for building the eastern front of the royal palace. Colbert was hostile to Le Vau, who had been Mazarin's principal architect, but after searching for alternative French designers he was compelled to admit defeat and turn to Italy. As a first step he proposed submitting Le Vau's plans to some of the leading Roman architects, but he then went further and asked the Italians to send drawings of their own. The resulting tragicomedy has been examined in detail by many writers and only the outlines and significance of the story need be discussed here.[6]

Arrogant nationalism had become very powerful as a result of the unscrupulously patriotic policies of Richelieu and even, paradoxically, of Mazarin, but the French hostility to Italian art which now began to make itself felt was based on more than purely racial feeling. Criticisms of the plans submitted by Bernini, Pietro da Cortona, Carlo Rainaldi and the unknown Candiani were precise and consistent: none of these architects had paid any serious attention to French conditions; all of them were too elaborate, too 'Baroque' for native taste. Pietro da Cortona's drawing 'avait plutôt l'idée d'un temple que d'un palais . . .'. Candiani's were 'extravagant'; Rainaldi's 'fort bizarres et n'avaient aucun goût de la belle et simple architecture'. Modern opinion has endorsed most of these views. It was Bernini who came nearest to imposing his taste on Paris, and he did this mainly through the personal support of the King, but in the end he too was unsuccessful. His first plans were rejected, but he was then invited to submit further ones and to come to Paris himself to discuss the problem. After a triumphant progress through the provinces he was introduced to Louis on 4 June 1665. His first words set the right tone: 'J'ai vu, Sire, les palais des empereurs et des papes et ceux

[1] Alazard, *passim*, and Bonnaffé, pp. 68-9 and 113-15.

[2] Alazard, p. 110.

[3] Ruffo, p. 298.

[4] Pascoli, I, p. 127. Canini, who accompanied Cardinal Chigi on his visit to Paris in 1664, was also employed at the French court—Pascoli, II, p. 124.

[5] Limentani, 1950, p. 21, and De Rinaldis, 1939, p. 193. Louis XIV's attitude to Rosa was later to change, for in 1697 a *Battle* by the artist which had been presented to him by the Papal Nunzio was sent to Paris from Versailles with the following note: 'tableau dont le roi ne veut point'—Bailly, p. 50.

[6] For this section see, apart from Blunt, 1953, and Wittkower, 1958, Hautecœur and Chantelou.

des princes souverains, qui se sont trouvés sur la route de Rome à Paris, mais il faut faire pour le Roi de France, un Roi d'aujourd'hui, de plus grandes et magnifiques choses que tout cela. . . . Qu'on ne me parle de rien qui soit petit.' But Colbert could hardly see the matter in the same light. He too was anxious for grandeur, but as a practical administrator he was just as concerned with expense and the detailed arrangement of rooms. Bernini was not helpful in this respect, and he failed to appreciate one essential difference between the French monarchy and the papacy to which he was accustomed: despite the age-old history of the institution itself, each new pope was determined to outshine his predecessor and start afresh; a French king, on the other hand, was always succeeding a father and a grandfather whom he revered and he felt no ambition to obliterate their memories. Louis tried to explain to Bernini 'qu'il avait quelque affection de conserver ce qu'avaient fait ses prédécesseurs . . .', but this made no impact on the Italian architect whose proposals were uncompromisingly new. Thus the bitter hatred which he aroused through his contempt for all things French could be crystallised into reasoned opposition. There were factions at court; the King himself remained keen, but by October Bernini was on his way back to Rome and it was widely—and correctly—believed that his plans would not be executed.

During his stay in Paris Bernini had given one unchallengeable proof of his genius. Within two or three weeks of his arrival he had been commissioned to make a marble bust of the King and here at last he found a subject worthy of his exalted visions of royalty (Plate 27b). Moreover this was his first opportunity to portray a secular prince from the life and he was thus able to seize upon those individual traits of character which he felt to be so important as well as build up an idealised, hieratic image of personal monarchy at its most supreme.[1] The bust he made in 1665 remains the most compelling record of absolutism in the visual arts. Louis was sufficiently impressed to order an equestrian statue. Bernini began work on this four years after his return to Rome, but it did not reach Paris until 1684, some time after his death.[2] By now French self-satisfaction was at its peak. In military power, in literature and in every other sphere no country—or combination of countries—could rival her. Two years earlier the 'Gallican' principles had signified the King's desire to establish a State religion as independent as possible from papal influences. No wonder that Bernini's monument was found uncongenial. He had been asked to base it on his statue of *Constantine* in the Vatican—now these echoes of ultramontane claims must have seemed jarring and tactless. And on purely aesthetic grounds a native taste had developed which found Italian floridity repugnant. Louis wanted to break up the statue. He then relented, but had it banished to the remotest corner of the grounds at Versailles. Soon Girardon made the necessary alterations and the figure was called Marcus Curtius.

Bernini's failure in Paris is always said to mark the collapse of Italian artistic prestige in France. It is true that criticisms and hostility towards Italian art became increasingly powerful as the French grew more self-assured. It is also true that, with the full support

[1] Wittkower, 1955, pp. 230-1, with bibliography.
[2] *ibid.*, pp. 234-6.

of Bernini himself, Louis established in 1666 the French Academy in Rome with the declared purpose of enabling French artists to share with the Italians the privilege of studying the masterpieces of the past and thus eventually replacing them. And indeed Italian participation in Versailles—the greatest architectural and decorative enterprise of Louis XIV's reign—was negligible. None the less the habit of seeking artists in Italy died hard and certainly did not come to an immediate end. A Genoese landscape painter Francesco Borzone who had been summoned to Paris at the beginning of the new reign was generously employed by the King until 1679.[1] A Roman sculptor of classicising tendencies, Domenico Guidi, was chosen by Louis 'from all those not only in Italy but in the whole of Europe' to make one of the sculptured groups for the gardens at Versailles—but it was to be based on drawings provided by Le Brun.[2] When, after many difficulties, the monument, which represented *Fame inscribing the glories of Louis XIV on the shoulders of Time*, finally reached France it was used to replace Bernini's equestrian statue. But even this Louis found 'un peu riche de draperie'. Meanwhile Carlo Maratta had been commissioned to paint a large picture of *Apollo and Daphne* for which he was well paid and given the title 'peintre du roi'.[3] Some years later the director of the French Academy in Rome was making enquiries as to whether the Bolognese artist Carlo Cignani, who painted a couple of pictures for the King, might be prepared to go to Paris. But the matter was not pressed as Cignani's draughtsmanship was considered too weak —yet another instance of the divergencies between Italian painting and the more rigorous French taste.[4]

It would be perfectly possible to choose many other examples of Louis' patronage of Italian artists, but here it must be pointed out how disappointingly little this was compared to their expectations. Again and again we come across instances of Italian painters looking—and often looking in vain—to Paris for support now that the Pope was no longer able to employ them. The hints that they dropped were broad enough. Bellori's *Le Vite de' Pittori . . . Moderni* of 1672 was dedicated to Colbert, Malvasia's *Felsina Pittrice* (lives of the Bolognese artists) of 1678 to Louis XIV. The Bolognese, especially, were anxious to attract French attention. We are told that Carlo Cignani, Benedetto Gennari, Luigi Quaini and Donato Creti were all keen admirers of Louis XIV, and it is not being excessively cynical to suspect that such admiration was not wholly disinterested.[5] Further south the situation was more complicated. Thus Mattia Preti made an allegorical portrait of Louis XIV which he intended to present to him as a gift, but when hostilities broke out between France and Spain he realised that his situation in Malta made such gestures imprudent and sold the picture elsewhere.[6]

Spain however retained a welcome interest in Italian painters and their works.

[1] Soprani, I, p. 254. [2] Pascoli, I, p. 255, and Wittkower, 1938.
[3] Montaiglon, I, p. 104, and Bellori, 1942, pp. 101 and 126.
[4] Zanotti, I, p. 245, and Montaiglon, I, p. 190. In 1685 the director of the French Academy in Rome tried to persuade Luca Giordano to paint a picture for the King, but the artist defaulted on his obligations—Alazard, p. 142.
[5] Zanotti, I, pp. 155, 170, 199, and II, p. 121.
[6] De Dominici, IV, p. 50.

Throughout the second half of the century Neapolitan artists were frequently employed by the Viceroys, who were themselves often acting on behalf of the court or other important collectors in Madrid. Against this general background certain specific occasions stand out. In 1649 Velasquez embarked on his second visit to Italy.[1] One of his duties was to acquire paintings and sculpture for the royal palace of the Alcazar, and in most of the towns he visited, but especially Venice, he looked at or bought pictures for this purpose. A living painter was also needed, and here Velasquez was not so successful. He had been told to try and persuade Pietro da Cortona to come to Madrid, but when he reached Rome he found that the artist was too busily engaged by the Oratorians to be able to move. So on his way back he stopped at Modena and made overtures to the architectural painters Angelo Michele Colonna and Agostino Mitelli, but with them too he had no luck and he was thus forced to return with several old masters in his baggage but no artist capable of reviving the practice of fresco painting in Spain. His employment of sculptors was more satisfactory: Giuliano Finelli, Alessandro Algardi and other less distinguished men in Rome and Naples made copies after the antique and original works for the royal collection. And in the long run even his attempts to induce Colonna and Mitelli to come to Madrid bore fruit, for in 1658 both men finally arrived and were assiduously employed.

Among all the viceroys of the second half of the seventeenth century one man stands out far above the rest both for his political ability and for his distinction as an art patron—a combination of qualities that was by no means frequent as this study will have shown. Don Gasparo de Haro y Guzman, known in Italy as the Marchese del Carpio, was appointed ambassador in Rome in 1677 at the age of 48.[2] His youth had been stormy and at one time he was even imprisoned for two years on suspicion of being implicated in an attempt on the King's life. Already he had shown a passionate love of painting and by 1651 he owned one of the masterpieces of his country's art: Velasquez's *Toilet of Venus* (the 'Rokeby' Venus).[3] This was also one of the most 'Italian' pictures ever painted by a Spaniard and Del Carpio must have welcomed the opportunity to go to Italy himself. Within three months of his arrival in Rome we find him visiting the picture gallery of Salvator Rosa's friend Carlo de Rossi and spending more than an hour and a half there.[4] Soon afterwards he was given a wonderful opportunity to add to his collections when Cardinal Camillo Massimi died full of debts and his heirs were compelled to dispose of his property. Del Carpio bought on a grand scale. He obtained two portraits by Velasquez—of the Cardinal himself and of Donna Olimpia—and a very large number of antiquities which he planned to have engraved.[5] Indeed he clearly

[1] Harris, in *Archivo Español*, 1960, pp. 109-36, and 1961, pp. 101-105 (for Colonna and Mitelli).

[2] For the fullest account of his political career see Ghelli.

[3] Maclaren, p. 76. [4] *Avviso* of 12 June 1677 published in *Roma*, XIX, 1941, p. 308.

[5] Harris, 1957, pp. 136-9. For his antiques see the album, belonging to the Society of Antiquaries, of which the frontispiece is inscribed as follows: '*DISEGNI d'Idoli, Statue, Filosofi, Busti, Urne piccole, Bassi Rilievi, Medaglie, Inscrittioni, Vasi di Marmi, e Porfidi, Fontane di Marmi, Alabastri, e Metalli antichi, e moderni; Quali Comprò in Roma l'Ecc. mo Signore Don Gasparo d'Haro e Guzman, Marchese del Carpio e' Helicce*. I am most grateful to Enriqueta Harris for this and much further information about del Carpio's collection.

felt an affinity between Massimi's classical taste and his own, for he paid special attention to assembling thirty volumes of drawings by old masters and contemporaries, particularly Carlo Maratta who was his favourite artist.[1]

Del Carpio was also a great admirer of Bernini, who died during his term of office in Rome. He owned a small version of the Fountain of the Four Rivers in the Piazza Navona and looked upon it as the finest piece in his collection[2]; on a visit to the sculptor's studio, he was able to acquire one of his self-portrait drawings from his son Domenico[3]; and in Naples there were rumours that he was offering 30,000 *scudi* for the ill-fated equestrian statue of Louis XIV.[4] We can share his disappointment that this offer was not accepted.

The Ambassador's enthusiasm for contemporary Roman painting is recorded in all the documents of the period. We are told that several times a week he would visit the studios of Niccolò Berrettoni, a pupil of Maratta, Giuseppe Ghezzi, later to be permanent secretary of the Accademia di S. Luca, and Giovanni Francesco Grimaldi, the landscape artist[5]; that he launched the career of the young painter Paolo de Matteis after finding him copying the altarpieces in St Peter's[6]; and that when he went to Naples at the end of 1682 'the painters lost a great lover and protector of their art'. They did indeed, for there was no native Italian to show such discriminating enthusiasm.

In Naples Del Carpio continued his patronage and increased his collection of paintings from 1100 to 1800,[7] putting in charge of them an obscure Sienese painter, Giuseppe Pinacci, who proved to be an expert restorer.[8] The palace, hung with masterpieces and rich furnishings of all kinds, impressed even those who were familiar with viceregal luxury.[9] Luca Giordano, whom he had already met in Rome, replaced Carlo Maratta as his chief painter and decorated churches and the palace for him. When the Viceroy died in 1687, it was said that 'Naples had lost a loving father and her artists a great support'.[10] Both parts of this judgement were true. For several years shiploads of pictures and antique statuary sailed out from Naples to enrich the collections of Del Carpio's descendants in Madrid.[11] And the city which they left behind was no longer what it had been only four years earlier. For Del Carpio's contribution to Neapolitan culture must be gauged not so much by the works he commissioned from local artists

[1] Bellori, 1942, pp. 117 and 121.

[2] See the introduction to the Society of Antiquaries' album and Pacichelli, Parte IV, Vol. I, p. 39.

[3] Domenico Bernino, p. 28.

[4] Letter from Duc d'Estrées to Louis XIV, dated 27 July 1684, in Montaiglon, VI, p. 388.

[5] Pascoli, I, pp. 48 and 186, and II, p. 202.

[6] De Dominici, IV, p. 315.

[7] See *Discursos leidos ante la Real Academia de Bellas Artes de San Fernando en la recepción pública del Excmo Sr. Duque de Berwick y de Alba*, Madrid 1924, p. 20.

[8] Bottari, II, p. 105, and Orlandi, p. 236.

[9] Pacichelli, Parte IV, Vol. I, p. 39.

[10] De Dominici, IV, p. 164. For Del Carpio's Neapolitan drawings see Saxl, p. 76.

[11] See *Listas de cuadros y objetos artísticos remitidos desde Italia a España por el puerto da Nápoles en los años 1683 a 1687*—MS. El Escorial &-IV-25 (photocopy in Warburg Institute).

as by the enlightened reforms with which he uprooted a hideously corrupt adminis-
tration. The misgovernment of rulers such as Monterey, followed by civil strife and
terrible natural disasters, had led to a situation unparalleled in civilised Europe. Brigan-
dage was openly encouraged by an irresponsible aristocracy. Justice was non-existent
despite an abundance of lawyers. The inequalities between rich and poor were too
glaring even for an age not unduly worried by social problems. Del Carpio's brief
administration made the first serious attempt to tackle these evils. In so doing he aroused
bitter hostility from some sections of the nobility, but he also laid the foundations for a
'new civilisation' which was soon to lift Naples once again into the forefront of intel-
lectual Europe.

When still in Rome Del Carpio had tried to persuade various painters, notably
Giacinto Calandrucci and Niccolò Berrettoni, to take employment under the King in
Madrid.[1] It was not, however, until 1692 that a considerable Italian artist left to work in
Spain although quantities of Italian pictures were reaching the Alcazar. In that year
Luca Giordano embarked on the voyage that was to keep him in Spain for nearly ten
years. He was welcomed by the King with enthusiasm and a vast salary. In return he
introduced into the many palaces and churches which he so beautifully decorated a type
of painting in which the Spaniards themselves were deficient: colourful, exuberant,
facile perhaps but composed with marvellous ability, making use of devices learned from
all the Baroque masters, yet with a personal note of airiness and fantasy.[2] From every
point of view the visit must be looked upon as the most fruitful paid by any Italian
artist outside his native country during the seventeenth century. Luca Giordano's
brilliance rightly dazzled the Spaniards and led eventually to their employment of
such master decorators as Corrado Giaquinto and Tiepolo; and his influence, though
at the time it may have proved enfeebling for some already feeble local painters, was
much later absorbed with profit by the young Goya. For Giordano himself the years in
Madrid were equally important. For, unlike Bernini in Paris a generation earlier, he was
as ready to learn as he was to express himself. Already a keen admirer of Venetian art,
he found in the royal palaces a collection of Titians unequalled in the world for quantity
and quality and under their impact he dropped most of the remaining vestiges of his
darker Neapolitan manner. He copied Rubens and he pleased his hosts through his
sincere appreciation of Velasquez. When he returned to Italy he only had two years more
to live, but even during that time he proved himself to be, at the age of 70, the most
'advanced' painter of his day.

– iv –

Despite the considerable impact of Spain, and even of France, on Italian artists, it was
in the Holy Roman Empire and then England that the true successors of the great
Italian patrons were to be increasingly found as the century drew to a close.

[1] Pascoli, I, p. 186, and II, p. 314.
[2] Griseri, 1956, pp. 33-9, and Longhi, 1954, pp. 28-39. Zanotti (I, pp. 247-8) says that Luca Giordano's
invitation followed a refusal by Marcantonio Franceschini to go to Spain.

The Thirty Years War had devastated much of Central Europe, but though Vienna, the capital of the Hapsburg Empire, had been threatened with military occupation, it finally emerged in 1648 unscathed if greatly impoverished. The royal collections, however, had been housed in Prague, where they had been looted by Swedish troops for the ultimate benefit of Gustavus Adolphus's daughter Christina. Quite soon the effects of this disaster were mitigated by the return from the Netherlands, where he had been Governor, of the Archduke Leopold Wilhelm with the marvellous pictures he had acquired there, some of which came from the gallery of Charles I. The Archduke was especially fond of the Venetian painters of the early sixteenth century and one of the contemporaries whom he most patronised was Pietro della Vecchia, part of whose reputation depended on his forgeries of Giorgione.[1] He also persuaded the most successful Venetian painter of the day, Pietro Liberi, to come to Vienna in 1658 and stay there for a year during which he painted a large number of pictures and was made Count Palatine in return.[2] On his death in 1662 the Archduke left all his possessions to his nephew, the Emperor Leopold I.

Leopold, who ruled from 1658 to 1705, was a keen but fitful patron who like his predecessors found it natural to turn to Italy for artists. His father had summoned the architect Lodovico Ottavio Burnacini, and Leopold commissioned from him a new wing for the royal palace and a succession of the most magnificent stage sets ever seen in Central Europe (Plate 28b). It was the theatre, in fact, which remained the centre of Italian influences, for Vienna was still a fortified town under constant threat from the Turks, and little large-scale building or decoration was yet possible.

Another dynasty that recovered with some speed from the effects of the Thirty Years War was that of the Wittelsbachs in Munich. Their position had been strengthened by the Peace of Westphalia, and when, in 1652, the Elector Ferdinand Maria married Adelaide Enrichetta of Savoy they found themselves allied to the most astute ruling family in Europe.[3] But Adelaide Enrichetta was also a keen lover of art and surrounded herself with a number of painters and architects from Italy. She failed in her attempt to attract Guarino Guarini, but in 1662 the Bolognese architect Agostino Barelli came to Munich and built a church for the Theatines, based on the Roman prototype of S. Andrea della Valle, and also the central block of the royal palace at Nymphenburg. He was followed by an architect of far greater versatility, Enrico Zuccalli, who, under the new Elector Max Emmanuel, was commissioned in 1712 to build a 'Versailles' at Schleissheim. A number of Italian painters, of whom the best known are Pietro Liberi, Antonio Triva and Pietro Bellotti, were also employed at Munich during the three decades that followed the end of the Thirty Years War.

Everywhere the pattern was much the same: autocratic rulers, intoxicated by the idea of Versailles, deprived of native talent and desperately anxious to make up for the

[1] von Holst, p. 132.
[2] Boschini, p. 44—The book is dedicated to the Archduke and discusses his collection of Venetian old masters; Gualdo, 1818, p. 15.
[3] Lavagnino, p. 69, and Heilbronner, pp. 887-904.

glories of the Renaissance which had passed them by or been cut short by strife, all turned southwards. By 1669 Johann Georg III of Saxony was employing an Italian painter called Stefano Cadani at Dresden[1]; in 1674 an Italian architect Arrighini built a theatre for Georg Wilhelm, the last Duke of Celle. Whole families of painters and craftsmen such as the Carlone moved into Germany and wandered from court to court. As yet these men tended to be only mediocre artists, but from the 1680s onwards several dozen German principalities were rich enough to attract the attention of the foremost Italian painters. So extensive and influential did this German patronage then become that there is little room here for doing more than recording its scope and indicating briefly its effect on Italy.

There can be no doubt that this was decisive for the very existence of painting. Three cities—Rome, Bologna and Venice—were principally affected by this new source of patronage, but all over the peninsula painters were devoting more and more of their labours to German princes, and in some cases almost the whole of their output was sent north of the Alps. The Liechtenstein family, which had been greatly enriched by the expropriations that followed Protestant defeats in the Hapsburg dominions, ordered forty-two paintings from the Bolognese Marcantonio Franceschini alone.[2] At Pommersfelden in Franconia the Schönborn family commissioned pictures from Antonio Balestra and Gregorio Lazzarini in Venice; Carlo Maratta, Benedetto Luti and Francesco Trevisani in Rome; Luca Giordano and Francesco Solimena in Naples; Carlo Cignani in Bologna.[3] It was—and often still is—in the palaces of patrons such as these, rather than anywhere in Italy itself, that representative collections of Italian late Baroque painting could be found. It is by comparison with Vienna, Pommersfelden and Vaduz that a certain provincialism in Roman patronage becomes apparent, for no pope or cardinal could now hope to assemble pictures from such a wide variety of sources and over such a long period of time.

As the money, gold chains and titles poured down upon them, these Italian painters were faced with certain new problems. Their patrons were still mostly Catholics, and large-scale altarpieces or devotional pictures were easy enough to provide. But lack of direct contact with their German employers left them with some added responsibilities. 'As for the subject,' wrote the Prince of Liechtenstein to Franceschini in a fairly typical letter,[4] 'I leave that to your good taste: perhaps a Flora with a few putti would be a good idea; or some figure representing Spring: in any case something that alludes to gardens.' Above all they were expected to send nudes.

There is no doubt that a careful and full-length study of the subject would reveal countless nuances of taste among the various German princes and show that some were far more discriminating than others; but a superficial survey such as the present indicates only an intense preoccupation with the erotic. 'Tutte le pitture che intrano questa

[1] Lavagnino, p. 66.
[2] Zanotti, I, pp. 227, 229 and 231, and Wilhelm, *passim.*
[3] Hantsch und Scherf and von Freeden, 1955.
[4] Wilhelm, p. 136.

galleria, son mondane', wrote the Prince of Liechtenstein in 1691,[1] and he proceeded to elaborate: 'Carlo Cignani has painted a *Bacchanal*, a beautiful picture; Carlo Maratta a *Bathsheba*; Baccinelli a *Susanna*; Piola a *Vanità*; Carlo Loth one of *Lot and his Daughters*; Fumiani a *Christ driving the Jews from the Temple*; Peter Strudel a *Tarquin and Lucretia* and a *Joseph*.' A generation later Lothar Franz von Schönborn wrote to much the same effect: 'Une Souzanne et la Pudiphar seroit assez de mon gout; quant a la nudité je ne m'en scandalise pas trop dans les peintures, pourvue quelles ne soit obscène, et qu'il n'y ayet pas des actions ou gesticulations infames, et comme j'ay observé que le plus fort de Strudel consiste in dem nakenden, allso muss man ihn davon nicht abhallten outre qu'un beau corps et visage de femme orne bien un tableau.'[2] Every other German patron would have agreed with this sentiment and under their impact the female nude played a more important rôle in Italian painting during the half-century after 1670 than ever before or since. One artist especially, Guido Cagnacci, devoted much of his career to satisfying the demand. After coming to Venice from his native Romagna he was summoned to Vienna in 1657 and there poured out a stream of Cleopatras and Lucrezias whose virginal and immature bodies undergoing outrages of various kinds added a note of sophisticated perversion to what had long been a familiar repertoire (Plate 28a). Many other painters were interested in the same market, though they tended to have a less equivocal approach. 'As he had a special gift for painting pretty naked women, he attracted all the best amateurs,' we hear of Gregorio Lazzarini, who sent much of his output to Germany.[3] So too did Carlo Cignani, of whom we are told that in his youth he painted 'subjects which were too alluring (*tenere*) and dangerous for lascivious men'.[4] But this was a small price to pay for uninterrupted German order books.

Compared to the torrent of commissions that came from Germany and Austria, the impact of England upon Italian art was almost negligible before 1700. But in the next century it was to be so important that some outline of the earlier stages must be given here.

After coming to the throne in 1660, Charles II made a few attempts to recover those of his father's pictures that were still available, but his motives were based more on filial piety than on any love of painting. He certainly showed no interest in contemporary Italian art, and when, some fifteen years after his accession, the painter Antonio Verrio entered his service he was employed with little discrimination.

Verrio, like Gentileschi before him, came to England from Paris, though he had been born in Lecce and liked to call himself a Neapolitan. In common with the other artists employed by Le Brun at Versailles, he had there been required to lose rather than develop a personality, but in his case the process cannot have been a difficult one. He was brought over by the Ambassador and introduced to the King by his first English patron Lord Arlington in about 1675.[5] His earliest royal picture—*A Sea triumph, being*

[1] *ibid.*, pp. 89 and 92. 'Mondane' seems a curious way to describe some of these subjects, but it gives us an indication of what the Prince was looking for even in sacred pictures.

[2] Letter of 10 October 1708—Hantsch und Scherf, p. 164.

[3] Da Canal, especially pp. 71-3.

[4] Zanotti, I, p. 154. [5] Whinney and Millar, pp. 296-302.

a large piece with King Charles II in it—was flattering if hardly very relevant to Charles's rule so far, and from then onwards he was much employed on a series of frescoes at Windsor designed to illustrate the extreme theories of later Stuart absolutism. In their possibilities of fulfilment these bore as much relation to the claims of Charles I as did the art of Verrio to that of Rubens. Basing himself partly on what he had learned in France, Verrio did, however, tardily introduce into England a type of Baroque decoration that had not hitherto been seen there. Whole ceilings were covered with illusionistic fresco and walls appeared to open up to the sky. The work was mediocre, but stylistically it brought this country into line with European developments.

Another Italian artist who came to England at about the same time as Verrio was Benedetto Gennari from Bologna.[1] He was the nephew of Guercino whom Charles I had tried to entice some fifty years earlier and he too was working in Paris, where he had enjoyed a certain success. We are told that in England he earned a regular salary of £500 a year and that he was given so many commissions from the King and Queen that he could scarcely fulfil those from other patrons 'not only for portraits but for other subjects more suitable for a good painter'. Some of these brash mythological paintings, heavily tinged with eroticism, have survived and we can see that in them he followed the current French practice of portraying his sitters in the guise of some ancient heroine or deity.

For a short time after 1685 James II's attempts to restore Catholicism to England led to an unprecedented demand for the work of these Italian artists. Gennari turned from *Danaë* or *Elizabeth Felton as Cleopatra* to altar paintings, and in combination with Verrio, Christopher Wren and Grinling Gibbons he helped to put into effect in Whitehall the most full-blooded Baroque decoration ever seen in an English church. But this could scarcely last, and in 1688 Gennari was compelled to leave 'quel funesto paese' and return to France and eventually Italy, having acquired abroad 'a new style . . . which devoted special care to the rich decoration of his royal sitters'.

Verrio was more cunning. With his coach and horses, parmesan cheese, bologna sausages, olives and caviar, he left the court and worked for a time in a number of country houses. Before the end of the century, however, he had been taken up by the new régime and was being employed at Hampton Court, where in a complex allegorical fresco, whose subject was chosen from the writings of Julian the Apostate, he portrayed the triumph of William III over the Catholic powers led by France (Plate 29).[2] Even in an age used to changing allegiances his career was remarkable. Within little more than a generation he had put his art at the service of Louis XIV and his greatest enemy William III; he had painted the most Catholic and the most anti-Catholic programmes ever seen in this country; and he had been required to figure the 1st Earl of Shaftesbury in the guise of *Faction* and then take advice from the 3rd Earl, his grandson, in depicting the Protestant virtues. He lived on until 1707, receiving a pension from Queen Anne,

[1] Whinney and Millar, p. 182, and Zanotti, I, pp. 170-1. See also *Raccolta di Memorie di Benedetto Gennari*—MS. B.344 in Archiginnasio, Bologna (photocopy in Warburg Institute).

[2] Wind, 1939-40, pp. 127-37.

and was doubtless there to greet the Genoese artist Niccolò Cassana whom she employed as her portrait painter until his death in 1714.[1]

But in the long run the patronage of English royalty is of little consequence compared to that of the tourists who flocked to Italy in increasing numbers during the second half of the seventeenth century. At first the majority of these were interested only in their own likenesses (Plates 30a, 30b, 31a): thus Thomas Killigrew, the playwright, James Altham, an artist, and Sir Thomas Baines, a medical student, each had his portrait painted by a leading artist in Rome, Naples and Florence.[2] The few men who were detained in Italy on business were more enterprising. Baines's friend, John Finch, who was Resident in Florence between 1665 and 1670, commissioned a number of religious pictures from Carlo Dolci and gave some of them to the royal family.[3] And there are other collectors on this scale.

Somewhat later two men especially stand out for their far more extensive patronage of Italian artists. Sir Thomas Isham, a gentleman from Northamptonshire, left England in October 1676 and spent nearly eighteen months in Italy, where he visited most of the important towns with his tutor.[4] Though he enjoyed a series of extravagant love affairs and got heavily into debt, he also managed to acquire a certain number of contemporary paintings, advised mainly by a dissolute priest called Buno Talbot. All his commissions were given in Rome and, apart from copies of famous works by Raphael, Guido Reni, Poussin, Pietro da Cortona and others, they included mythological pictures by Ludovico Gimignani, Giacinto Brandi and Filippo Lauri, as well as his portrait by Carlo Maratta (Plate 31b).

The 5th Lord Exeter was a collector and patron on a far larger scale.[5] He was in Italy on two occasions between 1680 and 1685 and he commissioned paintings in all the cities he visited. In Florence he ordered nine from Carlo Dolci and fifteen from Luca Giordano, who was engaged on his frescoes in the Palazzo Riccardi. These two artists, whose contrasting qualities of gentle, sweet, primitive restraint and dashing virtuosity were glaringly obvious, seem to have been his favourites, and this in itself tells us much about the breadth—or inconsistency—of his taste. In fact Lord Exeter, coming from an England still largely bereft of Italian painting, proved himself a glutton for every kind of aesthetic experience. In Venice he bought Liberis; in Bologna, Lorenzo Pasinelli; in Genoa, Piola, Assereto and Valerio Castelli; in Rome, Maratta, Brandi, Gaulli and Calandrucci. No Englishman had ever commissioned contemporary Italian painting on such a scale before; few were ever to do so again. He also persuaded the Franco-Italian sculptor Pierre Monnot to make a tomb for him[6] and when back again at

[1] Agnelli, printed at end of book after imprimatur. Ratti (Soprani/Ratti, II, p. 15) says that he died in 1713 after refusing an official post as the Queen's Painter. It is not known just when he came to England or whether he died in this country.

[2] Killigrew by Canini in 1651—Vertue, I, p. 114; James Altham as a hermit by Salvator Rosa in 1665 (Bankes Collection)—*Italian Art and Britain*, p. 20; Sir Thomas Baines by Carlo Dolci between 1665 and 1670 (Fitzwilliam Museum, Cambridge)—*ibid.*, p. 19. [3] Baldinucci, VI, 1728, p. 503.

[4] Burden, pp. 1-25. The pictures are all at Lamport Hall, Northants.

[5] Waterhouse, 1960, p. 57; Bellori, 1942, p. 98. The pictures are mostly still at Burghley.

[6] Pascoli, II, p. 491; Honour, pp. 220 ff.

Burghley, his country house, he took advantage of the circumstances that compelled Verrio to leave the court and employed him to paint ceiling frescoes.[1]

Lord Exeter played a highly significant rôle in the history of English collecting. We are told that he introduced Carlo Maratta to several members of the nobility, and it is not long before the Italian biographies are full of vivid accounts of the English *milordi* visiting studios, paying fabulous prices and inviting artists from all over the peninsula to come and settle in England.[2] It was just this indiscriminate enthusiasm that led to the theorising of the 3rd Earl of Shaftesbury, by far the most cultivated English aesthete of the day. More than anyone he welcomed and stimulated English patronage of the arts and yet he felt that the whole subject needed far more consideration than it had yet received.

His own contacts with Italian art had been intense but not always happy. He had visited Italy in 1686 when still only 15, but though he 'acquired great knowledge of the polite arts', nothing is known of the results.[3] Then as an eager Whig intellectual, deeply sympathetic to Holland and hostile to France, he had in all probability helped to draw up the programme for Verrio's frescoes at Hampton Court with their learned allusions to the policies of William III.[4] In 1699 he sent the portrait painter John Closterman to Rome in order to find there a sculptor capable of making for him a series of *Virtues*— a wholly characteristic choice of subject in a pupil of Locke and the Cambridge Platonists.[5] Closterman sent him some drawings of *Prudence* and *Justice* by Domenico Guidi with a highly discouraging letter which Shaftesbury must have endorsed, for nothing came of the project. At the same time Closterman, who had already painted a full-length portrait of his patron in classical dress with volumes of Plato and Xenophon at his side, suggested that Shaftesbury himself should give the most detailed instructions to those artists he proposed to employ in the future.

This became possible when in 1711 he was forced to retire to Naples because of ill-health. There he mixed in intellectual circles, bought pictures for his English friends and decided to put his aesthetic ideas into practice.[6] He chose the painter Paolo de Matteis for his experiment and gave him detailed instructions (which were later published) for a picture of *Hercules at the Crossroads between Vice and Virtue* (Plate 32b). The bewildered artist was made to realise all the visual and philosophical implications of the theme, for 'the merely natural must pay homage to the historical or moral . . . nothing is more fatal, either to painting, architecture or the other arts, than this false relish, which is governed rather by what immediately strikes the sense, than by what consequentially and by reflection pleases the mind and satisfies the thought and reason'. Shaftesbury's elevated ideas and his conception of the artist as a mechanical executant were not new, but they had rarely been so stringently applied to an actual creation.

[1] Vertue, II, p. 132.

[2] See, for instance, Pascoli, I, pp. 140, 215, 226; Baldinucci, VI, 1728, p. 503; de Dominici, IV, p. 292.

[3] Brett, p. 38.

[4] Wind, 1939-40, pp. 134-5.

[5] Wind, 1938, pp. 185-8.

[6] Croce, 1927, pp. 272-309; Shaftesbury, pp. 30-61; Wells, pp. 23-8; and de Dominici, IV, p. 329.

Nor in fact did—or could—the resulting picture betray the complex thought that had gone into its making. Though his ideas were always to be of greater interest to theorists than to artists, he himself was well satisfied with the outcome, and in 1713 he commissioned one further and deeply moving picture from de Matteis: 'Un homme de qualité, grand d'un certain Royaume, Virtuoso, Philosophe, et Auteur connu par ses Ouvrages, s'étant retiré dans une certaine Ville salutaire pour se soulager de ses Fatigues, poursuit encore ses Etudes, tout malade, épuisé, et presque mourant, comme il est.' Despite—or because of—its biographical content, the picture was to be a 'history' and once again Shaftesbury enclosed a rough drawing of his own to guide the artist, prescribed details down to the exact inclination of the head and insisted on examining the preliminary sketches. But this time he was too late and he died within a month of giving the order.[1]

Fortunately Shaftesbury had more to offer the English than doctrines which were bound to prove sterile in practice. He was one of the first to stress the rôle of art in 'civilising' society, though he extended this to the less acceptable concept that a good society would necessarily give birth to good art. And his informal writings prove that he was certainly not blind to the more emotional appeal of painting. Though the English soon showed a strong national taste for portraiture, views and landscape at the expense of the serious history pictures which he had recommended, the extent of their collecting and patronage was in some measure due to his example and preaching.

– v –

The conditions of art patronage in Italy had totally altered during the second half of the seventeenth century. Painters were compelled to look north rather than to Rome, and the declining prestige of the popes had thus, by a strange paradox, led to that very Italianising of Europe which had been one of their aims in happier days. Moreover, this loss of power had, by limiting the concentration of artists in Rome, indirectly encouraged the growth of a number of active 'provincial' centres. Roman art, represented above all by Carlo Maratta, continued to enjoy a great reputation, but it was no longer unique, for the aspiring collector in England and Germany could, and often did, turn instead to Bologna, Venice or Naples. Artists in these cities broke through the rather stifling barriers of the tight little régimes under which they lived and sent their works as far afield as London, Paris and Vienna, Munich, Stockholm and Madrid. Crespi and Franceschini, Luca Giordano and Solimena, Lazzarini and Sebastiano Ricci were European favourites just as much as were Maratta and Trevisani. The very end of the seventeenth and early years of the next century saw this isolation broken down still further, for a number of complex wars brought Italy back into the forefront of international politics and disrupted a *status quo* that had remained largely unaltered for nearly 150 years.

In 1683 Vienna was saved from the Turks and in the following year Venice joined a Holy League with the Holy Roman Empire and the King of Poland. Then came the

[1] Sweetman, pp. 110–16.

war of the Spanish succession. Victor Amadeus of Savoy broke loose from the tutelage of Louis XIV and after a series of tortuous manœuvres finally emerged as the leading independent ruler in Italy. The Austrians conquered Lombardy and seized Naples from the Spaniards. These changes, which were confirmed by the Treaties of Utrecht and Rastatt in 1713 and 1714, had their counterparts in the patronage of Italian art.

Military commanders of all the warring nations took advantage of the fleeting opportunities between campaigns to commission local talent and were served with fine impartiality by artists in many cities. There was Admiral 'Pekemburgh', for instance, who sailed into Genoa with a squadron of English ships sometime before 1703 and ordered his bust from the sculptor Domenico Parodi whom he then tried in vain to take back with him to England[1]; or the French Maréchal de Noailles who arrived soon after and was more successful in persuading Gregorio de Ferrari to come to Marseilles and paint some pictures for him there[2]; or the Duc d'Estrées who visited Naples with Philip V, French candidate for the Spanish throne, and was so struck by Paolo de Matteis that he took him back to Paris and introduced him to a number of influential nobles and bankers.[3] This was an important occasion for it stimulated interest in contemporary Italian painting among some of the younger generation of art lovers who were growing tired of the 'official' style at Versailles.[4] But hardly had Paolo got back to Naples when the city was conquered by the opposing forces and he found himself working for the English Admiral 'Binchs' and the Austrian commander Count Daun who had been responsible for its capture.[5] Daun, who in 1707 was made the first viceroy of the new régime, rivalled his Spanish predecessors in the patronage of Italian art.[6] Solimena, Giacomo del Po and Paolo de Matteis all produced canvases to decorate his palace in Vienna which was frescoed by the Bolognese Marc'antonio Chiarini. Although his first appointment in Naples only lasted for a few months, he came back for a further six years in 1713 and was one of the principal agents through whom Neapolitan painting was introduced into Central Europe—a process which was carried much further after 1728 by the most cultivated of all the Austrian viceroys, Count Harrach.[7] Besides these men there were a number of high commanders of Italian origin serving in the Imperial army and they were especially keen to take the opportunity of furnishing

[1] Soprani, II, p. 120. This may possibly be the famous 3rd Earl of Peterborough who arrived in Italy from Spain for a few months in 1707 and then returned for a much longer period in the next decade, when he certainly commissioned a number of pictures from dal Sole.—Zanotti, I, p. 309.

[2] Soprani, II, p. 115.

[3] The duc d'Estrées arrived in Naples in 1702—de Dominici, IV, p. 321. In Paris de Matteis worked for Pierre Crozat among other patrons—see Loret, p. 543.

[4] Among these was certainly the duc d'Orléans, later to be Regent, who in 1715 invited Solimena to Paris (Bologna, p. 191) and became an important patron of contemporary Italian art.

[5] De Dominici, IV, pp. 258 and 336. 'Binchs', whom we know to have been back in Naples in 1719 (*Archivio Storico per la Province Napoletane*, 1906, p. 453), must be Admiral Byng, as from 1718 Commander of the British fleet in the Mediterranean.

[6] *ibid.*, pp. 295, 332, 435-7, 444; Pascoli, II, p. 102; Zanotti, I, p. 277. In Bergamo he commissioned his portrait from Vittore Ghislandi—Tassi, II, p. 64.

[7] Harrach was the most enthusiastic Austrian patron of Neapolitan art, as can be seen from his surviving collection—Ritschl, *passim*, and de Dominici, IV, pp. 46, 439, 441, 444, 571.

Plate 29

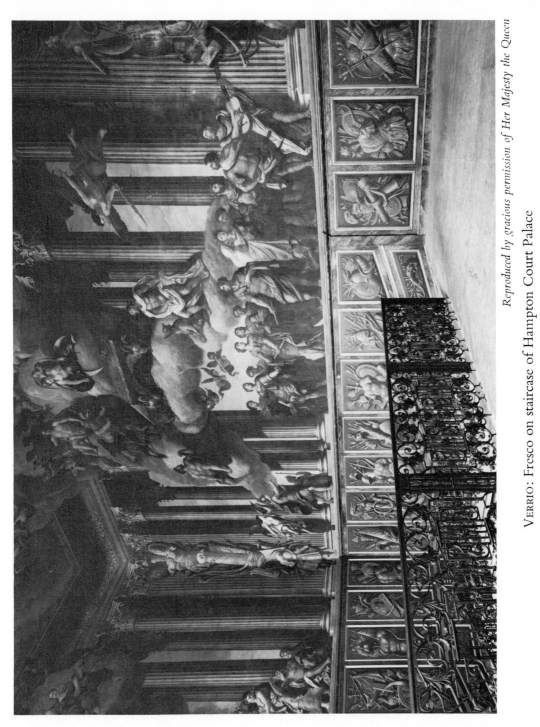

VERRIO: Fresco on staircase of Hampton Court Palace

Plate 30

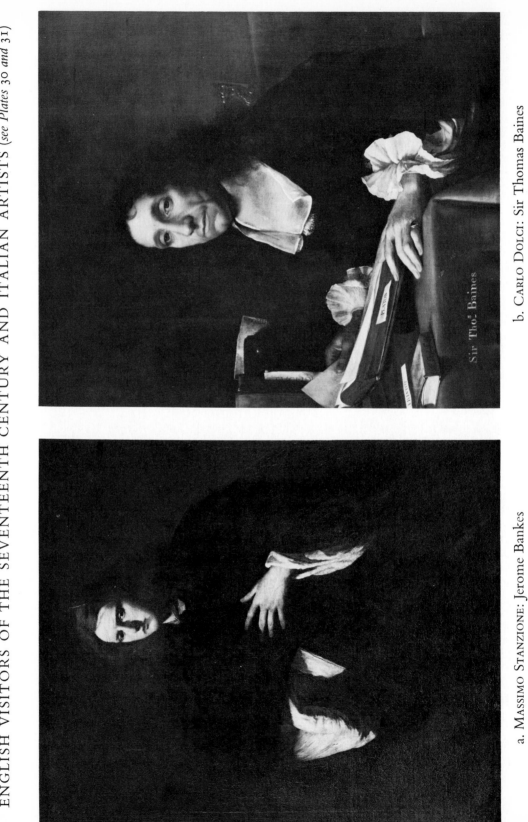

b. CARLO DOLCI: Sir Thomas Baines

a. MASSIMO STANZIONE: Jerome Bankes

Plate 31

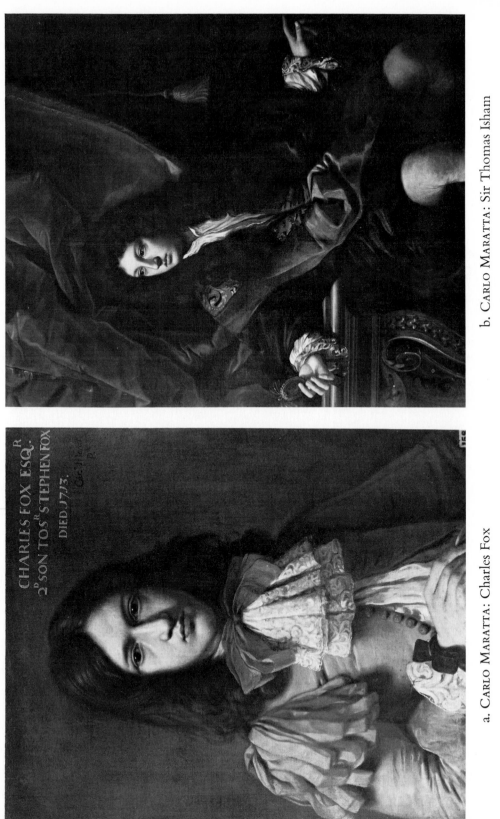

CHARLES FOX ESQ.R
2.D SON TOS.R S.TEPHEN FOX
DIED 1713.

b. CARLO MARATTA: Sir Thomas Isham

a. CARLO MARATTA: Charles Fox

Plate 32 NEAPOLITAN ARTISTS AND FOREIGN PATRONS

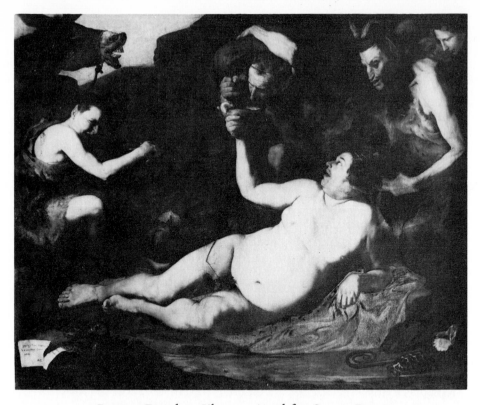

a. RIBERA: Drunken Silenus painted for Gaspar Roomer

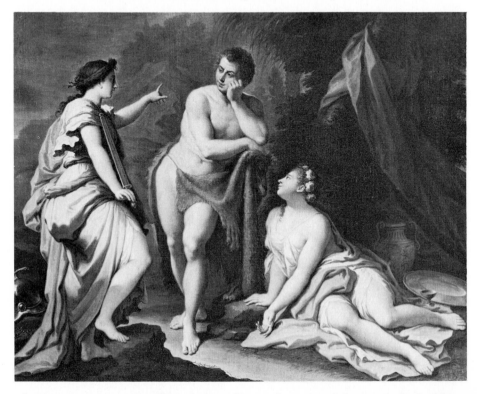

b. PAOLO DE MATTEIS: The Choice of Hercules painted for Lord Shaftesbury

their Viennese palaces with pictures from their native land. Thus Marshal Caprara commissioned many paintings in Bologna[1] and, above all, the great Prince Eugene of Savoy proved as loyal to Italy in the arts of peace as he was to Austria in those of war.

Prince Eugene was indeed the most grandiose and influential private patron in Europe.[2] His Winter Palace begun by Fischer von Erlach and the two Belvederes by Lucas von Hildebrandt are inspired testimonials to his passion for building; the marble *Apotheosis* by Permoser which he himself designed survives as an illustration of his megalomania if not of his taste; but his collection of pictures has been dispersed. Today it is celebrated chiefly for the unique Flemish primitives it once contained; but to the Italians of his own time Eugene was famous as a 'generous protector and supreme lover of the fine arts, especially those of our native land . . .'.[3] He proved this by his magnificent patronage of Italian painters and sculptors. Louis Dorigny, Marc'antonio Chiarini, Gaetano Fanti, Carlo Carlone and others came from Italy to paint frescoes in the Upper and Lower Belvederes; Lorenzo Mattielli and Domenico Antonio Parodi made statues for the hall and gardens; Solimena sent altarpieces for the chapel. In the gallery hung pictures by Crespi, whom he employed for five years, dal Sole and many other Bolognese painters[4]; by the Neapolitans Giacomo del Po and Solimena, and by Vittore Ghislandi from Bergamo.[5] These are only the most famous and the list could be doubled or trebled without difficulty. From the records and inventories that have survived we gain the impression that the subjects he loved best were those taken from the ancient poets, especially Virgil, whose 'portrait' writing the *Aeneid* he commissioned from Giacomo Antonio Boni in Bologna.[6] His taste was above all for the sumptuous and heavy. Though he lived until 1736 he seems to have shown no interest whatsoever in the lighter manner of the Venetians, many of whom came to work in Vienna for other patrons.

For Prince Eugene was only one among a multitude of nobles who were commissioning Italian art at the time. Delivery from the Turks and then victory against the French established the city as a great European capital—a new Rome, which rivalled the old in its appeal to artists. Domenico Martinelli came to build the town palace of the Liechtenstein family in 1691, and in 1704 Andrea Pozzo, who had been summoned by the Emperor, began to paint the ceiling of the hall in their garden palace. Mattielli made sculpture for many an aristocratic garden. Ferdinando Galli-Bibbiena produced marvellous theatrical spectacles. Painters travelling north to Germany all stopped to work in Vienna. And from everywhere in Italy pictures poured in to enrich the new collections that were being formed in the city. With its feudal aristocracy and all-powerful religious foundations Vienna provided a civilisation that the Italians could

[1] Above all by Crespi and dal Sole—Zanotti, I, p. 302, and II, p. 45.
[2] Ilg, *passim*, and Tietze, pp. 891-907. For the fate of the collection much of which was bought by Carlo Emanuele III of Savoy see Baudi di Vesme, 1886, pp. 161-256.
[3] Zanotti, I, p. 275.
[4] *ibid.*, I, p. 302, and II, p. 43.
[5] De Dominici, IV, pp. 432-3, 439.
[6] Zanotti, II, p. 234.

understand. It was the last conquest of the Baroque in a world whose values were already changing.

Savoy was the other continental state which emerged transformed from the war of the Spanish succession and here too victory was accompanied by a wonderful flowering of the arts.[1] During much of the seventeenth century the architecture of Turin had been of European significance, but patronage of painting had been almost laughable in its futility. Local talent was rare and attempts to attract artists from other towns had met with a long series of failures. Painter after painter had refused to make the journey north, and successive dukes, who were in any case more addicted to hunting and military pursuits than the cultivation of art, seemed generally resigned to the situation. Now in his hour of triumph Victor Amadeus was able, with the help of his artistic dictator Filippo Juvarra, to change all this. They followed the example of patrons in other uncreative centres and attracted leading painters, or at least their pictures, from a wide variety of more richly endowed cities. In carrying out this imaginative policy, however, they had already been anticipated in a number of smaller provincial towns and it is to them that we must turn in order to understand the significance of its origins and development.

[1] Claretta, 1893, pp. 1-309.

Chapter 8

THE PROVINCIAL SCENE

– i –

THE new world had helped to redress the balance of the old; but within Italy itself patronage continued to be extensive. In all the leading cities it was looked upon as the natural concomitant of wealth and power, and local schools of painting flourished vigorously on the support that they received from the great noble families and the religious orders. In Genoa a rich mercantile aristocracy dominated the Republic. Its principal members, the Balbi and the Brignole, the Doria and Durazzo, the Imperiali, Lomellini and Negroni, the Pallavicini, Saluzzi, Sauli and Spinola, filled their palaces with the works of native painters, the occasional contemporary picture brought back from Bologna, where the Legate or Vicelegate was nearly always a Genoese, and a selection of old masters.[1] It was the same in Naples, where the feudal landowners of the South, the Colonnas and the Maddalonis, the Monteleones, the Sonninos and the Tarsia Spinellis, prospered under Spanish rule and gave lavish support to a school of art that was second only to that of Rome in brilliance and diversity.[2] And within the papal states themselves Bologna, the second capital, was ruled by senatorial families who retained some semblance of autonomy—the Albergati and the Aldrovandi, the Ercolani and Ghisilieri, Pepoli and Sampieri—and who built up vast collections of the works of artists still basking in the reflected glory of the Carracci and their followers.[3] And similarly in Florence, Venice and other towns. Moreover, in each one of these cities patrons from the professional classes were also of importance. In Bologna there were the doctors: Paolo Battista Balbi, Beccari and the great Marcello Malpighi all owned pictures. Indeed the latter was a connoisseur of fine and decided tastes ('quel abito gesuitico fa melanconia', he wrote of a *S. Luigi Gonzaga* by Guido Reni), the friend of artists such as Guercino and Cignani and a keen collector.[4] And above all there were the merchants who, at the end of the century especially, played a very influential rôle in the artistic life of the city. Giovanni Antonio Belloni, for instance, who gave splendid hospitality to the exiled 'James III', owned large numbers of pictures by Giovan Gioseffo dal Sole, Felice Torelli, Crespi and Gambarini, and he sent the last artist on a journey to Rome[5]; and another businessman, Giovanni Battista Bellucci, also owned works by Crespi and many more by dal Sole. But the most cultivated and interesting of this little

[1]: See Soprani, *passim*. [2] See de Dominici, *passim*, and Maresca di Serracapriola, p. 49.

[3] See Malvasia and Zanotti, *passim*.

[4] Ruffo, pp. 122-3.

[5] Zanotti, I, p. 389. The essential source for the collections of Belloni, Bellucci and, indeed, all the Bolognese families is the manuscript B.109 in the Biblioteca Comunale, Bologna—*Descrizione delle Pitture che ornano le Case de' Cittadini della Città di Bologna*—Opera di Marcello Oretti Bolognese.

group of enlightened merchants was certainly Giovanni Ricci.[1] He was a rich and discriminating patron who showed a keen appreciation of many contemporary artists, above all Burrini and the young Crespi. He soon realised that the latter's imaginative gifts were bound to stultify in the provincial atmosphere of Bologna and he sent him on long visits to Venice and Central Italy to absorb a number of widely differing influences which soon made themselves felt in the pictures that Crespi painted for him.[2] Ricci also acted as a dealer for Crespi on unusual and altruistic terms: he agreed to buy any of the painter's work that became available and when he sold a picture he handed over all the profits to him, 'and it is certain', as the artist's biographer observed, 'that such noble and generous treatment which, as far as I know, is not given by anyone else, was of enormous advantage to Crespi'.

In Naples the lawyers who played such a vital rôle in the cultural life of the city were especially prominent in their support of the arts. Above all there was Giuseppe Valletta, poet and arbiter of taste, friend of Shaftesbury and the patron of Luca Giordano and Solimena.[3]

However, all these men—and there were countless more like them—crucial as their support was for the very survival of painting in Italy, could not possibly create the climate that had been established by families like the Barberini and their circle in Rome. With the general collapse of Italy under foreign domination and, ironically enough, with the peace that followed, all these cities with the possible exception of Venice remained essentially provincial. Between about 1600 and 1670 Rome was in fact the only 'capital' of Italy that could compete in prestige with the main towns in the nation states of Europe. At the beginning of the eighteenth century the wars which engulfed Italy, the vast increase in foreign travel, the decline of Spain, and then the reforms of enlightened despots helped to revive the cosmopolitan importance of some of the Italian city states. During most of the seventeenth century, however, the extravagant but somewhat unimaginative nobility and professional classes certainly kept alive local schools of painting of great value, but their isolation and the very vigour of individual traditions inevitably led to a stagnation of taste. Whereas the great Roman collections had included pictures by artists from all over Italy, and even Europe, and had thus stimulated a wide range of appreciation and new combinations of artistic sensibility— such as the classical-Venetian synthesis of Cassiano dal Pozzo and his circle—it was rare in Bologna to find a picture by a contemporary Neapolitan painter, or in Genoa to find one by a Venetian. Rare—but not impossible; for, in fact, stagnation was averted not only by foreign intervention (as has already been pointed out) but also by a few patrons within Italy itself, either expatriates or citizens, who looked beyond their native towns and included within their collections works by foreign artists.

[1] Zanotti, II, p. 35, and L. Crespi, pp. 204 and 244.

[2] See especially *The Marriage at Cana* of about 1686, now in Chicago, which shows the impact of Veronese and Barocci—van der Rohe, pp. 6-9.

[3] De Dominici, IV, p. 141, and Bologna, pp. 181 and 203. Valletta used to help Luca Giordano with his problems of iconography (de Dominici, IV, p. 196) and bought from another collector a number of architectural paintings by Codazzi with figures by Cerquozzi and Micco Spadaro (*ibid.*, III, p. 421).

By far the most important and influential of all such patrons was the Flemish merchant Gaspar Roomer.[1] He was born of a good family in Antwerp towards the end of the sixteenth century and by 1634 he had already been long settled in Naples and was the owner of an outstanding picture gallery. Some years later his activities as shipowner and trader had won him a fortune valued at five million ducats. His ships ranged as far afield as Scandinavia and Egypt, but most of his business was carried on with his native Low Countries. He lent money to the viceroys and even to the King of Spain, and in a city where titles and the feudal virtues counted more than anywhere else in Italy this rich foreign upstart entertained half the nobility—at first in his palace in Via Monte-oliveto and later in the Palazzo della Stella or in one of his many country houses. The strength of his religious convictions and his especial devotion to the Carmelites were shown by spectacular donations to their churches and the entry of his only daughter into one of their convents. During the revolt of Masaniello in 1647 Roomer naturally found himself in some danger—but luckily for him the public memory of his past generosity to some working men living near his palace, combined with his readiness to bribe their present leaders, saved him from the fate which befell others less cautious or less benevolent. He lived on, respected and successful, for another twenty-six years (recovering from the plague in 1656) and died, a very old man, in 1674. He left behind a vast fortune, most of which he bequeathed to charity, over 1500 paintings, which were quickly dispersed, and the proverb 'Do you take me for a Roomer?' with which to counter persistent borrowers.

Like many a Fleming devoted to the pleasures of life Roomer had a taste for the grotesque, the dark and the cruel which the painters of Naples were well able to satisfy. Over the years he collected a grim series of works by Ribera: *The Drunken Silenus*—a gross, dirty, fat-paunched, androgynous travesty of the god of wine lying obscenely across the picture attended by his goat-like fauns and a braying donkey, the very embodiment of harsh stupidity (Plate 32a)[2]; there was too *The Flaying of Marsyas*, who lies with his torn, naked limbs outstretched under Apollo's knee like some parody of the crucified body of St Peter while the satyrs gaze in anguish at his torments[3]; and Sandrart recalled seeing a *Cato* 'who lies in his own welling blood after committing suicide and tears his intestines into pieces with his hands'.[4]

In fact, Roomer was especially fond of the Caravaggists: besides his seven Riberas, he owned three paintings each by Caracciolo, the young Massimo Stanzione and Carlo

[1] Except where specifically mentioned, all the information given here about Gaspar Roomer comes from the two excellent articles by Ceci and de Vaes (1925). These include quotations from and references to all the available first-hand sources—Sandrart, Capaccio, Celano, de Dominici, etc.

[2] Although this painting now at Capodimonte is dated 1626 it is not referred to in Capaccio's list of the pictures in Roomer's house in 1634; but Palomino (III, p. 311) describes it and says that it was painted for him. See Trapier, p. 36.

[3] The picture of this subject now in the Museo di S. Martino, on which this description is based, cannot be the actual one owned by Roomer as it is dated 1637 and Capaccio refers to a painting of the subject as being in his house in 1634—Trapier, p. 133, and Ville sur-Yllon, p. 147.

[4] Trapier, p. 230. There is also a print by Sebastiano Marcotti of St Januarius by Ribera, dated 1665 and dedicated to Roomer '. . . affetti:mo della pittura e divot:o del Santo . . .'.

Saraceni; and he also acquired pictures by the Frenchmen Valentin and Simon Vouet and the Dutch David de Haen. War, too, appealed to him when it could be looked at safely as a picturesque muddle and required no active participation—his narrow escape from Masaniello surely confirmed the advantages of non-commitment—and he was particularly fond of the young Aniello Falcone who painted for him a number of lively 'battle scenes without a hero'.[1]

But, above all, Roomer liked the small landscapes and storms at sea, the animals and still lives with fruit and game piling up on the table, that were the special subjects of his native Flemish painters, many of whom settled for a time in Rome. He was particularly proud of these—'as all the pictures are very fine', he wrote, 'and as most of them are by foreign artists, unfamiliar to Neapolitan painters, I want foreign painters to be summoned to draw up the inventory; especially the painter Jan Vandeneynde of Brussels and others whom he chooses'—and he owned several hundreds by Paul Brill, Peter de Witte, Velvet Breughel, Leonard Bramer, Jacques Duyvelant, Cornelius Poelenburgh, Corneille Schut, Gioffredo Wals, Gerard van der Bos and many others. Images of plenty and wild fertility, the landscapes and produce of his distant birthplace mingled with the cruelty and lusts of his adopted home. What was missing was just what was most characteristic of Roman painting at the time: the clarity and serenity which classical discipline had imposed on Venetian colour. It is perhaps characteristic of Roomer's lack of intellectual interests that almost the only old masters in his collection were eight animal pieces by Bassano.

Such was Roomer's gallery in his early days in Naples—thereafter, although he went on buying hundreds of pictures, we have much less information about their nature, and have to rely on a variety of indirect sources. We know that all this time he was keenly trading in pictures as well as in other goods—sending Neapolitan paintings to the Low Countries (notably those of Ribera's pupil, Bartolommeo Passante) and, presumably, receiving in exchange works by his fellow-countrymen, though his two Van Dycks—a *Susanna and the Elders* and a *St Sebastian*—were probably acquired locally. In about 1640 one of the most important of all his pictures reached his palace— Rubens's large *Feast of Herod*, a work of the artist's full maturity painted probably some half a dozen years earlier (Plate 35b).[2] It caused a great impact in Naples, for it was quite unlike anything that had hitherto been seen in Roomer's gallery. The feast takes place in a crowded, stifling room full of luxury and extravagance while richly dressed guests, a boy with a monkey and negro servants all look on. In the foreground a tall, blowsy girl holds the severed head of John the Baptist on a silver plate, and the daughter of Herodias, with a strange, flirtatious expression, makes ready to stab the offending tongue with a fork—a touch of cruelty that must have appealed to Roomer. Only Herod, seated at the head of the table, with his chin cupped in his hand, looks anxiously aware that a terrible injustice has been done.

[1] For Falcone's relations with Roomer, see Saxl, p. 80.
[2] For the history of this picture, now in the National Gallery of Scotland, see L. Burchard, pp. 383-387.

The pageantry and colour of Rubens's great picture may either have stimulated or coincided with a certain taste on Roomer's part for paintings less 'realistic' in subject-matter or treatment than those that had hitherto formed the bulk of his collection. It seems probable that through his Flemish agents in Rome and elsewhere he commissioned and bought pictures from Guercino, Giacinto Brandi (who painted an altarpiece for his private chapel dedicated to S. Maria Maddalena dei Pazzi) and Sacchi; he was, however, just as keen to obtain works by the animal specialist Castiglione and by *bamboccianti* and battle painters such as Pieter van Laer, Jan Miel and Borgognone.[1] And during the last ten years of his life he made strenuous efforts to acquire architectural scenes by Viviano Codazzi.

When Mattia Preti returned to Naples in 1656 Roomer commissioned a picture from him and left the subject to the artist, who chose the *Marriage Feast at Cana*: it was a rich, colourful scene set in an open loggia which deliberately looked back to Veronese. The picture attracted attention in Naples, but Roomer himself seems to have acquired further works by Preti only to export them.

Roomer's relations with Luca Giordano, who was some forty years younger than himself, began in the middle 1650s on an uneasy note. The painter resented 'being treated as a beginner', and apparently forged a number of old masters both to prove his virtuosity and to tease the ageing collector. He was forgiven and thereafter Roomer became his staunch supporter in the many envious feuds which the prodigiously successful artist inspired. Unfortunately it is impossible to tell what pictures Giordano painted for him. Were they in the new, light, rich, Venetian manner that the artist was already practising long before Roomer's death in 1674, or did they carry on for him the tradition of violence which he had so fostered in the early years of his collecting?

In fact our scanty knowledge of Roomer's patronage during the last forty years of his life makes it very difficult for us to understand his place in Neapolitan culture. It was unquestionably of great importance. He was held to be the richest man in Naples and his collection of pictures was certainly the largest in the city. Above all it was permanent —for the Spanish viceroys, the only rivals to Roomer in the claims they made on painters, were always changing. 'All picture lovers of the day followed his advice', wrote de Dominici more than fifty years after Roomer's death.[2] But what was his advice? From the same source—our only one—we hear of him praising Mattia Preti on their first meeting for his '*maniera grande* which was firmly based on drawing, on nature and on chiaroscuro'. Can it be that he was disappointed in the 'Venetian' picture

[1] When Roomer died he left seventy of his pictures to Ferdinand van den Einden, the son of his business associate Jan. Van den Einden, who himself had a fine collection, in turn left a third of his pictures to each of his three daughters. One of these married Don Giuliano Colonna, and in 1688 the inventory of their collection was drawn up by Luca Giordano (Ferdinando Colonna, pp. 29-32). There are good—but not conclusive—grounds for believing that many of these paintings must have come from Van den Einden —and originally from Roomer. Indeed we know that the two pictures by Codazzi with figures by Micco Spadaro of *The Pool of Bethesda* and *The Woman taken in Adultery* did pass through the three collections in just this way (de Dominici, III, pp. 421-2). Unfortunately evidence as regards other pictures in the Colonna collection is lacking, and I cannot accept Vaes's certainty about their provenance.

[2] De Dominici, IV, p. 47.

which Preti then painted for him and that because of this he thereafter commissioned nothing for himself from the artist? We know too little to say, but it is interesting that he chided Luca Giordano 'for his new manner which was contrary to those of good artists'.[1] Did this new manner lie in the loose brushstrokes and lighter tonality adopted by the painter which offended other connoisseurs also? Roomer's rebuke was certainly not in the name of classicism—for we hear that he later backed Giordano against Francesco di Maria 'who was a great draughtsman but a weak colourist'. In fact, it was naturalism that seems to have been Roomer's greatest love from his earliest days when his gallery contained little else until the end of his life when he was so keen to acquire works by Codazzi,[2] when Jean-Baptiste de Wael dedicated to him a set of prints showing scenes from peasant life,[3] and when he was in touch with Ruoppolo, whose still lives he sent to Flanders.

His gallery crystallised that close relationship which had for so long existed between the cultures of the South and North of Europe. The Flemish still lives must have excited many of the Neapolitan painters in this genre who would otherwise have had little chance to see such work—and they repaid their debt with pictures of superb quality; and Rubens's *Feast of Herod* was certainly a source of inspiration to many artists breaking away from the Caravaggism of the early years of the century, whatever Roomer himself may have felt about the trend. 'The magic of its brilliant colouring laid on with such mastery' profoundly affected Bernardo Cavallino, we learn from de Dominici, and many other painters also studied this seminal picture.[4]

Closely associated with Roomer as patron were his business partners Jan and Ferdinand van den Einden. Jan van den Einden was also Flemish though, unlike Roomer, his origins seem to have been lowly.[5] After some early struggles his partnership with Roomer which began in the 1630s led to his enrichment, and his fortune was inherited by his son Ferdinand, who was thus able to buy himself the title of Marquis and to acquire a vast collection of pictures. His taste seems to have been largely modelled on that of Gaspar Roomer, seventy of whose pictures he inherited. But, being of a younger generation, it was the later painters, inspired by the Venetians, whom he specially patronised. Thus he was so struck by Mattia Preti's *Marriage at Cana* and the general approval it met with that he ordered several very large pictures by that artist. But the subjects of three of these, *The Crucifixion of St Peter*, *The Beheading of St Paul* and *The Martyrdom of St Bartholomew*, show that Van den Einden must have shared Roomer's taste for brutal realism.[6] He was also a keen admirer of Luca Giordano,[7] but unfortunately we do not know which pictures by that artist he possessed.

[1] De Dominici, IV, p. 131: 'gli fece una lunga esortazione a lasciar la nuova maniera, la quale dicea esser contra tutte quelle usate da' valentuomini . . .'.

[2] Ruffo, p. 176.

[3] Bartsch, V, pp. 5-10. There is a set in the British Museum.

[4] For the influence of this picture see Bologna, p. 20.

[5] Vaes, 1925, p. 185.

[6] De Dominici, IV, pp. 48-9.

[7] *ibid.*, p. 140.

There was another exceptionally far-ranging patron living in South Italy at this time. Don Antonio Ruffo was born in Messina in 1610 of one of the great aristocratic families.[1] This did not prevent him engaging in trade, and his income was still further increased by the vast revenues he drew from taxes on grain, silk and other vital goods. He played a limited part in what little political activity was permitted the nobility under Spanish rule, and in 1661 he was outlawed for a short time for supporting the privileges of his native city against the authority of the Viceroy. But most of his life was devoted to patronage of the arts and his palace in Messina became the centre of cultural life there until his death in 1678. At that time it contained more than 350 pictures painted by artists all over Italy and even elsewhere.

Ruffo began collecting in about 1646 shortly after moving into the palace in the Strada Emmanuela which his mother, the Duchess of Bagnara, had built for him. He continued almost without interruption for the next thirty years. A good deal of evidence makes it clear beyond doubt that he took a great personal interest in the works that he ordered, and yet it is an astonishing fact that his acquaintance with any paintings other than his own must have been negligible. He seems never to have travelled beyond Calabria, and he heard about the leading painters in Italy and elsewhere entirely through agents. Everyone was pressed into acting for him in this capacity: his family, his friends, the artists he employed and picture dealers. From them he was informed who were the more talented artists at work—for he was primarily interested in his contemporaries— and what was the state of the market. He then wrote to the artists directly or through his agents to order the pictures he required, sometimes with instructions as to the subject, at others leaving the painter a free hand. He was guided by two considerations: size and expense. His pictures were arranged according to a symmetrical pattern, and he was often anxious to make up pairs—either from the same artist or two different ones, and this concern naturally involved the actual composition. Thus Guercino asked for a rough drawing of Rembrandt's *Aristotle contemplating the Bust of Homer* (now in the Metropolitan Museum, New York) which his own picture was required to match. In general, Ruffo seems to have decided in advance the price he wished to pay for each work, and this too affected the structure of the pictures painted for him. As Guercino, for instance, had a fixed rate of 125 ducats for each figure, when Ruffo offered him a hundred *scudi* for a picture, the artist wrote that he would be prepared to paint 'a little more than half a figure'. Later Ruffo raised the sum to 100 ducats, and Guercino answered that he would 'paint something to your satisfaction proportionate to the amount of money that you are offering me'.

When the first picture by an artist reached Ruffo in Messina he could decide whether he wanted more by the same man; and in the absence of his own letters and instructions, the number of works by each painter in his gallery helps to give us some clues as to his taste. Above all he was obviously trying to amass a representative collection

[1] For all this section see the admirable and fully documented account by Vincenzo Ruffo. For Ruffo's relations with Rembrandt see also Slive, pp. 59 ff.

of works by all the leading contemporaries—'non si può dire infermità il desiderare quadri di Pittori famosi', his agent wrote to him—and it was probably this motive that led him to make his most remarkable and magnificent purchases, the three pictures by Rembrandt—*Aristotle contemplating the Bust of Homer* (Plate 35a), *Alexander the Great* and *The Blind Homer*—bought over a period of a dozen years. Rembrandt was fairly well known but not widely appreciated in Italy (except for his etchings), and Ruffo's Flemish agent in Rome Abram Breughel was probably not being insincere (as has been suggested) when he wrote in 1665 that 'the pictures of Rembrandt are not very highly thought of here'. Indeed Ruffo himself found the free brush strokes of the great master's last period unacceptable and sent back *The Blind Homer* 'to be completed'. Despite this it is obvious that he greatly admired Rembrandt, and that he was comparatively unaffected by the classicist doctrines that gained such force in Rome during the second half of the seventeenth century. He deliberately asked Guercino to paint the picture which was to match Rembrandt's *Aristotle* in his 'prima maniera gagliarda', and although this was for a particular purpose, at other times too he made special efforts to obtain examples of this artist's early and more robust style. Guercino, indeed, seems to have been among his favourites for he owned seven of his pictures compared to only one each by Sacchi and Maratta. Salvator Rosa, Giacinto Brandi and Michelangelo Cerquozzi were others among those working in Rome who especially appealed to him, but naturally the Neapolitans and South Italians were those best represented in his gallery—seven pictures by Novelli, twelve each by Ribera and Andrea Vaccaro and nine by Stanzione, though most of these were inherited from his brother. Religious subjects have a clear majority over all others, but he also collected flower pictures (more than a dozen painted by his Flemish agent Abram Breughel alone), landscapes and other themes of all kinds. Of old masters Ruffo showed a special interest in Polidoro da Caravaggio; he also owned a collection of prints which included 189 by Rembrandt. The astonishing number of pictures he had assembled was gradually dispersed after his death, and only a few of them can now be traced. But even in its heyday Ruffo's gallery must have been an isolated one, a stronghold of European culture in the backwater of the crumbling Spanish empire, whose reputation undoubtedly stimulated those artists who worked for him but which was of little significance in any wider context, though Ruffo tried hard to obtain public commissions in Messina for Guercino and Mattia Preti.

But Neapolitan painting spread far beyond the frontiers of the Spanish empire. Indeed, one of the characteristics of this phase in Italian patronage, when the absolute supremacy of Rome was being challenged in various provincial centres, is the international prestige acquired by Neapolitan artists. Even in Florence, a city as far removed as any in Italy from the spirit and traditions of Naples, there existed patrons whose enthusiastic appreciation of Neapolitan art was responsible for vitally important commissions. The principal outpost of this appreciation was to be found in a fine house, set in a beautiful garden with fountains and statues, in the Via Chiara near the church of S. Maria Novella. It was inhabited by three brothers, Andrea, Lorenzo and Ottavio

del Rosso, who were among the most notable collectors of their day.[1] They sprang from a family of rich merchants which throughout the previous century had been laboriously engaged in worming its way up to the centres of power and prestige. Money had opened all the doors: first, Florentine citizenship and admission to the recently founded chivalrous order of the Cavalieri di Santo Stefano; then a series of ingenious marriage alliances with the best families; and, finally, as a logical development, an increasing number of dignities and official posts. Andrea, the eldest of the brothers, who was born in 1640, was at the age of 36 awarded the lucrative flour monopoly which he shared with the slightly younger Lorenzo.[2] Both men later became Senators, and Andrea eventually died in Rome, where he frequently lent pictures to the exhibitions at S. Salvatore in Lauro, as director-general of the papal postal services. Ottavio entered the Church and became Bishop of Volterra, where he lived in 'concetto di straordinaria bontà'.

In their earlier days the brothers clearly travelled a great deal, for among the pictures recorded in their collection are 'two modern ones on glass' from Mainz and two 'by Albert Dürer bought by me in Cologne'. Inevitably, like Gaspar Roomer and so many other businessmen, their trading and patronage were closely connected: we hear of them sending Carlo Dolci's little *Flight into Egypt* to Lord Exeter in England[3] and another picture as far as Poland.

We can best appreciate the novelty of their patronage if we compare it with that of their immediate forebears. In 1642, two years before his death, their grandfather

[1] The main sources for the collection of the del Rosso brothers are the account given of it in 1677 by Cinelli and the complete inventory drawn up twelve years later by Andrea del Rosso himself published in Gualandi, II, pp. 115-28. Both these documents provide a certain amount of incidental biographical information. To supplement these I have drawn heavily on a number of published and manuscript sources in Florentine archives and libraries. I am most grateful to Dottoressa Paola Zambelli of the Archivio di Stato for her help.

General information about the family and genealogies exist in the manuscript collections of Passerini in the Biblioteca Nazionale—in particular, Passerini 19(25): *Informazione sopra la Nobiltà della Famiglia del Rosso di Firenze mandata a i SS:ri Falconieri di Roma, da me Gio:Batta Dei, quest'anno 1747*. There are also a number of references drawn from a variety of sources in the Poligrafo Gargano in the same library.

Very brief accounts of the careers of Andrea and Ottavio are given by Giuseppe Manini and Salvino Salvini.

The wills of Lorenzo and Ottavio are in the Archivio di Stato—*Protocolli del notaio Nicola Taddei, 24,253, Testamenti* and *Protocolli del notaio Niccolò Salvetti, Testamenti, 23,516*—but they are of no great interest and do not refer to pictures except for a bequest by Lorenzo to 'Priore Coriolano Montemagni Segretario di Stato di S.A.R. di un Quadro di mano del Caravaggio di Larghezza braccia due con l'orna-mento, et Altezza braccia uno, e due terzi incirca dipintovi fra l'altro S. Gio. Decollato.'

Andrea's artistic activities in Rome are referred to in Giuseppe Ghezzi's notes (see p. 125, note 1) and in two letters from Sebastiano Resta to Francesco Gabburri published by Bottari, II, pp. 100 and 104.

Ottavio died in 1714, Andrea in 1715 and Lorenzo in 1719. The heirs were the two sons, Antonio and Giovanni Battista, of a fourth brother Nicola who died in 1710.

[2] A copy of the decree conferring the *Appalto Generale della rendita della Farine della Città, e Dominio di Firenze* for nine years as from 1 June 1676 is preserved in the Archivio di Stato—*Miscellanea Medicea 533, Uffizio delle Farine*, and some information about its functioning can be found elsewhere in the same collection of documents.

[3] Baldinucci, VI, 1728, p. 500. This picture, which is still at Burghley, was exhibited in London in 1960—*Italian Art and Britain*, p. 24.

Andrea had had built in the Theatine church of S. Gaetano a sumptuous family chapel
dedicated to his name-saint. This was decorated with frescoes by Ottavio Vannini,
who himself died a year later leaving the altar picture to be completed by a pupil.[1]
Vannini was, indeed, the family painter: the four large scenes from the Old Testament—
The Sacrifice of Isaac, The Fall of Manna, Moses striking the Rock and *Susanna and
the Elders*—which he produced for the house were considered his finest works,[2] and the
del Rosso also owned a large number of other pictures by him, mainly of saints. He
was a methodical, correct, academic artist in the true tradition of Florentine 'disegno'—
characteristic in every way of the provincial backwater into which one section of that
city's painting had sunk during the first half of the seventeenth century.

It was into this peaceful, somewhat pietistic household—Carlo Dolci also painted
for the del Rosso family[3]—that the new generation introduced over a hundred Nea-
politan pictures (some acquired from the Roomer collection after its dispersal in 1674),
of which more than sixty were by Luca Giordano. Aesthetic taste alone is unlikely to
have caused such a spectacular departure from traditional patterns; business connections
were probably of greater importance. Indeed, various links with Naples turn up from
time to time in the family history. In 1613, for instance, we find the Grand Duke of
Tuscany writing to the Spanish Viceroy about some subjects of his, 'the sons and heirs
of Antonio del Rosso, Florentines, but living and trading in Naples',[4] and it is perfectly
possible that Andrea and Lorenzo themselves may have started their careers in that city.
But however the connection began, it led to striking results.

Luca Giordano was their principal artistic agent in Naples and their relationship
with him was particularly close. Many of their pictures were acquired through him,
and when he came to Florence in 1679 he stayed at their house.[5] Indeed, as they already
owned a number of his works before then, it may well have been they who arranged
for him to be given the commission to paint the Corsini chapel in the Carmine, which
in turn led to his great frescoes in the Palazzo Riccardi. Certainly they owned the
original *bozzetto* for one of the pendentives in the chapel.

Luca Giordano's paintings for the brothers were of various kinds and included a
large number of erotic works—many versions of the theme of *Venus and Amor*, one

[1] Richa, III, p. 215.

[2] Cinelli, p. 163, and Baldinucci, VI, 1728, p. 145. Two of the pictures—*The Fall of Manna* and
Moses striking the Rock—are published by R. Longhi, 1956, in an article on the del Rosso collection.

[3] They owned three pictures by Carlo Dolci—including the *Flight into Egypt* sold to Lord Exeter—
and four by Giovanni Bilivert. All these were of religious subjects. They also owned altarpieces by Pietro
da Cortona and Ciro Ferri. Pietro da Cortona's *Madonna and Four Saints*—a smaller version of the early
picture in S. Agostino, Cortona—was obtained for them in Naples by Luca Giordano—Gualandi, II,
p. 122, and *Mostra di Pietro da Cortona*, p. 28.

[4] Biblioteca Nazionale, Florence—Poligrafo Gargano.

[5] Baldinucci, VI, 1728, p. 506. Senator Francesco Panciatichi, who from 1682 held the important
post of Primo Segretario, was the father-in-law of Nicola del Rosso, the fourth brother. In the Archivio
Mediceo (Filza 4123) is a letter to him from Naples, dated 2 April 1686: 'Molto obbligantemente resto
da V.S.Ill.ma favorito nel particolare della lettera del Sig.r V.Re diretta al Pittore Giordani, mentre
oltre la briga presasi di fargliela sicuramente recapitare, s'è degnata anche d'assumersi il pensiero d'inviar-
mene la risposta, che già da me è stata presentata à S.E.'

of which showed in the distance an 'ignudo in atto assai lussurioso che si strugge per lui', and sets of fables—*Deianira and Nessus, Galatea and Tritons, The Rape of Proserpina.* But they also owned religious paintings by him with scenes from the Old and New Testaments, as well as more purely devotional pictures; and they showed a particular fondness for Giordano's *modelli* for altarpieces and other works.

This new appreciation of the sketchy, the unfinished, lively brush stroke, which was to be so important in eighteenth-century art and was to have another great Florentine devotee in the Grand Prince Ferdinand de' Medici, may have led to their collecting (through the intervention of Luca Giordano) the work of another artist of the Neapolitan school who has acquired enormous popularity in our own day. This was the Frenchman François Nomé, generally known as 'Monsù Desiderio', and described in their inventory as 'Lorenese'. They owned eleven of his mannered, visionary ruin pictures 'fatta di colpi', including a *Babylon*, an 'antichità di palazzi', a 'gran Tempio antico', a *Temple of Solomon* and an imaginary view of Venice. And the same taste for the Mannerist is shown in their possession of what was apparently the original plate for Callot's print of *La Fiera dell'Impruneta.*

As an isolated phenomenon the del Rosso collection with its great emphasis on Naples and its total neglect of Rome is of outstanding interest.[1] Whatever its motives, their sudden conversion from the Florentine tradition of 'disegno' to the values of 'colore' was symptomatic of the most advanced international taste towards the end of the seventeenth century on the verge of the great Venetian revival. But it is difficult to assess how far the collection represented something more important—a direct and influential contribution to the cultural life of Florence. If it was through del Rosso that Luca Giordano was commissioned to decorate the Corsini chapel in the Carmine and the ceiling of the Palazzo Riccardi, we can certainly claim such an influence for the brothers. These works, though they had disappointingly little effect on Florentine painting, were of crucial importance to central Italy, and in their own right they rank among the masterpieces of the century. Yet there are aspects of the del Rosso brothers' taste which are curiously puzzling. There was, for instance, in Florence only one artist whose freshness and vitality could surely have satisfied the friends and patrons of Luca Giordano. Yet Livio Mehus they largely ignored. In 1677 they owned three pictures by him; twelve years later these had disappeared. Somewhere, at the back of the mind, there persists the disturbing belief that their special patronage of Luca Giordano may have been dictated more by financial interests than by aesthetic taste.

The importance that Neapolitan painting had acquired all over Italy towards the end of the seventeenth century is shown by the collections of other patrons who looked beyond their native cities. Thus in Genoa the Marchese Girolamo Durazzo, a member of one of the leading patrician families which over the centuries had built up an extensive collection of local art, turned not only to Bologna for many of his pictures (as was

[1] Besides those mentioned, they also owned pictures by Ribera, Preti and Paceco de Rosa—the latter are published by R. Longhi, 1956.

usual enough),[1] but also to Naples. Luca Giordano painted four canvases for the family
—one scene from Tasso (*Sophronia and Olindo*), one from Roman history (*The Death of Seneca*), one from the Old Testament (*Queen Jezebel torn to pieces by Dogs*) and one from mythology (*Perseus and Andromeda*).[2] And, in about 1704, Francesco Solimena added two further vast histories from the Old Testament—*Judith with the Head of Holofernes* and *Deborah and Barach*.[3] Pictures by the same two artists hung together in one other important collection outside Naples, that of the Baglioni in Venice, a family of rich publishers who early in the eighteenth century bought their way into the nobility. They showed a great interest in Neapolitan art, for besides pictures by Mattia Preti they owned several by Luca Giordano and two by Solimena—*Jacob and Rebecca* and *Rebecca and Eliezer*[4]—whose influence on Pittoni and the young Tiepolo was considerable.

– ii –

The patrons hitherto considered, though living outside Rome, where artists from all over Italy and indeed Europe had congregated, were able in their own collections to reflect some of the variety which had been the most attractive and influential feature of Roman patronage. But all of them, with the exception of Don Antonio Ruffo, lived in centres of great artistic traditions and achievement characterised by flourishing local schools of painting. In most cases it was these local artists who provided the backbone of their collections which were then reinforced with additions from elsewhere, usually Naples. The difficulties facing a collector living in a city with no such tradition or local school on which to fall back were more complex and led to more interesting results. For in these cities the patron had to commission works of art almost exclusively from outside his province, and this involved a freedom of choice that did not face collectors in Bologna, Genoa or Naples. Thus it came about that some of the most interesting collections of Italian art in the later seventeenth or early eighteenth centuries were to be found in cities quite undistinguished for their native painters. It was in places like Bergamo, Ferrara, Macerata and Lucca, far more even than in Rome, that the enterprising traveller of the time might have found hanging together pictures by the younger painters from all over Italy—those men such as Crespi, Solimena, Sebastiano Ricci and others who had declined to visit or to remain in Rome. Indeed, the most striking

[1] They owned large historical pictures by Giovan Gioseffo dal Sole and Francesco Monti (Zanotti, I, p. 299, and II, p. 120) and they summoned Giacomo Antonio Boni to decorate the rooms of their palace with mythological frescoes—Zanotti, II, p. 231, and Soprani, II, pp. 376-80.

[2] De Dominici, IV, p. 188.

[3] *ibid.*, IV p. 428, and Bologna, pp. 89-90.

[4] De Dominici, IV, pp. 87, 188 and 428, and Bologna, p. 164. Both Luca Giordano and Solimena had a number of admirers in Venice. Besides the Labia, who are discussed separately in Chapter 9, the Procuratore Canale, Flaminio Corner, the Giovanelli and the Widmann all owned pictures by one or other of them—de Dominici, IV, p. 428, and the engravings of Pietro Monaco published in 1763, Nos. 42, 51 and 89. Early in the nineteenth century the French traveller Valèry (I, p. 342) said that the Palazzo Contarini contained 'quatre des meilleurs tableaux de Luc Giordano, parmi lesquels l'Enée emportant son père Anchise.' For Neapolitan artists in Rome see Mattia Loret.

aspect of these collections lies in their neglect of Roman painting. The classicising doctrines and institutions that paralysed or boycotted so many of those painters who actually went to Rome were not to be found in these out-of-the-way places, and a taste could thus grow up in them based on very different canons of appreciation. It is true that these collections were probably not many—though they obviously must have been far more than the few that are here recorded—but in at least one case they were highly influential. Moreover, the history of their development shows us the mechanism of an unusual type of patronage which is of great intrinsic interest and of some importance in the demolition of Roman values.

Work on the church of Santa Maria Maggiore in Bergamo began in 1137, and continued fitfully over the next few centuries.[1] In 1355 Giovanni da Campione erected the delicate but richly ornamented Gothic portico supported on two stone lions which faces the Palazzo della Ragione, and a few years later he also built the rather more restrained entrance to the south. The Renaissance brought further additions to this essentially Romanesque structure. In 1425, after nearly three centuries, the campanile was completed, and towards the end of the century a sacristy in the new Bramantesque style made it still harder to appreciate the original plan. The successive modifications of the interior were far more drastic. Traces of Gothic frescoes still remain, but from the middle of the sixteenth century the whole decoration was changed. Altar paintings by local and Venetian artists began to appear, and rich and heavy stucco ornamentation crept over the interior of the dome which was planned by the Milanese architect Francesco Maria Ricchini in 1612. Two years later the Bergamasque painter Giampaolo Cavagna, helped by two other local artists, completed the decoration of the dome with frescoes of angels and prophets.

Thus by the middle of the seventeenth century the interior must already have presented a confusing spectacle with the spasmodic and incomplete decoration of several very different periods competing for attention. It was in 1653 that the Consiglio del Consorzio, the governors of the church, decided to embark on an extensive programme of decoration, whose main purpose was to provide pictures for the central crossing of the church. A committee was appointed 'to order oil paintings in the manner that should seem most suitable to their considered judgement'.[2]

The task was a vast one, and the problems that faced the committee were difficult. It was clear that there were no longer any Bergamasque artists of the calibre required and that the commission would have to be given to a foreigner. Bergamo had been ruled by Venice since 1430, but it lies only thirty miles from Milan. Its artistic culture reflected those of the two cities with which it was so closely associated and it was natural enough that the committee should once again look to them. Their relative failure led to a complicated series of negotiations in towns all over Italy, and though

[1] Pesenti.

[2] Unless specially indicated, all the documents here are taken from the very full article by Angelo Pinetti, 1916. The interpretation put on these documents is naturally my own, though it will be seen that I have followed Pinetti closely. I am most grateful to Signorina Dora Coggiola of the Biblioteca Civica, Bergamo, for her great help.

these led to no real masterpieces and few pictures of any great value they give the historian an enthralling impression of the difficulties that faced a persistent patron in a small town.

Their first choice fell on a Swiss artist, Cristoforo Storer, a pupil of the Milanese Ercole Proccaccini, who had already had close contacts with leading families in Bergamo. In February 1654 he was commissioned to paint one of the thirteen pictures to be embedded in the stucco of the vault and lunettes above the cornice of the southern transept. The subject given was *The Levites*, and though the picture was eventually produced, the artist's dilatoriness caused the first of the many long delays which the committee had to suffer, so that by April 1655 they were considering changing their original scheme and having the vault frescoed as a quicker alternative. Indeed a few months later they sent two of their members to the country house of a local aristocrat to look at some frescoes he had had painted there and to decide whether or not the artist concerned would prove suitable for the church. However, they soon returned to the original plan, and in 1656 they commissioned a Neapolitan painter, Pietro Magni, who was then working for the Marquis of Mantua, to produce one picture for the site as an experiment, with the possibility, should it prove satisfactory, of being given the whole job. Evidently it did not—for when in January 1657 a Cremonese painter, Ottavio Cocchi, offered on his own initiative to paint one of the pictures, his proposal was accepted and he was subsequently asked to paint four more. It was clear that the commission was an attractive one to comparatively minor artists.

Meanwhile in the same year the committee began looking around for a suitable painter for one of the three very large canvases to be placed above the main doors of the church. After a unanimous vote it was decided that the task should be given to Guercino and a messenger was sent to him in Bologna. The subject chosen was *The Story of Esther*, but a few months later this was changed to the *Marriage at Cana*. Guercino, however, was already overwhelmed with commissions and this one seems to have made no appeal to him.

The committee's one attempt to move outside the limited range of local talent and employ an artist of international fame had thus met with no success. They put as good a face on this as they could and 'to the full satisfaction not just of the Magnifico Consiglio del Consorzio but of the whole city' they commissioned a *Massacre of the Innocents*, to be placed in the right wall of the southern transept, from a Capuchin pupil of the Veronese Brusasorci, Padre Massimo, a man who had already painted a number of altar pictures in the Veneto. So pleased were they with the work—a vigorous and efficient rehash of Paolo Veronese—that, with the promise of lavish alms, they implored the Capuchins to give temporary leave to Padre Massimo and allow him to settle in Bergamo to paint further pictures. But this too came to nothing. Instead, other artists from Milan and its surroundings were commissioned to paint *The Killing of Sisera*, *The Sacrifice of Isaac*, *Jacob's Ladder* and the *Murder of Cain*. By 1659 the first stage in the decoration was complete.

The committee now turned to the vault of the northern transept, where thirteen

Plate 33

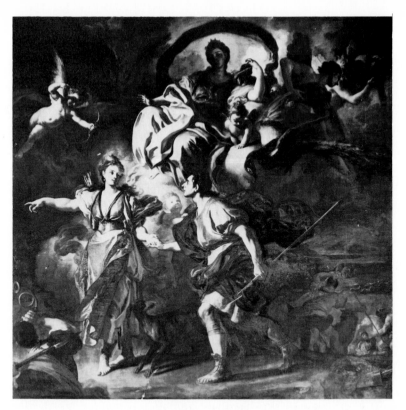

a. SOLIMENA: Dido and Aeneas

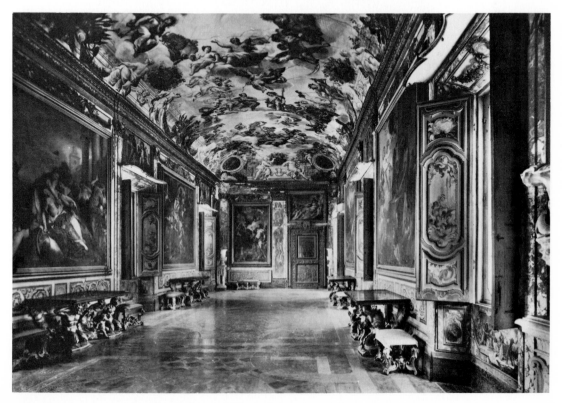

b. The gallery of the Palazzo Buonaccorsi, Macerata

Plate 34

FOREIGN MASTERPIECES IN ITALIAN
SEVENTEENTH-CENTURY COLLECTIONS (*see Plates* 34 *and* 35)

VELASQUEZ: Juan de Pareja

Plate 35

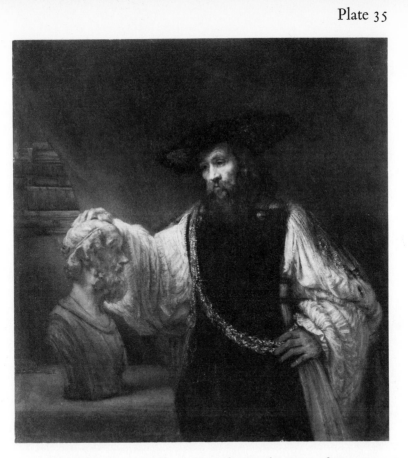

a. REMBRANDT: Aristotle contemplating the Bust of Homer

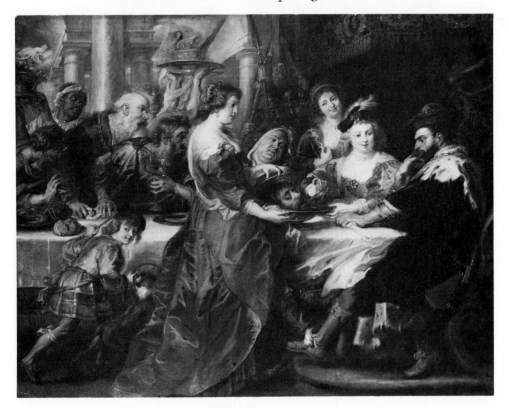

b. RUBENS: The Feast of Herod

Plate 36

GRAND PRINCE FERDINAND AND HIS PATRONAGE (*see Plates 36–40*)

a. Francesco Petrucci: Grand Prince Ferdinand

b. G. M. Crespi: Girl at her toilet

paintings were required to correspond to those in the south, as well as one on the inner wall and two huge ones to be placed above the main North and South doors, in view of Guercino's reluctance to comply with their request. Whereas in the first stage of the decoration they had looked primarily to Milan for artists they now turned instead to their other traditional source—Venice. In 1660 a contract was signed with Pietro Liberi, at that time the best known artist in the city and already a man with a European reputation. Liberi agreed to paint the entire sixteen pictures for 3800 ducats and was paid the first 500 as an advance guarantee. It must have seemed that Santa Maria Maggiore was at last able to attract a considerable painter. Seven months later, his first canvas—*The Flood*—arrived in Bergamo. But the committee did not like it. A cold letter was sent off to Liberi, complaining 'that it does not satisfy us and in no way corresponds to the promises that you made us, still less to what we expected. And so we require you to re-do it in a praiseworthy manner that satisfies us—meanwhile you must stop work on the other pictures which we commissioned and which you agreed to undertake, just as we will stop the payments in conformity with the contract.' It was a year before Liberi arrived in Bergamo, and after he had repainted the picture as demanded, it was placed above the South door, where it still is. He then returned to Venice to carry on with the commission. This time he was more cautious and instead of completing the second picture, *The Last Judgement,* he sent a sketch. This too was a total failure. The committee found it 'deficient in every respect', and thereafter the contract with Liberi was cancelled.

It is impossible, unfortunately, to know the reasons why Liberi's canvases met with such a hostile reception. It is perfectly true that he was a bad painter, but then so were many of the other artists employed in S. Maria Maggiore who were none the less greeted 'with complete satisfaction'. It is more likely that there was some precise cause. His free style must have seemed slipshod in the provinces—but stylistic problems of this kind only very rarely troubled seventeenth-century clerical patrons, and in any case the tone of their letter suggests some much greater offence. In fact it seems most probable that Pietro Liberi, who was notorious for the extreme indecency of his highly erotic nudes, had upset Bergamasque susceptibilities, unused as they were to the more sophisticated tastes of Venice. No two subjects could have provided him with more welcome opportunities than *The Flood* and *The Last Judgement*, and (from what we see of the former even after the alterations) we can be sure that Liberi took full advantage of them.

With the failure of their attempts in Venice the committee were now compelled to turn elsewhere. Ciro Ferri, the artist whom they chose to replace Pietro Liberi, was the most faithful follower of Pietro da Cortona and was at this time in Florence completing his master's frescoes in the Palazzo Pitti.[1] He was asked to come at once to Bergamo 'to see where the pictures were to be painted, be given the measurements and the subjects, and arrange the price'. He replied that he was unable to leave Florence for the moment, but asked for all the necessary details to be sent to him so that he could at

[1] See a number of letters published by Bottari, II, pp. 47-56, and III, pp. 352-4.

once begin work on the sketches which he would then submit for the committee's approval. This was agreed and after some months of delay, during which the relations between artist and patrons rather cooled, Ciro Ferri finally arrived in Bergamo in September 1665, and in December signed a contract to paint the sixteen pictures—partly in oil and partly in fresco. Everything at last seemed satisfactory. In private letters Ferri wrote of his pleasure, though he admitted that the sites for the frescoes were rather too small. On the other hand the large picture over the door was to represent the *Crossing of the Red Sea* and this 'is the grandest composition that I have ever done. On one side I am painting the Hebrews who have already crossed and Moses raising his rod above the sea.' The whole task, wrote Ferri, would take some two and a half years. In fact, he worked much quicker than he had expected. By May 1666 he had completed four of the frescoes; and by November a further six—all of subjects taken from the Old Testament. But now the first signs of trouble became apparent: 'I am working day and night to get through quickly; for I'm so bored that I can't stay any longer in this place.' By June 1667, however, eighteen months after his arrival, the business was nearly over. The thirteen frescoed compartments were all complete—little more than mannered and insipid variations on Pietro's style—so was one of the large oil paintings, and he was waiting to finish the other so that they could both be shown to the public together. In September the storm broke. Once again the committee showed how rigorous was their taste. They had doubts about the quality of the picture to be placed above the side door adjoining the Colleoni chapel and they decided to consult expert opinion as to its merits. Ciro Ferri, in a fit of rage at this insult, left Bergamo without completing his contract.

Three pictures remained to be painted—two large ones for the North and West doors and one, slightly smaller, for the inner wall of the North transept. The committee were once again in a dilemma as to whom to choose for them. Various artists proposed themselves, and eventually the young Venetian, Antonio Zanchi, was accepted and required to paint *Moses striking the Rock*.[1] By now the committee were in a much more wary frame of mind than they had been when engaging Ciro Ferri. Zanchi was to get no payment for submitting his drawings; even if they were approved and if the picture itself—which was to be painted in Bergamo—then turned out to be unsatisfactory it would be returned to him without fee. If it was accepted, experts would decide on the price. These terms were exceptionally hard and quite unlike those laid down in a normal contract. Zanchi, however, was still young and only at the outset of his extremely successful career. He agreed to everything, but on a visit to Bergamo to inspect the site he asked, and was given, permission to paint the picture in Venice. There the canvas was sent to him, followed by letters complaining of the delay and asking him to hurry. In fact, it was completed within four months, and it took the cautious committee almost as long again to make up their minds about it. Eventually it was accepted with obvious enthusiasm, for Zanchi was paid the considerable fee of 825 ducats, which he well deserved in view of the oustanding merits of this dramatic and richly

[1] Bottari, III, pp. 355–6.

coloured picture in which the blues, reds and greens of the women's costumes and the muscular backs of the men romantically emerge from a tumultuous background.

For the picture of the *Sacrifice of Noah* to replace Ciro Ferri's unsuccessful effort above the door of the Colleoni chapel the committee decided in 1677, after a delay of some years, to organise a competition. Three artists took part and submitted sketches : Federico Cervelli of Milan, Pietro Negri of Venice, who had followed Zanchi in painting for the Scuola di San Rocco a picture to commemorate the cessation of the plague of 1630, and the Turinese Cavaliere Perugino, a protégé of the King of Savoy. This was won by Cervelli, who, after a visit to Bergamo to make certain alterations, was paid 370 ducats.

The third of the large oil paintings—*The Crossing of the Red Sea*,[1] the subject that had so fascinated Ciro Ferri at the outset of his Bergamasque career—was entrusted in 1682 to the most distinguished painter that the committee were able to employ on their ambitious venture—Luca Giordano. The artist was then at the height of his career in Naples, and the picture which he sent them, with its warm glow of light bathing the faithful who have just emerged from the dark-green tempestuous sea, justified their great hopes. He was given a present of 100 *scudi* in addition to the 700 he had already been promised, and was pressed, unsuccessfully, to undertake all the remaining decoration of the church.

Fourteen more paintings were now required for the central nave and the usual difficult negotiations were soon under way. In 1681 a painter from Como, Cristoforo Tencala, was approached, but nothing was arranged. A year later a local artist Carlo Ceresa submitted a *modello*, which was considered to be 'very beautiful and precious'— flattering words designed to conceal the fact that the committee had now set their target much higher. Unfortunately their funds were unable to stand the strain. Carlo Cignani of Bologna, at this time probably the most famous painter in Italy, asked for exorbitant sums as well as all his expenses. He was obviously anxious to be given the commission, for he arrived in Bergamo to press his claims. The committee were sorely tempted, wavered, and suggested a compromise. But Cignani stuck to his position, and the plan fell through. Luca Giordano, whose *Crossing of the Red Sea* had been such a success, presented difficulties of much the same kind. He had first asked for 6000 ducats to paint the ten frescoes and four oils, but under pressure agreed to reduce this to 5000, provided that he himself, an assistant and a servant were given free board and lodging for as long as they should be required to stay in Bergamo.[2] The committee could just manage these conditions and a contract was signed—only to be ignored by the artist. One of the attractions of asking Giordano in the first place was his legendary speed. Now as year followed year, and letter after letter was met with conciliatory but evasive replies, Giordano's success with all the courts of Italy and Europe was seen to be a real drawback. Moreover, as time went by, his terms became stiffer and stiffer. Perhaps Cignani would

[1] An anonymous article in *Bergomum*, 1947, pp. 60-1, has shown that the subject represented was in fact the Hymn of Liberation after the Crossing.

[2] Tassi, I, p. 265.

prove more satisfactory after all. And so in 1692, when Giordano finally went to Spain, ten years after their original approach, the committee turned to Cignani once again. Much had happened in the meantime. He was now painting the cupola of Forlì Cathedral, a work which he intended should rival Correggio's at Parma. His preoccupation with vast expanses made him reluctant to engage on a reduced space, the limitations of which had already disconcerted Ciro Ferri a quarter of a century earlier. The smallness of the area available and the height of the bays would, he wrote in August 1692, make it impossible for him to paint the figures on such a scale that they would appear natural when seen from below in view of the crowded scenes he had been required to depict. 'Above all, I find myself unable to undertake the work because the pictures are to hang above a perpendicular wall and this means that the foreshortening would have to be so excessive—especially in view of the not very wide expanse of the church—that it would be impossible to correct the distorted effect.'

So the problem remained unsolved. In Rome meanwhile the Swiss painter Ludovico David heard 'from a colleague and friend of mine' about the fourteen pictures that were needed.[1] Anxious to prove himself in 'such a notable site', he wrote giving details of his career and offered to paint all the pictures within two and a half years at a price of 3500 *scudi*—or alternatively to take a share of the scheme at a price to be agreed with other artists. The committee, whose experiences over the last half-century had understandably made them cautious, proposed instead that painters all over Italy should paint three pictures each, entirely at their own expense, and that if these proved unsatisfactory no payment at all would be made. David was indignant. Hitherto he had always been paid at least a quarter of the agreed price in advance and the remainder immediately on completion of the work. 'I could not without shaming myself allow it to be remembered by posterity that I had degraded my noble profession in this way.' He proposed instead a highly elaborate scheme: three of the subjects required should be chosen and a price of 500 *scudi* offered for each. Then any two other painters and David himself—after being paid a quarter in advance—should begin work and agree to complete the picture within a year. At the end of this time they should submit their canvases to a public exhibition in Rome so that each could see his rival's work and the public could make criticisms. The canvases should then be sent to painters' guilds in Florence, Bologna and Venice 'which are thought to be the best in Italy after Rome, which in this case must be excluded because of the risk of favouritism'. The artist who was considered the best should then be given the remainder of the commission.

All this was much too complicated for the committee, which applied instead to a Bolognese pupil of Cignani, Marcantonio Franceschini. His terms were, however, even more expensive than his master's or Luca Giordano's had been, and though on hearing of a potential rival he hurriedly brought them down, the committee had already turned elsewhere.

To Naples, in fact—where a pupil of Luca Giordano, Niccolò Melanconici agreed to paint an *Abraham* at his own expense as an experiment. The picture arrived quickly

[1] Bottari, III, pp. 361-9.

and met with approval. It was arranged that Melanconici should be given the entire commission for a fee of 4000 ducats, which was to include all his expenses for travel and for board and lodging. The oils were painted in Naples, and then in June 1693 the artist himself arrived in Bergamo to undertake the frescoes. The results were controversial, but criticism, as the committee pointed out, 'is unavoidable'. In any case a willing artist working for a reasonable fee was too rare to be turned down, and Melanconici was given a certain number of other pictures to paint in the church and allowed to append a gigantic signature, easily visible to the naked eye, beneath the colourful, if slightly academic, figure of *David with the Head of Goliath*. And so by 1695, some forty years after the original proposals, the decoration was at last complete.[1]

The long-drawn-out and complicated manœuvres of the Governors of S. Maria Maggiore in Bergamo to commission artists from all the schools of Italy for the decoration of their church form by far the most ambitious (and the best documented) of such ventures in the seventeenth and eighteenth centuries. No private patron had either the resources or the available time to compete with this body. Yet in other small towns there were men who were helping, on however modest a scale, to break the cultural isolation of the Italian provinces. One such was Cardinal Tommaso Ruffo. He was born in Naples in 1663 of the same great southern family which had given birth to Don Antonio in Messina.[2] He entered the Church and in 1692 was made Vice-Legate in Ravenna by Pope Innocent XII. He then served as Inquisitor in Malta and Nunzio in Tuscany before becoming *maestro de camera* to the Pope. He was made Cardinal in 1706, after which he returned to Ravenna as Legate for a short time before going to Ferrara, with which his connection was particularly close. He remained there from 1710 as Legate and from 1717 as Archbishop until 1738, except for six years in Bologna from 1721 to 1727. As an old man he then lived in Rome in a palace opposite the Trevi Fountain which he bought from the Cibo family. He died there, aged 90, in 1753.

Even this brief outline of his career will show that Ruffo had plenty of opportunities for seeking works by most of the leading Italian artists with the notable exception of those in Venice. And the very varied contents of his gallery testify to the width of his tastes as well as to his enthusiasm. It was in Ferrara that he brought the collection together, though we know that he would commission paintings in most of the towns in which he resided.

The gallery was kept in the new Archbishop's Palace which was built for him in 1710 by the Roman architect Tommaso Mattei. In the centre of this vast palace adjoining the Cathedral a white stone stairway leads up to the *piano nobile* in two great flights of steps which bend back on each other. At the halfway mark on the balustrade stands a statue of *Vigilance* commissioned by Ruffo from the sculptor Andrea Ferrerio,

[1] Another church in Bergamo which, early in the eighteenth century, employed leading painters in several Italian towns was S. Paolo d'Argan. Among those who worked for it were G. M. Crespi in Bologna and Lazzarini, Ricci, Balestra and others in Venice as well as some local artists in Bergamo itself—Angelo Pinetti, 1920.

[2] For the outlines of his career see Moroni, Vol. 69, pp. 215-16.

a pupil of the Bolognese Giuseppe Mazza.[1] The same artist designed the rich stucco decoration of the staircase wall in which were placed medallions of the six popes who had in some way benefited the City of Ferrara or her Legate, culminating in Innocent XII, Ruffo's own patron. On the top floor was another medallion in full relief of the reigning Pope, Clement XI. On the ceiling of the staircase another Bolognese artist Vittorio Bigari, known primarily for his later architectural fantasies, painted a fresco of the Catholic Religion, represented by the Papacy, presiding over the provinces of Ravenna, Bologna and Ferrara shown symbolically in heroic dress—the three cities where Ruffo had principally served. It was in this grandiose setting, carefully designed by the Cardinal in collaboration with his architect and sculptor, that Ruffo kept a collection of paintings which aroused the enthusiasm of his contemporaries and which to us in retrospect still seems remarkably varied and impressive.

Ruffo owned a number of works attributed to the great Italian masters of the six-teenth and seventeenth centuries—Giorgione, Titian, Bassano, Correggio, Raphael, Parmigianino, Caravaggio, the Carracci, Guido Reni and Guercino as well as others by Rubens and Van Dyck less familiar in Italian collections.[2] John Breval on a visit to Ferrara commented on some of these—'four of the most capital Castigliones I remember to have seen; an incomparable Lucretia by Hannibal Carache; and a very fine Original of the famous Neapolitan Chief of the Mutineers, Masanella [sic]'.[3] But the most remarkable of all Ruffo's seventeenth-century pictures must have been Velasquez's portrait of his servant Juan de Pareja, 'cosa stupenda', which in 1704 he sent to an exhibition in Rome (Plate 34).[4]

The bulk of his modern pictures came from Bologna. Crespi was represented by four works, two of which were commissioned during Ruffo's legateship in the city: *Abigail giving Presents to David* and *The Finding of Moses*.[5] Both these religious themes are treated in a spirit of subdued and tender romanticism, and it was perhaps this quality that Ruffo found so congenial in Crespi's more aristocratic counterpart in the depiction of such subjects—Donato Creti. He was so fond of this painter that he used to sit

[1] This account of the Archbishop's palace, which is still today exactly as described, is taken from the most tantalising document I came across during the course of my researches. It is a manuscript in the Biblioteca Ariostea, Ferrara—Collezione Antonelli MS. 610—*Galleria di Pitture raccolte, ed esposte nel Palazzo Vescovale di Ferrara dall em.mo e rev.mo Sig.r Card.l Tommaso Ruffo Vescovo di detta Città, e Legato a Latere di Bologna descritta da Girolamo Baruffaldi*. After a long account of the palace comes the word *Galleria*, only to be followed by the following sentence: 'Ma il Card. Ruffo, annoiato, e malcontento dell' Arcivescovado di Ferrara lo rassegnò al Sommo Pontefice, e se ne andò a Roma portando seco le Pitture della sua Galleria, onde levò a me il contento, e l'onore di poterla più descrivere.'

[2] The list of Ruffo's pictures was published with verse commentaries by J. Agnelli.

[3] Breval, 1738, I, p. 193.

[4] The picture 'Il Ritratto da tre palmi rappresentante un servo che fu serv.re del S.r Diego Velasquez famoso pitt.re e cosa stupenda' was among those lent to the exhibition in S. Salvatore in Lauro in 1704 —see p. 125, note 1. It is the picture now in the Metropolitan Museum which was in the collection of Sir William Hamilton in Naples by 1798.

[5] Both of these, together with other pictures from Ruffo's collection, are now in the Museo di Palazzo Venezia in Rome. They are referred to by Zanotti, II, p. 56, and L. Crespi, p. 214. See also Santangelo, pp. 2 and 23.

watching him at work for hours and had him created *Cavaliere dello speron d'oro*.[1] He owned at least two paintings by him of scenes from the life of Solomon and a *Dance of Nymphs* described by the artist's biographer as a *capriccio pittoresco* with twenty-four figures. Ruffo commissioned religious paintings and histories by most of the other leading Bolognese artists such as Carlo Cignani, Marcantonio Franceschini (after 1720) and Giovan Gioseffo dal Sole and also two *bambocciate* by Giuseppe Gambarini.[2]

Despite a life spent almost entirely in the North, Ruffo remained closely attached to his Neapolitan background. Luca Giordano sent him four pictures, of which one, representing *Hebrew Women singing after crossing the Red Sea*, may well have been connected with his work for S. Maria Maggiore in Bergamo; Solimena painted for him a *Nativity* and a *Presentation*; and when he retired to Rome it was once again to his compatriots that he turned. The rich chapel which Nicola Salvi built for him in S. Lorenzo in Damaso was decorated by Sebastiano Conca and Corrado Giaquinto, the former of whom also painted other pictures for him.[3] Roman artists he found to be of little interest and his gallery in the Palazzo Cibo must have retained its exotic and delicate flavour until his death.

Another patron who during these years was ranging freely over Italy for his pictures was Raimondo Buonaccorsi, who lived in the little Marchigian town of Macerata. This provincial nobleman was born in 1669 of an old and important family with extensive ramifications throughout the peninsula and a particularly close relationship with the Church.[4] In 1699 he married Francesca Bussi, who by 1726 had brought eighteen children into the world, one of whom, Simone, was to become a Cardinal. He died in 1743. Of his personality and achievements we know next to nothing. The less than a handful of letters to and from him that can be traced suggest almost too characteristic an image of the early eighteenth-century gentleman as transmitted to us by subsequent writers—elaborately courteous, proud, and deeply attached to the established powers. But also ambitious with more than a touch of arrogance.[5] Until further evidence comes to light we must be content with this shadowy sketch: meanwhile we can see from the splendid decoration of his palace that he was also a patron of great enterprise and interest. The palace—the finest in this little hill town in the

[1] Zanotti, II, p. 115, and L. Crespi, p. 259.

[2] Zanotti, I, p. 239.

[3] De Dominici, IV, p. 538, and Moroni, XII, p. 71. He also commissioned his portrait from Andrea Pozzo—Pascoli, II, p. 265.

[4] I am grateful to Count Orlando Buonaccorsi for making available to me what little material survives about his ancestor and to Mr Dwight Miller for letting me have copies of the photographs he had taken of the gallery and for suggesting many of the attributions. Some information about the family can be found in Silvio Ubaldi, and there are a few details about Raimondo himself in a small manuscript *Memoria* which was written by his wife in 1726 and still belongs to the family.

[5] The letters, which are of little interest, are in the Vatican Library—(i) From Raimondo Buonaccorsi to Tiberio Cenci, dated 23 February 1705—Vat. Lat. 9041, c. 39; (ii) from Alessandro Borgia, Arcivescovo e principe di Fermo, to Raimondo Buonaccorsi, dated 15 September 1737—Borg. Lat. 236, c. 87; (iii) as (ii)—dated 7 December 1742, Borg. Lat. 236, c. 125.

States of the Church—was being built for Raimondo during the first two decades of the eighteenth century on the site of an earlier one which had been acquired in 1701 by his father.[1] The architect was the Roman Giovanni Battista Contini, and although work continued for many years, by 1707 enough progress had been made for Raimondo Buonaccorsi to begin the decoration of the long gallery. This survives intact today (Plate 33b). The low barrel-vault is covered from end to end with a single fresco and this alone gives some unity to the very varied decorative scheme that faces the visitor. On each side of the gallery three windows open on to a courtyard and on to the front of the palace, and the light which streams in reveals the general richness—a profusion of coloured marbles with elaborate wood and stucco ornamentation. Overriding everything are the paintings. The whole surface is covered with huge square and rectangular canvases which fit into all the wall space available between and above the doors and windows. Each one is painted in a wholly different style: we find the blond, carefully drawn figures of a Bolognese next to the darkly dramatic and rich swirling movement of a Neapolitan or the confusion of a late Venetian. Yet it soon becomes clear that each represents an episode taken from a single story—the *Aeneid*. It is such iconographic unity combined with extreme stylistic diversity, rather than any intrinsic merit in the canvases, which makes this decoration so exceptional in the Italy of its day.

In 1707 Raimondo Buonaccorsi summoned two Bolognese artists, Carlo Antonio Rambaldi and Antonio Dardani, to paint the fresco of the *Apotheosis of Aeneas* on the vault of his gallery,[2] and soon afterwards he began to commission the pictures of single episodes from the epic to be fitted into the walls. Rome, capital of the papal states in which he lived, was the obvious place to which to turn, but for him, as for so many of the livelier provincial patrons, Roman painting seems to have had little appeal and he chose only one example for his gallery: a picture of *Venus in the Forge of Vulcan*, painted apparently by Luigi Garzi.[3] For the rest his attention was firmly concentrated on Naples, Bologna and Venice.

The masterpiece of the whole series, Francesco Solimena's *Dido welcoming Aeneas to the Royal Hunt*, was among the first to arrive (Plate 33a).[4] The tremendous implications of the theme—'Ille dies primus leti primusque malorum/Causa fuit'—were realised by the artist in a picture of the utmost romantic splendour. Dark clouds lower over the landscape and, on the instructions of Juno, the winds prepare to pound the earth with driving rain as the young Trojan hero, oblivious of Cupid's arrow aimed at his breast, hurries forward to accept the guiding hand of Dido, who looks back at him with eyes full of tender passion. The picture aroused the greatest enthusiasm and

[1] Amico Ricci, II, p. 436.
[2] Zanotti, I, pp. 396 and 418.
[3] D. Miller, 1963 and 1964.
[4] De Dominici, IV, p. 428, who also mentions three other pictures painted by Solimena for the Buonaccorsi. Its arrival is recorded in a letter from Raimondo of 6 July 1714 in the family archives. Bologna (Plate 209) publishes a replica in the Scholz-Forni collection, Hamburg.

interest. In Bologna Giovan Gioseffo dal Sole, who was working on his own canvas of *Andromache weeping before Aeneas*, heard of its arrival and insisted on coming to the Buonaccorsi palace to see it.[1] A Bolognese painter travelling across the hills to Macerata to examine the latest masterpiece by his Neapolitan rival—here indeed was proof that Rome was no longer the great centre of cultural exchange that it had once been!

Yet we must not claim too much for the gallery. Giuseppe Gambarini[2] and Marcantonio Franceschini in Bologna,[3] Gregorio Lazzarini[4] and Antonio Balestra in Venice,[5] all of whom turned out further scenes from the poem were not men from whom anything very new could be expected. Their works have a clumsiness and a lack of conviction which suggests that the tradition of large-scale romantic history painting to which they harked back had been drained of vitality and was now little more than an empty academic exercise.

Indeed it was in some of the other rooms in Raimondo's palace that works by the more interesting and 'modern' painters of the day were to be found, and the striking contrast between these and the men who painted the scenes from the *Aeneid* shows that Raimondo must have had a genuine awareness of their essential qualities. Thus Crespi, who was quite unsuited to heroic melodrama, was required to paint four fables,[6] and the one that has survived—*Leto turning the Shepherds into Frogs*—shows with what engaging irony he could interpret the stories of classical mythology.[7] The attitude of Giuseppe Gambarini, who was also commissioned to paint pagan scenes, was rather different: more placid and more sensual and with none of Crespi's humour.[8] But he too was engaged in the characteristically eighteenth-century revolution of turning the great themes of antiquity, and even Christianity, into pretexts for genre.

Apart from the works of these masters we have few records of the collection. Little or no trace can be found of Corrado Giaquinto, who is reported to have worked for the Buonaccorsi,[9] for the pictures were repeatedly split up among members of the family and no inventory has survived. It is, however, possible to suggest that Raimondo may have been among those many patrons of the dawning Age of the Enlightenment whose great public galleries looked back resolutely to the past, but whose private

[1] Zanotti, I, p. 305.

[2] D. Miller, 1963 and 1964.

[3] Franceschini painted *Mercury awaking Aeneas*—Zanotti, I, p. 236, and an entry in the artist's *Libro dei Conti* (Biblioteca Comunale, Bologna—MS. B.4067) which shows that he was paid 1000 *lire*.

[4] Lazzarini painted *The Death of Dido* and *The Battle of Aeneas and Mezentius* as well as other pictures for the family—da Canal, p. 38.

[5] Balestra's painting of 'una favola d'Enea' for the Buonaccorsi is noted in the unpublished life of the artist by Pascoli (Biblioteca Augusta, Perugia—MS. 1383).

[6] Zanotti, II, p. 52.

[7] This picture is now in the Pinacoteca Nazionale, Bologna.

[8] D. Miller, 1958.

[9] Amico Ricci, II, p. 436. When I visited the collection a few years ago, none of the pictures there could be attributed to Giaquinto, and d'Orsi (pp. 31-2) limits his work in Macerata to some very minor decoration in the window niches.

apartments were filled with smaller and more intimate pictures betraying a wholly new range of sensibility.

On a much more modest scale we can notice a somewhat similar conflict in the contemporary collection of Stefano Conti, a business man of Lucca.[1] Though he owned only ninety-seven pictures, mostly of small dimensions, he too was forced by the very nature of his birthplace to look far outside his native province for talented artists. He confined himself to Bologna and Venice, and—partly by accident and partly by design —he managed in the process to acquire pictures by Crespi, Sebastiano Ricci, Canaletto and other leading eighteenth-century painters.

Conti was born in 1654 of a father who had been accepted into the Lucchese nobility some quarter of a century earlier. He himself carried on a flourishing trade in silks and cloth, and we can see from his will and other documents that he was an acute man of business. He married in 1685, but outlived both his wife and only son and died in 1739 at the age of 85. He began collecting quite suddenly at the end of 1704 after a journey which had taken him to Venice and Bologna, and for the next three years he methodically acquired a number of pictures in both cities in a spirit that suggests that he knew exactly what he wanted and had no intention of letting himself be carried away by any undue enthusiasm. He employed a local architect to construct a well-lit gallery, filled it with the right number of pictures, refused to sell them when pressed, and in his will tried to make sure that the collection should be preserved as a whole.

His dealings with the painters themselves were equally precise. He was a generous patron, but refused ever to pay more than he thought a picture was worth. He insisted that each work should be an original, painted for him alone and not copied. Though he allowed his artists complete freedom of choice as regards subject-matter, their pictures had to conform to certain specified sizes. And every artist was required to send him a written guarantee certifying the exact subject and date of his works.

When in Venice and Bologna—to which he subsequently returned on a number of occasions—Stefano Conti went to the studios of some of the leading artists and drew up his first commissions. At the same time he got in touch with a Veronese painter, Alessandro Marchesini, from whom he at once ordered a number of pictures and whom he appointed his agent. For this post Marchesini was ideally suitable despite his very limited gifts. He lived in Venice, but had studied in the school of Carlo Cignani in Bologna, from which sprung all the leading artists in the city. He was thus in close contact with everybody, and he carried out his job with keenness and efficiency— pressing on those who showed signs of delay, writing regularly to his patron to keep him informed, handing out the advance payments, suggesting new artists, and even proposing alterations in the work of established masters.

Conti was apt to pay his artists according to the number of figures in each picture,

[1] For this whole section see Haskell, 1956. This gives full references to the various manuscript sources in the libraries and archives of Lucca from which the material is taken.

and this sometimes led to problems. 'It is a little difficult', wrote Marcantonio Frances-chini from Bologna,[1] 'to find a history or fable with two figures and putti, and I would like the gentleman himself to choose what he wants.' However, he went on to propose various subjects—sacred and profane at random: *Adam and Eve, Bacchus and Ariadne* and so on, ending up that 'what I would really like to do would be a fanciful pastoral with a shepherd, a nymph and two or three putti *in atto bizzarro e curioso*'. And the suggestion was accepted. Other artists had more ambitious ideas. Also in Bologna, Felice Torelli wanted to paint a scene from Trojan history[2]—'Pyrrhus killing Polyxena in the temple and there will be Chalchas, the soothsayer, and other half-length figures or heads depicting Aeneas and Antinorus—in fact everything that is needed for the history, and also the tomb of Achilles, the father of Pyrrhus.' Conti was equally ready to accept a picture of this kind, but when it eventually arrived he wrote to ask once more what exactly it represented.

The Venetian artists were on the whole less imaginative in their choice of subject—stock scenes from the Bible and mythology were their usual standby; there is a definite preponderance of religious painting, and even Lazzarini, who was so much admired for his nudes, painted six subjects from the Old and New Testaments of impeccable morality.[3]

Conti's gallery, when completed by about 1707, must have presented a notably 'academic' appearance. The artists he had chosen—Marchesini himself, Lazzarini, Balestra, Fumiani, Bellucci, Angiolo Trevisani, Segala, Dal Sole and Franceschini—were all of his own generation and mostly adhered to 'correct' drawing and blond tonality in opposition to the violent *tenebrosi* who had enjoyed such a success in Venice. But his interests were not confined only to history painters. He had the portraits of his wife, his son and himself painted by Sebastiano Bombelli, the leading portraitist in the city—a local artist, Antonio Franchi, was considered good enough for his three daughters—and he also commissioned seven pictures of fruit and animals from Giovanni Agostino Cassana, a number of landscapes by other artists and three views of Venice by Luca Carlevarijs. Busts of Diana and Endymion by the Bolognese Giuseppe Mazza completed the gallery.

With all this Stefano Conti was satisfied for nearly twenty years, during which he bought only three pictures—a 'Correggio' *Christ in the Garden of Olives*, a Guercino *Flight into Egypt* and a *Cain and Abel* by the local artist Domenico Brugiori. Then in 1725, as suddenly as ever, he began to resume collecting. To Alessandro Marchesini's great delight, Conti turned once more to him for advice. Evidently some spare room had been found, because Conti was trying to get two further views by Carlevarijs to add to the three that he already owned, and one landscape by Francesco Bassi, il Cremonese, to make a complete set of four. But in the previous twenty years the artistic situation in Venice had been completely transformed. Carlevarijs, wrote Marchesini, was

[1] In a letter of 17 February 1705 in the Biblioteca Governativa, Lucca—MS. 3299. For the full text of the relevant section see Appendix 3.

[2] In a letter of 24 February 1705 in the Biblioteca Governativa, Lucca—MS. 3299. For the full text of the relevant section see Appendix 3.

[3] Da Canal, pp. 40, 58, 59.

old and il Cremonese was blind. Instead there was a 'Sigr. Antonio Canale, who astounds everyone who sees his work in this city—it is like that of Carlevarijs, but you can see the sun shining in it', and also 'a remarkable landscape painter, whose works are in great demand here and in London . . . with a style very much of his own and a very perfected manner. . . . Ricci is a marvellous painter at producing views and strange landscapes with buildings in the style of Poussin, all in lively and brilliant colour, which enchants those who look at them.' And so, under constant pressure from Marchesini, Conti commissioned his first two paintings by Canaletto and then, so pleased was he with the result, another two, despite the artist's difficult behaviour over money, and eventually five little landscapes with ruins and figures by Marco Ricci. Marco's uncle, Sebastiano, inserted the figures in these, but when he was asked to paint on his own 'two history pictures with full-length figures of half natural size . . . which must represent Alexander the Great and must hang opposite two others by good Bolognese artists', Ricci asked a price which the cautious Conti found exorbitant, and the proposal came to nothing. He did, however, buy a portrait by Rosalba Carriera of his daughter-in-law Emmanuela, and three years later, in 1728, he commissioned his last picture which was to be by Crespi.[1] Negotiations took place directly between the two men and began with some difficulty when Crespi haughtily explained that he had always had correct written contracts 'from His Highness the late Grand Prince Ferdinand, from the late Pope, and from Prince Eugene of Savoy in whose service I now am'. After this had been satisfactorily settled he wrote at great length to describe the subject he had chosen, *The Infant Jupiter handed over by Cybele to the Corybantes to be fed* (Plate 67), and enclosed a sketch which was 'to serve as an embryo'. However, when sending the painting itself in April 1729, he changed the title to *The Finding of Moses*, as sacred pictures paid lower customs duty than profane ones!

This little group of pictures by Crespi, Canaletto, Marco and Sebastiano Ricci, with their nervous brush strokes and dramatic contrasts of light and shade, must have looked strangely isolated in Conti's collection of essentially old-fashioned paintings, and he did nothing to increase their number. His taste was never very adventurous and his greatest interest was apparently to fill his gallery with accredited works. Like many of the other patrons who lived in small towns and ordered pictures from elsewhere, he had no chance to see the paintings he had commissioned until they reached him in Lucca. This was, indeed, the limitation of most of these provincial collections. Pictures from Bologna, Venice, Naples and even Rome might hang together and enrich local taste, but the artists themselves remained isolated both from each other and from the guidance of a cultivated patron. There was, however, one very significant exception to this general state of affairs.

– iii –

The most important figure in this strange interregnum of Italian art when any overriding sense of direction seemed to have been lost was, appropriately enough, a Medici.

[1] Biblioteca Governativa, Lucca—MS. 3299 and Zanotti, II, p. 62.

For a few years Florence once more became the most interesting city in Italy before sinking into utter provincialism. In the Grand Prince Ferdinand who was responsible for this short-lived but profoundly important revival we can see, as in no other single figure, the tastes of the seventeenth century changing into those of the eighteenth, and this alone makes him worthy of the closest to study (Plate 36a). But his significance is greater than that. As a Medici he bore a name that still carries its own magic. And he was a munificent patron when the race seemed to have died out—'the only support of all the fine arts in Italy', wrote a contemporary.[1] His individual tastes were thus of considerable importance for the development of painting.

He was born in 1663, the son of Cosimo III and Marguerite d'Orléans.[2] The tempestuous relationship between his parents—his mother, unable to stand the suffocating atmosphere of Florence, left in 1675 for the freedom of a convent in Montmartre which placed few obstacles in the way of her volatile appetites—and the bigoted pomposity of Cosimo himself left its mark on the two sons of the marriage: Ferdinand, who died at 50 before ruling, and Gian Gastone, the last of the Medici princes. Both were highly intelligent, but both had a streak of instability which in Gian Gastone eventually led to paralysing debauchery. Ferdinand was educated by all the most remarkable personalities in a city that was still notable in the intellectual Europe of the day—Viviani, Lorenzini, Redi. He became a highly cultivated and accomplished figure, handsome, good humoured, an excellent horseman and the great hope of all those who longed for a change from the extravagant, yet mean-spirited rule, of his father. This is the side of him that most of his contemporaries saw. But we have at our disposal letters, private memoirs and other records, and as we look back we can detect also another aspect of his character, and one that was to be profoundly reflected in his artistic tastes: a sort of *fin-de-siècle* preciosity in reaction against the stuffiness of his 'Victorian' surroundings, a love of *frisson*, an inclination for somewhat equivocal pleasures. All his biographers stress that Ferdinand's reaction against his father was one of the dominating emotions of his life. With his uncle Francesco Maria, only three years older than himself, he led the opposition, and, as so often where political activity is out of the question, this took the form of licence and wild behaviour. Accompanied everywhere by troops of followers in search of pleasure, the two young men outraged the solemn decorum of the court much as Marguerite d'Orléans had done already. Eventually marriage was insisted on and agreed to in return for permission to visit Venice at carnival time. After some futile negotiations with Portugal, a rather plain Bavarian princess, Violante, was discovered and wedded with spectacular ceremonies but little love. Year after year the court, and Europe, waited in vain for an heir to ensure the survival of the Medici line. A second reckless—and bachelor—visit to Venice in 1696 was scarcely calculated to promote this end, and during the early years of the eighteenth century other members of the family were called upon to try where the Grand Prince

[1] Zanotti, II, p. 50.
[2] See Galluzzi and, for more intimate details of the private lives of these last members of the family, Pieraccini, G. Conti and Acton.

had failed. Their efforts too came to nothing. Meanwhile Ferdinand gave up the struggle and retired to his country houses, especially Poggio a Caiano and Pratolino, there to enjoy himself and to organise his brilliant theatrical displays and picture collections. He was passionately fond of music and for many years he employed Alessandro Scarlatti to write operas for him and himself played a notable part in their composition.[1] His theatre at Pratolino was famous throughout Italy and for it he employed leading stage designers such as members of the Bibbiena family.[2] He corresponded with artists and musicians and his great sensibilities made him the most discriminating patron of many of the most interesting painters of the day. He welcomed foreign scholars and delighted to show them his great collections. He supported writers such as Apostolo Zeno, Benedetto Menzini and Scipione Maffei, and he financed the publication of sumptuous editions of Francesco Redi and other poets.[3] But now ill-health began to strike: epileptic fits and, apparently, the inevitable consequences of his earlier dissipation. His last years were more and more clouded by sickness, and he died in 1713 at the age of 50. His tyrannical old father was still on the throne after forty-three years. It was as if the Régent had died before Louis XIV. 'With his death,' wrote a contemporary admirer,[4] 'there died too all signs of brio and joyfulness in Florence and Tuscany. With his death there was lost the protector of painting, sculpture, letters and all the other liberal arts— for other princes did not share his magnanimous tastes.'

The most important events in Ferdinand's life were his two visits to Venice. The city already had the reputation it long retained of allowing and encouraging every pleasure known to man except that of political unorthodoxy, and the Grand Prince took full advantage of most of them. We can follow him throughout February and March 1696, 'delighted' from the very first day 'with the freedom of this country— especially the convenience of the mask which allows him to go anywhere without drawing attention to himself . . .'.[5] Night after night he goes to the opera and the *ridotto*; he visits all the specialities of Venetian carnival entertainment which we know so well from the paintings just then beginning to record them for tourists—the *forze d'Ercole*, the fight between the Castellani and the Nicolotti, the masked balls. The Republic gave him lavish presents and he reciprocated. It was all very different from Florence; no wonder that when he left he announced his intention of returning to Venice for the next carnival. He never did: but the memory haunted him for the rest of his life and he was able to put it to good use. For besides more spectacular pleasures, so diligently recorded by the Florentine agents, he had also been carefully admiring and studying

[1] The remarkable series of letters from Alessandro Scarlatti to Ferdinand are in the Archivio Mediceo. See also Fabbri and, for a full account of his musical activities, Puliti.

[2] Sgrilli.

[3] For all this see *Elogio del fu Serenissimo Ferdinando de' Medici Principe di Toscana* in Vol. XVII, 1714, of the *Giornale de' Letterati Italiani* of which he himself had been patron; and also the letter from Scipione Maffei, dated 14 April 1710, No. 370, Filza 5905 of the Archivio Mediceo.

[4] Probably the lawyer Luca Ombrosi, writing in the middle of the eighteenth century—see *Vita del Gran Principe Ferdinando di Toscana* in the Biblioteca Grassoccia, Firenze 1887, p. 96.

[5] Archivio Mediceo, Filza 3050ᴰ: Matteo del Teglia—*Carteggio e Avvisi da Venezia, 1695-7*.

the great pictures which still made Venetian collections and churches the richest in Europe. Years later he could recall some of them which he hoped to acquire for himself. In the masterpieces of Titian, Veronese and Bassano which filled the palaces of his hosts he saw a tradition of painting which had long been considered the antithesis to the great Florentine Renaissance. Ferdinand, like many other lively spirits of the early years of the eighteenth century, was seduced by this tradition and longed to make it live again.

Although Ferdinand had always been a keen collector and patron, his forcible personality could not find much scope for expression in Florentine art of the late seventeenth century. His early acquired pictures differed little from those that were regularly to be seen in the average noble collection of the day. They included, for instance, a number of religious works painted for him by Baldassare Franceschini, a late follower of Pietro da Cortona who died in 1689.[1] Yet quite soon he relied on his unerring instinct to pick out the one picture by this artist which could satisfy his love of novelty. Some time before 1693 he bought *La Burla del Pievano Arlotto* which Franceschini had painted in tempera many years earlier for a private citizen (Plate 37c).[2] Its homely and archaic simplicity owed more both in style and in the inspiration of its subject to Tuscan narrative of the fifteenth century than to experiments in naturalism being made elsewhere in Italy at this time. It was, however, not very long before Ferdinand had the opportunity of encouraging a comparable type of intimacy in the works of Crespi.

Meanwhile he showed his appreciation of the great tradition of Florentine painting by purchasing Fra Bartolommeo's *S. Marco* from the church dedicated to that saint and having it replaced by a copy in 1692.[3] This was, indeed, a habit to which Ferdinand was much addicted. During the 1690s he bought from various churches in Florence and elsewhere Raphael's *Madonna del Baldacchino*, Andrea del Sarto's *Madonna delle Arpie*, Cigoli's *Deposition* and Orazio Riminaldi's *Martyrdom of St Cecilia*.[4] Of his contemporaries he showed an interest chiefly in Anton Domenico Gabbiani, a painter faithful, as far as his talents lay, to the classical, Marattesque canons of art[5] to whom Ferdinand remained loyal long after his own horizons had been immeasurably widened.

This widening was clearly brought about by his visits to Venice, though a taste for Venetian art had already appeared at the Medici court through the activities of his great uncle Cardinal Leopold, who had amassed a very large collection of works by masters of the Renaissance.[6] Ferdinand now set out to amplify this collection. The names of Titian, Veronese, Bassano, Palma Giovane and many other painters of the Venetian sixteenth century constantly recur in the letters which he wrote over the next few

[1] Baldinucci, VI, 1728, p. 411.

[2] Now in the Pitti, No. 582. For its history see Giglioli, 1908, and Steinbart, 1936.

[3] Now in the Pitti, No. 125. The copy was painted by Antonio Franchi—see Bartolozzi.

[4] There is a certain amount of confusion about these pictures from Florentine and other churches—see Bencivenni and Jahn-Rusconi—but though slight discrepancies exist in the various accounts and in the sources, the general outline is clear enough.

[5] See especially Hugford and Bartarelli.

[6] For some general information on Cardinal Leopold's collecting see [Bencivenni], I, pp. 248-61, and II, pp. 181-7.

years to Niccolò Cassana, the Genoese artist who acted as his agent in Venice as from 1698.[1] From these letters it is possible to see just what he admired in the Venetians. The expressions which he uses most frequently to show approval are *gran gusto* or *buon gusto*—vague terms, perhaps, but ones that suggest his relish for painting. When used, as they so often are, about particular pictures, they give us a close insight into the nature of his feelings: a Veronese is admired because it is 'di un gran gusto di colore, bizzarro per l'invenzione, e pare uscito adesso dal penello dell'Autore'; an engraving is 'molto bizzarro, e di buon gusto'; an artist working for him is required to paint 'qualche cosa di bizzarro'; another is told to be 'meno flemmatico'. He sees a Maffei for the first time and is delighted with its 'bellissimo impasto'; in Livorno there is a *Rape of the Sabines* by Virgilio Bassanino which looks like a Strozzi and 'vi è un brio di pennello grande'; a Van Dyck *bozzetto* is 'spiritoso'. From these expressions and from many more we can gauge an entirely coherent taste based on an appreciation of the liveliness of the individual brushstroke and of colour—for him of very much greater importance than the correct drawing which played such a vital part in Roman art theory at the time. He showed an acute sensitivity to the actual quality of the paint, to that *belle matière* which was to be so very attractive to eighteenth-century connoisseurs. Like many of these connoisseurs, but unlike most of the great aristocratic collectors to whom by origin and status he belonged, Ferdinand combined this sensitivity with a very real understanding of artistic quality, and hence was able to show great discrimination in his appreciation of pictures. In a Rubens he suspects that one of the satyrs was added rather later than the others, and that there is a certain difference of touch in the foliage of the trees; he gives detailed practical instructions on how to pack a picture; he reads through Lives of the Painters; he jokes about those who cannot distinguish the work of one artist from another.

Such knowledge and refinement not only began to affect his collecting—in 1698 he bought Parmigianino's *Madonna del Collo Lungo* 'disegnata come da Raffaello, finita con l'anima'[2]—but were vital in his patronage of contemporary artists. Yet with two conspicuous exceptions he was not as successful in this field as his talents entitled him to be, for the whole trend of art theory conflicted with his personal tastes and it was not easy to find painters unaffected by the classicising doctrines of this phase of the Baroque.

For Ferdinand art patronage involved a greater degree of collaboration than was usual between prince and painter. This might range from sending his court painter an eagle to help with a Ganymede to discussing the figures of a composition.[3] His attitude is clearly shown in a significant remark he lets slip in a letter to Cassana[4]: 'Tell Fumiani that the only figure I want is that of David; it will then be easy enough to remove it and do it in *our* way.' He insisted on always seeing *modelli* of the pictures he ordered, as

[1] See Fogolari, 1937—with special reference to Letters 22, 23, 26, 49, 59, 71, 74, 81, 91, 93 and 124.
[2] See the letters from Ferdinand, dated 11 October and 1 December 1698 to the Duke of Parma, published by Emilio Robiony, and also Fogolari, 1937, Letter 28 of 9 January 1699.
[3] Hugford, Bartolozzi and the *Elogio* as well as Fogolari, 1937, Letter 45 of 16 May 1699.
[4] Fogolari, 1937, Letter 45 of 16 May 1699.

Plate 37

a. G. M. Crespi: The Painter's family

b. G. M. Crespi: The Fair at Poggio a Caiano
(detail)

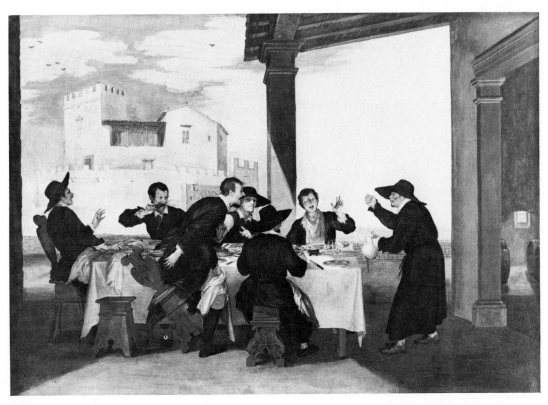

c. Baldassare Franceschini: 'La Burla del Pievano Arlotto'

a. Rape of Europa

b. Pan and Syrinx

Plate 39

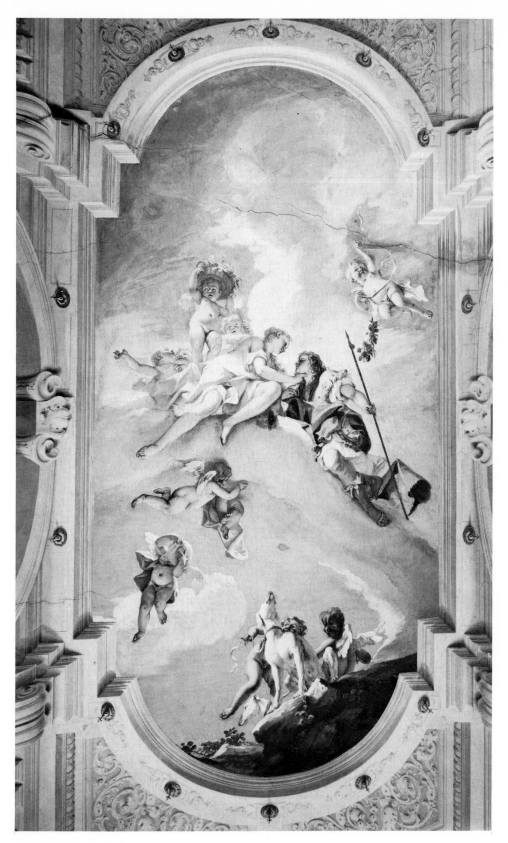

Venus and Adonis

Plate 40

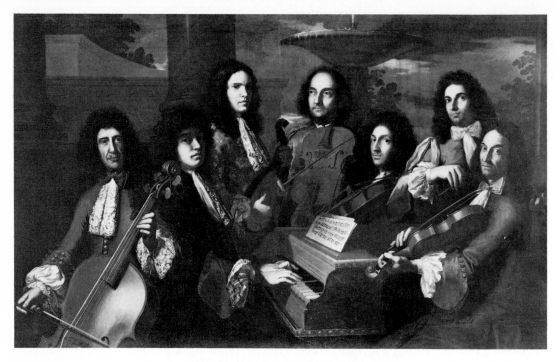

a. A. D. GABBIANI: A group of musicians

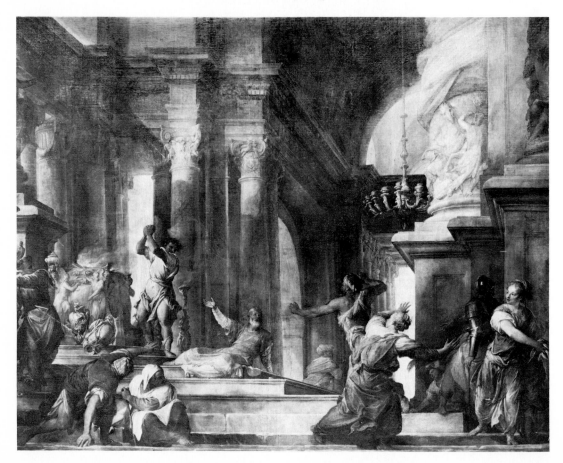

b. GIANNANTONIO FUMIANI: The stoning of Zechariah

much for purely aesthetic reasons as for checking the accuracy of the content. Indeed he collected *modelli* of pictures painted for other patrons before this was as common as it later became.[1] He enjoyed watching artists at work and discussing with them the actual procedure of painting—the colours to be used, the thickness of the canvas and so on. All these traits can be seen in his relations with Gabbiani (Plate 40a). The reasons why he employed for so long this rather mediocre, Marattesque painter while ignoring other Florentine artists such as Gherardini, Sagrestani or Galeotti whose styles corresponded far more to his tastes are impossible to fathom.[2] It may have been that same feeling of loyalty that made him take particular trouble not to hurt the ageing landscape painter Francesco Bassi despite the doubts he had about the value of his work.[3] More likely it was the feeling that Gabbiani (who always professed a passionate attachment to Venetian painting) was directly under his control and so could be used to express some of his own artistic ambitions. Whatever the reasons, the outcome was hardly very successful despite a special visit to Venice which Gabbiani paid in 1699 at the age of 47 to oblige his patron by improving his colour. Nor does Ferdinand's particular protégé Sacconi appear to have lived up to his hopes, though he too was sent to Venice.[4] The Grand Prince took the deepest interest in his career. He provided for him financially when his father died and kept him working under Niccolò Cassana. Constant exhortations and orders followed him there: for a St Sebastian 'as he must learn to paint full length figures', a St Giustina, a Bacchanal. Ferdinand notes that his colour is improving under Cassana's guidance, but warns him to be 'meno flemmatico'. He arranges for his pictures to be exhibited on Corpus Domini and is delighted with their humour. But it seems that not even Venice and the most encouraging of patrons could make much of the artist.

More fruitful were Ferdinand's contacts with some of the other painters living in Venice, among them Karl Loth with whom he must have got in touch on his first visit, for this German artist was already painting for him by 1691 and continued to do so until his death some seven years later.[5] But by then, although he made particular efforts to get hold of some half-length figures by Loth 'as that is what he was best at', Ferdinand had already paid his second visit to the city and found there an artist who, despite his mediocre abilities, was ideally responsive to the sort of pressure he liked to exert. The

[1] Francesco Trevisani sent him the *modello* of his *Banquet of Anthony and Cleopatra* painted for Cardinal Fabrizio Spada-Varallo—see MS. life of this artist by Pascoli in the Biblioteca Augusta, Perugia, MS. 1383.

[2] Payments to other painters and sculptors in Florence are recorded in the Archivio Mediceo, Guardaroba 1055. The most interesting of these are Pietro Dandini and Giovanni Battista Foggini. Other very minor Tuscan artists also worked for him: Antonio Franchi has already been mentioned; for Francesco Botti, Giuseppe Pinacci, Romolo Panfi, Cristofano Monari, etc., see Abate Orazio Marrini.

[3] Fogolari, 1937, Letter 83 of 17 March 1703.

[4] *ibid.*, with special reference to Letters 6, 12, 28, 60 and 71.

[5] Fogolari, 1937, publishes a letter from Loth of 14 August 1691 thanking the Prince for a present of oil and wine and telling him that he is about to embark on a copy of Titian's *St Peter Martyr*. In 1693 he sent his self portrait to Florence. The Pitti contains a *Death of Abel* by him and six of his pictures are recorded in Ferdinand's collection in the 1716 inventory—see p. 239, note 5, and also Fogolari, 1937, Letters 22 and 77. See catalogue entries in Ewald, 1965.

relations between Giannantonio Fumiani and the Grand Prince can tell us much about the fantasies which he was so eager to have expressed by the artists who worked for him.[1] He wanted a picture to match one by Domenichino and he proceeded to give Fumiani its dimensions and a very elaborate programme. It must show, he wrote to his agent Cassana, an architectural background into which must be inserted guards; in the foreground David must be seen at prayer. Cassana himself is to paint the figure of David, though if Fumiani insists he may do so and it can be changed later. He must send the *modello* to Ferdinand for inspection. It duly arrived and proved satisfactory, but David, commented the Prince, should display more movement. Perhaps it would be improved by an angel flying through the sky with a flaming sword and offering the king the choice of the three punishments.[2] David must show great surprise—here would be a good chance for expressing movement. Besides, the composition could be enriched by placing at his side his harp, his sceptre and his diadem. And then Ferdinand changed his mind. He wanted another subject from the Old Testament which would be the most *bizzarra* of all. The instructions have been lost, but this was evidently to be *The Stoning of Zechariah*, a picture which was recorded in Ferdinand's inventory and which is now in the Uffizi (Plate 40b).[3] It seems clear that these subjects, though unusual in art, held no special significance for him other than as pretexts for fanciful composition.

Niccolò Cassana also worked a good deal for Ferdinand as painter as well as artistic adviser. He visited Florence on various occasions chiefly so as to paint portraits of the Prince and his household, and from time to time he would send pictures from Venice.[4] In September 1707 his *Portrait of a Cook* reached Florence to the delight of the Prince, who commented on its realistic details (he particularly wanted to know who the sitter was) and above all on its bold, Venetian, 'painterly' quality, so different, as he pointed out, from the timid efforts of native Florentine artists. Cassana also painted history pictures for the Grand Prince, mostly in a light vein—a *Bacchanal*, a *Venus playing with Cupid* and so on, though there was also a *Conspiracy of Catiline*.[5]

[1] Fogolari, 1937, Letters 45, 47, 48, 49, 50, 53, 54, 55, 56, 57, 59, 61 and 63 between May and November 1699.

[2] This rather unusual subject is taken from II Samuel xxiv, 12.

[3] The picture is recorded in the 1716 inventory—see p. 239, note 5. The subject, which is taken from II Chronicles xxiv, 21, is wrongly described as *The Punishment of the Prophet Ananias* in the catalogue of *La Pittura del Seicento a Venezia*, 1959, p. 106. For another example of Ferdinand's patronage of Fumiani see the curious letter written by him directly to the artist and published in Note 34 of Fogolari, 1937.

[4] Ratti (see Soprani/Ratti, II, 14) refers to portraits by Cassana of the Grand Prince himself, his wife, his *gentiluomo di camera* and other courtiers including jesters, as well as his self-portrait and various history pictures. See also Fogolari, 1937, Letter 120 of 3 September 1707.

[5] *The Conspiracy of Catiline* is probably a copy from Rosa and is now in the Pitti (No. 111)—see Jahn-Rusconi, p. 238.

Giovanni Battista Langetti, another Genoese artist who worked in Venice, was also admired by Ferdinand. Ratti (Soprani/Ratti, II, 26), who reports seeing a portrait and a picture of card players by him in the Medici collection, says that Langetti was actually employed by Ferdinand in Florence. But this is impossible as Langetti died in 1676 when the Prince was only aged 11. See also Fogolari, 1937, Letter 92 of 25 January 1704.

Much more valuable were the pictures on glass of *The Flight into Egypt* painted for Ferdinand by Luca Giordano. The great Neapolitan painter called on the Grand Prince at Livorno in May 1702 on his return from Spain and is known to have worked for him for a time before setting out for home.[1]

The history of Ferdinand's patronage given so far suggests that with this one exception he was a very much more interesting figure than any of the painters who worked for him. And indeed he would be remembered merely as a remarkable person- ality in an artistic backwater were it not for the fact that towards the very end of his life he found two artists whose talents were at last equal to the demands he made on them and who consequently painted for him some of their most striking work.

It is not clear how Ferdinand first got into touch with Sebastiano Ricci, for the artist was not in Venice during either of the Grand Prince's two visits there. However that may be, in 1704 Ferdinand commissioned from him a *Crucifixion with the Madonna, St John and St Charles Borromeo* to replace Andrea del Sarto's *Madonna delle Arpie* which he had bought from the nuns of S. Francesco de' Macci for his own gallery.[2] Ricci seems to have paid a short visit to Florence in order to paint the picture on the spot and thereafter to have assisted Cassana in his duties of keeping the Prince informed as to what pictures were available on the Venetian market.[3] Within a year or two Ricci had already found other patrons in Florence among the Grand Prince's circle of friends, for the brothers Marucelli, of whom Francesco, the most distinguished, had died in Rome in 1703, were employing him to decorate several rooms in their palace. In May 1706 he enclosed some paintings for them in the two crates he sent to the Grand Prince which included a couple of small landscapes by his nephew Marco.[4] At the same time he made his first allusion to a forthcoming visit to Florence to paint a room in Ferdinand's gallery of Venetian pictures at Poggio a Caiano. Ferdinand's reply a week later was somewhat discouraging: ill-health was causing him to postpone the projected scheme.[5] However, shortly afterwards the situation improved and Ricci arrived to paint an *Allegory of the Arts* in Ferdinand's favourite gallery in his favourite villa. This work has unfortunately been destroyed,[6] but dazzling testimonials to Ricci's Florentine activities survive in the great decorations that he painted for Ferdinand's friends the Marucelli and for the Grand Prince himself in a small room in the Pitti.

[1] A Letter from the Grand Prince, dated 26 May 1702, (*ibid.*, Letter 75) says: 'Mentre che scrivo è qui [Livorno] da me Luca Giordano che ritorna da Napoli.' The Abate Orazio Marrini, Parte I, Vol. I, p. 38, says that on his return from Spain Luca Giordano 'colorì varie pitture' for Ferdinand in Florence.

[2] Fogolari, 1937, Letters 98 and 99 of 30 August and 20 September 1704.

[3] Some of these letters have been published by Fogolari, 1937. They show Ricci writing to Ferdinand of works by Livio Mehus, Ghisolfi, Lyss, Simon Vouet and others.

[4] Letter of 1 May 1706 in Archivio Mediceo, Filza 5903, No. 197: published in Appendix 4. In the exhibition of October 1706 (see p. 240, note 5) Orazio Marucelli exhibited a *Flora* by Sebastiano Ricci.

[5] Letter of 8 May 1706—Archivio Mediceo Filza 5903, No. 500—published in Appendix 4.

[6] At the end of the eighteenth century T. G. Farsetti referred to the ceiling as follows—Fogolari, 1937, p. 186: 'Nella camera de' quadri veneziani, che il Principe Ferdinando ha formato al Poggio, e ch'ora è sfornita per essersi trasportati detti quadri in Galleria, ed in altri luoghi, si vede un soffitto dipinto in figure di due terzi, mirabile per l'invenzione e contrasto, come per il vago colorito, e buon disegno. In questo si rappresentano allegorie convenienti alle Arti sorelle ecc.'

From everything we know of Ferdinand's patronage it is beyond doubt that he himself must have collaborated extensively in the work. Indeed, some forty years later, a writer who knew Ricci personally makes it quite clear that he had followed specific instructions from the Grand Prince in carrying out the decoration.[1] There is, of course, no record of these, but it is easy enough to see that Ricci's delightful frescoes, which represent a new departure in his career, reflect the more lighthearted and 'avant-garde' atmosphere of Ferdinand's court. The Prince's own character, indeed, symbolised the fact that the new century was going to be less harsh, less bigoted and less passionate than the one that was just over, and it is this change that seems to be asserted in Ricci's frescoes. The heavy drama which had marked most Baroque ceiling decoration, the crowds of solidly built figures which had been characteristic of Ricci's previous ventures in the field and even to some extent of his almost contemporary work in the Palazzo Marucelli, here give way at a single bound to delicacy and lightness of touch. The ceiling is a glorification of sun and air—a pale, cool blue sky with delicate pink clouds on which Venus, in brilliant yellow, takes her leave from Adonis dressed in a gay, purple tunic inspired by costumes of the sixteenth century (Plate 39).[2] Putti hover around, and below, on a rocky verge, strain two greyhounds, sleek and slender, the favourite animals of the new century. There is a delicate longing in the look between the two lovers, but no hint of the tragedy to come. Around the walls, and in elaborate cartouches above a painted balustrade, are further scenes from Ovid—*Diana and Callisto, Pan and Syrinx, Europa and the Bull, Diana and Actaeon* (Plates 38a, 38b)—and in the four corners are painted busts of men and women vaguely evoking the antique. Over the main door angels support a shield with the Medici arms while putti with a crown hover above, the whole forming a brilliant asymmetrical composition. Everything is painted with a verve and a nervous, fluent panache that were totally new to Florence and indeed to European art. The frescoes delighted Ferdinand, and yet their intimate, rococo style, which was to become so popular in the boudoirs of Paris, proved to have little future in Italy.

Ricci also painted various pictures for him at this time, particularly of little figures disporting themselves against architectural backgrounds which were usually the work of a collaborator. These especially appealed to his taste—'le figurette mi piacciono assaissimo, perchè sono graziose, ben distribuite e fatte con poco', he wrote of one pair of such scenes he had been shown,[3] and *macchiette* of this kind were to become enormously popular as the century progressed. Ricci wrote again to Ferdinand in 1708 after

[1] The Abate Gherardi, who in 1749 published an anonymous account of some of Consul Smith's pictures in Venice. Writing of Ricci, he says (p. 73): '. . . quivi [Florence] giunto che fu ed accoltovi benignamente intesi ch'ebbe i sentimenti di esso Gran Principe intorno la composizion dell'ideato lavoro pittoresco da fare: di tutto buon grado vi si appose secondando il genio dell'Altezza sua; ed avendolo con ispeditezza, bravura, e soddisfazion terminato, ebbe dal copioso pagamento e da i regali fattigli dare un manifesto riscontro della pienezza di gradimento di esso Gran Principe . . .'.

[2] The sketch for this fresco is now in the Orleans Museum.

[3] Fogolari, 1937, Letter 106 of 3 April 1705. It is not clear whether the pictures in question were by Ricci or not. The 1716 inventory (see p. 239, note 5) describes an architectural painting by Saluzzi with figures by Sebastiano Ricci. This is now in the Pinacoteca at Lucca. It is initialled and dated 1706.

his return to Venice, but a year later he went to England and stayed abroad until 1716.

The Grand Prince was not the only person to be impressed by Ricci's work in Florence. Back in Bologna in February 1708, after a brief visit to the Medici capital, Giuseppe Maria Crespi wrote to Ferdinand that he too had been very struck by the Venetian painter's 'spirit'.[1] And although the two most interesting artists of the period, both of whom were pioneering a decisive break with late Baroque conventions, missed meeting each other by two or three months at Ferdinand's court, the new mood that prevailed there profoundly affected them both. Crespi's own innovations had much in common with Ricci's—a looser brush stroke, a more painterly and spirited manner, a greater display of individual temperament and a devotion to the Venetian tradition; it is therefore hardly surprising that he received all possible encouragement from Ferdinand when he arrived in Florence at the beginning of 1708 to present him his *Massacre of the Innocents*.[2] Crespi's anxiety to work for Ferdinand provides clear evidence of the importance that the Grand Prince's court had by now assumed for artists outside Florence,[3] and when he brought the picture to Ferdinand he was deeply impressed by his discrimination and enthusiasm. The Grand Prince at once commissioned a couple of still lives from Crespi—a curious and significant choice of subject after the dazzling agitation of the history painting which had introduced the artist to him.[4] In fact, Ferdinand is of great importance in Crespi's career partly for this very reason. He seems to have been among the first to appreciate the essentially intimate nature of Crespi's talents. The commissions with which he flooded the artist were all 'd'argomenti piacevoli', and with the support of such a powerful protector Crespi was able to break away from the religious and secular histories which had hitherto formed the bulk of his output. On this first visit to Florence he remained scarcely more than a month[5]; but he

[1] Letter of 26 February 1708—Archivio Mediceo, Filza 5904, No. 22—published in Appendix 4.

[2] Crespi arrived with a letter of introduction—Archivio Mediceo, Filza 5897, No. 183—published in Appendix 4. The full story of how he came to give the *Massacre of the Innocents* to Ferdinand has been told by Zanotti, II, p. 46. It has subsequently been confirmed by documents—see catalogue of *Mostra Celebrativa di Giuseppe M. Crespi*, Bologna 1948, p. 29. The picture had been commissioned by a priest Don Carlo Silva to present to Ferdinand. When it was finished the priest defaulted on his obligations and announced that he had no further intention of giving it to the Grand Prince. It was then that Crespi decided to come in person to Livorno, where his arrival and welcome are colourfully described by Zanotti. Ferdinand himself took a hand in the disputes and litigation from which Crespi emerged victorious. See letters between Ferdinand and Silva in Archivio Mediceo, Filza 5904, Nos. 96, 155, 299 and 607; and also letter from Ferdinand to the Marchesa Eleonora Zambeccari in Archivio Mediceo, Filza 5897, No. 287.

[3] Crespi may possibly have been employed some years before the two men actually met. *The Ecstasy of St Margaret*, originally in S. Maria Nuova in Cortona and now in the Diocesan Museum there, was painted to replace Lanfranco's picture of the same subject which Ferdinand bought for himself. It seems a much earlier work than the group of paintings by Crespi considered here, and it is mentioned earlier by his biographer, Zanotti, II, p. 44. See also the *Mostra di Giuseppe M. Crespi*, p. 29.

Other Bolognese artists in touch with Ferdinand were Ercole Graziani, Giovan Gioseffo Santi (Zanotti, I, pp. 263 and 210) and Giovan Gioseffo dal Sole—see letters of April and May 1708 in Archivio Mediceo, Filza 5904, Nos. 44 and 64.

[4] L. Crespi, p. 211.

[5] He was back in Bologna by February 26, 1708—see above, note 1.

was clearly as anxious to maintain his connection with Ferdinand as was the latter to make use of a painter whose gifts so exactly suited his own temperament. Hardly had he returned to Bologna at the end of February before he began sending pictures to his new patron—a *Nativity* arrived early in March, followed by a *Selfportrait* a month later with assurances of the artist's eternal remembrance of the Prince's kindness and promises of his own 'vasallaggio'. The Prince wrote back to say how delighted he was with the *Selfportrait* that showed the artist's good humour[1] and thereafter the friendship between the two men was sealed. Indeed Ferdinand's interest in Crespi brought him into touch with the artist's patrons in Bologna—particularly Giovanni Ricci, the rich *marchand-amateur* who had financed his early travels throughout Italy and subsequently acquired a very large proportion of his work; and also the Pepoli family in whose palace he had some fifteen years earlier painted the great ceiling frescoes which first established his reputation as a considerable and highly original master. Now in 1708 the Pepoli were considering structural alterations to the palace which would involve destroying the frescoes, and only two urgent letters from Ferdinand stopped this plan being carried out.[2]

Meanwhile throughout 1708 Crespi continued to work for him. In December he sent a copy of Guercino's *St William of Aquitaine* as well as his own small painting of *The Painter's Family*, the most informal portrait group that had yet appeared in Italian art and a striking testimony to Crespi's confidence in Ferdinand's tastes (Plate 37a).[3] During these months he also sent a satirical picture of the priest who had originally commissioned the *Massacre of the Innocents* as a gift for Ferdinand and had then failed to stick to the agreement between them, as well as two small genre scenes of *Children at Play* and *Women washing their Laundry at a Fountain*—an early treatment of a subject that was to be immensely popular with artists throughout the eighteenth century.[4]

In 1709 Crespi returned to Florence with his family and was given rooms by Ferdinand in his villa at Pratolino, where he stayed for several months. During this visit he painted a large number of pictures for the Grand Prince, who collected his work with increasing enthusiasm and who showed his appreciation with lavish presents and by consenting to become godfather to Crespi's newborn son, called Ferdinando in his honour. At the same time he gave official recognition to Crespi's position at court by naming him his 'pittore attuale'. Crespi responded with a great many genre scenes and one of his masterpieces, the *Fair at Poggio a Caiano*, which included portraits of Ferdinand's courtiers (Plate 37b).[5]

By the beginning of November he was back in Bologna.[6] It is possible that he paid a third visit to Florence, but by this time Ferdinand's final illness was upon him and the

[1] Letters of March and April 1708 in the Archivio Mediceo, Filza 5904, Nos. 26, 38 and 357.

[2] For the correspondence between Ferdinand and Ricci see Archivio Mediceo, Filza 5904, Nos. 167 anf 476. For the letters between Ferdinand and the Pepoli, *ibid.*, Nos. 174, 489 and 490.

[3] See the letter from Ferdinand published by Luigi Crespi, p. 203. The original draft is in the Archivio Mediceo, Filza 5904, No. 475. *The Painter's Family* is in the Uffizi, No. 5382.

[4] These pictures are—or were in 1941—in the Gabinetto del R. Intendente di Finanza di Pisa—see Casini, pp. 42-50.

[5] The picture is now in the Uffizi—see Zanotti, II, p. 55, and L. Crespi, p. 211.

[6] A letter of 3 November 1709 (Archivio Mediceo, Filza 5904, No. 272) reports his return to Bologna.

great days of his patronage were over.[1] Crespi is indeed the last artist whom we know to have worked for him.

Both painter and patron had benefited greatly from the close partnership between them. Ferdinand was the most cultivated and sensitive collector that Crespi had yet (or ever was to) come across, and in his gallery the artist was able to study at length those Venetian painters whom they both loved. That he took full advantage of this is proved by a letter in which he speaks of having been shown in the Medici collections a picture attributed to Tintoretto which had in fact been painted by himself.[2] Fully as important was the support that Ferdinand gave him in his attempts to break away from the conventional 'history picture'. Such new ventures were bound to result in some loss of prestige and to meet with derision. The humour with which all his contemporaries approached Crespi in some ways reflects their bewilderment at his unconventional painting, and for many of them (and for many years later) it coloured their appreciation of his art. Genre scenes were expected to be humorous and so they laughed, without realising that Crespi's humour was often tinged with melancholy and was in any case counteracted by a deep, poetic sympathy for the people whom he painted. It is difficult to say how much Ferdinand himself shared these misconceptions about Crespi's art. His recorded opinions and—much more important—his letters suggest that he too saw him primarily as a humourist[3]; on the other hand the very great restraint with which the artist painted for him subjects which lay themselves open to gross or bawdy treatment (Plate 36b) makes clear that he must have relied on Ferdinand's appreciating a side of his temperament that was ignored by many. Indeed, the unique place held by Ferdinand in the history of Italian patronage is shown by the fact that such sober, sympathetic treatment of the poor and simple remained quite exceptional in Italian art. With the backing of a cultivated middle class Crespi might have turned into the Chardin to whom he is sometimes so near; in fact with the removal from the scene of Ferdinand, the most 'modern' prince of the age in Italy—and as yet only princes could be influential patrons—Crespi retired into the provincial backwater of Bologna.[4]

The pictures that Ferdinand amassed were distributed in his apartments in the Pitti Palace and in the various country houses through which he moved during the year. By the end of his life their numbers were very considerable. In the Pitti alone were 300 entirely from his private collection. quite apart from the many which had been assembled by earlier members of the family.[5] The accent was strongly on Venetian pictures,

[1] L. Crespi, p. 211, says that he was in Florence for two years, whereas it has been shown that during 1709 he was there for eight months at most. On the other hand Zanotti, II, p. 54, implies that he went there several times. [2] See p. 237, note 1.

[3] Zanotti, II, pp. 52 and 54, and Letter from Ferdinand of 28 April 1708 in Archivio Mediceo, Filza 5904, No. 357.

[4] The restricting effect of this on Crespi's art has been pointed out by R. Longhi in his introduction to the 1948 exhibition catalogue.

[5] *Inventario di Quadri, che si ritrovano negl'appartamenti del gran palazzo de Pitti di S.A.R.*, kept at the Soprintendenza alle Gallerie di Firenze. It can be dated between 1716 and 1723. For the sake of convenience I have referred to it as the 1716 Inventory. All the pictures from Ferdinand's own collection are marked S.P.F.

including about ten attributed to Titian. There were also Flemish works, but only the barest representation of contemporary Roman painting. Of the Florentine school of the day only one artist was present in bulk; the Flemish Livio Mehus, thirty of whose works Ferdinand owned. Such prominence is not surprising, for Mehus was by far the most Venetian of all the artists in his entourage and his tremendous vivacity combined with a slightly troubled eroticism made an obvious appeal to Ferdinand. Only the death of this painter in 1691, before Ferdinand's patronage had reached its fullest extent, can have prevented him working directly for the Grand Prince who sought to make amends for this neglect by assiduously collecting his canvases and giving support to his son.[1]

In Poggio a Caiano Ferdinand had a special room in which he kept small examples of each of his favourite artists, ancient and contemporary, and it was this that Sebastiano Ricci painted for him in 1707. He kept further large collections at Pratolino and the Villa di Castello.

But Ferdinand's activities as patron were not confined to increasing his own collection or supporting those particular artists who took his fancy. He was also anxious to guide the whole direction taken by painters in the Florence of his day. For this purpose he took advantage of the still rudimentary instrument of the art exhibition and used it in an entirely new way. Pictures had been exhibited in Florence, as in many other Italian cities, on the occasion of the Corpus Domini processions, and Ferdinand regularly showed works painted for him by those artists of whom he approved, such as Gabbiani, whose *Flight into Egypt* he put on view to the public in the Piazza del Duomo.[2] He adopted the same policy towards Sacconi[3] and especially Cassana to whom he wrote in 1707, full of admiration for the 'gran gusto' of his *Portrait of a Cook* which he intended to exhibit so that it would be seen 'by our own artists here who paint so timidly'.[4] But Ferdinand probably found such exhibitions too casual to produce the effect he hoped for, and by 1706 he had already organised something far grander. He had probably picked up the idea from the S. Rocco exhibitions in Venice (to be described in a later chapter), though he ran his own one on far more spectacular lines. A printed catalogue was issued—and this in itself was an innovation for Italy.[5] From this catalogue we can reconstruct the event. The exhibition was held on St Luke's day (18 October) in the chapel dedicated to that saint in the cloisters of the Annunziata. About 250 pictures were shown, nearly all of them borrowed from the great collections of Florence, though none came from the Grand Duke's. The pictures were hung in groups of about eight to ten in the lunettes of the cloister. As the visitor entered he turned to the right and, in the first lunette, he at once came across twelve pictures lent by Ferdinand himself, followed (above the door of the chapel) by a portrait of the Grand Prince

[1] Fogolari, 1937, p. 161, note 43, for Ricci acquiring works by Mehus for Ferdinand.
[2] Hugford, p. 10. [3] Fogolari, 1937, Letter 12 of 7 June 1698.
[4] *ibid.*, Letter 120 of 3 September 1707.
[5] The catalogue is called *Nota de' Quadri che sono esposti per la festa di S. Luca dagli accademici del disegno nella loro cappella posta nel Chiostro del Monastero de' Padri della SS. Nonziata di Firenze l'Anno 1706. In Firenze 1706.*

who thus unmistakably showed his patronage of the whole venture. No less clear was
the orientation of his taste, and hence the general impulse he wished to give to con-
temporary art. Of the twenty-odd pictures he lent in all, seven were Venetian old
masters—a Giorgione, a Titian, a Veronese, a Tintoretto, a Pordenone, a Schiavone
and a Paris Bordone; there were also an early Guercino, a Lodovico Carracci and a
Schedoni. Besides these he lent his Guido Cagnacci *Magdalene* ('di colore freschissimo'),[1]
his Cassana *Portrait of a Hunter* and, almost certainly, four landscapes by Marco Ricci.[2]
Not a single work by any of the Florentine artists, old or new, represented in his collection
was shown by the Grand Prince. The hint could hardly have been clearer, and it was
reinforced by further Venetian paintings lent by Cardinal Medici. In general, the
Venetians made an impressive showing in the exhibition, though there was also a strong
Neapolitan contingent mainly lent by the del Rosso brothers: thus Luca Giordano was
much in evidence.

The Grand Prince himself attended the exhibition which remained open for several
days and was evidently a success. But Ferdinand soon fell seriously ill, and thereafter
the Accademia del Disegno, under whose auspices it had been organised, returned to
the slumbers which had characterised most of its recent existence. Exhibitions, planned
on similar lines, took place at haphazard intervals in 1715, 1724, 1729, 1737 and 1767.[3]
But Ferdinand died before any of these.

By the time of his death the Venetian school of painting was widely recognised
as the most lively in Italy. Though he did not see the triumphs of its greatest masters,
he had derived immense satisfaction from his promotion of all that was most vital in
contemporary art. For a few years he turned Florence into a centre of the 'painterly',
in direct opposition to the classical-academic theories which dictated practice in Rome,
and it is not surprising that artists who rightly felt that their talents would have been
stifled in the papal city should have been delighted to work for him. It is for this reason
that he plays such a notable part in any account of Italian art patronage, and we can at
least understand, if not wholly endorse, the opinion of a mid-eighteenth-century writer
that he had been a prince 'unrivalled in the world for his magnanimity and generosity'.[4]
By that time, as he had anticipated, the most interesting Italian painting was to be
found in Venice itself.[5]

[1] Fogolari, 1937, Letter 116 of 17 October 1705. The picture is now in the Pitti, No. 75.
[2] The lender is not mentioned by name. But we know (p. 235, note 4, and Appendix 4) that Ferdi-
nand had received two of Marco's landscapes in May 1706, and it seems very likely that these were among
those lent.
[3] See the introduction to the 1767 exhibition: *Il trionfo delle Bell'Arti renduto gloriosissimo sotto gli
auspicj delle LL.AA.RR. Pietro Leopoldo Arciduca d'Austria . . . e Maria Luisa di Borbone.*
[4] Sgrilli, p. 3.
[5] Ferdinand's patronage of contemporary Venetian art had at least one significant follower in
eighteenth-century Florence: the Marchese Andrea Gerini, for whom see F. Haskell in *Boll. dei Musei
Civici Veneziani*, 1960. Francesco Gabburri, the connoisseur of drawings, also kept in touch with Venetian
artists, as can be seen from the many letters to him which are published by Bottari, Vol. II.

Part III

VENICE

Chapter 9

STATE, NOBILITY AND CHURCH

– i –

A STRIKING contradiction runs through the whole of Venetian history in the eighteenth century. The city was one of the greatest cosmopolitan centres of Europe, an acknowledged resort of international tourism which the government did everything possible to promote. And yet the same government systematically tried to keep Venice as isolated as possible from foreign influences and to insulate her against all those forces that were changing men's ideas of the world and that have been summed up under the general term Enlightenment. The policy was by no means altogether successful, but it was enforced with extreme rigour. Foreign ambassadors, and sometimes even ordinary travellers, were kept to themselves and refused contact with the nobility[1]; censorship was strict, if fitful, and prosecutions for political unorthodoxy threatened even the most highly placed[2]; and a law was passed in 1709, to be revived in 1783, forbidding patricians to travel abroad without special permission of the Council of Ten.[3] This contradiction affected every aspect of Venetian politics and culture, and it led to a tension that was never resolved. Complaints were made about the provincialism and ignorance of the nobility,[4] yet every hindrance was placed in the way of those who tried to remedy this state of affairs. Indeed some French travellers suggested that the government deliberately discouraged the sciences for political reasons, though there

[1] So many foreign travellers comment on the isolation of the ambassadors that we can be sure that it was vigorously maintained throughout the century. But there is disagreement as to how far the nobles were accessible to ordinary visitors. At one extreme there is the evidence of Gibbon who, in a fit of bad temper, wrote in 1765 (*Letters*, I, p. 193) that 'all communication with the natives of the place is strictly forbid'. At the other is that of Blainville who went out of his way to deny reports that the nobles were unapproachable (I, p. 492), and Cardinal de Bernis, the French Ambassador in 1752, said that the law had little effect even in preventing 'amitiés vives et constantes' between foreigners and Venetian nobles. But he admits that contacts could only be established through secret agents and that he only spoke once with the Procurator Emo whom he looked upon as his closest ally in Venice—*Mémoires*, I, pp. 183 and 435. The measures probably varied in severity at different times, and de Brosses sounds plausible when he says (I, p. 129) that in general nobles very rarely received foreigners. For the origins of the law see Molmenti, 1919, p. 27.

[2] In 1772, for instance, spies sent by the Inquisitors seized a number of 'heretical' books in the house of Caterina Dolfin, mistress and later wife of Andrea Tron, at the time one of the most influential men in the Republic. It was probably owing to his intervention that no further action was taken—Damerini, 1929, p. 81.

[3] Darmanno, 1872, pp. 278-300.

[4] In 1751 Andrea Tron wrote to his cousin Andrea Querini: 'Rinchiusi nel recinto delle nostre lagune, separati da ogni commercio con le nazioni forestiere, si formano essi [the nobles] certe idee veneziane, le credono infallibili e su quelle lavorono'—Tabacco, p. 11.

is no direct evidence for this.[1] Reforms were in the air, as throughout Europe, but in Venice they were all designed to restore an earlier situation.

One preoccupation can, indeed, be felt throughout the century: a desire to preserve the *status quo* or, if movement was absolutely necessary, to move backwards. In the international sphere the motives for this state of mind were all too obvious. Throughout most of the seventeenth century Venice had been losing ground. The triumphs of Francesco Morosini in the Peloponnese, celebrated with almost hysterical enthusiasm in 1686, were short-lived. In 1716 Venice just managed to withstand the siege of Corfù, but two years later, at the peace of Passarowitz, she was forced to give up all her conquests of thirty years earlier. From then on, though still extraordinarily rich despite her declining trade and though still able to live on past capital, she confessed herself too weak to take any further part in the struggles of Europe. Neutrality was the only hope, and quite soon many people realised that her survival depended more on the forbearance of the great powers than on her own ability to resist them. To compensate for this inherent weakness and obsessive longing for immobility the State turned to dreams of the past. It is for this reason, fully as much as for any value they might have in encouraging the tourist trade, that old traditions and customs were adhered to with such relentless fidelity. Indeed it was mainly the tourists who found such ceremonies as The Betrothal of the Sea somewhat ridiculous, though more thoughtful Venetians were also beginning to have doubts.[2] The fiction that Venice was still one of the great powers was maintained with every artifice at the disposal of the State and naturally affected such painting as it commissioned. Tiepolo's *Neptune paying Homage to Venice* is the most perfect illustration of this frame of mind (Plate 42a). Though painted in about 1745 when Venetian trade was causing nothing but concern, the picture expresses only the most entire self-confidence.[3] Veronese, the supreme personifier of triumphant Venice, provided the inspiration, as he did for so much eighteenth-century Venetian painting, but despite this harking back to past glories, the picture is in no sense nostalgic. Tiepolo was indeed outstanding in his day in that almost alone, quite wholeheartedly and without a tremor of doubt, he really believed in the Venetian *ancien régime*. It is surprising that the State failed to make more use of him beyond driving him against his will to Madrid as a gesture of appeasement towards Spain. In fact, however, State commissions to the arts which had earlier been of such enormous importance were virtually at an end, and it is to the State's component parts, the leading patrician families, that the greatest artists owed their most rewarding opportunities.[4]

[1] Richard, II, p. 474: 'Le gouvernement est encore attaché à cette vieille maxime, que les sciences sont contraires à la docilité qui doit faire le caractère dominant de tous les sujets. . . .' Similarly M. S[ilhouette]: I, p. 157.

[2] The Abbé Coyer wrote in 1764 that many people thought that the ceremony of The Betrothal of the Sea was ridiculous—II, pp. 25-6.

[3] The picture is still in the Palazzo Ducale. Unfortunately the circumstances of this rare State commission are not known.

[4] During the period considered in this chapter the State commissioned works of art to commemorate its few remaining heroes—notably a Triumphal Arch painted by Lazzarini in honour of Francesco Morosini and a statue by Corradini of Field Marshal Schulenburg; Tiepolo's *Neptune paying Homage to*

The whole government and higher administration of the State were in the hands of the nobility, yet here too there was cause for anxiety. The Venetian constitution, once the admiration of Europe, was by the beginning of the eighteenth century under heavy criticism from abroad.[1] Noble families, whose history and fortunes depended on trade, had long since drawn their incomes from the land. The divisions between rich and poor families became critical and soon began to endanger the stability of government. Yet despite this—or, perhaps, because of this—resistance to any change in the constitution became stronger than ever. While the wealthier nobles were increasingly monopolising all the leading positions in the administration, the poorer patrician families, alternately depending on and plotting against their more fortunate relations, agreed with them on one point only: there must be no widening of the basis of government. Yet as the resources of the State drained away during the seventeenth-century wars against the Turks, the Senate was, in fact, compelled to admit more and more new families, who were allowed to buy themselves into the nobility.[2] These more recent nobles, who were often treated with contempt by the older aristocracy and who were excluded from the more important spheres of the administration, had one aim: to disguise their mercantile origins and to integrate themselves into the existing order of things. They were hardly likely, therefore, to introduce any radical ideas into society, and the conservative tone of Venetian life soon became a byword: 'à Venise il suffit qu'une coutume soit ancienne pour être toujours suivie . . .'.[3]

The Church, as will become apparent later, was also governed entirely by the nobility and was maintained with the greatest splendour only at the price of absolute submission to the State. And although the formation of a rich bourgeoisie was the natural consequence of the nobles' withdrawal from trade, it never acquired any political power or autonomous culture. Its natural spokesmen either left Venice like Goldoni or, like Gasparo Gozzi, his keen admirer, became no more than the hangers-on of the more intelligent members of the aristocracy. Thus the history of Venetian art patronage in the eighteenth century is largely the history of the various forces which moulded aristocratic tastes at different periods. These tastes were reflected in their choice of artists, subjects and styles.

The decline of State patronage of the arts inevitably meant that this function was assumed by the limited number of families who held financial power in their hands. It was, indeed, looked upon as a necessary appurtenance of aristocratic status, and may

Venice in the Palazzo Ducale, and allegorical frescoes alluding to its virtuous government in the Antichiesetta as well as a few scattered frescoes by other artists such as Bambini elsewhere in the palace. In 1782 it ordered four paintings by Francesco Guardi to record the Pope's visit. It also established the Academy which is discussed in Chapter 12.

[1] See the attacks by Amelot de la Houssaye in 1677 which stirred up considerable controversy.

[2] For the process see Bardella, 1937, and also Conte Fulvio Miari.

[3] De La Lande: VII, p. 13.

Even the more intelligent and open-minded nobles were against changes in the constitution. Thus in 1767 Paolo Renier wrote: 'Pericoloso è introdurre dentro a corpi militari e civili cose che sentino di novità, e particolarmente in quei tali Paesi, che si trovano nel mezzo alla pace, perchè la tranquillità al di fuori, per l'ordinario, li rende inquieti al di dentro'—Marcellino, p. 30, note 78.

often have had little to do with appreciation or understanding. We hear of immensely rich families who began to amass their collections only upon their reception into the nobility[1]; and throughout the century there can have been few patricians who were not at one time or another acclaimed as glorious patrons by obsequious publishers or print-sellers—a tribute rarely if ever paid to non-nobles. Whereas the most familiar of Veronese's and Tintoretto's paintings had been devoted to glorifying Venice, Tiepolo was employed far more to exalt individual families. Patronage in Venice had always been aristocratic, as was the system of government, and it was therefore logical enough that the aristocracy itself should feature more prominently in Venetian painting than in the art of any other nation; for the identification of the aristocracy and the State was absolute. This was the reason for those huge votive pictures which came into prominence in the second half of the sixteenth century and which showed noble patrons on almost equal terms with their divine protectors. Individual glorification was carried a stage further during the first part of the seventeenth century when artists like Maffei, in series of canvases which filled churches in Este, Rovigo and other provinces, portrayed Venetian governors standing somewhat awkwardly in the middle of complex allegorical trappings.[2] But all these are as much a homage to the State as to the individuals depicted. So too are the paintings in the Palazzo Ducale designed to commemorate the actions of great commanders after victorious wars—reaching a climax in the triumphal arch painted by Gregorio Lazzarini, the best known painter of the day, in honour of Francesco Morosini's short-lived successes in the Peloponnese.[3] Yet during the seventeenth century a notable change had been occurring. More and more attention began to shift to the individual at the expense of the State or of God.

There was, for instance, the façade of S. Maria del Giglio, which was designed by Antonio Barbaro, who had fought in the war of Candia, as an apotheosis of himself and his brothers, and which was erected by Giuseppe Sardi between 1675 and 1683 (Plate 41a).[4] Crowning the façade stands the figure of Glory, and beneath the semicircular pediment are the Barbaro arms with the cardinal virtues on each side. Below, in the very centre, stands the fully armed Antonio, in general's uniform, while at his feet is the urn containing his mortal remains. Eight magnificent columns give strength and prominence to this level, and on niches to each side of him are statues of Honour and Virtue; Fame and Wisdom stand at the base of the great volutes. On the bottom storey, separated by massive sets of double columns, are Antonio's four brothers, and on the pedestals at their feet are plans of Candia, Corfù, Spalato, Zara, Padua and Rome, where Antonio had served as ambassador. Such was Antonio Barbaro's conception—devoid

[1] The Grassi, for instance—see Moschini, 1806, II, p. 105.

[2] See, in particular, Chiesa della Beata Vergine della Salute in Este, and Tempio della Beata Vergine del Soccorso in Rovigo. The pictures in this latter are almost entirely devoted to the glorification of the Venetian administrators of the city. The church indeed came under the jurisdiction of the City of Rovigo and not of the Bishop—see in the Accademia de' Concordi, Rovigo, Silvestriana MS. 431: *Memorie storiche intorno il V.e Tempio della B. Ve dl Soccorso giuspatronato della Città di Rovigo, 1768.*

[3] Da Canal, p. 30.

[4] Antonio Barbaro's will is published by M. Brunetti, 1952.

Plate 41

SELF GLORIFICATION OF THE VENETIAN NOBILITY (*see Plates* 41–44)

b. Monument to Doge Giovanni Pesaro in Church of the Frari

a. Façade of S. Maria del Giglio with portraits of Barbaro family

Plate 42

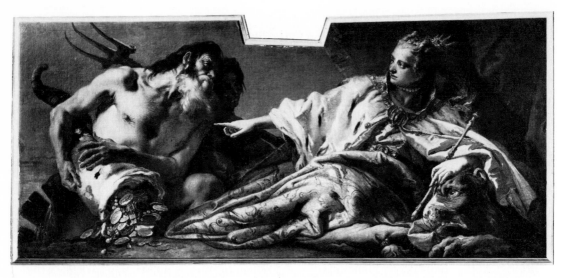

a. TIEPOLO: Neptune paying homage to Venice

b. NICCOLÒ BAMBINI: Allegory of Venice in Cà Pesaro

Plate 43

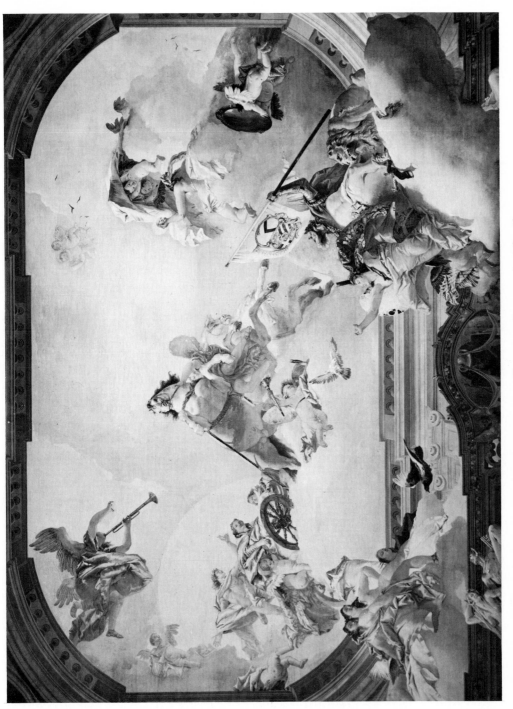

Tiepolo: Marriage Allegory of Rezzonico family

Plate 44

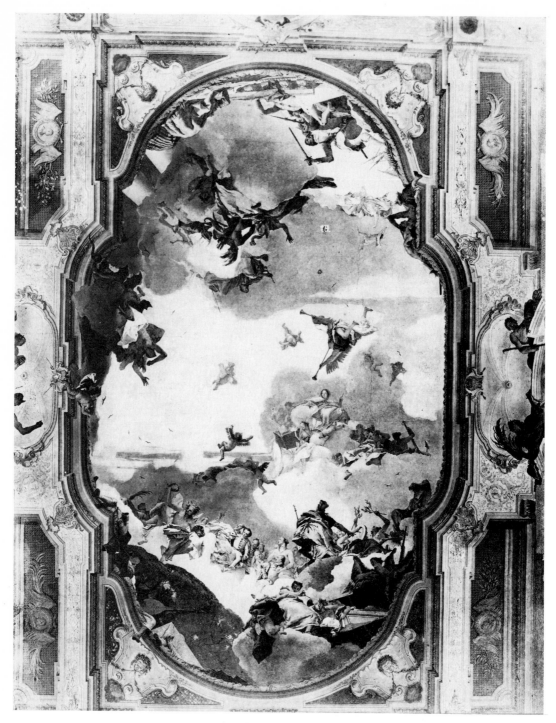

TIEPOLO: Glorification of the Pisani family

of a single religious symbol. We have to go back to the Tempio Malatestiano at Rimini to find such an extraordinary glorification of Man in a place usually reserved for the divine. In fact, the motives for this particular façade had immediate political origins. Antonio Barbaro's conduct in the war of Candia had been somewhat discreditable, and he had been dismissed by Francesco Morosini for incompetence. He thereupon returned to Venice and did everything possible to whip up hostility against Morosini,[1] and in his will he was careful to point out that the church was situated just opposite the Morosini palace. But Barbaro's arrogant self-justification had wider implications. Writers on the Venetian constitution and foreign observers at about this time particularly noticed the concern of the government to prevent any single noble gaining too much power and popularity[2]; the façade of S. Maria del Giglio shows the background against which such concern was expressed. The reasons for this extravagant behaviour are clear enough. The State was exhausted by long wars, but individual families were as rich or richer than ever. Admission to the nobility now depended purely on wealth. In such circumstances both old and new families were anxious to assert their various claims as vigorously as possible, and in the process they established a pattern which was later to be of great importance for the development of painting.

Throughout the last years of the seventeenth century the ostentation of the nobility was increasing dramatically. The new attitude was expressed most vividly by Leonardo Pesaro, nephew of the Doge. Contemporaries pointed out, with some justification, that the splendour with which he surrounded himself had never been seen on such a scale before and they came to the characteristic conclusion that the greatness of his virtue could be measured accordingly.[3] In 1669 he had a monument to his uncle built in the Frari which surpassed in grandeur anything that had preceded it (Plate 41b). He continued the vast family palace, whose dramatic façade on the Grand Canal was only completed some 17 years after his death, and in 1682 he commissioned from Niccolò Bambini a ceiling painting to represent the *Triumph of Venice*—the first time the theme had made its appearance in a private palace (Plate 42b).[4]

Old families, like the Pesaro, had all the political privileges, but the new mercantile classes who were buying their way into the aristocracy were making themselves felt more and more by the splendour of their patronage. In the provinces, at least, lavish building sometimes even proved an essential step towards gaining political status.[5] At

[1] Damerini, 1928.

[2] See p. 247, note 1. In 1704 the British Resident, writing of the official assumption by Soranzo of his post as Procuratore di S. Marco, described the great show of riches he made to impress the Turks and commented on the government's aversion to one man gaining too much popularity by such means— Public Record Office, State Papers, 99/57, p. 148.

[3] Ivanovich, 1688, p. 127.

[4] *La Pittura del Seicento a Venezia*, 1959, No. 221. The subject is sometimes described as *The Glorification of the Pesaro Family*, but in fact it appears to be Venice. See also Mariacher, 1951, pp. 1-6, and E. Bassi, 1959, pp. 240-64.

[5] In Vicenza, for instance, the Montanari were at first refused patrician status, but after building one of the most spectacular palaces in the city they were admitted to the nobility in 1687 for, among other things, the 'costruzione di fabbrica che accresce il lustro di questa Patria'—Coggiola-Pittoni, 1935, p. 296.

the beginning of the eighteenth century four or five families who had been ennobled only some fifty years earlier were in the very forefront of artistic patronage in Venice. The Zenobio were said to be the richest family in the city.[1] The palace at the Carmini which they had bought from the Morosini, one of the twelve oldest families (the so-called Apostles), was completely transformed and nearing completion by 1703. Some fifteen years earlier the French artist Dorigny had been called in to paint a series of spectacular mythological frescoes contained within a heavy and elaborate painted architectural framework of the Bolognese type with cartouches and Carraccesque nudes derived from the Palazzo Farnese in Rome. These frescoes were designed to celebrate the virtues of the family and their protection of the fine arts, which was indeed notable. Luca Carlevarijs, the painter of views, was lodged in the palace and painted for it a series of romantic landscapes which were inserted into frames along the corridor leading to the Salone.[2] Lazzarini decorated a ceiling with Ceres and Bacchus. The young Tiepolo produced some of his earliest works for them.[3]

The Widmann, of Carinthian origin, had a splendid palace near S. Canciano which they too were lavishly decorating with a series of large canvases by Lazzarini showing scenes from the life of Scipio Africanus[4]; while their country house at Bagnoli di Sopra was painted by Dorigny with frescoes of Diana and Actaeon.[5]

The Labia, rich businessmen of Catalan origin, had also set about building a gigantic palace which was completed in the early eighteenth century and were engaged in displaying their great wealth in as ostentatious a manner as possible.[6] Throughout the 1680s they were employing Lazzarini[7]; and they also owned the largest collection in Venice of pictures by Luca Giordano—presumably painted for them during his visit of 1682.[8]

[1] Coggiola-Pittoni, 1935, p. 22. [2] Valcanover, 1952, pp. 193-4.

[3] Da Canal, pp. 57 and 34. The main decorations survive in the palace, which is now the Armenian College, on the Fondamenta Foscarini, 2593.

[4] Da Canal, pp. 28, 42, 52. [5] Coggiola-Pittoni, 1935, p. 302.

[6] Tassini, 1915, p. 335. [7] Da Canal, pp. 53 and 57.

[8] *La Pittura del Seicento a Venezia*, 1959, p. 95, for the suggestion that Luca Giordano was in Venice in 1682. An inventory of some of the Labia pictures in 1749 (Archivio di Stato, Venezia—Sezione Notarile: Pietro Zuccoli 14292) includes the following pictures by him in the palace—all 4¾ *braccia* high and 3¼ *braccia* wide:

 (1) *La Beata Vergine in Egitto, e S. Giuseppe.*
 (2) *S. Gerolamo nel Deserto.*
 (3) *La Notte.*
 (4) *Il Giudicio di Paride.*
 (5) *Tre Animali.*
 (8) *Architettura.*
 (9) *Un trionfo d'armi.*
 (10) *Battaria di Cusina.*
 (11) *Quadi [sic], che rappresentano fatti della Sacra Scrittura.*
 (13) *4 Dissegni con Cristallo.*

Cochin, who was in Venice in 1750, refers to many of these pictures: Nos. 1, 2, 4, 5, 6, 7, 11, 12 (almost certainly the ones identified by him as *Job and his Wife* and *Isaac blessing Jacob*). He also mentions a *Socrates*, a *St Peter receiving the Keys* and a picture 'où sont des pasteurs, des bergères et des moutons'—III, pp. 138-139.

Perhaps most striking of all, the Manin from the Friuli were untiring in the decoration of palaces, country houses and churches in and around Venice[1] and they thus won a reputation for nobility of soul through the expenditure of money which was to lead eventually to the election of the futile Lodovico as the last of the Doges. More than any of the other 'new' families they indulged in megalomaniac display. Their country house at Passeriano was approached through two colonnaded wings adapted from Bernini's porticos for St Peter's.[2] Their palace on the Grand Canal, wrote a correspondent in 1708,[3] was so majestic that it lost nothing in grandeur when compared to the famous marvel of the Rialto which adjoined it. The value and the splendour of the decoration surpassed all expectations. The walls were covered with the richest hangings; there were tapestries derived from Raphael with scenes of the Old Testament. The smaller rooms shone with glistening mirrors like the sea in the Apocalypse—a new fashion just introduced from France and ultimately springing from Persia. In the gallery were bronzes by Giambologna and Sansovino and pictures by Giovanni da Udine and Andrea del Sarto. As far as contemporary art was concerned, the Manin turned to Bologna—two pictures by Cignani, the most expensive artist in Italy, and a marble Venus by Giuseppe Mazza 'the Phidias of Bologna'. In fact their taste was more consistent as well as more extravagant than that of other families and they employed the same team of artists, the architect Domenico Rossi and the painter Luigi Dorigny, on many of their enterprises. 'The rooms within', wrote a local poet about their country house,[4] 'are adorned with smooth, shiny marbles of fine colours and not with friezes of gold.' Coloured marble (or stucco), often cut so as to imitate great, hanging draperies, was indeed the hall-mark of the Manin style and can be found in the choir of Udine Cathedral and above all in the Jesuit church in Venice as well as in their palace and country house.

Unparalleled splendour and a love of display were of course shared by old and new families alike. 'Richness', observed the same contemporary who had described the Palazzo Manin with such enthusiasm, 'is the body of nobility, which has as its soul ancient lineage and virtue.' There was also a certain reluctance to break with the past. The artists with the greatest success—Zanchi, Lazzarini, Balestra, Dorigny, Bambini and others—were chiefly the ones most closely linked to seventeenth-century taste, and their prestige continued long after more adventurous painters had struck out in new directions. Thus Pellegrini, Amigoni and Sebastiano Ricci, all of whom were adult in the early eighteenth century, were scarcely employed in the decoration of great palaces and became far better known outside Venice. Indeed Ricci, despite the admiration

[1] See p. 268, note 5.

[2] After a long period of decay the villa has now been restored. The influence of St Peter's was noted by eighteenth-century poets—see Daniele Florio: *Le Grazie*, Venezia 1766, p. xli: 'Di Roma alla gran piazza area simile/Prima due mostra ali piegate in arco.'

[3] See 'Lettera del Co: di N.N. A Madama la Marchesa di N.N. a Parigi, in cui si dà conto delle solenni Pompe Nuziali vedute nel Palazzo di S.E. il Signor Co: Manin in Venezia' published in *La Galleria di Minerva*, VI, Venezia 1708, p. 83.

[4] Daniele Florio, p. xli.

with which he was surrounded, worked surprisingly little for the Venetian aristocracy once he settled in the city and was far more employed by the court of Turin, by churches and by the English business man, Joseph Smith.

When Tiepolo first began his immediately successful career in the 1720s it was his violent, tense style that appealed. Such a style matched the subjects he was particularly required to paint: battle scenes and triumphs taken largely from Roman history,[1] for many Venetian families claimed Roman ancestry—among them the Corner, for whom he is known to have worked before 1722.[2] In other cases the dramatic style and subject-matter clearly reflect Venice's great wars with the Turks in the 1680s and again in 1715 —the last occasion when the city and her aristocracy left their mark on European history. The most notable example of these echoes is certainly comprised by the ten large and forceful scenes from Roman history, chosen from the most patriotically fervent chronicler of her republican virtues, L. Annaeus Florus, which Tiepolo painted for the Dolfin, his greatest patrons of the 1720s.[3] They were a tremendous family in the old style.[4] Daniele III, who died in 1729, served the State abroad and at home throughout his life and was considered one of the finest orators of the day. In his will he regretted that 'God has not allowed me to see fulfilled the ideas which I had feebly conceived when serving in the Treasury to restore the economy of the State in the tranquillity of peace. . . . I could wish that I might be allowed to shed my blood to heal its wounds. . .', and he left all his substance to the Republic on the extinction of his male line. His brother, Daniele IV, who died in the same year, was one of the most heroic commanders in the Turkish wars, both under Morosini in the Peloponnese and again in 1715.[5]

The Dolfin also enjoyed a virtual monopoly of the patriarchate of Aquileia.[6] In 1698 Dionisio, younger brother of the two Danieles, was given the post and went to live in Udine, the seat of the bishopric. Despite the bitter opposition of Austria, he soon imposed his astute, authoritative and ambitious personality on the city and left many permanent records of his thirty-six-year residence there. In 1708 he built a sumptuous library, decorated with frescoes by Niccolò Bambini,[7] and some eighteen years later he summoned Tiepolo who had just finished working in the family palace at Venice

[1] As is shown by many surviving sketches and drawings from his early years.

[2] Da Canal, p. 32.

[3] *ibid.*, p. 33. The pictures are now divided between Leningrad and Vienna. The subject of one of the Vienna canvases, which has been described by Morassi (1955, fig. 11) and others as *Eteocles and Polynices* is, in fact, *Brutus killing Arruns*—also taken from L. Annaeus Florus (Loeb edition, p. 33.)

In the room where the Tiepolos once hung is a large ceiling fresco showing a dolphin amid various gods and goddesses of antiquity, representing Abundance, etc., and also attributes of the Arts and Sciences, Time, Fame and other symbolical figures. It is surrounded by a most elaborate architectural framework of the Bolognese type. Both the artist and date of this fresco are still very mysterious, but despite some suggestions to the contrary I am inclined to place it some years after Tiepolo's canvases.

[4] Dolfin, pp. 171 ff., and also Mss in Biblioteca Correr XI, E 2/6: *Discendenze patrizie.*

[5] The other great cycle of canvases with subjects taken from Roman history is in the Palazzo Vendramin-Calergi. These have been attributed to Niccolò Bambini—Ivanov, 1951, pp. 1-3.

[6] Apart from the works quoted in note 4 above, see de Renaldis.

[7] Niccolò Madrisio, 1711. See also Biasutti, 1958.

to paint frescoes in the Cathedral and his new Archiepiscopal Palace. After rather a melodramatic start on the ceiling of the staircase, the artist gradually changed his style when he came to paint scenes from the life of Abraham in the gallery and *The Justice of Solomon* in the hall of the tribunal. The dark and lumpish heaviness of his earlier work was replaced by an aristocratic incisiveness of line and a whole new range of magical colours—sparkling blues and pinks and greens—set against a light airy background. Thus, shortly before dying, Dionisio Dolfin, who ruled his petty state like some feudal bishop of the Middle Ages (the very type of patron most congenial to Tiepolo), had the privilege of seeing the first masterpieces of the greatest painter of the century.[1]

Indeed for Tiepolo, as for so many Venetian artists, the final break with the heavy style of the seventeenth century did not—perhaps could not—come in his native city, so conservative in temper. In the early 1730s he was frequently summoned outside Venice and, by the time he returned, his palette had lightened still further and his subjects had changed. The heroic days of an Antonio Barbaro or a Daniele Dolfin must now have seemed almost as remote as the Roman epics with which he had commemorated them, and indeed two members of the latter family were soon in prison or in exile for breaking the most fundamental laws of the State. Venice herself was firmly neutral. But Tiepolo remained as much in demand as ever: it is hard to resist the conclusion that his marvellous gifts and brilliance of execution created a need for his art fully as much as they satisfied it. He himself deliberately aimed at a special class of patron. He used to say that 'painters must try and succeed in large-scale works capable of pleasing the rich and the nobility because it is they who make the fortunes of artists and not the other sort of people, who cannot buy valuable pictures. And so the painter's spirit must always be reaching out for the sublime, the heroic, the perfect.'[2]

Thus it was that for the next two decades Tiepolo was working incessantly for an aristocracy that was now breaking up still further into individual components than it had been at the beginning of the century. But its ambitions were no longer military— and were soon to be scarcely even political. In 1761 the British Resident, reporting the death of the Procurator Alessandro Zen, added: 'what is very unusual, and without a precedent, no one has yet offered for a Candidate to succeed him, tho' one of the greatest Dignities in this Republick . . .'.[3] This situation was to become more commonplace,[4]

[1] In 1759 Tiepolo and his son Gian Domenico were recalled to Udine by a new patriarch, Daniele Dolfin, nephew of Dionisio, to decorate the Cappella della Purità near the Cathedral.

[2] See the sort of statement to the press, ignored, as far as I am aware, by modern writers, made before Tiepolo left for Spain and published in the *Nuova Veneta Gazzetta* of 20 March 1762: '. . . Ho udito dire dal Signor Tiepolo stesso, che molti giovani, anche fra suoi allievi, quando credono di saper qualche cosa, più non vogliono studiare, ed arenano quel progresso, per cui fare hanno bastante talento. Aggiunse che li Pittori devono procurare di riuscire nelle opere grandi, cioè in quelle che possono piacere alli Signori Nobili, e ricchi, perchè questi fanno la fortuna de' Professori, e non già l'altra gente, la quale non può comprare Quadri di molto valore. Quindi è che la mente del Pittore deve sempre tendere al Sublime, all'Eroico, alla Perfezione.'

[3] Public Record Office, State Papers—Venice 99/68, p. 233.

[4] In 1775 provincial nobles turned down the chance to acquire Venetian patrician status—Berengo, 1955, p. 14.

but for a full generation earlier the aristocracy, in the absence of great public exploits, had had to turn to the celebration of private deeds. The nobles, in fact, took refuge in a fabulous dream world, glowing with light and colour, where marriages and family histories were turned into events of supreme importance, attended by all the deities of the pagan and even Christian religions. It was a world given imperishable existence by Tiepolo, who recorded the more notable events in the aristocratic calendar in a series of eulogistic allegories. And yet it was a tense and unrelaxed world, always on show, with every muscle strained to the utmost, every expression hard and humourless, for never in history has the gap between everyday life and artistic fantasy been as great and as unbridgeable as it was in Venice during the middle decades of the eighteenth century. In 1758, for instance, Faustina Savorgnan, a young girl of the most select nobility, married Lodovico Rezzonico, second son of a family whose rise had been as spectacular as it was recent.[1] Of Genoese origin and ennobled only in 1687, their great wealth had secured them the leading positions in the State. Aurelio, Lodovico's father, was made Procuratore di S. Marco in 1751, and in that year bought one of the grandest palaces in Venice from the Bon family. Seven years later his brother Carlo was elected Pope as Clement XIII. In his marriage fresco for the Pope's nephew Tiepolo envisages a scene which puts even these successes in the shade (Plate 43). The bridal pair are being carried on the chariot of the sun drawn by four hurtling white horses and accompanied by Apollo himself, while Fame sounds the event to the world.

As the aristocracy declined in international importance, its glorification at Tiepolo's hands reached new peaks. Families could look up at the ceilings of their state rooms and see their virtues of constancy, strength and justice trumpeted to the four corners of the earth. Admiring Red Indians or black savages might help to compensate for the coldness and scorn of more uncomfortable neighbours such as France or Austria. The Grassi,[2] the Widmann, the Giustiniani[3] and the Soderini all had apotheoses of their families painted in their palaces or country houses, and as late as 1794 when the Republic was in its final stages of decay we find the artist Pietro Novelli recording the greatness of the Collalto.[4] In their more excessive forms these frescoes showed actual portraits of living members of the family sharing in the general exaltation. Pietro Barbarigo, the leading member of the extreme Catholic faction, had his nephews included in the fresco of *Strength protecting Wisdom* which Tiepolo painted for him in 1745.[5] And most striking of all, appropriately enough, was the last great work painted by Tiepolo before leaving Venice for ever—the *Apotheosis of the Pisani* in their country house at Stra.[6] The palace was acknowledged to be the grandest built near Venice in the eighteenth century[7] and

[1] Livan, 1935, pp. 406–8, and Giussani.

[2] Molmenti, 1909, pp. 177–88, attributes the fresco to Fabio Canal and unravels the iconography.

[3] Brunelli e Callegari, 1931, pp. 38 and 118.

[4] Novelli, p. 62.

[5] Muraro, in *Gazette des Beaux Arts*, 1960, pp. 19–34. For Pietro Barbarigo's political affiliations see Tabacco, p. 38.

[6] Gallo, 1945.

[7] G. A. Moschini, 1806, II, p. 105.

for it Tiepolo designed the most extraordinary family allegory he had yet painted (Plate 44). In this it is not the founding fathers or the great heroes who are celebrated, but the family's living members extending to its youngest son, Almorò, seated in his mother's lap. Actual portraits of these are shown in the ceiling while the Fatherland points out their merits to the Virgin and invokes her blessing on them. The Virgin is surrounded by the theological virtues, Faith, Hope and Charity, and by Wisdom. On the other side of the fresco flies Fame to spread the glory of the Pisani family throughout Europe, Africa, Asia and America. The year was 1762: England had just wrested Canada and India from France, and Robespierre was aged four.

Such flattery—and there is evidence that in at least some cases the artist himself took the initiative in choosing the subject[1]—was available to any noble with the money. A standard figure of *Time* could suggest that the family was old in wisdom and virtue, but the reference need not be too precise. There was, however, another kind of ancestral glorification which was necessarily confined to the older members of the Venetian aristocracy. It is easy enough to understand why the recording of specific achievements from the past should have first made an appearance when the new aristocracy was beginning to flaunt its titles and wealth, and should have proved even more attractive when refuge in that past was the only compensation for an inglorious present. Thus in 1700 the Corner commissioned Gregorio Lazzarini to paint a member of their family who had distinguished himself at the time of the League of Cambrai—Venice's finest hour.[2] And other old families followed suit—for subjects such as these were beyond the reach of a Widmann or a Grassi. It is true that the first elaborate reconstruction of an earlier period painted by Tiepolo was for the Soderini, ennobled as late as 1656, but they had a long and renowned Florentine ancestry which the artist was able to suggest in three scenes from the fifteenth century leading up to the climax of the family apotheosis on the ceiling.[3] In much the same way he painted the Contarini at the moment of their greatest glory—the welcome they gave in 1574 to Henri III of France when he visited their villa at Mira.[4] Social prestige now made a greater appeal than military prowess.

Such family allegories were not the only way in which noble patrons could be flattered. Sometimes the subject could be more allusive. The Sandi, who had been

[1] The almost complete absence of contracts for secular decorations in eighteenth-century Venice makes it difficult to decide how much choice of subject was left to the artist. There must have been a good deal of consultation between patron and painter. We can get some hints about current practice from artists' biographies. Thus Zannandreis, writing (p. 426) about the Veronese painter Francesco Lorenzi, suggests that it was he who provided Tiepolo with an allegorical scheme for glorifying the King of Spain. Though this may well be an apocryphal story designed to show off Lorenzi's culture, it does at least suggest that a good deal of freedom was left to the artist. Novelli specifically tells us in his Memoirs (p. 62) that it was he himself who chose to record the Greatness of the Collalto family. Most Venetian artists of the eighteenth century first produced *modelli* of their proposed work for inspection by the patron and there are only a very few cases of great discrepancy between these and the completed decoration. This too suggests that the painter was not tied down too rigidly by his instructions.

[2] Da Canal, p. 57.

[3] See Battistella, 1903. The villa was destroyed in the First World War.

[4] Musée Jacquemart-André, Paris.

ennobled only in 1685,[1] were among the first to employ Tiepolo, and as their fortunes were closely linked to the extremely lucrative profession of the law, they commissioned a ceiling in their palace which was to illustrate the *Powers of Eloquence*, as expressed in four stories from antiquity.[2] Goldoni tells us in his *Memoirs* that lawyers enjoyed a status in eighteenth-century Venice second only to that of the nobility,[3] and it is significant that one of the very few non-nobles who had the chance to employ Tiepolo was Carlo Cordellina, the leading advocate of the day. He was a man, we are told,[4] who did not like useless luxury, such as loading his wife with precious stones, but who believed in splendid living. And so he built himself two houses, one in his native Vicenza and one in the country at Montecchio. To decorate the latter he summoned Tiepolo, who was much irritated by the extensive entertainment for which Cordellina was renowned,[5] but who frescoed *The Continence of Scipio* and the *Family of Darius before Alexander the Great* on the walls—clear allusions to the magnanimity of his patron—and the *Triumph of the Arts* on the ceiling.

There was a familiar repertoire of Greek and Roman stories which had been codified in the sixteenth and seventeenth centuries as suitable for the display of aristocratic virtues, and all subsequent artists drew heavily on it. But it is probable that such scenes may often have had far more precise meanings than are at present understood. Not only did many patrician families claim Roman descent, as has already been pointed out, but officials in the service of the state were used to hearing themselves compared to Roman heroes on the most trivial pretexts. Thus in 1724 when Pietro Loredan left a neutral Venice for the fortress of Legnano of which he was commander, an orator alluded to the heroism of Mucius Scaevola[6]; and at about the same time another member of the Loredan family, Antonio, was, on leaving the governorship of Padua, compared to Pompey.[7] The theme of Sacrifice was particularly popular, for it satisfied the century's love of melodrama while alluding to the responsibilities of power. But antiquity also provided a fund of more exhilarating scenes. Tiepolo and his followers frequently painted *The Banquet of Antony and Cleopatra*, which glorified a beautiful Eastern queen successfully challenging the rough Roman hero from the West by her astuteness and wealth; this was surely a veiled allusion to Venice's own policy during these years but it also symbolised a final enthusiastic fling of aristocratic extravagance in the face of new theories of political economy which were everywhere gaining ground—a 'reactionary' manifesto which found its literary equivalent in some of the writings of Carlo Gozzi. There was, however, a more straightforward background to the choice of this theme. We learn from the memoirs of Antonio Longo

[1] Biblioteca Correr, Venezia—MSS. XI, E 2/6, *Discendenze Patrizie*.

[2] Morassi, 1955, pp. 4-12. The subjects were *Amphion building the walls of Thebes with his song, Hercules with the chained Cecrops, Orpheus claiming Eurydice* and *Perseus on Pegasus slaying the Sea Monster.*

[3] Goldoni, I, pp. 105 ff. (Chapter XXIII of the *Mémoires*). [4] [G. B. Fontanella].

[5] Letter from Tiepolo to Francesco Algarotti of 26 October 1743 published by Fogolari, 1942, p. 34.

[6] *La Rappresentanza del vero merito*—Orazione nella partenza del Glorioso Reggimento di S.E. il Signor Pietro Loredan Provveditore, e Capitanio degnissimo della Fortezza di Legnano, Venezia 1724.

[7] Orazione detta in nome della magnifica Città di Padova all' Eccellenza del Sig:r Antonio Loredan Podestà—nella partenza del suo Reggimento, In Padova (n.d.).

that nobles used to organise competitions as to who could offer the most expensive banquets[1]; and the Labia, whose palace contained Tiepolo's most magnificent version of the subject, became legendary for their extravagance.[2] Moreover, Maria Labia, *doyenne* of the family and a 'femme sur le retour qui a été fort belle et fort galante', owned a famous collection of jewelry of which she was especially proud.[3] There can be little doubt that Tiepolo intended a delicate compliment, and that Maria Labia felt no great difficulty in identifying herself with the beautiful Egyptian queen who won her wager by dissolving a priceless pearl in wine.

Unbridled dreams of power and grandeur on this scale, and the acute and genuine awareness of the Venetian nobles that (unlike their equivalents in France) they still represented the only real power in the State, kept history painting alive in Venice at a time when it was declining in expressive force and importance throughout Europe. 'There must be a great difference', wrote Paolo Renier in 1772,[4] 'between a minister who serves his Prince as a subject and one to whom God's special grace has granted the supreme boon of living in a free Republic and of being a small but essential part of the whole.' Some of the moral fervour of the French middle classes, which was to lead to a revival of history painting and culminate in the rhetoric of David, was here expressed by the aristocracy and found its champion in Tiepolo—though, of course, the results were wholly different in elegance, colour and subject-matter. Indeed, curiously enough, those Frenchmen who in the middle of the eighteenth century were especially concerned to revive native history painting were keen admirers of Tiepolo. Thus in 1754 the Marquis de Vandières (later Marquis de Marigny) wrote to the Director of the French Academy in Rome instructing him to send students to copy the artist's frescoes at the Villa Contarini-Pisani, for 'il en naîtra un autre bien pour l'histoire de France, puisqu'on aura les usages et les habillements de ces tems-là qui sont très intéressants pour elle'.[5] And Cochin, who had the same interests at heart, also thought very highly of Tiepolo.[6] Present-day taste finds the artist's *bozzetti* more appealing and, attracted by the general glamour of 'rococo' art, fails to grasp the grandeur and megalomania of Tiepolo's full-scale decorations. There is reason to believe that painters like Fragonard and some connoisseurs of the time may have made the same distinction. But admiration for Tiepolo's marvellous colour and fantasy should not blind us to his moral commitment to the cause he was serving any more than it does in the case of Rubens.

It was probably the Venetian nobility's awareness of real privileges and obligations that was responsible for the exaggerated dignity of their portraiture[7] and for the surprisingly small amount of that erotic and frivolous painting that was so typical of the French rococo. There is no Venetian equivalent to a Boucher or a Fragonard, and

[1] Antonio Longo, 1820, I, pp. 81-90.
[2] Tassini, 1915, p. 335.
[3] De Brosses, I, p. 149.
[4] Quoted by T. M. Marcellino, p. 18, note 32.
[5] Byam Shaw, 1960, p. 530.
[6] Villot, pp. 169-76.
[7] See the relevant chapter in Levey, 1959.

it is significant that the artists who most nearly approach the French from this point of view, Pellegrini and Rosalba Carriera, appear to have had more success abroad than in Venice. Even subjects such as *Bathsheba bathing* or *Susanna and the Elders* which had been enormously popular as pretexts for eroticism towards the end of the seventeenth-century later became very much rarer; while mythologies such as *Aurora*, *Flora* and so on were less in demand than scenes from Roman and Greek history. Similarly Gian Antonio Guardi, an artist of magical but quite unserious qualities, enjoyed a relatively insignificant career, whereas in Paris he would surely have had a triumphant success.

Only very rarely did Tiepolo stray from dreams of grandeur to the world of pure enchantment. The most striking instance is in the beautiful series of frescoes illustrating romantic scenes from Homer, Virgil, Tasso and Ariosto which he painted for the Valmarana family in Vicenza.[1] Unfortunately too little is known of the circumstances surrounding the commission and of its patrons to explain this interlude in his career, but it may just be worth pointing out that we are told of Leonardo Valmarana, who seems to have been the head of the family when the frescoes were painted in 1757, that he was of a 'sweet disposition, pleasant conversation, and the most agreeable character. He was far removed from any display, ostentation or pride . . . being aware that true nobility does not consist in boasting of ancestors which only proves oneself to be void of merits and virtue. He was always humble in his manner, almost forgetful of his birth, his blood and his greatness'.[2] The words come from a funeral oration—not the most reliable source for an impartial estimate of a man's character—but so insistent are they in stressing a virtue not often referred to, still less praised, in eighteenth-century Venetian orations, that they are worth bearing in mind when we try and explain the exceptional nature of Tiepolo's work at the Villa Valmarana and the rustic frescoes by his son in the *foresteria* there.

Amid the throngs of patricians who were decorating their palaces and villas with allegories of their virtues or scenes from their family histories there was one man who especially struck his contemporaries for his rectitude, intellectual authority and political stature. Marco Foscarini was descended from one of the oldest families in Venice.[3] He was educated in Bologna and in his younger days he travelled to Paris, Vienna and Rome, serving as ambassador in the two latter cities. In 1734 he was appointed official historiographer of the Republic, and though he never wrote the volumes expected of him he was always passionately interested in Venetian literature and history about which he planned a number of studies only some of which were published in his lifetime. This love of the past and constant dwelling on the ancient glories of Venice deeply affected his political thinking. As Procuratore di San Marco from 1741, and later as Doge for a few months before his death in 1763, he became increasingly identified with conservative causes, and it was he who took the strongest stand against Angelo

[1] Levey, in *Journal of Warburg Institute*, 1957, pp. 298-317.

[2] Ne' Solenni funerali celebrati nella Cattedrale Chiesa di Parenzo il dì 27 Aprile 1765 . . . dell' Illustriss. ed Eccellentiss. Leonardo Co: Valmarana Veneto Senatore . . . In Venezia 1765.

[3] There are a large number of works devoted to various aspects of Marco Foscarini's political and literary careers. The most useful general accounts are by Tommaso Gar, 1843, and Emilio Morpurgo.

Querini and his proposed 'reforms' in 1762.[1] Though the methods by which he became Doge are open to suspicion, he seemed to his contemporaries to represent the last surviving incarnation of the old virtues of integrity and learning that had made Venetian statesmen so respected. He was indeed a proud and cultivated man and his patronage shows him to have had ambitious and scholarly tastes.

The family palace was opposite the church of the Carmini,[2] and it was repeatedly decorated with great lavishness—'the family is the richest in Venice,' wrote one architectural painter working there in 1749,[3] 'they have 130,000 ducats a year and an infinite number of palaces and jewels and a gallery worth 200,000 ducats'. Many of the pictures, which included seven Tintorettos and other Venetian classics, had been left with the palace by its former owner, Pietro Foscarini, himself a Procuratore di San Marco, who died in 1745.[4]

Marco Foscarini was more interested in books than in pictures, and his main attention was devoted to his magnificent library of manuscripts and other works, mostly dealing with the history of Venice.[5] The paintings he commissioned were intended primarily to illustrate his literary interests, and with one exception it is unlikely that he made use of any of the leading artists of his day. During his embassy in Rome between 1737 and 1740 he employed Pompeo Batoni, who was living, like him, in the Palazzo di S. Marco to draw his portrait and to paint a *Triumph of Venice* according to a programme clearly drawn up by himself (Plate 45).[6] It was to represent 'the flourishing state of the Republic when, after the wars incited by the famous league of Cambrai, peace returned and the fine arts began to flourish again in Venice, summoned back and fostered by Doge Lionardo Loredano'. In its harking back to the recovery of Venice after earlier disasters, the subject typifies Marco Foscarini's desire to seek encouragement from past history. It is noteworthy too as one of the very few 'historical' pictures painted for a Venetian patron which has no reference to the triumphs of his own family but is purely devoted to exalting the State. Greek sages on the right of the picture are being shown the recorded achievements of Venice by Mercury; on the left a Roman warrior has her present grandeur pointed out to him by Neptune. In the foreground, at the feet of Minerva, are the arts; while in the centre the chariot of the Republic with Doge Loredan is surveyed by History and Fame. The figures of Minerva and the Roman warrior are extraordinarily classical for the period in which they were painted, and Batoni has made no concessions to Venetian taste.

We know much less about Foscarini's other pictures, beyond the fact that they

[1] For Angelo Querini see later, Chapter 15.

[2] Fontana, p. 291.

[3] Pietro Visconti to Gian Pietro Ligari published by Arslan, 1952, p. 63.

[4] Pietro Foscarini's will and the inventory of his pictures are in the Biblioteca Correr, Cod. Cicogna, MMDCCCCXLV—2686.

[5] The library was sold by Marco Foscarini's descendants to the Austrian government in 1800 and is now in the Hofbibliothek, Vienna.

[6] For a detailed discussion of this picture, now in the Kress Foundation at New York, see A. Clark, 1959, pp. 232-6.

represented the great writers of Venice and hung in the rooms where he kept their books. Many of them seem to have been painted in Rome where Marco Foscarini, whom the Président de Brosses found to be a man 'd'un esprit et d'un feu surprenants', did everything he could to maintain the prestige of his native city. It was in Rome too that he acquired large numbers of books and manuscripts which he brought back 'quasi trionfando' to the family palace; and in both cities he employed sculptors in marble, ivory and metal to record the great figures of the past.[1] All these images are now gone and we have no indication of the artists who made them. What little we know is not very encouraging. 'He was', wrote the minor painter Pietro Antonio Novelli,[2] 'an extremely learned prince and a great patron and lover of the fine arts. . . . When he saw a S. Marco I had painted for the engraver Marco Pitteri, he liked it so much that he insisted on keeping it in his room for four days, and then wanted a history picture from me. . . .' Giacomo Guarana, a follower of Tiepolo, painted frescoes in the palace[3]; Giuseppe Nogari his portrait.[4]

The great names of Venetian painting do not seem to have played much part in his life[5]; but his artistic patronage none the less made a striking impression on his fellow-citizens. As you walk through his rooms with the portraits and busts of great men, wrote a contemporary,[6] 'the emotion of elation and respect experienced by lovers of virtue is indescribable. You seem to enter a venerable sanctuary in which the most famous writers, and the very Muses themselves, have made their home.'

Enough has been said to show that certain artists at least received considerable patronage during the first half of the eighteenth century. Indeed, when he came to write of painting during this period the Abate Moschini specifically claimed that the arts had suffered from no lack of support.[7] And from other sources too we learn of families employing established artists as members of their households[8]: thus the Pisani organised a private academy with Pietro Longhi in charge, but this seems to have done little more than provide their son Almorò with drawing lessons and it came to an end with his death.[9]

Yet if we look rather more carefully we see that this patronage was more restricted in nature and scope than at first appears. Moschini was, after all, rebutting a charge that the arts owed nothing to Venetian support, and though this is clearly false, the type of art required was certainly very limited. Thus the patrician insistence on his own glorification inevitably led to a great concentration on the ceiling fresco. We know too

[1] Lodovico Arnaldi: *Orazione in lode di Marco Foscarini Doge di Venezia*. See also De Brosses, II, p. 39.
[2] Novelli, p. 16.
[3] G. A. Moschini, 1808, p. 139.
[4] Gradenigo, p. 91.
[5] Though prints taken from drawings by Tiepolo of Oriental heads were dedicated to him.
[6] Sebastiano Molino: *Orazione in lode di Marco Foscarini Procurator di S. Marco*.
[7] G. A. Moschini, 1806, III, p. 49.
[8] Such as the Zenobio employment of Carlevarijs (Mauroner, p. 15); the Miani of Camerata and the Baglione of Polazzo (Alessandro Longhi); and the Zambelli of Pittoni at the end of his life (G. A. Moschini, 1806, III, p. 70).
[9] Gallo, 1945, p. 53.

from travellers that pictures were hung on walls to fulfil a purely decorative function. 'The Venetians cover their walls with pictures, and never think their apartments properly finished until they have such as shall fill all the spaces from top to bottom, so as completely to hide the hanging. This being their object, there are in all the collections many more bad pictures than good; and on entering a room, the number of paintings are such, that it is not till after some recollection you can discriminate those pictures that merit attention, from amongst a chaos of glowing colours that surround them; and which are frequently so ill classed, that a picture which requires to be hung high, is perhaps the lowest in the room, whilst another that cannot be seen too close, touches the cornice: this is occasioned by their great object of covering the walls, never considering what light etc. may suit their pictures.'[1] By the early eighteenth century this aim had been achieved for most of the older patrician families. If we examine their inventories we are again and again struck by the fact that the commissioning or buying of contemporary pictures declined very considerably after this period.[2] The last generation of artists to be adequately represented in Venetian collections is that dating from the very end of the seventeenth century. The Pisani, for instance, by far the most lavish family of the time and for some years during the youth of Almorò (1740-66), himself an amateur artist, the special patron of the landscape painter Giuseppe Zais,[3] bought for their palace at S. Stefano only a few pictures painted after 1720, and while the number of contemporary paintings in their country house at Stra, built in the 1740s, is much larger, it is still noticeably inferior to that of the previous century.[4]

The decline of art patronage during the eighteenth century was in fact much discussed at the time—'I don't find', wrote one observer in 1745,[5] 'that these nobles like spending money on pictures'—and various reasons were given for it, most of which amounted to little more than well-worn diatribes about the corrupt state of the age. While these can be accepted only with caution—corruption (even decadence) and the fine arts have often proved the happiest of bed-fellows—it is difficult to find more concrete reasons. New fashions in interior decoration certainly played some part in limiting the amount of wall space, and in the palaces of older families galleries were already filled with the accumulation of centuries. But these factors cannot have been decisive. The economic situation is still more difficult to assess. It is certain that many extremely important families drastically declined in wealth during the century and that money became more and more restricted to a small inner group.[6] The Foscarini, who lived opposite the Carmini, were rumoured to be the richest family in the city and to

[1] *Letters from Italy . . . in the years 1770 and 1771 to a friend residing in France by an English woman*, London 1776, III, p. 274.

[2] A number of Venetian inventories of the eighteenth century are included in C. A. Levi's collection of 1900. Others are still unpublished in the Venetian archives, especially those of the Seminario Patriarcale, where MSS. 788.13 contains those drawn up by Pietro Edwards at the downfall of the Republic.

[3] Muraro in *Emporium*, 1960, pp. 195-218.

[4] Gallo, 1945, pp. 140 ff.

[5] Letter from P. E. Gherardi to L. A. Muratori of 20 February 1745 in Biblioteca Estense, Modena.

[6] Beltrami, 1954.

have an annual income of 32,000 *zecchini* a year.[1] At the very opposite end of the scale it has been estimated that bare subsistence could just be maintained on about 15 *zecchini* a year.[2] If we compare some of the prices charged by different artists we can see that, in the most successful cases, foreign competition kept them very high. Thus at the very outset of his career Canaletto was charging about 22 *zecchini* a picture; within ten years he had raised his price to 120 *zecchini* and this was understandably considered to be exorbitant. A miniature by Rosalba Carriera cost 50 *zecchini* and a pastel 20 or 30 depending on whether it was to include one or both hands or flowers. Curiously enough, large history paintings and even full-scale decorations were less expensive, comparatively speaking, than the small works of fashionable artists with a cosmopolitan clientèle. Thus Piazzetta's large picture of the *Angelo Custode* was valued at about 100 *zecchini*, and Tiepolo, who was himself required to pay for the canvas and pigments, was given only the same sum in 1743 for his *Martyrdom of St John the Bishop* in Bergamo Cathedral, and only 500 *zecchini* in 1754 for his frescoes in the dome of the church of the Pietà in Venice.[3]

The new nobles, who had to pay nearly 30,000 *zecchini* to be enrolled, were obviously not worried by problems of space or money, and their reluctance to buy contemporary pictures is still harder to explain. For an extensive gallery was a necessary corollary of nobility, and it is striking that the only patrician family to have built up a collection of pictures in the eighteenth century were the Grassi, who had bought their way into the aristocracy in 1699. But they seem—deliberately, perhaps, so as to emphasise their ancient lineage—to have ignored contemporary artists altogether and to have turned instead to those same old masters who could be found in such numbers in the galleries of older families: Titian, Veronese, Bassano, Van Dyck, Guido Reni, Guercino, Schiavone, Fetti and Rubens.[4] One wonders who began to paint the ancestral portraits.

The Labia were not much more adventurous in their choice of pictures: for them too art seemed to stop at the end of the seventeenth century, though they owned a portrait by Tiepolo as well as his frescoes, and employed Cignaroli for a time[5]; only the Giovanelli, ennobled in 1668, bought works by Tiepolo, Piazzetta, Canaletto and Zuccarelli as well as old masters.[6]

[1] The figures that follow are intended to give only the most approximate indication of monetary relationships: they do not take into account changes in the value of money at different times in the century. I have deliberately changed all currency into the unit of the *zecchino*, making use of the tables in De La Lande, VII, p. 81. The estimate of the Foscarini income is derived from a letter of Pietro Visconti who was working there in 1749—See p. 259, note 3. [2] Berengo, 1956, p. 86.

[3] For the prices mentioned see p. 264, note 6, p. 273, note 1. p. 276, note 1, and p. 292, note 4.

[4] Moschini, 1806, II, p. 105.

[5] See the unpublished Labia inventory of 1749 referred to in note 8, p. 250. The Tiepolos in the collection were described merely as *Ritratto con cristallo* and *Una Palla*. For Cignaroli see Bevilacqua. He worked for the Labia for four years and some of the oil paintings which he inserted into ceilings in the palace are still *in situ*.

''Ad ornato dei mezzani di sopra,' wrote Gio. Battista Biffi of the Palazzo Giovanelli in 1773, 'vi sono a carra i quadri di Paolo, di Palma, di Tiepolo, di Farinato, Le tavole greche del quattrocento, e senza numero i bei pezzi originali di Tempesta, di Zelotti, di Canaletto, di Piazzetta, e del mio Zuccharelli. . . .' Biblioteca Governativa, Cremona, MSS. aa.I.4. I am most grateful to Professor Franco Venturi for showing me the microfilms he had made of this correspondence.

Thus, apart from magnificent ceiling decoration, the nobility was not very imaginative in its support for the arts during the first half of the eighteenth century, and, in fact, we only find one patrician of any individuality as a patron and collector—Zaccaria Sagredo (Plate 48b).

The Sagredo were among the oldest of Venetian families and during Zaccaria's own lifetime they gave to the Republic one of its most impressive Doges, Niccolò, though he only lived for eighteen months after his election in 1675. There could have been no greater contrast between this decisive, haughty politician and his nephew the young Zaccaria, then aged 21. Though he too, like all Venetian aristocrats, was destined for public service, his ambitions clearly lay elsewhere, and he never achieved any higher post than the governorship of Bergamo in 1690.[1] He used his considerable resources to amass a large collection of paintings, drawings, sculpture, books and armour which in his later years won him the reputation of being the greatest patron of his day in Venice[2] and among foreign visitors that of being just about the only one. When John Breval came to the city in the late 1720s he said that he 'could hear of but one remarkable Dilettante, the noble Sagredo'.[3] This reputation was not wholly to his liking. For Zaccaria Sagredo seems to have been of a quite excessively nervous temperament and to have carried his scruples about meeting foreigners to an extreme. On one occasion he was seen hurrying 'down Stairs . . . as if the House had been on fire' to avoid such a perilous contact.[4] He never married, and he filled his palace at S. Sofia with paintings old and new, bought from previous collectors, commissioned directly from the artist or picked up at exhibitions.[5] He made anxious though, as it proved, unavailing provision for his collection to be kept intact after his death by putting it in charge of his favourite servant Tommaso de' Santi and leaving it to his nephew Gherardo.[6] And then in 1729 this timid, acquisitive, art-loving bachelor died. Gherardo survived him for ten years,

[1] Because of his retiring private life, information about Zaccaria Sagredo is scarce. Barbaro in the *Arbori de patritii veneti* (Archivio di Stato, MSS. VI, c. 507) says merely that he was born on 15 October 1653, the son of Steffano Sagredo and Vienna Foscarini, and that 'Fu Pod.a a Bergamo fece una Galleria di sculture, pitture, e stampe' and died in May 1729.

[2] Da Canal, p. 36: 'possiede per quadri. disegni, medaglie ed armi antiche una delle più ricche gallerie dell'Europa'. Moschini, 1806, III, p. 93, calls him 'grande amico della pittura'.

Keysler, who must have arrived in Venice soon after Zaccaria's death in 1729 (*Travels*, 1757, III, p. 295, and Schudt, 1959, p. 69), reported that the celebrated gallery 'consists chiefly of antiquities, natural curiosities and especially foreign arms and weapons', but he was in fact unable to get in as repairs were under way. Cochin, III, pp. 143-50, discussed many of the pictures in the collection.

An anonymous manuscript in the Biblioteca Correr—Cod. Gradenigo 185, cc. 379-86—called *Serie delli Nobili Veneti, e Cittadini Professori di Belle Arti, e delli dilettanti raccoglitori di cose antiche, e rare, e così delli scopritori, e inventori di valevoli industrie* mentions under the date 1710 'Zaccaria Sagredo con grandis.a spesa aveva per suo diletto proveduto a miliare di stampe, e carte disegnate da primi, e valenti uomini del mondo'.

[3] Breval, 1738, I, p. 230.

[4] Edward Wright, I, p. 77.

[5] He bought his Carracci drawings from the Bonfiglioli family in Bologna (Bottari, II, p. 186); he commissioned pictures from Crespi (Zanotti, II, p. 62); he bought Piazzetta's *Angelo Custode* at the S. Rocco exhibition (d'Argenville, I, p. 319).

[6] Zaccaria Sagredo's will is in the Archivio di Stato, dated 22 May 1729, notaio Pietro Grigis—17:93. The relevant passage reads: 'Per ciò voglio, et Intendo primieramente, che havendo fatto una

but after his death aged 49 in 1738, plans at once began to be made for the dispersal of the collection so lovingly built up.[1] Horace Walpole, travelling in Italy between 1739 and 1741, heard of the proposed sale.[2] So did Francesco Algarotti two or three years later.[3] In fact, the collection was broken up piecemeal over a long period. Sagredo's heirs, who were much less cautious than he had been, got in touch with anyone interested and had no scruples about selling to foreigners. Both the British Consul, Joseph Smith,[4] and his successor, John Udney, were among those who came to buy.[5]

The importance of the collection and its contemporary prestige can be gauged from the fact that in 1743 both Tiepolo and Piazzetta were required to draw up inventories, and were followed nearly twenty years later, in 1762, by Pietro Longhi.[6] It is from their work and from general contemporary eulogies that we have to derive most of our information about Zaccaria Sagredo as a patron and collector. Unfortunately it is very difficult to appraise the evidence, for there were already many pictures in the family collection before Zaccaria himself added his individual contribution. Thus the battle scenes by Borgognone, which were among the most highly valued pictures in the gallery, were painted for Doge Niccolò,[7] and many of the others later recorded in the palace must date from this or earlier periods.

It was not until ten years after this that Zaccaria, on the death of his father, became head of his branch of the family, but we first begin to hear of his passion for art very much later when he was already an old man.[8] Even in these last years of his life, however, Sagredo's sympathies extended to the younger generation of Venetian artists.

Spesa considerabile nella compreda di libri, carte, dissegni, et Arme, e Quadri, perche il tutto non vada dissipato, et con il progresso del tempo l'anienti, per ciò ellego Tomaso de Santi mio cameriere, acciò ne habia del tutto una particolar custodia, e cura, non sol della sudetta roba, come pure delli apartamenti, ove di presente s'atrova annichiata, volendo sperare, che come con tutta pontualità, et amore, mi hà sempre servito, cosi sarà per fare nel presente carico, che hora gl'ingiongo, et acciò egli possa vivere honorevolmente e senza essere distratto, intendo, ordino e voglio che gli vengono corisposti del mio erede annualmente di mesi trè in mesi trè, sempre anticipatamente, ducati correnti da 76.4 l'uno numero cento. . . . Residuo poi di tutti et cadauni miei Beni, mobili, stabili, prnti e futturi . . . lascio al Nobil Homo M. Girardo P.o Sagredio mio Amatissimo Nipote. . . .'
He left a Rubens and 'un Ritrato del Moron' to a friend, Sig. Salvator Varda.

[1] See 'Inventario del 1738 tempo della morte del Proc.r Sagredo' in Biblioteca Correr, MSS. P.D. C2193/IV.

[2] Horace Walpole, 1767, p. viii.

[3] Posse, 1931—Letter No. 8 of July 1743 reports that the pictures were to be sold as a complete collection.

[4] See the document from the Sagredo archives published by Blunt, 1957, p. 24, which shows that Smith was buying paintings and drawings from Zaccaria's heirs in 1751-2.

[5] In the Sagredo archives (Biblioteca Correr—MSS. P.D. C2193/VII) is a list of pictures dated 1762 'ricercati dal Sig. Zuane Udni Console d'Inghilterra'.
I am grateful to Sir Anthony Blunt for pointing out to me that some Sagredo pictures appear in an anonymous sale, 2 February 1764, Prestage, 1st day, lots 89 ff.

[6] M. Brunetti, 1951, pp. 158-60. The Longhi inventory has not been lost, as Brunetti maintains, but still survives with the other Sagredo papers in the Biblioteca Correr—MSS. P.D. C2193/I.

[7] Baldinucci, VI, 1728, p. 421.

[8] Thus of the few pictures listed in the various eighteenth-century inventories which must have been painted between 1685 and 1729 (the only ones that it is safe to assume were directly acquired by Zaccaria

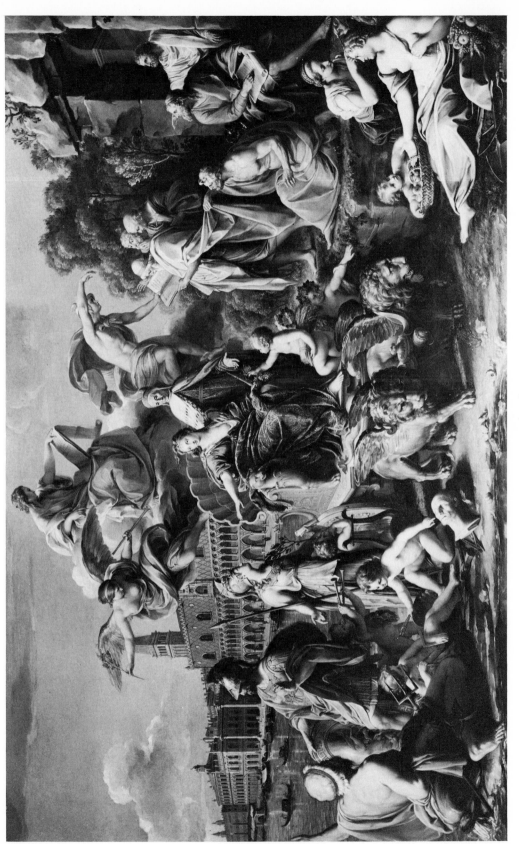

Plate 45

BATONI: Triumph of Venice

Plate 46

VENETIAN ARTISTS IN ENGLAND DURING THE EARLY YEARS OF
THE EIGHTEENTH CENTURY (*see Plates 46 and 47*)

PELLEGRINI: Pierre Motteux and his family

Plate 47

Marco Ricci: An operatic rehearsal

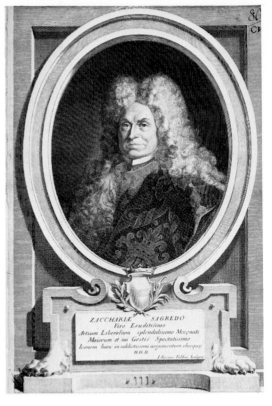

a. PITTERI: Flaminio Corner

b. FALDONI: Zaccaria Sagredo

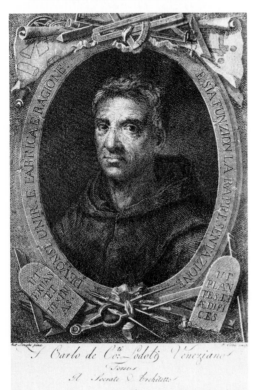

c. ALESSANDRO LONGHI: Carlo Lodoli

d. ANONYMOUS: Francesco Algarotti

Thus at one of the annual exhibitions at S. Rocco he bought Piazzetta's *Angelo Custode*, a huge altarpiece which the painter had been unable to dispose of elsewhere.[1] This picture was certainly the most important of his modern acquisitions. Both Tiepolo and (more obviously) Piazzetta himself agreed in valuing it very highly when they drew up an estimate of the collection; and Venetian and foreign visitors alike were aware of its fame.[2] Zaccaria Sagredo may well have been in touch with Tiepolo himself at an early stage in the great artist's career: an unidentified ceiling by him and several drawings were recorded in 1743, and though the former may have been commissioned after Zaccaria's death, the drawings were almost certainly acquired by him. Furthermore, sometime after 1721 Tiepolo drew for the engraver Andrea Zucchi the statue of *Virginity* by the sculptor Antonio Corradini in the church of S. Maria del Carmelo and this was dedicated to Zaccaria Sagredo 'who by means of his nobility, authority and generosity cherishes and promotes the fine arts'.[3] Sagredo was also among the very first patrons of Canaletto: he owned at least one view by him before the end of 1725 and he was interested enough in his career to comment on pictures painted for other clients.[4] It is finally just possible that Zaccaria Sagredo commissioned a work by one other artist destined to make a great name for himself later in the century, though here the results were less fortunate. Pietro Longhi put the date 1734 on the clumsy fresco of *The Fall of the Giants* which he painted on the staircase of the Palazzo Sagredo, but this must refer to the completion of the work, and there is reason to believe that he began it at the outset of his career very much earlier and consequently that the commission came from Zaccaria himself.[5] Certainly the old man went on collecting until the very end of his life. G. M. Crespi, who painted two religious works for him, wrote from Bologna in July 1729 that his patron's death had been hastened by the tricks played on him by dealers. 'He died a few days ago after having spent between seven and eight thousand *zecchini* on pictures and drawings, many original, most of which were not worth a *piastra*.'[6]

himself) there are some religious canvases by the German Johann Karl Loth and some portraits by Niccolò Cassana—certainly nothing that can remotely justify the claims made for Zaccaria's patronage in his own day. In fact it is certain that he bought many old masters which are quite impossible to identify among the many hundreds in the collection; and equally certain that as early as 1743, the date of the first inventory, many pictures had already been disposed of.

[1] Haskell and Levey, 1958, p. 182.

[2] Part of the picture is now in the Detroit Institute of Arts. Cochin, III, p. 150, who in 1758 wrote an account of the pictures then in the Sagredo palace, called it a 'tableau fort beau'.

[3] See print 428 in Vol. 3 of Raccolta Gherro in the Biblioteca Correr dedicated 'A Sua Ecc. il Sig. Zaccaria Sagredo, che con la nobiltà, autorità, beneficenza favorisce e promuove le belle arti. . . .'

[4] See letters from Alessandro Marchesini to Stefano Conti, dated 11 August and 1 December 1725 published by Haskell, 1956, p. 298. [5] See the arguments of V. Moschini, 1956, p. 12.

[6] The pictures were a *Nativity* and a *Mission*—L. Crespi, p. 215. The latter may be the pictures described as a 'Jesuit Mission' now in Chicago.

Crespi's letter to Stefano Conti of 4 July 1729 is in the Biblioteca Governativa, Lucca—MSS. 3299: 'Se così fatto avesse (come più e più volte pregato) l'Ecc.mo Zachario Sagredo Nobile Veneto, la quantità degl'inganni non gli avrebbero affrettata la Morte. Morì giorni sono doppo havere Speso più di 7000, in 8000 Zecchini in tanti Quadri, e disegni molti originali, la maggior parte che non valevano una Piastra.'

Despite his probable contacts with Tiepolo, Piazzetta, Canaletto and Longhi so early in their careers and so late in his, our knowledge of Sagredo is so slight that we would scarcely pay much attention to him as patron were it not for the enthusiasm of his contemporaries. But about one aspect of his collecting we are very much better informed, and here Sagredo's supremacy over any other aristocratic rival is so evident that it is possible for us to understand the extent of his reputation. He was a passionate collector of prints and drawings. Indeed, John Breval wrote that he 'is reckoned to have the largest Collection of Prints of any man in Europe', though he added rather unfairly: 'This is the only Branch of Virtù that Gentleman is famous for.'[1] In the inventories of the Sagredo collection drawn up some years after Zaccaria's death there are many volumes of drawings which we can assume to have been assembled by him. They include works attributed to Rembrandt and the German old masters as well as to contemporaries such as Tiepolo, Piazzetta, Cimaroli, Silvestro Manaigo and others. From Moschini we learn that Sagredo commissioned 100 views in pen and ink from the Brescian artist Andrea Torresani[2]; other sources tell us that he bought at a high price 'all the rare and very correct drawings of Lazzarini, and also bound into a volume all the drawings of the Bellunese [Gaspare] Diziani'.[3]

In later years these drawings were sold by Zaccaria's heirs, and among those who bought several complete volumes was the Englishman Joseph Smith. As these still survive in the Royal Collection we can gain some measure of Sagredo's connoisseurship. Thus the Carracci drawings there come from three volumes which he bought towards the very end of his life from the famous Bonfiglioli collection in Bologna.[4] This purchase, which included fine sheets by Raphael[5] and 'numbers of Original Pieces by the greatest masters', attracted much attention among connoisseurs of the day.[6] However, another of Sagredo's possessions was of very much greater importance for the future of Venetian eighteenth century taste and art: this was his magnificent set of drawings, the finest in existence, by the Genoese artist Giovanni Benedetto Castiglione.[7] In the generation after Zaccaria's death prints and drawings by this master were to be enormously admired in Venice and throughout Europe—with good reason, for his brilliant fluency and cult of the 'picturesque' anticipate much that was most vital in rococo draughtsmanship. The connoisseur Francesco Algarotti was keen to purchase Sagredo's volumes for the King of Saxony, but they were in fact obtained by Joseph Smith, who was also given a large number of additional Castiglione drawings by Algarotti himself. Another connoisseur, Antonio Maria Zanetti the Elder, himself a friend of Sagredo, was also a lover of Castiglione and in 1759 engraved twelve of his drawings.[8] Of greater

[1] See p. 263, note 3.
[2] G. A. Moschini, 1806, I, p. 84.
[3] Da Canal, p. 77, and Fontana, p. 64.
[4] See Smith's will published by Parker, 1948, p. 60.
[5] Popham and Wilde, 1949, p. 14.
[6] Letter from A. M. Zanetti to Francesco Gabburri of 11 January 1728 published in Bottari, II, p. 186.
[7] See especially Blunt, 1954, p. 24.
[8] See later, Chapter 13.

significance was the admiration that Tiepolo felt for Castiglione. We know that he himself owned a monotype by the artist, and his passionate study of his great Genoese predecessor is apparent in the subject-matter and technique of his own etchings, as Algarotti was the first to point out.[1]

This admiration for Castiglione's prints and drawings only became fervent and widespread after Zaccaria Sagredo's death, but he seems to have been the first in Venice to have experienced it, and to have collected these works by the master on an extensive scale. The drawings were chosen with great care and were said to have been bought by Sagredo for 1500 *zecchini*.[2] We have no certain knowledge of who sold them to him, but one source seems very likely. In 1706 Ferdinando Carlo Gonzaga, the last Duke of Mantua, sought refuge in Venice from the invading Austrians.[3] Two years later, 'usé par la débauche, malade de la goutte', he died in Padua at the age of 56. In the meantime, however, he had had sent to him over 900 pictures from the ducal collections, which before his death he had widely distributed among his courtiers. Eventually the Duke of Lorraine successfully established his claim to be heir to the Gonzaga effects, but despite this a great number of pictures from Mantua turned up on the Venetian market. Rosalba Carriera bought two for the Elector Palatine and the German collector Field Marshall Schulenburg bought a large batch[4] among which were several Castigliones, for this artist had been court painter at Mantua for over twenty years. Although there is no specific reference to drawings among the works of art sent to the Duke in Venice, either Ferdinando Carlo himself or someone in his immediate entourage may well have owned the large quantity from which Sagredo made up his volumes—especially as some of them specifically relate to pictures that Castiglione painted at Mantua.[5] But whatever their origin, Zaccaria Sagredo's main title to fame as an important pioneer in taste depends on his collection of these drawings. And, on a more personal level, the thought of the old man poring over the sad, secret poetry of Castiglione gives us an insight into his character which is missing from the all too scanty records that have survived.

– ii –

During the seventeenth and eighteenth centuries Venice maintained that independence from Rome that had long marked her policy—though financial necessity compelled her in 1657 to readmit the Jesuits in return for papal support. Within the State itself, however, the government insisted on a policy of religious orthodoxy that was as rigorous as anything that Rome could have desired—for it was a maxim, held even by the sceptical, that religious and political dissent went hand in hand.[6] There were doubts sometimes about the depth of Venetian piety; never about the lavishness with which

[1] See later, Chapter 14.
[2] According to Smith's will—Parker, 1948, p. 60.
[3] Fochessati, p. 278.
[4] Malamani, 1899, p. 46, and see later, Chapter 11.
[5] Blunt, 1954, p. 36.
[6] See, for instance, the attitude of Casanova as described by A. Bozzòla.

it was expressed.[1] Such lavishness was natural enough, for throughout the seventeenth and first half of the eighteenth centuries the Church, and in particular the religious Orders, were constantly growing in wealth, despite frequent and unsuccessful attempts by the State to stop this process. When in 1767 it was at last decided to forbid secular property passing into clerical ownership, it was discovered that although the clergy amounted to only two per cent of the population, the income from their land was almost equal to that of the rest of the Republic.[2]

And so the Church retained or even increased the position she had always held as the leading patron of contemporary art in Venice. Of the history painters in the city virtually all devoted well over half their work to the Church, and in many cases the proportion was considerably higher. Of Cignaroli in Verona it was claimed that like Barocci and Carlo Dolci (significant parallels) for years he painted almost nothing but saints,[3] though many of these must have been for private devotional pictures. With its constant demand for altarpieces the Church provided a market for modern painting that was lacking elsewhere.

Clerics were excluded from holding political office, but in fact they were inextricably associated with the government, as all the great ecclesiastical posts were in the hands of the nobility who—as a traveller pointed out[4]—had no other outlet for their younger sons, trade being considered dishonourable. It is not therefore surprising that the decoration of churches reflected patrician ideals fully as much as that of their palaces. Thus the haughtiness of the Virgin and Saints as seen by Piazzetta and Tiepolo, so different from most seventeenth-century religious painting, clearly shows the projection of aristocratic principles into sacred history.

Many nobles were, indeed, themselves directly responsible for the commissions involved and employed their own favourite artists in palace and church alike. Thus the Manin offered in 1706 to decorate the choir, transept and High Altar of the Cathedral at Udine. They tried unsuccessfully in the face of rivalry to build the High Altar of the church of the Scalzi in Venice and later took over the decoration of one of the chapels there; finally they were responsible for building the façade and the High Altar of the Jesuit church.[5] Whenever they could they made use of the painter Louis Dorigny, who also decorated their villa at Passeriano.

Most of the religious Orders had very rich backers and they were consequently by far the most important patrons of modern painting and architecture in early eighteenth century Venice. 'It is a disgrace', wrote one observer in 1743,[6] 'that monks find vast

[1] Thus [Etienne de Silhouette], I, p. 156: 'Si le grand nombre et la magnificence des Eglises ne prouvent pas leur piété, ils prouvent au moins qu'ils veulent paroître en avoir. . . .'

[2] Tabacco, p. 123. [3] Bevilacqua, p. 32.

[4] Burney, I, p. 140.

[5] Coggiola-Pittoni, 1935, p. 304; L. Ferrari, 1882, p. 22, and Biblioteca Marciana, MS. Ital. Cl. VII, 1620—*Libri di Memorie di Antonio Benigna*: 'NN.HH. S. Ant.o e S. Nicolò Fratelli Co:Co:Manini . . . a sue spese fatto erigere l'Altar Maggiore [of the Jesuit Chuch] tutta la Incrostradura di Verde antico à rimesso per tutta la Chiesa, con li Organi, e Oratorij, Pavimento, con il Soffitto a Stucco dorato et la Facciata di Fuori. . . .'—1729.

[6] [Girolamo Zanetti]: 22 Maggio 1743—published, 1885, p. 129.

sums to build their magnificent and splendid churches—such as the Jesuits and Domini-
cans, for instance—whereas the parishes only get the smallest help and have to wait for
years and years before their churches are ready for use.' The complaint was not wholly
justified. Parish churches, such as S. Tomà and S. Vitale, were either rebuilt or richly
decorated with remarkable speed. So too was S. Matteo di Rialto, about which we hear
that after 'the priest had in 1735 collected alms from his parishioners and other pious
people . . . he renovated it within a few months . . .'.[1] But it is true that for a period of
about a quarter of a century after 1720 the churches of the Carmelites and Dominicans,
Oratorians and Capuchins were being filled with many of the most striking paintings
and frescoes of the day.

The Scalzi, for instance, a particularly strict off-shoot of the Carmelite Order,
came to Venice in 1633.[2] After some difficulties they became closely linked with many
leading nobles and won special sympathy through their missionary work in the Pelo-
ponnese and their intimate association with the Venetian troops out there. Such was
their popularity that their original church became much too small, and Longhena and
Sardi were employed to build a new one. Nobles quarrelled for the privilege of erecting
the High Altar, and the façade, which cost 74,000 ducats, was paid for by a Conte
Cavazza, who had been admitted to the patriciate in 1653.[3] Though it was widely
praised as 'the most magnificent frontage not just in Venice but possibly in the whole
of Europe',[4] such luxury became embarrassing for an austere Order and in 1732 an
anonymous pamphleteer was called upon to justify the expense.[5] It was not true, he
commented, that the money could have been better spent on relieving poverty. What
about Christ and the ointment of Mary Magdalene? And St Peter's in Rome and St
Mark's in Venice? Worship of God was fully as important as looking after the poor. It
was not true that such a rich church conflicted with the spirit of poverty associated with
the Order. Their living-quarters were to be austere, but 'the Tabernacle of God must be
built with magnificence'. It was not true that the monastery had been despoiled to
decorate the church. The condition of the monks had not changed during the years that
the church was being built. In any case the monastery had no capital and it had no debts.
Benefactions had been considerable, and the Venetian public was too generous to
withhold alms from the monks because of the luxury of their church. But the most
interesting complaint that the writer had to answer concerned taste rather than morals.

[1] Corner, p. 163. Another parish church, S. Stae, was given a façade in 1709 from the proceeds of a
legacy of Doge Alvise Mocenigo; while a bourgeois, Andrea Stazio, left nearly 200 ducats for further
building and decoration. Some of this was spent on pictures in the choir painted by a remarkable group
of artists that included Piazzetta, Sebastiano Ricci and Tiepolo. Unfortunately, Stazio's will in the Archivio
di Stato (Sezione Notarile, Atti Giovanni Zon 1283:27) gives us no information about who actually
commissioned these pictures.

[2] L. Ferrari, 1882.

[3] Bianchini, 1894, p. 11.

[4] Pöllnitz, II, p. 149.

[5] *Risposta ad un amico sopra certi riflessi falsamente concepiti contra la Chiesa dei Carmelitani Scalzi a
Venezia*—a pamphlet of 32 pages by M.A.—published by Luigi Pavini in 1734 (Marciana, Misc. 1135,
n. 3) referred to by Ferrari, 1882.

So much richness, it was protested, above all so much gold, was out of keeping with the rules of good architecture. And here he could do no more than counter with the Temple of Jerusalem, and the churches and palaces of Tuscany, Rome and Bologna. The complaint certainly had force, though it was not insisted on, for the church was decorated in the full Baroque style of Roman grandeur and marked a break with the Palladian tradition which had always dominated ecclesiastical architecture in Venice and was soon to do so again. Rich families, old and new, employed Lazzarini, Bambini and Dorigny to supply pictures and frescoes. Above all Tiepolo was called in on several occasions to help with the decoration culminating in the superb ceiling fresco of 1745 which showed the Holy House of Nazareth being carried by angels to Loreto—a theme designed to celebrate a painting of the Madonna from the island of S. Maria di Nazareth which had been given to the Scalzi on their arrival in Venice.[1]

The patronage of their mother Order, the Carmelites, was fully as splendid. In 1708 Sebastiano Ricci frescoed one chapel in the church of the Carmini, and nearly half a century later his pupil Gaspare Diziani painted four large pictures for the same church.[2] Tiepolo painted one of his earliest works, the *Madonna del Carmelo*, in about 1720 for a chapel belonging to the Order in the church of S. Aponal[3]; while twenty years later he produced some of his greatest masterpieces for them—the frescoes on the ceiling of the principal room in the Scuola Grande dei Carmini, the headquarters of an association of non-noble laymen and religious under the general inspiration of the Carmelites.[4] Piazzetta painted his *Judith with the Head of Holofernes* for the same group, and many other leading painters were also employed by them.[5] It was, incidentally, a Carmelite, Padre Jacopo Pedozzi, Secretary General of the Order and a man 'very highly thought of, especially by the Venetian nobility', who was one of the very first patrons of Canaletto.[6]

Scarcely less imposing as patrons were the Dominicans, for whom between 1725 and 1727 Piazzetta painted his only frescoes, *The Glory of St Dominic*, in a chapel in the church of SS. Giovanni e Paolo. At much the same time another branch of the Order, the Gesuati, were beginning to employ Giorgio Massari to build a complete new church on the Zattere, financed largely by public support, a fact that they too, like the Scalzi, were very keen to emphasise.[7] When one visitor was taken round by one of the Gesuati fathers in 1742, he spent much time 'looking at the fine interior of the new church, decorated with beautiful paintings and chiaroscuri on its brilliantly lit vault, with

[1] Fogolari, 1931, pp. 18-32.

[2] Lorenzetti, 1956, p. 551.

[3] *Mostra del Tiepolo*, 1951, p. 8. The picture is now in the Brera.

[4] Documents for this commission are published by Urbani de Ghelthof, 1879, pp. 100-17.

[5] Lorenzetti, 1956, p. 553.

[6] Letter of Alessandro Marchesini to Stefano Conti dated 11 August 1725 in Biblioteca Governativa, Lucca, and Zarzabini, p. 19.

[7] [Girolamo Zanetti] wrote in 1743 that the Dominicans were still collecting alms all day long for the building of their church. It had been begun in 1725, when Benigna reported (Marciana, MS. Ital. Cl. VII, 1620): 'Li RR.PP. Domenicani Osservanti sopra le Zattere hanno principiato à dirroccare portione del suo convento, et ivi fabbricare la nuova Chiesa sopra il modello di quella del Redentore.'

sumptuous altars of marble in its seven chapels, with new seats in the choir and the floor entirely in marble; of the best architecture and proportions in the interior and an equally fine façade. And he told me that until now 120,000 ducats had been spent on it. When I began to congratulate him on the extent of his funds, he told me that the whole of that vast sum had come entirely from alms.'[1] The ceiling fresco of *St Dominic instituting the Rosary* was painted by Tiepolo between 1737 and 1739, during which years Piazzetta produced an altarpiece of *Three Dominican Saints: Vincent, Hyacinth and Lawrence*. It was not until 1748 that Tiepolo produced his own altarpiece of *Saints Agnes, Rosa and Catherine* for which the contract had been signed in 1740. A few years earlier Sebastiano Ricci had painted the first of these series of Dominican Saints: *Pope Pius V, Thomas Aquinas and Vincent Ferrer*—one of his last and most magnificent works.[2]

The note of exaltation and triumph was particularly suitable for a church that was at the centre of the most combative religious organisation in eighteenth-century Venice. It was from the Gesuati and the adjoining monastery that Padre Daniele Concina poured out a stream of invective against the Jesuits that accentuated the already bitter rivalries between the two Orders and it was he who was among the first to suggest that the Society should be suppressed.[3]

The Oratorians also commissioned altarpieces in 1724 and 1732 from Piazzetta and Tiepolo for their new church of the Fava, and during the middle years of the century they employed other leading artists such as Balestra, Amigoni and Cignaroli.

Another Order, the Capuchins, reached the peak of their glory in 1734 when one of their number, Fra Francesco Antonio Correr, was made Patriarch of Venice.[4] A few years later Tiepolo painted a canvas of *St Helen finding the True Cross* for the ceiling of their church at Castello.

This extraordinary prolongation of the Counter Reformation well into the eighteenth century, with the religious communities rivalling each other in the splendour of their commissions to the principal artists,[5] is notable for the absence of the Order that had played such a conspicuous part at an earlier stage in the movement—the Jesuits. This is not altogether surprising, for by the very nature of their absolute subjection to the papacy, the Society had never been popular in Venice.[6] Reluctantly readmitted in 1657 after some fifty years of exile, only after another half-century did the Jesuits begin to build a vast new church. Their resources, like those of many other Orders, came mostly from the exceedingly rich, but only recently ennobled, Manin family. When, years later, the Jesuits were under bitter attack in Venice, it was specially mentioned in

[1] Letter from P. E. Gherardi to Muratori of 26 October 1742 in the Biblioteca Estense, Modena.

[2] Arslan, in *Rivista di Venezia*, 1932, p. 19, and Lorenzetti, 1956, p. 30.

[3] For a general discussion of Concina's thought see Alberto Vecchi, 1960. There are a large number of works by him in the British Museum.

[4] Tentori, X, p. 288.

[5] Among patrons of the older established Orders the Benedictines were especially active. Tiepolo, Pittoni, Ricci and Trevisani were all employed by the nuns of SS. Cosma e Damiano alla Giudecca.

[6] Though Cardinal de Bernis (I, p. 421) said that in the 1740s the Jesuits were 'dans le plus grand crédit'.

a hostile pamphlet that 'they had managed to extract from a single family the enormous expense of their magnificent church'.[1] In fact, they were merely following a general precedent, but although both the exterior and the interior with its fantastically rich coloured marbles are as splendid as any in Venice and indeed were claimed to put all others in the shade,[2] the church, dedicated to the Assumption of the Virgin, remains geographically and artistically isolated from those of the other religious Orders. None of the leading painters left work there,[3] and Fontebasso, who frescoed the ceiling, depicted on it *The Three Angels visiting Abraham*, which had no specific relationship to Jesuit iconography, and *Elijah carried to Heaven in a Chariot of Fire*, a subject hitherto associated almost exclusively with the Carmelites.[4] Though the Jesuit saints appeared in one or two of the altarpieces, they were given no prominence and the general effect of the church is one of very great wealth but absolute anonymity. The contrast with the Dominicans could scarcely be greater: in S. Maria del Rosario every painting celebrates the triumph and glory of the Order; its great saints, painted in threes by the finest contemporary artists, all lead up to the climax of the ceiling where St Dominic himself is shown instituting the Rosary. In Santa Maria Assunta we are scarcely aware of the Jesuits, whose presence is felt only through the foreignness of the style.

One other wholly new church was erected and splendidly decorated during the first half of the eighteenth century—the Pietà.[5] The original foundation dated back to the fourteenth century when a refuge on the site had been established for exposed children and orphans, and it had soon come under the direct patronage of the Doge and Senate. The first stone was therefore laid by Doge Grimani when in 1745 it was decided to rebuild the church and by 1760 it was described in the *Gazzetta Veneta* as being nearly completed 'and one of the richest and most beautiful works of modern architecture'.

This was true enough, but the effect of grandeur was only achieved after difficulties which reveal the pitiful state into which official patronage of the arts had now sunk compared to that sponsored by private families and religious Orders. The Governors of the Pietà were in a position to draw on all the leading artists in Venice—but not to pay them. Massari was the architect and he commented rather ruefully on the conservative pressures which compelled him to work on orthodox Palladian lines.[6] He would, no doubt, have been still more rueful had he known at the time of this complaint that the façade would not be completed for 150 years. Tiepolo painted one of his most striking works—a *Triumph of the Faith*—on the oval dome between 1754 and 1755,

[1] *Appendice alla prima parte dei Monumenti Veneti in risposta alla lettera di un'uomo onesto*, 1762.

[2] See Pöllnitz, II, p. 152.

[3] [Count Seilern], 1959, No. 170, owns a *modello* for the *Glory of S. Luigi Gonzaga*, a Jesuit saint. Professor Wilde (*Italian Art and Britain*, 1960, p. 170) has very plausibly suggested that this was painted for the canonisation of the saint in 1726 and was probably intended as the sketch for an altarpiece which was never carried out. There is certainly no evidence that this altarpiece, if really planned, was for the Jesuit church in Venice.

[4] Mâle, p. 448. It had, however, been one of a whole series of Old Testament scenes prefiguring the Life of Christ painted by Rubens for the Jesuit Church at Antwerp.

[5] Bosisio.

[6] [Andrea Memmo], 1786, pp. 4 ff.

but although he was paid 500 *zecchini* for this, two years later he himself was lending the Governors of the church 6000 ducats (about three times as much) to help with its further decoration.[1] Five altar pictures were painted by the leading artists of Piazzetta's school, but they were paid for by private donations.[2]

The paintings in all these churches vary in kind—the Dominicans and Carmelites concentrate more on the exaltation of their Orders, the Oratorians seem to have encouraged a mystical ecstasy and, in Tiepolo's *Education of the Virgin*, an unusual tenderness—both qualities more familiar in certain Roman paintings of the early seventeenth century. But these are matters of emphasis rather than of rigorous consistency. In all there is a dominant note of triumph and an avoidance of cruelty or morbidity. Tiepolo's *Madonna del Carmelo* does not show the purgatorial fires, in much the same way that some years later Sebastiano Ricci was asked by his patron Conte Tassis of Bergamo not to show them in a picture of the same subject; Piazzetta even removes the skull that he had included in the preliminary version of *St Philip Neri and the Virgin*.[3]

It is difficult to say how much control was exerted over the artist in such matters. The Scuola del Carmine, about whose patronage we know most, showed extreme determination in securing the greatest artist of the day, Tiepolo: they put moral pressure on him and suggested that he should give precedence to religious over secular commissions.[4] They then asked his advice about the decoration of the main room and left the choice of subject to him. Tiepolo proposed two alternatives. In each case the central panel in the ceiling was to show the Virgin, with the prophets Elijah and Elisha surrounded by angels, handing the scapular to St Simeon Stock. According to the first scheme, this canvas was to be surrounded by eight others illustrating 'the privileges enjoyed by the Confraternity—that is to say the hope that the Brethren have of being saved from damnation through the intercession of the Virgin.' These canvases would therefore represent various doctrinal points such as the rescue by angels of souls in purgatory. According to the second scheme, the surrounding canvases were to depict the virtues which should inspire the Brethren—'Faith, Hope and Charity represented in the way everyone knows' and a host of others. Tiepolo took his descriptions of these from the illustrations in Ripa's standard iconographic Manual (a work he must have known by heart) and this second plan was chosen and carried out with a few modifications.

For the further decoration of the Scuola the governors organised a competition in which artists were invited to submit schemes.[5] The painter Gaetano Zompini, whose idea was accepted, put forward an iconographical proposal of some complexity drawn,

[1] Urbani de Ghelthof, pp. 124-6.

[2] For instance, Pietro Foscarini left money in his will in 1745 for an 'altare di marmo fine' to be erected in the church—Biblioteca Correr, Cod. Cicogna, MMDCCCCXLV—2686.

[3] The *modello* is in the Pennsylvania Museum.

[4] See p. 270, note 4: 'gli amorosi Confratelli sudetti continuarono con destri stimoli, e gli sortì, trattandosi del servitio di Maria Vergine, farle abbandonare hora l'impegno di Milano, et accettare l'opera di questa Scola . . .'. None the less Tiepolo went to Milan first to decorate the Palazzo Clerici.

[5] Battistella, 1930, pp. 38 ff.

so he claimed, from a reading of the Church fathers. This was to be a glorification of the Virgin, particularly as she was prefigured in the Old Testament—as Rebecca, Abigail, Esther, Judith and the Mother of the Maccabees. Like Tiepolo, Zompini must certainly have taken clerical advice, though in fact such schemes were commonplace in earlier churches, and in 1743—some five years before the commission—we know that a Jesuit had preached 'a fine panegyric of the Blessed Virgin, ingeniously comparing her to Esther'.[1] In any case the long plans submitted by both artists show how rigorously programmes were adhered to well into the eighteenth century at a time when iconography is usually considered to be far more casual in inspiration. But they also show how much initiative was left to the artist. A similar practice seems to have been followed in the Pietà, where the governors were required 'to seek plans from the most highly thought of painters with suitable ideas and choose the best'.[2]

We know of one patron of religious art in Venice who had decided views on the subject though he himself was not in fact a priest—through no fault of his own. Flaminio Corner (Plate 48a) was born in 1693.[3] So rigid was he, so unbending even with his friends, that Casanova himself had to admit that 'sa réputation était sans tache'.[4] He had been educated by the Jesuits and as a young man had wanted to enter a monastery. But after the death of his parents and his elder brother he reluctantly agreed to marry so as to prevent the extinction of his family, one of the oldest in Venice. Most of his life was devoted to writing scholarly books in Latin about the early history of the Venetian churches; his palace, in which he assembled a prodigious quantity of relics, was frequented especially by the clergy and by the learned.[5] He seems to have extended his patronage exclusively to religious paintings and sculpture, and he employed for these one artist especially—Giuseppe Angeli. The choice is interesting. Angeli was considered the best of Piazzetta's pupils, and he imitated his master's style long after the latter's death in 1754, confining himself almost entirely to religious painting. In the process he sweetened it, gave it much more intimacy and emphasised the more sentimental elements which he developed into a pietestic mawkishness far removed from the pride and grandeur of Piazzetta's own early paintings.[6] In many ways he is closer to some of the Counter Reformation artists of seventeenth-century Rome than the Venetian painters of his time. Flaminio Corner thought very highly of him and employed him on altarpieces in his parish church of S. Canciano as well as in S. Basilio, where he was one of a group of nobles devoted to propagating the cult of Beato Pietro Aconato, and in the Pietà. For his own private devotions he commissioned from Angeli paintings of the Four Evangelists, a series of the Apostles and various saints.

[1] [Girolamo Zanetti]: 25 Marzo 1743 (published 1885, p. 110).
[2] Urbani de Ghelthof, p. 123.
[3] For all the following see Don Anselmo Costadoni.
[4] Casanova, IV, p. 246.
[5] Biblioteca Correr—Cod. Gradenigo 185: 'Flaminio Corner, Senatore dedito alla Pietà, raccolse una quantità prodigiosa di Reliquie autentiche di Santi in modo che poteva ogni giorno dell'Anno esponere alla Veneratione quella che nel giorno stesso si apparteneva secondo il Rito di S. Chiesa.'
[6] Pallucchini, 1931, pp. 421-32.

Corner was also interested in the general problems of church architecture and decoration. He welcomed grandeur and is reported to have encouraged with advice, if not with money, the building of the great marble façades of S. Rocco and the Carità. Indeed, he laid especial stress on the importance of marble, being anxious that it should replace stone in the altars of all Venetian churches. But though he admired richness, he deplored 'the profane use of friezes as if in a theatre' and above all he insisted on uniformity of decoration. All the altars in a church should be made of identical marble, should be of the same shape and the same size. 'Harmony is delightful in everything' was his creed, and he tried to put it into effect wherever he extended his patronage. The most complete surviving example of the style he encouraged can be found in his parish church of S. Canciano. 'These very altars which he had built with such decorum speak to you of him', cried the priest at his funeral service in 1778,[1] and even today we can still sense the powerful personality of the man as we gaze at the richness of black and blue-veined marble columns topped with gold Corinthian capitals, which are yet designed with a symmetry and strict austerity that make no concession to the more exuberant style so prevalent in contemporary Venetian churches.[2]

[1] Don Giovanni Domenico Brustoloni, 1779. It is probable that the sentimental altar paintings by Bartolommeo Letterini were also commissioned by Corner.

[2] Other people too protested about the excessive decoration of Venetian churches. On 20 February 1746 P. E. Gherardi wrote to Muratori (letter in Biblioteca Estense, Modena): 'E cosa che ha del ridicolo il veder su gli altari davanti alle tavole o tele de'Santi dipinti, e di quà e là da i tabernacoli, statuette di Santi, fatte o di stucco o di legno, come appunto farebbe in un suo puerile altarino un tenero fanciuletto. Chiesa non c'è di Preti, ed anche di alcuni Frati, che non abbia su d'un altare la sua Madonna o di Loreto o del Rosario, o del Carmine, e su di un banco un'altra, che siccome di forma più picciola, sembra eesere suo Figliuolo.' The complaint is still more valid today than it was two hundred years ago.

Chapter 10

FOREIGN INFLUENCES

- i -

STATE, nobles and Church had been the traditional sources of patronage and we have seen how they operated during the first part of the eighteenth century. All three tended to promote the 'conservative', Counter Reformation elements in Italian painting, and this led to a type of art that could only be fully appreciated in countries with somewhat similar régimes—notably Southern Germany and, later, Spain, where Tiepolo was called in to satisfy illusions of grandeur that bore little relation to the realities of eighteenth-century European politics. Essentially, the paintings produced for all three types of patron reflected that Venetian desire to isolate herself from the contemporary world that was manifested in other fields through the censorship and the restrictions placed on foreign ambassadors and visitors. But there was another Venice—the famous, cosmopolitan city of pleasure with its throngs of tourists and dilettantes who came from societies totally different in spirit; and to cater for their tastes a wholly new kind of art came into being—one far more in touch with contemporary fashion elsewhere in Europe, whether it veered to the rococo or the neo-classical, than were the exalted visions of Tiepolo, Piazzetta and other history painters.

Europe was at war, but Venice remained neutral. Foreign embassies intrigued, foreign kings came to seek her alliance or to relax from the pressure of military campaigns. In 1703 the British Ambassador's first secretary, Christian Cole, came across a Venetian girl, Rosalba Carriera, painting snuff-boxes and miniatures on ivory. He persuaded her to turn to pastel portraits and within a few months her delicate, flimsy work was being compared to Guido Reni.[1] In 1707 the Ambassador himself, Lord Manchester, returned to Venice on a second official visit and commissioned Luca Carlevarijs to record his entry.[2] A year later he quarrelled with the Republic, and left, taking back with him to England Rosalba's brother-in-law, Giovanni Antonio Pellegrini, and the young landscape painter Marco Ricci.[3]

[1] Most early biographers report that a 'certo signor Colle inglese' was the first to advise Rosalba to turn to pastels—see *Memorie intorno alla vita di Rosalba Carriera celebre pittrice veneziana scritta dall'abate N.N. nel 1755* (Padova, 1843), p. 12, and Girolamo Zanetti: *Elogio*, 1781 (published 1818), p. 16. But Zanetti is mistaken when he says that this occurred in 1708, as on 26 June 1703 Crespi had already compared her work in this medium to Guido Reni—Malamani, 1899, p. 99. Crespi must have been thinking of Guido's very late, 'chalky' manner which was to be so attractive to eighteenth-century connoisseurs. Cole played a very important part in Anglo-Venetian artistic relations. It was almost certainly he who advised the Duke of Manchester to choose Rosalba's brother-in-law, Pellegrini, as the painter to take back to England in 1707, and in 1710 and 1711 he wrote to Lord Dartmouth enclosing estimates of pictures signed by Sebastiano Ricci and Niccolò Cassana—Osti, 1951, p. 119.

[2] The picture is now in the Birmingham City Art Gallery—Nisser, 1937.

[3] *Mostra di Pellegrini*, 1959, p. 15.

And the German princes came in force: Maximilian of Bavaria found time amid the disasters that befell him in 1704 to commission from Rosalba his portrait and those of the most beautiful women in Venice. He was followed by Duke Christian Louis of Mecklenburg and the Elector Palatinate with similar commissions and invitations to Germany. In 1709 Frederick IV of Denmark took time off from his war with Sweden for a holiday in Venice, where he was lavishly entertained and so impressed by Venetian women that he too commissioned Rosalba to record their beauty in twelve pastels,[1] while Luca Carlevarijs painted for him the regatta that had been offered in his honour.[2] Above all there was the Prince Elector of Saxony, later to be Augustus III of Poland, who visited Venice three times during the first two decades of the eighteenth century and whose admiration for Rosalba's art was limitless, as is testified by the huge collection of her work that he was to amass in Dresden.[3]

For these men and others like them Venice was not an impoverished Republic trying desperately to maintain her former status in the world; her inhabitants were not haughty nobles keen to assert their aristocratic claims in the face of upstarts who threatened to swamp them. Rather, she was a haven of peace, still fantastically rich, where their entertainment was encouraged by a government only too anxious to win as many friends as possible; a city whose palaces were filled, as nowhere else in Europe, with easily appreciated masterpieces of sensuous beauty and whose courtesans were renowned for their charms. It is hardly surprising that they wished to have both city and women recorded for them to take back to their warring kingdoms in the North.

With peace in Europe came the French; above all a new type of collector, symbolised by Pierre Crozat, the fabulously rich banker whose house in Paris had already replaced Versailles as a centre for young artists. In Rosalba's pastels which he saw during his visit of 1715 he found exactly what he was looking for; he wrote to her later and promised her a painting by Watteau in exchange for her work, as this artist whom he met on his return to France at the end of the year was the only man 'able to produce something worthy of you', and he was not satisfied until in 1721 he persuaded her to visit him in Paris.[4] But for years before this visit, Rosalba had already been working mainly for foreigners.

English, French and German visitors could agree with enthusiasm about the merits of her work, and ambassadors from all these nations might employ Carlevarijs and later Canaletto to record their entries into Venice,[5] but for other and more important

[1] Malamani, 1899, pp. 39 and 42.
[2] The picture is now in the Fredericksborg, Copenhagen—Mauroner, 1945, p. 51.
[3] Malamani, 1899, p. 49.
[4] For the relations between Crozat and Rosalba see Malamani, 1899, p. 50, and Sensier, pp. 22 ff.
[5] Besides Lord Manchester's Entry into Venice (1707) and the Regatta in honour of Frederick IV of Denmark (1709), Carlevarijs painted the Entry of the Count of Colloredo, the Imperial ambassador (1726)—this picture is now in Dresden (Mauroner, 1945, p. 37, note 17). Canaletto painted the Entry of the Comte de Gergy, the French ambassador (1725)—now in the Hermitage (Haskell, 1956, p. 298), and that of the Count of Bolagno, the Imperial ambassador (1729)—now in the Hermitage (V. Moschini, 1954, p. 29).

commissions there was a divergence of taste which was soon to become very pronounced.

It has been seen that many German courts had been obtaining works of art from Italy for at least a generation, and they went on purchasing pictures in the late Baroque style to which they had grown accustomed.[1] The more powerful of them were able to attract the artists themselves as well as their pictures. The Hapsburgs summoned Sebastiano Bombelli to Vienna, and in 1709 employed Antonio Bellucci as their court painter. In 1716 the Dalmatian Federico Bencovich followed them there.[2] Gaspare Diziani went to Dresden in 1717 and worked for three years as scene painter for Augustus the Strong.[3] By this time Giacomo Amigoni was already in Munich painting for the Elector Max Emmanuel and working alongside French craftsmen in the rococo pavilions of the Nymphenburg gardens.[4]

The English too made it worthwhile for Venetian artists to leave their native country, but as patrons they were very different from the autocratic princes of South Germany or Austria. Lord Manchester, who brought back Marco Ricci and Pellegrini from his embassy to Venice in 1709, was a cultivated diplomat with a wide experience of the world, a passionate lover of opera, a man in close touch with an influential group of dilettantes and poets.[5] He belonged to that society of Whig noblemen who were consolidating their victory of 1688 over the King and making sure that the new dynasty should look to them for support. He and his friends, the Duke of Marlborough, Lord Carlisle and others, were having their great country houses built for them by the gentleman-architect Vanbrugh and were laying the foundations of a revived feudal aristocracy that was to govern England for over a century. In some ways they resembled the Venetian oligarchy ruled by a Doge with little more than nominal powers, and it is not surprising that their sons should have looked back admiringly to sixteenth-century Venice and its leading architect Palladio as the embodiments of their own ambitions and tastes. Unlike the Venetians of their own day, however, these men were optimistic and fully aware that their country was entering on an age of unparalleled prestige and riches. They could afford to borrow from the Continent and yet be confident that the future lay with them. 'Music', wrote the Duchess of Marlborough to Lord Manchester,[6] 'is yet in its nonage, a froward child which gives hopes of what he may be hereafter in England, when the masters of it shall find more encouragement. It is now learning Italian, which is the best master, and studying a little of the French air to give it somewhat of gaiety and fashion.' So too with painting.

When Pellegrini and Marco Ricci arrived in London they were at once set by Lord Manchester to paint scenes for Scarlatti's opera of *Pyrrhus and Demetrius*, and then to

[1] See Chapter 7, and Lavagnino.
[2] Pallucchini, 1933-4, pp. 1491-1511.
[3] Donzelli, p. 82.
[4] The Amigonis in Nymphenburg date from 1716—Lavagnino, p. 121. See also Powell, pp. 68-70, 110 and 147.
[5] See Duke of Manchester, II, *passim.*
[6] *ibid.*, p. 140.

decorate his mansions in Arlington Street and at Kimbolton in Huntingdonshire, rebuilt for him by Vanbrugh.[1] The same architect had for some years been erecting in York-shire a country house as palatial as any German imitation of Versailles for Lord Carlisle, a young man who had already embarked on a career to be more noted for its dazzling social prestige than for any real political achievement. He, too, extensively employed the two Venetian artists who from Castle Howard then moved to Narford Hall in Norfolk, the country seat of the most interesting of all their English patrons, Sir Andrew Fountaine, a rich collector and connoisseur who had travelled widely in Europe.[2]

In England Pellegrini, like some glistening butterfly, shed the last fragments of the tough membrane of seventeenth-century stolidity that had hitherto inhibited his already adventurous achievement. In a series of mythologies, histories, *capricci* and portraits, a new style was created—weightless, sensual, sometimes clumsy and melodramatic, but nearly always free of tensions. Rose-pink plumes shimmer against a blue sky streaked with feathery white clouds; light sparkles on fragile armour; golden tresses spill down flushed and invitingly naked flesh; fancifully dressed musicians in costumes of shot silk lean over a balustrade and playfully allude to Veronese with none of the hard commit-ment of Sebastiano Ricci or, later, of Tiepolo (at this date still only an apprentice). New and subtle colour combinations of mauves and greens, transparent reds and silvers add to the remarkable freshness of Pellegrini's painting.

Some of the credit for these innovations must be given to the comparatively uninhibited atmosphere of England. The easy elegance and charm of Van Dyck's portraits, so different from the pompous images of Venetian Senators, not only gave him a number of technical hints, but also taught him something essential about the nature of English society. He learnt his lesson quickly, as is shown by a lively and informal drawing he made of Pierre Motteux, the enterprising translator of Rabelais and Cervantes, a journalist and picture dealer who moved in the theatrical group which circulated round Lord Manchester (Plate 46).[3] The engagingly 'private' and witty observation in a work of this kind anticipates the best conversation pieces that became so dear to English society—a vein also exploited by Marco Ricci in a number of half-caricatured musical groups that must certainly have fascinated Hogarth (Plate 47).

In 1712 Pellegrini and Marco Ricci quarrelled. Both left England, but within a year Marco returned with his uncle Sebastiano and the two men were soon busily at work. Sebastiano belonged to an older generation than Pellegrini. His early patrons had mostly been the powerful autocratic rulers of northern and central Italy, and from his extensive travels he had absorbed a wide variety of styles which he was liable to display with a sometimes excessive facility. Though he too could be a bold innovator, his manner was much more tied to the past than was Pellegrini's and also much more taut, solid and robust. One of his earliest employers in England was Lord Portland, who

[1] See above all for this whole section Watson, in *Journal of R.I.B.A.*, 1954, pp. 171-7.
[2] Vertue, III, p. 94.
[3] Mostra di Pellegrini, 1959, p. 56.

had already commissioned paintings from Pellegrini.[1] This young man was the son of William III's great favourite, the Dutch William Bentinck, whose loyalty to the Orange cause had been rewarded with vast estates.[2] Henry, who succeeded to the Portland title in 1709 and was created first Duke in 1716, had lived a great deal abroad and had had his portrait painted by Rigaud in 1699—a work that seems to endorse the opinion of a contemporary that he was 'a fine fellow, but very affected'. He commissioned paintings from Ricci for his town house, and above all for the chapel of his country house at Bulstrode Park in Buckinghamshire—*The Ascension, The Last Supper, The Baptism of Christ* and *The Visitation*.[3] Strangely enough this was a programme that would not have been out of place in any Catholic church. When Vertue saw the paintings some twenty years later, he understandably praised them for the 'noble free invention; great force of lights and shade with variety and freedom in the composition of the parts'.[4]

Within a few months of his arrival in England Ricci was working for Lord Burlington, soon to become the most influential patron of the first half of the century.[5] But it was not until May 1715 when the young peer had returned from his conventional Grand Tour to Italy and set about rebuilding and redecorating his great mansion in Piccadilly that he began to employ the Venetian artist on an extensive scale.[6] As yet he had no special interest in the austere Palladianism which was later to preoccupy him, and he was as keen as any other nobleman of the age to decorate the interior of his palace with large and colourful Italian paintings. 'The wall with animated pictures lives', wrote Gay rather clumsily of Burlington House in 1715, and indeed a great number of mythological and history paintings by Sebastiano Ricci were let into the walls and ceilings, some of which were later transferred to Burlington's villa at Chiswick.[7]

Ricci had many enthusiastic patrons among the Whig nobility and important officials—before leaving in 1716 he painted a fresco of The Resurrection in that most national of institutions, the Chelsea Hospital—and a few months after his departure another of his compatriots, Antonio Bellucci, arrived in England and was equally well received. Indeed, one of his first patrons was a man who had already given employment to Sebastiano Ricci. John Sheffield, Duke of Buckingham since 1703, in which year he had begun to have built his great London house, stood politically rather outside the circles which have so far been considered.[8] Though he acknowledged the new constitutional monarchy, he had been a staunch supporter of James II, one of whose illegitimate daughters he had chosen as his third wife. He was described by Prince Eugene in

[1] Vertue, I, p. 38. [2] Turberville, II, p. 14.

[3] A sketch for the *Last Supper* is in the National Gallery of Art in Washington and one for *The Baptism* was sold at Sotheby's on 7 December 1960.

[4] Vertue, IV, p. 48.

[5] Ricci dated two pictures for Lord Burlington in 1713. These pictures—*The Presentation in the Temple* and *Susanna and the Elders*—are at Chatsworth, the country house of the Dukes of Devonshire, who inherited Burlington's estate—Osti, 1951, pp. 119-23.

[6] Wittkower, 1948.

[7] Charlton. As Lord Burlington only began his villa in 1725, by which time Ricci had left England, it is probable that the works by him there were transferred from the Earl's town house.

[8] See the *Complete Peerage*, and H. Clifford Smith, p. 26.

Plate 49

VENETIAN ARTISTS IN GERMANY AND ENGLAND IN THE FIRST HALF OF
THE EIGHTEENTH CENTURY

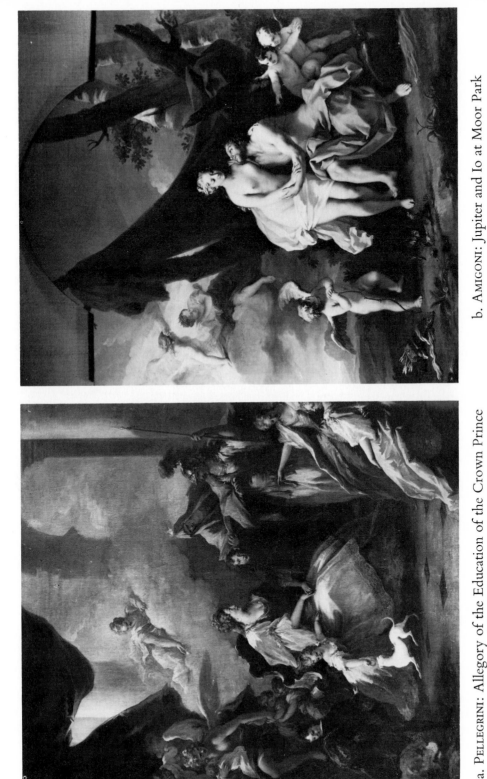

a. PELLEGRINI: Allegory of the Education of the Crown Prince
of the Palatinate

b. AMIGONI: Jupiter and Io at Moor Park

Plate 50

VENETIAN ARTISTS IN GERMANY AND ENGLAND IN THE MIDDLE OF
THE EIGHTEENTH CENTURY (*see Plates 50 and 51*)

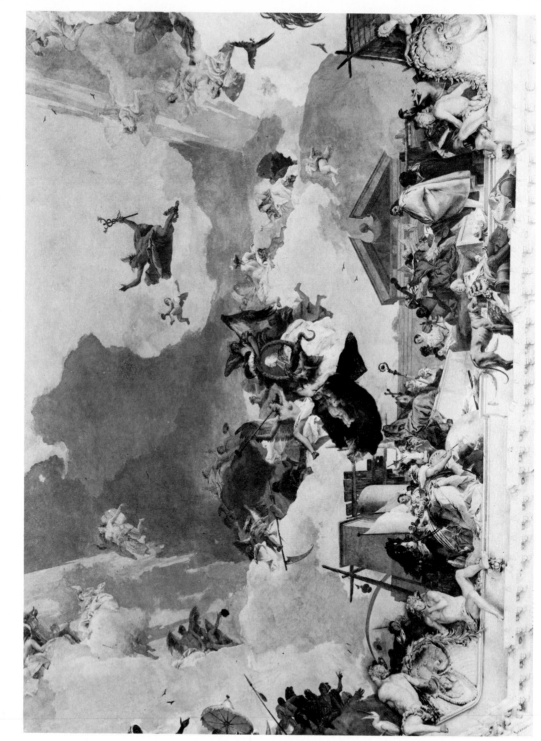

TIEPOLO: Detail from fresco glorifying the Archbishop of Würzburg, 1752

Plate 51

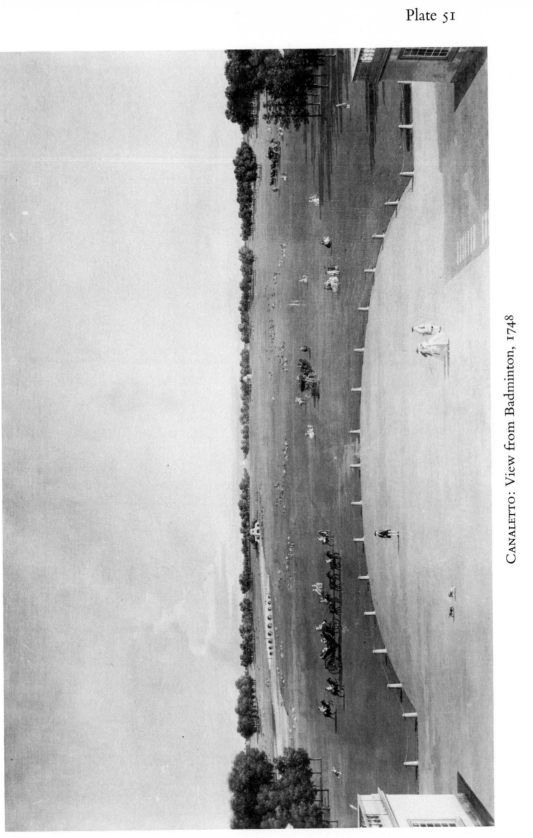

CANALETTO: View from Badminton, 1748

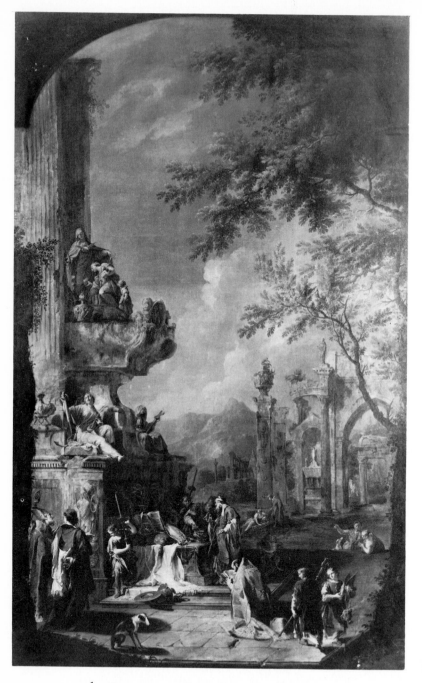

b. Canaletto, Cimaroli, and Pittoni:
Allegorical tomb to the memory of Archbishop Tillotson

a P. van Bleek: Detail from portrait of Owen McSwiney

1712 as 'a sanguine man, but of great parts and esteemed a true patriot'. He became a special favourite of Queen Anne, and when she died he retired from politics. He was by then aged 67 and despite his political affiliations had acquired a great and influential position in society. Within a year or two, as his mansion neared completion, he employed Bellucci to paint the walls of the staircase with scenes of Dido and Aeneas while the ceiling was, in his own words, 'filled with figures of gods and goddesses', and on the ceiling of another room Bellucci painted an allegorical tribute to himself and his Duchess, which she paid for in the year of her husband's death.

Bellucci's most important English patron was James Brydges, who managed to get himself created first Duke of Chandos in 1719 at the age of 46.[1] Though born in poverty he acquired an immense fortune from war profiteering after having served for eight years as Paymaster to the Forces. In 1713 he acquired the old Elizabethan manor of Canons at Edgware and he spent the next few years turning it into a vast palace in which he entertained his friends with magnificent concerts organised by Handel and Dr Pepusch. He had a number of ceilings in the state rooms both at Canons and in his London house painted with allegorical subjects by Bellucci and, above all, he employed this artist together with the Bolognese *stuccatore* Bagutti and a mysterious figure called Francesco Sleter to decorate the chapel. Bellucci painted three large and twenty smaller canvases which were let into the rococo ceiling, representing *The Nativity*, *The Descent from the Cross* and *The Ascension*, around which were grouped putti holding the Instruments of the Passion.[2]

Thus for a decade before about 1720 Venetian history painters received wide support in England. The rich, the powerfully placed and the leaders of fashion were keen to employ them on their new and ostentatious mansions. Unhampered by any long traditions of hereditary patronage, these men seem to have inspired the artists who worked for them with fruitful vitality. Most historians are agreed that the English work of Pellegrini, Ricci and Bellucci constitutes their greatest achievements. But the situation was not to last.

When Pellegrini left England in 1712 he went to Düsseldorf. When Bellucci arrived in London a few years later he came from Düsseldorf. So too did two other Venetian artists who arrived in England—Vincenzo Damini, a minor painter, and Giacomo Leoni, an architect who helped to inaugurate the Palladian movement. In fact, for a short time, Düsseldorf was with London and Paris one of the great centres of the more adventurous Venetian artists. The town was the capital of the Palatinate, and was ruled over by the Elector Johann Wilhelm, who was the most interesting of all the German art patrons during the first two decades of the eighteenth century.

Johann Wilhelm came to power in 1690, in a state which had been utterly devastated by the troops of Louis XIV. Almost at once he was forced to quell a serious revolt,

[1] Collins Baker and Muriel I. Baker.

[2] After the demolition of Canons in 1747 the chapel was transferred to the country house of Lord Foley in Worcestershire and it survives intact to this day as the parish church of Great Witley—Watson, in *Arte Veneta*, 1954, pp. 295-301.

but soon after, his fortunes turned. For some years between 1708 and 1714 he achieved unparalleled influence in German politics, and with the growing success of his intrigues and military prowess it seemed possible that the Palatinate might achieve the status of one of the great powers. His love of glory was reflected in the adulation of the artists who surrounded him. 'S'il auroit vêcu aux tems des anciens Romains', wrote one of his courtiers, Giorgio Maria Rapparini,[1] 'léur superstitieuse véneration n'auroit pas manqué de lui former son Apothéose'—but Rapparini himself, who could scarcely mention his master's name without comparing him to Alexander the Great, hardly lagged behind the Romans in superstitious veneration, and much of the art created at Düsseldorf during these years, such as the bronze equestrian statue by the Flemish sculptor Gabriel Gruppello, was inspired by the Elector's passion for self-display. But he also had a genuine love of art for its own sake: 'à l'égard de la Peinture, sa noble manie est si forte, qu'après avoir depouillé la plus grande partie de la Flandre amatrice pour en composer la plus belle Galerie de l'Europe, j'ay oui après de sa Serenissime bouche saisié d'un enthusiasme d'amour pour cet Art; *que pour une rare Piéce de quelque excellent Maitre, il se depouilleroit à moitié'*. This enthusiasm for collecting and patronage was no doubt spurred by Johann Wilhelm's marriage to Anna Maria Ludovica, the last of the Medici, and it was guided by Rapparini, who was a painter as well as a writer and who had studied under Carlo Maratta in Rome. In his writings Rapparini shows himself so anxious to give unqualified praise to everyone that his taste can only be described as eclectic. But despite the general enthusiasm all round, one theme constantly reasserts itself: 'Une austére regularité de l'Art rebutte les Amateurs memes de l'Art. Si le Peintre ne montre point au dehors quelque agrément de facilité, qui attire au plaisir d'imiter en cachant le dificile, on en décourage le Sectateur qui s'en va ailleurs. La Science vraiment de plaire à l'oeil materiel, consiste surtout dans le cromatique, c'est à dire dans le coloris. Sans ce charme mignon la Peinture perd trop de sa force, et n'a plus cette magie d'enchanter. Il faut égayer parci, parlà son Tableau par une maniére riante, qui regne d'un bout à l'autre de la Piéce.' It was in this spirit, so particularly congenial to Venetian artists, that Johann Wilhelm amassed vast quantities of works from Italy[2]—especially by Luca Giordano—and commissioned painters such as Cignani, Franceschini, Gian Gioseffo dal Sole and Francesco Trevisani to work for him in Bologna and Rome. He also tried, albeit without success, to persuade Antonio Balestra and Rosalba Carriera (who acquired pictures for him in Venice) to come to Düsseldorf.[3]

[1] I am most grateful to Dr Alessandro Bettagno for indicating to me the manuscripts of Rapparini which were published in Düsseldorf in 1958. His *Le Portrait du Vrai Merite dans la personne serenissime de Monseigneur l'Electeur Palatin* gives a fairly full account of Johann Wilhelm's patronage, but as the eulogy was written in 1709 there are naturally no references to Pellegrini. The extracts I have quoted can be found on pages 14, 18, 75, 83, 81 and 69.

[2] Nicolas de Pigage.

[3] Cignani painted two pictures for him: a *St John the Baptist* and a *Jupiter giving Suck* in 1702 and 1715 —Pascoli, I, pp. 165-8. These pictures are now at Augsburg and Munich (Lavagnino, p. 85). Franceschini painted for him a *Venus* and *The Three Graces*, and Dal Sole a *St Teresa wounded by Christ* and a *Rape of the Sabines*—Zanotti, I, pp. 228 and 306-7.

For references to Francesco Trevisani and Balestra who, 'geloso della sua libertà', refused regular

He was just as enthusiastic—if not more so—about the Dutch. He visited Holland in 1696, and he avidly collected works by Jan Weenix, Adrian van der Werff and many others. Both Weenix and Van der Werff were invited by him to Düsseldorf, and though the latter refused to accept an official post as court painter, he agreed to work exclusively for the Elector for six months in every year, and large numbers of his smooth, light, enamelled paintings—in which 'on ne voit rien de stanté, rien d'oisif, rien de leché, rien de sec, et de dur'—found their way into Johann Wilhelm's gallery. But the real importance of this gallery lay elsewhere. For it Johann Wilhelm had 'presque vuidé toute la Flandre et la Hollande'. Seventeen paintings by Van Dyck and forty by Rubens, whose 'bizarrerie et bravure' made a special impact and which are now among the most splendid treasures of the Alte Pinakothek in Munich, prove that for once Rapparini's claims were not excessively exaggerated. Despite the debt that both artists owed to Venetian painting, they were little known in that city and their effect on the receptive Pellegrini was considerable.

Some sixteen years after the Elector's death in 1716 the Baron de Pöllnitz passed through the Palatinate and described the achievements of this 'Prince magnifique en toutes choses . . . généreux, liberal. Il protegeoit les Arts et les Sciences; sa Cour et sa depense étoient Royales; sa bonté le rendoit aimable; il étoit les délices de ses Courtisans, l'amour de ses Sujets.'[1] The gallery consisted of five great rooms, three of them much larger than the others. The first was entirely devoted to Rubens; the second contained works by Van Dyck and other Flemish and Dutch artists. The third contained Italian paintings, then there was one given over to Van der Werff and finally the fifth contained pictures by the greatest Flemish, Dutch and Italian old masters—Raphael and Veronese, Titian and Carracci, Correggio and Guido Reni, Rubens and Rembrandt. In all the rooms were displayed bronzes and cabinets of miniatures, and below them was another gallery containing casts of the main sculptures in Florence and Rome.

In this exhilarating atmosphere Pellegrini worked for three years.[2] On a ceiling of a staircase in the Elector's castle at Bensburg he painted a magnificent fresco of the *Fall of Phaethon* unparalleled among his works for verve, colour and strength of drawing. But, above all, he was called upon to satisfy the Elector's insatiable desire for glorification. He painted a series of canvases depicting in allegorical form the benefits of Johann Wilhelm's rule (Plate 49a). There is a certain awkwardness about the composition of some of these and a confusion of styles that may reflect the impact on Pellegrini of the Elector's widely varied picture gallery and especially of the Flemish artists in it. But they are painted with a freshness, buoyancy and lighthearted delicacy of colour that have no parallel in Venice itself at this date. Bellucci, too, celebrated his German patron with allegories and group portraits which are much more clumsy than Pellegrini's, but

employment under him—see the manuscript lives of these two artists in the Biblioteca Augusta, Perugia, MSS. 1383.

For a long and fully documented account of the work of Foggini, Soldani and other Florentine sculptors for Johann Wilhelm—see Lankheit, 1956, pp. 185-210.

[1] Pöllnitz, III, p. 274. [2] Lavagnino, p. 120, and M. Goering, 1937, pp. 233-50.

which show that he was among the earliest of the eighteenth-century Venetian artists to appreciate the example of Veronese.[1]

Pellegrini's connections with Düsseldorf made it logical enough that he should move to the Low Countries when the Elector died in 1716.[2] He worked in Antwerp and Amsterdam, where he was actually commissioned to decorate the city hall with frescoes—the first time an Italian artist had ever painted in Holland and a remarkable sign of the cosmopolitanism of early eighteenth-century culture. From Holland he was taken back to England for a short time in the summer of 1719 to decorate the country house of the English Ambassador in The Hague, Lord Cadogan, a man who had served as commander with Marlborough in Flanders and had later been a Whig M.P.

Paris was the third town which helped to liberate Venetian painting from the bondage of the past. Sebastiano Ricci went there in 1716, on his departure from London. He was at once brought into touch with Pierre Crozat, then aged 51, whose fine mansion in the Rue Richelieu contained a superb collection of paintings and, above all, many thousands of drawings by all the greatest Italian and Flemish masters.[3] Crozat used to arrange weekly meetings of an exceptionally alert group of art-lovers, painters and writers, and he was generous in giving hospitality to artists and making his collection easily available to them. When Ricci arrived, Charles de la Fosse, who had himself been to London, was lodged in Crozat's house. He was in his eightieth and last year, and though an enthusiastic admirer of Venetian painting, he was not impressed by Ricci.[4] But, more importantly, Crozat's latest discovery, the 32-year-old Antoine Watteau, was living in his house, and the elderly Venetian admired his work sufficiently to copy a sheet of his drawings.[5]

Four years after Ricci came his rival Pellegrini with his sister-in-law Rosalba Carriera and their common friend Antonio Maria Zanetti, the engraver and connoisseur. This visit marked the peak of Venetian influence abroad and the last time that contemporary Italian art was to make a serious impact on France. The aristocratic society, with which the three artists were at once brought into contact through the patronage of Crozat, was indulging in a relaxed atmosphere of careless rapture induced by the death of their great oppressor Louis XIV and the apparently miraculous benefits that could be obtained from financial speculation. Pellegrini was at once given the task of decorating the very symbol of the new régime, the Mississippi Gallery in the Banque Royale, which was the headquarters of John Law's reckless, but as yet successful, Système. The programme given to the artist represented a curious combination of royal glorification on the lines made familiar under Louis XIV at Versailles and allegorical tributes to commerce which were to become general only in the second half of the

[1] Another Venetian painter who worked extensively for the Elector at Düsseldorf was Domenico Zanetti—de Pigage.

[2] See the letter from Rosalba Carriera to Mariette published by Sensier, p. 95.

[3] For Crozat see Mariette, II, pp. 43-53, Sensier, and H. Adhémar, p. 82, and Stuffman.

[4] De La Fosse's reported remark to Ricci, 'Paint nothing but Paul Veroneses and no more Riccis', quoted by Levey, 1959, p. 22, from Walpole's *Anecdotes* must presumably have been made on this occasion. [5] Blunt and Croft-Murray, 1957, pp. 61-3.

eighteenth century.[1] He was to express 'les différents avantages de la Banque, et de les rapporter à la gloire du Roi et de Mgr le Régent'. This extraordinary task was achieved by the use of a somewhat strained mythological iconography. The King was in the centre, supported by Religion and the Régent; these figures were surrounded by others representing 'le Commerce suivi de la Richesse, de la Sureté et du Crédit', and all the gods of Olympus were called in to portray Munificence, Magnanimity and the countless other virtues which characterised the scheme. Elsewhere the Seine and the Mississippi were seen embracing, and views of ports and ships and the Bourse with men bargaining made the same points in more concrete terms.

Exactly how well he coped with the commission it is impossible to tell as the destruction of the frescoes followed soon after the collapse of the *Système* which they had celebrated. Years later, when the whole climate of taste had changed, Mariette, who strongly condemned this destruction, said that the frescoes were of an 'invention . . . heureuse. Il y avait du fracas et des groupes agréables,' but he criticised the drawing and colour.[2] None the less it seems likely that the frescoes had a considerable influence on French painting of the first half of the eighteenth century.

Pellegrini painted other works in Paris, including at least one altarpiece,[3] but the real success of the trip was due to Rosalba. She was welcomed by Crozat, who lodged her in his house and organised a series of splendid receptions in her honour, and the delicate and subtle flattery of her informal portraits was greeted with wild enthusiasm by a society that was in full revolt against the artificiality and stiffness introduced by Louis XIV and his court. Within two or three months of her arrival she had painted the portraits of John Law, the Régent, and the little King himself who kept flatteringly quiet during the sittings—as well, of course, as those of Crozat and his family. Round these central figures flocked the aristocrats and the ambassadors, all fighting for their portraits or little mythological pictures. The artists themselves were as keen. By October, four months after her arrival, she heard the news that 'I have been unanimously admitted to the Académie. No vote was taken, as no-one wanted to make use of a black ball.'[4] She met Rigaud and Watteau, both of whom expressed their deep admiration, and all the other artists and connoisseurs—Coypel, Vleughels, Oppenord, de Troy, Mariette. When she left Paris in March 1721 she had conquered the city and made a number of friends and admirers who were to remain loyal to her through every change of taste until her death in 1757. More importantly she gave a stimulus to a type of elegant yet intimate portraiture that other artists were to bring to much greater heights than ever she had achieved and that remains one of the triumphs of French eighteenth-century painting.

– ii –

The cities of London, Düsseldorf and Paris were the most exciting centres of

[1] See the document published by Sensier, pp. 97-102, Garas, 1962.
[2] Quoted by Sensier from the *Abecedario*, pp. 102-3.
[3] For the Couvent des Augustins Déchaussés—Sensier, p. 107.
[4] Sensier, pp. 199 and 211.

Venetian painting until early in the 1720s. Thereafter the situation began to change all over Europe. In England there had been ominous signs for many years that national feeling resented the success of these foreign artists. Alessandro Galilei, the Florentine architect who had arrived in 1714, said that 'the English do not behave like people in Italy, where if a foreigner arrives with a barest hint of talent, everyone rushes after him and native artists with far greater abilities are left behind. Here it is just the opposite because they want to employ only their own countrymen though they are complete donkeys. . . .'[1] The remark was made by a disgruntled architect who had had no success —but it contains an element of truth.

The dome of St Paul's, which had been a great magnet for the Venetian artists, was given to Thornhill to paint. So too was the ceiling of the Queen's Bed Chamber at Hampton Court, after the Earl of Halifax had said that the Treasury would refuse to pay if the commission was given, as had been intended, to Sebastiano Ricci. Moreover, the new style of architecture, promoted by Lord Burlington after his return from Vicenza in 1719, gave little scope for great ceiling decorations 'filled with figures of gods and goddesses', and, as the Grand Tour became habitual and the English grew more sure of their tastes, they discovered that they did not like large-scale history painting—unless the artist was an Old Master who had died long ago. The career of Amigoni, who arrived in England in 1730, some eight years after Bellucci's departure, is symptomatic of the change. He was first greeted with great enthusiasm by Lord Tankerville, a prominent Whig and at that time Lord of the Bedchamber to the Prince of Wales. Amigoni painted his staircase, but this was pulled down only eight years later. He also painted a ceiling and the walls and staircase of Powis House in Great Ormond Street with the Seasons and the story of Judith and Holofernes.[2] It is impossible to be quite certain who was his patron here. Lord Powis himself was an elderly man of about 70.[3] He had been one of James II's most loyal followers, and as a consequence had been arrested on more than one occasion, the last time being during the Jacobite alarm of 1715. Two years earlier the great house which he had had built for himself had been occupied by the French Ambassador. During his tenancy it had been burnt to the ground and then rebuilt at the expense of the King of France. In 1722 Lord Powis's troubles came to an end. His estates, which had been forfeited on his outlawry many years before, were restored to him and he was summoned to take his seat in the House of Lords, where he sat with the Tories. If he was the patron of Amigoni, it shows that the artist was moving in very different and far less fashionable circles than those that had welcomed his predecessors a generation earlier. Amigoni's third and most important English patron was a Mr Styles who had made a fortune out of the South Sea Bubble. His country house at Moor Park was built for him in modified Baroque by Sir James Thornhill and later Giacomo Leoni. Styles had intended to entrust Thornhill with the decoration, but the two men quarrelled and to spite the artist Styles gave the job to

[1] Quoted by Ilaria Toesca, 1952, p. 208.
[2] For these events see Vertue, I, p. 45, and III, pp. 45, 49, 51, 67.
[3] *Dictionary of National Biography*, and Wheatley, III, p. 18.

Amigoni and Francesco Sleter instead. We can be grateful for the dispute, for Amigoni's four canvases illustrating the story of Jupiter and Io are the most beautiful that he painted in England (Plate 49b).[1]

Thus Amigoni's last big commission was due primarily to an accident. Thereafter he found it difficult to get any employment as a history painter, and he was compelled to turn more and more to portraiture. In this field his success was very great indeed and when he left England some ten years after his arrival he is supposed to have taken £4000 to £5000 with him, some of it derived from his work for the court. He also left a reputation which extended as far as Fielding's Joseph Andrews.[2]

The English went on employing Venetian painters, but with rare exceptions they confined themselves to views, landscapes and portraits—usually by Bartolommeo Nazari.[3] Only one man proved wholly original in his patronage of Venetian and other artists and his very isolation shows how quickly English taste had hardened into a conventional pattern. Owen McSwiny (Plate 52a) was an Irishman whose early life was closely connected with the stage—as actor, dramatist and eventually impresario.[4] In none of these careers was he a lasting success and it may have been this that encouraged him to make his first venture into the world of art with a plan to have engraved a series of Van Dyck portraits in English country houses.[5] This project too came to nothing, but it fascinated McSwiny, who returned to a similar plan in later years. Meanwhile his debts were pressing, and like many a man in such circumstances he left for the Continent in about 1711. For the next few years he disappears from sight but when he re-emerged it was with a scheme of great originality. Acting on behalf of Lord March, who became Duke of Richmond in 1723, he proposed to have painted by the leading Italian artists a series of allegorical tombs to commemorate the great men of England's recent history.[6]

McSwiny had judged his moment well. For a full generation England had been on the crest of a great wave of optimism brought about by a series of military, political and intellectual triumphs which had carried her to the very forefront of Europe. Everyone recognised that her progress since the Glorious Revolution of 1688 had been immense, but now the protagonists were old or already dead and the time had come to celebrate their exploits. Meanwhile wealth at home and peace in Europe were encouraging

[1] *English Taste in the Eighteenth Century*, 1955-6, p. 26, and Hussey, 1955, p. 43.

[2] Vertue, III, p. 94; also Woodward, 1957, pp. 21-3, and Haskell, 1960, pp. 71-3. In Chapter 6 of Book III Joseph Andrews refers to 'Amyconni, Paul Varnish, Hannibal Scratchi, or Hogarthi, which I suppose were the names of the painters'.

[3] Watson, in *Burlington Magazine*, 1949, pp. 75-9.

[4] McSwiny spelt his name in a great number of different ways at various stages in his career, for the broad outlines of which see *Dictionary of National Biography*. See also Whitley, I, pp. 9, 11, 24-6, and a number of librettos for operas adapted by him which are now in the British Museum.

[5] Vertue, III, p. 82.

[6] There have been many articles about McSwiny's commissions in recent years—see Voss, 1926, pp. 32-7; Arslan, 1932, pp. 128-40, and 1933, pp. 244-8; Zucchini, 1933, pp. 23-30; Borenius, 1936, pp. 245-6; Watson, 1953, pp. 362-5; Constable, 1954, p. 154; Arslan, 1955, pp. 189-92, and [Rivani] 1959; Mazza, 1976.

thousands of English noblemen to visit the Continent and enjoy the pleasures of Italian art. There was thus every reason to believe that a project which combined reverence for England's recent past with the prestige of modern Italian painting should do well.

McSwiny wrote[1] that the monuments were to glorify 'the British Monarchs, the valiant Commanders, and other illustrious Personages who flourish'd in England about the end of the seventeenth and the Beginning of the eighteenth Centuries'. It is almost certain that no definite list of these was drawn up from the start, for some of the characters who were eventually represented only died when the scheme was already under way. Most of those commemorated were, naturally, Whigs—but there was no strict political programme, for it was found possible to include Robert Harley, Earl of Oxford, who had played such a great part in bringing to an end the wars waged by Marlborough (also, of course, represented) and who had been imprisoned for two years in 1715. The pictures were all to be the same size, vertically inclined with semicircular tops like altar paintings. In fact, the scheme represented one of the first attempts to produce a secular and patriotic counterpart to the religious iconography of the Counter Reformation and the more generalised 'history painting' of the Continent—among the figures commemorated were many of the 'Saints' of the Enlightenment such as Locke and Newton. Each picture was to contain an urn 'wherein is supposed to be deposited the Remains of the deceased Hero. The Ornaments are furnish'd partly from the Supporters and Arms of the respective Families; and the Ceremonies supposed to be perform'd at the several Sepulchres, as well as the Statues and Basso-Rilievo's, allude to the Virtues, to the Imployments, or to the Learning and Sciences of the Departed.'

McSwiny wrote that these subjects which were 'of his own Invention' were 'elegantly executed by the Pencils of the most celebrated Painters in Italy'. With one or two exceptions[2] he chose these from Bologna and Venice, and he insisted that every picture was to be painted by three artists—one for the figures, one for the landscape and one for the buildings and other ornaments. Not surprisingly the painters concerned, who were not told the purpose of the scheme, were thoroughly puzzled by this 'amateur with as sound a knowledge of good pictures, books and antiquities as it is possible to have' who suddenly arrived to commission 'a number of strange and fanciful ideas which were neither histories nor fables'.[3] In fact, McSwiny's instructions to them must have rivalled Shaftesbury's in minuteness of detail.

In Bologna he relied mostly on Donato Creti and Francesco Monti as his figure painters and in Venice on Piazzetta and Pittoni, while Canaletto and Cimaroli painted some of the landscapes (Plate 52b). All four Venetian artists were beginning their

[1] In the pamphlet *To the Ladies and Gentlemen of Taste* (no date), of which there is a copy in the British Museum.

[2] Solimena was apparently considered for Sir Isaac Newton's tomb as is shown in a letter from McSwiny to the Duke of Richmond dated 28 November 1727 kindly shown to me by Mr Francis Watson. Francesco Imperiali of Rome painted the monument to King George I, a version of which belongs to Lord Kemsley—*English Taste in the Eighteenth Century*, 1955-6, p. 54.

[3] Zanotti, II, pp. 114, 221, 313.

careers and Canaletto was as yet almost unknown. But Sebastiano and Marco Ricci who collaborated on the monument to the Duke of Devonshire were already well-established painters and must have required a substantial fee to produce such menial work for a commoner.[1] The scheme began well, and by 1722 fifteen pictures had already been started, most of which were later acquired by the Duke of Richmond.[2] Yet it ran into difficulties which were almost inseparable from McSwiny's conception of the paintings. For attractive as many of the pieces are they entirely fail to achieve their declared aim which was 'to perpetuate (as long as the Nature of such Things can permit) the Remembrance of a Set of British Worthies, who were bright and shining Ornaments to their Country'. Rather, these 'monumental pieces' anticipate a taste, which only became general later in the century, for *capricci* in which a vague feeling of romantic melancholy is induced by the contrast between crumbling ruins of the past and elegant, fancifully dressed spectators—a gentle, 'picturesque' adaptation of the old

[1] The Venetian artists concerned in the enterprise were:

Canaletto Cimaroli Piazzetta	*Lord Somers*	(Birmingham)
Marco Ricci Sebastiano Ricci	*Duke of Devonshire*	(Barber Institute)
Domenico Valeriani Giuseppe Valeriani Cimaroli Balestra	*William III*	(Duke of Kent)
Domenico Valeriani Giuseppe Valeriani Pittoni	*Isaac Newton*	(Fitzwilliam Museum)
Canaletto Cimaroli Pittoni	*Archbishop Tillotson*	(English private collection)
Paltronieri Cimaroli Pittoni	*Lord Dorset*	(Rome, private collection)
Marco Ricci Sebastiano Ricci	*Sir Cloudesly Shovel*	(Washington)
Canaletto? Cimaroli? Pittoni	*Lord Stanhope*	(Walter Chrysler collection)

Paltronieri was a Bolognese painter. I am grateful to Sir Anthony Blunt for pointing out to me that at Sir Robert Bernard's sale at Christie's, 9 May 1789, lot 68 was described as Petoni—A pair of Triumphal Mausoleums.

[2] Constable, 1954, p. 154. In fact there is a great deal of confusion about which of these pictures were actually acquired by the Duke of Richmond. In 1741 McSwiny published nine of them in the *Tombeaux des Princes* and said that they all belonged to the Duke. These were those to William III, Tillotson, Malborough, Godolphin, Dorset, Cowper, Sir Cloudesly Shovel, Newton and Boyle/Locke/Sydenham. This list does not wholly coincide with the one given by Vertue, V, p. 149, who recorded ten after his visit to Goodwood a few years later—William III, George I, Devonshire, Wharton, Addison, Dorset, Tillotson, Stanhope, Cadogan, Godolphin. The explanation is probably that the Duke of Richmond owned some fourteen or fifteen but did not keep them all at Goodwood.

theme of *Memento Mori*. It was almost as difficult for McSwiny's contemporaries as it is for us to understand the complex allusions to the virtues of his heroes. 'I am persuaded you will forgive me', wrote one client in 1727,[1] 'if I tell you that it has been thought your other pictures tho' finely painted are defective in that respect [establishing the identity of the hero]—and I have already seen two of them which turned to a quite different design from what they were intended. I mean those for the late D. of Devonshire and Sir Cloudesly Shovel, the first of which is turned into a Brutus and the other into a Roman Admiral by my Lord Bingley in whose possession they now are.'[2] As large decorative paintings hanging in the Duke of Richmond's dining-room at Goodwood, where conscientious visitors could find 'a written description left to explain the meaning', they were admirable.[3] As a homage to the great men of England which might set a fashion among those who cared for the heritage of 1688 they were wholly unsuitable. McSwiny himself realised their drawbacks, but he quite rightly understood that the slavish following of too logical an iconographical programme would destroy the charm that they had. ' 'Tis impossible to tell (in such a Narrow compass)', he replied to his critic, 'more than one Man's story, without running into w.t wou'd be very Trivial, & y.e pieces wou'd resemble the cutts in *The Gierusaleme Liberata*. In the Monum.t to y.e Memory of the Duke of Malbro' I make a Soldier, attended with Guards &c as visiting y.e Monument of a great General. I mean nothing more in it but the visit—now if I was to represent his battles, Sieges and abilities as an able Counsellour I have no way to do it but by Medaglions, Medals Basso-rilievo's, Statues etc.'[4]

Despite these problems, the Duke of Richmond bought at least ten of the paintings, and other versions of some of them also found purchasers. Then in 1730 McSwiny scored 'a fortunate hitt' when Sir William Morice bought the remaining ones that had been completed.[5] And he had in any case decided from the first that further profits could be obtained by issuing engravings of the series, and for this purpose he employed the Bolognese artist D. M. Fratta to make drawings of the pictures as they appeared in Bologna and Venice.[6] Some time in the 1730s he issued a pamphlet addressed 'To the Ladies and Gentlemen of Taste' in which he invited subscriptions for a magnificent volume—'a more compleat Work of the Kind, than has ever yet been published in any part of Europe'. It was to include 'fifty copper Plates, viz. twenty four Sepulchral Pieces, twenty four Inscription Plates (ornamented with Emblematical Figures), the Frontispiece and the Title-Plate; all of the same size with the Sepulchral Pieces; viz two Foot two Inches in Height, and one Foot five Inches in Breadth.

[1] Letter from John Conduitt to McSwiny of 4 June 1729 kept among the Conduitt papers in the Library of King's College, Cambridge. I am most grateful to Mr A. N. L. Munby for pointing out this correspondence to me—Haskell, 1967.

[2] The *Duke of Devonshire* thus altered must be another version of the one which once belonged to the Duke of Richmond and is now in the Barber Institute. The one of Sir Cloudesly Shovel has not yet been traced, but this too must have been a second version of the one belonging to the Duke of Richmond.

[3] Vertue, V, p. 149.

[4] Letter from McSwiny to John Conduitt of 27 September 1730—see note 1 above.

[5] See letter from Joseph Smith to Samuel Hill of 26 November 1729 published by Chaloner.

[6] Zanotti, II, p. 313.

'To which will be added (if the Encouragers of this Undertaking shall hereafter think fit) not only the Characters of the above-mentioned deceased Worthies but likewise those of many of their Contemporaries, who made considerable Figures in the Court, the Camp, the Church and State, as well as in the several Branches of useful and polite Learning, and who contributed largely to the carrying of the Reputation and Credit of the British Nation to a much higher Degree than it was ever before; with a succinct Account of the most memorable Transactions in the Reigns of King William and Queen Mary, Queen Anne, and King George.

'The Whole to be adorn'd with Vignettes, Busto's, Medaillons, Culs des Lampes, and other proper and elegant Embellishments designed and engraved by the most celebrated Masters in Europe.'

The volume—*Tombeaux des Princes grands capitaines et autres hommes illustres, qui ont fleuri dans la Grande-Bretagne vers la fin du XVII et le commencement du XVIII siècle*—appeared in 1741, and was certainly very magnificent, but it must have disappointed McSwiny who had returned to England some ten years earlier. There were eighteen instead of fifty plates, and only nine of the allegorical tombs were engraved—all from the Duke of Richmond's collection. Only two of the heroes—Lord Dorset and Sir Isaac Newton—were given Characters, while there was no account of the memorable transactions of the reigns of William III, Anne and George I. It is none the less a fine tribute to McSwiny's enterprise and taste. Each painting is preceded by an inscription plate with the name of the hero surrounded by a rich decorative frieze designed by Boucher and engraved by C. N. Cochin, Laurence Cars and others. In many ways these plates are more satisfying than those of the actual tombs which were also engraved by French artists. They contain allegorical allusions to the hero's achievements and burst on to the page with a tense, virile vitality that is rarely found in Boucher's work.[1]

The criticisms of the paintings and McSwiny's failure to attract enough subscribers to complete the book shows once again how reluctant Englishmen now were to welcome contemporary Italian history painting—even when heavily disguised. But McSwiny also catered for more conventional tastes. With his close friend, the English business man Joseph Smith, he dealt in pastels by Rosalba Carriera[2] and views by Canaletto. Indeed he was among this artist's first foreign patrons, though he had strong doubts about his merits. 'I hope you'l like 'em when they are done,' he wrote to a client in 1727 of some pictures by Canaletto,[3] 'I am, it may be, a little too delicate in my choice, for of Twenty pieces I see of him, I don't like eighteen & I have seen several, sent to London y.t I wou'd not give house room too, nor Two pistols each. He's a covetous, greedy fellow & because he's in reputation people are glad to get anything at his own price.'

Though McSwiny's enthusiasm was only qualified, he commissioned a number of

[1] The inscription plate to Sir Isaac Newton's monument, which is very much more restrained than all the others, was designed by Joseph Perrot. Boucher, however, drew the medallion of Newton and the signs of the Zodiac above the extracts from Fontenelle's *Eloge* which are published on a separate page.

[2] Malamani, 1899, p. 142, publishes a letter of 1753 to Rosalba Carriera with a reference to McSwiny who had apparently not settled some account with her.

[3] Letter from McSwiny to John Conduitt of 27 September 1730—see p. 290, note 1.

pictures by Canaletto for English clients, and in doing so he was for once fully in touch
with national taste. On the Grand Tour noblemen regularly brought back their sets of
views by the master or his pupils. Canaletto took full advantage of such a steady clientèle
and raised his prices so much that he became virtually inaccessible to others and rightly
acquired the reputation of being spoilt by the English.[1] Several generations of English-
men saw Venice entirely through his eyes, sometimes with surprising results. When Dr
Burney, the great musicologist, arrived there in 1770 he confessed that 'we form such
romantic ideas of this city from its singular situation about which we hear and read so
much that it did not at all answer my expectation as I approached it, particularly after
seeing Canaletti's view all of one colour: for I find it like other famous cities composed
of houses of different magnitude, orders of architecture, ages, and materials.[2] Many
years later William Beckford, who rhapsodised about the mystery and decay of the city,
none the less found that it had been perfectly depicted by 'the pencil of Canaletti'.[3]

When in 1740 war in Europe greatly reduced the number of English travellers to
the Continent, Canaletto found it necessary to come to this country, encouraged by
Amigoni, who had had plenty of opportunity for gauging English taste. He moved
throughout the land painting a series of London views and country houses for dukes and
enthusiastic amateurs who welcomed him despite the denigration of jealous rivals and
boisterous patriots (Plate 51).[4] With short breaks he remained here for nearly ten years,
during which time his manner became increasingly mechanical, but his shorthand of
little blobs to represent the human figure was later adapted to brilliant comic purpose by
the satirist Thomas Rowlandson.

The career of the landscape painter Francesco Zuccarelli was even more successful.[5]
He arrived in England in 1752 and remained here for over fifteen years with one break
of three. His clients included George III and he became a founder member of the Royal
Academy.

The triumphs of Canaletto and Zuccarelli are symbolic of the complete break that
had occurred in artistic taste between England and the Continent. But in Europe too the
situation had changed notably after the second decade of the eighteenth century. In 1724
Pellegrini's ceiling for the Banque Royale was destroyed, and thereafter, with the
exception of Rosalba, contemporary Italian art proved of little interest to French
collectors. As had happened some sixty years earlier, the French had taken just enough
from the Italians to provide an impulse for their own native artists. But one man, who
though not himself French was so impregnated with French culture that he must be
considered here, continued to show great enthusiasm for Venetian art. Count Tessin
was a Swede, son of the architect who had built the Royal Palace in Stockholm.[6] He
was born in 1695 and during his early travels between 1714 and 1719 he first came into
contact with Watteau. A few years later he achieved great political importance in his

[1] De Brosses, I, p. 282. [2] Burney, I, p. 109.

[3] [William Beckford], I, p. 101. [4] Finberg, 1920-1.

[5] Levey in *Italian Studies*, 1959, pp. 1-20.

[6] For a brief account of Tessin's career and collecting activities see exhibition of *Le Dessin Français
dans les Collections du XVIIIᵉ siècle*, 1935, p. 43 and Bjurström, 1967.

native country and in 1728 he became Surintendant des Bâtiments Royaux. During his honeymoon in Paris in the same year he was engaged in buying pictures and furniture for the King of Sweden and this brought him into touch with a number of French artists. In 1739 he became ambassador to France and during his three years in Paris he assembled a superb collection of contemporary drawings and paintings by all the leading artists, especially Boucher, whose wife's lover he apparently became and from whom he had already commissioned a picture in 1737. The year before this he had been to Venice in search of a painter to decorate the Royal Palace in Stockholm. He was pleased with what he saw there—'il est constant que l'école de Venise est sur un très bon pied, et quelle se distingue en Italie'—but he found little that satisfied his immediate requirements. In a well-known letter he enumerated the merits and drawbacks of the leading artists and found that only Tiepolo was ideal.[1] 'Tout est dans ses Tableaux richement vetu jusqu'aux gueux etc. Mais n'est-ce pas la grande mode? Au reste, il est plein d'esprit, accomodant comme un Taraval, un feu infini, un colorit éclatant, et d'une vitesse surprenante. . . .' Unfortunately he was also able to command far higher prices than the Swedes could offer and the invitation to Stockholm met with no response. But Tessin was able to indulge his own taste for the colourful and the pretty. He bought a *Danaë* and a *modello* of the *Beheading of St John the Baptist* by Tiepolo for his personal collection, as well as views by Canaletto, Cimaroli and Richter, portraits and fanciful heads by Nazari and Nogari, drawings by Piazzetta and other works that attracted him. Having failed to get royal patronage for Tiepolo, he wrote that he would do his best for the sculptor Gai, whom he particularly admired, though he feared that 'jusqu'à cette heure je n'y vois encore que peu d'apparence, puis qu'il y a ici plusieurs sculpteurs François engagés aux services de la cour qui ont enterpris tout ce qu'il y a de plus pressé à faire'.[2] Tessin had made many friends in Venice and he remained faithful to them long after his art collecting was almost entirely confined to the French.

– iii –

Although French competition became increasingly serious as the century advanced —'hors de Paris point de salut', was the opinion in Berlin[3]—Venetian artists went on finding enthusiastic patrons all over Germany. After the death of the Elector Johann Wilhelm in 1716, Düsseldorf lost its importance, but the Hapsburgs and Schönborns who had hitherto stuck to the more traditional late-Baroque artists were now ready to welcome Pellegrini, Ricci and Rosalba Carriera—partly indeed, because of their very success in the more 'progressive' towns of London, Paris and Düsseldorf.[4] And in 1725

[1] Sirén, pp. 103 ff.

[2] Letter from Tessin to A. M. Zanetti the Elder dated 12 March 1737 in Biblioteca Marciana, Cl.XI, Cod. CXVI, 7356.

[3] Letter from Francesco Algarotti to his brother Bonomo dated 5 September 1749 in Biblioteca Comunale, Treviso, MSS. 1256.

[4] Pellegrini went to Vienna in 1725-7 and Rosalba Carriera in 1730. Ricci's *Bacchus and Ariadne* in Pommersfelden dates from after his visit to England—*La Pittura del Seicento a Venezia*, 1959, p. 151. A letter from Johann Philip Franz to Friedrich Karl Schönborn dated 12 July 1723 to introduce Pellegrini speaks of his success in London, Paris and Düsseldorf—Von Freeden, 1955, p. 848.

Pellegrini went to Dresden where there was another sovereign whose fame as a patron was attracting international attention. Frederick Augustus I, Elector of Saxony, and since 1697 King of Poland as Augustus II 'the Strong', had made his court the most brilliant in Europe, and his munificent architectural policy was transforming Dresden into a city of dazzling beauty. But his interest in contemporary Venetian art was somewhat limited. He employed Gaspare Diziani for three years almost exclusively on painting scenery for the theatre and the festivals which were his special delight. Pellegrini was considered as a possible decorator for one of the rooms in the Zwinger, the fantastic rococo pavilion which had recently been completed by Pöppelmann, but his project was later destroyed and his activities in the city were otherwise confined to two paintings in the Catholic church for which Sebastiano Ricci had three years earlier painted an *Ascension*.[1] A year after Pellegrini came Antonio Zucchi, the engraver, who was employed in the famous print cabinet,[2] and though Augustus considerably enlarged the gallery of pictures he had inherited, his purchases did not very much affect Venetian painters. Two large pictures by Pittoni, an artist particularly favoured by the Germans, were acquired by him before 1722—*Nero being shown the Corpse of Seneca* and *Agrippina being killed on the orders of her son Nero*. This gruesome subject evidently had a special appeal for him, for he owned a second version of it by another Venetian artist, Pietro Negri, a pupil of Zanchi. When, however, a third, painted by the Roman Marco Benefial, arrived in Dresden, his son clearly felt that its possibilities had been exhausted and he gave the picture away.[3]

Augustus the Strong also acquired six mythological and Biblical paintings by Francesco Migliori, an attractive but not very significant Venetian artist of the first half of the eighteenth century, and others by Molinari and Bellucci. Virtually all these conform closely enough to that ideal of 'nudité' which so appealed to German taste. The patronage of his son Augustus III, who succeeded to the throne in 1733, was of a wholly different order. Until the disaster of the Seven Years War nearly a quarter of a century later the collecting activities of this man and his dictatorial minister Count Brühl were among the most outstanding in Europe, and under the direction of a Venetian artist, Pietro Guarienti, the Dresden Gallery achieved its great pre-eminence over nearly all the others in Germany. His fabulous purchases for it—such as the hundred finest pictures from the collections of the Dukes of Modena—cannot be discussed here but must at least be mentioned as an indication of his vast artistic ambitions. Agents acquired works of art for him throughout Europe, and in Venice itself the brothers Ventura and Lorenzo Rossi, who acted in this capacity, were always on the look out for suitable pictures. Apart from a large number of old masters they acquired six landscapes for him by Marco Ricci in 1738. But the real impact of contemporary Venetian painting only made itself felt when Francesco Algarotti returned to his native city in 1743 especially to

[1] Pellegrini's drawing is reproduced in *Mostra di Pellegrini*, 1959, Plate 92. For Pellegrini's and Ricci's work for Dresden (and other information about the gallery) see Posse, 1929 and Garas, 1971.

[2] Lavagnino, p. 115.

[3] Bottari, V, pp. 27-8.

purchase pictures for the King whom he was then serving. Algarotti's commissions to Tiepolo, Piazzetta, Amigoni, Pittoni and Zuccarelli are discussed in a later chapter[1]; but he also bought many pictures by these and other contemporary artists from private collections—two superb Piazzettas, one of them the famous *Standard Bearer*, two fine mythologies by Sebastiano Ricci and portraits and fantasy heads by Nogari and Nazari, artists who specialised in this type of picture which was ultimately derived from Flanders.

No doubt all these appealed to Augustus, despite his initial reluctance to pay too much attention to the works of contemporaries, but he had one special favourite whose works he collected avidly on his own account—Rosalba Carriera. They had met during his own visits to Venice early in the century when, as crown prince, he had revelled in the company of the beautiful and vapid ladies whose features she recorded. But he was far from satisfied with the number of pastels he had acquired from her on those occasions. Throughout his reign he was always keen to get more—from the artist herself or from private collections. His choice was catholic—portraits of friends and acquaintances or of pretty women he had never known, allegories such as the Four Seasons, or the Four Continents, or the Four Elements, religious subjects such as the Magdalene or the Virgin Mary. It hardly mattered as they were all equally attractive. His appetite was inexhaustible, and by the end of his life he had acquired over 150 examples of her work, while Rosalba's best pupil Felicita Sartori, who had married one of his councillors, came to Dresden in 1741 and worked extensively for him.[2]

Another Venetian artist produced a great proportion of his output for Augustus III. In 1747 Bernardo Bellotto, the nephew of Canaletto, arrived in Dresden and within a year he was appointed 'pittore di corte'—a post which he held until the break-up of that court after the disasters of the Seven Years War.[3] During that time he painted large numbers of views showing, with an observation of everyday reality that had not been seen since the *bamboccianti*, the busy brilliant capital at the height of its glory. They were often produced in series of three sizes—the largest for the King, a smaller version for Count Brühl and a third example for other clients. In 1765, after he had already found employment elsewhere, Bellotto returned to Dresden. Augustus, his great patron, had been dead two years and the artist stayed just long enough to paint the ruins of the Church of the Cross which had been wrecked in a bombardment of Frederick the Great that had shocked Europe.[4] Then he left.

No sovereign in Germany could rival Augustus in his patronage or collecting, but there were others who showed within the range of their far more limited means an equal enthusiasm for contemporary Venetian painting. Thus Clemens August, Archbishop-Elector of Cologne and younger brother of the Elector of Bavaria, who had employed Amigoni, was also a frequent visitor to Venice.[5] He too was naturally an

[1] Chapter 14. See also L. Ferrari, 1900, pp. 150-4. [2] Malamani, 1899, p. 77.

[3] See catalogue of *Mostra di Bernardo Bellotto*, 1955. Another Venetian artist working at Dresden who left at this time was Pietro Rotari from Verona, who had arrived in 1750. [4] Posse, 1929, p. 300.

[5] For a summary of Clemens August's patronage of Venetian artists see Levey, in *Burlington Magazine*, 1957, pp. 256-61, and also the exhibition catalogue *Kurfürst Clemens August*, Koln 1961.

admirer of Rosalba and owned pastels by her. Soon after 1730 he began commissioning altar paintings for the many churches under his patronage by Pittoni, Piazzetta—whose *Assumption of the Virgin* painted in 1735 contained the first signs of his lighter manner— and by Tiepolo. But German patronage of Venetian art, and Venetian art itself, reached a climax in 1750 when Tiepolo was commissioned to decorate the Residenz in Würz- burg.[1] The bishopric had belonged to the Schönborn family, whose vast patronage has already been referred to, but after the death of Frederick Karl in 1746 and a short interval under his successor it was taken over by Karl Philip von Greiffenklau. It was he who with great difficulty and at enormous expense finally persuaded Tiepolo to come to Würzburg and decorate the Kaisersaal in the magnificent palace that had been built by Balthasar Neumann for his predecessors. The beautiful rococo room with its rich ornamentation of scagliola was quite unlike anything that Tiepolo had ever seen; the subjects to be painted, drawn from German mediaeval history, were equally foreign. But this unfamiliarity merely stimulated him to higher peaks of brilliance. On the ceiling he painted *Apollo conducting Frederick Barbarossa's bride Beatrice of Burgundy* in a chariot drawn by four prancing white horses to the awaiting Emperor—a scheme which he later adapted with suitable modifications to the Rezzonico family in Venice. On the walls he was required to paint the *Marriage of the couple being blessed by the Bishop of Würzburg in 1156* and *Bishop Harold von Hocheim being invested with the princedom by the Emperor in 1163*. The German princely clergy could not boast the Roman ancestry of Tiepolo's Venetian clients, and in any case mediaeval life was the only suitable precedent for their feudal existence in the Age of Enlightenment. None of this worried Tiepolo, who 'placed the scene firmly in sixteenth-century Venice, where in fact for him all history took place'.[2]

As soon as the decoration of the Kaisersaal had been completed Tiepolo agreed to paint the ceiling of the great staircase of the palace—by far the largest expanse he had ever undertaken—with a fresco depicting *The Four Continents paying homage to Karl Philip von Greiffenklau* (Plate 50). It would be charitable to describe this theme as anachronistic in 1752, but Tiepolo delighted in the dreams of absolutism. Unlike Pellegrini and the Riccis who had given of their best a couple of generations earlier in an atmosphere of change and relatively free enquiry, Tiepolo was most at home in the last bastions of an autocratic and backward looking society. In this fresco, so much fuller of possibilities than anything that he had yet been required to do in Venice, he painted his supreme and most imaginative vision of the *ancien régime*.

Other courts besides those of Germany looked to Venice for talent. The rise of Turin has been referred to in an earlier chapter.[3] By the second decade of the century she had become powerful enough to attract artists from all over the peninsula. During most of the 1720s and early 1730s the architect Filippo Juvarra was artistic director of the city and on his authority a vast number of commissions was given to Sebastiano

[1] Von Freeden, 1956.
[2] Levey, 1959, p. 192.
[3] See Chapter 7; and also Claretta, 1893, pp. 1-309 and Griseri, 1957, pp. 145-50.

Ricci for paintings in the Royal Palace and for various churches.[1] But the effects of this patronage were no longer as stimulating to Ricci, now an old man, as his travels of earlier days had been. He himself was prevented by a youthful misdemeanour from visiting Turin, and the grandiose scenes in the style of Veronese which he sent to the city have a somewhat hardened, academic quality which betrays a lack of inspiration.

Moreover, Juvarra himself showed only a very qualified attachment to Venetian painting. When, towards the end of 1735, he devised a scheme for decorating the Royal Palace in Madrid, he was asked by the King of Spain to commission pictures from all the different schools in Italy.[2] The list he drew up included only one work by a Venetian —Pittoni—as compared to four Romans and one each by a Genoese, a Neapolitan and a Bolognese. The proportion is extraordinary to present-day taste, but in some circles Roman painters were still looked upon as the most 'serious' artists working in the Grand Manner; though it is also possible that the old Spanish hostility for Venice may have played some part in determining the choice. If this is so, it no longer applied by 1739 when Amigoni went to Madrid as court painter.[3] There he was followed by the far more uncompromisingly Venetian Tiepolo, who, after ruthless pressure 'da chi puo comandare', was sent out to Madrid in 1762 as part of an astute diplomatic move by the Venetian government.[4] However much the nobility might still want to be immortalised by the great artist at the height of his powers, the old tradition of political cunning prevailed. On this his last mission Tiepolo, helped by his sons, once more drew upon all his resources to glorify a formerly powerful, but now declining, monarchy. And then, at the very end of his life, inspired perhaps by the traditional fervour of Spain, he produced his most personal and most deeply felt religious painting in a series of altarpieces for the royal chapel at Aranjuez. Soon afterwards they were removed and replaced with works by the new international star Anton Rafael Mengs.

Tiepolo died in 1770, but while he was still active in Spain new conquests were being prepared by Venetian artists in the most distant outposts of Europe. Pietro Rotari had gone to St Petersburg from his native Verona as early as 1756, and until his death there six years later he painted several hundred pictures of all kinds ranging from portraits to mythologies. He was followed in 1762 by Francesco Fontebasso, a pupil of Sebastiano Ricci, who decorated the Winter Palace,[5] and in the same year Giacomo Guarana, another pupil of Ricci and Tiepolo, painted a *Sacrifice of Iphigenia* for Moscow.[6]

[1] Gabrielli, 1950, pp. 204-11, gives a full account of Ricci's relations with the court of Turin.

In 1723 Juvarra commissioned a painting from Marco Ricci to indicate his proposals for the Castello di Rivoli. As was to occur later in his commissions for Spain he showed his preference for Roman painting by ordering four pictures from there (two each from Pannini and Locatelli) compared with only one each from a Venetian and a Turinese artist—see Viale, 1950-1, p. 161.

[2] Battisti, 1958, pp. 273-97.

[3] It is true that Amigoni was born in Naples, but he spent his working life in Venice when he was not abroad. Amigoni was followed to Madrid in 1753 by Corrado Giaquinto, whose influence on the young Goya was far greater than that of any other Italian painter.

[4] For the pressures put on Tiepolo to go to Spain see M. Brunetti, 1914.

[5] Donzelli, pp. 209 and 90. [6] A. Longhi.

The dramatic accession to the throne in June 1762 of the insatiable Catherine the Great provided a new but, as it turned out, not very fruitful impulse for the importation of Venetian pictures. Though her culture was mainly inclined towards France, Catherine showed in her artistic as in her other tastes a reluctance to confine herself to any one style and she did what she could to continue the policy of her predecessor. Thus Bernardo Bellotto was planning to go to St Petersburg after the collapse of the Dresden court and the death of Augustus III. But while already on the journey he was persuaded to stop in Warsaw by the new King of Poland Stanislas Poniatowski and, for twelve years until his death in 1780, he produced for that art-loving and reforming monarch a large number of views to record the rapidly changing aspects of his capital.[1] Meanwhile in 1772 Pietro Antonio Novelli painted for the Empress a picture of *Creusa imploring Aeneas to rescue his father Anchises from the fire of Troy*. Though he had gone out of his way to choose a 'learned' subject to compete with the painting by Pompeo Batoni opposite which it was to hang, the thought of the climate made him refuse the opportunity to outdistance his Roman rival by accepting an invitation to Russia.[2] In any case Catherine's admiration for Venetian art is testified not so much by the rather minor artists and their works that she was able to attract to her distant court as by her purchase of Tiepolo's *Banquet of Cleopatra*. This masterpiece had been among those acquired for Augustus III by Francesco Algarotti many years earlier[3] and its transference to St Petersburg in the 1760s provides a striking reflection of the changing balance of power in Europe which had always played such an influential rôle in the diffusion of Venetian art. But though it is true that Venice itself had perforce to remain a passive onlooker while many of the city's best artists and their pictures were drawn to London, Paris and Düsseldorf, Madrid, Dresden and Würzburg, it will become apparent in the next chapter that a more subtle relationship was possible between the dominant foreigner and native genius than one which was essentially built up on foundations of military strength and commercial wealth. For the Republic still retained many attractions and if kings and landowners could do little more than glimpse these on brief holidays, others were free to settle within her frontiers and gain a much deeper awareness of the city's treasures.

[1] *Mostra di Bernardo Bellotto*, 1955.
[2] Novelli.
[3] See later, Chapter 14.

Chapter 11

THE FOREIGN RESIDENTS

– i –

CONSUL JOSEPH SMITH

THE most important link in Venice itself between the city and the outside world
was an Englishman, Joseph Smith, who became the greatest art patron of his day.
He was born in about 1675, educated at Westminster School and settled in Venice
during the early years of the eighteenth century as a businessman and merchant.[1] He
traded extensively with Amsterdam and was concerned with the import of meat and
fish—an activity which sometimes involved him in disputes with the guild of the
Salumieri.[2] He quickly became rich and influential and his house was occasionally used
for meetings between the Venetian nobility and English diplomats, which would have
been awkward if held more openly.[3] Early in the 1730s he began to take an interest in
publishing which he put into practice by launching the firm of a young man, G. B.
Pasquali. Smith's concern with this was far greater than merely financial, though money
in any field was always a source of the keenest interest to him. For the first few years of
the new venture he was actively engaged in the intellectual work involved. In 1735, for
instance, he tried to enlist the help of the Florentine scholar A. F. Gori in a reprint of
Guicciardini's *Histories*, and he promised in return to find English subscribers for that
antiquarian's own *Museum Etruscum*. The difficulties were great: unpublished material
had to be secured from the family; a frontispiece, drawn by the 'famous painter' Gian
Domenico Ferretti of Florence, had to be engraved; and a suitable figure had to be
found to whom to dedicate the book. Smith exerted himself in all these and many other
aspects of the production, and also continued to buy books, gems and pictures for
himself and for his clients.[4] In 1744 he was made British Consul, a post inferior in status

[1] For the fullest account of his career see Parker, 1948, pp. 10 ff., who also publishes his will and other
documents.

[2] We can get some impression of Smith's business activities after about 1740 from the papers of his
notaio, Lodovico Gabrieli, among which references to Smith are very frequent—see in Archivio di Stato,
Sezione Notarile—Atti del Notaio Lodovico Gabrieli, Buste 7559-7570 (1740-70). Unfortunately I
have not been able to trace who was his *notaio* before that date. Also in the Archivio di Stato, among the
papers of the Avogaria di Comun—Civil 263/16—is an account of a dispute between Smith and the Arte
de' Salumieri.

[3] Public Record Office—State Papers 99/60: Letter from British Resident dated 18 May 1714: 'The
Signor Tron, who goes Ambassador to London, sent on Wednesday last to lett me know that he would
be glad to see me before his departure, and that he desired to meet me at the house of Mssrs. Williams
and Smith, British Merchants here.'

[4] See letters from Joseph Smith to A. F. Gori in Biblioteca Marucelliana, Florence: MSS. B. VIII, 4.
These extend from 1727 to 1744, but the majority were written between 1735 and 1737. The Guicciardini
was eventually published by Pasquali in 1738.

to the Residency for which he had hoped. In 1762, a year after resigning the consulship, he sold the bulk of his library and most of his pictures to King George III. Then five years later, at the age now of nearly 90, he temporarily resumed the post of consul when his successor went bankrupt.[1] He finally died in 1770 and was buried in the Protestant cemetery at S. Niccolò al Lido. His taste in pictures reflects much that we should expect from the two backgrounds, English and Venetian, hinted at in this outline of his long, acquisitive and persistent life.

As a patron of the arts and the owner of a superb library he was well known and appreciated in Venice, and he was in close contact with nearly all the leading painters. He was also an assiduous theatre-goer and fond of the opera.[2] And his palace on the Grand Canal near the church of the Apostoli was the meeting-place for a number of the more adventurously inclined nobles and intellectuals, for besides his great interest in scholarly works and fine editions, Smith was always keen to publish books which in hidebound Venice were bound to appear controversial, if not actually subversive.[3] Chief among these visitors was the sarcastic, anti-conformist Padre Lodoli who would come with his lively patrician pupil Andrea Memmo.[4] Both of them were to play important rôles in the art world of Venice, and Memmo later acknowledged the influence that the meetings at Consul Smith's house had had on his taste. But their great friendship did not long survive their rivalry in love: both men were courting the beautiful Giustiniana Wynne, the illegitimate daughter of an English gentleman and a Greek adventuress.[5] Memmo was some fifty-four years younger than the English Consul and his victory was inevitable. Thereafter Giustiniana was to turn up again and again as a link between many of the more intelligent patrons and writers of eighteenth-century Venice.

Smith's activities and influence may have diminished after 1744, in view of the government's discouragement of contacts between the nobility and foreign representatives, though we do hear from the Resident himself that the Consul was far better placed from this point of view than his more senior colleague[6]; and Smith in his claim to the appointment specifically boasted that he had 'contracted Friendships with some Principal men in the Government . . .'.[7] In his earlier days at least he had had friendly relations at various times with the connoisseurs Apostolo Zeno, Francesco Algarotti and Antonio Maria Zanetti, and Goldoni in the dedication to Smith of one of his plays,

[1] Public Record Office—State Papers 99/70—Letters of 10 and 31 January, 10 May and 10 June 1766. See also Archivio di Stato, Venice—Esposizione Principi, Reg. 112.

[2] See Goldoni's dedication to him of *Il Filosofo Inglese* in *Opere*, V, p. 259. He owned a large collection of operatic caricatures by Marco Ricci, A. M. Zanetti and others—see Blunt and Croft-Murray, pp. 137 ff.

[3] For many vivid comments on the publishing activities of Smith and Pasquali see the letters from P. E. Gherardi to L. A. Muratori in the Biblioteca Estense, Modena. See also Chapter 13 of this book.

[4] [Andrea Memmo], 1786, p. 1, which in turn refers to Lami: *Memorabilia*, Firenze 1742, p. 386.

[5] B. Brunelli, 1923.

[6] Public Record Office—State Papers 99/69, p. 224r.

[7] Letter from Smith to the Duke of Newcastle dated 26 August 1740—British Museum: Add. MSS. 32,802, f. 182.

Il Filosofo Inglese, says that the Englishman had been among his keen admirers. From his will, drawn up in 1761, we get the impression that by this stage in his long life Smith had few close contacts in Venice beyond those of business. By far the most important of these were with his client Pasquali, who published catalogues of his gems and some of his paintings and books as well as many other works of literature and philosophy which the Consul clearly suggested to him.[1] And it is also very likely that he had certain definite business arrangements with some of the artists whom he employed for himself and others.[2]

Two of his most interesting Italian friends lived in Padua. Of these, one was the Abate Facciolati, a professor of history in the University, to whom he left three books 'as a testimonial of my Esteem and respect and of my grateful sense of the friendship that for so many years [he has] honoured me with'. Facciolati had a remarkable collection of pictures which was designed to illustrate the history and progress of art beginning with a series of Byzantine paintings. Such private museums were still most unusual during the first half of the eighteenth century, though another one of Smith's friends, Padre Lodoli, collected works of art on a similar principle.[3] Smith's other acquaintance in Padua was the Marchese Giovanni Poleni, also a professor at the University, and an engineer and architect of some distinction—in many ways a typical product of the provincial Enlightenment.[4] These relationships suggest that Smith was most at home in scholarly surroundings.

This is all we know about the Consul's participation in the Venetian life of his day. With the English his links were much stronger. We find him writing to Gori of his friend the 'celeberrimo S.r Dottor Mead',[5] the most stimulating art collector of early eighteenth-century England and the great friend of Sir Isaac Newton, in whom Smith himself was closely interested.[6] His official duties brought him into touch with many of the most important visitors to Venice, but besides these his house was always open to English connoisseurs or artists in the city whom he treated with great courtesy. At one time or another John Breval, Horace Walpole, Richard Wilson, Sir Joshua Reynolds, James Wyatt and Robert Adam were all welcomed by him.[7] But no one really liked him. Walpole characteristically jeered at him as 'the Merchant of Venice'; Lady

[1] See p. 299, note 4. Grosley, who was in Venice in 1758, writes—II, p. 99—'L'Imprimerie de Jean-Baptiste Pasquali, l'une des meilleures et des plus occupées de Venise, roule, pour la plus grande partie, sur les fonds de M. Joseph Smith; riche Anglois qui a vielli dans le Consulat d'Angleterre à Venise.'

[2] The case of Canaletto is discussed separately, but it seems likely that Smith had some similar arrangement with Visentini.

[3] See Previtali.

[4] There are two very friendly letters from Poleni to Smith, dated 9 and 17 April 1747, in the Biblioteca Marciana—MSS. Ital:Cl.X. Cod CCLXXXVIII—6580. In these Poleni asks Smith to obtain some drawings for him from Visentini. There is an answer to the first of these letters, dated 14 April 1747, in which Smith refers to 'l'antica mia servitù et perpetua stima'.

[5] See p. 299, note 4. The undated letter is on page 211.

[6] Smith and Pasquali published many books referring to Newton. In a note on page 30 of his *Tempio della Filosofia*, 1757, the poet Arrighi-Landini tells how Smith supplied him with a copy of Pope's famous epitaph.

[7] Levey, in *Burlington Magazine*, 1959, pp. 139 and 143.

Mary Wortley Montagu found the self-congratulation with which he rendered her a service overwhelming; and James Adam burst out in a fit of rage: 'As to Smith's flummery 'tis all good for nothing with him—mere words, of course, that have no meaning except when he has some favour to ask.'[1] Even across the centuries we sense something vaguely unattractive about the man—the obsequiousness of his dealings with the King; the cynicism of his first marriage to the rich but mad operatic singer Katherine Tofts; his grotesque though pathetic pursuit of Giustiniana Wynne; and finally his second marriage, when aged 82, to the sister of John Murray, the Resident—the very job that he had wanted for himself.

Despite the unease that he inspired in his fellow-countrymen and despite the fact that he lived abroad virtually all his life, like so many Englishmen in a similar situation he insisted on retaining the atmosphere of his native land. When Mme du Boccage visited Venice in 1757 she noted that Smith's palace was 'entirely in the English taste; the very tables and locks of the gates are made after the manner of that country'.[2]

And yet this palace was by that time full to capacity with Italian paintings, not all of which would have suited the taste of an English gentleman at home. When he began collecting in the 1720s, Smith turned first to Sebastiano Ricci, at that time considered the finest painter in Venice. The veteran Lazzarini had virtually retired; his pupil Tiepolo was still too young to be known outside a restricted circle. Yet Ricci, for all the esteem in which he was held, was employed far more outside Venice, principally by the court of Turin, than in the city itself, where his most important commissions were largely confined to the Church, and henceforward to Smith.

The pictures that Smith bought or commissioned from the artist were painted in his most scintillating manner, and many of them were freely adapted from Veronese.[3] The most important were seven large pictures of themes from the New Testament which he hung together in a special room in his palace and which he had engraved and described in 1749, along with seven cartoons by the Bolognese Carlo Cignani, an artist enormously admired in early eighteenth-century Venice, which were hung in another room.[4] These paintings from the New Testament may well be connected with a similar series that Ricci was engaged on for the court of Turin at much the same moment.[5] In fact, apart from their fine quality all Smith's Riccis are of a kind which suggests either that they were bought from the artist or his heirs after his death or that, if

[1] Letter from James to Robert Adam dated 20 August 1760. I am most grateful to Mr John Fleming for showing me a copy of this letter.

[2] Mme du Boccage, I, p. 146.

[3] For a full account of these pictures see Blunt, *Burlington Magazine*, 1946, pp. 262-8, and 1947, p. 101.

[4] The Abate Pietro Ercole Gherardi, who wrote the *Descrizione* of Smith's Cignanis and Riccis, was a Modenese friend of Muratori with whom he engaged in a long correspondence, now in the Biblioteca Estense, Modena.

In the *Galleria di Minerva*, VI, 1708, p. 83, an anonymous writer said of Cignani, 'nessuno hà saputo fin'ora vendere in vita i suoi Quadri a sì alto prezzo'.

[5] This has been suggested by Blunt, 1957, p. 12, note 6, who discusses all the Sebastiano and Marco Ricci drawings owned by Smith.

commissioned, Smith had as yet formed no distinctive taste of his own. The remaining thirteen religious and classical compositions are of subjects that were commonplace in the artistic repertory of the day, and the fact that Smith also owned a series of studies of heads copied from Veronese strongly suggests that he acquired a section of the artist's studio *en bloc*—for such a commission would be most unusual. And it is likely that he acquired the 211 miscellaneous drawings which date from various periods in Ricci's life in the same way.

Many of these pictures have landscape backgrounds by Sebastiano's nephew, Marco, and he too was very fully represented in Smith's collection. Once again it is not clear what proportion of the 42 paintings and nearly 150 drawings were directly commissioned by him, for the subjects offer no clue and one of the drawings is dated 1710, when it is most unlikely that the two men knew each other. Some of them were engraved by Antonio Maria Zanetti in a book which recorded a few of his own paintings by Marco Ricci and which he dedicated to Francesco Algarotti in 1743.[1] The subjects include fantastic Roman ruins, genre scenes from country life and a number of landscapes (Plate 55b).

Among other artists whom Smith was especially patronising in the 1720s was Rosalba Carriera. There are records that she knew him in 1721 and was working for him by 1723 so that she must have been among the very first painters he employed—indeed her name appears first on the list of his pictures which he drew up when he sold them to George III.[2] Throughout 1725, 1726 and 1728 she was receiving payments from him, and we also know that Smith obtained commissions for her from other Englishmen.[3] In the end his large collection of pastel portraits formed the best known group of her paintings in Venice: in particular it contained what was universally recognised to be her masterpiece, *Winter*, represented (in Smith's words) by a 'Beautiful Female covering herself with a Pelisse allowed to be the most excellent this Virtuosa ever painted.'[4] Smith commissioned two versions of this, and after keeping the one he liked best for himself, he sent the other to a friend (or client).[5] He obviously guarded it jealously, for writing to Rosalba from London in 1735, a Mr Robert Dingley asked for a picture 'of a pretty young country girl . . . in the style of the *Winter* in Mr Smith's collection. . . . There is no need to say anything to Mr Smith about this. . . .'[6]

Such then are the outlines of Smith's career as collector and patron until about 1730. He was now aged 55, and living in the Palazzo Balbi near the Rialto where he had

[1] *Francisco Comiti Algarotto, Eruditissimo Viro, Bonarumque Artium Cultori, Hasce XXIV Tabulas Olim a Marco Ricci Bellunensi Colorib. Expressas, Quae Extant in Aedibus Joseph Smith, et Antonio Mariae Zanetti, D.A.F. Qui eas del. incid. et in lucem edit Venetiis Anno MDCCXLIII D.D.D.*

[2] Cust, p. 153.

[3] See her accounts for 21 May 1726, published by Malamani, 1899, p. 147: 'Dato le Quattro Stagioni, per spedire a Londra, al Sig. Smith.'

[4] Cust, p. 153.

[5] Letter from Smith to Rosalba Carriera (undated) in Biblioteca Laurenziana, Florence: Cod. Ashburn, 1781, Vol. IV: 'Giacchè Ella intende di voler finire anche l'altro Inverno, quando ciò si potesse terminare per Lunedì desiderei molto volontieri vederlo à confronto dell'altro per poter allora con più fondamento risolvere quali di Due inviare all'amico.' [6] Malamani, 1899, p. 134.

settled on arrival; in 1731 he bought the country house at Mogliano near Treviso which he had leased four years earlier from the Procuratore di San Marco, Gerolamo Canal.[1] In these two properties he displayed his paintings and drawings by Sebastiano and Marco Ricci, Carlo Cignani and Rosalba Carriera and probably also Piazzetta with whom he was in touch during these years.[2] It was already the most important collection of modern art to be found in Venice (and there was also a growing number of old masters), but reflected no particular originality of outlook. From now on, however, there seems to be a change in direction, and Smith began to accumulate a series of pictures which made his palace unique as an expression of individual taste. Essentially the shift reflected—consciously or not—one that was taking place at the same time in his native England: a move away from large-scale history pictures towards views and landscapes, though in his case not towards portraits. It is indeed remarkable that though he was anxious to have portraits of all the artists who worked for him, he never seems to have commissioned one of himself.

The new direction of his patronage was marked above all by his employment of Canaletto: the relations between the two men were central in the careers of both. Though there is no conclusive record of their having been in touch before 1729, it seems likely that Canaletto actually began working for Smith a year or two earlier, by which date he was already a well-known artist with a European clientèle. Thereafter Smith directed his whole output almost entirely into English channels, and conspicuously into his own collection. The exact nature of their relations has been extensively and authoritatively discussed, but remains uncertain.[3] There is, however, no doubt whatsoever that Smith's control over the artist was such that from a very early period commissions for his works were very frequently, if not exclusively, made through him.[4] This was not altogether an easy matter, for both artist and business man had notoriously mean characters: 'nor is it the first time', Smith wrote angrily after a brush in 1729, '[that] I have been glad to submitt to a painter's impertinence to serve myself and friends'.[5] He was, however, not the man to be put off by difficulties of this kind, and he retained his self-appointed rôle as the agent through whom Canalettos were purchased. It is probably this that the Swedish visitor Count Tessin meant when he said in 1736 that for a term of four years Canaletto was engaged by Smith to work exclusively for him.[6] Certainly besides the pictures that Smith obtained for others he was keeping a very large number for himself—far more than the fifty-three at present in the Royal Collection[7]—so that, if we include in the phrase 'work exclusively for him' those

[1] Archivio di Stato, Venice—Dieci Savi alle Decime, No. 1309, f. 84v, and Sezione Notarile, Vettor Todeschini, Atti 12,727, c. 135v and 12,731, c. 306v.

[2] Smith sent works by Piazzetta to Samuel Hill in November 1729—see Chaloner.

[3] Parker, pp. 9 ff.

[4] For instance in June 1730 John Conduitt 'desired Mr S[mith] to procure 3 pictures from Canaletto' —see p. 290, note 1.

[5] Letter from Smith to Samuel Hill of 17 July 1730 published by Chaloner. [6] Sirén, p. 107.

[7] For instance a further fourteen appear in one sale catalogue alone—Christie's, 16 May 1776: *A Catalogue of the Capital and Valuable Collection of Italian, French, Flemish and Dutch Pictures . . . of Joseph Smith, Esq.*, Some of the implications of this and other sale catalogues are discussed in Appendix 5.

pictures that Smith was commissioning for other customers, there is no reason to doubt the substantial truth of Tessin's observation.

Smith's first Canalettos were six views of S. Marco and its immediate surroundings, larger than anything he had painted until then, bold, free and almost impressionistic.[1] They are among his finest works, and in many ways the antithesis of what was to be his characteristic style when later working for the Consul and other English patrons. Already there is a change in the fourteen pictures which he painted for him between 1730 and 1735: the treatment is now less dramatic and much more sober. This change corresponds to the evident purpose of the series. With two large exceptions—depicting regattas—the group consists of twelve small views of Venice, chosen not because of the interest, importance or beauty of the objects to be represented, but purely so as to achieve a documentary record of the whole Grand Canal. Up and down, very systematically, the painter has worked his way through this great artery, leaving as fine and yet as unpretentious a memorial as any city has ever had. Such an attitude to art was quite new. Painters, even the most distinguished ones, had often been employed to record important scenes from contemporary life for their patrons or merely buildings and landscapes which were particularly associated with them. Other artists had exploited the 'picturesque' elements of back streets and slum life and ruins. Yet others had painted individual buildings of outstanding architectural interest. But these are all the very elements that are missing in this series. With his eye firmly on the Canal the artist here often records the palaces and churches in such steep perspective that we are not intended to admire them in themselves. There is something curiously prosaic and business-like in this approach of a painter who had until now shown himself so dramatic, indeed romantic. It is almost as if the patron were drawing up a prospectus, a sort of visual catalogue, of Canaletto's abilities. Can this in fact have been the real motive for these pictures? There is some evidence for the theory. In 1735 Visentini's engravings of the series were published, thus giving tourists an easy opportunity to get to know it. A year later Tessin reports that Canaletto has been engaged to paint exclusively for Smith for four years. And, paradoxically enough, it seems that at this very time Canaletto had virtually ceased working for Smith.

There are no paintings by Canaletto in the Consul's collection between the series engraved by Visentini and a number some ten years later. But it was at this very moment that Canaletto obtained some of his most important commissions from English visitors. If the Visentini series was indeed intended as an advertisement—if the pictures were painted, in fact, with the engravings in mind—the scheme was remarkably successful. For it was during the last half of the 1730s that Canaletto painted twenty views for the Duke of Bedford, another series of twenty for Sir Robert Hervey, and seventeen for the Earl of Carlisle. In all these groups the artist pays far more attention to the accurate delineation of specific buildings than he had done when working for Smith. And it is now that we first notice the mannerisms, the harshness, the signs of studio assistance—all

[1] Constable, 1976.

the deterioration that was to become characteristic of a painter 'whom the English have spoilt'.

It is impossible to tell exactly what Smith was doing during this period. No doubt he was buying old masters extensively. And he must also have been forming and adding to his great collection of drawings—in 1734 Sebastiano Ricci died and it was probably then that Smith acquired much of the contents of his studio. Many illustrated editions of books were published by Pasquali during these years, and Smith retained the original drawings most of which were by Visentini.[1]

We know too that he was buying gems and cameos, and from the many letters that he wrote about these to the Florentine antiquary A. F. Gori in 1737 and 1738 we can derive our only explicit indication of his artistic tastes.[2] He emerges as an enthusiastic and apparently discriminating collector. 'It makes no difference to me,' he writes,[3] 'whether the stone be cut or the figures in relief or of what size they be, as long as the workmanship is excellent; and although I do like modern things when they are extremely beautiful, I must be understood always to give preference to the antique, without however blindly praising a bad piece just because it is antique. If I come across beautiful things, I am glad to pay what they are worth.' Many people, including, naturally, the dealers of the time, went out of their way to praise Smith's choice of stones,[4] but not everyone would have acknowledged his claims of generosity or even taste. Girolamo Zanetti later said that his brother Antonio Maria who copied Smith's gems for publication had been extremely badly paid, and he commented scathingly on the quality and authenticity of many of the Consul's 'antiques',[5] despite the fact that Smith always showed himself careful to distinguish between 'the good or, rather, excellent works of the sixteenth century when fine masters were alive' and those produced in more recent years.[6]

It was at about this time too that the connoisseur John Breval visited Smith's collection and was shown a little statuette which represented 'seemingly an Aesculapio-

[1] Blunt and Croft-Murray, pp. 67 ff.

[2] See p. 299, note 4.

[3] On 30 March 1737: 'Giacchè Ella si dimostra si inclinata à favorirmi & satisfare il mio genio per tali Cose, Io Le dico che tutto ugualmente mi piace, che la pietra sia incisa ò con figura ò figure di rilievo et di ogni grandezza purche il lavoro ne sia eccelente, et benche dico ch'applico à cose moderne quando sono belle assai, vorrei essere inteso, di sempre dar la preferenza all'antico senza però ciecamente stimare una Cosa cattiva perche è antica. Capitando cose bello hò Cuore anche di pagarle quello vagliono. . . .'—Biblioteca Marucelliana, Florence—see p. 299, note 4.

[4] The dealer Lorenzo Masini said that Smith's medal cabinet was outstanding in its day for quality—see Zabeo, p. 16.

[5] Letter from Girolamo Zanetti dated 21 August 1751 in Biblioteca Marucelliana, Florence—MSS. B. VIII, 13, p. 170: 'Vengo al Pasquali. La faccenda appartiene tutto al Console Brittanico *Smith*. Mio fratello dissegnò le gemme e i Cammei, e gli Vantaggiò di molto colla matite perchè gli originali non sono di quella perfezione, che si vorrebbe far vedere. Molti, se non isbaglio, sono moderni . . .' [*in margin*: 'Fu assai male ricompensato.']

[6] Letter from Smith to Gori of 13 April 1737: '. . . Non rifiuto le cose buone ò per meglio dire le ottime del secolo XVI quando viveano de bravi maestri, ne in niuna città fiorirono più che in Firenze, mà questa Testa d'Adriano è molto piu recente, e quasi quasi direi chi l'ha fatta . . .'—Biblioteca Marucelliana, Florence—see p. 299, note 4.

Priapus; with a Pudendum of monstrous proportion' as well as some more conventional sculptures, the Cignani cartoons and various books and antiquities.[1]

Early in the 'forties he resumed the patronage of contemporary artists on a large scale, and also engaged in two interesting and important transactions. In 1741 he sold a number of paintings, which are now impossible to identify, to the Elector of Saxony[2] and in the same year, or thereabouts, he bought a collection of Dutch and Flemish pictures from the widow of the artist Pellegrini.[3] Indeed, it was almost certainly from her that he acquired at least one of his masterpieces of Dutch painting—Vermeer's *Lady at the Virginals* (now in Buckingham Palace). It has been claimed that the Vermeer greatly influenced Canaletto's development,[4] but though the theory is a tempting one, it is difficult to substantiate. If this picture, which was then in no way singled out for special praise and, indeed, was attributed to the secondary painter Frans van Mieris, really came from Pellegrini's widow, it arrived at a time when Canaletto's style was already fully formed and his best days were nearly over. In any case the subtly modulated lighting and precision of the Dutch interior bears little relation to the huge views which Canaletto was then painting. For it was now, soon after the outbreak of the war of the Austrian succession in 1740, which so cut down the numbers of English tourists, that he once again began to work for his most persistent patron.

Canaletto's return to Smith marked a very striking change both in his style and in his subject-matter. He entirely gave up the small-scale views of Venice, on which his international reputation was securely based, and turned instead to grandeur and fantasy and a vastly increased range of subjects. There was quite possibly a second visit to Rome, perhaps with Smith, and this led to the painting of six views of ancient Roman monuments. These were the largest pictures that Canaletto ever painted for Smith, and if for no other reason they must have made a great impact among those in his collection. And their subjects made them unique in Venice. With their concentration on the grandest of antique monuments they were like some signal to show that Rome and Roman values were once more about to resume the leading rôle in Italian art. Yet this is still Rome as seen by the outsider, and consequently lacks that matter-of-fact element which was so characteristic of the Venetian views of his earlier years. Though the paint is now harsh, there is in these pictures something of a return to the dramatic vision of his very first pictures. It is significant that Smith should have wished for views of antiquity only and ignored the contemporary Rome of Pannini; yet it is hard to see these playing more than a symbolical rôle in the rise of the neo-classic.

This is worth stressing because the next few paintings commissioned from Canaletto so clearly were intended to portray the style of architecture that Smith particularly liked. It was in 1744 that Canaletto painted the '13 Door Pieces . . . [of] the principal Buildings

[1] Breval, 1738, I, p. 230.
[2] Blunt and Croft-Murray, p. 11.
[3] *ibid.*, p. 14, and, for the list of Smith's Dutch and Flemish pictures, pp. 19-23, and Vivian, 1962, pp. 330-3.
[4] Most forcibly and, to my mind, least convincingly by Brandi, pp. 60 ff.

of Palladio'.[1] In fact, as Smith recognised in a note at the end of his catalogue, by no means all the pictures in the series do represent that architect's works, but this first reference by him reveals clearly enough what was the aim of the group—to show the 'most admired Buildings at Venice'. And the vast majority of these were by Palladian architects of the sixteenth century. Yet the series as a whole is not altogether consistent. Alongside the bland, almost mathematically precise, views of the Rialto as planned by Palladio or the Courtyard of the Carità are quite imaginary scenes such as the Horses of St Mark's detached from the church and placed on the piazza or a fantastic interpretation of the Scala dei Giganti. These are among the first 'caprices' in Canaletto's work and it is tempting to link them with the arrival in Venice in 1743 of Francesco Algarotti, who was later to show such enthusiasm for this type of picture and who was at this very time in touch with Smith. It is equally possible that Canaletto derived the idea from Pannini on his visit to Rome a year or two before, and it must certainly have been about now that he painted for Smith his two *capricci* with Roman ruins in 'a bold frank manner'.[2] Yet though such pictures are more readily associated with the fanciful Algarotti than the more phlegmatic temperament of Smith, it was to his English patron that Canaletto dedicated in these very years by far his most poetic excursions into the field of the imaginary—the series of thirty-one etchings 'altre prese da i Luoghi altre ideate' (Plate 55a). These represent a side of Canaletto's art which is totally absent in his paintings for the Consul, though it is occasionally hinted at in his drawings—an appreciation of distances, worn columns overhung with plants, the solitary black bird, arches, mountains. It is a deeply felt, informal, often poignant vision, in which—almost for the last time—Canaletto's genius blazes at full power. Very soon afterwards he left for England apparently on Smith's recommendation and for nearly ten years there was little contact between the two men.

After Canaletto's departure in 1746 Smith turned to two other artists to continue the series of overdoors illustrating Palladian architecture.[3] Antonio Visentini had already been employed by him for more than fifteen years as an architect and book illustrator and Francesco Zuccarelli was an established landscape painter, who worked a great deal for Smith, though it is not clear whether his '6 Landscapes representing the story of Rebecca with Jacob and Esau' and many other pictures had already been painted before 1746 or whether the commission of that year brought about the first contact between the two men. In any case Zuccarelli's part in the enterprise was a minor one despite its greater artistic quality. It consisted of adding attractive decorative landscapes of the Venetian kind for which he was famous to the architectural views painted by Visentini. The architecture was exclusively English and consisted of a series of country houses and surroundings which neither he nor his patron had ever seen. All were in the style which Lord Burlington and his followers had raised into a dogmatic canon of

[1] Most of these overdoors are dated 1744, but the *Horses of St Mark's* is dated in Roman fashion A.U.C. 1332, which is equivalent to 1753. Sir Anthony Blunt has solved the problem by suggesting that Canaletto accidentally added an extra x—see Exhibition of *The King's Pictures*, 1946-7, No. 440.

[2] Cust, p. 153. The settings are imaginary, but appear to have been inspired by Padua.

[3] Blunt, 1958, pp. 283-4, and Vivian, 1963, pp. 157-62.

taste—the Palladian. Five of the eleven pictures portray works by Inigo Jones, two by Lord Burlington, two by Colen Campbell, one by Roger Morris, and one—curiously enough—by Vanbrugh, though the example chosen shows him at his most Palladian. In some cases separated buildings are combined, but none of these *capricci* includes the playful distortions of Canaletto's *Horses of St Mark's* and it is clear that the genre was not inherently sympathetic to Smith. The pictures were based primarily on engravings taken from Colen Campbell's *Vitruvius Britannicus*, and as far as architectural details are concerned they are mostly of great, almost programmatic accuracy. The significance of the whole series is made absolutely clear by the portrait that Nogari was commissioned to paint for him of Inigo Jones, taken from 'Vandyke, with the plan of the Banquetting House in his hands'.[1] Smith also brought out many editions of the works of Jones and Palladio, and in 1767 he published one of the manuscripts in his collection by the seventeenth-century theorist Teofilo Gallacini. The title was indicative: *Trattato sopra gli errori degli architetti*, and within a very short time the book was brought up to date by Antonio Visentini with a series of bitter attacks on the Baroque architects and their successors down to Piranesi. The effect was not missed by the Venetians who frequented Smith's palace, and later Andrea Memmo was to write that 'a great number of books on architecture which I was able to see in his house, and the guidance of Signor Antonio Visentini, made me pick out and prefer that style which is called pure and simple'.[2]

This devotion to the strict canons of neo-Palladianism in 1746 shows Smith conforming closely to the English taste at the very time when it was wearing somewhat thin in his own homeland. But it coincided with a move towards classicism that was felt in all branches of Venetian art during the 'forties and that Smith's patronage during this decade did much to promote. Despite the commission of an important work from Tiepolo, which came to nothing because it was expropriated by Algarotti for the court of Dresden,[3] Smith tended to move away from history painting and fantasy and turn more than ever to landscapes and architectural paintings proclaiming the virtues of sobriety. This tendency continued in the 'fifties—in the first year of that decade Visentini built a new classicising marble façade for his palace[4]—but by now his patronage of contemporary artists was greatly diminished. Zuccarelli went to England in 1752 and it may therefore have been at this period that Smith began employing Zais,[5] whose landscapes he did not think worth including in the batch of pictures that he later sold to George III. In the same year, however, he acquired some of his most magnificent drawings—including many by Castiglione and the Carracci—as well as some old master paintings from the heirs of Zaccaria Sagredo.[6] He also bought some more pictures from Canaletto, among them a number of English views, on that artist's return

[1] Cust, p. 161.

[2] [Andrea Memmo], 1786, p. 1.

[3] Haskell, in *Burlington Magazine*, 1958, pp. 212-3. And see later, Chapter 14.

[4] Gradenigo, p. 5.

[5] G. A. Moschini, 1924, p. 82: 'Che se Giuseppe Zais e Francesco Zuccarelli ebbero un gran protettore nel Console Smith. . . .'

[6] See document published by Blunt and Croft-Murray, p. 24.

from London in 1755. These, together with the Riccis and Cignanis and most of his larger works, were hung in his palace; at his country house he kept the paintings by Dutch and Flemish artists, a number of Zuccarellis and many of the old masters.[1]

By this time he was already nearly 80 and was making plans to dispose of his library and collections. In 1755 he published an inventory of his books, grandly but slightly absurdly called the *Bibliotheca Smithiana*, almost certainly designed as an elaborate sale catalogue, and a year later he began negotiations with the English royal family. These were interrupted almost at once by the outbreak of the Seven Years War.[2]

Disappointment, old age and the disruption of trade deeply affected him, and he began to withdraw more and more from social life. In 1756 he gave up his box in the theatre of S. Giovanni Crisostomo[3] and four years later he resigned the consulship and wrote that he wished to return to England, 'but first, having spent all my vacant time in amusements of admiring the fine arts and possessing considerable collections of things relating thereto . . .' he proposed to visit the principal towns of Italy, as he knew only Venice.[4] At just this time James Adam met him and wrote[5] that he was 'devilish poor & should he live a few years longer which he may do, he will die a Bankrupt . . . he has a fine collection which he ought to sell if vanity wou'd allow him, but he is literally eaten up with it'. However, in 1762, after difficult negotiations he at last managed to sell most of his best pictures, books, drawings and gems to King George III.[6] Even so, enough remained to cover his walls. His vitality was impressive: he still actively engaged in business, including picture dealing, and in 1766 he again became Consul for a few months. But, apart from this, he seems to have lived a retired life, attracting little attention from native Venetians or tourists. He finally died in 1770, two years after Canaletto, with whom he will always be associated.

– ii –

MARSHAL SCHULENBURG

Another foreigner was commissioning and collecting pictures in Venice at much the same time as Joseph Smith, and the contrasts in background and activities between Marshal Schulenburg and the English Consul are reflected very closely in their aesthetic tastes. There is no record that they were on close terms, and although they often employed the same artists, their collections were very different.

[1] Orlandi, pp. 79–80 and 206 (under Pellegrini and Zuccarelli). In 1757 Robert Adam visited Consul Smith at Mogliano and saw there 'as pretty a collection of pictures as I have ever seen, not large pictures but small ones of great masters and very finely preserved . . .'. Fleming, 1959, p. 171.

[2] Parker, p. 11.

[3] Archivio di Stato, Venice: Atti del notaio Lodovico Gabrieli, 7564, p. 12v, 22 Marzo 1756.

[4] Letter from Smith to William Pitt of 29 October 1760—Public Record Office, State Papers 99/68, f. 96.

[5] Letters from James to Robert and Jenny Adam of 20 and 27 August 1760 published by Fleming, 1962, p. 270. [6] See Appendix 5.

Johann Matthias Schulenburg, who came from a Saxon family, was born in 1661.[1] After studying in France and Germany, he served as a professional soldier in most of the great wars fought throughout Europe at the turn of the century. He fought for the Hungarians and for the House of Savoy; he fought for the Saxons in a series of engagements against Charles XII of Sweden about which he liked to talk in later life; and he fought in the wars of the Spanish Succession, serving under Prince Eugene at Malplaquet. It was this latter connection that brought about his association with Venice, for when in 1715 the Republic appealed to Eugene for help against the Turks he advised them to turn to Schulenburg. This advice was fully justified by the Marshal's brilliant defence of Corfù against Turkish onslaughts in 1715 and 1716. The campaign, which was commemorated by various works of art commissioned both by Schulenburg himself and by the State, earned him the enthusiasm of Europe and the particular gratitude of Venice, which erected a statue to him and awarded him a life pension of 5000 ducats a year.[2] He continued to serve the Republic, though there was no further opportunity for actual fighting, and after travel all over Italy as well as to London, Berlin, Dresden and Holland, he settled in Venetian territory. He divided the last years of his life between Venice and Verona, where he died and was given a splendid funeral in 1747.[3]

Schulenburg remained a grandiose figure in his retirement. He was closely related to the Hanoverian dynasty and was on friendly terms with half the crowned heads of Europe, whose portraits—Bourbons and Hapsburgs, Farneses and Hohenzollerns—lined the walls of the Palazzo Loredan in which he lived. They would call on him during their visits to Venice and write to him for help and advice in problems of all kinds. Thus Crown Prince Frederick of Prussia (later the Great) applied to him for a young *castrato* of 14 or 15, but was disappointed that Schulenburg could only find 'une fille agée de près de trente ans'.[4] The old Marshal himself would have seen the arrangement in a different light. He liked talking to his guests about women,[5] and a young English nobleman who fell ill during his tour of Italy was disconcerted to have his doctor sent for by Schulenburg 'and strictly required . . . to tell whether or not I had been clapt'.[6] To these younger men Schulenburg with his lavish hospitality and stories of bygone wars was 'un vieux bonhomme' or 'the oddest old fellow in the world'. But though amiable enough, he remained excessively proud and could be very rude. The will that he drew up in 1740 reveals a commanding spirit, keen to assert its authority over distant descendants—he had no children of his own—and determined to maintain

[1] The main source for Schulenburg's life is *Leben und Dentwurdigkeiten Johann Mathias Reichsgrafen von der Schulenburg*, Leipzig 1834.

[2] Romanin, VIII, p. 53.

[3] There is a drawing for the procession at his funeral in Verona—Archivio di Stato, VIII—Vari No. 35. He was in Venice 1729/30; 1732-4; 1737-41, and in Verona 1734-6; 1742-7.

[4] *Leben*, II, p. 312.

[5] De Brosses, I, p. 142: 'C'est un bien honnête vieillard, qui entend la guerre à merveille et fort mal la morale. Il nous fait sur le chapitre des filles de fréquents sermons, peu écoutés et point du tout suivis. . . .'

[6] Letter from Lord Rockingham in Verona to Lord Essex dated 2 February 1733—British Museum, Add. MSS. 27,733, f. 13.

in every way the noble status of his family.[1] At one time or another nearly all the artists whom Schulenburg employed were commissioned to record his own dropsical features. Piazzetta drew him several times (Plate 53a), he was painted by Bartolommeo Nazari, Giuseppe Nogari, Giacomo Ceruti, Gian Antonio Guardi, Francesco Simonini and many others, sculpted by Corradini and Morlaiter, engraved by Pitteri. His principal battles were painted by Simonini, whom he apparently took on his campaigns with him, and in 1726 he employed Canaletto to paint a view (probably taken from a print) of Corfù, the scene of his greatest triumph.[2] All these artists he treated with royal generosity.[3]

Schulenburg's collecting began suddenly in 1724 with a large purchase of old master paintings and sculpture from a lawyer, Giovanni Battista Rota, who also acted as an art dealer.[4] Most of these came from the gallery of the last Duke of Mantua, Ferdinando Carlo Gonzaga, many of whose belongings turned up on the Venetian art market after his exile and death in Padua following the Austrian occupation of his state in 1706. The sculptures included a bas-relief by Puget of the *Assumption of the Virgin* which was highly valued, and among the pictures were many attributed to Raphael, Correggio, Giorgione and particularly to Giulio Romano and Castiglione, both of whom had been much employed by the Gonzaga in happier days. Unlike Smith, Schulenburg showed a notable interest in contemporary Venetian sculpture, and among the works he bought from other collectors and sometimes commissioned were a large group of bronzes by Bertos (including an equestrian portrait of himself) and marbles by Corradini (including a *modello* of the statue of himself which the Republic had commissioned for the island of Corfù). His taste in old master paintings, as far as can be seen from the list of his purchases, was conventional except for the very extraordinary inclusion of a picture claimed to be by Giotto.

His relations with contemporary artists are of much greater interest. The first with whom he came into touch seems to have been Gian Antonio Guardi who worked for him for some fifteen years from before 1730 until 1745.[5] Guardi received a monthly salary from Schulenburg and was clearly looked upon by him not so much as an

[1] Biblioteca Marciana, Venice: It. VII, 480 (7785), cc. 234-264.

[2] Haskell, 1956, p. 298.

Keysler, III, p. 296, writes of Schulenburg's collection: 'Some pieces by Castiglione deserve particular notice, together with the last siege and new fortifications of Corfu, which are not only represented in paintings but there is likewise a model of them cut in wood.'

Canaletto's painting is described as follows in Schulenburg's inventory—see p. 313, note 3: 'Canaletti —I Tableau grand rep:te la Perspective de Corfu pend.t le Siege fait des Turcs dans l'Année 1716 avec la Perspective de son Canal, une partie de l'Ile et de la Terre Ferme Ottomane, outre les deux Armées Navales, savoir la Venitienne, et l'ottomane tirée en file.' Many other models and pictures of Corfù are recorded in the inventory.

For some of Schulenburg's portraits see Morassi, 1952, pp. 85-91.

[3] See, for instance, his dealings with Pitteri as recorded by G. A. Moschini, 1924, p. 93.

[4] See the manuscript inventories of the Schulenburg collection between 1724 and 1737 in the Staatsarchiv, Hanover. Edward Wright, I, p. 78, referred to the Puget and an 'abundance of other fine things' from the Duke of Mantua's collection as belonging to Rota.

[5] Morassi, 1960, pp. 147-64 and 199-212.

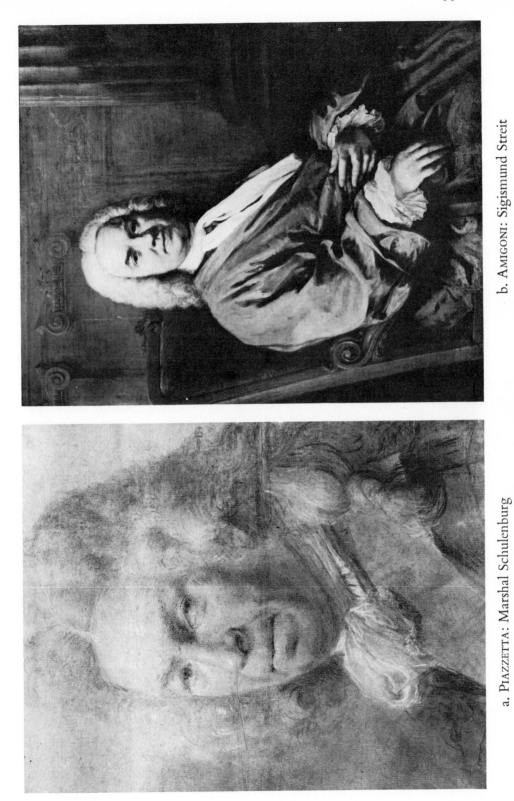

Plate 53

GERMAN PATRONS IN EIGHTEENTH-CENTURY VENICE

b. AMIGONI: Sigismund Streit

a. PIAZZETTA: Marshal Schulenburg

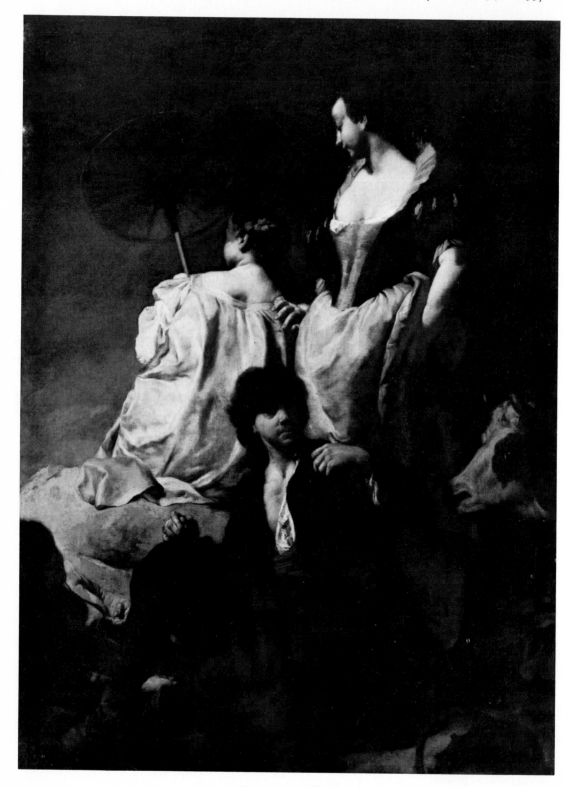

PIAZZETTA: Idyll

Plate 55

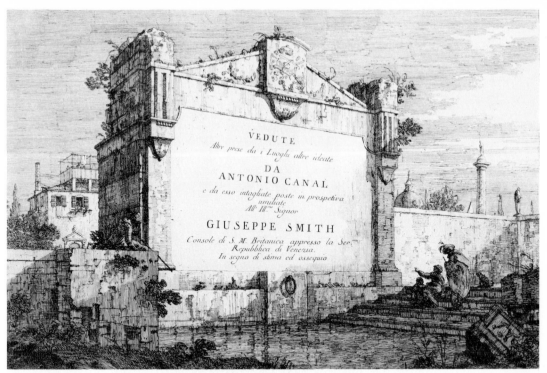

a. CANALETTO: Dedicatory frontispiece to Etchings

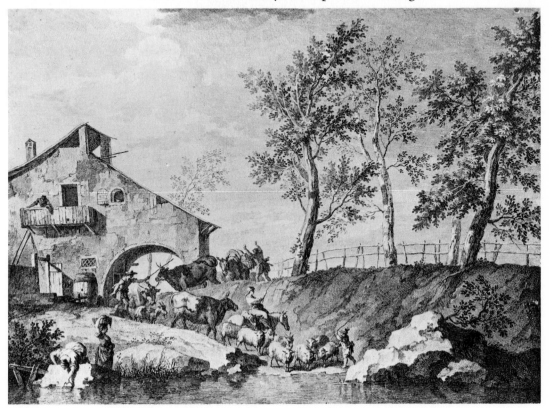

b. MARCO RICCI: Village Scene

Plate 56

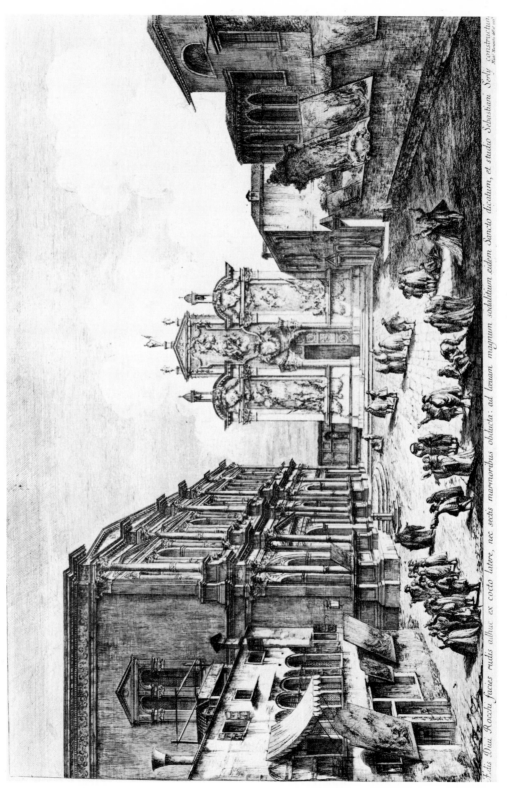

MARIESCHI: Picture Exhibition at Church of S. Rocco

original painter in his own right as a useful copyist and hack. During the whole period of his employment only once—in 1737—was he commissioned to paint history pictures of his own; and the miserable sum he was then paid (about ten *zecchini* for the lot) shows that they must have been small and of little consequence. In general, he was required to copy masterpieces of the Venetian Cinquecento—Veronese's *Marriage at Cana* in S. Giorgio Maggiore and *Madonna and Child with Saints* in S. Zaccaria, Tintoretto's *Temperance* and *Fortitude* in the Madonna dell'Orto, Bassano's *Nativity* in S. Giorgio Maggiore—and even pictures by his own contemporaries, Sebastiano Ricci, Piazzetta and Rosalba Carriera. His remaining time was spent on churning out an endless succession of portraits, sometimes as many as six a year, of Schulenburg himself to be given to his friends and royal admirers, or of those grand connections to be hung on his own walls. It is not surprising that the quality of those that have survived is generally low[1]; only rarely does the Guardi magic transform an obviously pedestrian original into a work of authentic beauty, most conspicuously in the little Turkish scenes copied in 1742 and 1743 from engravings taken from Van Mour—here at last the artist was given the opportunity to display his talent for delicate and sparkling fantasy.[2] There is a strange irony in the situation. Schulenburg, who was Guardi's most persistent patron, wholly failed to appreciate the true nature of his gifts except on the one occasion when he ordered him to paint these idyllic versions of the customs of his most ferocious enemies.

In fact, the Marshal's tastes veered in a very different direction. The nucleus of his collection was made up of history and genre paintings by Pittoni and Piazzetta.[3] During the 'thirties, when Schulenburg was commissioning pictures from him, Pittoni was considered to be one of the leading history painters in Venice. Almost alone among his fellow-citizens he would be asked to contribute a canvas when large-scale international commissions were being planned for some royal court, and he was already much in favour with German patrons.[4] For Pittoni turned the main episodes of Greek, Roman and Biblical history into melodramas which represented for his contemporaries the most acceptable and up-to-date versions of the old Baroque themes. Unlike Tiepolo who largely confined himself to frescoes, Pittoni rarely painted other than easel pictures and he was therefore much in demand among collectors. For Schulenburg he produced a series of pictures illustrating scenes of high Greek and Roman valour and sacrifice— Scipio and Alexander the Great, Polyxena and Iphigenia.

Piazzetta enjoyed a closer relationship with Schulenburg than any other artist except Gian Antonio Guardi, and in his case the results of this patronage were wholly beneficial. For the Marshal must have seen that Piazzetta's gifts did not lie in scenes of dramatic

[1] Apart from those reproduced by Morassi in the above articles see the portrait of Schulenburg attributed to Gian Antonio Guardi in the Museo Correr, Venice—Pignatti, 1960, p. 105.

[2] A number of these have turned up in exhibitions and sales during the last few years—see Watson, 1960, pp. 3-13, who now attributes the series to Gian Antonio rather than Francesco Guardi.

[3] See the published inventory (n.d.): *Inventaire de la Galerie de feu Mgr. le Feldmarechal Comte de Schulenburg*. This is referred to by Morassi, 1952, pp. 85-91.

[4] See Chapter 10.

action of the kind painted by Pittoni, and he therefore employed him on a totally
different type of picture which brought out the very best of this painter's talents. It was
Piazzetta also who acted as Schulenburg's chief agent in the purchase of interesting
pictures on the market—usually Flemish.[1] For the old Marshal was particularly fond of
Dutch and Flemish painting—a taste that was reflected in the type of patronage he
afforded to certain Venetian artists. He owned a drawing by Piazzetta of 'des animaux
et figures à la flamande' and some twenty heads of men and women by Bartolommeo
Nazari and Giuseppe Nogari in a genre that ultimately looked back to Rembrandt. It
was this taste for Flemish art that encouraged the Marshal to commission naturalistic
painting. Thus Piazzetta painted for him subjects such as a *Beggar holding a Rosary*, a
Girl with a Basket of Chickens and, above all, the great pastorals or idylls, now in Cologne
and Chicago. The significance of these pictures is not clear. Piazzetta himself who drew
up the inventory of Schulenburg's collection naturally valued them very highly, but
described them merely as 'représentant une femme assise au naturel, avec un garçon
entre les Jambes, un panier de raisins en main, des chiens, qui aperçoivent un canard dans
l'eau et deux hommes en distance' and 'Une femme avec un parasol, une servante, un
paysan, un garçon qui dort, et la tête d'un bœuf' (Plate 54). It has been suggested
that the former picture contains a hint of social satire.[2] While this is almost certainly
wrong, it does at least make the point that the pictures were probably taken to be far
more 'realistic' than our present appreciation of their poetic qualities allows. No
pictures of comparable size showing ordinary people were painted during the eighteenth
century in Venice except on occasion by Piazzetta himself. But perhaps the best reason
for believing that they appealed to a taste for naturalism in the Marshal is that his gallery
contained so many other genre pictures. In particular he owned seven by the provincial
realist Giacomo Ceruti, some of which portrayed beggars and others animals.[3] These
pictures alone would suffice to make Schulenburg's collection unique in Venice; and if
we imagine them hanging in his palace along with his Piazzettas and his various Dutch
and Flemish masters, we can see that the effect must have been strange enough to his
visitors brought up so largely on histories and mythologies.

Like Smith, Schulenburg patronised the *vedutisti* and landscape painters, but with
one or two important exceptions he owned nothing by Canaletto whose close relations
with the English made it difficult for other residents in Venice to acquire his work.
Instead he owned a view and a number of landscapes by Marieschi, and others by
Carlevarijs, Cimaroli, Joli and especially Marco Ricci and Zuccarelli.[4]

Schulenburg's collection of pictures attracted less attention from travellers than did
Smith's largely because he was constantly sending crates of them back to his estates in

[1] A number of pictures recommended to Schulenburg by Piazzetta, Pittoni and Angelo Trevisani
are recorded in the Archives in Hanover.

[2] See White and Sewter, 1959, pp. 96–100.

[3] See the published inventory, and for the subsequent sale of these pictures in England, Levey, in
Arte Veneta, 1958, p. 221.

[4] There are ten pictures by Marieschi; six by Carlevarijs; four by Cimaroli; two by Joli; nine by
Zuccarelli and six by Marco Ricci.

Germany. He began doing this in 1735, and thereafter he sent dozens of pictures on two or three occasions every year. If we try and reconstruct the collections of the two men and compare them, we notice several differences. Smith's was based largely on Sebastiano Ricci, Rosalba Carriera and Canaletto—all painters who were represented rather weakly in Schulenburg's, though he owned a portrait and some paintings of Ricci and was on good terms with Rosalba.[1] Schulenburg's collection was rich in works by Piazzetta, Pittoni and Gian Antonio Guardi, none of whom was particularly favoured by Smith. Both men owned works by Marco Ricci and Zuccarelli, though Smith had a far greater number. Neither had any painting by the finest artist of the age, Tiepolo. Smith showed a characteristically English penchant for landscape and views, Schulenburg for history, portrait and genre.

– iii –

SIGISMUND STREIT

Curiously enough a third foreign collector long resident in Venice seems to hold a position midway between those of the two great patrons who have just been discussed. A businessman like Smith, a German like Schulenburg and, like him, in close touch with Frederick the Great, Sigismund Streit owned far fewer pictures than either—only forty-eight in all—and made little impact on Venetian society. But some were of good quality and they seem to reflect so sensitively their owner's similarities and discrepancies with Smith and Schulenburg that they are worth discussing here.[2]

Sigismund Streit was born in Berlin in 1687, the son of a blacksmith, and he came to Venice in 1709. He soon began to engage in commercial activities which won him a fortune. He retired in 1750 and four years later he settled in Padua, moving to Venice only during the winters. He seems to have begun collecting pictures only about ten years earlier when he was already well past middle age and in 1758 and again in 1763 he bequeathed those he had acquired to various institutions, especially the Gymnasium zum Grauen Kloster in Berlin where he had been educated. He died, a bachelor, in 1775 and was buried in the Protestant cemetery of S. Cristoforo.

One of the strongest emotions in Streit's life was his admiration for Venice, the city that had transformed his situation and turned him into the rich and complacent figure who gazes at us from Amigoni's portrait. He arranged for a yearly speech to be made in Berlin in honour of his adopted city, and of the pictures he owned a strikingly high proportion were painted to celebrate its beauties and traditions. Works of art held a far more specific and also a far more personal meaning for Streit than they did for more sophisticated collectors. Of his four Canalettos, two showed scenes which were directly concerned with his own life, as he pointed out in the long notes which he made about

[1] On 28 July 1743 Schulenburg wrote to Rosalba Carriera recommending to 'di lei amorosa assistenza' a young woman painter called Angelica Griè—Biblioteca Laurenziana, MSS. Cod. Ashburn. 1781, Vol. IV, p. 266.

[2] For a brief outline of Streit's career and a list of his pictures with details of their subsequent fate see Rohrlach, 1951, pp. 198-200. For his position in Venice see Denina, p. 196.

his pictures.[1] One portrayed a sweep of the Grand Canal looking south-east from the Campo S. Sofia to the Rialto. Well in the foreground is a gondola in which stands Streit himself, while behind can be seen the Palazzo Foscari in which he lived. The other view was of the Campo di Rialto in which his business activities were carried out.

He was equally keen to have pictures of the ceremonies and festivals of the Republic. Two more Canalettos, among his very rare night scenes, show the *Vigilie di S. Pietro* and *di S. Marta*, the latter the most popular of all such occasions, and several other paintings by Canaletto's followers recorded the Doge taking part in official processions.[2] This section of Streit's collection culminated in an allegorical 'Glory of Venice' which has unfortunately been destroyed.

Streit shared Schulenburg's taste for portraits of royalty, and he commissioned his friend Antoine Pesne to paint Frederick the Great and the Queen of Prussia. But, above all, he liked to see representations of himself and his family. Portraits of his father, his mother and his sister hung from his walls as well as four of himself (Plate 53b)—not one of which wholly satisfied him.

Schulenburg was an enthusiastic collector of Pittoni and Piazzetta, Smith of Sebastiano Ricci—it seems almost inevitable that Streit should have turned to Amigoni, who painted his portrait and ten other pictures for him between 1739 and 1746.[3] Their subjects were among the most popular of the Old Testament and mythological repertoire, but they had none of the glitter or heroic melodrama of Ricci or Pittoni. In them everything tends to the pastoral or the mildly erotic. Suave and delicate, with no emotional change of key between *Lot and his Daughters* and *Solomon adoring the Idols* or between *Bathsheba* and the *Sacrifice of Isaac*, they were doubtless intended to be soothing to the eye of the tired businessman. This class of patron has since become much more familiar; in the early eighteenth century he was still rare.

Streit naturally owned a couple of Zuccarelli landscapes and the odd Dutch picture, but the only other artist well represented in his collection was Giuseppe Nogari. This painter was famous above all for his 'teste di fantasia'—imaginary half-length portraits, strongly influenced by Northern artists especially Rembrandt, usually of old men and women. Streit had two of these—an *Old man with a Pipe and Tobacco Pouch* and an *Old Woman with Glasses*, but he also employed Nogari to paint four allegories of Education and other elevating subjects which were characteristically turned by the artist into pretexts for rather mawkish genre—a branch of the art which he clearly found more congenial[4] and which, as will be seen in the following chapter, was winning much support at the time in some of the more 'progressive' circles in Venetian society.

[1] Streit's notes on his Canalettos have been published by Zimmermann, pp. 197-224. The Canalettos have also been discussed by W. G. Constable, 1956, pp. 81-93, who rejects the attribution to Moretti or some other follower.

[2] Zimmermann, pp. 199-203, attributes one of these—the *Sala del Maggior Consiglio*—to Gianantonio and Francesco Guardi.

[3] These were the years when Amigoni was in Venice after his visit to England and before that to Spain. His portrait of Streit, which is published by Zimmermann, was painted when the sitter was aged 52—i.e. in 1739.

[4] I am grateful to Mr Hugh Honour for letting me see his photographs of these paintings.

Chapter 12

THE ENLIGHTENMENT

VENICE had remained immobile—or so it seemed—but Europe had changed. The last ten years of the seventeenth century in England and France had seen the beginnings of an intellectual revolution that was to destroy the foundations on which Baroque civilisation had rested.[1] The absolute supremacy of any one authority, whether secular or religious, was seriously questioned. Reason slowly took its place as the ultimate criterion of judgement. Little by little and however grudgingly, tolerance and diversity came to be accepted. Trade began to replace landholding as an index of wealth. These great changes at first gradually and then with ever-increasing speed profoundly affected the nature of patronage and the arts. In both England and France royalty and the Church no longer monopolised the leading painters. And the new patrons, whether aristocratic or middle class, rejected the all-embracing cosmology of the Baroque. As the eighteenth century progressed, various styles were encouraged and dropped: a light-hearted rococo, which took over much of the formal language of the Baroque without its moral seriousness; a renewed interest in realism, often tinged with satire or didactic elements; an austere return to neo-classicism. The genesis of all these styles is confused; none of them can be identified with any one social class; all of them frequently overlapped. And combined with all these changes went a renewed investigation into the part that painting should be expected to play in the life of a nation—an investigation more searching than any that had taken place since that inaugurated by the fifteenth- and sixteenth-century humanists.

In Italy, too, new ideas were in the air. The creation in Rome of the Society of Arcadia in 1690 marked a deliberate and symbolic break with seventeenth-century culture—though significantly only in the field of literature. And links with the rest of Europe were greatly strengthened by the vast numbers of foreigners who crossed the Alps either as soldiers or as tourists at the beginning of the new century. Yet despite this, and despite the blossoming of learned journals in touch with Paris, Italy at first saw nothing comparable to the great changes that had shaken France and England, and more and more those Italians—writers, artists and intellectuals—who wished to experience the new developments were compelled to travel to London or Paris. On their return a great stocktaking of the state of Italian culture filled the journals with controversial articles. All this prepared the ground for the diffusion of 'enlightened' ideas which at first travelled only slowly and hesitantly. As late as 1737 the Pope tried to prevent the erection of a mausoleum to Galileo in the Florentine church of S. Croce and his *Dialogo* could not be published until 1744.[2] Although much had been achieved before

[1] Hazard, 1935.
[2] Maugain.

then, the peace of Aix-la-Chapelle in 1748 is usually taken as the starting-point for a new spirit in Italy. When in 1766 Voltaire turned his attention southwards across the Alps and commented on the great intellectual revival that had taken place he suggested that it had been going on for about twenty years.[1] The changes had been very striking indeed. All over Italy writers had become aware of the distance that separated them from the rest of Europe and had begun to narrow it. In 1749 Muratori published his *Della pubblica felicità, oggetto de' buoni principi* whose title alone proclaimed the advanced ideas inherent in the thesis; in 1750 appeared the Abate Galiani's treatise *Della Moneta*; in 1754 Antonio Genovesi took up his chair in Naples as the first professor of political economy in Europe; in 1764 Beccaria published his epoch-making *Dei delitti e delle pene* and was rapturously welcomed in Paris. For the first time since the silencing of Galileo Italy was in the vanguard of contemporary thought.

In these changes Venice had played little direct part. Though the ideas might filter through the censorship without too much difficulty and be discussed perhaps in Consul Smith's library or by Caterina Dolfin Tron and her intellectual friends, Venetian interest in maintaining the *status quo* was too powerful for the Republic to become the originator of any of the doctrines of the 'Enlightenment'—it was indeed a Venetian who proved to be the most vigorous opponent of Beccaria—nearly all of which presupposed the abolition of rule by aristocracy. Pietro Giannone, Carlo Antonio Pilati, Giuseppe Baretti and other unorthodox thinkers were rapidly expelled from her territory.[2] And yet, especially in those circles which were most in touch with foreign influences, we can trace the gradual spread of ideas which, among other things, were to have important effects on art.

One of the problems that was most discussed in Italian literary and philosophical circles in the early years of the eighteenth century was that of the relative proportions that fantasy and reason should assume in the creative act. The discussion had been stimulated by the formation of the Society of Arcadia with its deliberate call to reason and by contact with French critics who had attacked the style not only of Marino and his followers but of Tasso himself.[3] Among those who made interesting contributions to the debate that followed was a Venetian who sometimes extended the discussion into the field of the visual arts and thus—mainly through his influence on other writers— played some part in their development.

Antonio Conti, of noble origins, was among the pioneers of that growing number of Italian intellectuals who realised that a visit to England and France was essential to avoid the stifling provincialism of Venice.[4] In 1713, at the age of 36, he went to Paris, where he was in touch with Malebranche, Fontenelle and other leading figures. Two years later he crossed the Channel and met Sir Isaac Newton, who was to become the most influential man in his life. At first the relationship was highly satisfactory to both

[1] In a letter of 1766 quoted by Natali, p. 5.
[2] For Giannone's residence and expulsion from Venice see Pierantoni; for Pilati see Brol.
[3] See J. G. Robertson and Moncallero, I.
[4] For Conti see Robertson, Chapter IV, and Vol. II of his *Prose e Poesie*, 1756.

of them: Newton proposed Conti's election to the Royal Society—he was already an amateur scientist—and Conti wrote 200 verses on Newton's philosophy. Later there was a furious break when on a second visit to Paris Conti revealed to the French some confidential notes that Newton had shown him on the dating of classical history.[1] Although he was denounced in a public letter, Conti never abandoned his allegiance to Newton and the many other English writers he had met in London. He showed his appreciation of English literature by translating Milton, Dryden and other poets, and by being the first Italian to write on 'Sasper', whose *Julius Caesar* he imitated in a tragedy of his own. His second visit to Paris lasted eight years between 1718 and 1726, and among the many friendships he made was one with the Comte de Caylus.

In 1726 Conti returned to Venice, where he spent most of his time until his death in 1749. He had acquired a very extensive knowledge, unique in the Venice of his day, of modern English and French culture and he proceeded to display it in a series of essays, philosophical treatises, scientific pamphlets and so on, which undoubtedly influenced his friend Francesco Algarotti. From time to time he wrote about the arts, but as his papers were only edited in 1756 after his death and in a very abbreviated form, it is difficult to know just how close was his connection with contemporary painters—a treatise he wrote on painting has been lost. He certainly had some vague ideas about the effects that Newton's optical discoveries ought to have on the use of colour, but these made no impact.[2] He went out of his way to praise Canaletto for his sagacity in using the *camera ottica* to paint views of the Grand Canal.[3] And he made an interesting defence of fantasy in painting which chimed in well with contemporary practice and thus suggests that he was one of the few intellectuals of the day who did not disapprove of the licences taken by Venetian artists—though as it is not known just when he wrote his brief paragraph on painting it is impossible to estimate its polemical intentions. 'The painter's fantasy', he wrote,[4] 'should be expressed in breadth of knowledge, in subtlety and correctness of draughtsmanship, in liveliness and vigour of execution. Moreover,

[1] Apart from the above see Manuel, pp. 86 and 94.

[2] Conti, II, p. cxlviii: 'Leonardo da Vinci cita un suo manuscritto, dove egli parla dell'armonia de' colori in ordine alla pittura. Il manuscritto è nella Biblioteca di Milano, e si renderebbe un gran servigio alle bell'arti di stamparlo, in un tempo che la teoria Newtoniana de' colori ha data occasione a molti il determinare per la regola meccanica de' centri di gravità la loro composizione. Da questa ricavò il suo secreto quel Pittor Tedesco che stampa le pitture, della qual arte ne diede varj saggj a Londra, ed uno ne conserva quì in Venezia il Signor Antonio Zanetti. Io vidi questo Pittore all'Haja, ed egli mi assicurò, che seguendo i principj del Newtono su l'immutabilità e varia rifrangibilità e reflessibilità de' raggi della luce, egli avea stabiliti i gradi di vivacità e d'indebolimento da darsi a' colori per armonizarli. Se ciò è vero, si vede come in ombra, non esser impossibile il determinare nel corpo umano l'armonia de' colori, qual forse l'avea fissata Apelle, che dipingea le cose che non si possono dipingere, come i tuoni, i baleni, i folgori. . . .'

[3] *ibid.*, p. 250: 'S'adopri pure la camera ottica per far la perspettiva d'un canale di Venezia con le sue fabbriche: il Canaletto per la sua sagacità potrà trasferire nella sua pittura più punti di un altro; ma non è possibile che mai tutti li trasferisca. Contuttociò i trasferiti da lui faranno un'impressione così viva nell' occhio, che vedendo il suo quadro a prima vista io sarò persuaso di vedere l'oggetto stesso. . . .'

[4] *ibid.*, p. 278: 'La fantasia pittoresca deve essere secondo lui spaziosa nelle cognizioni, delicata e retta nel dissegno, vivace e ardente nell'esecuzione, appassionata e espressiva del senso e dell'affetto, e graziosa per discostarsi un poco dalla natura ed accomodarsi meglio al giudizio e al piacere del senso. . . .'

it should excite the senses and the passions, and grace requires it to move away some-
what from nature so as to be the better adapted to the judgement and pleasure of the
senses.' This seems to be the very justification of a *modello* by Tiepolo or Pittoni.

Such detached references are too brief for us to claim that Conti had any coherent
aesthetic ideas or that they played much part in encouraging any particular painters.
But we know that he showed an interest in the arts, for it was to him that the elder
Zanetti wrote to announce his rediscovery of the process for making colour woodcuts[1];
and we know too that Francesco Algarotti, who was in constant correspondence with
him, took over many ideas from this Italian pioneer in the understanding of Newton.
As we will see, even in his most neo-classical phase Algarotti never lost his belief in the
vital importance of creative fantasy, and it is certain that this belief was largely inherited
from Conti. Indeed, a thin trickle of support for the artist's right to make use of his
unfettered imagination runs right through Italian eighteenth-century thought until
with Saverio Bettinelli's *Dell'entusiasmo per le Belle Arti* (Milan, 1769) it merges into
outright acceptance of the 'genius' with all his vagaries.

But there was in Venice during the first half of the eighteenth century a thinker
whose artistic ideas were to prove far more immediately stimulating than those of Conti,
even if no more effective in practice. Among the men who frequented Consul Smith's
palace on the Grand Canal was Padre Carlo Lodoli, a brother of the Minori Osservanti.[2]
Lodoli had studied mathematics and French, travelled in Rome and other parts of Italy
and returned at the age of 30 to his native Venice in 1720. Here he opened a private
school for the sons of some of the leading families as well as those of his friends. This
school was run on the most advanced, modern lines. Lodoli's favourite authors were
Galileo and Bacon; he took his pupils to visit libraries and distinguished scholars. He
brought them up on Cicero and Puffendorf on the duties of man. And he had a brush
with the Inquisitori di Stato because he insisted on using State documents as suitable
subject-matter for grammatical and literary investigation. He was a keen admirer of
Vico and he was among those who persuaded the Neapolitan philosopher to write his
Autobiography, which was first published in Venice.[3] After some years he was appointed
chief censor of the Republic with duties which he carried out conscientiously but in a
liberal spirit. He soon became associated with a number of the more enlightened figures
in the city—Andrea Memmo, especially, but also Angelo Querini and Giambattista
Pasquali, the publisher, who in later years could never mention his name without tears
in his eyes. Nearly all these were also friends of Consul Smith and for a time he had a
number of admirers among the Venetian aristocracy. Outside Venice he was in touch
with Montesquieu and Scipione Maffei.

In appearance Lodoli was uncouth and his manner was gruff. He indulged in a
degree of outspokenness which would hardly have been tolerated in anyone else; but

[1] Lorenzetti, 1917, p. 49, note 1.

[2] Our only source for Lodoli's life is Andrea Memmo's anonymous *Elementi dell'architettura lodoliana*,
first published in Rome in 1786, but there are many scattered references to him in Venetian learned
journalism of the first half of the eighteenth century. See also Petrocchi, 1947.

[3] In [P. Angelo Calogerà]: Raccolta, I, 1728. See also Fisch and Bergin, pp. 183-4.

this is almost certainly because he was not taken wholly seriously even by those who most admired him. He enjoyed some of the privileges of the licensed jester. Besides, he knew how to turn back when the situation was becoming awkward. We learn that he 'never objected to the luxury of great noblemen, for without their generosity, ambition or whim countless good craftsmen would die of starvation'—the sort of perverse logic that has often been used by radicals tolerated in a conservative society.

Though Lodoli must sometimes have found it difficult to express openly his moral and political ideas, there was no need for any reticence when he came to deal with the arts—though in his view they were all inextricably linked. As interpreted for us by most of his contemporaries (for his own writings were lost), Lodoli insisted on a wholly functional architecture in which reason and comfort should be the final arbiters of style. In this way he was rejecting not merely the late Baroque of his own youth, but also the classicism that was beginning to replace it. Nothing shocked his contemporaries more than his dispassionate investigation of the architecture of antiquity. He certainly did not condemn it out of hand, but he called its infallible authority into question. Even the Pantheon, he said, was not perfect; and in any case everyone had interpreted classical art in a different manner.

As far as current architecture went, Lodoli's influence was negligible, perhaps because, as one writer complained, 'when he is on his own he is so overwhelming that he gives me indigestion for days afterwards', and even among critics who shared his views of the Baroque he was considered to be an 'impudent impostor'.[1] He himself only practised on one occasion, when he introduced some functional modifications into the monastery of his own Order, the Minori Osservanti, outside S. Francesco della Vigna.[2] He was once invited by the governor of the Ospedale della Pietà to look at Massari's *modello* for the proposed church. When Lodoli began to criticise this on logical grounds, the architect answered: 'If I were to submit some totally new conception, however reasonable, I could be quite sure that the plans of some other architect, imitating for example a façade of Palladio or Vignola, would be chosen instead of mine. And then who would support my family?'

Yet he made an impact on some of the more open-minded thinkers of the day. The essayist Gasparo Gozzi must certainly have had Lodoli in mind when he complained that 'we put so much into ornamentation that we build more for the eyes of passers-by than for the people who actually live in houses: and if someone were to come from a country where houses are used just as shelter from the cold and the rain and were to see our houses and not their inhabitants, he would think that they must all be giants'.[3] Francesco Algarotti was, as usual, somewhat scared of public opinion, and he produced a rather distorted version of Lodoli's opinions which failed to please their author, though he had originally welcomed Algarotti's interest and the intention had been

[1] Letter from the Abate Ortes to Francesco Algarotti of 26 September 1749 in Algarotti, XIV, p. 315, and Temanza, p. 87.

[2] G. A. Moschini, 1815, I, p. 48.

[3] Gozzi, I, p. 26—*Dialogo tra un librajo e un Forestiere.*

friendly.[1] On the whole, however, Lodoli's keenest admirers, Andrea Memmo, Angelo Querini and Filippo Farsetti, all became strong supporters of that very classicism which Lodoli had questioned.

Lodoli's views on painting were also exceptional. Although the two men were satirised together in a bitter and 'reactionary' sonnet which accused them of wanting to 'weigh the moon',[2] he wholly rejected Conti's sympathy with fantasy and adopted a far more austere standpoint. Like Smith's other friend, the Abate Facciolati in Padua, with whom he too was in close touch, he arranged his gallery on didactic lines so as to show the progress of the arts from the Greeks (i.e. the Byzantines) until the moderns.[3] He acquired so many pictures from Jews and second-hand dealers that they not only covered his walls but were stacked on the floor as well. Unfortunately, we know almost nothing precise about his relations with contemporary painters. We are told that they were extensive; that he used to go and watch the leading artists at work; that he would obtain commissions for them and be given pictures by them in return; that he would give advice to people who were decorating their town and country houses. But we have no idea who these painters and clients were. From what we know of his love of reason and authenticity it is very hard to believe that Lodoli can have admired Tiepolo, Piazzetta and the other Venetian 'history painters'. It seems more likely that he may have been in close touch with artists like Canaletto and Visentini, with whose work he must have been very familiar through Consul Smith. Certainly he knew Bartolommeo Nazari and Alessandro Longhi, both of whom painted portraits of him.[4] The latter picture (Plate 48c) was commissioned by a friend of Lodoli's, Pietro Moscheni, and it is one of the very few penetrating studies of the Venetian eighteenth century: no attempt is made to beautify the rather coarse head with its large bulbous nose, lively eyes and straggling hair. The painting was soon engraved and at the base of the print were added the words: 'P. Carlo de Co:ti Lodoli Veneziano forse il Socrate Architetto'. Lodoli himself chose the decorative border and this caused a good deal of controversy. Apart from the usual attributes of the architect—plans, rulers, compasses, etc.—he had his portrait surrounded by a circular frieze on which was written DEVONSI UNIR E FABRICA E RAGIONE—E SIA FUNZION LA RAPPRESENTAZIONE—words derived from Vitruvius which his disciple Andrea Memmo admitted were difficult for most people to understand. At the base of the portrait were two tablets bearing a text from Jeremiah: UT ERUAS ET DESTRUAS UT PLANTES ET AEDIFICES (See, I have this day set thee over the nations and over the kingdoms, *to root out*, and to pull down, *and to destroy*, and to throw down, *to build and to plant*)—proof, said his opponents, that he was only interested in destroying. On the contrary, replied his disciples, he was merely following Socrates who believed that prejudice must be uprooted before truth could be appreciated.

It is tempting to assume that Lodoli may have admired Alessandro's father, Pietro.

[1] For Algarotti's reactions to Lodoli see Kauffmann, 1944 and 1955.
[2] Biblioteca Correr, Venice—MSS. Correr, Misc. XI/1348 (1140).
[3] Previtali.
[4] The portrait by Alessandro Longhi is in the Accademia in Venice. For its history see [Memmo]: *Riflessioni*, 1788.

For we know that Pietro Longhi was highly thought of in other advanced circles of Venetian society. Significantly, it was in 1750 that Goldoni first hailed him as a 'man who is looking for the truth'.[1] This was the very period when Goldoni was making his deliberate and decisive break with the old masked comedies and was trying to reform the theatre by a return to nature. So it may well have been the painter who inspired the poet—Longhi had already been painting genre scenes for many years—rather than, as is usually assumed, the other way round. Seven years later Goldoni returned to the subject and again praised Longhi for his 'manner of representing on canvas the characters and passions of men'.[2] Goldoni's sympathies were 'advanced', at least by implication,[3] and he was accused by his opponents of being 'a corrupter no less of poetry than of decent behaviour (buon costume)'.[4] Could Longhi's pictures—those little 'conversations, meetings, playful scenes of love and jealousy'—have been interpreted in the same sense? The very idea seems absurd, despite the fact that early in the nineteenth century a Venetian historian claimed (with no supporting evidence) that he 'went so far in depicting the truth that he was several times punished by the laws'.[5] None the less it is significant that the most enthusiastic praise of his work should have come from men who were anxious to look more steadily at the actual circumstances of Venetian life than was usual at the time.

Despite this, Pietro Longhi was certainly admired and collected by a great number of patrician families in no way associated with advanced ideas, and in most people's eyes his break with fantasy can have had no connection with directly political motives. By the middle of the eighteenth century the irrational in all the arts was coming under attack, and the ideas of men like Lodoli were making at least an indirect impact. Thus we hear that in 1749 Gian Domenico Tiepolo's series of paintings in S. Polo representing the Via Crucis met with strong criticism because 'all the figures were wearing different costume—some Spanish, some Slav and some are just caricatures. And people say that in those days that sort of person was not found and that he has painted them in that way only out of personal whim.'[6] One at least of Longhi's admirers made it quite clear that he liked him just because of his rejection of this sort of thing. Gasparo Gozzi, who was also a strong defender of Goldoni, despite the attacks of his brother Carlo, twice wrote about Longhi in the *Gazzetta Veneta* and the *Osservatore Veneto* which he edited on the lines of English journals such as *The Spectator*. On both occasions he compared him to Tiepolo. In August 1760 he reaches the conclusion that Longhi's 'imitations' of the life he sees around him are 'no less perfect' than Tiepolo's great scenes of the imagination.[7]

[1] Goldoni: *Al Signor Pietro Longhi veneziano celebre pittore*—Opere, XIII, p. 187.

[2] Goldoni, II, p. 92—dedication of *Il Frappatore*.

[3] Dazzi.

[4] Goldoni is not actually named, but the allusion to him is clear in the letter from Giuseppe Gennari to Gaspare Patriarchi of 5 November 1761 published by Melchiori, p. 142.

[5] [Paoletti], 1832, p. 122. There is no evidence for this in the Archives of the Inquisitors, and Paoletti. who calls the artist 'Antonio' Longhi, does not seem wholly reliable.

[6] Letter from Pietro Visconti to Gian Pietro Ligari of 19 December 1749 published by Arslan, 1952, p. 63.

[7] *Gazzetta Veneta*, No. 55, 13 Agosto 1760.

Grandeur and grace are each to be found in nature: artistic merit consists in recording them at their best as do both artists. As a general idea this was not very new. Lione Pascoli had made much the same point some thirty years earlier when writing about the *bamboccianti*[1]: 'Whatever the art that man practises, and in whatever manner, as long as he does so well, he deserves success and a good reputation.' But, when applied to actual artists working in different branches of painting in a rigidly hieratical society, the observation gains an entirely new force. Pascoli would never have compared Guido Reni and Cerquozzi in the way that Gozzi was now prepared to compare Tiepolo and Longhi. A few months later he returned to the question with a much more startling observation. Longhi was admired, he claimed,[2] 'because he has left behind figures dressed in the antique manner and imaginary characters, and paints instead what he sees with his own eyes'. The force of this is somewhat weakened by his later insistence on the amiable nature of Longhi's realism, but it is still a remarkable statement, for it implies that Gozzi actually considered Longhi superior to Tiepolo.[3]

Elsewhere Gasparo Gozzi made the same point with far greater social implications, though without directly naming any artist. He describes in a fable a visit he made to an old philosopher thought by the world to be mad but in fact the incarnation of true wisdom.[4] As Gozzi enters his isolated house, he looks at the pictures on the walls. 'Each picture had beneath it a motto of some good intention. The foreshortened figures were not overemphasised, but the movements were all natural, and the figures were all clothed like living men and women, though they were much more beautiful. Seeing that I was carefully looking at these noble images, he said: "Here everything is natural. I know that today most people paint in such a way that everything shown in the picture seems to come from those clouds that float through the sky in summer in which you see and yet don't see what they show. Lots of light, lots of darkness, men and women who are, and yet are not. My painter has beautified nature as it really is, and nothing else." ' In another room the walls are hung with pictures which show various scenes from country life—ploughing, sowing, the gathering of grapes. And the old man explains that whereas he used to own pictures of beautiful women, he has now given them away, and instead wishes to honour 'a class of people, which through its efforts and the sweat of its brow is the main support of all others'. There can be no doubt who is referred to in the jibe about exaggerated foreshortenings appearing through the

[1] Pascoli, I, p. 31.

[2] *Osservatore Veneto*, 14 Febbraio 1761.

[3] Some years later in 1770 a very vague comparison was to be made between Goldoni and Alessandro Longhi, Pietro's son—see *Poesie in lode del celebre ritrattista viniziano il signor Alessandro Longhi*, In Venezia MDCCLXX. In the dedication to Goldoni, Girolamo Garganego writes: 'La discrepanza, che passa fra voi, e il Signor Alessandro non è, che nei mezzi, di qui vi servite; per altro ambi pingete; e direi quasi, che a Voi tocca supplir à ciò, a cui non può giugner il pennello di lui ... Sarebbe adunque questa relazione, che passa fra l'uno e l'altro un bastante motivo per giustificarmi, ma vi è di più. Vi è una vecchia amicizia, che vi lega l'un l'altro dolcemente, e fa che ognuno di Voi goda delle lodi, e degli encomj dell'altro. ...' Recently the suggestion that there is an affinity between Goldoni and Alessandro Longhi has been made by Michael Levey, 1959, p. 156.

[4] Gozzi, IV, p. 5—*L'abitazione d'un filosofo creduto pazzo.*

summer clouds, but the actual pictures described seem to anticipate Millet rather than anything being produced in contemporary Venice. Gian Domenico Tiepolo, the son of Giambattista, did paint in the *foresteria* of the Villa Valmarana near Vicenza some scenes from rural life which were certainly realistic by the standards of his day, but beautiful and sympathetic as they are, they hardly conform to the programme drawn up by Gozzi's philosopher—if only because the peasants are always shown eating or resting rather than at work. Even so, Gian Domenico was certainly the artist most influenced by the new ideas on society, but he confined his satirical observations of Venetian life to frescoes in his own villa or to drawings which were presumably distributed only among friends. Another artist at the end of the century, Francesco Maggiotto, was so far affected by advanced scientific ideas that he actually invented an electrical machine and wrote a treatise on the subject.[1] But in his many genre paintings he veered rather unsteadily between a coarse version of Longhi and a sentimental interpretation of the more ruthless Zompini, and when showing peasants he was always tempted to revert to a crude Flemish tradition of mockery which did little to assert the dignity of labour.

In later years Gozzi turned again to the didactic possibilities of painting. In 1782 he visited Giotto's Arena chapel in Padua and, struck by the use that the Church had always made of art, he wrote to a friend[2]: 'Who has ever caused to be represented in painting or sculpture the piety of some of our patricians and had these displayed in cloisters or schools or other public places? Or the nobility of certain others? The blood that they have shed for their country, their support for literature, the vast sums spent on great artists, the honour paid to writers—that is what I should like pictures to represent.' In fact, such themes were commonplace in private palaces, but Gozzi's idea to make them public was a new one. He must have been aware, however, that in that very year, in Padua itself, Andrea Memmo was putting into effect a scheme very similar to the one he was calling for, as will be described in a later chapter.[3]

A much more deliberate attempt to make use of the propagandist effects of art was planned at about this time by a man whom one would hesitate to include in a chapter on the Enlightenment were it not for the fact that Gozzi himself and many others saw him for a year or two as an 'advanced' figure battling against the entrenched forces of conservatism. Giorgio Pisani belonged to that class of poor nobles, the *Barnabotti*, which caused the government so much trouble during the eighteenth century.[4] As soon as he entered politics he agitated violently for a series of reforms which were designed far more to improve the conditions of himself and his friends than to help the State as a whole. The remedy for all the evils that afflicted Venice lay in a return to the 'sacred laws of the past'. But, like Angelo Querini a generation earlier, he was driven by the logic of his position to oppose the rich and the powerful and above all the increasingly

[1] See Andrea Tessier, 1882, pp. 289-315, and *Considerazioni elettriche del signor Francesco Maggiotto*—no date or publisher indicated—[Biblioteca Correr, Venice—Misc: 105113].

[2] G. Gozzi: *Lettere familiari*: 1808, I, p. 239—[no date, but 1782].

[3] See Chapter 15.

[4] For Giorgio Pisani see Grimaldo.

active Inquisitori di Stato. And this won him some support—as well as the attentions
of a government spy. In 1780, after complicated intrigues, he was suddenly elected
Procuratore di San Marco. The appointment was greeted with great enthusiasm.
Congratulations poured in, Gozzi wrote a tribute, and in the pamphlets that were
printed in his honour were included strange allegorical prints that aroused the hostility of
the *bienpensants*: in one frontispiece a nude youth reclined while a putto carried aloft
the works of Montesquieu which were highly controversial in Venetian society; on
another, steps were shown leading up to a Temple, presumably of Justice, with the
implication that Pisani alone was prepared to climb them; a third set of poems was called,
significantly, *Il Patriotismo*.[1]

Giorgio Pisani made matters worse by designing a strange visiting-card, which has
proved difficult to interpret, but which was considered provocative at the time.[2] It
shows a young man, leaning on a ramp to which is attached a sail with the words IL
PROCURATOR GIORGIO PISANI. He holds a swan and above his head there shines a star.
On the left of the card is a cat on a pilaster which holds between its paws a rod on which
is perched the cap of liberty. In the background can be seen the prow of a gondola.

It was the custom when a new Procurator was elected to have the palaces along
which the procession would have to pass hung with pictures which were very often
specially commissioned for the occasion. Here too Pisani and his friends offended the
authorities, though the trouble seems to have been caused by a misunderstanding natural
enough in the prevailing tension. A few years earlier a pedantic and clearly somewhat
crazy Veronese doctor, Lazzaro Riviera, had commissioned a local artist, Felice Bos-
carati, to paint four allegorical pictures of the most incomprehensible subtlety designed
to illustrate a sort of ideal philosophical and educational system for young men. As
no one had the remotest conception of what the pictures meant he had them copied in
large engravings with a text in garbled Latin underneath and issued an equally incom-
prehensible pamphlet to explain them. There the matter would have rested but for the
fact that Boscarati moved to Venice and was taken up by Pisani as his official painter.
At this stage the pictures were resurrected from the obscurity into which they had
rightly fallen and displayed along the processional route—either by the artist himself
in order to take advantage of his situation or by Pisani's advisers who rather liked
abstruse symbolism for its own sake. The Inquisitors could hardly be expected to
appreciate this and they decided that the allegories were intended as subversive propa-
ganda.[3] They had some reason to be suspicious, for other pictures, much more obviously

[1] *Componimenti poetici in occasione del solenne ingresso di Sua Eccellenza Missier Zorzi Pisani . . . In
Trevigi MDCCLXXX, presso Antonio Paluello; Poesie per il solenne ingresso di Sua Eccellenza Mss.r
Zorzi Pisani . . . In Venezia MDCCLXXX, presso Carlo Palese; Il Patriotismo. Poemetto per l'ingresso di Sua
Eccellenza M.r Giorgio Pisani . . . In Venezia CIƆ IƆ CCLXXX Nella Stamperia Albrizziana.*
The set of these pamphlets in the Biblioteca Marciana, Venice [Misc. 212] are all marked in an
eighteenth-century hand with indignant comments such as *Perfidioso, Seditioso*, etc. For the reputation of
Montesquieu in Venice see Ambri, chapter 6.
[2] See the reproduction and comments in Molmenti, 1908, III, pp. 45-6.
[3] This is the only coherent explanation I can give of this very mysterious episode. The paintings and
their destination were referred to by Zannandreis, p. 415, but he is clearly wrong when he says that they

political, were exhibited outside the Procuratie Nuove showing 'the sleeping lion; the scales [of justice] unbalanced, the cap of liberty, the public buildings collapsing, and the Procurator occupied in rebuilding them and encouraging his own sons to copy him'.[1] Even prints that to the unsuspecting eye seem totally harmless caused trouble. Pisani commissioned from Giampiccoli, one of the most prolific engravers of the day, a view of the Campo di S. Maria Formosa in which his palace was situated. At the base of the print were the words ECCEL.MO GIORGIO PISANI DIVI MARCO MERITO PROCURATORI AC UNO EX QUINQUEVIRIS CORRECTORIBUS. UTILIUM SCIENTIARUM CULTU, ET PUBLICAE LIBERTATIS STUDIO PRAECLARO MOECENATI HUMANISSIMO. The combination of self-advertisement and references to freedom was considered dangerous and the print was hurriedly withdrawn.

But the real trouble came on the evening of the procession when a huge celebration was held in the palace. Spies moved among the guests and noted in the main reception room 'a picture showing Pisani with various emblems denoting Freedom, Power, Sovereignty, and the collapse of the present form of government and the adoption of a completely new system'. The atmosphere was fraught with suspicion—even the menus were carefully noted, for on them were printed two lines in French:

La science, le bon cœur, l'Amour patriotique
Sont-ils les fondements de la République.

The guests must have felt uneasy, and the saying went around: 'Oggi Bordello, dimani in Castello; oggi l'Ingresso, dimani il Processo. Dio ti guardi.'

The prophecy was apt enough. Four days later the Inquisitors moved into action. Pisani was arrested, and his painter Felice Boscarati, who was dangerously fond of satire, also had trouble after the disgrace of his patron.[2] Such was the intensity of feeling that a later writer thought it worth recording as significant the fact that Cristoforo dall'Acqua, the engraver of the emblematic pictures, had not also been involved in Pisani's downfall.[3] Thereafter politics and art separated until the French Revolution and the collapse of the Venetian Republic.

Among the less offensive poems that had been published to celebrate Pisani's

were especially commissioned for Pisani's entry. Not only are the prints by Cristoforo dall'Acqua (Biblioteca Correr, Venice—Raccolta Gherro, Vol. VIII) all dated before 1780 when there was as yet no question of Pisani's election, but Riviera's own explanatory pamphlets (*La Educazione Virile*), one in French and one in Italian, were published in Verona in 1773. [Copies of both versions of this rare pamphlet can be found in the Biblioteca Correr—Op.P.D. 3577-8.] On the other hand there is good reason to believe that the pictures or the prints were exhibited in 1780, for this is stated not only by Zannandreis but also implied by the well-informed Moschini (1924, p. 145), who refers to Dall'Acqua's prints 'nell'ingresso del procuratore Giorgio Pisani' and we also know of the very close relations between Pisani and Boscarati.

A version of one of the pictures turned up in a London saleroom some years ago (*Settecento Paintings* —Arcade Gallery, February-March, 1957), but this is unlikely to be one of the originals, which are described by Zannandreis as being large.

[1] Grimaldo and *Memorie Storiche della Correzione 1780, raccolte in XXIV Lettere Familiari scritte al N.U. S.r Francesco Donado . . . dal N.U. S.r Gio. Mattia Balbi*—Biblioteca Correr, Venice, MSS. Cicogna 2229.

[2] Zannandreis, p. 416. [3] Moschini, 1924, p. 145.

election was one called *Il Filosofo dell'Alpi*.[1] As the title suggests, this enthusiastic work about the Alps and Nature, which had been translated from the French, was strongly influenced by Rousseau; and the spirit that informed it was partly responsible for the outstanding success of almost the only Venetian artist of the eighteenth century who won unqualified praise from every different kind of patron. Francesco Zuccarelli was called 'non mai abbastanza lodato' by the elder Zanetti as early as 1738, only a few years after his arrival in Venice from his native Tuscany.[2] Consul Smith employed him constantly and his success with the English, whose love of country house life and landscape painting was already famous, is easy to understand. More significant is the praise that he won even from those who most strongly rejected the whole conception of Arcadia. Thus Baretti, chief scourge of the effeminate culture of Venice and close friend of Dr Johnson, wrote enthusiastically of him.[3] And, above all, Giambattista Biffi, the friend of Beccaria and Verri,[4] speaks of him with a rapture that he expresses for no other painter[5]: 'If only you could see this King of landscape painters! What softness, freshness, waving of leaves! His prints alone are not enough to reveal his merits, good though they are. Those limpid waters seem like glass on his canvas, and those lively and brilliant *macchiette* carry one up to Paradise. Dear Zuccarelli—thanks to you we do not have to envy the ancients.' The language alone would betray a follower of Rousseau, and indeed when Biffi heard later of that philosopher's death, he wrote in his diary[6]: 'The greatest genius of the century is dead. . . . He was my father, my guide, my master, my idol. . . .' This appreciation of Zuccarelli by such a dedicated disciple shows that the more scrupulous and deeply felt treatment of nature that was adopted by later artists was by no means a necessary consequence of that philosopher's teaching. Purely artificial Arcadias, suffused in a golden mist, were convincing enough for the most impassioned believers in the natural life: while Giuseppe Zais, a more authentic and robust interpreter of the countryside, was wholly neglected.

Various individuals might support different painters, but towards the middle of the century there was another, more basic problem that was being widely discussed. How far could painting be deemed to be of any importance whatsoever in modern life? Gasparo Gozzi was among the first to tackle the problem in Venice. Writing in 1760 he admitted that he had been attacked for devoting too much space in his journalism to buildings, altars and pictures.[7] After making the traditional reply that these represent

[1] *Il Filosofo dell'Alpi—Ode del Signor de la Harpe dell'Accademia Francese liberamente ridotta in Versi Sciolti italiani da Giuseppe Fossati Veneziano. . . .* In Venezia per Giacomo Storti, MDCCLXXX.

[2] Letter from A. M. Zanetti to A. F. Gori of 23 August 1738 in Biblioteca Marucelliana, Florence —MSS. B. VIII, 13 p. 289r.

[3] Baretti, I, p. 279. [4] F. Venturi, 1957, pp. 37-76.

[5] In an unpublished letter to Signor Vacchelli in 1773 in the Biblioteca Governativa, Cremona, MSS. aa.I.4., the knowledge of which I owe to Professor Franco Venturi: 'Se Lei vedesse questo Rè dei pittor paesista [sic], che morbidezza, che fresco, che batter di fronda; Le carte sue unicam.te non bastano a farne conoscere il preggio, quantunque belle. Quelle acque limpidi veri Cristalli anche sulla tela, le più vive, e significanti macchiette spiritosissime imparadiscono. Caro Zuccarelli per te non abiamo ad'invidiare gli antichi. . . .'

[6] F. Venturi, 1957, p. 45. [7] *Gazzetta Veneta*, 26 Luglio 1760.

the finest claim to glory of the country that produces them, he refers almost tentatively to their social value. The arts employ people; consequently money circulates and families are kept alive. It is plain that Gozzi is here implicitly answering charges by the new political economists. Eleven years later A. M. Zanetti the Younger obviously feels that a more considered reply is needed, and he develops at some length the view that painting must be thought of as one of the useful arts.[1] He too begins with the old, accepted theory of the didactic function of painting: sacred and heroic subjects inspire sacred and heroic deeds. But he then brings the theory up to date with a notable concession to the art of his city and century. Painting not only teaches; it also provides mental relaxation. Even this, however, is merely a fashionable adaptation of the old theory of 'diletto ed utile', and a few pages later, Zanetti feels bound to take part in the more modern 'utilitarian' discussion and justify painting, or rather its patronage, on rather different grounds. Flourishing artists attract foreigners to their schools; these foreigners take back works of their masters to their own countries where they are noticed and encourage foreign princes to buy Italian pictures. Even more, these princes often invite Italian artists to come and work in their own countries, where they are extremely well paid; consequently when these artists return to Italy they bring large sums of money with them. 'And so,' he concludes, 'we cannot doubt that Painting has its part to play in trade.' Alas, whatever else might help the Venetian economy at this stage, it was certainly not the sums—however great—brought back by her artists from England, Spain, Germany and Russia. None the less, the same sort of argument was echoed in 1772 by an official committee set up to consider the general economic situation: the liberal arts, it concluded, provide attractions and pleasures and a certain reputation to the State, for they encourage foreigners to come here.[2]

It was ideas of this kind that persuaded the State to make its single important venture into the realm of art patronage. As early as 1724 it had been planned to found an Academy of Painting and Sculpture 'so as to attract and encourage to remain here those foreigners who have to pass Venetian territory on their way to Florence, Bologna and Rome'.[3] When in 1756 the Academy was finally established (after a number of similar institutions in other towns of Italy and Europe), the Senate hoped, with a mixture of shrewd calculation and naïveté which is characteristic of much of its legislation at this period, to gain some commercial benefit from the arrangement. The actual organisation of the body, however, reflected none of the new theories about the value of paintings that had been attracting attention, for the rigid stratification of subject-matter, based on the absolute supremacy of history painting and the complete subordination of such inferior branches as view painting, looked back to a much earlier period rather than anticipated the opinions of the neo-classicists. And the artists themselves were firmly graded in a hierarchy according to the subjects that they painted.

Very shortly after the institution of the Academy the position of the artist in society

[1] In the preface to *Della Pittura Veneziana*, 1771, p. xiii.
[2] *Relazione per le riforme*, 18 Agosto 1772—quoted by Agostino Sagredo, 1857, p. 208.
[3] E. Bassi, 1941, and Fogolari, 1913.

was debated again, but with much more insight into real problems. Andrea Memmo, himself a patron of great interest to be discussed in a later chapter, was one of the Inquisitori alle Arti, who were concerned with the reorganisation of the guilds. Among his papers there survives a sheet on which he briefly scribbled some queries to himself when preparing his report.[1] 'It will be necessary', he begins, 'to show how important it is for the liberal arts to free from the subjection of dues those men who practise them, and to explain how strange is the temperament of Painters. An example is the famous living Venetian painter C. Why does C. claim to be freed from taxes?'[2] Memmo looks to other towns for suggestions of reform—Rome, Florence, Bologna and, above all, Paris. What about the new Academy of Arts at Parma? And to other professions. What about musicians? And engravers? He looks to the past and reminds himself to read Vasari's life of Montorsoli.[3] He even wonders what is the device and the name of the Venetian Academy and whether they could not be improved. Under the protection of which saint is the Academy placed? And at the end of his remarkably open-minded survey of the situation he concludes: 'It is right that the imaginative side of painting should be exercised freely and with nobility; genius should not be fettered in the practice of the fine arts. That is why they were called liberal.' But Memmo, with his interest in the concept of genius and his appreciation of certain anarchic tendencies in artists, was exceptional among administrators, even if his ideas in themselves were not wholly new. The status of the artist remained unchanged, and the only theoretical question that was seriously discussed—particularly at the Academy prize-giving sessions—was whether patronage of the traditional kind was necessary for the survival of art or whether, as Francesco Algarotti maintained, the existence of great art would of itself bring patrons into being.

One other development reflected the impact of new ideas on the organisation of the arts in Venice and helped to bring painting in touch with a more informed, if less powerful, public opinion than had yet been possible. By the early years of the eighteenth century there were two spots in the city which were given over to art exhibitions.[4] In the Piazza S. Marco, by the left-hand projecting wing of the Procuratie Nuove adjoining

[1] Published in full in Appendix 6.

[2] This almost certainly refers to Canaletto although he died in 1768 before Memmo began work.

[3] This *Life* contains an account of the formation of the Accademia di Disegno in Florence.

[4] For a full discussion see Haskell and Levey, 1958, pp. 179-85. For the sake of completeness I add here the only three references to the S. Rocco exhibitions that I have discovered since this article was published:—

 (i) A report from the papal Nunzio of 20 August 1729 in the Archivio Vaticano—*Venezia*, n. 180: '. . . e in tal congiuntura si viddero esposti diversi Quadri di antichi, e moderni Pennelli, con numero concorso di Popolo . . .'.

 (ii) Thomas Martyn, p. 448: 'On S. Rocco's day, the Signory goes in procession to that Saint's church: and the painters of the present Venetian school exhibit their performances in the Scuola.'

 (iii) *Nuova Gazzetta Veneta*, 21 Agosto 1762: 'De' Quadri fu al sommo applaudito il Ritratto del Serenissimo nostro Doge Marco Foscarini, fatto dal Signor Nassi [sic—Nazari?], e incontrato a segno che nulla più si potrebbe desiderare. Vi si videro anche altre Opere de' Pittori antichi, e viventi, e tutti ebbero la dovuta lode.'

the church of S. Geminiano, painters sometimes chose to show their work to the public in a thoroughly casual way when other means were not available. But there were also far more systematic exhibitions at the Scuola di S. Rocco which probably grew up quite informally from the processions which the Doge and Senate made to the church each 16 August (Plate 56). The occasion was a fixed one and every year a number of artists took part. By 1751 Francesco Algarotti could write to Mariette that the exhibition was 'in some ways the tribunal of our painting like the Salon in Paris'. In fact, however, the S. Rocco showings never approached the Salon in complexity of organisation or the attention they attracted. Scarcely any written criticism has survived, and it is difficult to estimate how seriously they were taken. None the less, in a smaller way than in Paris but for the same reasons, these exhibitions did help to bring artist and public together, and did provide a forum where values other than those established by the State and the aristocracy could be discussed.

In 1777 a much more official type of exhibition was organised when a number of nobles asked the members of the Academy to display their work each year at a stand in the Piazzetta. The artists viewed the arrangements without enthusiasm as they themselves were required to meet all the expenses, which were heavy. Many of them did not have pictures available for exhibition, and the Academy had to resort to loans to make up the required numbers. Complaints were frequently made and by 1787 the cost had become crippling and the shows were discontinued. Thus ended State interference in the arts which had at no time proved very happy.

Chapter 13

PUBLISHERS AND CONNOISSEURS

THERE was in Venice during the eighteenth century one section of society whose contacts with the rest of Europe were particularly close and whose extensive patronage of the arts was correspondingly in tune with international taste. Ever since the sixteenth century book publishers had played an important rôle in the Venetian economy, and in the last hundred years of the Republic's life great, and sometimes successful, efforts were made to uphold Venetian supremacy in this field.[1] As long as criticism of the aristocratic régime was avoided, the censorship remained fairly lax: indeed, the traveller Grosley noted that 'on imprime tous les jours, avec approbation et permission, des traductions d'ouvrages françois, qui, à Paris meme, n'osent paroître que sous une permission tacite',[2] and this helped to create an international market for Venetian books. We know from many travellers that the bookshops were one of the centres of cultural life where it was most possible to get in touch with Venetians.[3]

Many publishers therefore wished to produce lavishly illustrated books for export, and the government encouraged this policy by enforcing advantageous copyright laws.[4] In the long run these laws, which granted twenty-year monopolies, lowered the quality of books aimed at the Venetian market, but luxury editions to tempt English, French and German amateurs greatly gained. Moreover, the increasing number of travellers to Venice, not all of whom could acquire original views of the city or employ copyists to record its main masterpieces, led to a new demand for good engraving. The best works of the early years of the new century, heralding the great revival of the 'thirties and 'forties, are books like Carlevarijs' *Le Fabriche e Vedute di Venetia* (1703) or *Il Gran Teatro delle Pitture e Prospettive di Venezia*, published in 1720 by Domenico Lovisa with drawings of famous monuments and pictures by a number of artists, including the young Tiepolo. Both of these publications were designed for travellers, as were Marieschi's views of 1741 which so appealed to Fragonard on his visit to Venice many years later.[5] In fact, for the first time for two or three hundred years many of the leading artists of the day devoted much of their labour and talents to book illustrating. And because of the very different market at which they were aiming and the limitations of size and technique, they often produced work which seems wholly out of character with their more familiar large-scale painting.

[1] For a general survey of the whole field, reproducing many of the most important documents, see Horatio Brown.

[2] Quoted by M. Berengo, 1957, p. 1322.

[3] See, for instance, the comments of J. G. Goethe, I, p. 38.

[4] Berengo, 1957, and Morazzoni. See also Gallo, 1948, pp. 153-214. It should be noted that Marin, VIII, p. 234, challenges the optimistic view generally given of eighteenth-century engraving in Venice.

[5] Morazzoni, p. 70.

To understand the part played by publishers in this new source of patronage four ventures, closely related but not identical, must be distinguished. In the first place draughtsmen and engravers, or sometimes merely engravers, might reproduce well-established masterpieces of Venetian art. Such was the book sponsored by Domenico Lovisa. This practice naturally continued throughout the eighteenth century as it had in the past, but it is of little direct relevance to the history of patronage. Secondly, leading contemporary painters sometimes produced pictures whose primary purpose was to be reproduced by some engraver. Thirdly, and far more frequently, artists produced drawings designed to be engraved as book illustrations. And fourthly a number of artists produced their own engravings.

It is evident that the expense and authority required to persuade an artist of the stature of Tiepolo or Piazzetta to produce paintings or drawings designed for repro-duction could not be borne by the engraver himself. A well-established publisher was essential. Such publishers always owned their own shops, and, in the more important cases, their own printing works. They dealt either in sets of loose prints or in illustrated books. In either case they employed the print makers and commissioned drawings or sometimes paintings from the artists they found suitable. In this way they were consider-able patrons in their own right; but often, especially when the venture was an expensive one, they themselves depended on patronage to make it possible; and the list of sub-scribers and the dedications in their books can tell us much about the market they aimed at.

Two broad categories of illustrated books were published in Venice during the eighteenth century. There were, first, the innumerable collections of poems and eulogies brought out to commemorate specific ceremonies involving the nobility—a processional taking up of office, a marriage, the entry of a young girl into a convent and other occasions of the same kind. These might be little more than the briefest pamphlets with the title page decorated with an elaborate frieze, though frequently there were also full-page illustrations. Such pamphlets were commissioned from the publisher with instructions as to their make-up. 'The paper must be of excellent quality,' wrote Caterina Barbarigo in 1765 through her agent Gasparo Gozzi,[1] 'the characters good and well laid-out; no frieze of engravings, but rather a pretty title page, some handsome heads of pages and a few attractive end plates where convenient. The family arms must be intertwined with those of the Zorzi. . . . The book must have 24 pages . . . and 500 copies must be printed.' These collections, which were the plague of Venetian poets who were required to contribute verses and the mainstay of many fine artists, were enormously popular with the public. 'Bundles of them are sent round, like baskets of flowers or sweetmeats, to guests, parents and friends. And the books meet just the same fate. They are fingered by the butler and the servants; they fall to pieces within a day; and whereas flowers can be smelt and sweets have at any rate some taste, no one at all reads these verses. All the same at the very first wedding new collections turn up, and a woman would not think herself well married if she did not have a trousseau of verses.

[1] Roberti, 1900, pp. 326-35.

I suspect that she insists on it in the marriage contract . . . everyone complains about the abuse; everyone wants it.'[1] And the practice could be expensive. One noble said that he had spent a thousand ducats on such a collection, and here Saverio Bettinelli exploded: 'I have never seen a scientific or important book more luxuriously produced. Print and paper of the finest quality, vignettes and endpapers by the best engravers, with the lightest and most costly and delicately printed frames on every page. So that the most wretched sonnet is sometimes more elegantly produced than was ever any ode of Horace or psalm of David.' But despite an element of truth in this outburst, it was for the second class of illustrated books, which consisted of fine editions of modern and especially ancient authors, that many of the most striking designs were produced.

Three publishers stand out above all the others for the enterprise and quality of their patronage—Giambattista Albrizzi, Giambattista Pasquali and Antonio Zatta. Albrizzi was a notable collector of contemporary pictures as well as the publisher of some of the most finely produced books of the century. He was born in 1699 and inherited a flourishing concern from his father.[2] In his youth he travelled widely, especially in Germany and Austria with which he maintained close links. Indeed, he sent his son to be educated in Vienna.[3] He was always keenly interested in the foreign market and one of his most popular books was a guide to Venice *Il Forestiere Illuminato* which he first brought out in 1737 with a dedication to the Elector of Saxony. Albrizzi also played a fairly prominent part in the intellectual life of Venice. His brother Almorò organised a society, the *Accademia Albrizziana*, which concerned itself with literary and scientific phenomena,[4] and he himself edited a weekly bulletin, the *Novelle della Repubblica delle Lettere*, which commented on and reviewed the latest books published all over Europe.[5] From the advertisements and dedications in this journal and elsewhere we derive the impression that Albrizzi was a devout and militant Catholic in close touch with clerical circles and many of the great aristocratic families, especially the Pisani. He figured prominently among the members of the Scuola di S. Rocco, of which he became Guardiano in his old age. All these connections are stressed in the choice and style of his publications.

In 1736 he began to bring out a complete edition in French of the works of Bossuet, each volume of which was dedicated to a member of the Austrian royal family. The revived interest in Bossuet at this time was directly concerned with the increasing spread of heretical opinions throughout Europe,[6] and by printing the works in the original French, Albrizzi was clearly hoping to reach a wide international public. But for us the main interest of this splendid publication is that in it for the first time Albrizzi employed Piazzetta as his illustrator. He had for some years been planning to revive 'the reputation of Venetian prints, which has in the past understandably fallen in the

[1] Bettinelli: *Lettere inglesi—lettera seconda.*
[2] Morazzoni, p. 131.
[3] This seems clear from the dedication of the eighth volume of the Bossuet in 1755.
[4] Battagia, p. 76.
[5] The *Novelle della Repubblica delle Lettere* was published as from 1729.
[6] Hazard, 1946, I, pp. 105-7 and note.

eyes not only of our own writers, but in those of foreigners also'.[1] This book gave him a
wonderful opportunity to achieve his aim. Thereafter the two men were so intimately
linked in friendship as well as in business partnership that Albrizzi eventually had the
artist buried in his own family vault. Albrizzi had not discovered Piazzetta as an illus-
trator—twelve years before their first enterprise together the artist had already produced
a frontispiece for a devotional book published by Recurti with whom Albrizzi main-
tained close relations[2]—but for many years he enjoyed an almost complete monopoly
of Piazzetta's work in this field and their co-operation left its mark on all his most
splendid editions. For the worldly publisher with his wide international contacts the
solitary and painstaking artist produced a series of illustrations quite unlike the rest of
his work. Long before he painted his first tentative arcadian rococo pictures and at a
time when he was mainly concerned to produce exalted religious altarpieces, Piazzetta
began drawing for Albrizzi's Bossuet a series of vignettes and illustrations of a delicate
fantasy that were as new to Venetian books as they were to him. Views, landscapes,
small genre scenes and frankly irrelevant Chinoiserie and putti, quite apart from the
more familiar religious imagery and hieratic portraits, helped to make digestible the
thundering tomes of Bossuet for the archbishops and rich monasteries of Central
Europe. The book set a pattern for their future ventures, and in general Albrizzi's
editions are characterised by an opulent, aristocratic elegance, often tinged with melan-
choly, and weighty even at its most frivolous, that sets them apart from other publi-
cations.

Albrizzi's patronage of Piazzetta reached its climax in the most famous of all
Venetian eighteenth-century books—the *Gerusalemme Liberata* which he brought out
in 1745 (Plate 57a). Like most of his enterprises this too was designed for an international
public. It was dedicated to the Empress Maria Teresa, whose taste for the luxurious is
well attested by the decorations carried out during her rule at Schönbrunn, and the list
of subscribers provides a glittering series of names from all over Europe as well as the
more familiar connoisseurs and artists in Venice itself such as Marshal Schulenburg and
Consul Smith, Rosalba Carriera and Pellegrini. For this book Piazzetta produced some
seventy drawings[3]; the dramatic ones show that inability to tell an heroic story which is
apparent in many of his paintings, but the pastoral compositions with their elegantly
posed shepherds and other country-folk about their ordinary pursuits have some of the
quality of Boucher, though Piazzetta's world is much less artificial. The book was in
fact a success in France. It was much admired by the Abbé Richard,[4] and it inspired

[1] From an advertisement in the *Novelle* of 19 March 1730 for a proposed edition of the works of
St Augustine.

[2] The book was Padre Antonio da Venezia: *La Chiesa di Gesù Cristo vendicata ne' suoi contrasegni e
ne' suoi dogmi*, for which Piazzetta drew *Religion trampling on Heresy* engraved by Pitteri—see Gallo, 1948,
p. 176, note 4.

For Albrizzi's relations with Recurti, another religiously minded publisher, see the *Novelle* (*passim*).

[3] The drawings originally belonged to Albrizzi himself. They were at one time in England and
are now in the Royal Library, Turin.

[4] Richard, II, p. 492—quoted by Morazzoni, p. 125.

Francesco Gerbault, Louis XV's interpreter of Spanish and Italian, to issue an invitation for subscriptions for an equally sumptuous edition of the *Orlando Furioso*—a project that came to nothing.[1] Indeed, on other occasions when working for Albrizzi, Piazzetta himself could achieve an entirely French sophistication as he showed in 1747 when designing a frontispiece for the most unpromising of books, Platnerus' *Institutiones Chirurgicae*. Meanwhile in Venice the Guardi brothers plagiarised his illustrations for the *Gerusalemme Liberata* in a series of large decorative canvases depicting scenes from the poem.[2]

Albrizzi was well aware of the debt that he owed to his friend. After Piazzetta's death in 1754 he published an account of his life as the preface to a collection of the artist's academic drawings and he did everything he could to keep his memory alive. But he also employed a number of other illustrators on his books. Pietro Antonio Novelli, Giuseppe Zais and Alessandro Longhi all provided occasional drawings for the firm,[3] and his shop became one of the most flourishing artistic centres in Venice, as Robert Adam realised when he passed through in 1761 and entrusted Albrizzi with the sale of his book on Diocletian's palace.[4]

Besides employing artists for commercial purposes Albrizzi was keen to build up a private collection for himself. He owned several hundred drawings and many paintings by Piazzetta, including a *Sacrifice of Iphigenia* of which he was particularly proud,[5] and he was a special admirer of Rosalba Carriera. Above all he patronised the landscape artists Francesco Zuccarelli and the strangely neglected Zais for whom he had a high regard.[6] When in 1770 he was Guardiano of the Scuola di S. Rocco, he took two of that artist's pictures to the exhibition on 16 August, but his attempts to help the poverty-stricken painter met with little response. In 1777 this generous publisher died at the age of 85 after a successful life as one of the most influential patrons of the century.

Giambattista Pasquali also produced many fine and luxurious books, but his outlook was very different from that of Albrizzi. He was a vigorous man of independent opinions, the friend of non-conforming spirits, such as Angelo Querini, Carlo Antonio Pilati and Francesco Albergati-Capacelli.[7] 'They are complete opposites,' wrote a forthright friend of both men in 1749,[8] 'Albrizzi is incapable, timid to a degree and lacks strong support. Pasquali is shrewd, powerfully backed and gives the impression of

[1] Hofer, p. 37.

[2] These paintings are divided between the museums of Washington, Copenhagen and Hull and private collections in London.

[3] Morazzoni.

[4] G. A. Moschini, 1809, p. 5, and Gradenigo, p. 71.

[5] [G. B. Albrizzi]: *Memorie*.

[6] G. A. Moschini, 1815, I, p. xv. See the same writer, 1806, III, p. 49, and 1924, p. 82, for references to Albrizzi's vast collection of prints. I have unfortunately been unable to trace the catalogue of these which was made by Pietro Brandolese.

[7] Morazzoni, p. 117.

[8] Letter from P. E. Gherardi to L. A. Muratori of 12 July 1749 in the Biblioteca Estense, Modena: '... Il Pasquali è il rovescio dell'Albrizzi. Questo incauto e pauroso di soverchio, e privo di forti appoggi; quegli accorto, ben appoggiato, e che ha maniera di riuscir negli affari di suo interesse. ...'

succeeding in the affairs that interest him. . . .' Pasquali worshipped Carlo Lodoli,[1] and he chafed under the censorship, which, he implied in a letter to a bookseller in Prato, prevented him publishing what he wanted.[2] From time to time he was prepared to take the law into his own hands: in 1764 he got into trouble with the Inquisitori di Stato for secretly distributing copies of Beccaria's forbidden *Dei delitti e delle pene*; but he was no martyr and under pressure he revealed the names of all the clients to whom he had sold the book.[3] He showed little interest in producing elegant pamphlets for aristocratic ceremonies, and in his general outlook he was guided by his patron Joseph Smith, who retained a controlling interest in the firm—it is significant that one of the first books produced by Pasquali was an English grammar.[4] It was naturally Pasquali who published the fine illustrated books which recorded some of the treasures in Smith's collection—his paintings by Cignani and Ricci in 1749, and eighteen years later the *Dactylografia Smithiana*. This contained 100 plates engraved by Brustolon, mostly in a severely neo-classical style, illustrating Smith's medals and gems, and it was clearly influenced by Albrizzi's publication a few years earlier of the gems in A. M. Zanetti's collection. But the general presentation is far simpler with none of the rich and elaborate decoration of that book, and the text—printed in Latin only—is aimed at a more scholarly public. The only concession to the more painterly, Baroque style is an endplate of *Perseus and the Head of Medusa*, engraved by Brustolon from a drawing by Pietro Antonio Novelli, an artist almost as closely associated with Pasquali as Piazzetta was with Albrizzi.

On one occasion Pasquali too employed Piazzetta to provide illustrations for a religious work, the *Beatae Mariae Virginis Officium*, published in 1740 with plates of great religious intimacy.[5] But this little book was especially commissioned and financed by a rich merchant called Caime and it stands out from the general run of Pasquali's publications. His most enterprising venture was the seventeen-volume edition of the works of Goldoni, which began to appear in 1761. This was produced in the closest collaboration with the author, and was designed to mark a new departure in book illustration. Until now, complained Goldoni,[6] his works had been produced in a style that could only be described as 'commercial'. Paper and printing had been economised to a degree that would discredit the best book in the world. Now all this was to change. Much more attention was to be paid to paper, to printing, to illustration. It was true that this would mean a more expensive book, but 'My dear friend, I reply, surely you too like an elegant, clean and well adorned page'. In fact, despite the tone of these remarks, Pasquali's edition of Goldoni was not designed as a luxurious enterprise.

¹ [Andrea Memmo], 1786, p. 45. We know that Lodoli, who was Revisore della Stampa, had a great influence on publishers and booksellers (see Conti's letter to Vico of 1728 published by Fisch and Bergin, p. 184) and it is reasonable to assume that Pasquali paid a good deal of attention to his advice.

² See his letter of 7 January 1785/6 to the Prato bookseller Niccola Mazzoni published by Nuti, 1941, p. 199: 'La Toscana è felice per un altro conto giacchè non si censura i libri come qui, e si può stampare quello si vuole. . . .'

³ Archivio di Stato, Venice—*Inquisitori di Stato*, 537, p. 32v, 27 Agosto 1764.

⁴ *Novelle della Repubblica delle Lettere*, 8 Settembre 1736.

⁵ Morazzoni, p. 116.

⁶ *Delle Commedie di Carlo Goldoni avvocato veneto*, Vol. I, 1761—L'Autore a chi legge, pp. v and vi.

There was no list of subscribers, and the volumes were aimed at a wide general public. For the illustrations Pasquali employed the young Pietro Antonio Novelli, who was just beginning to acquire a reputation. Over a hundred drawings were required and these were reproduced by various engravers.

Goldoni himself explained the novelty of the undertaking. He was tired of the general run of frontispieces with their Muses, Apollos, Masks, Satyrs, Apes and so on, which were now so common that artists could not think of any new way of treating them. In any case such generalised symbols no longer attracted the interest of the public. And so 'from that love of novelty which has always been my aim' he proposed that the frontispiece to each volume should represent a scene from his own life.[1] Thus we come across him as a young boy of nine, writing his first comedy to the delighted surprise of his parents; brilliantly passing his Latin exams at school in Perugia (Plate 57b); acting his first rôle in the theatre, dressed as an old woman—and so on through a whole sequence of illustrated biography. The intimacy of these drawings and the idea of taking the public into his confidence in this way affected the plates that Novelli designed to illustrate the plays themselves. The scene is set in the prosperous but relatively simple world of the rich professional classes of mid-eighteenth-century Venice, and from no other source—certainly not from the pictures of Pietro Longhi—can we get such a vivid impression of the period. The quality of the drawings, which are of great delicacy and refinement, justify Goldoni's enthusiasm. As in most of Pasquali's books, which were aimed at the very same sort of public as that illustrated in Novelli's drawings, there is a complete lack of the pomp that characterises Albrizzi's publications. His were the ideals of that enlightened bourgeoisie in whose future so many hopes were placed all over Europe. He brought experimental science within its reach through his wittily illustrated translations of the latest works by the Abbé Nollet in Paris; he dedicated his edition of Vignola to the 'rinomatissimo Padre Carlo Lodoli, Professore celeberrimo d'Arti e Scienze', and later we find him supporting Visentini's attack on Baroque architecture. Among the publishers of sumptuous books his was certainly the most 'enlightened' voice in Venice.

The third of the greater Venetian publishers, Antonio Zatta, was also a controversial figure in the political field. He took a combative part in the storms that raged about the Jesuits, whose side he strongly supported.[2] This made him unpopular with the authorities, who were often antagonistic to the Society and who were at all times anxious to damp down any religious disputes. On two or three occasions Zatta actually ran into trouble with the Inquisitori for proposing to publish attacks by the Jesuits on their principal enemies at home and abroad—the local Dominicans and the Portuguese

[1] *Delle Commedie di Carlo Goldoni avvocato veneto*, Vol. II, 1762, p. 1.
[2] See *Lettera del Magnifico Signor Antonio Zatta a Sua Eccellenza il Signor Duca di . . .* In Fiorenza [in fact, Venice], 1761, and also *Lettera Giustificativa di Antonio Zatta*, Venezia, 1761. Because of Zatta's sarcasm and devious way of conducting an argument there has hitherto been some controversy about his position in relation to the Jesuits. The material published here makes it clear beyond doubt that he strongly supported them.

government[1]—and he himself was said by contemporaries to be a lay member of the Society.[2] But as a private individual he emerges far more indistinctly from the past than do the other two men. He seems to have played little part in social life, and there are no traces of his activities in the writings of others. His own prefaces are usually vivid, and show him to have been a man of enterprise, intelligence and sometimes trenchant wit. He once mocked his enemies for finding Jesuits everywhere and parodied their pedantic efforts to give heavy symbolical interpretations to merely decorative ornament: the vignette on one of his books, writes an indignant 'Segretario dell'Accademia dei Cacadubbj', must clearly be an attack on the Jesuits. It shows a fountain supported by a dolphin. The dolphin, which lures fish into nets, is treacherous and therefore represents the Jesuits, and the basin of water obviously depicts the accommodating nature of Venetian morals. . . .[3] A glance at his catalogues shows that Zatta was the most prolific publisher in eighteenth-century Venice.[4] He did not promote illustrated books much before the second half of the century, but thereafter he ranged widely. Apart from ceremonial pamphlets, his most important contribution lay in the elegant production of well-established Italian classics—Petrarch in 1756, Dante in 1757, and some years later Ariosto, Tasso and Metastasio. Zatta was indeed a passionate supporter of Dante when such views were unfashionable, and the illustrated edition that he sponsored was the first to appear for two centuries. The strain of coping with mediaeval iconography proved a difficult one for the two artists who especially worked for him, Francesco Fontebasso and Gaetano Zompini, and the results, though often engaging, hardly contribute much to an interpretation of the poem. Much more satisfactory are Novelli's illustrations for the works of Metastasio which began to appear in 1781, and which show clear signs of heralding the Romantic movement.[5] Seven years later the same artist produced a second set of drawings for a complete edition of Goldoni, and this time he placed the comedies in a far lower social world than he had done when working earlier for Pasquali.

Many other publishers besides Albrizzi, Pasquali and Zatta produced fine illustrated books, but on the whole they failed to influence artistic output in the striking way achieved by their more important colleagues and they cannot therefore be discussed here. On the other hand the publisher Maffeo Pinelli, who during the eighteenth century was mostly engaged in turning out books for the State of no artistic interest, was a private collector and patron on a large scale. Though he is best known for his library, one of the most famous in Europe, he also owned many hundred pictures.[6]

[1] Archivio di Stato, Venice—*Inquisitori di Stato*, 535, p. 173, 18 Giugno 1759, and 536, p. 41v, 19 Novembre 1760.

[2] '. . . terziario, a quel che pare, dei Gesuiti,' wrote Giovanni de Cattaneo of him, and 'le fameux Zatta, imprimeur de la Societé, et Jesuite du Tiers Ordre,' said the *Nouvelles Ecclésiastiques*—Neri, 1899, pp. 109 and 114.

[3] *Lettera del Magnifico Signor Antonio Zatta* (see p. 338, note 2), p. 23.

[4] *Catalogo di Libri latini e italiani che trovansi vendibili nel negozio di Antonio Zatta e figli Libraj Stampatori in Venezia*, 1790. [5] G. da Venezia, 1934, pp. 25-34.

[6] *Catalogo di quadri raccolti dal fu Signor Maffeo Pinelli ed ora posti in vendita in Venezia*, 1785. See also G. A. Moschini, 1806, II, p. 64.

He was born in 1735 and soon acquired a great reputation for learning. There is indeed about his collection a certain element of scholarly completeness and eclecticism which suggests that he too, following in the footsteps of Lodoli and others, was interested in the historical approach to art: but his real enthusiasm seems to have been for the sixteenth century. Pictures attributed to Giorgione, Bassano, Veronese and Titian, as well as others by Palma Giovane, Padovanino and Pietro della Vecchia, figure very strongly in his collection. Most of the artists of his own century were also well represented—Tiepolo with four pictures—and the painter with whom he was most in touch was a late and second-hand follower of Piazzetta, Francesco Maggiotto. He painted for Pinelli a series of portraits of all the Doges (Plate 68a), Venetian Popes and Cardinals, as well as allegories of *Good Inclinations leading a Youth to Knowledge*, and the Arts of Painting, Typography, Diplomacy and Numismatics. After Pinelli's death in 1785 both his library and picture collection were dispersed, to the great distress of many contemporaries.[1]

Print sellers too were often important art patrons and among these the most conspicuous was the firm of Remondini which was established at Bassano, but which had a branch in Venice.[2] The Remondini also published books, but the main activity of the firm lay in issuing separate prints. On the whole their market was restricted to a very different public from that of the great enterprises that have been discussed so far. They specialised in cheap romantic novels and in devotional prints to be hung up in peasants' houses; but towards the middle of the eighteenth century they greatly expanded and began to acquire an international clientèle. This brought them into rivalry with the more established institutions which greeted their appearance on the scene with bitter hostility, the more so as the Remondini had few scruples about producing facsimiles of other publications at much reduced prices. As the firm grew richer it was able to employ not only some of the best printers but also many leading artists to produce paintings and drawings for extensive reproduction. Piazzetta, Amigoni, Guarana and, above all, Pietro Longhi were popularised by the Remondini in this way.[3]

Other particularly important printsellers were the German Joseph Wagner, who opened a shop in 1742, which was of the utmost significance to printers, though he seems to have commissioned little original work from other artists[4]; Teodoro Viero, himself a printer, who opened a shop in 1754 to which the same applies[5]; and Lodovico Furnaletto, who was a dealer in prints with no claims to practice the art himself. Furnaletto was established for more than thirty years on the Ponte de'Baretteri; his most significant gesture was the commissioning in 1766 of twelve drawings by Canaletto, representing the principal Ducal ceremonies, to be engraved by Brustolon.[6]

[1] Morelli, V, p. 348.
[2] Berengo, 1957, and also *Mostra dei Remondini*, 1958.
[3] See the seven letters from Pietro Longhi to Remondini between 1748 and 1752 published by A. Rava, 1911.
[4] G. A. Moschini, 1924, p. 132.
[5] Gallo, 1948, p. 184, and G. A. Moschini, 1924, p. 132.
[6] Gallo, 1948, pp. 158 and 186.

Around these printsellers and publishers was grouped a number of men who sometimes dabbled in both activities, and whose patronage was very important in diversifying the Venetian scene. By far the most interesting was Antonio Maria Zanetti the Elder (Plate 58a).[1] He was himself a draughtsman and engraver of talent as well as an influential collector, and he lived in the very centre of that cosmopolitan world of connoisseurs that was so characteristic of Venice in the first part of the century. He was born in 1679, and studied painting in Venice and later Bologna. Early in the eighteenth century he was already in contact with most of the leading artists, above all Sebastiano and Marco Ricci (whose particular friend he was)[2] and Rosalba Carriera, and he soon became known as one of the chief connoisseurs and collectors, especially of gems. When Crozat came to Venice in 1716, he formed a close friendship with Zanetti, who in turn set out for Paris in 1720 after passing through Rotterdam. He stayed in Paris at the same time as his friend Rosalba Carriera and her brother-in-law Giovanni Antonio Pellegrini, and he shared the welcome that they received from the connoisseurs of the city. He met Mariette, with whom he corresponded to the end of his life,[3] and he was introduced to the Régent, who entrusted him with the purchase of pictures for his gallery and sent him his own indecent illustrations for an edition of *Daphnis and Chloe*. From Paris he went to London, where he visited the leading collectors and where he succeeded in buying Lord Arundel's Parmigianino drawings which were to exert great influence on his taste. Soon after his return to Venice in 1722 he seems to have gone to Vienna, and he certainly returned there in 1736. On this visit he bought pictures from the heirs of Prince Eugene—among them a Poussin, a Castiglione, and a pastoral by Crespi, 'one of the finest things he ever painted'.[4]

In Venice itself Zanetti was in touch with Joseph Smith and Schulenburg, the two leading foreign collectors, as well as with virtually all the principal artists for whom he sometimes acted as agent. Among foreign visitors the Swedish Count Tessin was his especial friend. Tessin had a particular fondness for the rococo and the lighthearted— 'peu d'anciens, mais l'élite des modernes et tous sujets gracieux et rians'—and he made

[1] See especially G. Lorenzetti, 1917, and F. Borroni.

[2] Marco Ricci, who painted six pictures for Zanetti, wrote of him in 1723 as 'mio amico oltre misura'—Bottari, II, pp. 128-30. Zanetti helped to get Marco Ricci commissions from other patrons such as Federico Correr—Lorenzetti, 1917, p. 138.

[3] Mariette wrote a charming account of Zanetti in his *Abecedario*, and Zanetti, in his will, left the French connoisseur a pastel by Rosalba—Lorenzetti, 1917, p. 145.

[4] Biblioteca Marciana, Venice—MSS. Italiani—Cl. XI, Cod. CXVI, 7356. This is a volume belonging to A. M. Zanetti containing some of his notes and a number of letters to him, notably from the Prince of Liechtenstein, Count Tessin and Marshal Schulenburg. These are indexed and summarised by Zanetti himself at the beginning of the volume. A receipt, dated 10 August 1736 in Vienna, signed Anne Marie de Savoye, refers to 'un Poussin representant un Miracle des Apotres; L'autre de Castiglione Benedetto avec des animaux et figures' as well as fifteen gems and cameos as having been sold to Zanetti; while he himself in his *Memorie de gl'acquisti fatti da me Antonio Mra Zanetti q Girolamo in Vienna dall' Heredita del Pncipe Eugenio di Savoia, l'Anno 1736* mentions the Castiglione, but not the Poussin. He adds a 'bellissimo Quadretto in rame con magnifica cornice dorata rappresentante una vezzosa Pastorella, che dorme, con Pastore, che si piglia gioco con picciola paglia a risvegliarla, et che addita silentio à giovine Pastorello, che ride, et altre figure in Lontano delle cose più belle, che lo Spagnolo di Bologna habbia dipinto'.

use of Zanetti's taste and scholarship to increase his own collections.[1] He sent him a young protégé for instruction: 'il s'agit de l'employer d'abord selon ses talens, et de Luy faire gagner l'argent des Ignorants, jusqu'a ce qu'il soit en état de travailler pour les Connoisseurs', but the unfortunate young man died almost immediately.[2] Through Zanetti Tessin sent friendly messages to Tiepolo, hoping that the painter had not been offended by the King of Sweden's refusal to pay the exorbitant sum required to lure him to Stockholm.[3] Tessin also bought from Zanetti pictures by Zuccarelli and Nogari, as well as prints by G. M. Crespi, and used his good offices to commission a figure by the sculptor Gai, whom he considered to be 'un demi-Michel Ange'. The figure was, characteristically enough, to represent 'une Venus sortant des Bains pour figurer avec une Bathsheba de Giovanni da Bologna qui m'appartient'.[4]

It is thus clear that Zanetti frequently acted as an intermediary between Venice and the rest of Europe. But his actual collections reflected very little interest in contemporary art outside his own city. He owned pictures by the German artists Brand and Dietrich, but there is no evidence to show that he ever bought modern French or English paintings, drawings or prints, though some of the older works that he acquired in those countries were of great significance and proved influential in the development of his taste. Besides three history paintings by Sebastiano and half a dozen landscapes which he commissioned from Marco Ricci, he also owned pastels and miniatures by Rosalba Carriera and was a keen admirer of Canaletto and Zuccarelli at the very beginning of their careers. More important, for their novelty, were the medals and gems that he brought back from London, Paris, Rotterdam and Vienna, and above all his large collection of prints.[5]

This collection was the source of endless pride to him. 'With the greatest effort and expense', he wrote with some complacency in 1752,[6] 'I have assembled a collection of prints in Italy and on my travels which exceeds anything that might be expected of a private citizen. Indeed I can hope to be able to show you any rare print by any artist you ask for, except the dish engraved with a Bacchanal by Annibale[7] and the lascivious

[1] Biblioteca Marciana, Venice—MSS. Italiani—Cl. XI, Cod. CXVI, 7356. The seven letters from Tessin are dated 23 September 1736 (from Vienna), 9 November 1736 (from Strahlsund), 12 March 1737, 20 April 1744, 5 April 1748, 11 June 1748 (all from Stockholm), 26 October 1743 (sic—but 1748)—from Copenhagen. The present quotation comes from the last of these letters.

[2] ibid. From the first and third letters. There is no indication who the painter was.

[3] ibid. From the third letter: '. . . Je vous prie de me dire un mot du Sr Tiepolo, il me tient toujours a cœur, et j'auray grande envie de savoir, il n'y a que le prix qui nous eloigne encore trop . . . je suis persuadé que Tiepolo ne se repentiroit pas, et je luy donneray, ainsy que je le luy ay offert, chambres et table dans ma maison, outre la pension du Roy.'

[4] ibid. Third letter—see also Chapter 10.

[5] See Lorenzetti, 1917, p. 75, and Bottari, II, pp. 129 and 179 ff. Two of Zanetti's Sebastiano Riccis—Esther and Ahasuerus and The Presentation in the Temple—were engraved by Pietro Monaco in Raccolta di Opere scelte, Nos. 41 and 84. A portrait of Zanetti by Rosalba Carriera was used as the frontispiece to his Dactyliotheca in 1749.

[6] Biblioteca Marucelliana, Florence—MSS. B. VIII, 13, p. 400: Letter to A. F. Gori of 22 December 1752.

[7] 'all'esclusione della tazza d'Annibale, intagliata in una sottocoppa, rappresentante un Baccanale'—for this see Kurz, 1955, pp. 282-7.

prints of Giulio Romano engraved by Marc'Antonio with Aretino's sonnets. I have never seen these in all my life—either in Italy, or in Holland, France or England. At various times I have owned a number of copies of some print; but for me it is enough to have a single fine copy—for I am not one of those collectors who make a great flourish and boast of having three or four or even more copies of a rare print. And so, when I have owned several different examples of one, even a rare one, I have taken little account of it. And for one little print missing from my collection which I have been unable to buy I have often given all the spare copies I have owned. And to tell you the truth I have frequently made mad exchanges of this kind.'

Yet although completeness was his principal aim, he did show certain preferences —above all for those Mannerist and 'picturesque' works which bore the closest resemblance to the rococo: Ugo da Carpi and Parmigianino whom he had engraved by Faldoni; Rembrandt and Callot whom he bought on his foreign travels; and Castiglione, twelve of whose drawings he himself engraved in 1759.[1] 'There are people', wrote his namesake the younger A. M. Zanetti,[2] 'who like prints engraved with great speed and liveliness and with broad strokes. Such people are artists and, with them, those collectors who are held to be perfect connoisseurs. On the other hand the general public likes carefully finished prints, and especially those with strong contrasts of light and shade, which strike the imagination at first sight.' There can be no doubt that Zanetti belonged in the first of these two groups.

Zanetti himself considered that his most important achievement was his rediscovery of the process for making chiaroscuro woodcuts in three or four different colours. He revived this technique, which had been familiar to sixteenth-century artists, during his stay in London, and he produced about fifty cuts in all, mostly copied or adapted from his Parmigianino drawings. He then destroyed the plates and dedicated the set as a whole to the Prince of Liechtenstein, while individual sheets were dedicated to English, French and Venetian friends.[3] As works of art these are not very attractive, but they are important because they reflect so faithfully that combination of the scholarly and the fanciful which was such a feature of Zanetti's taste and that of similar amateurs elsewhere in Europe. For these men the rococo and the neo-classical were not in conflict. Zanetti had a passion for antiquity, but he was just as enthusiastic about the etchings of Tiepolo which he was the first to publish[4]: they are 'of a lively and extremely spirited taste and worthy of the highest praise'. Francesco Algarotti was one of the last men to retain this synthesis of opposing styles, but being of a more theoretical cast of mind, he was more worried by apparent contradictions in his taste. Zanetti felt no such qualms.

His most important work, *Delle Antiche Statue Greche e Romane*, was begun in 1725, though it was only published fifteen years later (by Albrizzi). In it Zanetti subordinated

[1] Lorenzetti, 1917, p. 122.

[2] In the preface to *Varie Pitture a Fresco de'Principali Maestri Veneziani*, 1760.

[3] Among these were Mariette, Crozat, Vleughels, the Duke of Devonshire, Sir Andrew Fountaine, Dr Richard Mead, Joseph Smith, Rosalba Carriera and Zaccaria Sagredo.

[4] Lorenzetti, 1917, p. 55. Zanetti may well have published these as early as 1743.

fantasy to the exigencies of scholarship, and his plates mark an important stage in the arrival of neo-classical taste in Venice. Nine years later, in 1749, he showed still further awareness of these tendencies in the illustrations which he provided for the catalogue of his own collection of gems and medals—*Dactyliotheca Ant. M. Zanetti*, for which Albrizzi was, after some hesitation, again chosen as publisher.[1] The famous Florentine antiquary Francesco Gori wrote a Latin commentary, but a more general public was kept in mind and an Italian translation was provided. A suitable foreigner to whom to dedicate the book was searched for, first the King of Poland, and then the Queen of Sweden, who was eventually chosen. Though Zanetti wrote that he had produced the book to please his friends and especially 'those foreigners who were unable to come to Venice to see his medals', there can be little doubt that the magnificent volume, which was published at his own expense, was partly designed as an exceedingly luxurious sale catalogue, thus justifying the Abbé Clément's description of Zanetti as 'fameux amateur, et un peu marchand d'antiques. . .'.[2]

Zanetti himself used to paint for his own pleasure,[3] and he drew some lively caricatures of the leading operatic figures of the day.[4] Combined with his revival of wood chiaroscuro and the many prints that he engraved at different periods of his life, these habits gave him considerable insight into the processes of more genuinely creative artists. It was claimed at the end of the eighteenth century that Rosalba Carriera had learnt much from him[5]; and it is easy enough to see what an important figure he must have been for the Tiepolo of the *Vari Capriccj*. But as a patron Zanetti is of real significance chiefly for his employment of Gaetano Zompini, whom he took into his house and provided with a regular allowance.[6] Zompini engraved a series of Castiglione drawings belonging to Zanetti, and in 1753 he made the drawings for his masterpiece *Le Arti che vanno per via nella Città di Venezia*, the most serious attempt of any Venetian artist to break new ground in his subject-matter and a genuinely moving and convincing survey of the life of the tradesmen and the poor in a city celebrated chiefly for its wealth and frivolity.[7]

Zanetti's rôle was thus important, but instead of being one among many, as he would have been had he lived in Paris, he was alone. 'Every day I realise more', he wrote as early as 1752,[8] 'that there are no more amateurs or patrons here in Italy who are interested in the fine arts. And the few that there are turn over each *zecchino* two

[1] Borroni, p. 28.

[2] P. Clément, p. 124. In 1767 John Northall wrote (p. 438): 'There are plates published of these antiquities, which are to be seen at Signor Lanetti's [sic], a dealer, who has a fine collection of pictures and drawings; some of his own from wooden plates; cameos, and intaglios. . . .'

[3] Bottari, II, pp. 129-30.

[4] Blunt and Croft-Murray, p. 146.

[5] This was the opinion of the first editor of Rosalba's diary, Vianello—see Lorenzetti, 1917, p. 12. Zanetti also employed Rosalba's pupil Felicita Sartori as an engraver and owned a large collection of her work—see *Memorie*, published 1843, and referred to in note 1, p. 276.

[6] G. A. Moschini, 1806, III, p. 92.

[7] Battistella, 1930, pp. 60 ff.

[8] Biblioteca Marucelliana, Florence—MSS. B. VIII, 13—Letter of 26 August 1752 to A. F. Gori.

Plate 57

b. NOVELLI: Goldoni passes his Latin exams at school
—frontispiece to Vol. 2 of his works published by
Pasquali, 1761

a. PIAZZETTA: Portraits of the artist and his publisher Albrizzi—
endpiece to *Gerusalemme Liberata*, 1745

Plate 58

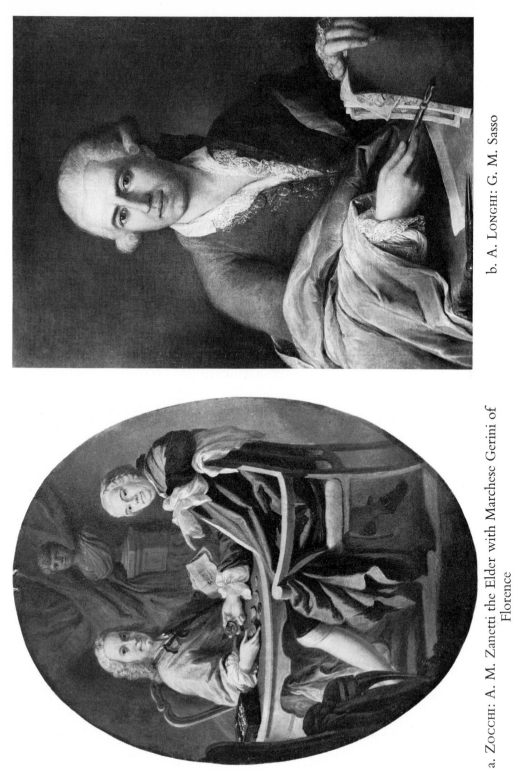

MORE VENETIAN PATRONS OF THE EIGHTEENTH CENTURY (*see Plates 58 and 59*)

b. A. LONGHI: G. M. Sasso

a. ZOCCHI: A. M. Zanetti the Elder with Marchese Gerini of Florence

Plate 59

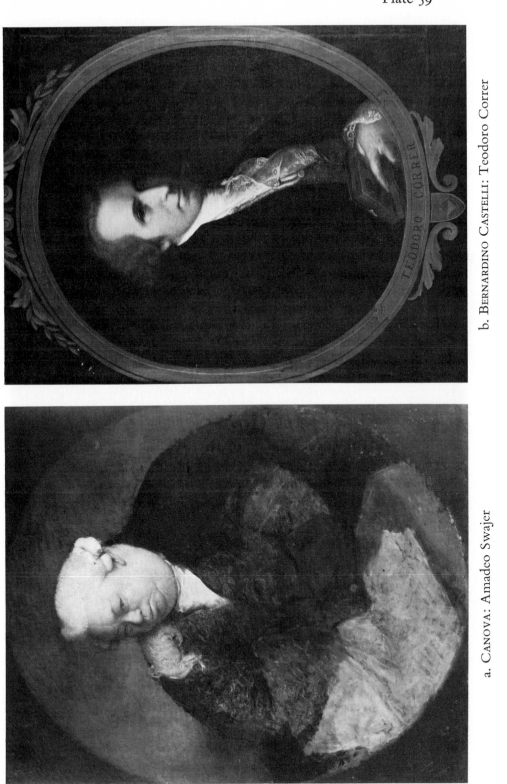

b. BERNARDINO CASTELLI: Teodoro Correr

a. CANOVA: Amadeo Swajer

Plate 60

G. Volpato: Mourners at tomb of Francesco Algarotti in Pisa

or three times before being ready to spend it on that sort of thing. . . .' The situation was Venetian rather than Italian, but when Zanetti died in 1767 at the age of 89 his words were even truer.

He was outlived by his identically named younger cousin with whom he had collaborated on his two main books. Antonio Maria the Younger was, however, an extremely perceptive critic rather than a patron or connoisseur. His own drawings and prints were limited to copies of some of the great classic artists which he published as *Varie Pitture a Fresco* in 1760, and though mention must be made of his admirable revision of Boschini's *Ricche Miniere* edited in 1733 with a friendly dedication to his elder cousin and his own *Della Pittura Veneziana* of 1771, he played little part in contemporary artistic life. But his taste and scholarship were put to practical use and he was made responsible for preventing the export of the great masterpieces of the past.

On a much lower level, but still recognisably within the same world, was the engraver Pietro Monaco, who in 1743 published a collection of fifty-five prints taken from religious pictures mostly in Venetian private collections. Later editions in 1763 and then in 1779, posthumously published by Viero, brought the number of plates up to 112.[1] Of the contemporary works reproduced a strikingly high proportion belonged to Monaco himself: eight drawings by Tiepolo, nine paintings by Pittoni, and one each by Zais, Piazzetta and Nazari. Such a collection might well suggest that Monaco was a patron similar to Albrizzi or Zanetti. In fact, he was almost certainly using the plates to advertise his activities as a dealer, of which we know from a letter written in 1763 to John Strange enclosing a list of seventeen pictures 'singolari e scielti' which he owned and was anxious to sell.[2]

And we can penetrate still further into this world of connoisseurs. There was, for instance, the priest Don Pietro Antonio Toni, who was born near Modena in 1692 and who settled in Venice thirty years later.[3] Though he was desperately short of money, he was a keen collector, and through his friendship with all the leading artists of the day he was able to amass a number of prints. His closest friend was Sebastiano Ricci whom he cared for during an illness and who in return gave him engravings after his works and a *modello* of an *Adoration of the Magi*. In happier moments he would gamble on Ricci's behalf, for the painter was something of a 'voyeur' in this respect and preferred to watch others rather than take part himself. Toni was also in close touch with Pittoni, and above all he acted as adviser and patron to his special protégé the young Pietro Antonio Novelli to whom he left his collections when he died in 1748. Toni was a learned man, and the discussions he had with Novelli and the explanations he gave of the pictures that they visited together may have played their part in bringing out the pedantry that was to be such a feature of that artist's later years. He was also a dealer, and he acted as

[1] Pietro Monaco: *Raccolta di centododici stampe.*
[2] Letter of 4 February 1763/4 in British Museum, Add. MSS. 23,729, f. 49.
[3] Toni is referred to in G. A. Moschini, 1924, p. 167, who derives all his information from a manuscript life by the artist P. A. Novelli which is now in the Seminario Patriarcale, Venice—MSS. 788. 25. This was written in 1790, but internal evidence makes it clear that it was sketched out by 1762.

agent for many far more important collectors than himself, such as Zaccaria Sagredo, Zanetti, Consul Smith and various foreign visitors.

With Toni as guide we can descend yet another stage into the flourishing and parasitic art world of Venice, and follow him to a stall in the Merceria where he would go and buy prints from the hunchback Leonardo Pasquetti. And after that we finally reach anonymity and silence.

Chapter 14

FRANCESCO ALGAROTTI

IT has always been acknowledged that among the Venetian art patrons of the eighteenth century Francesco Algarotti holds a leading position: not so much for his own collection of paintings (which was never as striking as that of Consul Smith), or for those he commissioned for the royal gallery at Dresden (which were few in number as far as living artists were concerned); but chiefly for his clearly expressed artistic tastes and for his very close contacts with the leading painters of the day, especially the two greatest—Tiepolo and Canaletto. Moreover, Algarotti conveniently sums up all the confused tendencies in Venetian art patronage that have so far been recorded. He was a bourgeois, but the intimate friend of princes and patricians; he toyed with 'enlightened' theories, but was closely tied to the old order; he was a Venetian patriot of sorts, though rarely in Venice, and he was in touch with all the most advanced European ideas. Above all the very weaknesses of his reasoning power and temperament made him unable to choose between the opposing tensions which he tried so hard to reconcile. His was an exceptionally receptive character, open to all the new experiences that were coming to the fore in Europe, and in evaluating his influence on the painters of the day it is therefore important to investigate what were his artistic ideas at various stages in his life, and also when exactly he came into contact with the painters of Venice.

Francesco Algarotti (Plate 48d) was born in Venice in 1712, the second son of a rich merchant.[1] He was educated for a year in Rome, and in 1726, after the death of his father, in Bologna, where he studied principally the natural sciences and mathematics, in which he was always to be interested. He kept up the contacts he made with the scholarly world of Bologna until the end of his life, and remained in constant correspondence with Eustachio Manfredi, the Zanotti brothers and others whom he met during his student days.[2] His other strong attachment was with his elder brother Bonomo, himself a man of great taste, whose influence on the more mercurial and spectacular Francesco was certainly considerable though difficult to evaluate. It was to Bonomo that Francesco wrote from half the great courts of Europe; it was Bonomo who bought many of the pictures that made up their joint collection; it was Bonomo

[1] The literature on Algarotti is vast. Six years after his death appeared Michelessi's *Memorie* and in 1791 this was included in the first volume of the seventeen-volume edition of Algarotti's works published by Carlo Palese in Venice to which reference is constantly made in this chapter. There is also a short and rare Latin life by T. G. Farsetti dedicated to Francesco's brother Bonomo who died in 1776. The only complete modern life is by Ida Treat. His aesthetics have been examined by Annamaria Gabrielli, 1938, pp. 155-69, and 1939, pp. 24-31, and there is a stimulating article on him by Aurelio Lepre, 1959, pp. 80-99. Other references are noticed as they occur.

[2] For the Bologna of this period and Algarotti's relationships there see Bosdari, 1928, pp. 157-222.

who helped to put into practice most of Francesco's ambitious plans and who in turn kept him regularly informed of the social and artistic gossip of Italy.

After leaving Bologna Algarotti returned to the Veneto for a short time. He travelled between Venice, Padua, Vicenza and Verona, and it is now that we first hear of his interest in the arts. The taste he expresses is conventional enough, and in no way differs from that of the majority of cultivated dilettantes of the day. Admiration for Veronese and Guido Reni—the two painters he specially singles out for praise—was the natural result of his Venetian and Bolognese upbringing; while his passionate enthusiasm for the works of Palladio was characteristic of the early stages of neo-classicism in the Veneto: 'I go again and again to look at the divine works of Palladio without ever growing tired of them', he wrote from Vicenza in August 1732. His later career was to show him paying far more than mere lip service to the divine Palladio, and he helped to spread the cult for the architect to Prussia. Towards the end of 1733 he went to Florence, where he stayed three months. He admired Cellini's *Perseus* and the doors of the Baptistery; found Raphael's *St John the Baptist* disappointing after the *S. Cecilia* in Bologna; talked of the excitement of discovering the Titians in the Grand Ducal collections; and above all he was overwhelmed by the greatness of Fra Bartolommeo, of whom he now heard for the first time.[1]

In February 1734 he moved on to Rome. In letters to his brother and to Francesco Zanotti he describes the impact of the city. 'These magnificent ruins', he writes,[2] 'are more beautiful than any modern building in perfect condition,' and in his dogmatic reverence for antiquity he compares St Peter's unfavourably with the Pantheon. He claims that in taking up this attitude he is running against current taste, but in fact the revolt against the Baroque was already well under way when he arrived in Rome and in any case Algarotti was never to be much of a rebel. More interesting is his judgement on pictures which, he says, has been severely shaken by what he has seen.[3] Carracci, especially in the Galleria Farnese, and Domenichino have totally replaced in his esteem such Bolognese masters of the late Baroque as Monti or Torelli. It is notable too that he equates Baroque art and literature—Bernini and Borromini with Fulvio Testi and Marino—in a way that was later to become a commonplace of criticism. Very soon after his arrival he met Giovanni Bottari, with whom he began a lifelong correspondence. Bottari was one of a group of scholars and antiquarians in Rome who disapproved of contemporary art on theoretical grounds and who, for a full generation before Winckelmann and Mengs, were preparing the way for neo-classicism. This then was Algarotti's first approach to painting. It was made through scholars, often guilty of the greatest pedantry, rather than through artists and collectors, who were later to liberalise his views. On this, his only visit to Rome, made at the age of 22, Algarotti appears in fact to have had little if any contact with living artists. He remained less than

[1] See his letters to F. M. Zanotti between 1732 and 1734 published in *Opere*, XI and XII.

[2] Letter of 22 February 1734 to his brother Bonomo in Treviso, Archivio Comunale, MSS. 1256.

[3] See letters to F. M. and Eustachio Zanotti and Antonio Conti from Rome between February and June 1734 published in *Opere*, X and XII.

a year and in November he left for Paris.[1] There he resided for some time, during which he met Pierre Crozat, Maupertuis and Voltaire, with whom he stayed at Cirey. Both in Paris and in London, where he next went, his good looks and charm dazzled society, and as always he took full advantage of these gifts. With some cynicism he played off the advances of Lord Hervey and Lady Mary Wortley Montagu, both of whom were enraptured by him.[2] After another short visit to Voltaire he returned to Italy at the very end of 1736 and stayed for about a year between Venice and Milan, where he published the work that brought him immediate fame, *Newtonianismo per le Dame*. It was the first of a long series of books and articles which were to constitute Algarotti's most important contribution to Italian culture—the translation into easy and attractive forms of some of the more complex and enlightened ideas of European thinkers. It was for this reason that the book proved impossible to publish in Venice and was not altogether well received.[3] Immediately after its appearance in December 1737 Algarotti left Italy, not to return till May 1743 except for a diplomatic mission to Turin early in 1741. During the interval he travelled in France, England and Russia, before settling in the court of one of his most enthusiastic admirers, Frederick the Great, who made him a Count in December 1740. But the two men quarrelled, and in 1742 he was in Dresden, working for Augustus, Elector of Saxony. In May 1743 he payed a visit to Venice to buy pictures for the King, and he remained there until 1745. He then returned to Prussia for eight more years. He was back in Venice from 1753 to 1756, after which (except for a short visit of less than a month in 1760) he lived in Bologna, Florence and Pisa until his death in 1764.

Thus, after leaving Venice at the age of 20, he only returned to his native city for three relatively short visits—most of 1737; 1743-5; 1753-6. Only during these years was he in direct contact with the Venetian artists whose champion, patron and critic he professed himself. Yet on all three occasions Tiepolo and Canaletto were at work in the city, while during his later years of ill-health he bombarded them with letters and wrote theoretical treatises which played a notable part in changing the climate of opinion within which they worked.

We must now look at his views in somewhat greater detail during these three periods of his life. We left him in 1734 converted by the ancient monuments of Rome and the frescoes of the Carracci and Domenichino. Was anything likely to modify this classical taste during the two years he then spent in England and France? Unfortunately he gives us little information on this point, and it is only indirectly that we hear of his meetings with Crozat.[4] But the effect of French rococo painting which he came across in Paris, and still more in Berlin, must have been powerful on a man of his temperament,

[1] Among the large collection of letters from Algarotti to his brother Bonomo in the Archivio Comunale in Treviso are a number from Paris between November 1734 and January 1736.

[2] Halsband.

[3] Albrizzi's *Novelle della Repubblica delle Lettere* said, for instance (12 April 1738): 'avvertiremo, che certe espressioni e sentimenti qui sparsi, deono esser letti con una somma circospezione, principalmente dalla Gioventù Cristiana.'

[4] Through a letter from G. P. Zanotti of 12 February 1735 published in *Opere*, XI, p. 213.

and there are many indications that he turned for inspiration to artists who were appreciated more in the north of Europe than in his native city. Thus in Berlin in 1741 he was to write of a portrait being painted of him that it was 'd'una forza tra il Rembrandt e il Giorgione bello bellissimo'.[1] However, during his visit to Venice in 1737 there is no evidence that he had any particular contact with living artists beyond looking carefully at their works. He was still only a young man of 25; his *Newtonianismo* had not yet been published; and though he had already made friends with Voltaire and been a social success in London and Paris, he was not very rich, he was not well known in Venice and he had not yet formed any of those powerful associations which were later to prove such a feature of his career and to be so very useful to him.

It is in 1742 that he first assumes real importance as a figure in the international art world, and from now on we are well informed about his activities as patron and critic. In that year, in Dresden, he drew up a plan for extending and completing the spectacular art gallery which was being formed by Augustus of Saxony.[2] His proposals are remarkably interesting. In the first place they reveal that scholarly approach to art which was to remain characteristic of him and his century. Until now art galleries had usually been built up according to the collector's personal tastes. Algarotti rejects this conception and substitutes for it the outlook of the historian. He wants the gallery to reflect the whole history of painting and to include the finest representatives of all schools. It is evident that such an approach inevitably led (though not in Algarotti himself) to what we can call 'the first rediscovery of the primitives'—in other words those collections of the works of early Italian artists which were built up in the eighteenth century not because they corresponded to any real change in taste (as was to be the case with the Romantics somewhat later) but because they were looked upon as valuable evidence and as precursors of the Renaissance. We have seen that Padre Lodoli owned just such a collection.[3] Algarotti was in fact following in the footsteps of historians such as Muratori, but he was among the first to apply their principles to the collecting of art on a large scale.

This approach must be borne in mind when we consider what is to us the most interesting part of his scheme, though this is not how it appeared to his royal master: the commissioning of a number of works by living artists. For here too he was in advance of much critical opinion in his day. Though he still insisted on giving the subjects in great detail to the artists concerned and was always to stress the importance of contacts between the literary man and the painter, he showed far greater awareness than most patrons of their different styles, and these differences determined his approach. Patrons had always recognised that certain artists specialised in particular subjects and had regulated their commissions accordingly: a picture which could include many animals was suitable for Castiglione, while landscape was an essential ingredient of any picture ordered from Claude. But Algarotti's appraisal of the different Venetian artists was far more subtle and sensitive, and went very much deeper. He tried to base his

[1] To his brother Bonomo, 5 September 1741—Treviso, MSS. 1256.
[2] *Opere*, VIII, pp. 351-88. [3] See Chapter 12.

choice of subjects largely on stylistic considerations. Thus Tiepolo, Pittoni and Piazzetta were all 'history painters': but Algarotti chose very different subjects for them, because Piazzetta was 'a great draughtsman and a good colourist, but has little elegance of form or expression'; while Pittoni was 'distinguished for painting the vestments of priests ... and gladly decorates his compositions with architecture'; and Tiepolo was 'a spirited *pittore di macchia*'; and so on with all the others. How far the subjects chosen really corresponded to the particular talents of the painters concerned, or how far we today would endorse Algarotti's analysis of those talents, is not really the question: the very fact that he was prepared to go thus far shows us that he looked at paintings with unusual sensitivity and that he had none of the bullying approach with which other patrons of the day were sometimes charged. Indeed, this openness to experience is one of his most attractive characteristics, but it makes it difficult to gauge the strength of his influence on individual painters.

His undogmatic and liberal views can be seen in the choice of artists he proposes for the gallery. It is true that only 'history painters' were included and this led to Zuccarelli being given a subject such as *The Hunt of Meleager and Atalanta* 'or something else, either sad or cheerful, in which the story corresponds to the mood of the landscape where it takes place', and to Pannini being required to paint ancient Romans among his *vedute*, while Canaletto was ignored altogether. Yet within the limits of the 'history picture' Algarotti was wide ranging, and this was no doubt due to the influence exerted by his foreign travels, far out of reach of the scholars and pedants of Italy. For instance, despite rather a scornful aside, he included Boucher among the artists to be given 'soggetti graziosi e leggeri', along with Balestra and Donato Creti—one of the very rare occasions in the eighteenth century when French and Italian artists were required to co-operate in a single venture. He found subjects for Francesco de Mura and Solimena among the Neapolitans; Ercole Lelli and Donato Creti in Bologna; the four Venetians already mentioned and Jacopo Amigoni; and in Rome, only Mancini besides the rather special case of Pannini. Nothing could show more clearly his detachment from Roman values. The other surprising omission is Crespi, whom he was later to single out for special praise.[1]

It is worth emphasising once more that Algarotti drew up this ideal list after he had been away from Venice, Bologna and Rome for nearly five years, and that consequently many of his comments must have been based on what he had heard at second hand from correspondents and travellers or at best on what he had seen in foreign collections. But very soon after making these proposals he came to Venice to try and put them into effect. Despite Augustus's far greater enthusiasm for old masters, Algarotti's plans for promoting modern art were to some extent successful. Amigoni, Piazzetta, Pittoni, Tiepolo and Zuccarelli painted the pictures that he chose for them, but unfortunately all have been lost.[2] We can, however, see the effect of his patronage in a painting

[1] In the *Saggio sopra la Pittura*—see *Opere*, III, p. 125.
[2] See L. Ferrari, 1900, pp. 150-4, and Algarotti's letter to Mariette of 13 February 1751 published in *Opere*, VIII, pp. 15-40; also Posse, 1931.

by Tiepolo which did not form part of the original series, but which was ordered by
him for the King on his own initiative. The episode of *The Banquet of Cleopatra* gives us
our first indication as to the nature of the relations between Algarotti and Tiepolo,[1] for
we have seen that there is no evidence that the two men had been in contact at all during
his previous stay in Venice in 1737.[2] When he drew up his projects for the royal
gallery he referred to Tiepolo as 'pittore di macchia e spiritoso' but did not suggest
that he was in any way remarkable. However, within a few days of his arrival in Venice
he was in touch with the artist and asking his advice about the pictures to be bought
for the Dresden gallery. Tiepolo was by now unanimously recognised as being the
greatest painter in Venice, as he had been to perceptive critics for a number of years. But
Algarotti's own position had considerably changed since his last visit. The brilliant
young dilettante of 25 now found himself on an official mission to buy pictures for the
greatest of European collectors. It was therefore natural enough that he should at once
get in touch with Tiepolo even if he had never known him before. The two men took
to each other at once, and in October Tiepolo wrote Algarotti an exceedingly friendly
letter from the Villa Cordellina, which he was then decorating, saying how much he
would enjoy having a discussion with him about painting.[3] It was a few months after
this, in January 1744, that Algarotti mentioned for the first time to Count Brühl in
Dresden that he was planning to send a large picture by Tiepolo that had already been
begun for another patron. The picture was *The Banquet of Cleopatra* and the original
patron was almost certainly Consul Smith, who for some reason (probably financial)
had agreed to waive his claims.

Two very similar versions of the composition can with some certainty be related
to this double commission. The first is the small *modello* (now in the Musée Cognacq-
Jay in Paris) which shows what were Tiepolo's original intentions (Plate 61a); the
second is the large picture itself which is in Melbourne (Plate 61b). Both are painted with
dazzling brilliance in light, rich and subtle colours; yet between them there are a
number of highly significant differences. In the sketch we see in the distance a small, but
nobly pedimented, entrance into an Italian garden, with cypresses rising high above the
walls as Tiepolo so frequently painted them. The banquet, in fact, takes place in the open,
and though it is fully as sumptuous as required by the story, there is about it an air
almost of informality and eager, delightful casualness. In the second version all this
changes. The scene is now powerfully enclosed by a huge loggia from the balcony of
which the crowds look down. The garden has disappeared, and so too has most of the
blue, cloud-streaked sky. We are definitely in some great capital. Cleopatra's gesture is
correspondingly more imperious, more theatrical; her servants more awestruck and

[1] For the complicated history of this picture see especially Levey, 1955, pp. 193-203, and Haskell,
1958, pp. 212-3.
[2] Despite Morassi's claim (1955, p. 21) that by 1743 'the friendship between them was of long
standing'. It is in fact just possible that they may have met in Milan in 1737 when Tiepolo was painting
in the Palazzo Clerici and Algarotti preparing the publication of his *Newtonianismo*, but there is no real
evidence of any contact before 1743.
[3] Letter of 26 October 1743 published by G. Fogolari, 1942, p. 34.

more disciplined. In the completed version everything has been done to emphasise the classical nature of the scene. Recession into the picture is abandoned in favour of clear, parallel planes. Rigid verticals and horizontals divide up the spectacle. The curved arch has gone, and the columns rise to the very top of the canvas and are cut off by the frame. The sleek greyhound, which in the sketch faced into the picture and presented its tail to the spectator, now sits parellel to the horizontal lines of the floor paving, a tame pet rather than a curious interloper. A jug embossed with a mask has been replaced by a simple Greek wine vase, such as the excavations at Pompeii and Herculaneum will soon introduce into painting and decoration all over Europe. The feathers on Mark Antony's helmet, shimmering in the light breeze, have been discarded to make way for the eagle. In the niches of the colonnade are two antique statues of Isis and Serapis; in the sketch there had only been one, and that half-concealed by a hanging jug.

Small changes, perhaps, but all pointing so decisively in one direction that we can attribute them unhesitatingly to the mind of Algarotti. 'I am bringing with me an engraving of the original *modello* so that His Majesty can see how greatly the imagination of the author has enriched and improved the composition', he wrote to Brühl, and he singled out for special praise some of the features that have been mentioned. The 'reality' of the architecture and its 'historical accuracy' win his particular approval, as do its perspective and grandeur. Above all he admired its 'pictorial scholarship' which was now making its first appearance in Venice after being considered for so long the exclusive prerogative of the Roman school. The idea of Tiepolo as an 'accurate' painter comparable to Poussin (as Algarotti claimed) may well surprise us: and yet this was certainly a more classical picture than any that he had hitherto painted, or, indeed, that had been painted by anyone in Venice since the end of the Renaissance. And we must remember that, quite apart from Algarotti's personal convictions, he had every reason to encourage this aspect of Tiepolo's art and to stress it in his dealings with Augustus. The King had not been very eager about commissioning contemporary artists; he was much more anxious to increase his collection of old masters. In this first and crucial example of a favourite modern painter that Algarotti was sending him on his own initiative it was therefore doubly important to emphasise the link with the great tradition of Italian painting: to show Tiepolo as a latter-day Veronese, if anything rather more concerned with accuracy than the High Renaissance master had been.

Algarotti commissioned two other pictures from Tiepolo at this time, both of which he sent to Augustus's all-powerful minister, Count Brühl.[1] He himself chose the subjects—'les Beaux Arts amenez par Mecène au Trone d'Auguste . . . et l'empire de Flore qui change en endroits delicieux les lieux les plus sauvages'—to flatter the artistic pretensions of the minister, and he emphasised this aim by making Tiepolo insert into the picture two of Brühl's most treasured possessions: the hanging gardens and the Neptune fountain by Lorenzo Mattielli from his town and country houses. As in *The*

[1] For the two pictures ordered by Algarotti for Brühl—the *Maecenas* is in the Hermitage and the *Flora* in the De Young Memorial Museum, San Francisco—see Levey, in *Burlington Magazine*, 1957, pp. 89-91. An engraving by Leonardis of the *Maecenas* is reproduced as Plate 68b.

Banquet of Cleopatra Algarotti laid great stress on the classicism and accuracy of the two scenes, going to particular trouble in his choice of antique sculpture and correct uniforms.[1]

At about the same time as he ordered these pictures for his important patrons in Saxony, Algarotti commissioned a picture by Tiepolo for himself—the *Bath of Diana*.[2] In this painting the artist shows altogether different preoccupations: it is a relaxed, sensual scene of naked nymphs in the style which Boucher had made fashionable in Paris, and it is quite exceptional among his works, clearly reflecting Algarotti's eclectic, cosmopolitan tastes, which like those of so many people at the time veered widely between the 'public' and the 'private'. In general, however, his classical bias is clear: it is more difficult to assess the influence of his views on colour. He was particularly keen that Newton's discoveries in optics, which he had propagated some years earlier, should be studied by artists, and there can be little doubt that he must have discussed them with Tiepolo and that he must certainly have encouraged the artist to lighten his palette.[3] But after some theoretical discussion of the problems involved Algarotti himself admits that the real answers are to be found in the works of the great colourists such as Giorgione and Titian; the new scientific knowledge is valuable more because it provides a theoretical justification for existing practice than because it makes for new departures.

Algarotti's influence on Tiepolo at this stage was thus considerable, and it has always been agreed by art historians that the early 'forties marked the peak of the artist's classical phase. But just as great was Tiepolo's influence on Algarotti: an influence observable both in the drawings and etchings of oriental heads that he produced for his amusement during these years,[4] and—much more importantly—in the development of his critical ideas. For this was Algarotti's first real contact with a practising artist of genius, and it inevitably modified some of his more theoretical and preconceived notions. In fact, we find in his comments on Tiepolo a first indication of that dilemma that was more and more going to perplex admirers of Venetian painting as the century advanced. For despite Algarotti's attempts to praise the artist as 'learned' in the spirit of Raphael or Poussin, he was at least as much attracted by another aspect of Tiepolo's art: his brio and his fantasy. Later he was to sum up Tiepolo as 'a painter of the most fertile imagination, who has managed to combine the manner of Paolo with that of Castiglione, Salvator Rosa and the most fanciful (*bizzari*) painters, the whole treated with delightful colours and an incredible freedom of brushstrokes'.[5] Algarotti was constantly trying to reconcile this vision of Tiepolo with the demands of neo-classical

[1] Knox, p. 16.

[2] For this picture, and the relations between the two men generally, see the important article by Levey in *Burlington Magazine*, 1960, pp. 250-7.

[3] Algarotti's ideas on the subject are discussed in his *Saggio sopra la Pittura* (*Opere*, III, pp. 111-21) and in a letter to Eustachio Zanotti of 13 May 1756 (*Opere*, VIII, pp. 48-52) in which he implies that the 'fantasia' that artists should paint on white grounds rather than on the more usual reddish brown has only just occurred to him. The suggestion that these ideas were especially important for Tiepolo has been made by Watson, 1955, p. 214.

[4] Rava, 1913, pp. 58-61.

[5] In the *Saggio sopra l'Accademia di Francia che è in Roma* (*Opere*, III, p. 296).

'correctness', though both writer and artist died before a really critical stage in the controversy had been reached. This clash between two sets of values crystallised Algarotti's own personal dilemma as well as that of his century. As a Venetian who never renounced his Venetian heritage and who understood and loved what had made Venetian painting great, he was able to recognise these characteristic qualities in the most gifted of his contemporaries. Yet as an internationalist, in touch with scholars and princes, he must have realised equally clearly the way the wind was blowing and the shortcomings of Tiepolo measured by the new standards that were everywhere being talked about. It was this conflicting attitude that led him always to admire Tiepolo as the greatest artist of the day and yet to try and induce him to 'moderate somewhat his blazing poetic fantasy'.[1]

Although the pictures that Algarotti commissioned for the King have been lost, the impact that he made on this visit to Venice can be noted in other works painted during or soon after his stay in the city. For Piazzetta, as for Tiepolo, the period marked an important (though, in his case, isolated) phase in his career. The commission from Algarotti to paint *Caesar and the Corsairs of Cilicia* for Augustus came after his most successful ventures into genre and pastoral painting. Large-scale 'historical' pictures of classical themes were completely foreign to his genius, but Algarotti's commission was followed by two further paintings of the same kind; and these (together with the lost picture) make up the only such classical works in Piazzetta's *œuvre*.[2] In fact, Algarotti seems to have had no special admiration for Piazzetta: he only owned one small painting by him, though the first edition of the *Newtonianismo* had one of his most sophisticated Parisian-style illustrations as frontispiece.

During this stay in Venice Algarotti was adding to the family collection of pictures which had been formed by his father and greatly increased by his brother.[3] He kept preliminary sketches or replicas of many of the canvases, new and old, that he sent to Dresden; and often when he acquired some work which was not suitable for the royal collection he kept it for himself. His pictures were thus obtained in a somewhat casual way, and as often as not they were given away or sold when a suitable client became available. And so, although he eventually built up the collection to nearly 200 paintings and a large number of drawings, it is impossible to gauge anything very precise about his tastes or the extent of his commissions from the inventory as we have it. Certainly Tiepolo stands out among all his contemporaries with some 13 paintings and 116 drawings. This is as we would expect; on the other hand there is no evidence that Algarotti made contact with Canaletto during this visit to Venice. None of the Canalettos in Dresden seems to have reached the gallery through his agency, nor did Algarotti write that he had any intention of sending any. Canaletto at this stage was still intensively

[1] According to Michelessi (see *Opere*, I, p. lxii).

[2] *Mucius Scaevola at the Altar* and *The Death of Darius*—in the Palazzo Barbaro Curtis and Cà Rezzonico in Venice. According to Pallucchini (1956, p. 41) both were painted just after the Algarotti commission.

[3] For Algarotti's collection see [G. A. Selva] and for the Tiepolos in it Levey, in *Burlington Magazine*, 1960, pp. 250-7.

employed by Consul Smith, and a year or two earlier Bonomo had written that he took several years to finish paintings, so pressed was he by commissions.[1]

In 1746, after about two and a half years in Venice, except for one short break, Algarotti left Italy and did not return there until 1753. He went at first to Dresden, but very soon afterwards left for Berlin and spent most of the next seven years between there and Potsdam. During this time, however, he kept in touch with artistic affairs in Italy, for more than ever he was acting as adviser to Frederick the Great and his courtiers who had ambitious plans for turning Berlin into a great centre of the arts. Algarotti's attempts to promote Italian (and especially Venetian) art abroad were prompted by a number of motives. Patriotism certainly played its part and when he obtained a commision for the sculptor Giovanni Marchiori to produce some figures for a church in Berlin, he wrote to Bonomo to urge him on 'for the honour of Italy: for here the general opinion is—hors de Paris point de salut'.[2] He also did everything possible to encourage foreign artists to study in Italy, providing letters of introduction, for instance, for the French sculptor Bouchardon and the German painter Rode who was to be much influenced by Tiepolo.[3] But he was also very well aware of the fact that his own prestige gained with every successful coup. All his life he was somewhat excessively anxious to give expensive presents to the right people: as early as 1738 he was planning to get hold of a Veronese for Walpole[4] and in his will, drawn up in 1764, he left two pictures to the elder Pitt—a gesture that aroused sarcastic comments from Diderot.[5] And undoubtedly he saw opportunities for financial gain.[6] He was always writing to Bonomo asking him to look through their collection and send suitable examples to be disposed of abroad; and he kept fully in touch with the Venetian art market and looked out for pictures that he thought might appeal to his new patrons. All these mixed motives can be traced in his purchases for Dresden and in his various proposals to Frederick the Great.

He had been struck by the neo-Palladianism that he had seen in England some years earlier and he set about trying to obtain illustrations to convince Frederick of its merits. He wrote for the plans of Lord Burlington's house at Chiswick as well as for original drawings of Palladio.[7] He also wrote to acquaintances in Italy asking them to supply

[1] Letter from Bonomo dated 28 January 1740/1 in Treviso, MSS. 1256: 'Il Canaletto poi oltre che pretenderebbe un assai considerabil Prezzo per farli, pressato da più Commissioni dimanderebbe qualche anno di tempo per compirli.'

[2] ibid., letters of 11 April, 20 May, 7 June, 5 November 1749.

[3] ibid., letters of 25 October 1750 and 23 April 1752.

[4] ibid., letter to Bonomo from Carcassonne of 2 July 1738: 'Se il prezzo [of the Veronese] non fosse che mediocre, io sarei d'opinione di comperarlo per farne un regalo al Cavalier Walpole in Inghilterra, che potrebbe facilitare l'esecuzione di qualche idea.'

[5] Quoted by Treat, p. 209: 'Ce que je trouve de plus beau et de plus glorieux c'est qu'il a pu laisser par son testament une marque de souvenir au roi de Prusse et une autre à M. Guillaume Pitt. C'est annoncer au public qu'il a été honoré de l'amitié de deux grands hommes, et je trouve plus de vanité à cela qu'à son épitaphe, quoi qu'en disent les pédants.'

[6] Letters of December 1742 in Treviso, MSS. 1256.

[7] See letters to Frederick the Great of 4 August and 13 December 1751 in Opere, XV, pp. 153-5.

him with prints of the palaces, churches and country houses of Genoa.[1] Nor did he stop commissioning pictures, though he now turned more and more to Rome which he evidently thought was more suitable than Venice as an exemplar for his royal friend and master[2]—despite the fact that he had never returned since his short visit in 1734. He suggested that Batoni (whose *Triumph of Venice* he had seen in Marco Foscarini's palace) should paint a *Cleopatra* which could be transferred to mosaic and would be just right for the King.[3] For himself he commissioned Pannini to paint an *Interior of the Pantheon* which he asked Bonomo to keep for him in his rooms and possibly to exhibit.[4] He had much admired Pannini when he had seen paintings by him in Dr Mead's collection in London, but by now he found his colour 'languid compared to that of our Canaletto', and thought that the artist was only at his best as a painter of interiors.[5]

At the end of 1753 Algarotti left Germany and arrived in Venice at the beginning of the next year. He was now no longer in an official position as he had been ten years earlier but he obviously remained in close touch with painters, and he probably continued collecting on a fairly extensive scale for himself. He saw for the first time and deeply admired Tiepolo's fresco of *The Reception of Henri III of France* for the villa of the Contarini at Mira, and he obtained the *modello* of it.[6] In general, however, he turned more and more to architectural painting and views during this last decade of his life. It was now that he got in touch with Canaletto from whom he commissioned a view of a section of the Grand Canal as Palladio might have designed it.[7] In particular, the Rialto was to be shown according to Palladio's scheme and adjoining it was to be the same architect's Palazzo Chiericati in Vicenza. On the other side of the Canal he wanted the Palazzo della Ragione also in Vicenza. Like most of Algarotti's ideas this was not a new one. Architectural *capricci* of the kind had long been familiar in Rome where Pannini had made a speciality of them; moreover Canaletto himself had often indulged in the same sort of fancy. Nor was the tribute to Palladio an innovation, for Consul Smith had already launched his Palladian programme some years earlier and this had included Palladio's plans for the Rialto.[8] Nevertheless Algarotti was the first to draw up a theoretical scheme for such a commission, and as his letters, with their description of

[1] See letter to Girolamo Curli of 20 November 1751 published by A. Neri, 1885.

[2] In 1748 he wrote from Potsdam to the Abate Scarselli asking for details about all the leading Italian painters, sculptors and architects in Rome—*Opere*, XIII, p. 207.

[3] Letter from Potsdam of 13 March 1751 in *Opere*, XIII, p. 217.

[4] Letter to Bonomo from Berlin of 13 August 1750 published by Campori, 1866, p. 201.

[5] Letter from Berlin dated 21 November 1750 in Treviso, MSS. 1256. Fantuzzi (I, p. xxxiii) says that the painter Andrea Lazzarini painted a *Cincinnatus summoned from the Plough* and *The Capture of Syracuse with the Death of Archimedes* for Frederick the Great and that Algarotti read some unpublished observations on painting by this Marchigian artist and used them in his own work. However, a later reference in letters from Lazzarini (II, pp. 174-81) and the contents of Algarotti's inventory suggest that the pictures were painted for him and not the King.

[6] For the dating before 1750 of these frescoes see Levey, in *Burlington Magazine*, 1960, p. 257, and Byam Shaw, *ibid.*, 1960, pp. 529-30.

[7] Letter to Prospero Pesci of 28 September 1759 in *Opere*, VIII, pp. 89-100. A version of Canaletto's picture—if not the original itself—is in the Parma gallery.

[8] See Chapter 11.

the work were soon published, the idea gained ground that he was responsible for this type of painting. The explanation of the picture given by Algarotti is of great interest in showing his attitude to Palladian architecture and is highly characteristic of his whole outlook. It is an essentially 'frivolous' attitude with none of the reforming passion that inspired Winckelmann and the neo-classical theorists. Indeed Algarotti went out of his way to point out that too much regularity was undesirable and that the Strada Balbi and the Strada Nuova of Genoa were not as 'picturesque' as the Corso in Rome or the Grand Canal in Venice.[1] He had always judged landscape and architectural paintings from this picturesque point of view. In Berlin, in 1741, he had already employed a Flemish artist 'who does not have the dry finish characteristic of the Flemish, but rather the dash and brio of the Italians' to paint subjects chosen by himself—'fine ruins of ancient cities, aqueducts, bridges and other buildings, with figures and soldiers dressed in the Roman manner'.[2] Now, back in Italy, he devoted the last years of his life more and more to similar fantasies, though he also paid considerable attention to the structure of the classical buildings which he required to be inserted in his pictures. In Bologna, to which he moved in 1756, he came across two artists, Prospero Pesci and Mauro Tesi, whom he employed to give expression to his ideas, often directing them to paint pictures from his own rough sketches.[3] The principle behind these is nearly always the same. The main element was to be some 'classical' building, either real or reconstructed, and, by drawing on his fine library of archaeological books, Algarotti was often able to give instructions as to its appearance down to the most minute details. This was then to be set off by a fanciful background which would act as a deliberate foil to the pedantic accuracy of the building. Again and again Algarotti insists on the 'picturesque' element. 'This sketch', he writes to Pesci,[4] 'is an attempt to give you the same sort of help that a composer does when he provides Caffariello with the bare elements of an aria. You yourself will know how to vary and break up the tones, passing from one to another, now smoothly and now abruptly; and you will introduce all the charms and attractions' of art.' For these reasons he recommends studying Flemish painters such as Teniers and Wouwermans, as well as Vernet and Pannini. Thus 'we will have combined the nobility of Italian draughtsmanship with the taste and flavour of the Flemish.'[5] This combination between didacticism and the picturesque is very similar in conception to the parallel creations of Piranesi in Rome which Algarotti greatly admired.[6]

But Algarotti fully realised that there were limits to the picturesque invention which he could expect from essentially architectural painters such as Tesi and Pesci,

[1] Blainville, I, p. 492, disliked this mixture but admitted that 'some people' found it attractive.
[2] Letter from Berlin dated 5 September 1741 in Treviso, MSS. 1256: 'Faccio lavorare ora ad un Fiammingo che è stabilito qui da moltissimi anni alcuni paesi, che riescono maravigliosi. La esecuzione è sua, e non à quella secca finitezza degli Fiamminghi, ma più tosto l'estro e il brio italiano. [I pens]ieri son miei ricchi di belle rovine di Città antiche di [ac]quedotti ponti e d'altri con figure e soldati alla Romana.'
[3] Apart from the many letters published in the Opere see MSS. at Bologna, Biblioteca Comunale, MSS. Hercolani 207, and above all the introduction to the Raccolta di disegni originali di Mauro Tesi.
[4] Opere, VIII, p. 95.
[5] ibid., p. 100.
[6] ibid., pp. 104, 109, 111.

and to supplement their efforts he asked his favourite Tiepolo to insert figures into their backgrounds.[1] Working within a classical framework devised by Algarotti himself and his executants, the great Venetian artist's fantasy would thus be limited and yet would add that very life and variety which Algarotti craved for. He writes enthusiastically of a landscape 'derived from Titian' and a boat and white horse 'worthy of Wouwermans' which Tiepolo had added to Pesci's dry architectural setting.[2]

Algarotti's commissions to Tiepolo were now mainly confined to small-scale works of this kind—figures to be added in architectural paintings by others and copies after Veronese. He was in no position to order the great pictures that he had delighted to commission when he himself had been in the service of ambitious patrons. Nor was Tiepolo able to fulfil even these modest requirements. Overwhelmingly in demand and compelled to go to Spain, he was fighting against time, and Algarotti's requests had to be sacrificed. Meanwhile Algarotti himself, increasingly stricken with ill-health, had to rely almost exclusively on Mauro Tesi.

Indeed, with Tesi and his wife he established extremely intimate relations. He became godfather to their daughter and took the artist with him throughout central Italy to make copies of the works he especially admired. He employed him also to copy landscapes by Dietrich and to engrave vignettes for the edition which he was preparing of his collected works. In 1764 it was Tesi whom he summoned to decorate the very room in Pisa where he lay dying.

During these final years Algarotti produced a number of theoretical works in which he tried to formulate his views on the arts.[3] They add little to the more casual expressions to be found in his letters, commissions and projects. There are the same confusions and contradictions which weaken his position as a theorist but which must have made him an enormously more sympathetic and helpful critic to artists than most men who have written about painting. By now, it is true, he had moved somewhat further in the direction of neo-classicism with his categorical statement that drawing is of greater importance than colour, his insistence on the necessity of Greek sculpture for study, his idealistic theory of art, his rigid hierarchy of values. But even when Algarotti was not in direct touch with painters and was adopting a purely theoretical approach, he was careful not to commit himself too far. Every point he makes is at once qualified: too much study of sculpture may lead to dryness, too much severity is harmful.

In every work he commissioned Algarotti demanded from the artist a reconciliation between two contrasting styles of painting—the Roman and the Venetian, the learned and the fantastic, the classical and the picturesque. He was, in fact, always trying to effect a synthesis between the two styles that were just beginning to clash in a

[1] Baudi di Vesme, 1912, pp. 309–29.
[2] *Opere*, VIII, p. 101.
[3] For a general discussion of these see Annamaria Gabbrielli, 1938 and 1939.
[4] For a general discussion of these see Annamaria Gabbrielli, 1938 and 1939.

battle only to be resolved after his death. Algarotti played with all the stage props of early neo-classicism, but his heart remained with an older, less austere tradition. That is why he found in Tiepolo the ideal painter and why he reported the Venetian artist's admiration of antiquity with such satisfaction, while conversely he was so keen to encourage the painterly qualities of such an essentially architectural artist as Mauro Tesi.

Such an undecided attitude makes him a fairly representative figure of this early stage of neo-classicism. But there is no doubt that his personal temperament also was at least partly responsible for the vacillating nature of many of his views. All his contemporaries agreed that his most pronounced characteristic was the desire to please—at the cost, if need be, of being 'all things to all men'.[1] His uncertainties found expression in many fields, and his sexual tastes seem to have been as unstable as his artistic views.[2] Like many people in this psychological condition he found it impossibly difficult to commit himself. This undoubtedly accounts for that element of flabbiness which has so often been criticised in his writings. 'Algarotti', wrote the dogmatic Comte de Caylus,[3] 'sont [sic] de ces gens qui ont vécu et qui ne laissent rien après eux.' But he found more responsive readers in a world more sympathetic to him—that of the artist— and he would have been delighted to know that more than thirty years after his death John Constable whiled away the long winter evenings by studying his works.[4] Thus *Algarottus non omnis*—the proud adaptation of Horace's *Non omnis moriar* which was inscribed on the monument erected to his memory by Frederick the Great—proved truer than might have been anticipated (Plate 60).

[1] For the contempt with which many people treated Algarotti see the comments of Girolamo Zanetti in 1743 (published 1885) and the words of Gaspare Patriarchi in 1758 (published by L. Melchiori, p. 22): 'Veramente sa egli le arti tutte delle corti; e loda indistintamente ogni cosa e ogni persona, per essere lodato egli per cortesia.'

[2] Algarotti's homosexual tendencies have been discussed by Halsband. On the other hand when Giambattista Biffi came to Venice in 1773 nine years after Algarotti's death he wrote (see p. 328, note 5): 'Povero Algarotti amava con ardore una donna, che tuttora vive quì abbenchè inferma. Cecilia Emo vedova Morosini allora, adesso Contessa Zenobio è il nome suo.'

[3] In a letter to Paciaudi, edited by Charles Nisard, II, p. 27.

[4] C. R. Leslie: *Memoirs of the Life of John Constable*, London 1951, p. 7.

a. Early version

b. Final version

Plate 62

IMPACT OF ANDREA MEMM

CANALETTO: The Prà della Valle in Padua

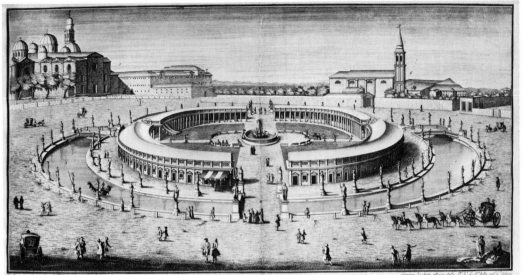

LA NUOVA FIERA NEL PRATO DELLA VALLE NELLA CITTA DI PADOVA

Plate 64

FRANCESCO GUARDI: View of John Strange's villa at Paese near Treviso

Chapter 15

A NEW DIRECTION

– i –

FILIPPO FARSETTI

BY 1764, the year of Algarotti's death, the great flowering of Venetian art was very nearly at an end. Piazzetta had been dead for ten years; Tiepolo was in Spain and showed no desire to return to Italy; Pittoni, though president of the Accademia, was increasingly neglected as his powers declined. Everyone recognised that the new generation of history painters—men like Fontebasso and Zugno (born in 1709) and Guarana (born in 1720) —were adding little beyond imitation to the heritage of the past. Of the view painters, Canaletto went on mechanically repeating himself until he too died in 1769, while Francesco Guardi was virtually unknown to the great patrons and was working for an altogether different public, as will become clear in a later chapter. Zuccarelli was mostly out of Venice, and Zais was living in poverty, almost completely neglected. Of the great names of the first half of the century only Pietro Longhi carried on for another twenty years, while his son Alessandro was bringing a new spirit of detached observation into his portraits of the grandees and intellectuals of the dying Republic.[1]

The artists were vanishing—but so too were the patrons and even the great collections they had amassed. The Sagredo pictures were being dispersed; the Schulenburg collection was broken up in 1775, and in any case most of it had long since been sent to Germany; Smith's best paintings had been acquired for George III in 1762, and the remainder of his gallery was sold by his widow a few years later. Algarotti's own pictures began to be dispersed soon after the death of his brother Bonomo in 1776. When Zanetti died in 1767, Mariette wrote that he assumed that his pictures too would soon be leaving Venice, as no one seemed interested any longer in forming a collection there.[2] These were the men who had encouraged the revival of Venetian painting during the first half of the century, and the great patrician families were even more concerned to sell their possessions to the hordes of agents that descended like vultures on Venice.

And yet a few men of great distinction proved that the 'Enlightenment', as it had reached Venice through publishers and travellers or men of letters such as Lodoli and Algarotti, suggested new possibilities for a different kind of patronage, though it is

[1] For a vivid account of the deplorable state of Venetian painting during the last quarter of the century see G. A. Moschini, 1810.

[2] Letter from Mariette to Temanza of 15 April 1768 published by E. Müntz, 1890, p. 116.

not surprising that they tended to turn away from painting. The man who exercised the greatest influence in this way was Filippo Farsetti.[1] He was born in 1703 of an exceedingly rich family that had only acquired patrician status in 1664, and at about the age of 17 or 18 he became the pupil of Padre Lodoli[2]—the direct inspirer of all three patrons discussed in this chapter. Like the others he too travelled a great deal and thus acquired a far wider range of culture than was common in the Venetian nobility. In particular he lived for some years in Paris. He avoided the political responsibilities attached to his status by becoming an *abate*, and most of his time, energy and money was devoted to the arts.

The originality of Farsetti's tastes could be better gauged if we had more information about the chronology of his collecting. There is, however, no doubt that he was by far the most important figure behind the neo-classical movement in Venice, and that as the century advanced, his contemporaries, and then his successors, considered him to be the most significant of all patrons in the city. This reputation was earned chiefly by the immense collection he assembled in his family palace near the Rialto of casts taken from antique statues all over Europe, but especially in Rome. He was able to do this through the intervention of his cousin, Carlo Rezzonico, who became Pope Clement XIII in 1758. In Rome he moved with all the assurance of an English *milord*, employing the sculptor Ventura Furlani to make casts from the main statues of antiquity and the painter Luigi Pozzi to copy the principal works of Raphael and Annibale Carracci. That his taste was not as hidebound as that of the later, more rigid, theorists of neo-classicism is shown by his choice of four statues to represent modern sculpture— Michelangelo's *Risen Christ* in Santa Maria sopra Minerva, Sansovino's *Bacchus*, Giambologna's *Mercury* and Bernini's *Neptune*—and also by his small collection of paintings. Few contemporaries were represented, apart from the inevitable Zuccarelli, but he showed great enthusiasm for the Dutch and Flemish and he owned pictures attributed to a wide range of seventeenth-century Italian masters. Essentially his outlook was cosmopolitan rather than Venetian, and this was reflected in his choice of paintings, in the strong classical bias of his sculptures and in the architecture of his country house.

This far surpassed in extravagance even the collections he had assembled in Venice. He had originally planned to construct a Roman-type villa at Padua, but when a dispute with local landowners made this impossible, he turned to the family estates at S. Maria di Sala, a few miles away. The villa, designed to hold his expanding collections, was wholly unlike the standard Venetian prototypes, and was in some ways much closer to the Austrian pattern. A convex bay in the centre projects from the main block, which is joined by lower two-storey wings to small, square pavilions at each end. The lower storey of these wings is made up of rectangular arcades into which are inserted forty-two Doric columns from the Temple of the Dea Concordia in Rome which were ceded to

[1] The main sources for Farsetti's life are the relevant passages in the family history published by his cousin Tommaso Giuseppe in 1778 and the pamphlet of 1829 by [P. A. Paravia]. The pictures in the Farsetti gallery and a great deal of useful material about Filippo and other members of the family are recorded in the article by Giovanni Sforza, 1911, pp. 153-95.

[2] [Andrea Memmo], 1786, p. 60, for Farsetti's admiration of Lodoli.

him by the Pope.[1] An excessive rigidity breaks up the natural rhythm demanded by the plan, and even at the height of its glory it must have been impressive rather than beautiful. It is now a battered shell used as a store by local peasants. Farsetti was said to have spent a million ducats on its adornment, thus nearly ruining his family, but striking the imagination of his contemporaries beyond measure. 'The marvellous splendour of the villa', wrote one of them breathlessly,[2] 'the richness, the grandeur, the fine taste, the collection of rarities, the arrangement of the different parts, everything that is there, everything that decorates it and goes to make up the whole, everything proclaims the genius, the nobility, the fine taste, the magnificence of this man who was so highly thought of in Paris'. As much attention was paid to the gardens as to the house itself: its great botanical rarities were among the most celebrated sights of the Veneto, and it was decorated with columns, temples and towers.

Farsetti's ostentatious wealth and devotion to classical sculpture would in themselves have made him a most important figure in the society of his time. But his real influence derived from his keen interest in the contemporary arts. There seems no doubt whatsoever that he was making a deliberate attempt to change the nature of Venetian painting and sculpture, and that he was at least partly successful. His collections were open to students who were encouraged to come and copy them. And as the Academy had nothing that could even remotely compare with his casts from the antique, his palace became the main centre for all those who were absorbing the theories of Algarotti and others about the need to follow classical models—it is particularly fitting, therefore, that Farsetti should have given Algarotti a regular allowance during the last year of the latter's life.[3]

Among all those who studied in the Palazzo Farsetti the most famous was Antonio Canova, who came to Venice in 1768, and whose first works, two baskets of fruit and flowers, were placed on the staircase of the palace.[4] Thus well before the sculptor went to Rome he was already steeped in the works of antiquity, and when he was actually on the spot he often commented in his diary that he had already seen Farsetti's copies of the originals that he was now viewing; he even found that Raphael's loggie had been much easier to study in the version that he had known in Venice.[5]

But Farsetti did not live to see the success of the one artist who appeared to justify his faith in a classic revival. Some five or six years before his death in 1774 he was struck down by illness and thereafter he was largely incapacitated. He was, however, by no means the only member of his family to encourage the arts. His cousin Daniele (1725-1787), himself an amateur painter who once showed some of his pastels at the exhibition of S. Rocco,[6] inherited the collection and even increased it, and also continued the

[1] De Tipaldo, 1833, and Mazzotti, 1954, p. 133.
[2] Letter from P. Boscovich to Vallisnieri of 1772 published 1811, p. 33.
[3] Archivio di Stato, Venice—Sezione Notarile: Lodovico Gabrieli—Atti, 7567, p. 788v, shows that on 11 April 1764 N. H. Filippo Farsetti made a yearly allowance of 550 *zecchini* to Algarotti.
[4] Malamani: *Canova*, p. 6.
[5] Canova: *Quaderni*, pp. 18 and 31.
[6] Haskell and Levey, 1958, p. 185.

patronage of contemporary artists. Daniele's brother, Tommaso Giuseppe (1720–91), was more interested in his fine collection of books and manuscripts than in works of art, but he too remained loyal to the family tradition of which he wrote an exalted account. However, a note of ruefulness comes in when he describes Filippo's collecting and mentions the enormous expense that was involved, and the last years of his life were embittered by the dissipated extravagance of his nephew Anton Francesco whom he even denounced to the Inquisitors.[1] This was to no avail, and in the first years of the nineteenth century the property was finally broken up and the collections sold, to the indignant dismay of Venetian scholars.[2]

Because Canova was the only important artist to emerge from Venice at the end of the eighteenth century, the influence of Farsetti seems in retrospect to have been negligible or deleterious. His contemporaries thought very differently, and all their hopes for a great cultural revival were based on his patronage. At a time when the nobility was no longer playing its traditional rôle of supporting the arts, he alone was held up as an example in a flood of poems and speeches. For all that, he remains a shadowy character, more interesting for his apparent aims than for his achievements. He stands midway between the self-sufficient and magnificent patrons of the past and those new men, exemplified by Andrea Memmo, who saw in their support for the arts a public service designed to benefit the community.

– ii –

ANDREA MEMMO

Andrea Memmo, whom we have already encountered in another capacity,[3] was indeed a much more interesting patron. He was born in 1729,[4] of one of the great patrician families, and in his younger days he was a close frequenter of Consul Smith, in whose library, as he later declared, he first learnt to appreciate 'chaste' architecture.[5] But the main influence on his life was that of Carlo Lodoli, and Memmo missed no opportunity of propagating his ideas and proclaiming the debt that he owed to his master. In later life he became the most 'enlightened' member of the Venetian aristocracy, and looked increasingly to French culture and ideas for his intellectual formation.[6] He showed an enthusiasm for political reform that was altogether exceptional and he made repeated efforts to break down the isolation in which his fellow-nobles lived. He also took full advantage of the many pleasures that were open to the aristocracy of his day—he was not the close friend of Casanova for nothing. As a young man he had become involved with the ubiquitous Giustiniana Wynne, then being wooed by Consul Smith, and he

[1] Archivio di Stato, Venice—*Inquisitori di Stato* (Busta 540), Annotazioni, p. 164—30 Maggio 1792.
[2] Moschini, 1806, II, p. 114.
[3] See Chapter 12.
[4] For a brief general biography of Andrea Memmo see P. Molmenti: 'Un nobil huomo veneziano del secolo XVIII', n.d. and above all Torcellan, 1963.
[5] See Chapter 11.
[6] Tabacco, pp. 32 ff.

continued to enjoy (and write about) a series of love affairs with great enthusiasm.[1] His political career was impressive—he himself turned down an almost certain chance of becoming Doge—and in 1775 he was made Provveditore at Padua. Here he began to show the patronage that was to become the main concern of his life and that has remained the one really significant contribution he made to history. Both in origin and in execution Memmo's ideas reflected a new attitude to art and one that was characteristic of the Enlightenment.

When he arrived in Padua in 1775 Memmo was approached by the municipal authorities with a request that he should take some steps to help the annual agricultural fair, which had been inaugurated some two or three years earlier.[2] His first suggestions were realistic enough, but of little permanent value. The Venetian nobility, he explained, would never come if they were not entertained. So arrangements must be made to organise theatres, operas and masked balls. And then a suitable site must be found for the dealers to set up their stalls. In front of the church of S. Giustina lay a vast area of abandoned marsh land, the Prà della Valle (Plate 62). Memmo decided to reclaim this land, to avoid the danger of flooding to which it was exposed, by building a canal, and in the centre to construct an island which could be used by the traders. He drew up an oval plan, based on the Colosseum, and summoned a professor of architecture at Padua university, the Abate Cerato, to put it into effect (Plate 63). As a conception this was probably the greatest example of town planning to be devised in Italy since the papal schemes in Rome some 150 years earlier. But its motives were very different. Commerce, not religion or family glory, was now the mainspring. And correspondingly Memmo was not an absolute sovereign with unlimited funds. Opposition had to be overcome through negotiations and persuasion. Above all, money had to be raised. It was for this purpose that Memmo designed the scheme which justifies discussing the Prà della Valle in a book concerned with the arts. He invited the co-operation of the public all over Italy, and indeed Europe, by opening subscriptions for the erection of a series of statues to be placed round the island, whose subject and artist could—within limits—be chosen by the donor. As befitted a plan devised by a pupil of Lodoli, it was strictly functional as well as a brilliant commercial idea for attracting international funds and support. The banks of the canal surrounding the island would be strengthened by the foundations of the statues. The statues themselves would act as a public gallery of exemplars to teach civic virtue, as required by the opinion of the Enlightenment.

Memmo's plan was inspired by the examples of Bologna and Vicenza, whose citizens had co-operated to build porticos with shrines leading up to the pilgrimage churches which dominate the hills outside those towns. But his own proposal was more ambitious in every way. It was calculated that eighty-eight statues would be required, and certain conditions were laid down, which sometimes showed the limitations of the Venetian Enlightenment. Only nobles or men who had brought particular glory to the

[1] Brunelli, 1923.
[2] For the history of the Prà della Valle see Radicchio, 1786, and for the figures, inscriptions, etc. see Neu-Mayr, 1807.

city could be represented; moreover, only certain classes of people could present statues in their own names—nobles or important churchmen or a few old and distinguished professions such as university teachers. On the other hand Memmo was especially anxious that the opportunity to raise a statue should not be available only to the rich. If precious marbles and famous sculptors were avoided—and, after all, he claimed, it was the general appearance that mattered—the price could be kept low enough: 135 *zecchini* or, for something rather better, 150. A certain standard of quality was insisted on and a committee was appointed to see that it was adhered to. The same kind of stone must be used for every statue; the inscriptions must be in Latin and must be brief and, with characteristic ingenuity, this was ensured by designing pedestals with only limited available space.

Memmo himself inaugurated the scheme by offering a statue, to be made by Francesco Andreosi, of Antenor, the legendary founder of Padua. He was followed by the Duke of Gloucester who happened to be passing through and who erected a statue of Azzo, Marchese d'Este, a Paduan citizen who had been the originator of the house of Brunswick.[1] And a third was offered by the city of Padua, which chose one of Memmo's ancestors, a fourteenth century podestà, after he had turned down their proposal that he himself should be represented.

Within a few months enough progress had been made for the poets to ask whether they were dreaming or whether they really found themselves in some new Athens. But in 1777, with 19 statues in place, Memmo left for four years as Ambassador in Constantinople to be followed immediately by another six in Rome. While he was away the Prà della Valle ran into serious difficulties. Debts piled up; the councillors objected to the expense; work slowed down alarmingly. Meanwhile in Rome Memmo remained as enthusiastic as ever. He was constantly badgering his friends to put up statues, proposing subjects to them and spreading his ideas in every way. He had his plans drawn by Giuseppe Subleyras, son of the French painter, and hung in his apartments where they were admired by all the nobility and distinguished visitors, many of whom followed the example of the Pope and contributed a statue. The Grand Duke of Tuscany paid for two—Petrarch and Galileo; the Kings of Poland and Sweden both subscribed. Then Francesco Piranesi engraved Subleyras's drawing, and in 1786 one of Memmo's secretaries, Don Vincenzo Radicchio, wrote an account to accompany the engraving. And so the news spread still wider afield. Indeed by that year only eight out of the original eighty-eight had not yet been promised, and fifty-three were already *in situ*.

Memmo's reputation as an expert and patron was by now very great, and during

[1] The Duke of Gloucester was in Padua, where he fell ill, in September 1775 and again in May 1777. Memmo was certainly in touch with him during his first visit, but it is not quite certain when he persuaded him to order his statue—see the letters to John Strange in the British Museum: Egerton MSS. 1969 No. 80 is from Memmo in Padua, dated 18 October [1775] and refers to the Duke's ill-health. In any case the statue was erected by October 1777, for on the 8th of that month Strange wrote to G. M. Sasso asking him to get Mingardi to make a drawing of the statue in the Prà della Valle 'donata dal nostro Duca'—see p. 373, note 2.

his last year in Rome he published the *Elementi dell' Architettura lodoliana*,[1] the first and only work to give a complete account of his master's architectural theories. He must certainly have felt that the essentially utilitarian basis of the Prà della Valle was as much a tribute to the teaching of Lodoli as was this extensive defence of his system.

In 1787 he returned to Venice to take up the post of Procuratore di San Marco to which he had been appointed two years earlier. To celebrate his official assumption of office he published fifty-eight of Lodoli's *Apologhi*—a series of incisive fables which satirised many of the leading figures of Venetian society.[2] The panegyric which greeted his return spoke enthusiastically of his great achievement in organising the Prà della Valle,[3] but Memmo himself was far from satisfied with the progress that had been made. Huge debts had to be cleared up, more grandiose plans for an amphitheatre were rejected by the municipal authorities, further statues needed to be installed. Memmo wrote to his old friend Casanova and asked whether his patron at Dux, the Count of Waldstein, might not be prepared to pay for one—Giovanni Dubravio Skala, perhaps, from Pilsen, the first German student to study at Padua after the League of Cambrai? Or Giovanni Adalbertho Veith, a student of some fame in 1709?[4]

The final results of the Prà della Valle are difficult to assess. The strange division of patronage and the anxiety to complete the work cheaply and quickly led to notable variations in quality and style. Of the sculptors involved only Canova, who was commissioned in 1781 to make a statue of the Marchese Poleni for Leonardo Venier, has survived his age. Indeed within fifteen years the sculptor's own statue, commissioned by Antonio Cappello from Giovanni Ferrari, was to find its place among a host of great and legendary heroes—the only contemporary to be so honoured and an astonishing tribute to the artist's reputation. Many of the others, however, show great competence and sometimes a graceful elegance which curiously enough makes the Prà della Valle one of the best places in Italy to look at the last remaining vestiges of rococo sculpture before neo-classicism swept it all away. Very many of the heroes celebrated, who vary in distinction between some noble donor's insignificant ancestor to Livy or Galileo, date from the Middle Ages, and their costumes are reproduced with varying degrees of accuracy and seriousness. Now time and the Italian climate have modified much of the original impression. In summer the vegetation withers and dust robs the Prà della

[1] See della Valle, III, p. 459: 'Il prato della Valle ornato da esso voi con le statue degli uomini illustri che fiorirono in Padova, e tra queste la destinata al celebre mio paesano e confratello P. Vallotti, e finalmente il sistema Lodoliano, già in parte per opera vostra pubblicato vi rendono degno dell'universale stima, ed onore, non che di esser tra i primi mecenati. . . .' For some reason Memmo published only the first volume of his *Elementi* in 1786, and though he completed the whole work before his death the full two-volume edition did not appear until 1834.

[2] *Apologhi immaginati, e sol estemporaneamente in voce esposti agli amici suoi dal Fu Carlo de' Conti Lodoli Min. Osservante di S. Francesco, facilmente utili all'onesta Gioventù, ed ora per la prima volta pubblicati nell'occasione del Solenne Ingresso che fa alla Procuratia di S. Marco l'eccellentissimo Signor Andrea Memmo, Cavaliere della Stola d'Oro.* Bassano [Remondini], 1787.

[3] *A Sua Eccellenza il Signor Andrea Memmo Cavaliere e Procurator di San Marco in occasione del suo ingresso solenne—orazione*, Venezia, Zatta, 1787.

[4] Molmenti: *Un nobil huomo*, pp. 143-4. For many other examples of Memmo writing to his friends in this way see Torcellan, 1963.

Valle of the effect it must originally have made of an oasis in the general confusion and wilderness. The inscriptions are worn, the figures have retreated into anonymity, and the weaker sculptures have gained from the general decay. In its time, however, the Prà della Valle represented one of the most noble attempts made by a Venetian patron to combine beauty with utility and thus solve a problem which obsessed many thinkers of the Enlightenment.

During his last years Memmo became involved in friendly controversy with another patrician, Pietro Zaguri, over the merits of Lodoli, to whose memory he remained passionately faithful.[1] But his political ambitions declined with the declining fortunes of Venice. He had had the family palace decorated with a frescoed gallery of classical orators, poets and philosophers, the name of each carefully inscribed on the pedestal,[2] but he seems to have had almost no interest in paintings, of which he owned only forty-eight, mostly copies.[3] In this palace, in the company of his brothers, he would hold open house to the more advanced spirits of the day until his death in 1792.[4]

– iii –

ANGELO QUERINI

Farsetti and Memmo were both men whose patronage of the arts was inextricably bound up with their services to the public life of Venice and Padua. The last important patron to emerge in Venice, Angelo Querini, carried his 'enlightened' views much further than either of these men, but he confined his love of art strictly to his private life—indeed he was accused of furthering his own interests in this field at the expense of those of the public.[5] In his later years he provides the most perfect example of that recurrent ideal—the scholar-gentleman of cultivated tastes who lives quietly on his estates and views the world with a certain detachment. But his earlier life had been very much more stormy.

Born in 1721, he too had been a keen admirer of Carlo Lodoli, and it was he who gave Memmo much information about the earlier years of that influential figure.[6] After beginning a successful career in politics, he was soon in difficulties with the authorities because of a possible association with a foreign ambassador, though—characteristically, perhaps—the association concerned a woman rather than politics. He first achieved notoriety during the constitutional crisis of 1761 in which he played the leading part.[7] The dispute centred on the powers of the State Inquisition which Querini wished to

[1] Molmenti: *Un nobil huomo*, pp. 137 ff.

[2] Fontana, p. 142. These were destroyed in about 1960.

[3] See the inventory drawn up by Sasso and Viero in the Archivio di Stato, Venice—*Petizion* 488, 30 Gennaio 1792 and 24 Febbraio 1792/3 M.V., part of which is published by Levi, II, p. 254. Among the more valuable items in Memmo's collection was a drawing of the holy family by Mengs. He also owned several hundred prints but there is rarely any indication of the artist.

[4] Lorenzo da Ponte, p. 52.

[5] In particular he was accused of obstructing plans for stopping the flooding of the Brenta because they represented a threat to his garden—see Brunelli Bonetti, 1951, pp. 185-200.

[6] [Andrea Memmo], 1786, p. 29, note 1.

[7] See Bozzòla, 1948, pp. 93-116.

reduce. It is doubtful how far this can be interpreted as a 'progressive' move. In fact, the reforms he advocated merely meant an alteration in the balance of power within the ruling class—the substitution of one faction by another—and in no way involved any fundamental change. But even this was quite unacceptable, and the victory of the 'conservatives', led by Marco Foscarini, was followed by Querini's arrest and detention in a fortress for a couple of years. After his release he played no further part in active politics, but devoted himself to intellectual and cultural pursuits.

More and more he became involved with the forces of the Enlightenment. In 1764 rumour credited him with being the author of Beccaria's anonymously published *Dei delitti e delle pene*.[1] In 1777 he went to Switzerland and visited Voltaire.[2] He presented the philosopher with a medal he had had specially coined depicting Philosophy destroying Superstition surrounded by a text from Lucretius EXAEQUAT VICTORIA COELO. During the trip he and his companion, the doctor and scientist Girolamo Festari, stopped everywhere to admire pictures and architecture and to comment on the trade and industry of the places they visited. Most of his life was thereafter devoted to building and decorating his remarkable country house at Alticchiero, a mile or two from Padua. Among his closest friends was the inevitable Giustiniana Wynne, now much older and more respectable than when we first met her flirting with Consul Smith and the young Andrea Memmo. This strange woman, who thus so closely links these three significant patrons, had in 1762 married the Austrian Ambassador, Count Rosenberg, but her main interest in life was still the company of the learned—a condition to which her husband hardly aspired.[3] It is from her rapturous account that we know most of Alticchiero, which has long since been razed to the ground.[4]

The aim of the house is clear enough from her opening remarks. In contrast to 'les grands . . . [qui] ont des palais immenses' and 'les voluptueux, des asyles délicieux', philosophers, she explains, hide themselves in modest retreats. And so at Alticchiero 'the building is not sumptuous, nor is the furniture lavish or choice; but—far better—the arrangement is as simple and convenient as possible'. On the tables are busts of ancient and modern philosophers, among them Voltaire and Rousseau by Houdon, and the influence of both men is felt throughout the villa and gardens. No precautions are taken against theft: nothing is locked up, no dogs roam the grounds. Only at Tahiti and Alticchiero, exclaims Mme Rosenberg, can such trust in human nature be found. Certainly it is unique in Italy, and would be edifying even in Switzerland.

On the walls of the various rooms are plans of the great European cities, while the

[1] This is reported by the anonymous author of *Voyages en differens pays de l'Europe en 1774, 1775, et 1776*—published in The Hague in 1777, I, p. 211.

[2] Festari.

[3] The Cardinal de Bernis wrote of him as follows: 'Le Comte de Rosenberg, qui lui succéda [the Marquis de Prié as Imperial Ambassador] avec plus de naissance, d'esprit et d'intrigue, n'avait guère plus de mérite que M. de Prié,' who was himself 'un homme fort médiocre'—*Mémoires et Lettres*, I, p. 166.

[4] Giustiniana Wynne-Rosenberg: *Alticchiero*, Venezia 1787. The remains are discussed and illustrated in a sad little article by Bruno Brunelli, 1931, pp. 4-11. At that time the busts of Heraclitus and Democritus were in the Casa Soster at Padua.

bathroom is lined with prints by Piranesi. Thus everywhere decoration is combined with utility. Other walls are lined with engravings by Picart of oriental customs 'qui amusent les passants, et arrêtent ceux qui aiment à réfléchir sur les folies de tant de prétendus sages'. The library contains all the great classics as well as a large collection of books on agriculture, philosophy 'and even theology'. The 'idol of the temple' is a bust of Bacon—the founding father of the Enlightenment and the particular hero of Lodoli. Querini's own study contained a series of prints designed to lighten his overburdened mind. They were illustrations to *Daphnis and Chloe* drawn by the Régent Philippe d'Orléans and engraved by Audran.[1]

The garden was even more important than the house as an expression of Querini's taste. The main outlines were severely regular, but within this framework could be found an 'agreeable confusion' of bushes and plants. At some distance from the house was a wild area thick with cunningly sited trees through whose branches could just be seen columns and burial urns strewn on the ground with artful casualness. This was called 'Young's Wood' in honour of the poet whose *Night Thoughts* had caught the romantic imagination of Europe.

The main part of the garden was designed as a complete allegory of the philosopher's way of life, and his various ideals were expressed in a number of shrines and carefully chosen pieces of antique and modern sculpture distributed in the grounds. There was, for instance, the Altar of Friendship with its colossal busts of Epicurus 'le Philosophe de la sage volupté', so much misunderstood by vulgar minds, and of Phocion 'le Philosophe Citoyen'—the man who had dared to stand out against the ignorant mob and who was Querini's particular hero. The choice clearly shows his aristocratic cast of mind—long since apparent to the populace which, realising that his proposed 'reforms' certainly augured them no good, had rejoiced at his downfall in 1761. Below the Altar was an inscription dedicated to his closest friend, Girolamo Ascanio Giustiniani. Other altars, formed of real antique sculpture or of modern imitations, celebrated other friendships—those formed in Switzerland, for example, and after her death in 1791 that of Mme Rosenberg herself[2]—and other ideals: Tranquillity and Country Life, Fortune and Apollo, rendered 'in noble repose in the full beauty of his youth' by a modern and still living sculptor.

The romantic nature of the whole conception came to the fore most explicitly in the 'cabane de la folie'—a thatched hut on the door of which was fixed Montaigne's dictum 'De la plus grande sagesse à la folie il n'y a qu'un demi-tour de cheville'. Inside was an antique bust which resembled an old mad woman who used to roam the streets of Venice, and the sight of this stimulated Mme Rosenberg to think of the veneration felt in the East for the mad and to recall their proverbial relationship with prophets and poets. Engravings designed to bring home the point hung round the walls, among them one by Huber of the head of Voltaire taken from a number of different angles.

[1] A very unclassified inventory of Angelo Querini's effects at Alticchiero is published by Levi, II, p. 255.

[2] G. A. Moschini, 1806, II, p. 116.

The same aspect of Querini's temperament was emphasised in the Altar dedicated to Ignorance, Envy and Calumny; for, as Mme Rosenberg pointed out, his soul was 'somewhat pagan or at least Manichean', and he believed that, the world being what it was, one should sacrifice to evil as well as to good spirits if one was to hope for happiness. Hence these vices were depicted in a bas-relief based on the famous composition of Apelles as recorded by Pliny.

Querini's villa attracted enormous attention. Among the visitors who came to see it was the Grand Duke of Tuscany, and Querini recorded the occasion by erecting a monument, crowned with a sphinx, containing a flattering inscription and a bas-relief in which the reforming prince was allegorised as Apollo. Like many people during the second half of the eighteenth century Mme Rosenberg distrusted allegory—she found painted ceilings hard to understand, but in sculpture the whole problem was much easier, for so few figures were involved. And above all she found that the allegories in Querini's garden were absolutely straightforward.

Despite the illustrations in Mme Rosenberg's book it is difficult to assess the quality or even the type of sculpture that Querini collected and put to such strange use. His taste for the antique was clearly inspired by the 'digne et malheureux' Winckelmann; in it he saw a restraint and lack of excess which constituted its main character.[1] His more modern work included a Hercules by Algardi and sculpture by the young Canova. But he also ranged much further afield. He owned ancient Etruscan phallic symbols, which caused Mme Rosenberg a certain amount of difficulty in explaining, and a large number of Egyptian figures.

Apart from sculptors the only artist with whom he had close contacts was Dominique De Non, who later (as Dominique Vivant-Denon) became Napoleon's celebrated director of museums.[2] De Non settled in Venice for about five years in the early 'nineties, and led a busy life as a controversial but highly admired engraver and also as a collector. He bought a large proportion of Zanetti's prints, including the Rembrandts, which had a profound effect on his own style and that of his principal pupil Francesco Novelli. At Ferney he had engraved a portrait of Voltaire and in Naples he had worked on the Abbé de Saint-Non's *Voyage Pittoresque de la Grèce et de la Sicile*, and he was thus well qualified through his political and antiquarian interests to appeal to Querini. He moved a great deal in his circle and drew his portrait (which he signed 'amico suavissimo') and also that of Mme Rosenberg among her friends.

The literary inspiration of Querini's collecting and patronage is obvious enough. In many ways it encouraged him to live with his works of art in a spirit that had largely died out since the early Renaissance. In his younger days he had been closely associated with another potential reformer, Paolo Renier, and he had commissioned Canova to make him a bust of this friend after his successful (but exceedingly corrupt) campaign

[1] Querini was in touch with a number of antiquarians and neo-classicists such as Isidoro Bianchi, Francesco Milizia and Jacopo Morelli, all of whom dedicated books or monographs to him.

[2] For the relationship with De Non see de Tipaldo, and for De Non himself G. A. Moschini, 1924, and Pallucchini; *Mostra degli Incisori Veneti del Settecento*, 1941, p. 112.

to become Doge in 1779. When, later, Renier compromised with the forces that he had once attacked, Querini flung the bust in a rage of disappointment against the Altar of Furies in his garden.[1] For him the shrines and temples of paganism had a real significance, however sentimental or romantic, that they lacked for most of the scholars and antiquarians of his age. It is this that distinguishes his activities so greatly from those of a man like Scipione Maffei who in an earlier generation had also collected antique sculpture and lovingly recorded the evidences of the past. More even than Winckelmann —though, of course, with far less intellectual or critical insight—Querini, after his baffled retirement from contemporary politics and problems that henceforward admitted of no solution, returned to the ideal world of the past. And his view of it was inextricably bound up with the influence of Rousseau. When he died in 1796 his heart was, at his request, buried in the Temple of Pallas in his garden.

[1] Brunelli Bonetti, 1951. Actually what must be the bust (in terracotta) survives in the Museo Civico at Padua, and as it shows no obvious signs of irreparable damage it has been suggested that Querini kept it in the servants' lavatories.

Chapter 16

DEALERS AND *PETITS BOURGEOIS*

W E have seen that the most significant art patrons to emerge in the second half of the eighteenth century were those men who had been affected by the new ideas which penetrated into Venice through the medium of figures like Carlo Lodoli and Francesco Algarotti. But in some ways the taste that they promoted—whether severely functional or a return to the classical—bore little relation to what had hitherto been the most fruitful tradition of Venetian art. This tradition, which found its last great master in Francesco Guardi, was carried on rather by men of far less exalted position, who in their own day attracted little attention as did the kind of painting that they enjoyed and encouraged. In so far as they were known at all, these men were looked upon purely as dealers or agents who helped to plunder on behalf of foreign embassies the riches of the seemingly inexhaustible city in which they lived. Yet, while fulfilling these activities, they often found time to build up small collections of their own which reflect a definite taste that may well appeal to us today more than the spectacular patronage of a Farsetti, a Memmo or a Querini.

In the very centre of this world was Giovan Maria Sasso (Plate 58), buying and selling as fast as he could, putting a small collection on the side for himself, dealing with British agents who alternatively flattered and bullied him, finding the time somehow to engage in long exchanges of letters with friends and other dealers, turning out the odd pamphlet, amassing facts of all kinds and planning a great book, which he never completed, on the history of Venetian painting.[1] It was a life typical of a number of figures at the time, and characteristically Sasso only just survived the Republic and died in 1803.

He had been born some sixty years earlier of poor parents, and had himself studied painting for a short time, but his real moment did not come until 1774 when he first made contact with the British Residency. He was soon on excellent terms with the new occupant of the post, John Strange, and the two men saw each other and corresponded for nearly twenty years.[2] They grumbled about the times: the old days are gone for ever; domestic life is at an end; women go out at all hours of the day and night. They condoled with each other in their losses and illnesses, exchanged gossip. And above all they did involved, lucrative business together. Strange employed Sasso to buy him Venetian pictures of all kinds—Giorgiones and Titians, Veroneses and Tintorettos, and

[1] For a short biography see Cicogna's footnote to his edition in 1856 of Sasso's *Osservazioni sopra i lavori di niello*; also Lorenzetti, 1914. For his portrait by Alessandro Longhi see *Bollettino dei Musei Civici Veneziani*, 1959, No. 2.

[2] The letters from Strange to Sasso are in the Epistolario Moschini, Biblioteca Correr, Venice. There are quotations from them in Mauroner, 1947, pp. 48-50. Sasso's replies are mostly missing, but there are four letters from him to Strange in the British Museum, Add. MSS. 23,730—ff. 359-63.

—less frequently—the moderns: Rosalba, Canaletto and Tiepolo especially. These pictures found a temporary resting-place in Strange's country house near Treviso or his apartments in London, and were then sold to rich amateurs—or would have been, were it not for the fact that 'no one likes old pictures any more; they want modern trash'. The process could be difficult. Collections likely to be dispersed had to be examined in absolute secrecy; transport was enormously expensive; the customs were troublesome and had to be evaded if possible. And in the midst of all these complications Strange occasionally commissioned a modern work of art—for himself or for a client. He planned to bring out an edition of Zompini's *Le Arti che vanno per le vie nella città di Venezia*; and he employed the little-known Francesco Guardi (Plate 64).

He was somewhat diffident about this, for the artist, though 'spirited', was all too apt to miss the 'truth' of the views that he painted.[1] And so Strange would implore Sasso to tell Guardi that his drawings must be 'not just clear, well finished and *a pair*, but also coloured *exactly*'. Yet Strange admired Guardi, and at one time or another he owned a large number of his works; for like many others who were settled in Venice, far removed from the more advanced currents of London, Paris or Rome, he loved the brio and rich colour of Venetian painting, and was out of sympathy with the new, dry, neo-classical works that were the rage in those towns. And so we find him speaking enthusiastically of Tiepolo, and 'falling in love' with a detail from one of his pictures— a pigeon on a twig—which he wants cut out for himself.[2]

Not all Sasso's clients were so keen. The painter and dealer, G. A. Armanni, travelling between Bologna and Rome, wrote derisively of an English visitor Mr Poore: 'How strange that someone who loves the subtlety of the Greeks should have the patience to look at the *stranezze* of Tiepolo, the caricatures of Celesti and the *schiribizzi* of so many other lesser painters!'[3] But Armanni was in touch with all the new fashions, while in the enclosed world of Venice itself, among the agents and dealers, the minor clerics and doctors with whom we are concerned, there was no need yet to reject the heritage of recent Venetian painting. Certainly Sasso seems to have felt all the admiration of a previous generation for the rich, bold virtuosity of the earlier eighteenth-century painters. When Canova wrote from Rome to ask for a *modello* by Tiepolo, he was told that Sasso had bought them all.[4] In fact this was not true, but the rumour probably reflects his known love of this kind of painting. In the collection he made for himself which was auctioned after his death in 1803 there were a number of such pictures—by Giambattista and Gian Domenico Tiepolo, as well as one of his own copies of one of them, and 100 drawings; he also owned *modelli* by Sebastiano Ricci, Pittoni

[1] For all references to the patronage of Guardi with full indications of sources see Haskell, in *Journal of the Warburg Institute*, 1960, pp. 256–76.

[2] Strange-Sasso correspondence, Letter 8, dated 22 December 1784.

[3] Two volumes of *Lettere pittoriche di G. A. Armanni a G. M. Sasso* containing hundreds of letters arranged in the vaguest of chronological orders between 1783 and 1803 are in the Archivio of the Seminario Patriarcale, Venice—MSS. 565 and 566. Mr Poore is discussed in a letter of 7 July 1789. In two auctions—4 and 19 April 1805 (Richardson)—prints and drawings belonging to an Edward Poore were sold, but there is no reference to any Tiepolo among them.

[4] Published by Haskell in *Journal of Warburg Institute*, 1960, p. 276.

and Piazzetta; drawings and sketches by Canaletto and Carlevarijs; and a painting and seven drawings by Guardi.[1]

Strange left, but he provided a letter of introduction to Sasso for his successor, Sir Richard Worsley: 'He is a great lover and a great connoisseur of all beautiful things. He already has fine treasures and I know that you will be able to find more for him.'[2] Sasso did; and quite soon Sir Richard Worsley was himself presenting a Guardi to Lady Palmerston. In fact no English dealer in Venice thought of doing without Sasso whose trustworthiness and expert knowledge were responsible for stripping the city of many masterpieces during the last years of the eighteenth century.[3]

Sasso was the best known of such dealers to the English, but there were many others of a similar kind, whose tastes helped to keep alive a love of colour and fantasy in Venetian art. The Abate Giacomo della Lena, for instance, was also on the fringes of scholarship.[4] He was a close friend of the Abate G. A. Moschini, an antiquarian who saved many Venetian records from destruction, and he himself wrote an account of the 'Spoliation of Pictures from Venice'.[5] This deals with the activities of various collectors who had removed pictures from the city, ranging from Cardinal Leopold de' Medici to his own contemporaries. As a nineteenth-century historian drily commented, he was well qualified to write such an account, for he himself was deeply involved in picture dealing—mainly with the Germans. Della Lena had been born in Lucca in 1732, but he spent most of his life in Venice, where he acted as Spanish vice-consul and where he died in 1807. He probably owed the job to his brother Innocenzo, who was the Spanish Ambassador's doctor, while another brother, Eusebio, was a friend of Casanova. Della Lena, like Sasso, also collected pictures for himself, though on a more modest scale. He owned a few Canalettos, some works by very minor contemporaries, and, above all, thirty-two paintings by Francesco Guardi. The enthusiasm that della Lena felt for this artist is rationalised in a letter that he wrote to the economist, Giuseppe Maria Ortes.[6] The arts, he comments, are unlike the sciences. For in the arts fantasy must dominate and take precedence over the intellect. In other words, truth must be made to serve falsehood. What is of value and pleasurable in the arts is indirect and unformulated; while the value of the Sciences is clear and complete.

It was only in such an atmosphere as this that Francesco Guardi, with his disregard for 'truth', could flourish, untroubled by the more literal-minded English, who demanded a clear and unimaginative rendering of what they saw with their own eyes.

[1] Sasso's collection is documented in the *Catalogo de'quadri del q. Giammaria Sasso, che si mettono all'incanto nella sua casa al ponte di Cannareggio, n. 381*—not recorded by Lugt, but copies exist in the Biblioteca Civica, Padua and the Accademia Carrara, Bergamo.

[2] Strange-Sasso correspondence—Letter 57—3 October 1793.

[3] Among those in touch with Sasso were A. Hume—see Lorenzetti, 1914, who publishes three letters of 1790-2; John Skippe (1778-9) and Hamilton, Marquis of Douglas (1800-2)—see letters in the Epistolario Moschini, Biblioteca Correr, Venice.

[4] Haskell, in *Journal of Warburg Institute*, 1960, pp. 261-2.

[5] Biblioteca Correr, Venice—MSS. Raccolta Cicogna 3006/9 and other versions. See Haskell, 1967.

[6] Of 14 January 1786—in Biblioteca Correr, MSS. Cod. Cicogna, 3198.

Another collector who took the same line and who may well have belonged to the circle of Sasso and della Lena was a canon of Chioggia Cathedral, Dr Giovanni Vianello.[1] Like them he had pretensions to scholarship which he showed—though hardly justified—in the edition he brought out in 1793 of Rosalba's journal. It is not certain whether or not he was a dealer, but the publication of a catalogue of his paintings in 1790, some three years before his death, strongly suggests that he was by then willing to dispose of them. He owned over 200 pictures, the vast majority of which were Venetian of the seventeenth and eighteenth centuries. His special favourite was Pietro della Vecchia by whom he owned twenty-five pictures, many of them fantasy heads 'alla Giorgionesca'. Most of the great artists of his century were well represented with many drawings and paintings by Rosalba, Ricci, Piazzetta and Tiepolo. Of these artists he seems to have preferred the sketches, and above all the capricious bust portraits that were so popular at the time. Vianello also owned three works by Francesco Guardi—two paintings and a drawing—but his appreciation of this artist was greater than such a small number would suggest. He deplored Guardi's absence from the standard reference books. Alone among those who wrote about him, he did not drag in Canaletto and make the inevitably unfavourable comparison. By implication, indeed, he defended Guardi from the attacks that were made on his deficiencies in perspective. Above all he specially admired him for those qualities that were peculiarly his own—the movement, the colour, the vivacity, the sparkling lights, the *macchiette* 'secondo si dice dalli Pittori'.

More modest than any of these but with similar tastes was the Dominican Padre Giuseppe Toninotto.[2] We come across him rather pathetically begging from foreign tourists as he shows them round the Frari, or in disgrace with the State Inquisition for selling improper prints. Yet he too played his part in helping to record—and to collect—some of the glories of Venetian art before the Republic finally collapsed. In 1785 he was responsible for publishing a series of nine large prints by Giovanni del Pian of Carpaccio's famous scenes of the Life of St Ursula. And his collection shows a similar taste to those that have already been investigated. There were, of course, some old masters with ambitious attributions to Titian, Bassano and others. There were a number of *modelli*, a couple of Pietro della Vecchias 'sulla maniera di Zorzone' and many Flemish paintings, as well as a selection of eighteenth-century pictures, mainly small views and landscapes by Carlevarijs, Marco Ricci and Marieschi. He too owned several paintings by the most neglected masters of his day—Giuseppe Zais and Francesco Guardi: twelve paintings and four drawings by the former and eight paintings by the latter. Four of these were 'caprizi copiosi di figure' and four were unnamed Venetian views.

Another figure in this group was the rich German business man Amadeo Swajer (Plate 59a) who lived most of his life in Venice and died there in 1792.[3] He was principally a collector of manuscripts, and after his death the possible dispersal of the secret

[1] See the catalogue of his pictures published in 1790.

[2] Haskell, in *Journal of Warburg Institute*, 1960, pp. 263-4, for all references.

[3] A good deal of Swajer's correspondence is in the Seminario Patriarcale in Venice—above all a volume of letters dating from the 1750s and 1760s, mostly concerned with literature, addressed to him

ones caused some anxiety to the Inquisitors of State, who acquired them all. But he was also in touch with a number of artists, notably Giambattista Tiepolo and his son Gian Domenico on whose behalf he negotiated a few commissions, and with Canova who painted his portrait.

A much more adventurous and successful dealer than any of these was the Abate Luigi Celotti, who survived the downfall of the Republic by half a century.[1] But he was at home in all régimes—as long as there were clients to buy his pictures. Constantly building up collections and then dispersing them, he turns up again and again in London, Paris and his native Venice, usually preceded by a discreet little announcement in the papers that an 'amateur éclairé' was wishing to dispose of some of his works of art.[2] These were of all kinds and included 'illumined miniature paintings taken from the Choral Books of the Papal Chapel in the Vatican during the French Revolution'.[3] But apart from such mediaeval treasures for which he was famous, he owned—and, of course, sold—old masters of all sorts and many eighteenth-century Venetian paintings. It is legitimate to infer from his rhapsodic accounts of these not only a considerable gift for salesmanship but also a genuine and individual taste which is similar to that of some of the humbler dealers so far recorded.[4] Of his eight Canalettos, four 'joignent à la richesse de leur composition, à l'imitation exacte et spirituelle dans tous leurs détails, et à la manière vague et légère que l'on admire ordinairement dans les Productions de cet habile Peintre, le précieux avantage d'etre enrichis de Figures de la main du célèbre Tiepolo, son ami', an unusual recommendation in 1807. His Sebastiano Ricci pastoral scene is 'd'un coloris frais et d'un pinceau léger'. His Tiepolo sketches—of the *Rape of Ganymede* and an allegorical subject—are 'd'une grande facilité de touche, et d'une composition fougueuse . . .'.[5]

In all these men, so similar in their status and their place in society, we can see a strikingly similar type of collection and patronage. They were outside the main currents of the intellectual life of Venice which have been examined in the last few chapters.

by Valerio Vannetti in Roveredo; and another set of the 1780s and 1790s, mostly about politics, from the Durazzo family in Genoa with which he was in close touch.

A letter from him to G. B. Tiepolo and one from G. D. Tiepolo to him are published by Urbani de Ghelthof, 1879, pp. 19 and 32. The former, which refers to Tiepolo's 'consaputo quadro' for the King of France, is claimed to belong to Urbani de Ghelthof's own collection and should perhaps be treated with some caution, as it appears (*Ateneo Veneto*, Maggio 1937) that he was far from reliable in his use of documents. His papers and manuscripts are mentioned in the Archivio di Stato, Venice—*Inquisitori*, 540, p. 164—30 Maggio 1792.

[1] Levi, I, p. cxxxv, says that he died in about 1846.

[2] See, for instance, the announcement 'Agli amatori delle Arti belle' in *Gazzetta di Venezia*, 4 Maggio 1821.

[3] Christies', 26 May 1825. The miniatures are described by William Young Ottley.

[4] *Notice de Tableaux, par les plus grands maitres d'Italie, . . . composant le cabinet de M. Celotti de Venise . . .*, Paris 1807.

[5] In 1814 he sold some more Tiepolos and also Piazzettas—see *Notice d'une collection de tableaux* [appartenant à M.r Celotti] *dont la vente aura lieu le lundi 14 Novembre 1814*. The words in brackets are added in ink to the printed catalogue in the copy which I have seen.

They earned their livings by pandering to the international demand for old masters, and they themselves assembled pictures by artists who were the victims of the change in taste that swept through Europe during the second half of the eighteenth century. Time has effected a remarkable revolution and to us they now appear as the true guardians of the Venetian tradition.

Chapter 17

THE LAST PATRONS

– i –

FOR a full generation before the Republic finally collapsed there was a general feeling that an epoch was drawing to a close. There are countless references to this in the political speeches and literature of the time, and eventually it began to affect the patrons and picture collectors. The feeling is embodied in the activities of a number of men who turned to the past rather than the present or the future—as if anxious to give subsequent generations some impression of what Venice had been like in the great days of her independence.

Girolamo Manfrin was almost the caricature of a type of figure that has at all times depressed the conservative supporters of an old order.[1] He was a nouveau-riche business man, who through sheer unscrupulous Balzacian energy and talent achieved a high position in a society where such achievements were despised in favour of the more gracious attributes of life. Such men have always made their mark, but there are periods in history when their success appears symbolic of a whole trend. This was to be the case with Manfrin. He was born in Zara of a humble family—*in mezzo al fango, e dalla Merda nato* in the words of one of his aristocratic denigrators[2]—and he was accused of all the characteristic evils of the successful businessman—'iracondo' incivil, avaro, ingrato, /Sospettoso, infedel'. In 1769 he was granted a monopoly of the tobacco plantations in Dalmatia, where he made himself hated and soon acquired an enormous fortune, much of it through somewhat discreditable means.[3] At one stage his willingness to take bribes and his general financial trickery led to his being banished for life from Venice[4]; but this was revoked, and in 1786 we find him back again with a special permit to carry arms so as to discourage possible attempts on his life.[5] In 1787 he was in a position to buy the palace of the ancient family of Venier on the Cannaregio, as well as their country house near Treviso,[6] and by then he had already established himself as one of the most important patrons and collectors in Venice. Indeed, within five years,

[1] Most of the available material about Manfrin is still unpublished and will be referred to as occasion arises. The only general account of him and his gallery is given by G. A. Moschini, 1806, II, p. 107.

[2] Biblioteca Correr, Venice—Cod. Cicogna 2947/18: *Sonetti XVI ossiano Satire contro il Manfrin, Impressario di Tabacchi.*

[3] See, for instance, the pamphlet *Risposta alla lettera apologettica imparciale per il Cittadino Gerolamo Manfrin*, In Venezia 1797, Anno I della Libertà Italiana (Biblioteca Marciana: 183.C.89, p. 321). From this and a mass of similar controversial material it is obvious that Manfrin made himself highly unpopular, though it is not quite clear to what extent he was actually dishonest.

[4] Archivio di Stato, Venice—*Inquisitori*, 538, p. 43—29 Genaro 1770.

[5] *ibid.*, 540, p. 6—12 Giugno 1786.

[6] Tassini: *Curiosità Veneziane*, 4th edition 1887.

when a false rumour of his death reached Bologna, the painter and dealer G. A. Armanni at once wrote to Giuseppe Maria Sasso in alarm 'because he is almost the only man in Venice who spends anything on the fine arts'.[1]

We first come across Manfrin in this connection in 1785 when the posthumous edition of Tiepolo's etchings *Varj Capriccj* was dedicated to him.[2] Two years later there followed a volume of painters' portraits[3] and thereafter he remained in the forefront of the Venetian art world until his death in 1802. The vast gallery that he built up was apparently designed to give a general view of the history of Italian (and, to some extent, Flemish) painting[4]—but it is notable that Manfrin took no account of the opinion that had long been current among scholars that art had something to offer before the sixteenth century. The Venetian pictures began with Mantegna and Bellini, and thereafter most of the great and lesser painters were included up to his own contemporaries, Francesco Guardi and Gian Domenico Tiepolo.[5]

In private, at least, Manfrin made few pretensions to connoisseurship. In a letter to Pietro Edwards, who acted as his adviser, he wrote in a strain that has become familiar through the activities of more recent collectors[6]: 'As I wish that everything should proceed as satisfactorily as possible in the choice of pictures to be included in my gallery, I naturally wanted real experts in painting, such as yourself and Sig. Gio. Battista Mingardi, to take over the responsibility of choosing, identifying and excluding pictures as they think fit, without paying any attention to the expense involved; for I only wanted pictures of the highest quality in my gallery. . . . You must have no hesitation in being ruthlessly selective—and you need have no fear that your rejection of any picture will cause you difficulties or hostility; for I entirely accept your terms never to reveal your objections to a picture, and to keep them entirely private for my own guidance.' In Manfrin's words we see all the snobbishness of the self-made millionaire; but in his insistence on a historical choice of pictures we also recognise that the gallery was to have some of the definitive status of a national institution. It was to be a tribute to the achievement of Venetian painting—at a time when it was felt that Venetian painting was virtually at an end.

[1] Seminario Patriarcale, Venice—MSS. 566—Letter of 20 July 1790.

[2] *Varj capriccj inventati, ed incisi dal celebre Gio. Battista Tiepolo, dedicati all'Ill.mo S. Girolamo Manfrin,* MDCCLXXXV.　　　　　　　　　　　　　　　　[3] Biblioteca Correr, Venice—Stampe D.30.

[4] Moschini, 1806, II, p. 107: '. . . egli una Galleria di più camere di Quadri aperse de'più sperti pennelli, incominciando da'pittori primi ed a'giorni nostri discendendo; ed era di lui pensiero, se la morte non lo avesse troppo presto mietuto, di offerire di mano in mano tele de'diversi tempi e delle diverse scuole, perchè vi si potessero a un colpo di occhio riconoscere gli scapiti ed i vantaggi, che nelle varie età ebbe quest'arte.'

[5] The first record of Manfrin's gallery was made by Pietro Edwards, his adviser, just before the end of the eighteenth century. It exists in manuscript in the Seminario Patriarcale, Venice—MSS. 788.13. A printed catalogue, made for the sale, was published in 1856—a photographic copy of this exists in the Biblioteca Correr. A further catalogue of the pictures still remaining in the collection was published by Ab. G. Nicoletti in 1872 (Biblioteca Marciana: Misc. C. 11231). There is also a manuscript *Catalogo delle Stampe della Collezione annessa alla Galleria Manfrin,* Venezia (n.d.), in the Biblioteca Correr: Cod. Cicogna 3007/XIII.

[6] Biblioteca Correr—Epistolario Moschini—published in full in Appendix 7.

The expertise of his advisers combined with Manfrin's own wealth assembled a huge collection of over 400 pictures. Many had once been commissioned by important patrons—there was Batoni's *Triumph of Venice* painted for Marco Foscarini—and the gallery gradually came to be among the finest in Venice. It long remained one of the chief tourist attractions in the city, and among its treasures was Giorgione's *Tempesta*. Manfrin's ventures into patronage were less satisfactory. Although this was hardly his fault, in view of the lack of talented painters available, his activities in this field certainly seem characteristic of the vulgarian his enemies laughed at. He would organise competitions among the painters to produce pictures on erotic themes which he himself devised—*Joseph and Potiphar's Wife*, *Bathsheba bathing*, *Lot and his Daughters*, *Susanna and the Elders*.[1] But despite the enthusiasm aroused among history painters starved of commissions it is hardly this that has entitled him to the gratitude of posterity.

– ii –

The other great collector who survived the downfall of the Republic but whose name will always be linked to its history was Teodoro Correr.[2] He was born in 1750 and except for their common love of art his life and character were different in every way from those of Manfrin. His portrait, painted in early middle age (Plate 59b), shows him to have been elegant and rather withdrawn[3] and he was descended from one of the oldest of the Venetian aristocratic families. As a young man he began to show the love of learning that was to characterise his life. In 1768 he read an elaborate and rather strained paper on 'The Sacrifices of the Ancients' to a club to which he belonged: the evening ended on a more congenial note with fencing matches, and odes and sonnets by his friends on the sacrifices of Juno, Ceres and Minerva.[4] In 1776 he embarked on the traditional political career that was expected of one born in his position and within three years he was a member of the Council of Ten. But soon after this he tired of politics and to avoid further responsibilities he became an *abate*. In 1787 we find him writing to the Doge to explain that his lack of means made it impossible for him to take up his post as governor of Treviso: 'There is certainly nothing more mortifying for a citizen, Most Serene Prince, than to find himself in such circumstances that he is unable to place himself at the disposal of his fatherland. . . .'[5] He was to grow accustomed to the situation, for this was only his first of many applications, renewed with every subsequent change of régime, to escape from the duties of official life. However, there

[1] Moschini, 1806, II, p. 107 and the same author, 1810.

[2] For Correr and his collections see V. Lazari and the catalogues of the museum by G. Mariacher, 1957 (until the Renaissance), and T. Pignatti, 1960 (seventeenth and eighteenth centuries).

[3] By Bernardo Castelli—painted before 1795, in which year it was engraved—see Pignatti, 1960, p. 62.

[4] Biblioteca Correr—Archivio Correr $\frac{1468}{10}$ (6 a-d).

[5] *ibid.*, $\frac{1468}{10}$ (5).

is no doubt that the services which he rendered Venice in other ways were far greater than anything he could have achieved by politics at this stage in the city's history.

It is impossible to be certain when Correr began to assemble the vast collections which he later left to Venice, but it is probable that he did so when still very young.[1] Already he was looking entirely to the past and it seems unlikely that at any stage in his life he commissioned work from living artists.[2] We know that he obtained many of his pictures from the great patrician and trading families—especially the Molin, the Orsetti and the Pellegrini—and in his obsessive accumulation of objects he took ruthless advantage of the financial weaknesses of his contemporaries.[3] We also find him attending sales and public auctions.[4] His aim was to amass everything he could—books, manuscripts, prints, coins, medals and bronzes as well as pictures—which threw light on the history and cultural achievements of his city, and his palace near S. Giovanni Decollato was already a museum long before his death. Correr's contemporaries had some doubts about the sureness of his taste, and these aspersions were repeated by nineteenth-century writers.[5] But this criticism was partly due to the indifference he showed to the more orthodox views of his age. He collected works of the fifteenth and eighteenth centuries alike when neither was fashionable—and in the process he sometimes acquired masterpieces of the very highest quality, such as Antonello da Messina's *Deposition* and Cosimo Tura's *Pietà*. But it is true that he also owned a good deal of very inferior painting and it is possible to be as struck by how few in number were the great early Renaissance pictures that he picked up as by his adventurousness in buying any at all. In fact, it is almost certain that Correr was more inspired by historical curiosity than by scholarship or aesthetic appreciation.

Of eighteenth-century artists one painter completely dominates the collection—Pietro Longhi. In view of his passion for Longhi's 'documentary' scenes, it is strange that Correr should have paid no attention whatsoever to the view-painters.[6] It almost seems as if he were aware that the physical aspect of the city would remain unaltered but that the 'douceur de vivre' had gone for ever. And so he collected his twenty-odd Longhis to record the family life of the nobles and the street scenes, the stiff little ceremonies of morning chocolate and the portraits of the clergy. He was so pleased with these pictures that he obtained from the artist's son Alessandro (one of whose portraits he owned) as many drawings by Pietro Longhi as he could lay his hands on. It was no doubt this love of recording the varied aspects of Venetian life that led him

[1] Dandolo, p. 97.

[2] It is just possible, though it is unlikely, that he obtained the occasional painting direct from Pietro Longhi who died in 1782.

[3] See the hints in [Urbani de Ghelthof]: *Teodoro Correr e il suo museo*, n.d. (Biblioteca Correr: Op. P.D.18796), confirmed by papers in his archives.

[4] For instance, he almost certainly bought Zocchi's double portrait of A. M. Zanetti and the Marchese Gerini at the Sasso sale in 1803—see Haskell, *Bollettino dei Musei Civici Veneziani*, 1960, 3/4, pp. 32-7.

[5] Dandolo, p. 97.

[6] For the sake of accuracy it should be mentioned that he owned one view of Venice attributed to Canaletto, now thought to come from his studio, and one damaged view of Castel Cogolo probably by Francesco Guardi.

to buy Gian Antonio Guardi's excursions into Longhi's manner—the *Parlatorio* and the *Ridotto*, the gambling room which was closed by the government just as he was beginning his political career.[1]

The break-up of aristocratic life and collections brought about by the revolution of 1797, followed so soon by foreign occupation, was responsible for many pictures coming on to the market, and Correr obtained a great deal when the Republic had already collapsed. Once again he was careful to avoid committing himself. Under the headings of *Libertà* and *Eguaglianza* he wrote to his new democratic rulers that he was unfortunately compelled 'to resist the violent stimulus of patriotism' and seek exemption from the Civic Guard owing to general ill-health—and he enclosed certificates from his doctors and dentist to strengthen his case.[2] Safely in the background, a crotchety old bachelor, he went on buying well into the nineteenth century, unnoticed in the Venice of Byron and Bonington, and an easy prey to the more unscrupulous second-hand dealers.[3] He died at last in 1830 and left the fruits of more than half a century's avid collecting to his native city—thus worthily ending a tradition of aristocratic interest in the arts that had begun many centuries earlier.

[1] In view of all the controversy that has surrounded these pictures it is of interest that, although they were catalogued as Longhis by Lazari in 1859, in Correr's own day they were known to be by 'Guardi'—Pignatti, 1960, p. 96.

[2] Biblioteca Correr—Archivio Correr $\frac{1468}{10}$ (9ª).

[3] Levi, I, p. cxix.

CONCLUSION

BETWEEN 1623 and 1797 the political decline of Rome and Venice, the two most vital centres of Italian Baroque art, was almost continuous. In both cities, architects, sculptors and painters of the first rank were employed by those in authority—in Rome the constantly changing upholders of a theocratic absolutism, in Venice the old and new families that composed a rigid oligarchic aristocracy—to impress themselves and foreigners alike with illusions of power which had little basis in reality. The achievements of Bernini, Pietro da Cortona and Tiepolo are there to prove with what conviction and genius great artists can serve great patrons however unpromising the cause. Nor can it be denied (though many have tried to do so) that these achievements, and others of a similar nature, represent the finest Italian contribution to the art of the period; and the significance of this is brought to light if we compare the situation with that of foreign artists. There are no Italian equivalents to Velasquez, Rembrandt, Vermeer, Louis Le Nain, Georges de la Tour, Poussin, Watteau or Chardin—all painters who expressed a private and individual outlook that is far removed from the 'public' masterpieces of the greatest Italians.

This may be due only to the fortuitous distribution of talent, but there are so many cases in Italian art during these two centuries where a fresh and original approach to life becomes buried under the pressing claims of society that the temptation to seek an answer other than the last resort of 'national character' becomes irresistible: one thinks of the *bamboccianti* who hover for a few years on the brink of a new, dignified 'realism', only to fall into picturesque sentimentality; of Salvator Rosa, so bold to exploit his gifted temperament in the cause of artistic conformity; of Crespi, just able to carry along with him an eccentric Medici prince, but never quite prepared to throw over his 'humour' and raise genre painting to a more noble status; of Canaletto, who turned so soon from gazing with steady penetration at the backwaters of his native city to stereo-typing shorthand versions of the familiar views to tourists; of Padre Lodoli, the 'scourge of society', who was yet honoured with an official government post and whose ex-plosive writings were never even published.

Modern Italian historians have noted, and bitterly resented, the same kind of conformity in the writers of the time. Until detailed investigation has been made of the contrasting conditions elsewhere it will be difficult to account for it, but such an in-vestigation is not likely to reflect harshly on the Italian patrons. Where else in Europe can we find men more cultivated and more liberal? Was Philip IV more tolerant or better educated than Urban VIII and his nephews? Richelieu than Cassiano dal Pozzo? the Régent, Crozat or Mme Geoffrin than Grand Prince Ferdinand or Francesco Algarotti?

It is perhaps precisely in the broad culture and tolerance of Italian patrons that the

answer should be sought. Like 'advanced' parents of the most humane opinions, who apply no direct pressure to their children, yet whose views are all too paralysingly communicated to them, the aristocracy, traditional and upstart, of Baroque Italy, may have stifled revolt through the very self-assurance of their inherited values. None of the artists mentioned above was deflected from his path by specific pressures; at no period in Italy did an orthodox Academy or a dominating religious organisation impose its artistic doctrines. Unorthodoxy was killed with kindness.

Such an attitude had its advantages as well as its drawbacks. If it is true that we miss a certain type of individual and withdrawn artist in Italy (Domenico Fetti is surely the most beautiful exception), it is also true that the general level of painting in Rome, Bologna, Naples and Venice—to name only a few of the most important centres—was certainly higher than in almost any other town in Europe. The opportunities and encouragement given to architects, painters and sculptors have rarely, if ever, been equalled, and the debt of gratitude we owe to the liberal patrons of the time can be seen not only in Italy but in every art gallery of the world.

Yet the price to be paid was a high one. Artists so closely tied to the patronage of a particular society could not adapt themselves to new conditions when the foundations of that society collapsed. The 'bourgeois' painting of England and France had no real roots in Italy, and the attempts made by bodies such as the Academy at Parma to promote a more modern and 'enlightened' type of art met with little success. Whereas in France and England painting took on a new and more glorious lease of life with the decline of the Church and the feudal aristocracy, the fall of Venice signified no less than the humiliating expiry of Italian art.

APPENDIX 1

Documents relating to the altarpieces in S. Andrea al Quirinale by Giacinto Brandi and Carlo Maratta in the Jesuit Archives, Borgo S. Spirito, 5, Rome: Fondo di Gesù—N. 865-13. See Chapter 3, p. 88, notes 2 and 3.

– *a* –

Letters from Brandi:

Molto Illustre et Molto Rev. Padre mio Signore,
È verità che il Signor D. Lerio Licà moltissime volte mi à fatto grande istanze et solicitatomi per il quadro che devo fare per questo Noviziato di S. Andrea nel nome del Rev. P. Loro rettore. Ma perchè ò sempre stimato non avesse a servire sino che la happella non era fornita, ora che Lei mi à fatto grazia avvisarmene, progurarò sbrigarlo, avendo io mutato il pensiero di quello che anhe tengo sbozato. Dico che mi soleciterò con rubare il tempo per servirli che tanto devo.
Intanto suplico V.R. a favorirmi. Con il R.P. rettore mia abia per isqusato, e se non sono andato a riverirla come qui per ora faccio ò stimato di non incomodarlo, e verei ora, se l'essere impedito di un piede causa il mio [illegibile] non venire a bagiarli le mani, come faccio anche a V.R. facendoli così ogni magior effetto riverenza. Casa li 4 X 1675. Di V.P. Molto Rev. Devot.mo et oblig.mo suo servitore Giacinto Brandi.

Molto Reverendo P. e mio Signore,
Credo fu il mese di Novembre scorso che suplicai il Signor Mattia di Rossi si compiacesse ordinare il telaro nela cornice e sito proprio dove va locato il quadro che io faccio per Lor chiesa ad efetto che non si abia a rimovere e ritirare doppo fornita la pittura che porta discapita a quella. Ò più volte rimandato. Ma per le molte occupazioni del Signor Derossi si sarà desmentihato. Suplico la P.sua a favorirmene farlo fare che io rimanderò qui per la risposta. Squsi per grazia V.R. del'ardire a qui resto con fare a tutti li R.P. riverenza, Casa li 25 febbraio 1676.
Di V.R.

Suo Servitore River.mo
Giacinto Brandi

Molto Ill.re et R. Padre,
. . . Dico a V.R. che se da domattina, o quando lei li sarà comodo, vol vedere il quadro sborzato e tutto il Redentore, pol restar servita, come anche conoscerà il disfatto, chè vi era la Madalena non di mio gusto. Ò gran disgusto del disgusto di V.R. che molto mi preme il servir il meglio che saprò: resti V.R. disinganato dal aprensione che non sia prencipiato, che a suo piacere pol acertarsene e ne resterò favoritissimo al magior segno. . . .
8 Marzo 1676

Giacinto Brandi

Io . . . ho ricevuto dal P. Paolo Ottolini Vice Procuratore Generale della C. di G. sc. Duecento moneta, quale mi ha pagati di ordine del P. Domenico Brunacci Vice Rettore della Casa di Probatione di S. Andrea . . . per intiero pagamento di tre Quadri, Volta, et altri ritoccamenti

e spese di Pittore da me fatti, o fatti fare nella Cappella della Passione di detta Chiesa, restando io intieramente sodisfatto sino a questo giorno 28 Marzo 1682 per sc.200 moneta:
Io Giacinto Brandi

– *b* –

Receipts signed by Maratta:

Io sottoscritto ho ricevuto dalla Ven. Casa di Probatione di S. Andrea . . . per le mani del P. Severino Vittori Procuratore della medesima Casa sc. 100 moneta, sono a conto d'un Quadro, che dovero fare nella Cappella del B. Stanislao, secondo il pensiero fatto, e come meglio giudicarò, e prometto farlo fra il termine d'un anno prossimo, e mancando mi obligo di restituirgli detti sc.100, o altra somma che avessi presa, e ciò s'intenda essendo io sano, e non havendo legittimo impedimento, e curo che (Dio non voglia) per qualche infermità o altro fortuito accidente non potesse finirlo, in tal caso non sia tenuto alla detta restitutione, e non altrimente. . . .
Io Carlo Maratti 22 Settembre 1679

Io infrascritto ho ricevuto per mano del P. Giuseppe Tonini della Casa di Gesù scudi 300 m[oneta] da Persona a lui nota, i quali con altri scudi Cento simili havuti sotto li 22 settembre 1679 . . . sono il prezzo del Quadro da me fatto per la Cappella del B. Stanislao . . . con che mi dichiaro interamente sodisfatto.
Io Carlo Maratti 19 Settembre 1687

APPENDIX 2

Documents relating to commissions from Paolo Giordano Orsini, duke of Bracciano, to Bernini and Tacca in the Fondo Orsini, Biblioteca Vallicelliana, Rome. See Chapter 4, p. 97, notes 1 and 6.

– *a* –

171, c. I:

Ill.mo, et Ecc.mo mio sig.re,
Io hebbi venerdi sera dal Caval.re Bernino il Modello della Mad.a, e la mattina seguente lo portai a Giacomo Ant:o, e se bene lo trovai in Casa [*sic*] lo lasciai perche gia ci eravamo intesi. Hier matt:a egli fù da me, e mi fece vedere che tutti quattro i modelli erano differenti, et in grossezza, et in altezza, e che in piccolo ogni poca differenza importava assai. Per fare cosa giusta vorrebbe formare da se la gioia in mia presenza di mistura appropriata, perche l'Argento è troppo crudo, oltre che bisogna gettare anche un Manichetto dove stia attaccato il modello della gioia per poterlo tenere in mano.

Il Tedesco, che haveva il segreto del gettare pulito mori. la moglie si rimarito, ad un suo garzone, e questo pure s'è morto. Di nuovo s'è rimaritata ad un altro suo garzone. fin qui si scuopre, che la Polvere si fa di dalco beniss:o abbrucciato, e poi questo, e setacciato finissi-mam:te. Se più saprò subito lo significherò a V.E.

Se frà quei quattro zaffiri ne haverà trovato alcuno à suo gusto, mi farà grā à rimandarmi

gl'altri, et accennarmi insieme se li devo far pagare, e qui umilissim:te le inchino. Di Roma li 3 di Maggio 1623
Di V.E.

 Sarò qui li quattro ore delli del [illegibile] acciò V.E. veda che non sono eguali.
S:re Duca Umiliss:o et Obbligat:mo
 Domenico Fedini

ibid., c. 140:

 Ill.mo, et Ecc:mo mio sig:re,
Concorremmo hiersera il Caval:re Bernino, et io, che sarebbe stato bene dare fino à 25 scudi à m.r Bastiano Sebastiani che deve fare il getto di Bronzo della testa di V.E., poiche il gesso, e la cera, volendo fare la prova del cavo con due cere almeno, e forse tre, verranno à importare questo denaro. M'è parso doverlo accennare à V.E., acciò se le pare, possa dare l'ordine che sia necessario, assicurandola che si come il Caval:re hà fatto il ritratto con suo grandiss:o gusto, così il gettatore hà ambizione di mostrare tutto quelche possa la diligenza, e l'arte. E qui à V.E. umilissim:te m'inchino. Di Roma li 27 di Giugno 1623
S:re Duca Umiliss:o et Obblig.mo Ser.e
 Domenico Fedini

173, c. 2:

 Ill.mo, et Ecc:mo mio sig:re,
Fummo lunedi matt.na il s:r Caval.re Bernino, et io à vedere il getto di Bronzo della testa di V.E., che è riuscito beniss:mo e ogni uno che l'hà veduto poi afferma che magg:re pulitezza non si possa desiderare, e che l'arte non arrivi à far più, pche ci si veggono tutti i colpi della cera rinettata, si che spero che V. Ecc:za ne resterà soddisfatta. Il S:r Cavaliere hà ordinato al Gettatore che tagli solo i getti che sono attorno, e che non lasciano godere perfettam.te la Testa, e che del resto non tocchi ne con ferri ne con lime cosa alcuna, non volendo far noi niente più senz'ordine di V. Ecc:za. La testa s'è gettata alla fonderia di S. Pietro, e perche potrebbe ess:re che il Gettatore per la comodita e vicinanza del lavoro dell'Altare di S. Pietro facesse difficultà à mandarla quà sù in Casa il s:r Caval:re, in presenza del quale è necessario che si rinetti, dove sarà di bisogno, però desiderei che V.E. con due suoi versi mi comandassi espressam:te ch'io facessi portare la testa in Casa il s:r Caval:re acciò io gli potessi mostrare al Gettatore, e non havessi occas:ne di replicare Come la Testa sarà in Casa il s:r Caval:re aspetteremo nuovi comandamenti di V.E., alla quale per fine umilissim:te m'inclino. Di Roma li 21 di Sett:re 1624.
Di V. Ecc:za Umiliss:mo, et obblig:mo ser.e
S.r Duca Domenico Fedini.

175, c. 463:

 Ill.mo, et Ecc:mo mio sig:re,
Il s:r Caval.re Bernino mi prega à volere accompagnare con questa m.r Gio: Paolo Baldi, che se ne viene costà per spedire di persona, e con brevità certi suoi interessi, e spera di poterlo fare con un cenno che venga dall'autorità di V. Ecc:za à cui il med.o s:r Cavall:re lo raccomanda

con molto affetto, come suo amico amorevole, per doverglene restare infinitam:te obbligato, et io senza distendermi da vantaggio à V.E. umiliss:te m'inchino. Di Roma li 12 di luglio 1626.

Di V. Ecc.za Umiliss.o, et obblig.mo serv.re
S. Duca Dom.o Fedini

— *b* —

172, c. 306:

 Ill.mo et Ecc.mo mio sig.re et Pron Col.mo,
Se bene era assai dificile poter mandare il modello del Cavallo senza pericolo di guastarsi, non dimeno perche cossi V.E. comanda l'ho accomodato al meglio, che sia stato possibile in una cassa e si manda, consiste ora che sia scassato con grande diligenza e rincassato secondo l'istrutione che ho dato al sig.r Federighi, accio ritorni salvo, ricordando a V.E. che rissolvendosi a volerlo di bronzo, vi si faranno tutti li adornam:ti necessarj, che non sono nel modello, come la testiera pettorale, e groppiera, colla statua, se ne le pararà farvi le casse alla spagnuola e il cirmiere, si può ridure come comandarà V.E. della quale starò aspettando li suoi comandam.ti, mentre le facio humiliss:ma reverenza e le prego da [?] ogni felicità, di firenze li 30 di Xbre 1624.

Di V.E. Ill.ma Humiliss.mo Serv.re
 Pietro Tacca

APPENDIX 3

Documents relating to commissions from Stefano Conti of Lucca to Marcantonio Franceschini and Felice Torelli in the Biblioteca Governativa, Lucca: MS. 3299. See Chapter 8, p. 227, notes 1 and 2.

Letter from Marcantonio Franceschini to Alessandro Marchesini of 17 February 1705:

. . . Il ritrovare Istoria, o favola di due figure con putti è un poco dificile, e quanto a me gradirei che cotesto Cav.re suggerisse a me il soggetto di suo genio, ondè a questo fine farò proposizione di qualcuno di quelli che, a mio parere, non farebbero cattiva riuscita, acciò da questo detto Sig.r ne ricavi il più geniale. Arianna e Bacco con un Amore, e vi si puo introdur Venere. La Tona [*sic*] che hà partorito sotto un Arbore Febo e Diana, con Giunone in poca distanza che la minaccia. Eva che accarezza i figli Caino, et Abele bambini con Adamo che lavora la Terra, e qualche Animale. . . .

Letter from Giuseppe Torelli to Alessandro Marchesini of 24 February 1705:

. . . Ho letto la v.ra lettera a Felice mio fratello il quale ha di già trovata l'Istoria da far nel quadro consaputo, et è L'Istoria di Troja, cioè Pirro che ammazza Polissena nel Tempio, dove vi farà Calcante Mago et altre mezze figure, overo Teste che dinotteranno Enea et Antinoro et in Somma ciò che fara di sibogno in tal historia, e vi sarà il Sepolchro d'Achile Padre di Pirro, e sarà L'historia espressa nel tempio come dissi di sopra, il quadro sarà all'in sù ⌐ cosi, e dice Felice che sarà un quadro di qualche fatica prima per le espressioni e poi per le Idee, e per le pieghe essendo Polissena persona di Stirpe Reggia perche figlia di Priamo Rè di Troja, e poi Pirro altra persona di alto grado perche figlio di Achile. . . .'

APPENDIX 4

Documents relating to the employment of Sebastiano Ricci and G. M. Crespi by Grand Prince Ferdinand of Tuscany. See Chapter 8, p. 235, notes 4, 5 and p. 237, notes 1, 2.

– a –

Letter from Sebastiano Ricci of I May 1706 in Archivio Mediceo, Filza 5903, No. 197:

Ecco a Piedi del A. V. Reale due cassette, una con due paesi di mio Nipote Um.mo Serv.re di V.A.R.S. et l'altra con li due sfondi del Sig.r Canonico Marucelli. Li due Paesi et un altro picciolo nella cassetta delli duoi sfondi. Quando V.A. perdoni alla troppo temerità de medemi [illegibile] implorano d'essere locati in una Villa di V.A. e sarà ingrandita la povertà del Dono del alto merito del A.V.m. Le figurine del picciolo sono fatte da me, e l'altre dal Paesista.

 Nel principio di giugno spero d'essere ad hum.mi all'altezza vostra, e con questa occasione haver la gloria di poter dipingere la stanza del museo che con tanta clemenza si degno V.A. comandarmi. Mi sono impegnato pure di dover dipingere un altra stanza al Sig. Can Marucelli.

Letter to Sebastiano Ricci of 8 May 1706—Archivio Mediceo, Filza 5903, No. 500:

Mi sono arrivate in buone condizioni le due Cassette accennatemi da lei colla lett sua amorevole, ed ho ritrovato in una di esse li due Paesi del suo Nipote, che son ben degni del gradim.o ch'io ne ho a lui, et a lei ancora, e nell'altra li due Sfondi del Canonico Marucelli, al quale ho ordinato che si facciano avere, e vi si è pur ritrovato l'altro piccolo Quadro, di cui come de gli altri le sono parzialm.te grato. Quanto alla Stanza del Museo, ch'io destinai di far dipingere dal suo virtuoso Pennello, come nel tempo che presi tal risoluzione mi trovavo giacente nel letto, che mi convenne guardare sino alla mia gita a Pisa, e che dopo il ritorno di là ho stimato bene di venirmene a prender aria in questa Villa, non ho avuta campo di pensarci e perciò non è ancora in grado da potersi lavorare. Ella nond.m sia certo che a suo tempo d.a stanza è destinata p. esser dipinta da lei, la quale p.ora, quando non abbia altro motivo da condursi quà, p. qualche riguarda d.a mia stanza può astenerse, mentre quando sarà tempo farò ch'Ella ne sia avvisata.

– b –

Letter from Crespi of 26 February 1708 in Archivio Mediceo, Filza 5904, No. 22:

Mi umilio à piedi V.ra Altezza Ser.ma Reale dandogli raguaglio del mio arrivo in Patria colmo di Giubilo, e confuso p. le benignin.me gratie compartitemi dall'Altezza V.S.R. in qualunque luogo sono transit. non manciro di eternamente conservarne la memoria. Nel vedere le pretiosissime Per.n della galleria di V.A.S.R. ricercato da me l'autore di un quadro picolo mi fu esebito essere dal Tintoreti; posso con verita dirle essere di mia mano. Ho veduto ancora con molta mia sodisfatione l'opere del Sig. Sebastiano Ricci, che p. verita, e con tutto candore d'Animo sono tutte espresse con spirito, e sapere e nuovamente humiliandomi all'A.V.R. ardisco di umiliarmi dell'Altezza Vra Serma Reale

Giuseppe Maria Crespi

Letter from Vincenzo Ranuzzi of 31 January 1708 in Archivio Mediceo, Filza 5897, No. 183:

 Serenissima Altezza Reale,

Col mio Umilissimo rispetto renderà à V.A.R.le questo foglio, lo Spagnuolo Pittore [inserted

into the margin are the words *Gius.e Crespi d.o*]. Vuole che la mia reverenza li sia un ombra di merito per poterla inclinare; Io mi fò ardito à sperarlo, tanto più che la sua mossa, hà per unico oggetto la di Lei alta stima, et ossequio. Al Caldari scrivo informandolo d'un accidente sopra un Suo Quadro, da rappresentarlo à V.A.R. she supplico non tenere oziosa la mia servitù, e prostrato le bacio la Veste Reale Di V.A.R.le

> Bologna 31 Gennaro 1708
> Umilissimo Serv.re Ferdinando
> Vincenzio Ranuzzi

APPENDIX 5

Consul Smith and the Royal Collection

Our estimate of Smith's activities as a collector and patron is very gravely impaired by one crucial gap in our knowledge. The matter is too serious not to be discussed at length, but too complicated to be inserted into the main narrative, where I have referred to it only briefly. The problem is this: in 1762 Smith sold to George III a very large number of paintings and drawings which still form one of the chief glories of the Royal Collection. These were catalogued by him; most of them are recognisable or traceable, and on them is necessarily based our main estimate of Smith as a collector. However, when he died in 1770, only eight years later, several hundred pictures were recorded by the notaio Ferdinando Uccelli as being in his palace. The list of these, which gives the subject only and *not* the artist, is reprinted from the Archivio di Stato-Petizion 467 by C. A. Levi, II, pp. 236-48. Two alternatives face us. Did Smith in 1762 sell only a selection of his pictures to the King, and keep the remainder for himself and perhaps go on adding to his collection? Or did he, in fact, sell *everything* to the King and purchase all these several hundred pictures between 1762 and 1770? This dilemma is central to our knowledge of him, for if the second alternative is correct, then we can at least obtain a very reliable gauge of his tastes until 1762 from the pictures in the Royal Collection; whereas if he sold only a selection of his pictures anything we say about his patronage may be falsified, for as yet we simply cannot check just what were the pictures in his palace and when they were bought.

Until some proof is forthcoming, the following is the evidence on which discussion must be based:

In his will of 1761 Smith wrote that his widow was to sell all or part of his collection 'to establish thereby a decent and comfortable settlement for the remainder of her life'. However, he went on, he had 'always' hoped that 'some entire classes of my collection might remain united, such as my Library, Drawings, Gemms or Pictures'; and by about 1755 negotiations were under way for the purchase by George III of the Library (which included the drawings). Then the Seven Years War broke out and the plans came to nothing. In 1761, therefore, when he drew up his will, Smith assumed that all the collection of books, gems, pictures and drawings that he had so lovingly built up over the years would be sold after his death by the young wife whom he had married three years earlier. Then in 1762 the position changed again, and in that year Smith successfully concluded the deal whereby the pictures, books etc., now in the Royal Collection were sold to the King.

That is our only certain knowledge; to it we can add a great deal of conflicting evidence which can be tabulated as follows:

(*a*) We know that in 1761 Smith was thinking of leaving Venice and settling in England, and Venetian reports at the time claim that he was preparing to sell his palace, with his library, print collections 'ed altre rarità pregevoli' [Gradenigo, p. 82]; a year later he himself wrote that he planned to return to England [Parker, p. 62]. It is therefore likely that at this stage he may have wished to dispose of his entire collection. Indeed, he went out of his way to refer twice to 'this whole Collection, the work of my life' [Parker, p. 61]. On 20 August 1760 James wrote to Robert Adam of Smith that 'I find he is devilish poor and shou'd he live a few years longer which he may do, he will die a Bankrupt . . .' [Fleming, 1962, p. 270]. All this suggests that he may well have decided to sell all his collections (or at least anything of value). On the other hand it is equally possible to deduce that his penury and extreme old age make it improbable that he at once started to buy expensive pictures—though old age did not prevent him taking up the consulate again in 1766.

(*b*) Moschini suggests [1806, III, p. 51] that Smith did not in fact sell all his pictures to George III, because, after referring to the sale of books, cameos, etc., he writes, 'i migliori quadri della Veneta Scuola, ch'egli avea per se riserbati, si recarono della di lui vedova nell' Inghilterra'. Unfortunately, far from helping to solve the problem this really only succeeds in confusing it still further. For Moschini, writing forty years later, seems unaware that Smith sold *any* of his pictures to the King. Indeed he refers to Smith receiving £20,000 for the books and cameos only. It is therefore still quite unclear whether Smith's widow took to England those pictures which Smith kept for himself in 1762 or those that he bought afterwards.

(*c*) It is certainly of significance that all the contemporary artists most fully represented in the pictures sold to the King—the two Riccis, Rosalba Carriera, Canaletto and Zuccarelli—should have been just those who were most familiar to the English. This certainly seems to hint at some deliberate process of selection.

(*d*) It is equally significant that after 1762 Smith's activities are almost never referred to in either Venetian or English sources. This surely makes it unlikely that he was engaged in very extensive purchases. The only references to his artistic activities after 1762 that I have been able to trace come in a letter from the engraver Giovanni Volpato to the publisher Remondini [Biblioteca Civica, Bassano—Epistolario Trivellini, XXX, 10]. This is dated 22 April 1766: '. . . hò poi due Rametti per il Smit di impegno perche mi dà settanta Zecchini, oltre di questi per l'istesso di cose che vano à Londra averò da far più di un ano . . .' and in a letter from Smith to an unknown correspondent in Bologna [Biblioteca Comunale, Bologna—MS. B.153, No. 92] which shows that as late as 1768 Smith was dealing in pictures even if not buying them for himself. I owe the knowledge of this letter to Mr Denis Mahon who has very kindly allowed me to publish it here:

Mio Sig. e Prone Colmo Venezia 9 Aprile 1768
Ricevo con la Grata Sua de' 5 corr^te la nota della raccolta Gennari, consistente in depinti et desegne et La ringrazio della memoria che tiene di quanto in tale proposito La pregai et in Risposta Le Dico, che quando il Proprietario fosse disposto a privarsene a discreto prezzo volontieri ne farò l'acquisitore ond'è necessario che ne faccia la dimanda o di tutte assieme ovvero separatamente, et si ricordi di regolarsi ne'prezzi come saprà che presentemente queste tali cose non sono più in quella considerazione come una volta,

ne più ve ne sono quel numero de Compratori, almeno posso con verità asserire che quadri ogni giorno se ne presentano et stampe in vendita, et io n'hò fatt'acquisto di parecchi dell'una et l'altra forse siccome Le farò vedere se havrò il contento di riverderLa. Altra cosa mi par proprio di suggerirla, et è che la nota o note che mi potrà favorire di mandarmi, che siano scritte di buon carattere et intelligibile, et a questo fine Le rimando la nota della raccolta Gennari accio me La rimandi scritta più chiara, pche non piace darla in mano di altre Persone. Attenderò Sua risposta et procurere' sempre darLe saggii della mia buona disposizione et incontrare [illegible] negozio, et in modo di convincerLa della mia onestà, et che desidero di contestarmi.

D.V.S. mio Ill^{tre} Sig^e

Hum div serv^{re}
G. Smith

(e) We know from Venetian sources (Moschini, 1806, III, p. 78) of at least one painter, Giuseppe Zais, who worked for Smith and whose pictures are not among those sold to George III. But is this because the artist was unknown in England and therefore not selected by the royal agent, or did Zais only begin to work for Smith after 1762?

(f) Smith himself said that a collection of the kind he had built up would no longer be possible to form 'because the Subjects themselves either are no longer existing or, where similar ones may be, hardly purchasable at any rate'. But of course the £20,000 he received in 1762 would certainly have helped. . . .

This is the thoroughly confusing evidence. From it no final conclusion is possible, but I strongly believe that in 1762 Smith only sold part of his collections to the King, and that the vast majority of the pictures found in his palace in 1770 had been acquired by him over a very long period. I am aware that this may invalidate much that I have said in Chapter II about the nature of his patronage. On the other hand, I feel that a discussion of Smith can only be based on what we do know about him for certain and, still more, that such evidence as we do possess about the pictures found in his palace does not suggest that our conception of him would have to be too drastically modified if (as is possible) their history is one day established.

We know that, in accordance with Smith's desires, these remaining pictures and drawings were sold in London in 1776 (Christie's, 22 April and 16 May). The lists are not very satisfactory, and the attributions cannot be treated as definitive. The only eighteenth-century pictures recorded are fourteen views of Venice by Canaletto, 'two conversations, Mr Murray and family' by Pietro Longhi, and Amigoni: 'The portrait of Farinelli and two others'. To these we can add a number of pictures said to have come from Smith's collection in an anonymous sale (in fact, John Strange) of 10 December 1789. These include a self portrait by Sebastiano Ricci, landscapes by Marco Ricci and Zuccarelli, and a number of pictures by Giulio Carpioni, Mastelletta, Pietro Liberi, Strozzi, Fetti and Lazzarini.

No further pictures from Smith's collection have been traced, but it seems likely that, if they are, they will conform to the above pattern, and that it is most improbable that paintings by Tiepolo or other important artists not included in the lot bought by George III will turn up. The drawings and etchings in the 1776 sale are far more numerous, and Canaletto, Marieschi, Pannini, Zais, Zuccarelli, Marco Ricci and Tiepolo are all well represented.

I have therefore felt justified, albeit reluctantly, in discussing Smith's taste on the basis of what we know to have been in his collection in 1762, even though I think it very likely that he owned large numbers of other pictures at the time.

It may finally be added that the history of Smith's books is as difficult to reconstruct as that

of his pictures. Indeed the two problems are exactly parallel, for although in 1762 he sold the library catalogued in the *Bibliotheca Smithiana* (published by Pasquali in 1755) to George III, a large number of books was recorded in his palace on his death in 1770. Some of these were very recent publications, and this shows that he must have continued buying books until the end of his life. However, some years earlier he had sold 'una grossa molla di libri' to SS.ri Giacomo Caraboli and Domenico Pompeati, and the last few months of his life were spent in bitter dispute about the contract [Archivio di Stato, Venice—Atti del Notaio Ludovico Gabrieli, Busta 7570—pp. 1215 and 1278]. Finally, two catalogues were published after Smith's death—*Catalogo di Libri Raccolti dal fù Signor Giuseppe Smith e pulitamenti legati*, Venezia MDCCLXXI, an octavo book of 136 pages [Correr—I. 5911] and *Bibliotheca Smithiana, pars altera—A Catalogue of the remaining part of the Curious and Valuable Library of Joseph Smith, Esq., His Majesty's Consul at Venice, lately deceased . . .* which will be sold cheap, for ready Money this Day, 1773.

APPENDIX 6

Andrea Memmo's Notes on the Status of Painters

(see Chapter 12, p. 330, note 1)

I owe the knowledge of this very interesting document in the Archivio di Stato, Venice—Inquisitoriato alle Arti, Busta 15, fascicolo 6—to my friend Gianfranco Torcellan, to whom I am most grateful. Memmo was Inquisitore alle Arti from 1772 to 1775, but these notes were probably written two or three years before his assumption of office.

Memorie e Ricerche.

In una nota converrà accennare quanto sia necessario nell'arti liberali di scogliere dalla soggezion delle gravezze gl'uomini, che vi si esercitano, e quanto sia bizzaro il genio de Pittori. Esempio del vivente celebre Pittor C. Veneziano.

Cerca perchè C. prettenda d'essere sciolto dalla tansa.

Cerca se i Maestri di Musica sieno tansati—Non sono tansati, e nemmeno gl'Intagliatori in rame.

Cerca la tansa degl'Architetti.

Cerca se i Pittori sieno tansati a Parigi, Roma, Firenze e Bologna.

Cerca se a Napoli vi sia Accademia di Pittura.

Cerca la nuova instituzione dell'Accademia di Parma.

Cerca se le Pittrice come Rosalba paghino tansa.

Cerca qual possa essere il modo migliore per scegliersi dall'Accademia i più Valenti Professori Forastieri per Accademici associati.

Cerca quante, e quali sieno l'Accademie mantenute dal Pubblico nella Terra-ferma, e quanto costino.

Cerca quali sieno i privilegii, essenzioni o non, prerogative, e preminenze degl'Accademici dell'Arti del Disegno a Parigi.

Cerca se altrove come nell'Accademia di Parigi si facciano delle conferenze, e delle lezioni.

Cerca qual sia l'Impresa della nostra Accademia, e 'l nome per confermare, o migliorare queste due cose.

Cerca sotto la prottezione di qual Santo sia la n.A.

Cerca *Ordini, di Capitoli e privilegi* conceduti dal Duca Cosimo a Pittori—Vasari lett.

Leggi la vita del Montorsoli in Vasari—Letta.

Se il secretario dell'Acc.a di Parigi sia in vita—in vita.

Così del Diretore.

Se il Secretario a Bologna sia in vita—e in vita.

Cerca i Statuti dell'Arte dei Pittori Scult: e Archit.

Statuti dei intagliatori in Rame, gittatori in bronzo, e altri, cerca di privilegiar i giovani dell'Acc.a per entrar in queste Scuole o Comunità.

Carlo VI Re di Francia accordò a Pittori oltre l'esenzione dalle tanse, dai Dacii, delle sovvenzioni, de delle abitazioni—v. Monier 179.

È conveniente che la parte speculativa della Pittura sia esercitata liberamente, e con nobiltà; i genii non denono essere messi in soggezione nella prattica delle belle Arti, per questo furon dette liberali.

APPENDIX 7

Letter from Girolamo Manfrin to Pietro Edwards of 3 December 1793 concerning the formation of his picture gallery (Biblioteca Correr, Venice—Epistolario Moschini). See Chapter 17, p. 380, note 6.

Illmo Sig. Sig. Pron. Colmo,

Nel desiderio di veder proceder il tutto con il migliore buon ordine nella scelta de Quadri, che devono essere inclusi nella mia Galleria, non potevo che bramare soggetti di conosciuta esperienza e di celebre fama nella Pittura, qual appunto è V.S. non che l'altro Professore S�r Gio. Batta Mingardi, i quali si assumessero il pensiero di sceglierli, di riconoscerli, e di escludere quelle, che più loro piacesse, senza riflettere al costo; mentre appunto io voglio che non entrino nella mia collezione che opere di reale merito ed assoluto.

Molto me la professo obbligato per la facile adesione, con cui si mostra ella parata a compiacermi; giacchè nella di Lei vasta erudizione e virtù, unita alla cognizione del Sr Mingardi su espresso, potrò riposare tranquillo.

Ella non deve farsi il minimo riguardo a pronunciare un severo giudizio, ne l'esclusione potranno cagionarle dispiaceri, diferenze, od inimicizie giacchè ametto senza esitanza la da Lei ricercata condizione di non publicare giammai il di Lei disaprovazione, che servirà soltanto di segreta mis regola, e di norma privata alle mie determinazioni.

Troppo riconosco fondata su giuste e convenienti basi la condizione medesima, e lo do la mia parola di esattamente osservarla.

Intanto Ella si assicuri della mia vera estimazione, di cui potra rimanere una non dubbia prova nella premura, che mi son fatto di averla per giudice in affare, che m'interessa sommamente, e riservandomi a darle attestati della mia riconoscenza passo a rispettosamente protestarmi.

Di Casa 3 Xbre 1793

Di V.S. Illma
Dmo Obmo Serv.
Girolamo Manfrin.

Illmo Sig. Pietro Edwards
Venezia

POSTSCRIPT TO SECOND EDITION

Chapter 1

A great deal of material (visual as well as documentary) which touches on almost every one of the chapters devoted to Rome in my book has been assembled by Fagiolo dell'Arca and Carandini in their study of seventeenth-century festivals in the city.[1] Drawing on sources which have been hitherto barely explored they have illuminated the relationship of these festivals not only to the arts, but also to the patrons, the politics and the intellectual climate of the period, and their researches will be of the highest value for anyone concerned with Baroque Rome.

Chapter 2

Our knowledge of the patronage and collecting of various members of the *Barberini* family has been transformed by the well-indexed publication by Marilyn Lavin of all the inventories which eluded me when I was working in Rome.[2]

Further documents published by Cesare d'Onofrio are of interest in elucidating the character and poetry of Maffeo Barberini (Pope Urban VIII),[3] but one major problem concerning his patronage is now more confusing than ever. The reliable Bellori specifically states that Caravaggio painted a portrait of Maffeo Barberini—and this was already hinted by Mancini, a contemporary of the artist.[4] Following many other writers, in the first edition of this book I reproduced and described as such a well-known but not at all good portrait in the Corsini collection (which had originally belonged to the Barberini). Not long afterwards Roberto Longhi published another candidate for the role (then, as now, in an undisclosed private collection),[5] and as—from a photograph—this looked much more persuasive, I substituted it for the Corsini picture in the Italian edition of this book. Unfortunately, however, we can now see that the Barberini inventories record no portrait of Maffeo by Caravaggio. I am, nonetheless, reproducing the 'Longhi version' with a very tentative attribution as it at least carries conviction as a vivid portrait of the young and energetic Barberini (Plate 2a).

Howard Hibbard's monograph on Carlo Maderno has greatly clarified our understanding of the origins of the family palace,[6] and Irving Lavin's very thorough and important analysis of Bernini's transformation of the crossing of St Peter's has confirmed my own far more casual impression that this was (in Lavin's words) 'an

[1] Fagiolo dell'Arca and Carandini. [2] Lavin, M. A.
[3] d'Onofrio, 1967. [4] Bellori, 1976, p. 224; Mancini, I, p. 227.
[5] Longhi, 1963. [6] Hibbard, 1971.

evolutionary process that took place over a considerable period and that was never fully realised. There is no evidence to suppose that all the details of the crossing were worked out in advance as a general scheme'.[1] On the other hand, Hibbard's discussion of Lavin's book and of recent literature on Borromini shows that my straightforward attribution of the *baldacchino* to Bernini and his Barberini patrons needs some qualification.[2]

The tapestries given to Cardinal Francesco Barberini by the French have been fully described by David Dubon,[3] and those that were woven much later to celebrate the papacy of Urban VIII have been discussed in an article by Don Urbano Barberini which replaces previous literature on the subject and which alters some of the attributions repeated from this literature in the first edition of my book.[4]

Cardinal Antonio Barberini's patronage of Sacchi has been fully discussed by Ann Sutherland Harris.[5] Her monograph on the artist modifies many of my statements on the style of his ceiling in the Palazzo Barberini (though I still feel unable to give it more than 'half-hearted praise') and provides a balanced interpretation of its complicated iconography which, she suggests, could have been inspired by Sforza Pallavicino. Above all, she qualifies the traditional view of a sharp division between 'classical' and 'baroque' artists in mid-century Rome, and Poirier has reaffirmed that the so-called 'debate' between the two camps was not, as has sometimes been claimed, concerned with the merits of colour and drawing.[6]

Of the patrons other than the Barberini mentioned in this chapter, the *Ludovisi* have been discussed by Garas, who has published an inventory of Cardinal Ludovico's pictures dating from 1633.[7] It is, however, *Cardinal Del Monte* who has received by far the most attention from recent writers. In 1966 Heikamp investigated his relations with the Tuscan court and drew on a number of published and unpublished sources to illustrate the range and depth of his artistic tastes.[8] Five years later important inventories of his collection were published by Christoph Frommel (in the course of a lively enquiry into the nature of the Cardinal's influence on Caravaggio)[9] and by W. Chandler Kirwin;[10] while Luigi Spezzaferro—also starting from the extreme importance that he attributes to the Cardinal's patronage of the young Caravaggio— examined his cultural formation in considerable detail and laid particular stress on his interest in scientific investigation.[11] A different aspect of Del Monte's character has been emphasised by Posner who, following up a suggestion made in the first edition of this book, has drawn attention to the 'homo-erotic' nature of Caravaggio's early works which was probably encouraged by the Cardinal and members of his circle.[12]

Another patron whose early career has been much illuminated in recent years is *Giambattista Agucchi*—so much so that we now probably know (or feel we know)

[1] Lavin, I., 1968.
[2] Hibbard, 1973.
[3] Dubon.
[4] Barberini, 1968.
[5] Harris, A. S.
[6] Poirier.
[7] Garas, 1967.
[8] Heikamp.
[9] Frommel.
[10] Kirwin.
[11] Spezzaferro.
[12] Posner, 1971.

more about his taste in art than we do about that of anyone else of the time. D'Onofrio has attributed to him a remarkably fresh, as well as detailed, description of the Villa Aldobrandini (Belvedere) at Frascati[1] and has also suggested—again plausibly but without conclusive evidence—that it was Agucchi who commissioned or bought the forty or so Bolognese paintings in Cardinal Aldobrandini's collection, of which he certainly drew up the inventory.[2] Battisti has published a number of vivid, even if sometimes recondite, letters that he wrote to a friend about an *Erminia and the Shepherds* he had commissioned from Lodovico Carracci,[3] and Whitfield later discovered and analysed Agucchi's 'programme' for this picture.[4]

The collecting and approach to art of *Giambattista Marino* have been studied by Viola,[5] and we can derive an extraordinarily vivid impression of the imaginative role played by *Guido Bentivoglio* as artistic adviser and entrepreneur for Cardinal Borghese from the series of documents published by Baschet in 1861 and 1862 but hitherto overlooked by me.[6] Van Dyck's magnificent portrait of the Cardinal has recently been cleaned, and I have therefore substituted a new photograph for the one published in my first edition (Plate 4a).

Chapter 3

Of the various Orders discussed in relation to the arts, only the *Jesuits* have continued to attract widespread attention and a symposium was devoted to this theme at Fordham University, New York, 1969. Some of the papers (which have all been published) bear directly on this chapter and need to be singled out.[7] Wittkower's suggestion that 'while it seems futile to speculate on whether there was a way from their spiritual stewardship to artistic sublimation, we are certain that they had a firm and measurable hold on what they wanted to have represented in their churches' is clearly one that I can only accept with great reservations. Indeed in my own paper I tried to demonstrate again the conflicts that repeatedly arose between the Jesuits and their princely patrons about the architecture and decoration of their churches; and I also emphasised that even when they did have sufficient wealth and power to impose their own will successive Jesuit leaders could, and did, differ radically among themselves about artistic issues. In his investigation of the sources of the Gesù, James Ackerman pointed to 'two camps: a Borgia [i.e. Jesuit] camp committed to the Sangallesque architectural tradition, and a Farnese camp, under Alessandro Cardinal Farnese, supporting Vignola. . . . The Farnese, like the princes they were, wanted an elegant avant-garde building by a famous architect—one that would have a Farnese "look". And they ultimately won, because it was they who had the money, and they gave lavishly.' But, in a persuasive

[1] d'Onofrio, 1963. [2] d'Onofrio, 1964.
[3] Battisti, 1962, pp. 201-3 and 529-49. [4] Whitfield.
[5] Viola. [6] Baschet.
[7] Wittkower and Jaffé.

paper, Howard Hibbard pointed out that though the Jesuits were not interested in stylistic uniformity they did, even at an early stage in the history of the Gesù, control the ornamental and iconographic programme far more than I had allowed for: 'although the chapels were painted with funds from private patrons, the dedications were already set at the time of transfer and are often mentioned in the earliest documents; Jesuit decorators remained in charge; and the money paid to the artists, even of the altarpieces, was paid through Jesuit intermediaries. The patrons may have had some limited say in the character of the programme—as they surely had their choice of artists for the altarpieces—but the coherence of the chapel iconography did not allow room for much independent choice of subject.'

In 1976 an interesting article by Thomas Buser also challenged my scepticism about the reality of 'Jesuit art'.[1] Drawing attention to the engravings in a book of gospel meditations by the Jesuit Jerome Nadal, which had been commissioned by St Ignatius himself, he discussed their influence not only on one of the chapels of the Gesù (as had already been noted by Hibbard), but, 'in their didactic intent and format' (though not in their actual compositions), on the horrific scenes of martyrdom painted by Circignani in the Jesuit church of S. Stefano Rotondo and elsewhere. Buser has some valuable comments on the significance of these frescoes and also on the curiously 'pastoral' episodes of torture depicted in the church of S. Vitale, whose style—he suggests—may have been chosen out of a desire, influenced by Roman wall painting, to give an 'antique feeling' to the sufferings of these early Christian victims. As I have always emphasised that it was with just such scenes of martyrdom that 'a truly Jesuit style was brought into being for the first time' I am puzzled to find Buser referring, in the context of these frescoes, to my view that elsewhere the Jesuits were nearly always forced, by political or economic weakness, to accept gratefully what they were given by powerful patrons.

My account of Gaulli's frescoes in the Gesù also needs to be supplemented (and sometimes corrected) by Robert Enggass's important monograph on the artist which appeared at much the same time as the first edition of my book.[2] Enggass's study of the content of the frescoes is far more complete than my own, but he discusses their iconography essentially within the general context of the 'church triumphant' rather than in relation to those specific theological issues which (partly following Lancko-ronska) I describe at some length and which, I infer from his silence, he considers to be largely irrelevant. In this attitude he is clearly right for, in the course of an important article partly concerned with Bernini's relationship to the Jesuits, Lavin has confirmed the conclusions of a number of recent historians in rejecting Lanckoronska's theory that the drawings by Gaulli (now in Berlin and Düsseldorf) related to Bernini's composition of the *Sangue di Cristo* were made for an alternative—and rejected—design for the dome of the Gesù.[3] I was therefore wrong in proposing that the theme could have been turned down by the Jesuits because of its possible association with Quietism.

[1] Buser. [2] Enggass, 1964. [3] Lavin, I., 1972, pp. 169-71.

In addition to his monograph on Gaulli, Enggass has written an essential article
on the altar of St Ignatius in the Gesù,[1] and in a book on eighteenth-century sculpture
in Rome he has added to our knowledge of the statues by Théodon and Legros in the
church—and thus to our knowledge of Jesuit patronage in general.[2]

Finally, an edition by Vittorio Casale of the treatise on painting and sculpture
jointly written by the Jesuit father Ottonelli and by Pietro da Cortona has examined
the parts contributed by the theologian and the artist to this strange publication,[3] and
Casale's subsequent discovery of the censor's comments on it at last gives us some
indication of the way in which these issues were discussed in Jesuit circles.[4]

Other religious orders have aroused much less interest, but the documents about
the early building history of the *Oratorian* Chiesa Nuova published and analysed by
Jacob Hess provide further evidence of the control maintained by that Order on its
construction and also demonstrate the autonomy that the patrons of individual chapels
insisted on trying to maintain as regards their decoration.[5] This control was in fact a
consequence of the deliberate (and exceptional) policy of self-restraint exercised by
the patron Cardinal Cesi which contrasts strikingly with Cardinal Farnese's treatment
of the Jesuits. 'There is no need to send me copies of the plans so that a design that
appeals to my taste can be chosen', he wrote to a leading Oratorian in 1581, 'because
my taste will be whatever satisfies you and the other Fathers.'[6] Maria Teresa Bonadonna
Russo who publishes this and many other letters to the same effect does, however,
point out that the appointment of Martino Longhi the Elder as (the second) architect
of the church was probably due to the Cardinal's intervention and that his brother,
Monsignor Angelo Cesi, was a much less accommodating patron.[7]

Chapter 4

The most recent discovery concerning the patronage of *Cassiano dal Pozzo* has been
referred to in print but not yet published: this consists of the inventories, dated 1689
and 1695, of the collections of Cassiano's brother and heir Carlo Antonio (himself a
notable collector and patron) and of the latter's son Gabriele.[8] Only the French pictures
recorded in these inventories have been studied in detail.[9] Cassiano's early taste has
been illuminated by an article on his journey to Spain in 1626, during the course of
which he disapproved of a (now lost) portrait of Cardinal Barberini by the young
Velasquez as being 'd'aria malinconica e severa', preferring in its place one (also lost)
by Juan van der Hamen.[10] Only that section of his journal describing his visit to the

[1] Enggass, 1974. [2] Enggass, 1976.
[3] Ottonelli and Berrettini. [4] Casale.
[5] Hess, 1963. [6] Bonadonna Russo, 1968, p. 135.
[7] Bonadonna Russo, 1967 and 1968.
[8] Bréjon, p. 94, note 21—the documents were found in 1969 by Marcello del Piazzo.
[9] Bréjon. [10] Harris, 1970.

Plate 65

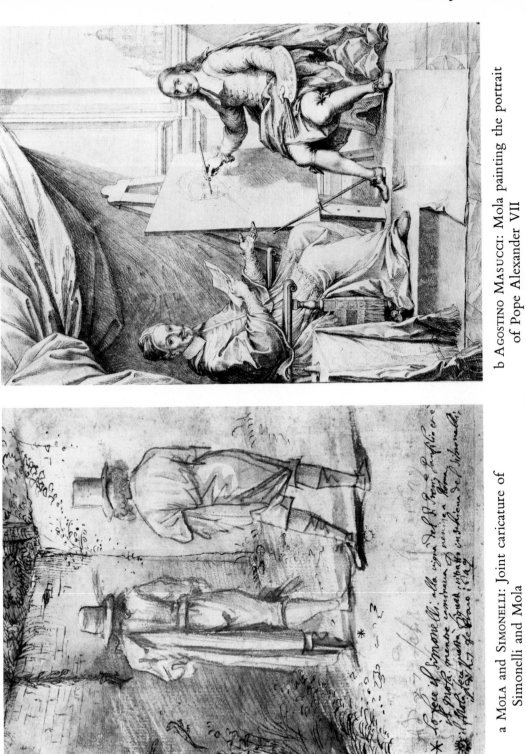

b AGOSTINO MASUCCI: Mola painting the portrait
of Pope Alexander VII

a MOLA and SIMONELLI: Joint caricature of
Simonelli and Mola

Plate 66

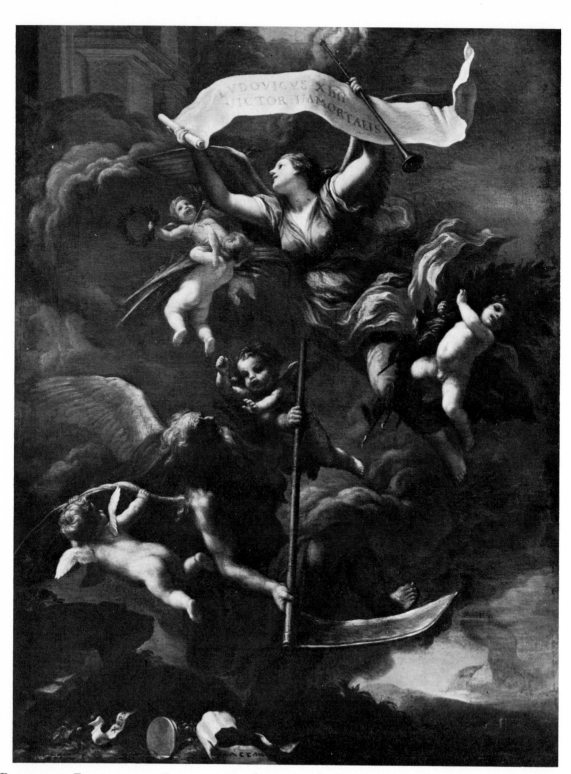

BALDASSARE FRANCESCHINI: Fame carrying the name of Louis XIV to the Temple of Immortality

Plate 67

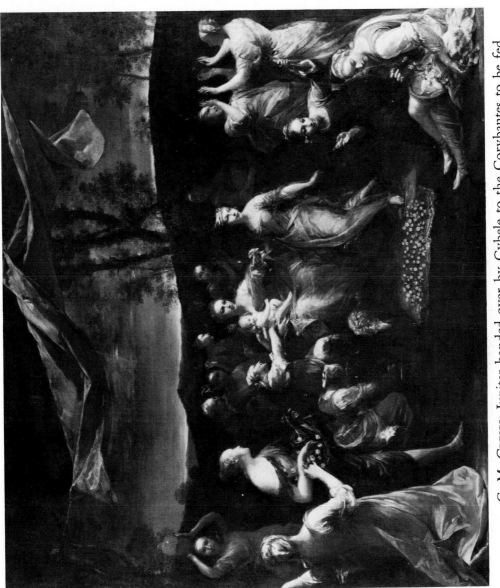

G. M. CRESPI: Jupiter handed over by Cybele to the Corybantes to be fed

Plate 68

a FRANCESCO MAGGIOTTO: Three portraits of Doges

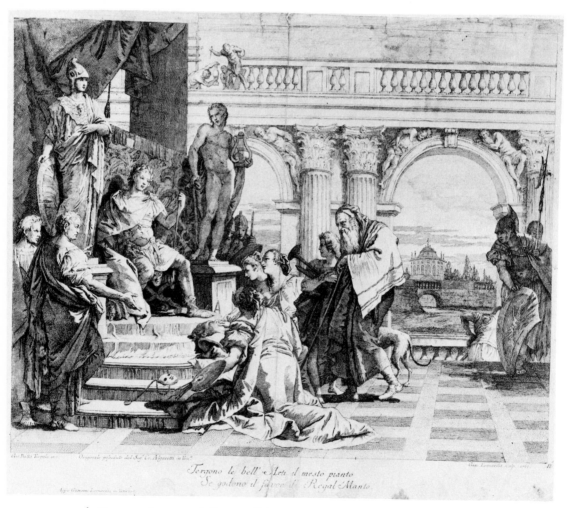

b TIEPOLO (engraved Leonardis): Mæcenas presenting the Arts to Augustus

Escorial has been published in full. As was to be expected this interesting account shows his keen appreciation of the great Titians and other pictures to be found there, and also his particular fascination with drawings of plant and bird life in Mexico.[1] Some support for my suggestion that Cassiano may not altogether have liked Poussin's 'austere' style can perhaps be found in the report, made in 1664, that he had at one time actually thought of giving away the 'Seven Sacraments' to an un-named friend.[2]

After the appearance of the first edition of this book a small bronze bust of *Paolo Giordano II Orsini, Duke of Bracciano* came into the possession of Cyril Humphris, London, and in 1966 Wittkower proposed that this was the portrait of him by Bernini about which I had published a number of documents[3] (another version, in the City Museum and Art Gallery, Plymouth, was discussed by Anthony Radcliffe in 1978 and 1979).[4] I understand, however, that there are convincing documentary reasons for believing that the attribution to Bernini of this attractive bust has to be rejected.

Chapter 5

An engaging double caricature made by *Niccolò Simonelli* and his friend the artist Pierfrancesco Mola has come to light (Plate 65a).

Chapter 6

Some of the general conclusions drawn in this chapter are discussed in the introduction to the new edition of this book. The continued absence of any economic history of Rome in the seventeenth century makes it impossible as yet to investigate the period at all adequately. Petrocchi contains some useful information and a bibliography, but the author himself acknowledges how little the economic life of the city has been studied.[5]

On the other hand our knowledge about some of the individual patrons has been enriched by a number of new works. The documents from the Doria-Pamphili archives necessary for a serious account of the art patronage of *Innocent X* and his family were published in 1972,[6] and we can get an unusually fresh view of *Alexander VII*'s interest in the arts (Plate 65b) through the publication of the relevant extracts from his diary. Though his comments are always terse, we learn from them that Bernini was a very frequent visitor and that—as the editors emphasise—the Pope 'apparently felt that it was he, rather than Bernini or Cortona, who ultimately decided the planning of a building'.[7] And the nature of *Clement IX*'s patronage of Bernini has been analysed in a careful study of the decoration of the Ponte S. Angelo.[8]

[1] Harris and de Andrés.
[2] Pierre du Colombier.
[3] Wittkower, 1966, pp. 203-4.
[4] Radcliffe, 1978 and Sotheby's, 1979, pp. 31-2.
[5] Petrocchi, 1970, p. 158.
[6] Garms.
[7] Krautheimer and Jones.
[8] Weil.

A good deal of material concerning *Queen Christina*'s life and artistic patronage in Rome was assembled at the Council of Europe exhibition held in Stockholm in 1966, and information about this is to be found in the catalogue[1] and a related volume or studies and documents:[2] these provide the essential starting point for any further research.

There have been some important contributions to our understanding of *Bellori*, most of which are discussed in Giovanni Previtali's spirited and polemical introduction to a superb new critical edition of the Lives and are not therefore mentioned here.[3] However, Nicholas Turner's demonstration that some of Bellori's most famous critical comments on Lanfranco were very closely derived from the writing of *Ferrante Carlo* shows that I did not fully appreciate the significance of this latter figure when writing about him in Chapter 5.[4]

Chapter 7

The subject with which this chapter is concerned—the 'Italianisation' of European culture during the seventeenth century—is clearly so vast that now, as when writing the first edition of this book, I can offer no more than a few indications of some of the material that might one day be used for a general survey.

Spanish patronage of Italian Baroque art is briefly summarised by Perez Sanchez in the preliminary chapters of his catalogue of the Italian seventeenth-century paintings still to be found in Spain, while the catalogue itself and the documents and bibliography provide a vast amount of information which has hitherto been inaccessible and which will at last make possible a study of the subject as a whole.[5] Some notable information about individual Viceroys in Naples has also been published by Wethey.[6]

By far the most enterprising patron and collector of Italian art in *France* was in fact the Italian Cardinal *Mazarin*, and in a series of very fully documented articles published since the appearance of my book Madeleine Laurain-Portemer has shown how relentlessly determined he was to introduce into the country of his adoption Italian Baroque artists or, failing that, the finest examples of Italian Baroque art, both under Richelieu and when he himself held supreme power. These articles endorse my own view of the Cardinal's individual taste, but they go well beyond what I wrote in 1963, for they show that his artistic policy (to characterise which Mme Laurain-Portemer freely uses some very aggressive military metaphors) was directed to far wider ends than to satisfying the personal hedonism to which, by implication, I attributed his ambitions.[7] In stressing that the young *Louis XIV* continued to look to Italy for artistic talent I alluded to Alazard's reference to a picture commissioned

[1] *Christina of Sweden.* [2] Von Platen.
[3] Bellori, 1976. [4] Turner.
[5] Perez Sanchez. [6] Wethey.
[7] Laurain-Portemer (with a list of her other important articles on the subject).

(through Colbert and the Abate Luigi Strozzi) from Baldassare Franceschini, il
Volterrano, of *Fame Carrying the Name of the King to the Temple of Immortality*: this
picture, which is still at Versailles, has now been identified and published by Pierre
Rosenberg[1] (Plate 66).

Of the patrons of the *Holy Roman Empire* specially interested in Italian art we have
learned a great deal more about *Prince Liechtenstein* through the researches of Lankheit,[2]
and there have been contributions to this aspect of *Prince Eugen*'s collecting.[3]

There is a general survey of *English* royal patronage of Italian painting of the
seventeenth and eighteenth centuries in Michael Levey's catalogue of the later Italian
pictures in the Queen's collection,[4] and Croft-Murray's very detailed (and very
entertaining) account of the career of Antonio Verrio in England adds substantially
to our knowledge of patronage in the Restoration period.[5] Of the individuals I discussed
Sir Thomas Isham has been the subject of an exhibition of which there is a useful
catalogue.[6]

Chapter 8

The art of seventeenth-century Florence has been radically reappraised since 1963, and
in the light of fine exhibitions in New York (1969), Florence (1965 and 1974)
and London (1979) I now realise that I rather underestimated the quality of much that
was being painted in the city in order to pinpoint the achievements of the *Del Rosso*
brothers and especially of *Grand Prince Ferdinand de' Medici*. I still believe that the
Prince's patronage was marked by a quite exceptional flair and originality, but one of
the gratifying features of the new interest in Florentine *Seicento* art is that it has been
accompanied by a close study of many of the Medici patrons, and this allows one to
form a more balanced appreciation of the Prince's taste than was possible when this
book was first published. A general survey of the patronage offered by the Medici
court in the seventeenth and eighteenth centuries was provided by the exhibition
'Artisti alla Corte Granducale' of 1969 for which the important catalogue was written
by Marco Chiarini.[7] In an article,[8] and in a well documented book[9] (which also throws
light on the patronage of the *Barberini* and the *Sacchetti*) Malcolm Campbell demon-
strated the great significance of Grand Duke Ferdinand II's decision in 1637 to break
with provincial Florentine artists and employ Pietro da Cortona on the decoration of
the Palazzo Pitti. In her catalogue of the exhibition devoted to the collection of Don
Lorenzo de' Medici, that Grand Duke's uncle, Evelina Borea[10] amply illustrated the
nature of just that provincialism from which Ferdinand II and his brilliantly gifted
brother Cardinal Leopoldo so successfully helped to rescue Florentine culture: an

[1] Rosenberg. [2] Lankheit, pp. 326-38.
[3] *Eugen, Prinz*, especially pp. 115-41. [4] Levey, 1964.
[5] Croft-Murray, 1962, pp. 50-60 and pp. 236-42. [6] *Sir Thomas Isham*.
[7] Chiarini, 1969. [8] Campbell, 1966.
[9] Campbell, 1977. [10] Borea.

exhibition,[1] and a series of articles by the Procaccis,[2] Muraro,[3] Meloni,[4] Chiarini de Anna,[5] and Bandera[6] have greatly added to our knowledge of the Cardinal's taste, while the formation of the Uffizi gallery of self-portraits has been analysed by Prinz.[7]

Klaus Lankheit has shown that the role even of Cosimo III, a blinkered 'villain' to me in 1963 as to most previous writers, was far more positive (especially as regards sculpture) than I then suggested,[8] and this became clear beyond all doubt in 1974 when an important exhibition devoted to late Baroque Art in Florence was mounted successively in Florence and Detroit.[9] In two interesting articles, one of them devoted to the 'stile Cosimo III', Stella Rudolph has discussed Florence in the context of a more general revival of Italian provincial culture at the end of the seventeenth century (a revival that went hand in hand with the decline of Rome) and has emphasised the very lavish patronage of many of the aristocratic families in the city.[10]

So much valuable research on some of the forerunners and contemporaries of *Grand Prince Ferdinand* has fortunately been accompanied by the discovery of much new information about the Prince himself in the form of inventories published by Chiarini[11] and Strocchi.[12] From these I was glad to discover, among much else, that Ferdinand did (as I had so much hoped and expected but could never establish) employ Magnasco, a painter whose talents must surely have been congenial to him, and the significance of this (admittedly limited) patronage has been stressed by Guelfi in her monograph on the artist.[13] Finally a very full account of seventeenth- and eighteenth-century art exhibitions in Florence has helped to clarify the Prince's part in organising the one held in 1706[14] (though the discovery of a catalogue for the exhibition of 1705 shows that I somewhat exaggerated his role in inaugurating this aspect of the exhibition)[15], while the cleaning of a number of paintings by Antonio Domenico Gabbiani in the Pitti and interesting articles on him by Chiarini[16] and Ewald[17] have convinced me that I much underrated the merits of this talented artist—and hence the perception of the Grand Prince who so much admired him.

The other Florentine patrons whom I discussed, the *Del Rosso* brothers, have also been set in a wider context by Silvia Meloni who has discussed the work of Luca Giordano in the city and who has identified many of the pictures they owned.[18]

The patronage of *Raimondo Buonaccorsi* has suffered grievously. His uniquely fascinating 'Gallery of the Aeneid', which survived virtually intact until the early 1960s, was acquired by the Comune of Macerata in 1967, but not alas before many of the finest pictures in it had been dispersed.[19]

[1] *Omaggio a Leopoldo de' Medici.*
[2] Procacci, Lucia e Ugo.
[3] Muraro, 1965.
[4] Meloni Trkulja, 1975.
[5] Chiarini de Anna.
[6] Bandera.
[7] Prinz.
[8] Lankheit.
[9] *Twilight of the Medici.*
[10] Rudolph, 1971 and 1973.
[11] Chiarini, 1975.
[12] Strocchi.
[13] Guelfi, pp. 65 ff.
[14] Borroni Salvadori.
[15] Meloni Trkulja, 1972, p. 53.
[16] Chiarini, 1976.
[17] Ewald, 1976.
[18] Meloni Trkulja, 1972.
[19] *Urbino: Restauri*, pp. 532-52.

It is some consolation that *Stefano Conti*'s last commission—a picture by Crespi of *Jupiter among the Corybantes*, cunningly described by him as *The Finding of Moses* because, as a sacred subject, it would pay less customs duty—which was known to me only from documentary sources has now turned up[1] (Plate 67).

Chapter 9

The political and economic situation of the Venetian aristocracy in this last phase of its ascendancy, when its numbers and wealth were diminishing, has been discussed by James C. Davis,[2] and a great deal of incidental information about its artistic patronage can be derived from a number of monographs devoted to individual artists and also from the extensive investigations of the last few years into the decoration of country villas, much of which has been made conveniently accessible in a volume edited by Pallucchini.[3] Of the individual families referred to in this chapter, the patronage of the *Zenobio* has been looked at in some detail,[4] and Puppi has demonstrated beyond the shadow of a doubt that I was quite wrong in attributing to the sweet-tempered and humble *Leonardo Valmarana* the commissioning of Tiepolo's frescoes in the family Villa near Vicenza illustrating scenes from Homer, Virgil, Ariosto and Tasso. These beautiful works, so different in feeling from those generally produced by Tiepolo for the local nobility, were in fact commissioned by Conte Giustino Valmarana (who died in 1757)—about whom we know little except that he was a very rich, efficient and retiring landowner.[5] Puppi has also given us new information about the patronage of *Carlo Cordellina* (another employer of Tiepolo), and especially about the palace in Vicenza which he began to have built in 1770 at the age of 73 and where he died eighteen years later.[6]

Chapter 10

The second volume of Croft-Murray's book on Decorative Painting in *England* now gives by far the fullest account of the work of the Riccis, Pellegrini, Amigoni, Bellucci and other Venetians who were attracted to Britain,[7] and additional information about Sebastiano Ricci is to be found in the monograph on him by Daniels.[8] The hostility to Amigoni which was felt and propagated in some quarters is explored in a lively article by Shipley.[9] Barbara Mazza has made a full survey of all the literature relating to the commemorative pictures painted for *Owen McSwiny*, some of which have emerged since the first edition of this book. Her conclusions concerning the nature and progress of the enterprise confirm my own, but her detailed catalogue of all those at

[1] Merriman.
[2] Davis.
[3] Pallucchini, 1978.
[4] Aikema.
[5] Puppi, 1968, pp. 211-50.
[6] Puppi, 1968, pp. 212-16.
[7] Croft-Murray, 1970.
[8] Daniels.
[9] Shipley.

present identified, either as originals or in the form of copies (with four more possibly still to be discovered) replaces the summary list I published in 1963. In general Dr Mazza is as baffled as I was—and as were McSwiny's own contemporaries—about the precise meaning of these strange and attractive pictures.[1]

There is a useful survey by Ivanov of contemporary *French* interest in eighteenth-century Venetian art,[2] but the most important contribution to this subject that has become accessible since the appearance of my book is the authoritative account by Garas of everything that can now be ascertained about the appearance of Pellegrini's destroyed decoration of the Banque Royale in Paris. Dr Garas believes that the influence of this has been overestimated.[3]

In the same article Dr Garas discusses Pellegrini's employment in Vienna, and in another article on him in *Germany* she points out that, contrary to what I wrote in my first edition, he did in fact paint the frescoes in the Zwinger in Dresden for which he had been proposed. These survived much longer than his work in Paris, but they were destroyed long before the destruction of the city itself in 1945.[4] An article on Bellucci in Vienna (and especially on his decorations in the Liechtenstein palace there) makes it appear likely that the artist was in the city between 1692 and 1704, well before I suggested.[5]

Tessin's taste in the arts and his standing as a collector of drawings have been discussed by Bjurström, who gives important bibliographical references to the Swedish literature on him.[6]

The interest of the eighteenth-century *Russian* court in attracting artists from Venice was investigated in a fully documented book about Giuseppe Valeriani in 1948,[7] and two further articles have been devoted to the topic in recent years.[8] My assumption that Catherine the Great herself purchased one of the great masterpieces of the century, Tiepolo's *Banquet of Cleopatra* (Plate 61b), now seems to me over-confident.

Chapter 11

In some articles and a book Frances Vivian has added much to our knowledge of *Consul Smith* as merchant and collector, but unfortunately she has not been able to solve the baffling problem of Smith's 'second collection' (which I discuss at length in Appendix 5)—i.e. the several hundred paintings which were recorded as being in his palace when he died in 1770, eight years after he was believed to have sold all his pictures to George III. Like me, however, she is inclined to believe that in 1762 he sold only a portion of what he then owned and she argues therefore that the pictures later in his possession had probably been acquired at an earlier date.[9] Jeffrey Daniels

[1] Mazza.
[2] *Venise au dix-huitième siècle.*
[3] Garas, 1962.
[4] Garas, 1971.
[5] D'Arcais.
[6] Bjurstrom, 1967.
[7] Konopleva.
[8] Ernst; Fomiciova.
[9] Vivian (with references to earlier articles).

disagrees with a number of writers (including myself) who think that Smith's large paintings by Sebastiano Ricci may have derived from another commission that had fallen through, and writes that 'there is no reason to believe that Smith was not the originator of his set'.[1] The precise details of Smith's financial arrangements with Canaletto are still not entirely clear, and W. G. Constable (supported, implicitly, by Links) is not convinced—as I was when I wrote my first edition—of the likelihood that the two men, or even Canaletto alone, paid a visit to Rome in the early 1740s.[2] Michael Levey has, however, given us a particularly fascinating insight into one side of Smith's patronage by showing us that in 1751 Canaletto was required to alter a view of Venice he had made for Smith sixteen years earlier in order to paint in the grand new façade which had just been added to his patron's palace on the Grand Canal:[3] this touch of vanity makes it all the more surprising that no portrait has yet come to light. Another aspect of Smith's patronage of Canaletto—his 'glorification of Palladio and his architectural principles'—which found expression in the evidently carefully devised commission for a series of fantasising overdoors depicting sixteenth-century buildings and monuments has been analysed by William Barcham.[4]

Marshal Schulenburg's collection has been discussed in two recent articles. After tracking down the whereabouts of some of the pictures he once owned, Alice Binion concludes that he was unlikely to have had 'a discriminating mind. Apparently he was no match for Zanetti in artistic erudition, for Algarotti in aesthetic sensitivity, or for Joseph Smith in experience with the art market. Nor does he seem to have influenced the painters he patronised, or to have discovered unknown talents. He did buy treatises on painting and lives of the painters, and must have developed some artistic discernment over the years. But collecting for the sake of collecting, with a view to establishing a permanent gallery, appears to have been the greatest part of the fun for him.'[5] As Binion acknowledges, we know too little about Schulenburg to be sure of his taste, but I find it difficult to accept that the man who could commission in succession from Piazzetta the two great 'pastorals' in Chicago and Cologne (Plate 54)—works so different in feeling from anything else produced in eighteenth-century Venice—can either have lacked sensitivity or failed to have influenced at least some of the painters who worked for him. Elizabetta Antoniazzi Rossi concentrates essentially on the 'wrongly called "minor genres"' to be found in Schulenburg's collection—small landscapes, battles, animal pictures, and so on—and after examining some of these in rewarding detail she accepts Alice Binion's conclusion about the general nature of his patronage only in so far as it can be turned to his credit: 'it seems as if he conceived of his collection as illustrating on a grand scale the local school of painting . . . as if he felt the duty, not quite consciously perhaps and certainly without any special enthusiasm, of defending and spreading a taste for minor types of painting.'[6]

[1] Daniels, p. xv.
[2] Constable (revised by Links), p. 32.
[3] Levey, 1962, p. 338.
[4] Barcham.
[5] Binion.
[6] Rossi.

Chapter 12

The Venetian Enlightenment has received serious attention in recent years from Franco Venturi[1] (who pays much attention to the significance of *Lodoli*)[2] and Gianfranco Torcellan[3] (but for whose tragic death at the age of twenty-eight this book would have been much improved). It is now clearer than ever that my own use of the term can only be thought of as very vague, but the ideas and art patronage of two of the very varied figures whom I discussed in connection with this movement of ideas have been clarified since 1963. James Byam Shaw has shown that the German painter in whom *Antonio Conti* was interested because his invention of a new method of colour printing could be related to the theories of Sir Isaac Newton was in fact Jakob Christoffel Le Blon, whose invention made a notable impact in England as well as in Italy.[4] And Thomas J. McCormick has published in his catalogue of selections from the Vassar College Art Gallery another of the very bizarre allegorical canvases by Felice Boscarati which helped to create such a political uproar around *Giorgio Pisani* when they were displayed along his processional route as he took up his appointment as Procuratore di S. Marco.[5] In a recent article Loredana Olivato accepts my tentative suggestion that the choice for such an occasion of these abstruse pictures, originally painted some years earlier for someone quite different, was more likely to have been casual than deliberately provocative. Dr Olivato also quotes from Boscarati's evidence at the trial of Pisani during which he claimed that his patron showed little interest in the subject matter of the pictures he commissioned, and she makes it clear that Boscarati himself continued to hold subversive opinions long after Pisani's downfall.[6]

Chapter 13

Of the patrons mentioned in this chapter *Anton Maria Zanetti* (*the Elder*) has received some attention recently because of the discovery of an album containing 350 of his caricatures. This was presented to the Fondazione Giorgio Cini in Venice, and the catalogue by Alessandro Bettagno of the exhibition held there to mark the gift contains a useful summary of his life and activities while the illustrations give a vivid indication of the circles in which he moved.[7]

Students of *Maffeo Pinelli* have also been rewarded by a discovery, though it is less spectacular. At least six of the little oval portraits on copper of the Doges which were painted for him by Francesco Maggiotto (to which I referred on the basis of documents only in the first edition of this book) have now come to light (Plate 68). As Sir Karl Parker (who first told me of their reappearance) has pointed out to me, they are adapted from engravings—probably those by Piccino in Matina's volume

consisting essentially of 'portraits'—in the form of medallions—of all the Doges who had presided over Venice until 1659, the date of publication.[1] Maggiotto's paintings thus provide an exceptionally fascinating instance of mediaeval and later portraiture as seen through the eyes of the seventeenth and eighteenth centuries.

Chapter 14

Two scholars have added significantly to our knowledge of *Algarotti* in recent years. Giovanni da Pozzo has published both a critical edition of the essays (with a useful bibliographical commentary)[2] and also the full text of his will for a discussion of which previous writers (including myself) have had to rely on inadequate summaries.[3] This shows that the two pictures which, much to the sarcastic amusement of Diderot, Algarotti left to the Elder Pitt were painted by Mauro Tesi, and also that Algarotti bequeathed to Cosimo Mari two paintings by Tiepolo 'uno che rappresenta Cristo condotto al Calvario e l'altro un convitto di Marco Antonio e Cleopatra'. Pictures by Tiepolo of these subjects were known from other sources to have belonged to Algarotti,[4] and their absence from the catalogue of his collection drawn up twelve years after his death can thus now be explained. *The Road to Calvary* is almost certainly the sketch in Berlin for the large painting in the church of S. Alvise in Venice, and the sketch of 'The banquet of Mark Anthony and Cleopatra' is perhaps the one in the Musée Cognacq-Jay in Paris (Plate 61a), though there are difficulties in the way of accepting this.[5]

The late Dr Maria Santifaller published a series of articles bearing on Algarotti. She showed that the vast majority of portraits of him—of which she illustrated some hitherto not known—were derived from the classicising print made in Berlin by Georg Friedrich Schmidt in 1752, a year after the same artist had etched for Algarotti the rather epicene features of a singer called Felice Salimbeni;[6] and Dr Santifaller has also explored in detail the etchings made by Algarotti himself, sometimes in collaboration with Tiepolo.[7] In connection with this fruitful friendship Michael Levey has pointed out that the theory that Tiepolo either projected or began a portrait of Algarotti as, following previous writers, I suggested in the first edition of this book, is based on a misreading of the documents[8]—a conclusion with which one must reluctantly concur.

Finally Dr Santifaller has also discussed the charming painting of Algarotti's tomb in the Campo Santo in Pisa[9]—a picture probably derived from the Volpato engraving (Plate 60). When I wrote about the picture in 1963 it was in the John Bryson collection in Oxford, and it is now in Schloss Charlottenburg, Berlin. Dr Santifaller followed

[1] Matina.
[3] Da Pozzo.
[5] Haskell, 1958, p. 213.
[7] Santifaller, 1977.
[9] Santifaller, 1978.

[2] Algarotti, 1963.
[4] Haskell, 1958, p. 213; Levey, 1960, p. 250.
[6] Santifaller, 1976.
[8] Levey, 1978.

earlier writers in ascribing it to Bernhard Rode, but Marianne Roland-Michel who has made a special study of it believes it much more likely to be by an Italian artist.

A detail from this picture is reproduced on the dust jacket.

Chapters 16 and 17

Sasso has attracted some attention recently because of his close association with a number of cultivated scholars and artists in and around Venice who were rediscovering the 'primitive' Italian painters of Northern Italy;[1] and in the catalogue of an important exhibition devoted to methods of reproducing Italian art before the invention of photography Christopher Lloyd has set his projected, but uncompleted, *Venezia Pittrice* within the context of other similar publications[2]. As a dealer he has been discussed in an interesting article by Loredana Olivato which corrects some errors by me and includes a number of letters linking Sasso to some of the other figures mentioned in these chapters.[3]

Among these is the *Abate Della Lena*, whose treatise on the 'Spoliation of Pictures from Venice' I published after the appearance of this book.[4] This treatise gives an extremely illuminating, and sometimes lively, account of the many foreigners who, aided by Della Lena himself and his friends, were removing works of art from Venice during the last years of the Republic, and it also demonstrates that Della Lena's intense enthusiasm for Guardi in no way inhibited an admiration for the 'beautiful simplicity' of Vivarini, Carpaccio and Bellini.

The dispersal of the *Manfrin* collection (which at one time included Giorgione's *Tempesta*) belongs to the history of nineteenth-century Venice, and we are still badly informed about the sources from which he obtained his pictures. However, the part he played in manufacturing tobacco—and hence the fortune with which to build up his collection—has been emphasised in an article by Vincenzo Fontana.[5]

[1] Previtali, 1964, pp. 153–8.
[2] *Art and its images*, pp. 75–6.
[3] Olivato, 1974.
[4] Haskell, 1967.
[5] Fontana.

BIBLIOGRAPHY

This is not intended to be a complete bibliography relating to the patronage of Italian artists in the seventeenth and eighteenth centuries. Many contributions to the subject, some of them important, have been omitted because they are not directly relevant to the purpose of this list, which consists only of those sources to which I have referred in the text and notes. Journals and Exhibition catalogues have been printed in italics. Anonymous publications are indicated by putting the author's name in square brackets.

— *a* —

MANUSCRIPTS DRAWN FROM THE FOLLOWING ARCHIVES AND LIBRARIES

Great Britain

London:
 British Museum
 Public Record Office

Cambridge:
 King's College Library

Italy

Bologna:
 Biblioteca Comunale

Cremona:
 Biblioteca Governativa

Ferrara:
 Biblioteca Ariostea

Florence:
 Archivio di Stato
 Biblioteca Laurenziana
 Biblioteca Marucelliana
 Biblioteca Nazionale
 Soprintendenza alle Gallerie

Lucca:
 Biblioteca Governativa

Modena:
 Biblioteca Estense

Perugia:
 Biblioteca Augusta
 Chiesa del Gesù

Rome:
 Accademia di S. Luca
 Archivio della Compagnia di Gesù
 Archivio Secreto Vaticano
 Archivio Storico Capitolino
 (Biblioteca Vallicelliana)
 Archivio di Stato
 Biblioteca Casanatense
 Biblioteca Corsini
 Biblioteca Vaticana
 Museo di Roma

Rovigo:
 Accademia dei Concordi

Treviso:
 Biblioteca Comunale

Venice:
 Archivio di Stato
 Biblioteca Correr
 Biblioteca Marciana
 Seminario Patriarcale

Verona:
 Archivio di Stato

Germany

Hanover:
 Staatsarchiv

Sweden

Kunglige Biblioteket

— b —

PUBLISHED MATERIALS

Ackerman, G.: 'Gian Battista Marino's contribution to Seicento Art Theory' in *Art Bulletin*, 1961, pp. 326-336.

Acton, Harold: The last Medici, London 1958.

Ademollo, A.: I teatri di Roma nel secolo decimosettimo, Roma 1888.

Adhémar, Hélène: Watteau—sa vie—son œuvre, Paris 1950.

Agnelli, J.: Galleria di pitture del Card. Tomm. Ruffo vescovo di Ferrara, Ferrara 1734.

Agnello, Giuseppe: 'Un caravaggesco: Mario Minniti' in *Archivi*, 1941, pp. 60-80.

Aikema, Bernard: 'Patronage in late baroque Venice: the Zenobio' in *Overdruk uit de Mededelingen van het Nederlands Institut te Rome*, Deel XLI—Nova Series 6—1979, pp. 209-218.

Alazard, Jean: L'Abbé Luigi Strozzi correspondant artistique de Mazarin, de Colbert, de Louvois et de La Teulière, Paris 1924.

Albion, G. H. J.: Charles I and the Court of Rome, Louvain 1935.

[Albrizzi, G. B.]: Memorie intorno alla Vita di G. B. Piazzetta, Venezia 1760.

Algarotti, Francesco: Opere, 17 vols., Venezia 1791-4.

Algarotti, Francesco: Saggi (a cura di Giovanni da Pozzo) Bari 1963.

Ambri, Paola Berselli: L'opera di Montesquieu nel settecento italiano, Firenze 1960.

Amelot de la Houssaye, A. N.: Histoire du gouvernement de Venise, Paris 1677.

Andrés, Gregorio de: *See* Harris, Enriqueta and Andrés, Gregorio de.

D'Arcais, Francesca: 'L'attività viennese di Antonio Bellucci' in *Arte Veneta*, 1964, pp. 99-109.

D'Argenville, A. J. Dézallier: Abrégé de la vie des plus fameux peintres, 4 vols., Paris 1762.

Armanni, Vincenzo: Delle lettere del Signor V. A. nobile d'ugubbio, 3 vols., Roma 1663, 1674.

Armellini, M.: Le chiese di Roma, Roma 1942.

Arnaldi, Lodovico: 'Orazione in lode di Marco Foscarini Doge di Venezia' in [G. A. Molin]: Orazioni, elogj e vite scritte da letterati patrizj, Venezia 1795.

Arrighi-Landini, Orazio: Il Tempio della Filosofia, Venezia 1755.

Arslan, W.: 'G. B. Tiepolo e G. M. Morlaiter ai Gesuati' in *Rivista di Venezia*, 1932, pp. 19-25.

Arslan, W.: 'Alcuni dipinti per il MacSwiney' in *Rivista d'Arte*, 1932, pp. 128-140.

Arslan, W.: 'Altri due quadri per il MacSwiney' in *Rivista d'Arte*, 1933, pp. 244-248.

Arslan, W.: 'Quattro lettere di Pietro Visconti a Gian Pietro Ligari' in *Rivista Archeologica dell'antica provincia di Como*, fasc. 133, 1952, pp. 63-72.

Arslan, W.: 'Altri due dipinti per il McSwiny' in *Commentari*, 1955, pp. 189-192.

Art and its images—an exhibition of printed books containing engraved illustrations after Italian paintings, Oxford (Bodleian Library), 1975.

d'Aumale, duc: Inventaire de tous les meubles du Cardinal Mazarin dressé en 1653 d'après l'original, conservé dans les archives de Condé, Londres 1861.

Baglione, Gio.: Le Vite de' Pittori Scultori et Architetti dal pontificato di Gregorio XIII del 1572 in fino a' tempi di Papa Urbano Ottavo nel 1642—facsimile dell'edizione di Roma di 1642, Roma 1935.

Bailly, N.: Inventaire des tableaux du Roy rédigé en 1709 et 1710, Paris 1899.

Baldinucci, Filippo: Notizie de' Professori del disegno da Cimabue in qua, Secolo V dal 1610 al 1670, vol. VI, Firenze 1728.

Baldinucci, Filippo: Vita del Cavaliere Gio. Lorenzo Bernini—studio e note di Sergio Samek Ludovici, Milano 1948.

I Bamboccianti, Pittori della vita popolare nel seicento—mostra organizzata da Alessandro Morandotti; catalogo a cura di Giuliano Briganti—Organizzazione Mostre d'Arte 'Antiquaria', Roma 1950.

Bandera, Sandrina: 'Un corrispondente cremonese di Leopoldo de' Medici: Giovan Battista Natali e la provenienza dei disegni cremonesi degli Uffizi' in Paragone, 1979 (347), pp. 34-116.

Banti, Anna: Europa Milleseicentosei—diario di viaggio di Bernardo Bizoni, Milano 1942.

Barberini, Urbano: 'Pietro da Cortona e l'arazzeria Barberini' in Bollettino d'Arte, 1950, pp. 43-51 and 145-152.

Barberini, Urbano: 'Gli arazzi e i cartoni della serie "Vita di Urbano VIII" della Arazzeria Barberini' in Bollettino d'Arte, 1968, pp. 92-100.

Barbi, Michele: Notizie della vita e delle opere di Francesco Bracciolini, Firenze 1897.

Barcham, William: 'Canaletto and a Commission from Consul Smith' in Art Bulletin, 1977, pp. 383-393.

Bardella, A.: 'Come si acquistava la nobiltà Veneta nella seconda metà del '600' in Vicenza, Maggio-Giugno 1937.

Baretti, G.: An account of the manners and customs of Italy, London 1768.

Barozzi, Niccolò e Berchet, Guglielmo: Relazioni degli Stati Europei lette al Senato dagli Ambasciatori Veneti del secolo decimosettimo, Serie III—Italia Relazioni di Roma, 2 vols., 1877-8.

Bartarelli, Aldo: 'Anton Domenico Gabbiani' in Rivista d'Arte, 1951, pp. 107-130.

Bartolozzi, Sebastiano Benedetto: Vita di Antonio Franchi Lucchese, pittor fiorentino, Firenze 1754.

Bartsch, Adam: Le Peintre Graveur, Leipzig 1854.

Baschet, Armand: 'Négotiation d'œuvres de tapisserie de Flandre et de France par le nonce Guido Bentivoglio pour le Cardinal Borghèse (1610-1621) in Gazette des Beaux-Arts, 1861 (XI), pp. 406-415 and 1862 (XII), pp. 32-45.

Bassi, Elena: La Regia Accademia di Belle Arti di Venezia, Firenze 1941.

Bassi, Elena: 'Episodi dell'edilizia veneziana nel secolo XVII e XVIII—Palazzo Pesaro' in Critica d'Arte, 1959, pp. 240-264.

Batiffol, Louis: La vie intime d'une reine de France au XVIIème siècle, Paris 1906.

Battagia, Michele: Delle Accademie Veneziane—dissertazione storica, Venezia 1826.

Battistella, O.: La Villa Soderini, Nervesa 1903.

Battistella, O.: Gaetano Zompini, Bologna 1930.

Battisti, E.: 'Alcune "Vite" inedite di L. Pascoli' in Commentari, 1953, pp. 30-43.

Battisti, E.: 'Juvarra a Sant'Ildefonso' in Commentari, 1958, pp. 273-297.

Battisti, E.: L'Antirinascimento, Milano 1962.

Baudi di Vesme, A.: 'Sull'acquisto fatto da Carlo Emanuele III, Re di Sardegna, della quadreria del Principe Eugenio di Savoia' in Miscellanea di Storia Italiana, 1886, pp. 161-256.

Baudi di Vesme, A.: 'Paralipomeni tiepoleschi' in Scritti in onore di R. Renier, Torino 1912.

Baudi di Vesme, A.: 'L'Arte negli Stati Sabaudi' in *Atti della Società Piemontese di Archeologia e Belle Arti*, 1932.

Baudson, E.: 'Apollon et les Neuf Muses du Palais du Luxembourg' in *Bulletin de la Société de l'Histoire de l'Art Français*, 1941-4, pp. 28-33.

Baumgarten, S.: Pierre Legros artiste romain, Paris 1923.

Bazzoni, A.: Un nunzio straordinario alla corte di Francia nel secolo XVII, Firenze 1882.

Beani, G.: Clemente IX—Giulio Rospigliosi Pistoiese, Prato 1893.

[Beckford, William]: Italy, with sketches of Spain and Portugal—by the author of Vathek, 2 vols., London 1834.

[Bellori, G. P.]: Nota delli Musei, Librerie, Gallerie e Ornamenti di statue e pitture ne' palazzi, nelle case e ne' giardini di Roma—appendice a Lunadoro: Relatione della corte di Roma, Roma e Venezia 1664.

Bellori, G. P.: Le Vite de' Pittori, Scultori et Architetti moderni—facsimile dell'edizione di Roma di 1672, Roma 1931.

Bellori, G. P.: Le Vite inedite (Guido Reni, Andrea Sacchi, Carlo Maratta)—edizione a cura di M. Piacentini, Roma 1942.

Bellori, G. P.: Le Vite de' Pittori, Scultori e Architetti Moderni (a cura di Evelina Borea—introduzione di Giovanni Previtali), Torino 1976.

Mostra di Bernardo Bellotto—opere provenienti dalla Polonia, Venezia 1955.

Beltrami, D.: Storia della popolazione di Venezia dalla fine del secolo XVI alla caduta della Repubblica, Padova 1954.

[Bencivenni, già Pelli]: Saggio istorico della Real Galleria di Firenze, 2 vols., Firenze 1779.

Benedetti, Elpidio: Pompa funebre Nell'Esequie celebrate in Roma al Cardinal Mazarini nella Chiesa di S.S. Vincenzo Anastasio, In Roma 1661.

Bentivoglio, Cardinal: Memorie, Milano 1807.

Bentivoglio, Cardinal Guido: Relazione della famosa festa fatta in Roma alli xxv di Febbraio mdcxxxiv sotto gli auspicj dell'Eminentissimo Sig. Cardinale Antonio Barberini—in Raccolta di lettere scritte dal Cardinal Bentivoglio, Roma mdcliv, and reprinted by Ludovico Passarini in 1882.

Berengo, Marino: La società Veneta alla fine del '700, Firenze 1955.

Berengo, Marino: La crisi dell'Arte della Stampa Veneziana alla fine del XVIII secolo in Studi in onore di Armando Sapori, 2 vols., Milano 1957, pp. 1321-1338.

Bernino, Domenico: Vita del Cavalier Gio. Lorenzo Bernino, Roma 1713.

De Bernis, Cardinal François-Joachim de Pierre: Mémoires et lettres 1715-1758, publiés par Frédéric Masson, 2 vols., Paris 1878.

Berthier, J. J.: L'église de Sainte Sabine à Rome, Roma 1910.

Bertolotti, A.: Giornalisti, Astrologi e Negromanti in Roma nel secolo XVII, Firenze 1878.

Bertolotti, A.: Artisti belgi ed olandesi a Roma nei secoli XVI e XVII, Firenze 1880.

Bertolotti, A.: Artisti subalpini in Roma nei secoli XV, XVI e XVII, Mantova 1884.

Bertolotti, A.: Un professore alla Sapienza di Roma nel secolo XVII, Roma 1886.

Bertolotti, A.: 'Le ultime volontà di Michelangelo delle Battaglie' in *Arte e Storia*, 1886, p. 22.

Bertolotti, A.: Artisti bolognesi, ferraresi ed alcuni altri del già stato pontificio in Roma nei secoli XV, XVI, XVII (n.d.).

Betcherman, L. R.: 'Balthazar Gerbier in seventeenth century Italy' in *History To-day*, 1961, pp. 325-331.

Bettagno, Alessandro: Caricature di Anton Maria Zanetti—Fondazione Giorgio Cini, Venezia (catalogo della Mostra), Vicenza 1969.

Bettinelli, Saverio: Lettere inglesi.

Bevilacqua, Ippolito: Memorie della vita di Giambettino Cignaroli, eccellente dipintor veronese, Verona 1771.

Bialostocki, Jan: 'Une idée de Léonard réalisée par Poussin' in *Revue des Arts*, 1954, pp. 131-136.

Bialostocki, Jan: 'Poussin et le "Traité de la Peinture" de Léonard' in *Actes du Colloque Poussin*, 1960, I, pp. 133-140.

Bianchini, Giuseppe: La chiesa di S. Maria di Nazareth detta degli Scalzi in Venezia, Venezia 1894.

Biasutti, Mons. Dott. Guglielmo: Storia e Guida del Palazzo Arcivescovile di Udine, Udine 1958.

Bildt, Baron C. de: 'Queen Christina's pictures' in *The Nineteenth Century*, LVI, 1904, pp. 989-1003.

Bildt, C. di: 'Cristina di Svezia e Paolo Giordano II duca di Bracciano' in *Archivio della Società Romana di Storia Patria*, 1906, pp. 5-32.

Binion, Alice: 'From Schulenburg's Gallery and Records' in *Burlington Magazine*, 1970, pp. 297-303.

Bjurström, Per: Giacomo Torelli and Baroque Stage Design, Stockholm 1961.

Bjurström, Per: 'Carl Gustaf Tessin as a collector of drawings' in Contributions to the History and Theory of Art, Figura, new series 6, Uppsala 1967, pp. 99-120.

Blainville, de: Travels through Holland, Germany, Switzerland and Italy, 3 vols., London 1767.

Blunt, Anthony: 'Poussin's "Et in Arcadia Ego" ' in *Art Bulletin*, 1938, pp. 96-100.

Blunt, Anthony: 'The heroic and the ideal landscape in the work of Nicolas Poussin' in *Journal of the Warburg and Courtauld Institutes*, 1944, pp. 154-168.

Blunt, Anthony: French drawings in the Royal Collection at Windsor Castle, London 1945.

Blunt, Anthony: 'Two newly discovered landscapes by Nicolas Poussin' in *Burlington Magazine*, 1945, pp. 186-189.

Blunt, Anthony: 'Pictures by Sebastiano and Marco Ricci in the Royal Collections' in *Burlington Magazine*, 1946, pp. 263-268, and 1947, pp. 101-102.

Blunt, Anthony: 'The Annunciation by Nicolas Poussin' in *Bulletin de la Société Poussin*, I, 1947, pp. 18-25.

Blunt, Anthony: Art and Architecture in France 1500-1700, London 1953.

Blunt, Anthony: The drawings of Castiglione and Stefano della Bella at Windsor Castle, London 1954.

Blunt, Anthony: 'A neo-Palladian programme executed by Visentini and Zuccarelli for Consul Smith' in *Burlington Magazine*, 1958, pp. 283-284.

Blunt, Anthony: 'Poussin dans les Musées de province' in *Revue des Arts*, Janvier-Février, 1958, pp. 5-16.

Blunt, Anthony: 'The Palazzo Barberini: the contributions of Maderno, Bernini and Pietro da Cortona' in *Journal of the Warburg and Courtauld Institutes*, 1958, pp. 256-287.

Blunt, Anthony: 'Poussin studies VIII—a series of Anchorite subjects commissioned by Philip IV from Poussin, Claude and others' in *Burlington Magazine*, 1959, pp. 389-390.

Blunt, Anthony and Cooke, Hereward Lester: Roman drawings at Windsor Castle, London 1961.

Blunt, Anthony and Croft-Murray, Edward: Venetian drawings of the XVII and XVIII centuries in the collection of Her Majesty the Queen at Windsor Castle, London 1957.

Blunt, Anthony: Nicolas Poussin—the A. W. Mellon Lectures in the Fine Arts, 1958, New York 1967.

Blunt, Anthony: Supplements to the catalogues of Italian and French Drawings—published with Edmund Schilling: The German Drawings in the Collection of Her Majesty the Queen at Windsor Castle, London and New York 1971.

Blunt, Anthony: Borromini, London 1979.

Boccage, Mme de: Letters concerning England, Holland and Italy, 2 vols., London 1770.

Bologna, Ferdinando: Francesco Solimena, Napoli 1958.

Bonadonna Russo, Maria Teresa: 'I Cesi e la Congregazione dell'Oratorio' in Archivio della Società romana di Storia patria, Vol. 90, 1967, pp. 101-163 and Vol. 91, 1968, pp. 101-155.

Bonnaffé, Edmond: Dictionnaire des amateurs français au XVII siècle, Paris 1884.

Bonomelli, Emilio: I Papi in campagna, Roma 1953.

Borea, Evelina: La Quadreria di Don Lorenzo de' Medici, Firenze 1977.

Borenius, Tancred: 'A Venetian apotheosis of William III' in Burlington Magazine, 1936, pp. 245-246.

Borroni, Fabia: I due Anton Maria Zanetti, Firenze 1956.

Borroni Salvadori, Fabia: 'Le Esposizioni d'Arte a Firenze dal 1674 al 1767' in Mitteilungen des Kunsthistorischen Institutes in Florenz, XVIII. Band, 1974, Heft I, pp. 1-166.

Borsari, L.: Il castello di Bracciano, Roma 1895.

Borzelli, Angelo: Il Cavalier Marino con gli artisti e la 'galeria', Napoli 1891.

Borzelli, Angelo: Il Cavalier Giovan Battista Marino, Napoli 1898.

Borzelli, Angelo: L'Assunta del Lanfranco in S. Andrea della Valle giudicata da Ferrante Carli, Napoli 1910.

Boschini, Marco: La carta del navegar pittoresco, Venezia 1660.

Boscovich: Lettere pubblicate per le nozze Olivieri-Balbi, Venezia 1811.

Bosdari, Filippo: 'Francesco Maria Zanotti nella vita bolognese del Settecento' in Atti e Memorie della R. Deputazione di Storia Patria per le provincie di Romagna, 1928, pp. 157-222.

Bosisio, Achille: La chiesa di S. Maria della Visitazione o della Pietà, Venezia 1951.

Bottari, Giovanni: Raccolta di lettere sulla Pittura, Scultura ed Architettura scritta da' più celebri personaggi dei secoli XV, XVI e XVII pubblicata da M. Gio Bottari e continuata fino ai nostri giorni da Stefano Ticozzi, Milano 1822.

Boyer, Ferdinand: 'Documents d'Archives Romaines et Florentines sur le Valentin, le Poussin et le Lorrain' in Bulletin de la Société de l'Histoire de l'Art Français, 1931, pp. 233-238.

Boyer, Ferdinand: 'Les Orsini et les musiciens d'Italie au début du XVII siècle' in Mélanges de philologie, d'histoire et de littérature offerts à Henri Hauvette, Paris 1934, pp. 301-310.

Boyer, Ferdinand: 'Le mécenat des Orsini au début du XVII siècle' in Dante, III, Décembre 1934.

Bozzòla, A.: 'Inquietudini e velleità di riforma a Venezia nel 1761-2' in Bollettino Storico-Bibliografico Subalpino, 1948, pp. 93-116.

Bozzòla, A.: Casanova illuminista, Venezia 1956.

Bracciano, Duca di: See Paolo Giordano.

Brandi, Cesare: Canaletto, 1960.

Brauer, H. und Wittkower, R.: Die Zeichnungen des Gianlorenzo Bernini, Berlin 1931.

Bréjon de Lavergnée, Arnauld: 'Tableaux de Poussin et d'autres artistes français dans la collection Dal Pozzo: deux inventaires inédits' in Revue de l'Art, 1973, no. 19, pp. 79-96.

Brett, R. L.: The Third Earl of Shaftesbury, London 1951.

Breval, John: Remarks on several parts of Europe relating chiefly to their antiquities and history collected upon the spot in several tours since the year 1723, 2 vols., London 1738.

[Bricarelli, C.]; 'La chiesa di S. Ignazio e il suo architetto' in L'Università Gregoriana del Collegio Romano, 1924, pp. 77-100.

Brienne, Louis-Henri de Loménie Comte de: Mémoires, publiés par Paul Bonnefon, 3 vols., Paris 1916-19.

Brigante Colonna, G.: Olimpia Pamfili, Milano 1941.

Briganti, G.: 'Cerquozzi pittore di natura morte' in Paragone, vol. 53, 1954, pp. 47-52.

Briganti, G.: 'Opere inedite o poco note di Pietro da Cortona nella Pinacoteca Capitolina' in Bollettino dei Musei Comunali di Roma, IV, 1957, pp. 5-14.

Briganti, G.: Pietro da Cortona, Firenze 1962.

Brol, E.: 'Carlo Antonio Pilati a Venezia' in Pro Cultura, III, 1912.

Brosses, Charles de: Lettres d'Italie, 2 vols., Dijon 1927.

Brown, Horatio: The Venetian printing press, London 1891.

Brugnoli, M. V.: 'Il soggiorno a Roma di Bernardo Castello e le sue pitture nel Palazzo di Bassano di Sutri' and 'Gli affreschi dell'Albani e del Domenichino nel Palazzo di Bassano di Sutri' in Bollettino d'Arte, 1957, pp. 255-277.

Brunelli, Bruno: Un'amica del Casanova, Milano 1923.

Brunelli, Bruno: 'Un Senatore Veneziano ed una villa scomparsa' in Le Tre Venezie, 1931, pp. 4-11.

Brunelli, Bruno e Callegari, Alfredo: Ville del Brenta e degli Euganei, 1931.

Brunelli Bonetti, B.: 'Un riformatore mancato—Angelo Querini' in Archivio Veneto, 1951, pp. 185-200.

Brunetti, M.: 'Per la storia del viaggio in Ispagna di Gio. Batt. Tiepolo' in Ateneo Veneto, 1914.

Brunetti, M.: 'Un eccezionale collegio peritale: Piazzetta, Tiepolo, Longhi' in Arte Veneta, 1951, pp. 158-160.

Brunetti, M.: S. Maria del Giglio volgo Zobenigo nell'arte e nella storia, Venezia 1952.

Brusoni, Cavalier Girolamo: Degli Allori d'Eurota, poesie di diversi all'Eccellentiss. Sig. Principe D. Camillo Pamphilio raccolte dal Cav. G. B., Venezia 1662.

Brustoloni, D. Gio. Domenico: Elogio funebre dell'eccellentissimo S. Flaminio Corner amplissimo Senatore . . . 29 Dicembre 1778, S. Canciano, Venezia 1779.

[Brydges, Grey, 5th Lord Chandos]: Horae Subsecivae: observations and discourses, London 1620.

Burchard, L.: 'Rubens' "Feast of Herod" at Port Sunlight' in Burlington Magazine, 1953, pp. 383-387.

Burden, Gerald: 'Sir Thomas Isham, an English collector in Rome in 1677-8' in Italian Studies, 1960, pp. 1-25.

Burney, Charles: Musical Tours in Europe, edited by Percy Scholes, 2 vols., Oxford, 1959.

Buser, Thomas: 'Jerome Nadal and early Jesuit Art in Rome' in Art Bulletin, 1976, pp. 424-433.

Byam Shaw, J.: 'Two drawings by Domenico Tiepolo, and a note on the date of the frescoes at the Villa Contarini-Pisani' in *Burlington Magazine*, 1960, pp. 529-530.

Byam Shaw, J.: Paintings by Old Masters at Christ Church, Oxford, London 1967.

Calberg, M.: 'Hommage au Pape Urbain VIII—Tapisserie de la manufacture Barberini à Rome' in *Bulletin des Musées Royaux d'Art et d'Histoire*, 4ème série, 1959, pp. 99-110.

Callari, Luigi: I Palazzi di Roma, 3ª edizione, Roma 1944.

[Calogerà, P. Angelo]: Raccolta d'opuscoli scientifici, e filologici, 51 vols., Venezia 1728-1754.

Cametti, Alberto: 'Arcangelo Corelli: i suoi quadri e i suoi violini' in *Roma*, 1927, pp. 412-423.

Campbell, Malcolm: 'Medici Patronage and the Baroque: A Reappraisal' in *Art Bulletin*, 1966, pp. 133-141.

Campbell, Malcolm: Pietro da Cortona and the Pitti Palace, Princeton 1977.

Campori, G.: Lettere artistiche inedite, Modena 1866.

Canal, Vincenzo da: Vita di Gregorio Lazzarini (1732), Venezia 1809.

Canevazzi, G.: Papa Clemente IX poeta, Modena 1900.

Canova, Antonio: I quaderni di viaggio (1779-1780)—edizione a cura di Elena Bassi, Venezia 1959.

Cantalamessa, Giulio: 'Le gallerie fidecommissarie romane' in *Le Gallerie Nazionali Italiane*, I, 1894, pp. 79-101.

Capecelatro, Francesco: Degli annali della Città di Napoli, Napoli 1849.

Carandini, Silvia: *See* Fagiolo dell'Arca and Carandini.

Cardella, Lorenzo: Memorie storiche de' Cardinali della Santa Romana Chiesa, 9 vols., Roma 1792-7.

Carusi, Enrico: 'Lettere di Galeazzo Arconato a Cassiano dal Pozzo per lavori sui manoscritti di Leonardo da Vinci' in *Accademia e Biblioteche d'Italia* III, 1929-30, pp. 504-518.

Carutti, Domenico: Breve storia della Accademia dei Lincei, Roma 1883.

Casale, Vittorio: 'Trattato della pittura e scultura "opera stampata ad istanza del S.r Pietro da Cortona"' in *Paragone*, 1976 (313), pp. 67-99.

Casanova de Seingalt, Jacques: Histoire de ma vie—édition intégrale, Paris-Wiesbaden, 6 vols., 1960-1962.

Casini, Giorgio: 'Aggiunte al Crespi' in *L'Archiginnasio*, Gennaio—Giugno, 1941, pp. 42-50.

Cavallo, Adolf S.: 'Notes on the Barberini tapestry manufactory at Rome' in *Bulletin of the Museum of Fine Arts*, Boston, Spring 1957, pp. 17-26.

Caylus, Comte de: Correspondance inédite avec le P. Paciandi—edited by C. Nisard, 2 vols., Paris 1877.

Ceccarelli, Giuseppe: I Sacchetti, Roma 1946.

Ceci, Giuseppe: 'Un mercante mecenate del secolo XVII: Gaspare Roomer' in *Napoli Nobilissima*, 1920, pp. 160-164.

Chaloner, W. H.: 'The Egertons in Italy and the Netherlands, 1729-1734' in *Bulletin of the John Rylands Library* 1949-50, pp. 157-170.

Chantelou, Paul Fréart de: Journal du voyage du chev. Bernin en France—manuscrit inédit publié et annoté par L. Lalanne in *Gazette des Beaux-Arts*, 1877-84.

Charlton, John: Chiswick House and Gardens, London 1958.

Chiarini, Marco: Artisti alla Corte Granducale, Firenze 1969.

Chiarini, Marco: 'I Quadri della Collezione del Principe Ferdinando di Toscana' in *Paragone*, 1975 (301), pp. 57-98; 1975 (303), pp. 75-108; 1975 (305), pp. 55-88.

Chiarini, Marco: 'Antonio Domenico Gabbiani e i Medici' in Kunst des Barock in Toskana, pp. 333-343, München 1976.

Chiarini de Anna, Gloria: 'Leopoldo de' Medici e la sua raccolta di disegni nel "Carteggio d'Artisti" dell'Archivio di Stato di Firenze' in Paragone, 1975 (307), pp. 38-64.

Christina Queen of Sweden—a personality of European civilisation, Nationalmuseum, Stockholm 1966.

Ciampi, Ignazio: Innocenzo X Pamfili e la sua corte, Roma 1878.

Cicogna, E.: Delle Iscrizioni Veneziane, 6 vols. in 7, Venezia 1824-53.

Cinelli: Le bellezze di Firenze, Firenze 1677.

Cipolla, Carlo M.: 'The decline of Italy—the case of a fully matured economy' in Economic History Review, 1952, pp. 178-187.

Claretta, Gaudenzio: 'Relazioni d'insigni artisti e virtuosi in Roma col Duca Carlo Emanuele II di Savoia' in Archivio della Società Romana di Storia Patria, 1885, pp. 511-554.

Claretta, Gaudenzio: 'I Reali di Savoia munifici fautori delle arti: contributo alla storia artistica del Piemonte nel secolo XVIII' in Miscellanea di Storia Italiana, 1893, pp. 1-309.

Clark, Anthony: 'Some early subject pictures by P. G. Batoni' in Burlington Magazine, 1959, pp. 232-236.

Clark, Anthony: ' "Lost" frescoes by Niccolò Berrettoni' in Connoisseur, 1961, vol. 148, pp. 190-193.

Clemens August, Kurfürst—Ausstellung in Schloss Augustusburg zu Brühl, Köln 1961.

Clément, Pierre: Lettres critiques, La Haye 1767.

Clementi, F.: Il carnevale di Roma, 2 vols., Roma 1939.

Cochin, Charles-Nicolas: Voyage d'Italie—nouvelle édition, 3 vols., Lausanne 1773.

Coggiola-Pittoni, Laura: 'Luigi Dorigny e i suoi freschi Veneziani' in Rivista di Venezia, 1935, pp. 13-38.

Coggiola-Pittoni, Laura: 'Di alcuni freschi inediti di Luigi Dorigny in vari centri della Serenissima' in Rivista di Venezia, 1935, pp. 295-314.

Colapietra, Raffaele: Vita pubblica e classi politiche del viceregno napoletano (1656-1734), Roma 1961.

Collins Baker, C. H. and Muriel: The life and circumstances of James Brydges, first duke of Chandos, patron of the liberal arts, Oxford 1949.

Colombier, Pierre du: 'Un texte négligé sur les Sacrements de Cassiano dal Pozzo' in Gazette des Beaux-Arts, 1964 (Vol. 63), pp. 89-90.

Colonna di Stigliano, Ferdinando: 'Inventario dei quadri di casa Colonna fatto da Luca Giordano' in Napoli Nobilissima, 1895, pp. 29-32.

Colonna, Prospero: I Colonna, Roma 1927.

Como, Ugo da: Girolamo Muziano—note e documenti, Bergamo 1930.

Conforti, Michael: 'Pierre Legros and the role of Sculptors as Designers in late Baroque Rome', in Burlington Magazine, 1977, pp. 557-560.

Constable, W. G.: 'An allegorical painting by Canaletto and others' in Burlington Magazine, 1954, p. 154.

Constable, W. G.: 'Four paintings by Antonio Canale in the Gymnasium zum Grauen Kloster, Berlin' in Scritti di Storia dell'Arte in onore di Lionello Venturi, 1956, II, pp. 81-93.

Constable, W. G.: Canaletto—second edition, revised by J. G. Links, 2 vols., Oxford 1976.

Conti, Antonio: Prose e poesie, 2 vols., Venezia, 1739 and 1756.

Conti, Giuseppe: Firenze dai Medici ai Lorena, Firenze 1909.

Corner, Flaminio: Notizie storiche delle chiese e monasteri di Venezia e di Torcello tratte dalle chiese veneziane, e torcellane illustrate da F. C., Padova 1758.

Corti, G.: Galleria Colonna, Roma 1937.

Cosnac, Comte Gabriel-Jules de: Les richesses du Palais Mazarin, Paris 1885.

Costadoni, Don Anselmo: Memorie della vita di Flaminio Cornaro, Venezia 1780.

Costello, Jane: 'The twelve pictures "ordered by Velasquez" and the trial of Valguarnera' in *Journal of the Warburg and Courtauld Institutes*, 1950, pp. 237-284.

Coyer, Abbé: Voyages d'Italie et de Hollande, 2 vols., Paris 1775.

Cozzi, Gaetano: 'Intorno al Cardinale Ottaviano Paravicino, a Monsignor Paolo Gualdo e a Michelangelo da Caravaggio' in *Rivista Storica Italiana*, 1961, pp. 36-68.

Crescimbeni, G. M.: Dell'Istoria della Volgar Poesia, Venezia 1730.

Crespi—*Mostra celebrativa di Giuseppe M. Crespi*, Bologna 1948.

Crespi, Luigi: Vite de' Pittori bolognesi non descritte nella 'Felsina Pittrice', Roma 1769.

Crinò, Anna Maria: 'Due lettere autografe inedite di Orazio e di Artemisia Gentileschi' in *Rivista d'Arte*, 1954, pp. 203-206.

Croce, Benedetto: Lirici marinisti, Bari 1910.

Croce, Benedetto: 'Shaftesbury in Italia' reprinted in Uomini e cose della vecchia Italia, Bari 1927, pp. 272-309.

Croft-Murray, E.: Decorative Painting in England 1537-1837: Volume I—Early Tudor to Sir James Thornhill, London 1962.

Croft-Murray, E.: Decorative Painting in England 1537-1837: Volume 2—The 18th and early 19th centuries, London 1970.

Croft-Murray, E.: *See also* Blunt and Croft-Murray.

Crozet, René: La vie artistique en France au XVII siècle, 1598-1661: les artistes et la société, Paris 1954.

Cugnoni, G.: 'Agostino Chigi il Magnifico' in *Archivio della Società Romana di Storia Patria*, 1879, pp. 37-83, 209-226; 1880, pp. 213-232, 291-305, 422-448; 1881, pp. 56-75, 195-216.

Cust, L.: 'Notes on pictures in the Royal Collections' in *Burlington Magazine*, vol. XXIII, 1913, pp. 150-162 and 267-275.

Damerini, Gino: Morosini, Milano 1929.

Damerini, Gino: Caterina Dolfin Tron, Milano 1929.

Dandolo, Girolamo: La caduta della Repubblica di Venezia ed i suoi ultimi cinquant'anni, Venezia 1855.

Daniels, Jeffery: Sebastiano Ricci, Hove 1976.

Darmanno, Domenico: 'Inediti documenti sulle vicende di Alvise Zenobio' in *Archivio Veneto*, III, 1872, pp. 278-300.

Dati, Carlo: Delle lodi di Cassiano dal Pozzo, Firenze 1664.

Davis, James C.: The decline of the Venetian Nobility as a ruling class, Baltimore 1962.

Dazzi, Manlio: Carlo Goldoni e la sua poetica sociale, Torino 1957.

Delogu, Giuseppe: G. B. Castiglione detto Il Grechetto, Bologna 1928.

Delumeau, J.: La vie économique et sociale de Rome dans la seconde moitié du 16ème siècle, Paris 1957.

Demonts, Louis: 'Essai sur la formation de Simon Vouet en Italie' in *Bulletin de la Société de l'Histoire de l'Art Français*, 1913, pp. 309-348.

Denina, Carlo: Considérations d'un italien sur l'Italie, Berlin 1796.

Derschau, J. von: 'Irrige Zuschreibungen an Sebastiano Ricci' in *Monatshefte für Kunstwissenschaft*, 1916, pp. 161-169.

Derschau, J. von: Sebastiano Ricci, Heidelberg 1922.

Desjardins, Abel: L'œuvre de Jean Bologne, Paris 1883.

Le Dessin Français dans les Collections du XVIII siècle—catalogue of exhibition organised by *Gazette des Beaux-Arts*, Paris 1935.

Dhanens, Elizabeth: Jean Boulogne, Brussel 1956.

Dolfin, Bortolo Giovanni: I Dolfin, patrizii veneziani nella storia di Venezia, 2ª edizione, Milano 1924.

Dominici, Bernardo de: Vite dei pittori scultori ed architetti napoletani, 4 vols., Napoli 1843.

Donahue, Kenneth: 'The ingenious Bellori—a biographical study' in *Marsyas*, 1946.

Doni, G. B.: De' Trattati di Musica . . . raccolti e pubblicati per opera di A. F. Gori, 2 vols., Firenze 1763.

Donzelli, Carlo: I pittori Veneti del Settecento, Firenze 1957.

Dubon, David: Tapestries from the Samuel H. Kress Collection at the Philadelphia Museum of Art, London 1964.

Dudon, Paul: Le quiétiste espagnol Michel Molinos, Paris 1921.

Dumesnil, J.: Histoire des plus célèbres amateurs italiens, Paris 1853.

Dworschak, Fritz: 'Der Medailleur Gianlorenzo Bernini' in *Jahrbuch der Preussischen Kunstsammlungen*, 1934, pp. 27-41.

Ehrle, Franz: 'Dalle carte e dai disegni di Virgilio Spada' in *Atti della Pontificia Accademia Romana di Archeologia*, 1927.

Enggass, Robert: 'Bernini, Gaulli and the frescoes of the Gesù' in *Art Bulletin*, 1957, pp. 303-5.

Enggass, Robert: The Painting of Baciccio, Philadelphia 1964.

Enggass, Robert: 'The Altar-rail for St. Ignatius' Chapel in the Gesù di Roma' in *Burlington Magazine*, 1974, pp. 176-189.

Enggass, Robert: Early Eighteenth-Century Sculpture in Rome—an illustrated catalogue raisonné, 2 vols., Philadelphia 1976.

English Taste in the Eighteenth Century—catalogue of Exhibition at Royal Academy of Arts, London 1955-6.

Erithraeus, Janus Nicius [G. V. Rossi]: Pinacotheca imaginum illustrium, 3 vols., Coloniae, 1645-8.

Ernst, Serge: 'Stefano Torelli in Russia' in *Arte Veneta* 1970, pp. 173-184.

Eugen, Prinz, und sein Belvedere, Wien 1963.

Evelyn, John: Diary—edited by E. S. de Beer, 6 vols., Oxford 1955.

Ewald, Gerhard: Johann Carl Loth 1632-1698, Amsterdam 1965.

Ewald, Gerhard: 'Appunti sulla Galleria Gerini e sugli affreschi di Anton Domenico Gabbiani' in Kunst des Barock in der Toskana, München 1976, pp. 333-343.

Fabbri, Mario: Alessandro Scarlatti e il Principe Ferdinando de' Medici, Firenze 1961.

Fabrini, P. Natale: La chiesa di S. Ignazio in Roma, Roma 1952.

Fagiolo dell'Arca, Maurizio & Carandini, Silvia: L'Effimero Barocco—Strutture della festa nella Roma del '600, 2 vols., Roma 1977-8.

Faldi, Italo: 'I busti berniniani di Paolo Giordano e Isabella Orsini' in *Paragone*, 57, 1954, pp. 13-15.

Faldi, Italo: 'Paolo Guidotti e gli affreschi della "Sala del Cavaliere" nel Palazzo di Bassano di Sutri' in *Bollettino d'Arte*, 1957, pp. 278-295.

Fantuzzi, Conte Marco: Opere del Canonico Giovanni Andrea Lazzarini, Pesaro 1806.

Farsetti, T. G.: Notizie della famiglia Farsetti con l'albero e le vite di sei uomini illustri a quella spettanti, Venezia 1778.

Félibien: Entretiens sur les vies et sur les ouvrages des plus excellens peintres anciens et modernes . . . nouvelle édition, 6 vols., Trévoux 1725.

Felici, Giuseppe: Villa Ludovisi in Roma, Roma 1952.

Feliciangeli, B.: Il Cardinale Angelo Giori da Camerino e G. L. Bernini, Sanseverino-Marche 1917.

Ferrari, L.: I Carmelitani Scalzi a Venezia, Venezia 1882.

Ferrari, Luigi: 'Gli acquisti dell'Algarotti pel Regio Museo di Dresda' in *L'Arte*, 1900, pp. 150-154.

Ferrero, G. G.: Marino e i Marinisti, Milano-Napoli, 1954.

Festari, Girolamo: Giornale del viaggio nella Svizzera fatto da Angelo Querini Senatore Veneziano nel 1777—a cura di E. Cicogna, Venezia 1835.

Finberg, Hilda: 'Canaletto in England' in *Walpole Society*, IX, 1920-1, pp. 21 ff., and X, pp. 75-78.

Fisch, M. H. and Bergin, T. G.: The autobiography of Giambattista Vico, New York 1944.

Fleming, John: 'Cardinal Albani's drawings at Windsor—their purchase by James Adam for George III' in *Connoisseur*, 1958, vol. 142, pp. 164-169.

Fleming, John: 'Mssrs. Robert and James Adam: Art dealers (I)' in *Connoisseur*, 1959, vol. 144, pp. 168-171.

Fleming, John: Robert Adam and his circle, London 1962.

Florio, Daniele: Le Grazie, Venezia 1766.

Fochessati, G.: I Gonzaga di Mantova e l'ultimo duca, Milano 1930.

Fogolari, Gino: 'L'Accademia Veneziana di Pittura e Scoltura del Settecento' in *L'Arte*, 1913, pp. 364-394.

Fogolari, Gino: 'Il bozzetto del Tiepolo per il trasporto della Santa Casa di Loreto' in *Bollettino d'Arte*, 1931, pp. 18-32.

Fogolari, Gino: 'Lettere pittoriche del Gran Principe Ferdinando di Toscana a Niccolò Cassana (1698-1709)' in *Rivista del R. Istituto d'Archeologia e Storia dell'Arte*, 1937, pp. 145-186.

Fogolari, Gino: 'Lettere inedite di G. B. Tiepolo' in *Nuova Antologia*, 1942, Sett.-Ott., pp. 32-37.

Fomiciova, Tamara: 'Alcune opere di artisti della cerchia di Tiepolo nei musei dell'U.R.S.S.' in *Arte Veneta*, 1971, pp. 212-220.

Fontana, G. J.: Cento palazzi di Venezia—prima ristampa dall'originale, Venezia 1934.

Fontana, Vincenzo: 'Girolamo Manfrin e la manifattura tabacchi a Venezia di Bernardino Maccaruzzi' in *Bollettino dei Musei Civici Veneziani*, 1977, pp. 51-63.

[Fontanella, G. B.]: Memorie intorno la vita di Carlo Cordellina, Venezia 1801.

Les Français à Rome—exhibition at Hôtel de Rohan, Paris 1961.

Fraschetti, S.: Il Bernini, Milano 1900.

Freeden, Max H. von: Quellen zur Geschichte des Barocks in Franken unter dem Einfluss des Hauses Schönborn, I. Teil, zweiter Halbband, Würzburg 1955.

Freeden, Max H. von: Das Meisterwerk des G. B. Tiepolo, München 1956.

Friedlaender, Walter: Caravaggio Studies, Princeton 1955.

Frommel, Christoph Luitpold: 'Caravaggio's Frühwerk und der Kardinal Francesco Maria Del Monte' in Storia dell'Arte, 1971, pp. 5-52.

Gabbrielli, Annamaria: 'L'Algarotti e la critica d'arte in Italia nel Settecento' in La Critica d'Arte, 1938, pp. 155-169, and 1939, pp. 24-31.

Gabrieli, Giuseppe: Il carteggio Linceo della vecchia accademia di Federico Cesi (1603-1630), 4 vols., Roma 1939-42.

Gabrieli, Noemi: 'Aggiunte a Sebastiano Ricci' in Proporzioni, 1950, pp. 204-211.

Galassi Paluzzi, C.: 'Le decorazioni della sacrestia di S. Ignazio e il loro vero autore' in Roma, 1926, pp. 542-546.

Galassi Paluzzi, C.: Storia segreta dello stile dei Gesuiti, Roma 1951.

Galilei, Galileo: Ristampa dell'edizione nazionale, 20 vols., Firenze 1929-39.

Gallo, R.: I Pisani ed i Palazzi di S. Stefano e di Strà, Venezia 1945.

Gallo, R.: 'L'incisione nel '700 a Venezia e a Bassano' in Ateneo Veneto, 1948, pp. 153-214.

Galluzzi, J. R.: Istoria del Granducato di Toscana sotto il governo della Casa Medici, Firenze 1781.

Gamba, Carlo: 'Sebastiano Ricci e la sua opera fiorentina' in Dedalo, 1924-5, pp. 289-314.

Gar, Tommaso: 'Storia arcana ed altri scritti inediti di Marco Foscarini' in Archivio Storico Italiano, V. 1843.

Garas, Clara: 'Le plafond de la Banque Royale de Giovanni Antonio Pellegrini' in Bulletin du Musée Hongrois des Beaux-Arts, Budapest, 1962 (21), pp. 75-93.

Garas, Clara: 'The Ludovisi Collection of Pictures in 1633' in Burlington Magazine, 1967, pp. 287-289 and 339-348.

Garas, Clara: 'Giovanni Antonio Pellegrini in Deutschland' in Arte Veneta, 1971, pp. 285-292.

Garms, Jörg (editor): Quellen aus dem Archiv Doria-Pamphilj zur Kunsttätigkeit in Rom unter Innocenz X, Rome-Wien 1972.

Ghelli, M. E.: 'Il viceré marchese del Carpio (1683-1687)' in Archivio storico per le province napoletane, 1933, pp. 280-318, and 1934, pp. 257-282.

[Gherardi, P. E.]: Descrizione di cartoni disegnati da C. Cignani, e de' quadri dipinti da Sebastiano Ricci posseduti dal Signor Giuseppe Smith, Venezia 1749.

Gibbon, Edward: Letters—edited by J. E. Norton, 3 vols., London 1956.

Gigli, Giacinto: Diario Romano—a cura di Giuseppe Ricciotti, Roma 1958.

Giglioli, O. H.: 'Su un quadro del Volterrano nella Galleria degli Uffizi creduto finora di Giovanni da San Giovanni' in Bollettino d'Arte, 1908, pp. 335-358.

Giglioli, O. H.: Giovanni da San Giovanni, Firenze 1949.

Gilmartin, John: 'The Paintings commissioned by Pope Clement XI for the Basilica of S. Clemente in Rome' in Burlington Magazine, 1974, pp. 305-310.

Giussani, Antonio: I fasti della famiglia patrizia comasca dei Rezzonico, Como 1931.

Giustiniani, Abbate Michele: Lettere memorabili, 3 vols., Roma 1667, 1669, 1675.

Goering, M.: 'Pellegrini-Studien' in Münchner Jahrbuch der bildenden Kunst, 1937-8, pp. 233-250.

Goethe, J. G.: Viaggio in Italia (1740)—a cura di A. Farinelli, Roma 1932.

Goldoni, Carlo: Tutte le opere—a cura di Giuseppe Ortolani, Milano, 14 vols., 1935-1956.

Golzio, V.: 'Pittori e scultori nella chiesa di S. Agnese a Piazza Navona in Roma' in Archivi, 1933-4, pp. 300-310.

Golzio, V.: Documenti artistici sul Seicento nell'Archivio Chigi, Roma 1939.

[Gotti, A.]: Le Gallerie di Firenze—relazione al Ministro della Pubblica Istruzione in Italia, Firenze 1872.

Gould, C.: 'Bernini's bust of Mr Baker: The solution?' in *Art Quarterly*, 1958, pp. 167-176.

Gozzi, Gasparo: Lettere familiari, Venezia 1808.

Gozzi, Gasparo: Opere—edizione seconda, 22 vols., Venezia 1812.

Gradenigo, Pietro: Notizie d'arte tratte dai Notatori e dagli Annali—a cura di Lina Livan, Venezia 1942.

Grassi, L.: 'Pietro da Cortona e i "bozzetti" per la Galleria di Palazzo Doria Pamphili' in *Bollettino d'Arte*, 1957, pp. 28-43.

Grimaldo, C.: Giorgio Pisani e il suo tentativo di riforma, Venezia 1907.

Grisar, J.: 'Päpstliche Finanzen Nepotismus und Kirchenrecht unter Urban VIII' in *Miscellanea Historiae Pontificiae* edita a Facultate Historiae Ecclesiasticae in Pontificia Universitate Gregoriana, VII, 1943, pp. 207-365.

Griseri, A.: 'I bozzetti di Luca Giordano per l'Escaliera dell'Escorial' in *Paragone*, 81, 1956, pp. 33-39.

Griseri, A.: 'The Palazzo Reale at Turin' in *Connoisseur*, 1957, vol. 140, pp. 145-150.

[Grosley, Pierre Jean]: Nouveaux Mémoires ou observations sur l'Italie et sur les italiens, 3 vols., Londres 1764.

[Gualandi, Michelangelo]: Memorie originali risguardanti le Belle Arti, 6 vols., Bologna, 1840-5.

Gualdo Priorato, Galeazzo: Historia della Sacra Real Maestà di Christina Alessandra Regina di Svetia, Venezia 1656.

Gualdo Priorato, Galeazzo: Vita del Cav. Pietro Liberi pittore padovano, 1664, published Vicenza 1818.

Guelfi, Fausta Franchini: Alessandro Magnasco, Genoa 1977.

Guibert, J. de: La spiritualité de la Compagnie de Jésus, Roma 1953.

Guidalotti Franchini, Gioseffo: Vita di Domenico Maria Viani, Bologna 1716.

Hager, Luisa: Nymphenburg—official guide, München 1955.

Halsband, R.: Lady Mary Wortley Montagu, Oxford 1956.

Hanotaux, G.: Recueil des Instructions données aux Ambassadeurs et Ministres de France—VI (Rome 1648-1687), Paris 1888.

Hantsch, P. Hugo und Scherf, Andreas: Quellen zur Geschichte des Barocks in Franken unter dem Einfluss des Hauses Schönborn, I. Teil, erster Halbband, Augsburg 1931.

Harris, Ann Sutherland: Andrea Sacchi, Oxford (Phaidon), 1977.

Harris, Enriqueta: 'El Marqués del Carpio y sus cuadros de Velázquez' in *Archivo Español de Arte*, 1957, pp. 136-139.

Harris, Enriqueta: 'Velasquez's portrait of Camillo Massimi' in *Burlington Magazine*, 1958, pp. 279-280.

Harris, Enriqueta: 'La misión de Velázquez in Italia' in *Archivo Español de Arte*, 1960, pp. 109-136.

Harris, Enriqueta: 'A letter from Velasquez to Camillo Massimi' in *Burlington Magazine*, 1960, pp. 162-166.

Harris, Enriqueta: 'Angelo Michele Colonna y la decoración de San Antonio de los Portugueses' in *Archivo Español de Arte*, pp. 101-105.

Harris, Enriqueta: 'Cassiano dal Pozzo on Diego Velázquez' in *Burlington Magazine*, 1970, pp. 364-373.

Harris, Enriqueta & Andrés, Gregorio de: 'Descripción del Escorial por Cassiano dal Pozzo (1626)' in *Archivo Español de Arte*, 1972 (anejo).

Haskell, F.: 'P. Legros and a statue of the Blessed Stanislas Kostka' in *Burlington Magazine*, 1955, pp. 287-291.

Haskell, F.: 'Stefano Conti, patron of Canaletto and others' in *Burlington Magazine*, 1956, pp. 296-300.

Haskell, F.: 'Algarotti and Tiepolo's "Banquet of Cleopatra" ' in *Burlington Magazine*, 1958, pp. 212-213.

Haskell, F.: 'Painting and the Counter Reformation' in *Burlington Magazine*, 1958, pp. 396-399.

Haskell, F.: 'The market for Italian art in the 17th century' in *Past and Present*, April 1959, pp. 48-59.

Haskell, F.: 'Art exhibitions in Seventeenth century Rome' in *Studi Secenteschi*, I, 1960, pp. 107-121.

Haskell, F.: 'A note on artistic contacts between Florence and Venice in the 18th century' in *Bollettino dei Musei Civici Veneziani*, 1960, N. 3/4, pp. 32-37.

Haskell, F.: 'Pictures from Cambridge at Burlington House' in *Burlington Magazine*, 1960, pp. 71-72.

Haskell, F.: 'Francesco Guardi as *vedutista* and some of his patrons' in *Journal of the Warburg and Courtauld Institutes*, 1960, pp. 256-276.

Haskell, F.: 'The Apotheosis of Newton in Art' in *Texas Quarterly*, Autumn 1967, pp. 218-237.

Haskell, F.: 'Some Collectors of Venetian Art at the end of the Eighteenth Century' in Studies in Renaissance and Baroque Art presented to Anthony Blunt on his 60th birthday, London 1967, pp. 173-178.

Haskell, F. and Levey, M.: 'Art exhibitions in 18th-century Venice' in *Arte Veneta*, 1958, pp. 179-185.

Haskell, F. and Rinehart, S.: 'The dal Pozzo collection—some new evidence' in *Burlington Magazine*, 1960, pp. 318-326.

Hautecœur, L.: L'Histoire des Châteaux du Louvre et des Tuileries, Paris 1927.

Hazard, P.: La crise de la conscience européenne (1680-1715), Paris 1935.

Hazard, P.: La pensée européenne au XVIIIème siècle, 2 vols., Paris 1946.

Heikamp, Detlef: 'La Medusa del Caravaggio e l'armatura dello Scià 'Abbas di Persia' in *Paragone*, 1966 (199), pp. 62-76.

Heilbronner, P.: 'Arte italiana nel mondo—Architetti del Barocco a Monaco di Baviera' in *Le Vie d'Italia e del Mondo*, 1936, pp. 887-904.

Hervey, M. F. S.: The life, correspondence and collections of Thomas Howard, Earl of Arundel, Cambridge 1921.

Hess, J.: 'Die Gemälde des Orazio Gentileschi für das "Haus der Königin" in Greenwich' in *English Miscellany*, 1952, pp. 159-187.

Hess, J.: 'Contributi alla Storia della Chiesa Nuova (S. Maria in Vallicella)' in Scritti di Storia dell'Arte in onore di Mario Salmi, 3 vols., 1963, II, pp. 215-238.

Hibbard, H.: 'The early history of S. Andrea della Valle' in *Art Bulletin*, 1961, pp. 289-318.

Hibbard, H.: Carlo Maderno and Roman Architecture 1580-1630, London 1971.

Hibbard, H.: 'Recent Books on Earlier Baroque Architecture in Rome' in *Art Bulletin*, 1973, pp. 127-135.

Hinks, R.: Michelangelo Merisi da Caravaggio, London 1953.

Hofer, P.: Fragonard's drawings for Ariosto, London 1945.

Holst, Niels von: 'La pittura veneziana tra il Reno e la Neva' in *Arte Veneta*, 1951, pp. 131-140.

Honour, H.: 'English patrons and Italian sculptors in the first half of the eighteenth century' in *Connoisseur*, 1958, vol. 141, pp. 220-226.

Hoog, M.: 'Attributions anciennes à Valentin' in *Revue des Arts*, 1960, pp. 267-278.

Hoogewerff, G. J.: Bescheiden en Italie omtrent Nederlandsche Kunstenaars en Geleerden, 's-Gravenhage 1913.

Hoogewerff, G. J.: 'Il conflitto fra la insigne Accademia di S. Luca e la banda dei pittori neerlandesi' in *Archivio della Società Romana di Storia Patria*, 1935, pp. 189-203.

Hoogewerff, G. J.: Die Bentveughels, 's-Gravenhage, 1952.

Huetter, L. e Golzio, V.: S. Vitale, Roma n.d.

Hugford, Ignazio Enrico: Vita di Anton Domenico Gabbiani pittor fiorentino, Firenze 1762.

Hussey, C.: English country houses—Early Georgian, London 1955.

Ilg, A.: Prinz Eugen von Savoyen als Kunstfreunde, Wien 1889.

Incisa della Rocchetta, G.: 'Notizie inedite su Andrea Sacchi' in *L'Arte*, 1924, pp. 60-76.

Incisa della Rocchetta, G.: 'Il museo di curiosità del Cardinale Flavio Chigi Seniore' in *Roma*, 1925, III, pp. 539-544.

Incisa della Rocchetta, G.: 'Tre quadri Barberini acquistati dal Museo di Roma' in *Bollettino dei Musei Comunali di Roma*, 1959, pp. 20-37.

Isham, Sir Thomas—an English Collector in Rome, Northampton 1969.

Isnello, P. Domenico da: Il convento della Santissima Concezione de' Padri Cappuccini in Piazza Barberini di Roma, Viterbo 1923.

Italian Art and Britain—exhibition at Royal Academy of Arts, London 1960.

Ivanov, N.: 'Una postilla tiepolesca' in *Ateneo Veneto*, 1951, pp. 1-3.

Ivanovich, Cristoforo: Minerva al Tavolino, Venezia 1688.

Jaffé, Irma: *See* Wittkower and Jaffé.

Jaffé, M.: 'Peter Paul Rubens and the Oratorian fathers' in *Proporzioni*, IV, 1961.

Jahn-Rusconi, A.: La R. Galleria Pitti in Firenze, Roma 1937

Jones, Roger: *See* Krautheimer and Jones.

Kauffmann, E.: 'At an eighteenth-century crossroads: Algarotti vs. Lodoli' in *Journal of American Society of Architectural Historians*, 1944, pp. 23-29.

Kauffmann, E.: 'Piranesi, Algarotti and Lodoli (a controversy in XVIII century Venice)' in *Gazette des Beaux-Arts*, 1955, II, pp. 21-28.

Keysler, J. G.: Travels through Germany, Bohemia, Hungary, Switzerland, Italy and Lorrain, 2nd edition, 4 vols., London 1757.

King's Pictures—exhibition at Royal Academy of Arts, London 1946-7.

Kirwin, W. Chandler: 'Addendum to Cardinal Francesco Maria del Monte's Inventory: the Date of the Sale of Various Notable Paintings' in *Storia dell'Arte*, 1971, pp. 53-56.

Knox, G.: Tiepolo drawings in the Victoria and Albert Museum, London 1960.

Konopleva, M. S.: Teatralni Zhivopicets Giuseppe Valeriani, Leningrad 1948.

Krautheimer, Richard and Jones, Roger: 'The Diary of Alexander VII: Notes on Art, Artists and Buildings' in *Römisches Jahrbuch für Kunstgeschischte*, Band 15, 1975, pp. 199-233.

Kurz, O.: 'Engravings on Silver by Annibale Carracci' in *Burlington Magazine*, 1955, pp. 282-287.

Lalande, Joseph Jérôme le Français de: Voyage en Italie, seconde édition, 7 vols., Yverdon 1787.

Lancellotti, Secondo: L'Hoggidì overo il mondo non peggiore nè più calamitoso del passato, Venezia 1627.

Lanckoronska, K.: Decoracja Kosciola Il Gesù, Lvov 1935.

Lankheit, K.: 'Florentiner Bronze-arbeiten für Kurfürst Johann Wilhelm von der Pfalz' in *Münchner Jahrbuch der bildenden Kunst*, 1956, pp. 185-210.

Lankheit, Klaus: Florentinsche Barockplastik—Die Kunst am Hofe der Letzten Medici, 1670-1743, München 1962.

Laurain-Portemer, Madeleine: 'La politique artistique de Mazarin' in Atti dei Convegni Lincei, 35 (Colloquio italo-francese: Il Cardinale Mazzarino in Francia), 1977, pp. 41-76.

Lavagnino, E.: Gli artisti italiani in Germania, III: I pittori e gl'incisori, Roma 1943.

Lavin, Irving: Bernini and the Crossing of Saint Peter's, New York 1968.

Lavin, Irving: 'Bernini's death' in *Art Bulletin*, 1972, pp. 159-186.

Lavin, Marilyn Aronberg: Seventeenth-Century Barberini Documents and Inventories of Art, New York 1975.

Lazari, V.: Notizia delle opere d'arte e d'antichità della Raccolta Correr, Venezia 1859.

Leman, A.: Recueil des Instructions Générales aux Nonces Ordinaires de France de 1624 à 1634, Paris 1919.

Lepre, A.: 'Note sull'Algarotti' in *Società*, 1959, fasc. I, pp. 80-99.

Levey, M.: 'Tiepolo's "Banquet of Cleopatra" at Melbourne' in *Arte Veneta*, 1955, pp. 199-203.

Levey, M.: 'Tiepolo's "Empire of Flora" ' in *Burlington Magazine*, 1957, pp. 89-91.

Levey, M.: 'The modello for Tiepolo's altarpiece at Nymphenburg' in *Burlington Magazine*, 1957, pp. 256-261.

Levey, M.: 'Tiepolo's treatment of classical story at Villa Valmarana' in *Journal of the Warburg and Courtauld Institutes*, 1957, pp. 298-317.

Levey, M.: 'A note on Marshall Schulenburg's collection' in *Arte Veneta*, 1958, p. 221.

Levey, M.: 'Wilson and Zuccarelli at Venice' in *Burlington Magazine*, 1959, pp. 139-143.

Levey, M.: 'Francesco Zuccarelli in England' in *Italian Studies*, 1959, pp. 1-20.

Levey, M.: Painting in 18th century Venice, London 1959.

Levey, M.: 'Two paintings by Tiepolo from the Algarotti Collection' in *Burlington Magazine*, 1960, pp. 250-257.

Levey, M.: 'Canaletto's Fourteen Paintings and Visentini's *Prospectus Magni Canalis*' in *Burlington Magazine*, 1962, pp. 333-341.

Levey, M.: The later Italian pictures in the collection of Her Majesty the Queen, London 1964.

Levey, M.: 'Three slight revisions to Tiepolo scholarship' in *Arte Veneta*, 1978, pp. 418-422.

Levey, M.: *See also* Haskell and Levey.

Levi, C. A.: Le Collezioni Veneziane d'arte e d'antichità dal secolo XIV ai nostri giorni, Venezia 1900.

Limentani, U.: 'Poesie e lettere inedite di Salvator Rosa' in *Biblioteca dell'Archivum Romanicum*, 1950.

Limentani, U.: La satira nel Seicento, Milano-Napoli, 1961.

Litta, Pompeo: Famiglie celebri italiane, Milano e Torino, 1819-81.

Livan, Lina: 'Alcune date su Palazzo Rezzonico' in *Rivista di Venezia*, 1935, pp. 406-408.

Livan, Lina: *See also* Gradenigo.

Longhi, Alessandro: Compendio delle vite de' pittori veneziani istorici più rinomati del presente secolo, Venezia 1762.

Longhi, R.: 'Velazquez 1630: "La rissa all'ambasciata di Spagna" ' in *Paragone*, I, 1950, pp. 28-34.

Longhi, R.: 'Il Goya romano e la "cultura di Via Condotti" ' in *Paragone*, 53, 1954, pp. 28-39.

Longhi, R.: 'Un collezionista di pittura napoletana nella Firenze del '600' in *Paragone*, 75, 1956, pp. 61-64.

Longhi, R.: 'Il vero "Maffeo Barberini" del Caravaggio' in *Paragone*, 1963 (165), pp. 3-11.

Longo, Antonio: Memorie della vita—edizione seconda, 4 vols., Venezia 1820.

Lorenzetti, G.: 'Il mercato artistico a Venezia nel Settecento' in *Fanfulla della Domenica*, 1 Febbraio 1914.

Lorenzetti, G.: Un dilettante incisore veneziano del XVIII secolo—Anton Maria Zanetti di Gerolamo, Venezia 1917.

Lorenzetti, G.: Venezia e il suo estuario, Roma 1956.

Loret, M.: 'I pittori napoletani a Roma nel Settecento' in *Capitolium*, 1934, pp. 541-555.

Lotti, Giuseppe Antonio: Cenni storici della famiglia Carandini di Modena, Modena 1784.

Lumbroso, G.: Notizie sulla vita di Cassiano dal Pozzo, Torino 1874.

Luzio, Alessandro: La galleria dei Gonzaga venduta all'Inghilterra nel 1627-38, Milano 1913.

Maclaren, N.: The Spanish School (National Gallery Catalogue), London 1952.

Madrisio, Niccolò: Orazione all'Illustriss. e Reverindiss. Monsignor Dionigi Delfino Patriarca d'Aquileja in rendimento di grazie per la sontuosa Libreria da lui aperta in Udine à pubblico, e perpetuo commodo della sua Diocesi, Venezia 1711.

Mahon, D.: Studies in Seicento art and theory, London 1947.

Mahon, D.: 'Guercino's paintings of Semiramis' in *Art Bulletin*, 1949, pp. 217-223.

Mahon, D.: 'Addenda to Caravaggio' in *Burlington Magazine*, 1952, pp. 3-23.

Mahon, D.: 'Poussin's early development: an alternative hypothesis' in *Burlington Magazine*, 1960, pp. 288-304.

Mahon, D.: 'Mazarin and Poussin' in *Burlington Magazine*, 1960, pp. 352-354.

Mahon, D.: 'Réflexions sur les paysages de Poussin' in *Art de France*, 1961, pp. 119-132.

Mahon, D.: Poussiniana, published by *Gazette des Beaux-Arts*, Paris and New York 1962.

Malamani, V.: Canova, Milano n.d.

Malamani, V.: 'Rosalba Carriera', in *Le Gallerie Nazionali Italiane*, 1899, pp. 27-149.

Mâle, E.: L'art religieux de la fin du XVIème siècle, du XVIIème siècle et du XVIIIème siècle, Paris 1951.

Malvasia, Carlo Cesare: Felsina Pittrice, 2 vols., Bologna 1841.

Manchester, Duke of: Court and Society from Elizabeth to Anne, 2 vols., London 1864.

Mancini, Giulio: Considerazioni sulla Pittura, pubblicate per la prima volta da Adriana Marucchi con il commento da Luigi Salerno, 2 vols., Roma 1956.

Mandosio, Prospero: Bibliotheca Romana, Romae 1682.

Manini, Giuseppe: Serie de' Senatori Fiorentini, Firenze 1722.

Manuel, F. E.: The Eighteenth Century confronts the Gods, Oxford 1958.

Marabottini, A.: 'Novità sul Lucchesino' and 'Il "Trattato di Pittura" e i disegni del Lucchesino' in *Commentari*, 1954, pp. 116-135 and 217-244.

Marabottini, A.: 'Il naturalismo di Pietro Paolini' in Scritti di storia dell'Arte in onore di Mario Salmi, 1963, III, pp. 306-324.

Marcellino, T. M.: Una forte personalità nel patriziato veneziano del Settecento: Paolo Renier, Trieste 1959.

Marcheix, L.: Un Parisien à Rome et à Naples en 1632, Paris 1897.

Maresca di Serracapriola, A.: 'Il museo del duca di Martina' in *Napoli Nobilissima*, 1893, pp. 49-52, 74-77 and 109-111.

Mariacher, G.: 'Il continuatore del Longhena a Palazzo Pesaro ed altre notizie inedite' in *Ateneo Veneto*, 1951, pp. 1-6.

Mariacher, G.: Il Museo Correr di Venezia; dipinti dal XIV al XVI secolo, Venezia 1957.

Mariette, P. J.: Abecedario et autres notes inédites de cet amateur sur les arts et les artistes . . . ouvrage publié . . . par Ph. de Chennevières et A. de Montaiglon, Paris, 6 vols., 1853-1862.

Marrini, Abbate Orazio: Serie di Ritratti di Celebri Pittori dipinti di propria mano, 2 vols., Firenze 1765.

Martin, C. A.: Storia civile e politica del commercio dei Veneziani, 8 vols., Venezia, 1798-1808.

Martin, W.: 'The life of a Dutch artist'—Part VI: 'How the painter sold his work' in *Burlington Magazine*, XI, 1907, pp. 357-369.

Martyn, Thomas: A Tour through Italy, new edition, London [1791].

Marucelli, Francesco: Indice del Mare Magnum pubblicata a cura del Prof. Dott. Guido Biagi, Roma 1882.

Matina, L.: Ducalis Regiae Lararium, Venezia 1659.

Matteoli, A.: 'Macchie di sole e pittura: carteggio L. Cigoli-G. Galilei 1609-1613' in Accademia degli Eutelèti, Città di San Miniato 1959.

Maugain, G.: Évolution intellectuelle de l'Italie 1657-1750, Paris 1909.

Mauroner, F.: Luca Carlevarijs, Venezia 1945.

Mauroner, F.: 'Collezionisti e vedutisti settecenteschi a Venezia' in *Arte Veneta*, 1947, pp. 48-50.

Mazarin, G.: Epistolario inedito pubblicato da Carlo Morbio, Milano 1842.

Mazarin, G.: Lettres pendant son ministère recueillies et publiées par M. A. Chéruel, 9 vols., Paris 1872-1906.

Mazarin, homme d'état et collectionneur 1602-1661—exposition organisée pour le troisième centenaire de sa mort, Bibliothèque Nationale, Paris 1961.

Mazza, Barbara: 'La vicenda dei "Tombeaux des Princes": Matrici, storia e fortuna della serie Swiny tra Bologna e Venezia' in *Saggi e Memorie di storia dell'arte*, 10, 1976, pp. 79-102.

Mazzotti, G.: Le Ville Venete—catalogo, 3ª edizione, Treviso 1954.

Melchiori, L.: Lettere e letterati a Venezia e Padova a mezzo il secolo XVIII, Padova 1942.

Meloni Trkulja, Silvia: 'Luca Giordano a Firenze' in *Paragone*, 1972 (267), pp. 25-74.

Meloni Trkulja, Silvia: 'Leopoldo de' Medici collezionista' in *Paragone*, 1975 (307), pp. 15-38.

[Memmo, Andrea]: Elementi dell'architettura lodoliana, Roma 1786.

[Memmo, Andrea]: Riflessioni sopra alcuni equivoci sensi espressi dall'Ornatissimo Autore Della Orazione recitata in Venezia nell'Accademia di Pittura nel 1787, In Padova 1788.

Memmoli, Decio: Vita dell'Eminentissimo Signor Cardinale Gio. Garzio Mellino, Roma 1644.

Merriman, Mina Pajes: 'Giuseppe Maria Crespi's "Jupiter among the Corybantes"' in *Burlington Magazine*, 1976, pp. 464-472.

Mezzetti, A.: 'Contributi a Carlo Maratti' in *Rivista dell'Istituto Nazionale d'Archeologia e Storia dell'Arte*, 1955, pp. 253-354.

Miari, Conte F.: Il nuovo patriziato veneto dopo la serrata del maggior consiglio e la guerra di Candia, Venezia 1891.

Michaelis, A.: Ancient marbles in Great Britain, Cambridge 1882.

Michaud, E.: Louis XIV et Innocent XI, 4 vols., Paris 1882-3.

Miller, D.: 'Per Giuseppe Gambarini' in Arte Antica e Moderna, 1958, pp. 390-393.

Miller, D.: 'An unpublished letter by Giuseppe Maria Crespi' in Burlington Magazine, 1960, p. 530-531.

Miller, D.: 'The Gallery of Aeneid in the Palazzo Bonaccorsi at Macerata' in Arte Antica e Moderna, 1963, pp. 153-158 and 1964, p. 113.

Missirini, Melchior: Memorie per servire alla storia della Romana Accademia di S. Luca, Roma 1823.

Misson, Maximilien: Nouveau Voyage d'Italie, 4ème édition, 4 vols., La Haye 1717-22.

Mitchell, C.: 'Poussin's "Flight into Egypt"' in Journal of the Warburg and Courtauld Institutes, I, 1937-38, pp. 340-343.

Molinier, Em: See Müntz et Molinier.

Molino, Sebastiano: Orazione in lode di Marco Foscarini Procurator di S. Marco in [G. A. Molin]: Orazioni, elogj e vite scritte da letterati veneti patrizj, Venezia 1795.

Molmenti, P.: La storia di Venezia nella vita privata, 3 vols., Bergamo 1908.

Molmenti, P.: 'Il Palazzo Grassi a Venezia e un affresco attribuito a Tiepolo' in Emporium, 1909, XXIX, pp. 177-188.

Molmenti, P.: 'Le relazioni tra patrizi veneziani e diplomatici stranieri' in Curiosità di Storia Veneziana, Bologna 1919.

Molmenti, P.: 'Un nobil huomo veneziano del secolo XVIII' in Epistolari veneziani del secolo XVIII, Milano n.d.

Monaco, Pietro: Raccolta di centododici stampe di pittura della storia sacra incise per la prima volta in rame, e fedelmente copiate dagli originali esistenti in Venezia di celebri autori antichi e moderni, Venezia 1763.

Moncallero, G. L.: L'Arcadia, vol. I, Firenze 1953.

Monconys, Balthazar de: Journal des Voyages, 4 parts in 2 vols., Lyon 1665-6.

Montagu, Jennifer: 'The painted enigma and French seventeenth-century art' in Journal of the Warburg and Courtauld Institutes, 1968, pp. 307-335.

Montaiglon, A. de: Correspondance des Directeurs de l'Académie de France à Rome avec les Surintendants des Bâtiments, 18 vols., Paris 1887-1912.

Montalto, L.: 'Gli affreschi del Palazzo Pamphilj in Valmontone' in Commentari, 1955, pp. 267-302.

Morassi, A.: 'Settecento inedito III' in Arte Veneta, 1952, pp. 85-98.

Morassi, A.: G. B. Tiepolo, London 1955.

Morassi, A.: 'Some "modelli" and other unpublished works by Tiepolo' in Burlington Magazine, 1955, pp. 4-12.

Morassi, A.: 'Antonio Guardi ai servigj del Feldmaresciallo Schulenburg' in Emporium, 1960, pp. 147-164 and 199-212.

Morazzoni, G.: Il libro illustrato veneziano del Settecento, Milano 1943.

Morelli, J.: Bibliotheca Maphaei Pinelli Veneti . . . a Jacobo Morellio . . . descripta et annotationibus illustrata, 6 vols., Venetiis 1786.

Moroni, G.: Dizionario di erudizione storico-ecclesiastica da San Pietro sino ai nostri giorni, 109 vols., Venezia 1840-79.

Morpurgo, E.: Marco Foscarini e Venezia nel secolo XVIII, Firenze 1880.

Moschini, G. A.: Della letteratura veneziana nel secolo XVIII fino a' nostri giorni, 4 vols., Venezia 1806.

Moschini, G. A.: Della vita e delle opere del pittore Jacopo Guarana Veneziano e di altri veneti antichi pittori, Venezia 1808.

Moschini, G. A.: Sulla vita e sulle opere di Pietro Brandolese, Venezia 1809.

Moschini, G. A.: Memorie sulla vita del pittore Bernardino Castelli, Venezia 1810.

Moschini, G. A.: Guida per la Città di Venezia, Venezia 1815.

Moschini, G. A.: Dell'Incisione in Venezia—pubblicata a cura della Regia Accademia di Belle Arti di Venezia, Venezia 1924.

Moschini, V.: Canaletto, Milano 1954.

Moschini, V.: Pietro Longhi, Milano 1956.

Müntz, E.: Les Archives des Arts—recueil de documents inédits ou peu connus, première série, Paris 1890.

Müntz, E. et Molinier, Em: 'Le château de Fontainebleau au XVII siècle d'après des documents inédits' in Mémoires de la Société de l'Histoire de Paris et de l'Ile-de-France, XII, 1885, pp. 255-358.

Muraro, M.: 'L'Olympe de Tiepolo' in Gazette des Beaux-Arts, 1960, I, pp. 19-34.

Muraro, M.: 'Giuseppe Zais e un "giovin signore" nelle pitture murali di Stra' in Emporium, 1960, pp. 195-218.

Muraro, M. 'Studiosi, collezionisti e opere d'arte veneta dalle lettere al Cardinale Leopoldo de' Medici' in Saggi e Memorie di storia dell'arte, 4, 1965, Venezia, pp. 65-83.

Narducci, E.: 'Artisti dimoranti in Roma nel rione di Campo Marzio l'anno 1656' in Il Buonarotti, 1870, pp. 122-126.

Natali, G.: Storia letteraria d'Italia—Il Settecento, Milano 1929.

Naudaeana et Patiniana ou Singularitez remarquables prises des conversations de Mess. Naudé et Patin, seconde édition revue, Amsterdam 1703.

Neri, A.: Costumanze e sollazzi—aneddoti romani nel pontificato di Alessandro VII, Genova 1883.

N[eri], A.: 'Una lettera inedita di Francesco Algarotti' in Giornale Linguistico, 1885, pp. 296-299.

Neri, A.: 'Giuseppe Baretti e i Gesuiti' in Giornale Storico della Letteratura Italiana, 1899, Supplemento No. 2, pp. 106-129.

Neu-Mayr, A.: Illustrazione del Prato della Valle ossia della Piazza delle Statue di Padova, Padova 1807.

Nicodemi, G.: 'Otto lettere di Ludovico Carracci a Don Ferrante Carlo' in Aevum, 1935, pp. 305-313.

Nisser, W.: 'Lord Manchester's Reception at Venice' in Burlington Magazine, 1937, vol. 70, pp. 30-34.

Noack, F.: Das Deutschtum in Rom, Berlin und Leipzig 1927.

Nolhac, P. de: Le Virgile du Vatican et ses peintures, Paris 1897.

Northall, John: Travels through Italy, London 1767.

Novelli, Pietro Antonio: Memorie della vita—per le auspicate nozze del Marchese Giovanni Selvatico colla contessa Laura Contarini, Padova 1834.

Nuti, R.: 'Lettere di Giambattista Pasquali libraio editore in Venezia' in *Bibliofilia*, 1941, pp. 193-200.

Olivato, Loredana: 'Gli affari sono affari: Giovan Maria Sasso tratta con Tommaso degli Obizzi' in *Arte Veneta*, 1974, pp. 298-304.

Olivato, Loredana: 'Politica e retorica figurativa nella Venezia del Settecento. Alla riscoperta di un pittore singolare: Felice Boscarati' in *Arte Veneta*, 1977, pp. 145-156.

Omaggio a Leopoldo de' Medici—Gabinetto disegni e stampe degli Uffizi, XLIV, 1976, 2 Vols. (Parte I—Disegni; Parte II—Ritrattini).

[Ombrosi, Luca]: Vita del Gran Principe Ferdinando di Toscana in 'Biblioteca Grassoccia', Firenze 1887.

D'Onofrio, Cesare: La Villa Aldobrandini di Frascati, Roma 1963.

D'Onofrio, Cesare: 'Inventario dei dipinti del cardinal Pietro Aldobrandini, compilato da G. B. Agucchi nel 1603' in *Palatino*, 1964, pp. 15-20, 158-162, 202-211.

D'Onofrio, Cesare: Roma vista da Roma, Roma 1967.

Orbaan, J. A. F.: 'Virtuosi al Pantheon—Archivalische Beiträge zur römischen Kunstgeschichte' in *Repertorium für Kunstwissenschaft*, vol. 37, 1914-15, pp. 17-52.

Orbaan, J. A. F.: Documenti sul Barocco in Roma, Roma 1920.

Orlandi, Pellegrino Antonio: Abecedario Pittorico, Venezia 1753.

Orsi, Mario D': Corrado Giaquinto, Roma 1958.

Ortolani, Sergio: S. Andrea della Valle, Roma n.d.

Osti, O.: 'Sebastiano Ricci in Inghilterra' in *Commentari*, 1951, pp. 119-123.

[Ottonelli, Gio. Dom. S. J. e Pietro da Cortona]—Odomenigio Lelonotti da Fanano e Britio Prenetteri: Trattato della Pittura e Scultura, uso ed abuso loro, composto da un Theologo e da un Pittore, per offerirlo ai Sigg. Accademici del Disegno di Firenze, Firenze 1652.

Ottonelli, Gio. Dom.—Berrettini, P.: Trattato della Pittura e Scultura, (a cura di Vittorio Casale), Treviso 1973.

Ozzola, L.: 'L'Arte alla corte di Alessandro VII' in *Archivio della Società Romana di Storia Patria*, 1908, pp. 5-91.

Pacichelli, Abbate Gio: Battista: Memorie de' viaggi per l'Europa Christiana, Napoli 1685.

Pallavicino, P. Sforza: Della vita di Alessandro VII, Prato 1839.

Pallucchini, R.: 'Il pittore Giuseppe Angeli' in *Rivista di Venezia*, 1931, pp. 421-432.

Pallucchini, R.: 'Contributo alla biografia di Federico Bencovich' in *Atti del Reale Istituto Veneto di Scienze, Lettere ed Arti*, 1933-4, vol. 93, parte seconda, pp. 1491-1511.

Pallucchini, R.: Mostra degli Incisori Veneti del Settecento, Venezia 1941.

Pallucchini, R.: 'Studi ricceschi—(i) Contributo a Sebastiano' in *Arte Veneta*, 1952, pp. 63-84.

Pallucchini, R.: Piazzetta, Milano 1956.

Pallucchini, R. (prefazione): Gli affreschi nelle Ville Venete dal Seicento all'Ottocento: testi —Francesca d'Arcais, Franca Zava Bocazzi, Giuseppe Pavanello, 2 vols., Venezia 1978.

Palomino, Antonio: El Museo Pictorico, y escala optico, Madrid, 3 vols. in 2, 1715-1724.

Panciroli, : Tesori nascosti dell'alma città di Roma, Roma 1625.

Panofsky, E.: 'Imago pietatis', pp. 261-308 in Festschrift für Max J. Friedländer, Leipzig 1927.

Panofsky, E.: Galileo as critic of the arts, The Hague 1954.

Panofsky, E.: 'Et in Arcadia ego'—reprinted in Meaning in the Visual Arts, New York 1957.

[Paoletti, Ermalao]: Continuazione alla storia della Repubblica di Venezia, Venezia 1832.

Paolo Giordano II, duca di Bracciano: Rime e Satire, Bracciano 1649.

[Paravia, P. A.]: Delle lodi dell'Ab. Filippo Farsetti patrizio veneziano, Venezia 1829.

Parker, K. T.: Canaletto drawings in the Royal Library at Windsor Castle, London 1948.

Pascoli, Lione: Vite de' Pittori, Scultori ed Architetti moderni, I, 1730, and II, 1736—facsimile edition published by R. Istituto d'Archeologia e Storia dell'Arte, Roma 1933.

Passeri, G. B.: Vite de' Pittori Scultori et Architetti dall'anno 1641 sino all'anno 1673—herausgegeben von Jacob Hess, Leipzig und Wien 1934.

Pastor, Ludovico Barone von: Storia dei Papi dalla fine del medioevo—versione italiana di Mons. Prof. Pio Cenci, Roma 1943.

Patrignani, A.: 'Una rara medaglia del Card. Camillo Massimi (1620-1678)' in *Rivista italiana di Numismatica*, 1948, pp. 92-97.

Pecchiai, P.: Il Gesù di Roma, Roma 1952.

Pecchiai, P.: I Barberini, Roma 1959.

Peiresc, Nicolas Claude Fabri de: Lettres publiées par P. Tamizey de Larroque, 7 vols., Paris 1888-98.

Pellegrini, Giovanni Antonio, Disegni e Dipinti—catalogo della mostra, a cura di Alessandro Bettagno, Venezia 1959.

Perez Sanchez, Alfonso E.: Pintura Italiana del S. XVII en España, Madrid 1965.

Pergola, Paola della: Galleria Borghese—I Dipinti, 2 vols., Roma 1955-9.

Pesenti, P.: La basilica di Santa Maria Maggiore in Bergamo, Bergamo 1938.

Petrocchi, M.: Razionalismo architettonico e razionalismo storiografico, Roma 1947.

Petrocchi, M.: Roma nel Seicento, Bologna 1970.

Pevsner, N.: Academies of art, Past and present, Cambridge 1940.

Pieraccini, G.: La stirpe de' Medici di Cafaggiolo, 3 vols., Firenze 1925.

Pierantoni, A.: Lo sfratto di P. Giannone a Venezia, Roma 1892.

Pietro da Cortona—mostra a cura di A. Marabottini, Cortona e Roma 1956.

Pigage, Nicolas de: La galerie électorale de Düsseldorf, Bruxelles 1781.

Pignatti, T.: Il Museo Correr di Venezia—dipinti del XVII e XVIII secolo, Venezia 1960.

Pinetti, A.: 'La decorazione pittorica seicentesca di S. Maria Maggiore' in *Bollettino della Civica Biblioteca di Bergamo*, 1916, pp. 113-142.

Pinetti A:,. 'Di alcuni quadri settecenteschi di Bergamo e provincia tornati da Roma' in *La Fiera di Bergamo*, 1920.

Pintard, R.: Le libertinage érudit dans la première moitié du XVII siècle, Paris 1943.

Pirri, P.: 'Intagliatori Gesuiti Italiani dei Secoli XVI e XVII' in *Archivum Historicum Societatis Jesu*, 1952, pp. 3-59.

Pisano, G.: 'L'ultimo prefetto dell'Urbe—Don Taddeo Barberini' in *Roma*, 1931, pp. 103-120, and 155-164.

Pittura del Seicento a Venezia—catalogo della mostra, Venezia 1959.

von Platen, Magnus (editor): Queen Christina of Sweden—documents and studies, Stockholm 1966.

Poirier, Maurice: 'Pietro da Cortona e il dibattito disegno-colore' in *Prospettiva*, 1979 (16), pp. 23-30.

Pollak, O.: 'Italienische Künstlerbriefe aus der Barockzeit' in *Jahrbuch der Königlich-Preuszischen Kunstsammlungen*, 1913—Beiheft.

Pollak, O.: Die Kunsttätigkeit unter Urban VIII, 2 vols., Wien 1927 and 1931.

Pöllnitz, Baron Charles Louis de: Mémoires contenant les observations qu'il a faites dans ses voyages, 3 vols., Liège 1734.

Ponnelle, L. and Bordet, L.: St Philip Neri and the Roman society of his times, London 1932.

Ponte, Lorenzo da: Memorie, Milano 1960.

Pope-Hennessy, J.: 'Two portraits of Domenichino' in *Burlington Magazine*, 1946, pp. 186-191.

Pope-Hennessy, J.: Domenichino drawings in the Royal Library at Windsor Castle, London 1948.

Pope-Hennessy, J.: 'Some bronze statues by Francesco Fanelli' in *Burlington Magazine*, 1953, pp. 157-162.

Popham, A. E. and Wilde, J.: Italian drawings of the XV and XVI centuries in the Royal Library at Windsor Castle, London 1949.

Portoghesi, P.: 'I monumenti borrominiani della Basilica Lateranense' in Quaderni dell'Istituto di Storia dell'Architettura, Luglio 1955.

Portoghesi, P.: 'Il palazzo, la villa e la chiesa di S. Vincenzo a Bassano' in *Bollettino d'Arte*, 1957, pp. 222-240.

Posner, Donald: 'Caravaggio's homo-erotic early works' in *Art Quarterly*, 1971, pp. 301-324.

Posse, H.: Der römische Maler Andrea Sacchi, Leipzig 1925.

Posse, H.: Die Staatliche Gemäldegalerie zu Dresden—Erste Abteilung: Die romanischen Länder, Dresden und Berlin 1929.

Posse, H.: Die Briefe des Grafen Francesco Algarotti an den sächsischen Hof und seine Bilderkäufe für die Dresdner Gemäldgalerie 1743-1747 in *Jahrbuch der Preuszischen Kunstsammlungen*, 1931. Beiheft.

Poussin, Nicolas: Correspondance publiée d'après les originaux par Ch. Jouanny, Paris 1911.

Poussin, Nicolas—catalogue de l'exposition par Sir Anthony Blunt, Paris 1960.

Powell, N.: From Baroque to Rococo, London 1959.

Pozzo, Giovanni da: 'Il Testamento dell'Algarotti' in *Atti dell'Istituto Veneto di Scienze, Lettere ed Arti*—1963-4, Tomo CXXII (Classe di scienze morali e lettere), pp. 181-192.

Precerutti Garberi, Mercedes: 'Di alcuni dipinti perduti del Tiepolo' in *Commentari*, 1958, pp. 110-123.

Presenzini, A.: Vita ed opere del pittore Andrea Camassei, Assisi 1880.

Previtali, G.: 'Collezionisti di primitivi nel Settecento' in *Paragone*, 1959, 113, pp. 3-32.

Previtali, G.: La Fortuna dei Primitivi dal Vasari ai Neoclassici', Torino 1964

Prinz, Wolfram: Die Sammlung der Selbstbildnisse in den Uffizien—Band I: Geschichte der Sammlung, Berlin 1971.

Procacci, Lucia & Ugo: 'Il carteggio di Marco Boschini con il Cardinale Leopoldo de' Medici' in *Saggi e Memorie di storia dell'arte*, 4, 1965, Venezia, pp. 85-114.

Prota-Giurleo, U.: Pittori Napoletani del Seicento, Napoli 1953.

Prunières, H.: L'opéra italien en France avant Lulli, Paris 1913.

Prunières, H.: La vie et l'œuvre de Claudio Monteverdi, Paris 1926.

Puliti, L.: Cenni storici della vita del serenissimo Ferdinando dei Medici, Gran Principe di Toscana, Firenze 1875.

Puppi, Lionelli: 'I Tiepolo a Vicenza e le statue dei "nani" di Villa Valmarana a S. Bastiano' in *Atti dell'Istituto Veneto di Scienze, Lettere ed Arti*, 1967-8, Tomo CXXVI (Classe di scienze morali, lettere ed arti), pp. 211-250.

Puppi, Lionello: 'Carlo Cordellina committente d'artisti' in *Arte Veneta*, 1968, pp. 212-216.

Puyvelde, L. van: 'Les "Saint Ignace" et "Saint François Xavier" de Rubens' in *Gazette des Beaux-Arts*, 1959, I, pp. 225-236.

Radcliffe, Anthony: 'Two Bronzes from the Circle of Bernini' in *Apollo*, 1978, pp. 418-423.

Radicchio, Don Vincenzo: Descrizione della general idea concepita, ed in gran parte effettuata dall'eccellentissimo signore Andrea Memmo quando fu . . . nel MDCCLXXV, e VI provEditor straordinario della città di Padova sul materiale del Prato, che denominavasi della Valle onde renderlo utile anche per la potentissima via del diletto a quel popolo ed a maggior decoro della stessa città, Roma 1786.

Rapparini: Die Rapparini-Handschrift—herausgegeben und kommentiert von Hermine Kühn-Steinhausen, Düsseldorf 1958.

Rava, A.: 'Contributo alla biografia di Pietro Longhi' in *Rassegna Contemporanea*, IV, 1911, pp. 297-307.

Rava, A.: 'Incisioni su stagno di Francesco Algarotti' in *L'Arte*, 1913, pp. 58-61.

Rava, A.: 'Il teatro Ottoboni nel Palazzo della Cancelleria' in Quaderni del Centro Nazionale di Studi di Storia dell'Architettura, III, 1942.

Redig de Campos, D.: 'Intorno a due quadri d'altare di Van Dyck per il Gesù di Roma ritrovati in Vaticano' in *Bollettino d'Arte*, 1936, XXX, pp. 150-165.

Remondini—catalogo della mostra a cura di G. Barioli, Bassano 1958.

Renaldis, Conte Girolamo de: Memorie storiche dei tre ultimi secoli del patriarcato d'Aquileia (1411-1751), Udine 1888.

Reni, Guido—catalogo critico della mostra a cura di G. C. Cavalli, saggio introduttivo di C. Gnudi, Bologna 1954.

Ricci, Amico: Memorie storiche delle arti e degli artisti della Marca d'Ancona, 2 vols., Macerata 1834.

Richa, Giuseppe: Notizie istoriche delle chiese Fiorentine divise ne' suoi quartieri, 10 vols., Firenze 1754-62.

Richard, l'Abbé: Description historique et critique de l'Italie, 6 vols., Dijon 1766.

Richeôme, Louis: La peinture spirituelle, Lyon 1611.

Rinaldis, A. de: 'D'Arpino e Caravaggio' in *Bollettino d'Arte*, XXIX, 1936, pp. 577-580.

Rinaldis, A. de: 'Le opere d'arte sequestrate al Cavalier d'Arpino' in *Archivi*, 1936, pp. 110-118.

Rinaldis, A. de: Lettere inedite di Salvator Rosa a G. B. Ricciardi, Roma 1939.

Rinehart, S.: 'Poussin et la famille dal Pozzo' in *Actes du Colloque Poussin*, 1960, I, pp. 19-30.

Rinehart, S.: 'Cassiano dal Pozzo (1588-1657), Some unpublished letters' in *Italian Studies*, 1961, pp. 35-59.

Rinehart, S.: *See also* Haskell and Rinehart.

Ritschl, H.: Katalog der Erlaucht Gräflich Harrachschen Gemälde-Galerie in Wien, Wien 1926.

[Rivani, G.]: 'Opere di Donato Creti nella Raccolta della Cassa di Risparmio di Bologna' in *Strenna Storica Bolognese*, 1959.

Roberti, T.: 'Lettere inedite di Gasparo Gozzi al tipografo Giambattista Remondini' in *Antologia Veneta*, 1900, pp. 326-335.

Robertson, J. G.: The genesis of romantic theory, Cambridge 1923.

Robiony, E.: 'La Madonna dal collo lungo di Parmigianino' in *Rivista d'Arte*, 1904, pp. 19-22.

Rohe, W. M. van der: 'The marriage at Cana by Giuseppe Maria Crespi' in *Art Institute of Chicago Quarterly*, 1958, pp. 6-9.

Rohrlach, P.: 'La collezione di quadri Streit nel Graues Kloster a Berlino' in *Arte Veneta*, 1951, pp. 198-200.

Romanin, S.: Storia documentata di Venezia, 2ª edizione ristampata sull'unica pubblicata, 1853-1861, 10 vols., Venezia 1912-21.

Romano, P.: Pasquino e la satira in Roma, Roma 1932.

Rosenberg, Pierre: 'Un tableau de Volterrano réattribué: l'Allégorie à la gloire de Louis XIV' in *Paragone* 1976, (317-319), pp. 167-172.

Rosi, M.: 'La congiura di Giacomo Centini contro Urbano VIII' in *Archivio della Società Romana di Storia Patria*, 1899, pp. 347-370.

Rossi, Elisabetta Antoniazzi: 'Ulteriori considerazioni sull'inventario della collezione del Maresciallo von Schulenburg' in *Arte Veneta*, 1977, pp. 126-134.

Röthlisberger, M.: 'Les pendants dans l'œuvre de Claude Lorrain' in *Gazette des Beaux-Arts*, 1958, I, pp. 215-228.

Röthlisberger, M.: Claude Lorrain—The Paintings, 2 vols., Yale and London 1961.

Rudolph, Stella: 'Mecenati a Firenze tra Sei e Settecento: 1—I Committenti Privati; 2—Aspetti dello stile Cosimo III' in *Arte Illustrata*, 1971 (49), pp. 228-239; 1972 (54), pp. 213-228.

Ruffo, V.: 'La galleria Ruffo nel secolo XVII in Messina' in *Bollettino d'Arte*, X, 1916.

Sagredo, A.: Sulle consorterie delle Arti edificatorie in Venezia, Venezia 1857.

Salerno, L.: 'The Picture Gallery of Vincenzo Giustiniani' in *Burlington Magazine*, 1960, pp. 21-27, 93-104, 135-150.

Salvagnini, F. A.: I pittori Borgognone-Cortese, Roma 1937.

Salvino, Salvini: Catalogo cronologico de' Canonici della chiesa metropolitana fiorentina compilato l'anno 1751, Firenze 1782.

Santangelo, A.: Museo di Palazzo Venezia-Catalogo, 1—I dipinti, Roma 1947.

Santifaller, Maria: 'In margine alle ricerche tiepolesche. Un ritrattista germanico di Francesco Algarotti: Georg Friedrich Schmidt' in *Arte Veneta*, 1976, pp. 204-209.

Santifaller, Maria: 'Alcuni "griffonnages" su stagno di Francesco Algarotti e la grafica di Giambattista Tiepolo' in *Arte Veneta*, 1977, pp. 135-144.

Santifaller, Maria: 'Christian Bernhard Rode's painting of Francesco Algarotti's tomb in the Camposanto of Pisa at the beginning of neo-classicism' in *Burlington Magazine*, Feb. 1978, advertising supplement.

Sasso, G. M.: Catalogo de' quadri del q. Giammaria Sasso, che si mettono all'incanto nella sua casa al ponte di Cannareggio, n. 381.

Sasso, G. M.: Osservazioni sopra i lavori di niello—a cura di E. Cicogna, per nozze Michieli-Segatti, Venezia 1856.

Saxl, F.: 'The battle scene without a hero—Aniello Falcone and his patrons' in *Journal of the Warburg and Courtauld Institutes*, III, 1939-40, pp. 70-87.

Schlosser-Magnino, J.: La letteratura artistica, seconda edizione, Firenze 1956.

Schudt, L.: Italienreisen im 17. und 18. Jahrhundert, Wien 1959.

Seicento Europeo—mostra organizzata dal Ministero Italiano della P.I. sotto gli auspici del Consiglio d'Europa, Roma 1956-7.

[Seilern, Count A.]: Italian paintings and drawings at 56 Princes Gate, London 1959.

[Selva, G. A.]: Catalogo dei quadri dei disegni e dei libri che trattano dell'arte del disegno della galleria del fu Sig. Conte Algarotti in Venezia, Venezia [1776].

Sensier, A.: Le journal de Rosalba Carriera pendant son séjour à Paris en 1720 et 1721, Paris 1865.

Sforza, G.: 'Il testamento d'un bibliofilo e la famiglia Farsetti di Venezia' in *Memorie della R. Accademia delle Scienze di Torino*, 2ª serie, vol. 61, 1911, pp. 153-195.

Sgrilli, Bernardo Sansone: Descrizione della Regia Villa, Fontane e Fabbriche di Pratolino, Firenze 1742.

Shaftesbury, Third Earl of: Second Characters or The Language of Forms—edited by Benjamin Rand, Cambridge 1914.

Shipley, John B.: 'Ralph, Ellys, Hogarth, and Fielding: The Cabal against Jacopo Amigoni' in *Eighteenth-Century Studies* (University of California), Vol. I, no. 4, June 1968, pp. 313-331.

S[ilhouette, Étienne de]: Voyage de France, d'Espagne, de Portugal et d'Italie du 22 Avril 1729 au 6 Février 1730, Paris 1770.

Sirén, O.: Dessins et tableaux italiens de la Renaissance dans les collections de Suède, Stockholm 1902.

Skippon, Philip: An account of a journey through parts of the Low Countries, Germany, Italy and France in A Collection of Voyages and Travels, vol. VI, London 1752, pp. 359-736.

Slive, S.: Rembrandt and his critics 1630-1730, The Hague 1953.

Smith, H. Clifford: Buckingham Palace, London 1930.

Solerti, A.: Musica, Ballo e Drammatica alla Corte Medicea dal 1600 al 1637, Firenze 1905.

Soprani, Raffaello: Vite de' Pittori, Scultori ed Architetti Genovesi—in questa seconda edizione rivedute accresciute ed arrichite di note da Carlo Giuseppe Ratti, 2 vols., Genova 1768.

Sotheby's—*An Exhibition of Old Master Drawings and European Bronzes from the Collection of Charles Rogers (1771-1784) and the William Cotton Bequest* on loan from The City Museum and Art Gallery, Plymouth 1979.

Spezzaferro, Luigi: 'La cultura del Cardinal Del Monte e il primo tempo del Caravaggio' in *Storia dell'Arte*, 1971, pp. 57-92.

Spini, G.: Ricerca dei libertini, Roma 1950.

Spon, Jacob et Wheler, George: Voyage d'Italie . . . fait aux années 1675 et 1676, 2 vols., La Haye 1724.

Steinbart, K.: 'Die Gemalten Schwänke des Pfarrers Arlotto' in *Pantheon*, 1936, pp. 233-234.

Sterling, C.: 'Gentileschi in France' in *Burlington Magazine*, 1958, pp. 112-120.

Stone, L.: 'The market for Italian art' in *Past and Present*, 1959, pp. 92-94.

Strocchi, Maria Letizia: 'Il Gabinetto d''opere in piccolo' del Gran Principe Ferdinando a Poggio a Caiano' in *Paragone*, 1975 (309), pp. 115-126 and 1976 (311), pp. 83-116.

Strong, E.: La Chiesa Nuova (S. Maria in Vallicella), Roma 1923.

Stuffmann: 'Les tableaux de la collection de Pierre Crozat' in *Gazette des Beaux-Arts*, 1968, pp. 11-144.

Sweetman, J. E.: 'Shaftesbury's last commission' in *Journal of the Warburg and Courtauld Institutes*, 1956, pp. 110-116.

Tabacco, G.: Andrea Tron e la crisi dell'aristocrazia senatoria a Venezia, Trieste 1957.

Tacchi-Venturi, P.: 'Le convenzioni tra Giov. Battista Gaulli e il Generale dei Gesuiti' in *Roma*, 1935, pp. 147-156.

Tacchi-Venturi, P.: La casa di S. Ignazio di Loiola in Roma, Roma n.d.

Tamizey de Larroque, P.: 'Deux testaments inédits' in *Bulletin Critique*, 15 Mai 1886.

Tapié, V. L.: La France de Louis XIII et de Richelieu, Paris 1952.

Tassi, F. M.: Vite de' Pittori, Scultori e Architetti Bergamaschi, Bergamo 1793.

Tassini, G.: Curiosità Veneziane, 5ª edizione, Venezia 1915.

Taylor, F. H.: The taste of angels—a history of art collecting from Rameses to Napoleon, Boston 1948.

Temanza, T.: Vite dei più celebri architetti, e scultori veneziani, Venezia 1778.

Tentori, Abbate D. Cristoforo: Saggio sulla storia civile, politica, ecclesiastica e sulla corografia e topografia degli stati della repubblica di Venezia, 12 vols., Venezia 1785-90.

Terrebasse, Alfred de: Relation des principaux événements de la vie de Salvaing de Boissieu, Lyon 1850.

Tervarent, G. de: Attributs et symboles dans l'art profane 1450-1600, Genève 1959.

Tesi, Mauro: Raccolta di disegni originali estratti da diverse collezioni pubblicata da Lodovico Inig calcografo in Bologna—aggiuntavi la vita dell'autore [Bologna 1787].

Tessier, A.: 'Di Francesco Maggiotto—pittore veneziano' in *Archivio Veneto*, 1882, pp. 289-315.

Teti, Girolamo: Aedes Barberinae ad Quirinalem a comite Hieronymo Tetio Persino descriptae, Romae MDCXLII.

Thuillier, J.: 'Un peintre passionné' in *L'Œil*, No. 47, Nov. 1958, pp. 26-33.

Thuillier, J.: 'Pour un "Corpus Poussinianum" ' in *Actes du Colloque Poussin*, 1960, II, 49-238.

Tiepolo—catalogo della mostra a cura di Giulio Lorenzetti, Venezia 1951.

Tietze, H.: 'Andrea Pozzo und die Fürsten Liechtenstein' in *Jahrbuch für Landeskunde von Niederösterreich*, 1914-15, pp. 432-446.

Tietze, H.: 'Eugenio di Savoia amico dell'arte' in *Le Vie d'Italia e del Mondo*, 1933, pp. 891-907.

Tipaldo, Emilio de: Descrizione della deliziosa villa di Sala di proprietà del signor Demetrio Mircovich, Venezia 1833.

Tipaldo, Emilio de: Biografia degli Italiani illustri nelle scienze, lettere ed arti del secolo XVIII, e de' contemporanei, 10 vols., Venezia 1834-45.

Toesca, I.: 'Alessandro Galilei in Inghilterra' in *English Miscellany*, Roma 1952, pp. 189-220.

Toesca, I.: 'Note sulla storia del Palazzo Giustiniani a San Luigi dei Francesi' in *Bollettino d'Arte*, 1957, pp. 296-308.

Torcellan, Gianfranco: Una figura della Venezia settecentesca: Andrea Memmo, Venezia-Roma 1963.

Torcellan, Gianfranco: Settecento veneto e altri scritti storici, Torino 1969.

Trapier, E. du Gué: Ribera, New York 1952.

Trauman-Steinitz, K.: 'Poussin illustrator of Leonardo da Vinci' in *Art Quarterly*, Spring 1953, pp. 40-55.

Treat, I.: Un cosmopolite italien du XVIIIème siècle—Francesco Algarotti, Trévoux 1913.

Turberville, A. S.: A history of Welbeck Abbey and its owners, London 1939.

Turner, Nicholas: 'Ferrante Carlo's Descrittione della Cupola di S. Andrea della Valle depinta dal Cavalier Gio: Lanfranchi; a source for Bellori's descriptive method' in *Storia dell'Arte*, 1971, pp. 297-325.

Twilight of the Medici—Late Baroque Art in Florence 1670-1743, Detroit and Florence 1974.

Ubaldi, S.: I Buonaccorsi a Macerata, cenni storici, Macerata 1950.

Urbani de Ghelthof, G. M.: Tiepolo e la sua Famiglia, Venezia 1879.

Urbino—Restauri nelle Marche: testimonianze, acquisti e recuperi, 1973.

Vaes, M.: 'Le séjour de Van Dyck en Italie' in *Bulletin de l'Institut Belge de Rome*, 1924, pp. 163-234.

Vaes, M.: 'Corneille de Wael (1592-1667)' in *Bulletin de l'Institut Belge de Rome*, 1925, pp. 137-247.

Vaes, M.: 'Appunti di Carel van Mander su vari pittori italiani suoi contemporanei'; in *Roma*, 1931, pp. 193-208.

Valcanover, F.: 'Per Luca Carlevaris' in *Arte Veneta*, 1952, pp. 193-194.

Valery, A. C. P.: Voyages historiques, littéraires et artistiques en Italie, 2ème édition, 3 vols., Paris 1838.

Valfrey, J.: Hugues de Lionne—ses ambassades en Italie 1642-1656, Paris 1877.

Valle, G. della; Lettere Sanesi, 3 vols., Roma 1782-6.

Vassar College Art Gallery—Selections from the Permanent Collection, Poughkeepsie, N.Y. 1967.

Vecchi, A.: La vita spirituale in 'La Civiltà Veneziana del Settecento', Venezia 1960.

Venezia, G. da: 'Il Metastasio di P. A. Novelli' in *Rivista di Venezia*, 1934, pp. 25-34.

Venise au dix-huitième siècle, Paris (Orangerie), 1971.

Venturi, A.: La R. Galleria Estense in Modena, Modena 1883.

Venturi, F.: 'Un amico di Beccaria e di Verri: Profilo di Giambattista Biffi' in *Giornale Storico della Letteratura Italiana*, 1957, pp. 37-76.

Venturi, F.: Settecento riformatore, 2 vols., Torino 1969 and 1976.

Vermeule, C.: 'The dal Pozzo-Albani drawings of classical antiquities' in *Art Bulletin*, 1956 pp. 32-46.

Vertue, George: Notebooks, published in 6 vols., and an index by the Walpole Society, XVIII, XX, XXII, XXIV, XXVI, XXIX, XXX, (1930-55).

Viale, V.: 'Un dipinto del Pannini con la veduta orientale del Castello di Rivoli secondo il progetto originale di Filippo Juvarra' in *Bollettino della Società Piemontese di Archeologia e Belle Arti*, 1950-1, pp. 161-169.

Vianelli, Don Giovanni: Catalogo di quadri esistenti in casa il signor Don Giovanni Dr Vianelli canonico della cattedrale di Chioggia, Venezia 1790.

Ville sur-Yllon, Ludovico de la: 'Il palazzo dei duchi di Maddaloni alla Stella' in *Napoli Nobilissima*, 1904, pp. 145-147.

Villot, Frédéric: 'Lettre de Charles-Nicolas Cochin sur les artistes de son temps' in *Archives de l'Art Français*, I, 1851-2, pp. 169-176.

Viola, Gianni Eugenio: Il verso di Narciso—tre tesi sulla poetica di Giovan Battista Marino, Roma 1978.

Vitzthum, W.: 'A comment on the iconography of Pietro da Cortona's Barberini ceiling' in *Burlington Magazine*, 1961, pp. 427-433.

Vitzthum, W.: 'Roman drawings at Windsor Castle' in *Burlington Magazine*, 1961, pp. 513-518.

Vivian, Frances: 'Joseph Smith and Giovanni Antonio Pellegrini' in *Burlington Magazine*, 1962, pp. 330-333.

Vivian, Frances: 'Joseph Smith, Giovanni Poleni and Antonio Visentini' in *Italian Studies*, 1963, pp. 54-66.

Vivian, Frances: Il Console Smith mercante e collezionista, Vicenza 1971.

Voss, H.: 'Gio Antonio Canal und Owen McSwiny' in *Repertorium für Kunstwissenschaft*, 1926, pp. 32-37.

Voss, H.: 'Die Flucht nach Aegypten' in Saggi e Memorie di Storia dell'Arte, Venezia 1957, pp. 25-61.

Walker, D. P.: Spiritual and demonic magic from Ficino to Campanella, London 1958.

Walker, J.: Bellini and Titian at Ferrara, London 1956.

Walpole, Horace: Anecdotes of Painting in England, 5 vols., Strawberry Hill 1726.

Walpole, Horace: Aedes Walpoliane, 3rd edition, London 1767.

Waterhouse, E. K.: 'Some Old Masters other than Spanish at the Bowes Museum' in *Burlington Magazine*, 1953, pp. 120-123.

Waterhouse, E. K.: 'A note on British collecting of Italian pictures in the later seventeenth century' in *Burlington Magazine*, 1960, pp. 54-58.

Waterhouse, E. K.: 'Painting in Rome in the Eighteenth Century' in *Museum Studies*, Art Institute of Chicago, 1971, pp. 7-21.

Watson, F. J. B.: Canaletto, London 1949.

Watson, F. J. B.: 'The Nazari—a forgotten family of Venetian portrait painters' in *Burlington Magazine*, 1949, pp. 75-79.

Watson, F. J. B.: 'An allegorical painting by Canaletto, Piazzetta and Cimaroli' in *Burlington Magazine*, 1953, pp. 362-365.

Watson, F. J. B.: 'A Venetian Settecento chapel in the English countryside' in *Arte Veneta*, 1954, pp. 295-301.

Watson, F. J. B.: 'English villas and Venetian decorators' in *Journal of the Royal Institute of British Architects*, 1954, pp. 11-177.

Watson, F. J. B.: 'Giovanni Battista Tiepolo: a masterpiece and a book' in *Connoisseur*, 1955, vol. 136, pp. 212-215.

Watson, F. J. B.: 'A series of "Turqueries" by Francesco Guardi' in *Baltimore Museum of Arts Quarterly*, Fall 1960, pp. 3-13.

Weil, Mark S.: The History and Decoration of the Ponte S. Angelo, Pennsylvania 1974.

Wells, W.: 'Shaftesbury and Paolo de Matteis' in *Leeds Art Quarterly*, Spring 1950, pp. 23-28.

Wethey, Harold R.: 'The Spanish Viceroy, Luca Giordano and Andrea Vaccaro' in *Burlington Magazine*, 1967, pp. 678-686.

Wheatley, H. B.: London past and present, London 1891.

Whinney, M. and Millar, O.: English Art, 1625-1714, Oxford 1957.

White, D. Maxwell and Sewter, A. C.: 'Piazzetta's so-called *Group on the Sea shore*' in *Connoisseur*, 1959, vol. 143, pp. 96-100.

Whitfield, Clovis: 'A Programme for "Erminia and the Shepherds" by G. B. Agucchi' in *Storia dell'Arte*, 1973, pp. 217-229.

Whitley, W. T.: Artists and their friends in England 1700-1799, 2 vols., London 1928.

Wibiral, N.: 'Contributi alle ricerche sul Cortonismo in Roma—I pittori della Galleria di Alessandro VII nel Palazzo del Quirinale' in *Bollettino d'Arte*, 1960, pp. 123-165.

Wilhelm, F.: 'Neue Quellen zur Geschichte des fürstlich Liechtensteinschen Kunstbesitzes'

in *Jahrbuch des Kunsthistorischen Institutes der K.K. Zentralkommission*, 1911, Beiblatt pp. 87-142.

Wind, E.: 'Shaftesbury as a patron of art' in *Journal of the Warburg and Courtauld Institutes*, II 1938-39, pp. 185-188.

Wind, E.: 'Julian the Apostate at Hampton Court' in *Journal of the Warburg and Courtauld Institutes*, III, 1939-40, pp. 127-137.

Wittkower, R.: 'Domenico Guidi and French classicism' in *Journal of the Warburg and Courtauld Institutes*, II, 1938-39, pp. 188-190.

Wittkower, R.: The Earl of Burlington and William Kent—published by the York Georgian Society 1948.

Wittkower, R.: The sculptures of Gian Lorenzo Bernini, London 1955.

Wittkower, R.: Art and architecture in Italy 1600 to 1750, London 1958.

Wittkower, R.: Gian Lorenzo Bernini—the Sculptor of the Roman Baroque, Second edition, London 1966.

Wittkower, R. and Jaffé, Irma (edited by): Baroque Art: The Jesuit Contribution, New York 1972.

Woodward, J.: 'Amigoni as portrait painter in England' in *Burlington Magazine*, 1957, pp. 21-23.

Wright, Edward: Some observations made in travelling through France, Italy &c in the years 1720, 1721 and 1722, 2 vols., London 1730.

Wynne-Rosenberg, Giustiniana: Alticchiero, à Padoue 1787.

Zabeo, Prof. Prosdocimo: Memorie intorno l'antiquario Alvise Meneghetti, Venezia 1816.

Zanetti, A. M.: Varie pitture a fresco de' principali maestri veneziani, Venezia 1760.

Zanetti, A. M.: Della Pittura Veneziana, Venezia 1771.

Zanetti, Girolamo: Elogio di Rosalba Carriera letto in una privata sessione dell'Accademia di Belle Lettere ed Arti in Padova il di 6 Dicembre 1781, Venezia 1818.

[Zanetti, Girolamo]: 'Memorie per servire all'istoria dell'inclita città di Venezia' in *Archivio Veneto*, 1885, pp. 93-148.

Zannandreis, Diego: Le vite de' Pittori, Scultori e Architetti Veronesi—edizione a cura di Giuseppe Biadego, Verona 1891.

Zanotti, G. P.: Storia dell'Accademia Clementina, 2 vols., Bologna 1739.

Zarzabini, Padre Maestro Valerio Antonio: Serie storica de' Religiosi Carmelitani, Venezia 1779.

Zeri, F.: La Galleria Spada in Roma, Firenze 1953.

Zeri, Federico: Pittura e Controriforma, Torino 1957.

Zimmermann, H.: 'Über einige Bilder der Sammlung Streit im Grauen Kloster zu Berlin' in *Zeitschrift für Kunstwissenschaft*, 1954, pp. 197-224.

Zucchini, G.: 'Quadri inediti di Donato Creti' in *Comune di Bologna*, 1933, pp. 23-30.

INDEX

Notes

Surnames with the prefixes *de, van, von*, etc., are indexed under the principal name.

Authors mentioned in the Bibliography are included in the Index only when strictly relevant to the text. Modern authorities are referred to in the Index only when they have provided the author with unpublished material.